WILLIAM BLAKE

THE COMPLETE

ILLUMINATED BOOKS

by Kay Redfield

William Blake's World.
A New Heaven Is Begun

Morgan Library, New York
Through Jan. 3, 2010

"For a show titled *A New Heaven Is Begun*, there's a helluva lot of hell" on view at the Morgan's new exhibition of William Blake watercolor prints, said Barbara Hoffman in the *New York Post*. "Writhing serpents, cloven feet, tortured souls" were all grist for the mill of the visionary English poet and printmaker. Though considered a radical eccentric up to his death in 1827, Blake posthumously came to be seen as a master. By the early 1900s, J.P. Morgan had snapped up many of the watercolor prints that best encapsulated the artist's apocalyptic religious worldview, and they remain in the collection of his namesake museum. But since they can fade with the light, they're put on display only every other generation or so.

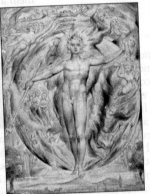

The Sun at His Eastern Gate
(c. 1896–20), from L'Allegra

divine justice drove him to create some of the most gorgeous illuminated texts ever, said Holland Cotter in *The New York Times*. Many volumes here contain his "difficult to decode" prophecies about world events, but even the strangest of these is worth studying for their glorious imagery. Blake also produced illustrated versions of his own most famous poems—including "Songs of Innocence and Experience"— *poems + art* using gorgeous printing techniques that still aren't completely understood. Finally, he created stunning interpretations of classic literary and religious texts. The "rock-star Satan" in his Book of Job makes evil seem convincingly "vivid and sexy." His late editions of two John Milton poems, by contrast, show an inspiring optimism. "Here happiness is a strapping English rose of a ballerina named Mirth, and joy is a nude sun god wreathed in flames."

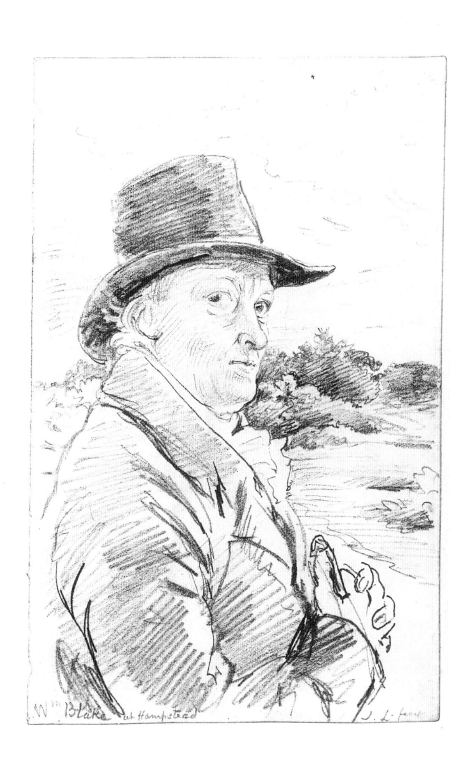

W^m Blake at Hampstead

William Blake

THE COMPLETE
ILLUMINATED BOOKS

With an introduction by
DAVID BINDMAN

With 393 plates, 366 in color

Thames & Hudson

IN ASSOCIATION WITH

THE WILLIAM BLAKE TRUST

© 2000 The William Blake Trust and The Tate Gallery
Text © 2000 David Bindman

First published in the United States of America in paperback in 2001 by
Thames & Hudson Inc., 500 Fifth Avenue,
New York, New York 10110

thamesandhudsonusa.com

Reprinted 2008

Library of Congress Catalog Card Number 00-101383

ISBN 978-0-500-28245-8

Printed in China by C & C Offset Printing Co. Ltd.

Contents

Foreword

THE PRESENT volume is the latest product of The William Blake Trust's commitment to the publication of Blake's Illuminated books. The endeavour began in 1951 when a splendid facsimile of the unique coloured copy of *Jerusalem*, printed by collotype and hand coloured by *pochoir* (stencil), was printed and published by Arnold Fawcus's Trianon Press in Paris. Over the next thirty or so years copies of all the other Illuminated books were similarly produced by Trianon on behalf of the Trust. The method of production employed, while ensuring astonishing verisimilitude to Blake's originals, was of necessity expensive and meant that the number of copies that could be printed was limited. On both counts, the books soon became collectors' items or confined to special collections in libraries.

These restrictions led the Trust in the late 1980s to plan a new edition of the Illuminated books, this time employing the greatly improved techniques of colour reproduction and printing that had by then been developed, in order to re-issue Blake's pages in affordable and accessible form. Unlike the earlier facsimiles, the new edition was to be fully edited by leading Blake scholars, under the general editorship of David Bindman. Between 1991 and 1995 the six volumes of the *Collected Edition of Blake's Illuminated Books* were published jointly by the Blake Trust and the Tate Gallery, and by Princeton University Press in North America. These volumes contain extended introductions, explications, notes and commentaries on the texts and plates, and together provide the currently most comprehensive presentation of Blake's key works as poet, artist and printer. It is the Trust's intention that the series shall continue to be available as a primary source for the better understanding of Blake's complex and often difficult meanings.

While thus fulfilling its responsibility to scholars, the Trust has been keenly aware that the pages of the Illuminated books offer delights for the eye and excitement to the imagination that are independent of full understanding of textual and visual significances. To make such satisfactions open to the widest possible public the Trust has re-assembled all the plates included in the six volumes of the Collected Edition into the present single volume; now, for the first time ever, all the Illuminated books are available in colour in concise and convenient form. The richness of the plates, together with David Bindman's new introduction, will extend even further the constituency of readers for whom Blake is a vital source of enjoyment and enlightenment. That the volume is being published by Thames & Hudson is gratifying endorsement of the Trust's aims and the best guarantee of their fulfilment.

As in all its endeavours, the Blake Trust is beholden and deeply grateful to the libraries, institutions and individuals who have generously made Blake materials in their care and ownership available for reproduction. Without the support of the community of Blake scholars world-wide and the collaboration of the Tate Gallery in the original publication of the Collected Edition, the purpose of the Trust to promote appreciation, understanding and enjoyment of Blake's work would not have been realised.

JOHN COMMANDER
Executive Director
The William Blake Trust

Introduction

WILLIAM BLAKE's 'Illuminated' books, as he called them, were a challenge to the way books had been made since the invention of movable type in the fifteenth century, and continued to be made until recently. In them, he produced text without the need for typesetting, and illustrated books without the need for separate plates. The traditional method was to produce the text by letterpress: metal type, set by a skilled craftsman, was printed on to paper as many times as required by another craftsman using a mechanical press. Illustrations, in Blake's time and later, were typically prepared by engraving or etching (both intaglio methods) on thin copper plates, which had to be run through a separate press because they required different pressures to squeeze the ink from lines incised into the plate. Blake's books, by contrast, are hand-made objects, individually produced by the author-artist himself, and even copies of the same book can differ from each other in the complement of pages, page order, colour, and occasionally the wording. Of course he could – and occasionally did – produce books with text and design printed entirely in intaglio, but these were less striking in effect, needed a special press, and the print-run would be limited because of wear on the copper.

They are, nonetheless, *printed*, despite the handwork that went into each copy. Their print-runs were limited by what he could print off by hand, varying from a single copy to fifty at most. All but a few of the volumes and plates here reproduced use a technique of Blake's own invention, a form of etching in relief that he called 'Illuminated' printing, perhaps in reference to medieval illuminated manuscripts in which text and pictures were combined. Relief etching allows the dynamic integration of text and design on the same page, and enables the artist to work on a book from start to finish, without the intervention of a professional printer, a particular advantage for someone bringing uncomfortable theological and political messages to the world.

Blake's invention was to make a copper engraving plate into the equivalent of a woodcut block, printing not from incised lines but from the raised surface: his method involved etching away with acid the parts of the surface that did *not* print, while protecting the text and design to be printed (which he had probably drawn in reverse on the plate) with a 'stopping-out' solution resistant to the acid. This is an exceptionally demanding process to devise and to execute. The acid can easily get out of control, as it clearly did in experimental plates, but once the plate was completed it could, in theory at least, like a woodcut be used for a limitless number of impressions. For this reason Blake was able to persuade himself that his method could empower and liberate all writers, enabling them to express themselves freely to a universal audience without leave from worldly authority. He announced exultantly in a prospectus of 1793:

> The Labours of the Artist, the Poet, the Musician, have been proverbially attended by poverty and obscurity; this was never the fault of the Public, but was owing to a neglect of means to propagate such works as have wholly absorbed the Man of Genius. Even Milton and Shakespeare could not publish their own works. This difficulty has been obviated by the Author of the following productions now presented to the Public; who has invented a method of Printing both Letter-press and Engraving in a style more ornamental, uniform, and grand, than any before discovered, while it produces works at less than one fourth of the expense.

Blake thus made an extraordinary claim for his invention: it allowed literature and art to be universal, enabling the author-artist to pass on his vision of liberation to the world without the

mediation of those hostile to that vision. The few Illuminated books that Blake was actually able to produce, and the care he lavished on each copy, might seem to mock his universal ambitions, but then he was, like other prophets, well aware that he might not live to see the day when 'all God's Children were Prophets'. His new method offered the *hope* that poets and artists would finally have the means to drown out the ubiquitous message of Satan, carried by religious and state ritual and the printing press.

The mature Illuminated books of the 1790s are predominantly prophetic and apocalyptic, responding to the upheavals of the times by invoking Biblical parallels and predictions. Prophecy was in Blake's bones, but he was also a craftsman, brought up in London among the small traders of Soho. He was born in 1757, and his background would have made it inevitable that his early promise as a draftsman would have led him towards engraving, rather than towards the more prestigious career of a painter. He became apprenticed to the well-known engraver James Basire in 1772, and learned a rather old-fashioned style of commercial rather than artistic engraving, working mainly on antiquarian publications. When he completed his apprenticeship in 1779 he was thus equipped with skills that were to guarantee a modest but steady income for life, and in his case engraving did remain a regular if inexorably declining source of money. Commercial engraving was laborious and tedious, even soul-destroying, but Blake's eye was always on the Royal Academy, founded as recently as 1768, where the ideals of art in the grand style were taught and serious paintings were exhibited. For the rest of his life, despite every possible discouragement, he retained the ambition to be a public artist, making designs for large-scale paintings to be shown in public places, though he never had the opportunity to realise them.

He was then a professional engraver, but he occasionally exhibited watercolours of mainly Biblical subjects at the Royal Academy, and he was – in early years at least – on good terms with many of the leading artists who specialised in the imaginative treatment of historical and literary subjects, like the sculptor John Flaxman and the Swiss painter Henry Fuseli. In addition he had been a poet from an early age, thoroughly steeped in the learned English tradition of Milton and Shakespeare. From his earliest years there was a tension between a prophetic desire to excoriate materialism and false religion, and the need to make his way as an artist in the competitive and materialistic climate of late eighteenth-century London. There was also tension between his profession as engraver, working essentially for luxury trades, and his belief in the divine mission of art.

Blake's distinctive achievement in the Illuminated books derives ultimately from his ability to create a unity out of the potentially fragmentary aspects of his life, by refusing to be confined within the professional compartments of printmaking, painting and poetry. Life, work and art were to be indivisible, united by the idea that all art was a form of prayer. Blake's passionate sincerity and spiritual ambition were always at war with material circumstances, but he was able to bring an almost superhuman energy and technical ingenuity to his desire to give concrete expression to his visions. At the same time the urgency of prophecy is frequently leavened by allusions to the mundane life of struggle as a jobbing engraver with ambitions above his station.

Experience of the constraints of reproductive engraving convinced Blake quite early that he would have to publish his own poetry and designs. The idea of self-publication was very much in the air, with printers applying for patents, and artists like Gainsborough and Stubbs

publishing their own designs. Blake developed the method of Illuminated printing around 1788, following a period of crisis caused by the death of his beloved younger brother Robert: he later claimed that his recently dead brother had imparted the secret to him in a vision, and what appear to be the first works in the new method, *There is no Natural Religion* and *All Religions are One*, probably date from this time. The first completely successful use of the technique was in his most popular and enduring work, *Songs of Innocence*, which appeared in 1789. Less forbidding than much of his later work, it became something of a standby for him. He was able to produce copies for the rest of his life, in 1794 combining it with *Songs of Experience*, colouring them on demand or making small editions.

The *Songs of Innocence* were pastoral poems, ostensibly directed towards children, and the pastoral is also present in the contemporary *Book of Thel*. It gives way, under the growing impact of the revolutionary events in France and their ramifications in Britain, in *The Marriage of Heaven and Hell* (*c.* 1790) and *Visions of the Daughters of Albion* (1793). The last bears the marks of the circle of radical liberals gathered around the publisher Joseph Johnson, which included Mary Wollstonecraft, whose hopes of sexual and political liberation affected the vision of national and individual redemption that dominates the subsequent Illuminated books. The books *America a Prophecy* (1793) and *Europe a Prophecy* (1794) represent a turning point: both have the word 'Prophecy' in their title, and Blake thereby placed himself openly in the succession to the prophets of the Old Testament and the bards of ancient British history, warning of the need for moral transformation in the face of imminent apocalypse. The voice of apocalyptic warning had been heard from at least the Middle Ages, and in England especially strongly in the seventeenth century. Blake's art and poetry are apocalyptic to the core; almost everything he wrote or designed makes a direct or an oblique reference to the Book of Revelation, its contempt for worldly power, the threat of earthly destruction, and the ultimate promise of a New Jerusalem.

The Book of Revelation was something of an embarrassment for orthodox churchmen in the eighteenth century, but it continued to flow through the popular culture, to surface with the American War of Independence, and the French Revolution of 1789. Apocalyptic expectations in England reached their highest point, to government alarm, as civil order deteriorated in France in the years 1793 and 1794. For Blake and others of a prophetic cast, like Richard Brothers, 'the Nephew of the Almighty', the French Revolution was not a portent of the impending fulfilment of the prophecy of Revelation, it was a sign that *the process of Revelation had already begun*. The French Revolution, and even the English Revolution of the seventeenth century with its civil war, fire and plague, were proof that the Four Horsemen of the Apocalypse, Conquest, War, Famine and Death, had already begun their journey, and would not rest until the Antichrist and Satan had been purged from humanity.

The Prophecies *America* and *Europe* make up with *The Song of Los* (Asia and Africa) of 1795 the 'Continental Books'. They are also part of a larger prophetic group that includes *The First Book of Urizen* (1794), *The Book of Ahania* (1795) and *The Book of Los* (1795). These books show Blake at his most sublime. The overwhelming note is of conflict, human despair and suffering, and the effects of malign power; the rhetoric is of disjunction – between text and design, between different authorial voices, and between matter and spirit. Some at least were clearly written and etched as news was breaking of the Terror and (almost as shocking to Blake) of Robespierre's reinstatement of the cult of the 'Supreme Being' in France, and of the repression of radical sympathisers at home. There is no doubt that Blake felt in personal

danger in this period; people who held similar views were examined as potential traitors, or were confined as lunatics, like Richard Brothers.

The Prophetic books of 1793–95 show that Blake was now in possession of an extraordinary new method that gave him limitless possibilities of playing off text and design against each other. Tiny figures and forms dance among the lines of the text, flames appear to burn up the page, and dense passages of Biblical-sounding text are brought to a jarring halt by startling images of death, destruction and liberation. Sometimes an image acts in counterpoint to the text nearby; at other times the images form sequences that appear to be independent of the text. The connections between the books of this period can also be hard to fathom, but they are perhaps best seen as making up a kind of Bible, some, like *The First Book of Urizen*, dealing with the creation of the earth, and others, like *America* and *Europe*, showing the perversion of Christianity by Church and State in modern times.

From 1794, the Prophetic books show another technical innovation: a new method of colour printing. It was a form of monotype, producing only a very small number of impressions, but enabling very striking effects. Blake seems to have coloured up with stiff inks the relief-etched surface of the copper plate and to have printed off the design onto paper; there, areas of detail such as faces could be finished with pen or a light wash of watercolour. As he could only get about three impressions from each application of colour to the plate, it saved little labour, but the mysterious effects could not have been obtained by any other means. The effect is intentionally sinister, and is used to suggest the primeval chaos of the material world's formation, or the effects of divine wrath. Colour printing is used to outstanding effect in copies of all the books dated 1794–95, and he later published separate volumes, known as *The Small* and *The Large Book of Designs*, purely to demonstrate the possibilities of his new method (complete copies are in the British Museum).

Blake virtually gave up relief etching in the years 1796–1804, probably because he was engaged in thinking through a new synthesis of his myth, the workings of which are to be found in the unfinished manuscript *Vala or the Four Zoas* (British Library). His return to Illuminated printing came probably towards the end of a three-year stay in the coastal village of Felpham in Sussex, what he called his 'three years slumber on the banks of the Ocean', his only long period of residence outside London. The result was his two last and most ambitious works, *Milton a Poem* and *Jerusalem*, both of which are dated 1804, but which went on, in bursts of activity, into the 1820s. *Milton* is essentially an autobiographical meditation on his mentally turbulent time in Felpham, a kind of *apologia* for prophecy, while *Jerusalem*, consisting of one hundred plates of relief-etched text and images, is the culmination of a lifetime of artistic and visionary progress.

Jerusalem remains a work of almost legendary complexity, on a far grander scale than any of Blake's earlier prophecies. Most of the plates are relief-etched, but there is much additional white-line work (lines are cut into the copper as in intaglio, but in the relief process they remain uninked), giving an unearthly luminosity to many of the images. *Jerusalem* presents a vision of national and universal redemption, the restoration of the primal unity of man and Britain, embodied in the figure of Albion. Albion is represented as lying in a state of Job-like misery and division until he is redeemed towards the end of the final book, though Blake makes it clear that he still thinks that Britain is firmly in the grip of materialism. Albion is divided from Jerusalem the object of his quest, from his sons and daughters, from the nations,

from Christ and the spirit, and from all the other creatures on earth. Jerusalem as a woman represents the prospect of the healing of Albion's divided self, but as a city she is the goal of humanity's quest for redemption.

Jerusalem is only to be reached by individual and national rejection of materialism, the 'God of this World', the Moral Law, the church of ceremony and ritual, and the domination of reason, and as a state of being is only glimpsed in the final vision in the last few pages of the volume. Against the materialistic domination of Albion's Children are set the spiritual example of Jesus and the arts of painting and poetry, and music. The artist Los is the primary agent of national awakening, and his sufferings mirror those of Albion; he is consoled only by a vision of a Jerusalem that might be built on the site of London, now little more than a Babylon ripe for destruction.

The final question to be addressed is: why are Blake's Illuminated books so hard to understand, even for professional scholars, when he proclaimed, though admittedly not consistently, a desire that the books should reach a universal audience? There are many possible reasons for this. One is that they are syncretic: they attempt to combine many myths and histories, pagan and Christian, into one. They are also psychodramas, the action of all the books taking place notionally within the mind of a single person. All the characters with names of Blake's invention, like Los, Urizen, Orc and Enitharmon, have multiple roles. Urizen, for instance, appears to resemble Jehovah, Jupiter, warrior figures from Assyrian reliefs, and even George III in his madness, and as a generic tyrant he is all of these. He is also an aspect of the human mind, representing unconfined rationality, the effects of his actions the consequences of a mind lacking imagination or compassion. Similarly Los is the creative, imaginative force, the poet, the artist, and the architect throughout the ages, forced to give an acceptable form to Urizen, but enslaved by his own creation.

A realisation that there are different levels of meaning does not, however, make the Prophetic books easy to decipher, nor did Blake intend us to find them so. A certain obscurity of meaning was a protection; it had been understood since the Church Fathers that the Bible had been preserved from distortion because those who wished to distort it did not understand it well enough to be able to do so. Blake's larger motive, as far as we can discern it, was to lead the reader into a process of perpetual discovery, without the closure given to a simple understanding. It is for the reader to tease out meanings, make connections, get to know the characters, and in the process to move further into the work. For Blake salvation was a lifetime's journey, and his books were guides that would always reveal new wisdom. As he put it himself in the address to 'the Christians' in *Jerusalem*,

> I give you the end of a golden string,
> Only wind it into a ball:
> It will lead you in at Heavens gate,
> Built in Jerusalems wall.

DAVID BINDMAN

Looking Further into Blake

For present-day readers this compendium of reproductions of fine examples of all of Blake's Illuminated books offers immense delight and unfolding enlightenment, but many will want to go further into Blake's world, or simply want an explanation, as far as it can be given, of particular characters or episodes. Readers who want to know more are advised to seek out the series of six volumes already published by the Blake Trust: *Blake's Illuminated Books*, edited by David Bindman, published in the UK by The William Blake Trust/The Tate Gallery, London, and in the USA by The William Blake Trust/Princeton University Press, which appeared in hardback in 1991–95 and in paperback in 1998. Each has the plates and transcripts of Blake's texts as in the present volume, and in addition, a lengthy introduction and full page-by-page commentary and textual notes by a noted Blake scholar.

The volumes are edited as follows:

Paley, M. D., *Jerusalem The Emanation of the Giant Albion* (*Blake's Illuminated Books*, vol. 1), 1991

Lincoln, A., *Songs of Innocence and Experience* (*Blake's Illuminated Books*, vol. II), 1991

Eaves, M., R. N. Essick and J. Viscomi, *The Early Illuminated Books* (*Blake's Illuminated Books*, vol. 3), 1993

Dörrbecker, D. W., *The Continental Prophecies* (*Blake's Illuminated Books*, vol. 4), 1995

Essick, R. N., and J. Viscomi, *Milton a Poem* (*Blake's Illuminated Books*, vol. 5), 1993

Worrall, D., *The Urizen Books* (*Blake's Illuminated Books*, vol. 6), 1995

Further reading

Bindman, D., *Blake as an Artist*, Oxford, 1977

—— *The Complete Graphic Works of William Blake*, London, 1978

—— *William Blake, His Art and Times*, New Haven/London, 1982

Butlin, M., *The Paintings and Drawings of William Blake*, 2 vols, New Haven/London, 1981

Erdman, D. V., *The Illuminated Blake*, New York, 1975

Essick, R. N., *William Blake, Printmaker*, Princeton, 1980

—— *The Separate Plates of William Blake*, Princeton, 1983

Foster Damon, S., *A Blake Dictionary*, London, 1973

Lindberg, B., *William Blake's Illustrations to The Book of Job*, Abo, 1973

Paley, M. D., and M. Phillips, eds, *William Blake: Essays in Honour of Sir Geoffrey Keynes*, Oxford, 1973

Viscomi, J., *Blake and the Idea of the Book*, Princeton, 1993

Readers who wish to explore Blake's Illuminated books via the internet may consult 'The William Blake Archive' at *blake@jefferson.village.virginia.edu.* whose well-organised site provides fine quality reproductions of a widening range of copies, together with detailed analyses of texts and images.

A Chronology of Blake and his Times

BLAKE'S LIFE

1757
28 Nov.: William Blake born at 28 Broad Street, Golden Square, Soho, London.
11 Dec.: baptised in St James's Church, Piccadilly.
1767–68
Probably enters Henry Pars's drawing school in the Strand.
1772
Begins as apprentice to the engraver James Basire.
1779
8 Oct.: admitted to the Royal Academy schools as engraver. Probably drops out in first year, setting up as a commercial engraver.
1780
Exhibits at the Royal Academy a watercolour, *The Death of Earl Goodwin*.
1782
18 Aug.: marries Catherine Butcher (or Boucher).
1783
Publication of a volume of poems, *Poetical Sketches*.
1784
Exhibits two watercolours at the Royal Academy. Death of Blake's father. Opens print shop with the engraver James Parker.
1785
Exhibits at the Royal Academy four watercolours.
1787–88
11 Feb. 1787: burial of Blake's brother Robert. First experiments with Illuminated printing.
1789
Songs of Innocence and *The Book of Thel.*

1790
Moves to Hercules Buildings, Lambeth.
Begins *The Marriage of Heaven and Hell.*

BLAKE'S TIMES

1760s
Age of new prosperity, beginnings of technological developments that led to the Industrial Revolution, and enormous imperial gains abroad, but also beginnings of constitutional unrest.

1770s
Captain Cook's explorations in the South Pacific; growing conflict with American colonies.
1774–76
Outbreak of conflict in American colonies, culminating in the Declaration of Independence in 1776, and war with the new United States.

1780
Anti-Catholic Gordon Riots break out in London with much destruction; Blake participates, according to legend.

1783
Peace treaty with and recognition of the United States.

1788
Bill to abolish slavery before Parliament.

1789
14 July: outbreak of the French Revolution with the taking of the Bastille. Blake, along with other poets and most of the population, greets the events in France with enthusiasm, seeing them as following from the American revolt of the previous decade.

1790
Removal of the privileges of the nobility and Church in France, and beginnings of divisions between radicals and moderates in the French assembly.

1791
Feb.: publication of Tom Paine's *Rights of Man.*
June: unsuccessful flight of the French royal family, who are brought back and confined to the Tuileries.

1792

Death of Blake's mother.

1792

Growing external threats to France and internal division, leading to the attack on the Tuileries, the imprisonment of the royal family (10 Aug.), and the declaration of a French republic (22 Sept.).

In England, growth of radical organisations, encouraged by the spread of Paine's *Rights of Man*, and growing unease among constitutionalists, culminating in the foundation of the Association for Preserving Liberty and Prosperity against Republicans and Levellers, to campaign against revolutionary ideas.

1793

Visions of the Daughters of Albion and *America*.

1793

Execution of the French King (21 Jan.), followed almost immediately by war between England and France.

In France the radicals (Montagnards) take power (June); the 'Terror' begins (Sept.). Execution of Marie Antoinette (16 Oct.).

In England, growing execration and isolation of radicals like Blake, under threat from increasingly nervous government.

1794

Songs of Experience, Europe and *The First Book of Urizen*. Develops colour-printing methods.

1794

8 June: Festival of the Supreme Being in Paris, a cause for disquiet on Blake's part.

27–28 July: Robespierre executed, and end of Terror.

Oct.–Nov.: assault on English radicals continues with Treason Trials, potentially threatening to Blake and some of his associates.

1795

The Song of Los, The Book of Ahania and *The Book of Los*.

1795

Attacks on English radicals unabated, culminating in Seditious Meetings and Treasonable Practices Act (Nov.–Dec.).

1796

Probably begins work on *Vala or the Four Zoas*.

1796

Rise of Bonaparte, and French preparations to invade Ireland.

1797

Engravings for Edward Young's *Night Thoughts* published, including 43 engravings from a total of 537 watercolours made by Blake.

1797

April: British naval mutinies.

1798

Threat of French naval invasion of England eventually forestalled by defeat of Irish rebellion, and Nelson's victory over the French fleet at the battle of the Nile.

1799

Exhibits at the Royal Academy a tempera painting. Patronage of Thomas Butts begins.

1799

Nov. 9–10: Bonaparte's *coup d'état*.

1800

Exhibits at the Royal Academy a tempera painting. 18 Sept.: moves to Felpham near Chichester to work for William Hayley.

1801–3
Working on watercolours for Butts and minor projects for Hayley, producing mainly book illustrations.
12 Aug. 1803: incident with a soldier, John Scholfield, that leads to a charge of sedition.
19 Sept.: returns to London.

1804
11 Jan.: acquitted on sedition charge. Date on title-pages of *Milton a Poem* and *Jerusalem*, both probably begun at Felpham.
1805
Commissioned by Robert Cromek to illustrate Robert Blair's *The Grave*. Probably working on first watercolours for *The Book of Job*.
1806
Probably working on *Milton a Poem*, *Jerusalem*, and watercolours for Butts.
1807
Portrait of Blake by Thomas Phillips exhibited at the Royal Academy.
1808
Exhibits at the Royal Academy two Butts watercolours. Publication of Blair's *The Grave* illustrations, engraved by Luigi Schiavonetti.
1809
May: opening of Blake's own exhibition with *Descriptive Catalogue*.
1810
Works on engraving of *Canterbury Pilgrims*.

1811
Publication of Henry Crabb Robinson's 'William Blake, Künstler, Dichter, und Religiöser Schwärmer' in *Vaterländisches Museum*, Hamburg.
1812
Exhibits three large tempera paintings and specimen pages from *Jerusalem*.
1813–17
Blake drops almost completely out of sight except for reported visits from his friend George Cumberland, who remarks on his poverty and activity. Working on a large tempera painting of *The Last Judgment*, now lost but known from drawings.

1801
Union of Great Britain and Ireland.
1802
Peace of Amiens brings brief period of peace between Britain and France.
1803
Threat of French invasion of England accounts for nervousness that causes Blake to be arrested on the Sussex coast as a possible spy.
1804
Bonaparte crowns himself Emperor.

1805
Nelson's victory over French and spanish fleets at Trafalgar.

1806
Extinction of the Holy Roman Empire.

1807
Slave-trading now illegal in Britain.

1810
High point of Napoleon's power, with annexation of Holland and much of North Germany.
1811
Prince of Wales becomes Regent.

1812
War between Britain and United States; French defeated in Spain and Russia.
1813
Napoleon defeated at Leipzig.
1814
Napoleon defeated and exiled to Elba. Bourbons return to power under Louis XVIII.
1815
Napoleon's return to power in Paris lasts 100 days until he is defeated at Waterloo by British and German armies.

1818

Decisive meeting with John Linnell, the great patron and facilitator of his last years, through George Cumberland, Jr. Linnell introduces Blake to a new generation of artists.

1819–20

Work on 'Visionary Heads' for John Varley.

1821

Publication of woodcut illustrations to R. J. Thornton's *Virgil*. Moves to 3 Fountain Court, off the Strand.

1822

Receives distress payment from the Royal Academy.

1823

Linnell commissions *Book of Job* engravings.

1824

Visits Linnell (who has moved to Hampstead) and the Royal Academy with Samuel Palmer.

1825

Meets most of the circle of painters known as 'The Ancients' through Palmer. Meets for the first time and is interviewed by Henry Crabb Robinson. Begins Dante watercolours commissioned by Linnell.

1826

Publication of *Book of Job* engravings to modest acclaim. Works intensively on Dante watercolours.

1827

12 Aug.: Blake dies at 3 Fountain Court, still working on the Dante watercolours.

1816–20

Beginning of a long period of social unrest in England, and frequent demonstrations for social and political reform.

1820

With the death of George III, the Prince Regent becomes George IV.

1820–27

Growing evidence of industrialisation, urbanisation and prosperity, especially in London.

1824

Charles X becomes king after the death of Louis XVIII.

1825

First railway opens in England between Stockton and Darlington.

Notes on the plates

All the plates in this volume reproduce Blake's originals same size with the exception of *Laocoön* (page 403), which is reduced by approximately thirty per cent.

In the introductions preceding the individual books Blake's originals are identified alphabetically ('Copy A', 'Copy B' etc.). The letters refer to Geoffrey Keynes and Edwin Wolf, *William Blake's Illuminated Books: A census*, New York, 1953.

All Religions are One

c. 1788, as printed c. 1795

Plate 1 from the Keynes Collection, Fitzwilliam Museum, Cambridge. Plates 2-10 from the Huntington Library, San Marino, Calif.
Relief etchings, touched with pen.

There is No Natural Religion

c. 1788

Pierpont Morgan Library, New York. As printed *c.* 1794, copies G and I; and as printed *c.* 1795, copy L. [These two series are made up from leaves from a number of copies, and are certainly incomplete.]
Relief etchings, touched with pen.

All Religions are One and the two tracts grouped under the title of *There is No Natural Religion* are a direct assault on Deism (made synonymous with 'Natural Religion'), in the form of a series of propositions demonstrating the existence of a world beyond the senses, and associating the Poetic Genius with the Spirit of Prophecy. The tracts seem not to have been issued at the time of their etching (*c.* 1788): all known copies appear to have been printed later, and left as loose sheets by Blake. They are usually taken to be Blake's first attempts to unite text and design through the medium of relief etching.

Blake's aphorisms propound principles fundamental to his thought and art, more fully developed in later books in Illuminated printing.

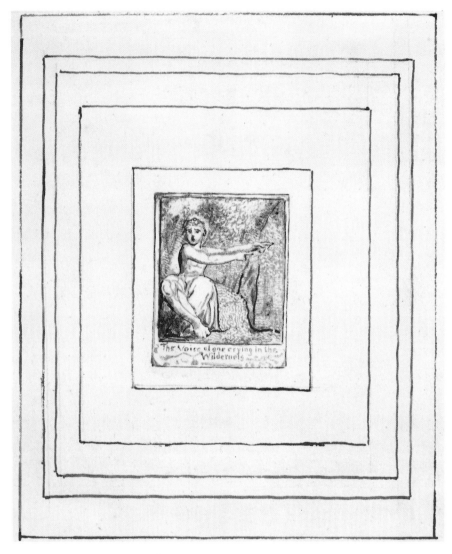

The Voice of one crying in the
Wilderness

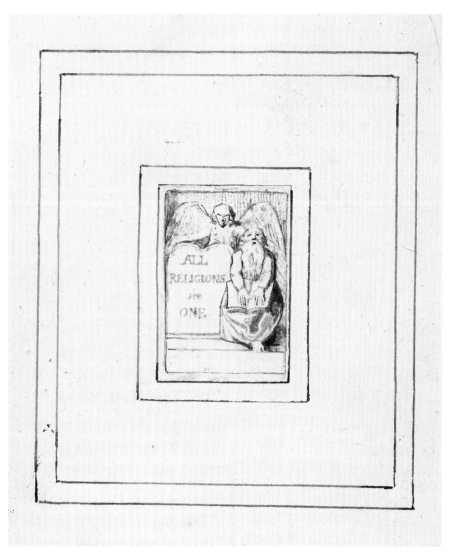

ALL

RELIGIONS

are

ONE

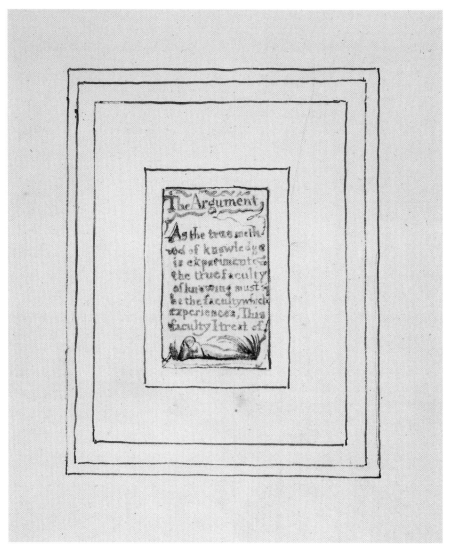

The Argument

As the true meth-
-od of knowledge
is experiment
the true faculty
of knowing must
be the faculty which
experiences, This
faculty I treat of.

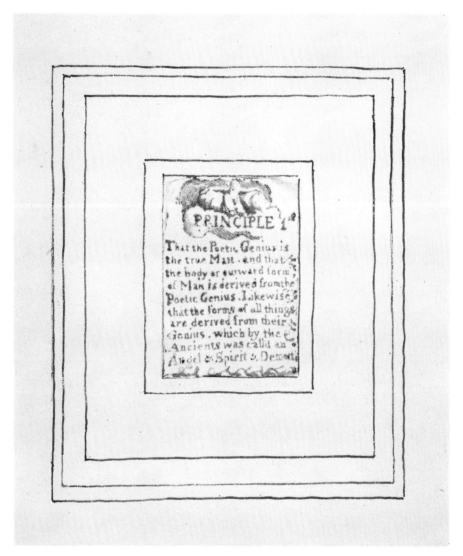

PRINCIPLE 1st

That the Poetic Genius is
the true Man. and that
the body or outward form
of Man is derived from the
Poetic Genius. Likewise
that the forms of all things
are derived from their
Genius. which by the
Ancients was call'd an
Angel & Spirit & Demon.

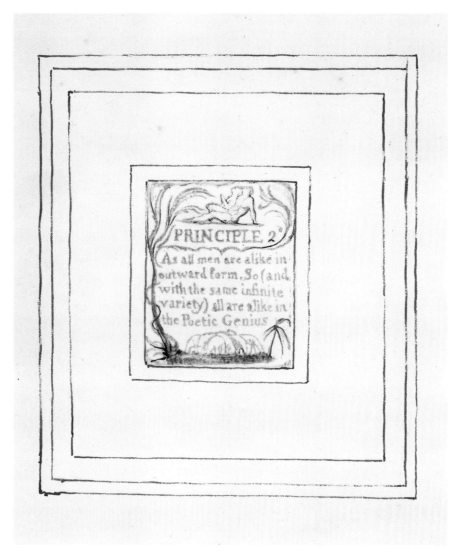

PRINCIPLE 2d

As all men are alike in
outward form, So (and
with the same infinite
variety) all are alike in
the Poetic Genius

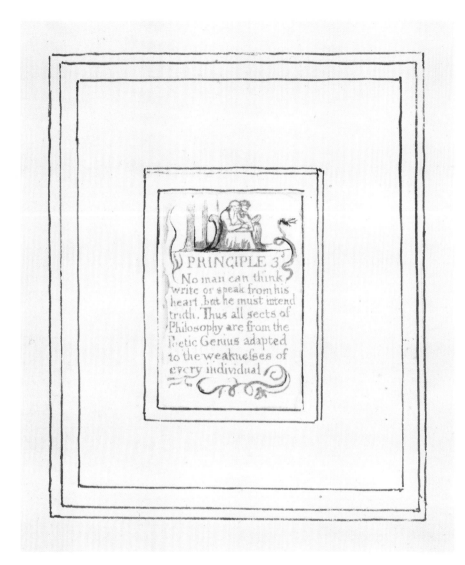

PRINCIPLE 3d

No man can think
write or speak from his
heart but he must intend
truth. Thus all sects of
Philosophy are from the
Poetic Genius adapted
to the weaknesses of
every individual

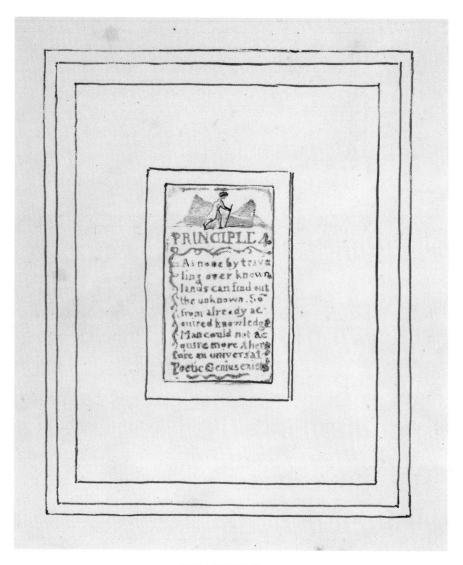

PRINCIPLE 4.

As none by trave
ling over known
lands can find out
the unknown. So
from already ac-
quired knowledge
Man could not ac
quitre more. there
fore an universal
Poetic Genius exists

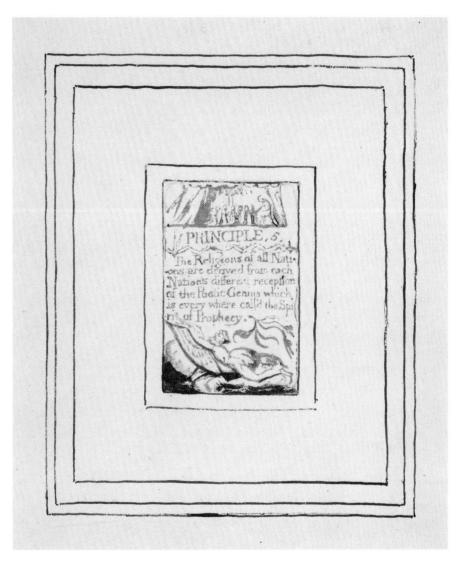

PRINCIPLE, 5

 The Religions of all Nati-
-ons are derived from each
Nations different reception
of the Poetic Genius which
is every where call'd the Spi
-rit of Prophecy.

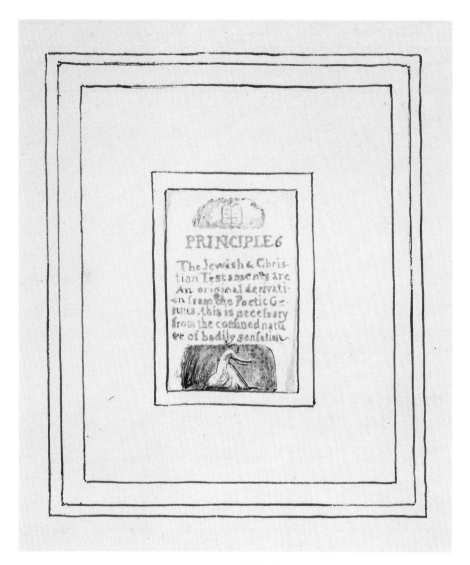

PRINCIPLE, 6

The Jewish & Chris-
tian Testaments are
An original derivati-
-on from the Poetic Ge-
nius. this is necessary
from the confined natu
re of bodily sensation

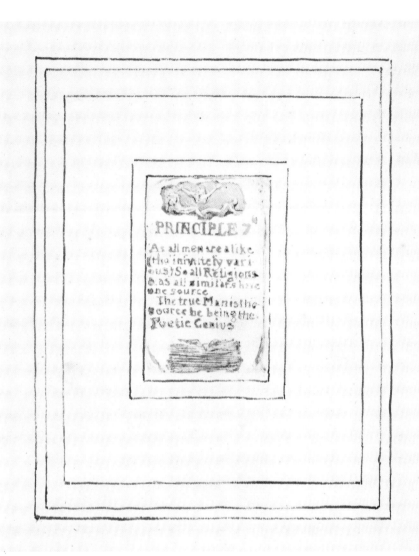

PRINCIPLE 7th

 As all men are alike
(tho' infinitely vari-
ous) So all Religions
& as all similars have
one source
 The true Man is the
source he being the
Poetic Genius

There is No Natural Religion

as printed *c.* 1794

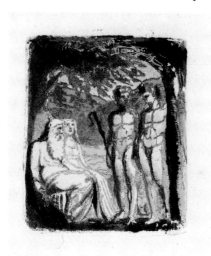

The Author & Printer W Blake

[In reverse lettering, obscured by hand colouring]

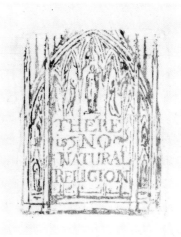

THERE

is NO

NATURAL

RELIGION

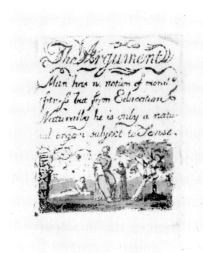

The Argument

Man has no notion of moral
fitness but from Education
Naturally he is only a natu-
ral organ subject to Sense.

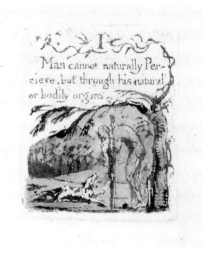

I

Man cannot naturally Per-
cieve, but through his natural
or bodily organs

II

Man by his reason-
ing power. can only
compare & judge of
what he as already
perciev'd.

III

From a perception of
only 3 senses or 3 ele
-ments none could de-
-duce a fourth or fifth

IV

None could have other
than natural or organic
thoughts if he had none
but organic perceptions

V

Mans desires are
limited by his percepti
ons. none can de-
-sire what he has not
perciev'd

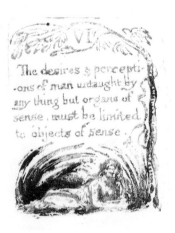

VI

The desires & percepti-
-ons of man untaught by
any thing but organs of
sense, must be limited
to objects of sense.

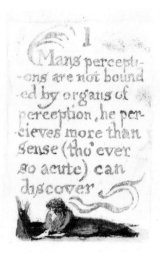

I

Mans percepti-
-ons are not bound
-ed by organs of
perception, he per-
-cieves more than
sense (tho' ever
so acute) can
discover

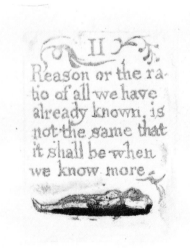

II

Reason or the ra-
-tio of all we have
already known. is
not the same that
it shall be when
we know more

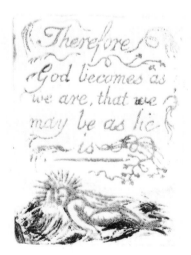

Therefore

God becomes as
we are, that we
may be as he
is

There is No Natural Religion
as printed *c.* 1795

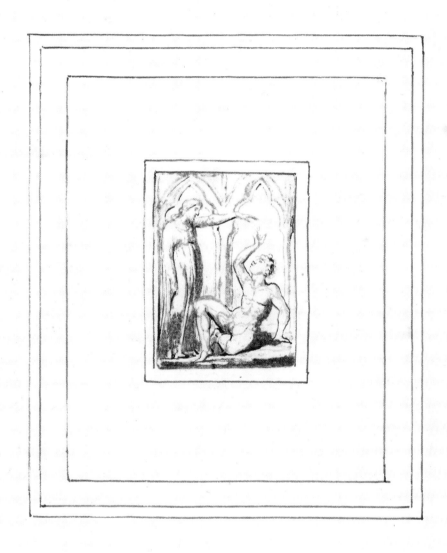

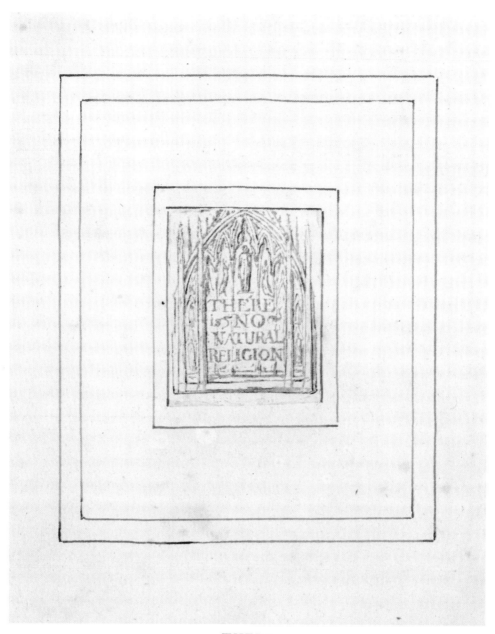

THERE
is NO
NATURAL
RELIGION

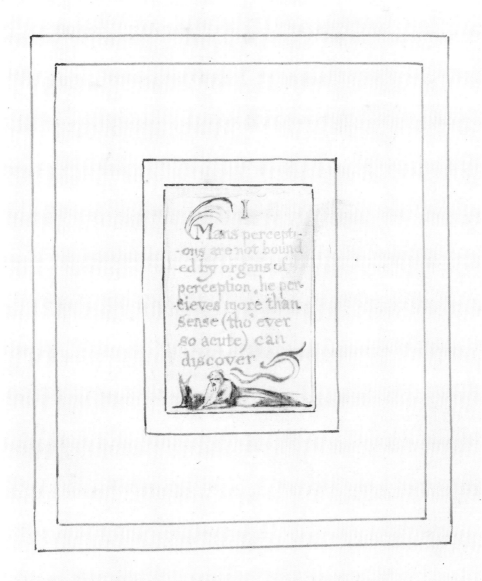

I

Mans percepti-
-ons are not bound
-ed by organs of
perception, he per-
-cieves more than
sense (tho' ever
so acute) can
discover

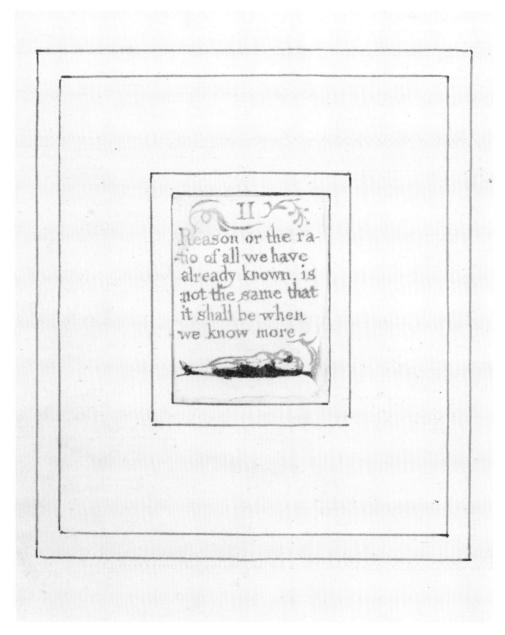

II

Reason or the ra-
-tio of all we have
already known, is
not the same that
it shall be when
we know more

There is no extant impression or record of a plate numbered III

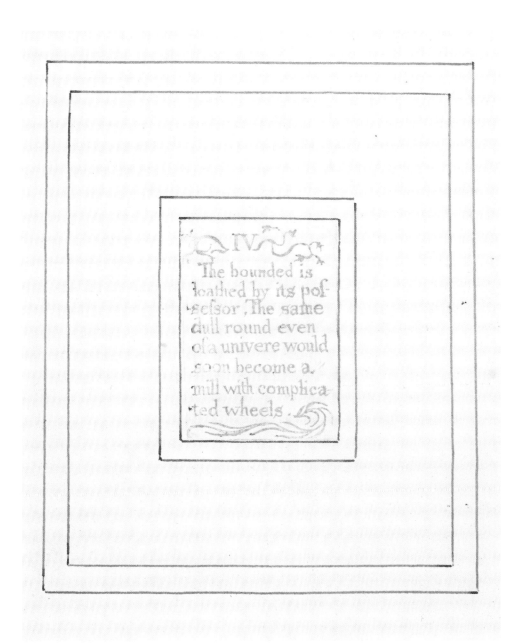

IV

The bounded is
loathed by its pos-
-sessor, The same
dull round even
of a univer[s]e would
soon become a
mill with complica-
-ted wheels.

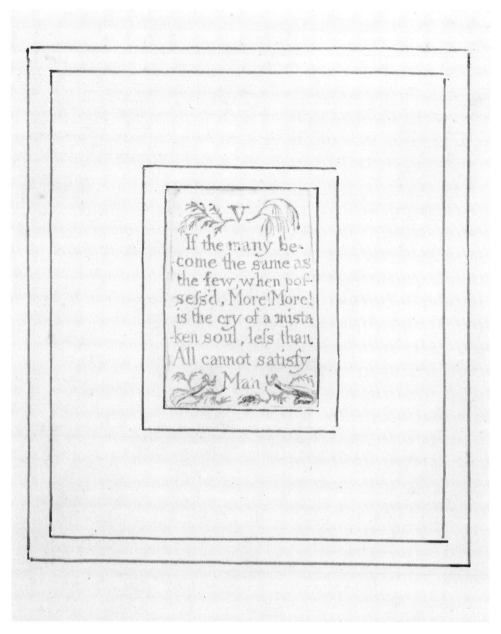

V

If the many be-
-come the same as
the few, when pos-
-sess'd, More! More!
is the cry of a mista
-ken soul, less than
All cannot satisfy
Man

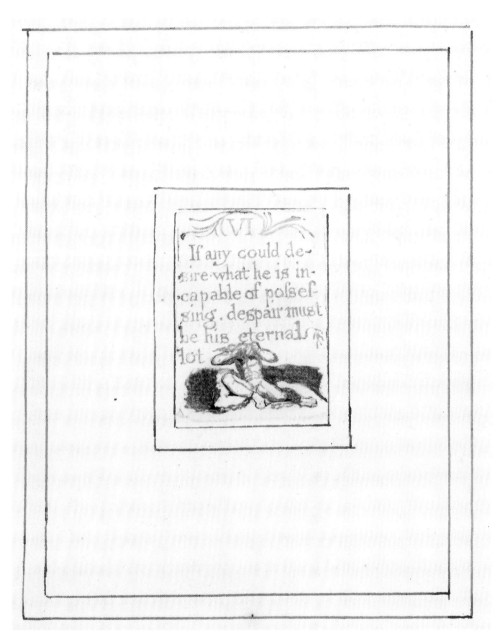

VI

If any could de-
-sire what he is in-
-capable of posses-
sing, despair must
be his eternal
lot

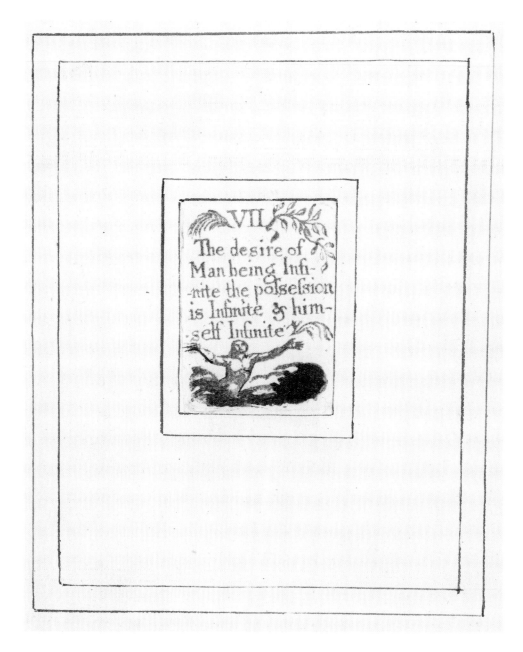

VII

The desire of
Man being Infi-
-nite the possession
is Infinite & him-
-self Infinite

Conclusion

If it were not for the
Poetic or Prophetic
character, the Philo-
-sophic & Experimen-
-tal would soon be
at the ratio of all
things. & stand still,
unable to do other
than repeat the same
dull round over a-
-gain

Application

He who sees the in-
-finite in all things,
sees God. He who
sees the Ratio only
sees himself only

Therefore

God becomes as
we are, that we
may be as he
 is

Songs of Innocence and of Experience

1789 and 1794

King's College, Cambridge. Copy W.
Relief etchings, with pen and watercolour, touched with gold.

Songs of Innocence is a collection of pastoral poems, some of which probably date from very early in Blake's career. They can be read as children's poems, but they subsume profound meditations upon the state of childhood and the presence of Christ. The influence of Swedenborg is evident. *Songs of Experience* was added to it in 1794, many of the poems being counterparts from the Fallen world of the poems in *Innocence,* though in early copies of the combined volume at least three of the plates can be found in either part.

Songs of Innocence and of Experience was the one Illuminated book to achieve even limited success in Blake's lifetime, and he reprinted and coloured it until the very end of his life. There are some twenty-four known copies of the combined volume; the present copy dates from his last three years. It remained in the possession of Blake's widow after his death and the exceptional care in finish, colouring and decoration may indicate that this copy had some special significance for the Blakes.

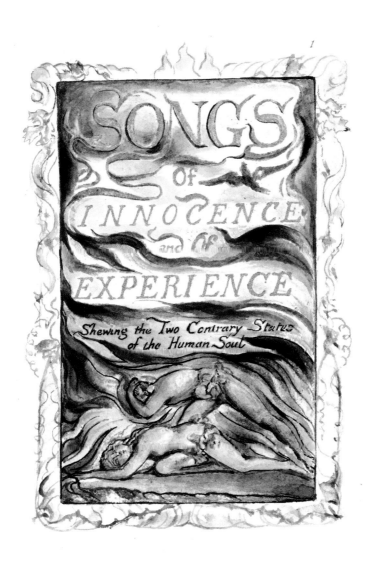

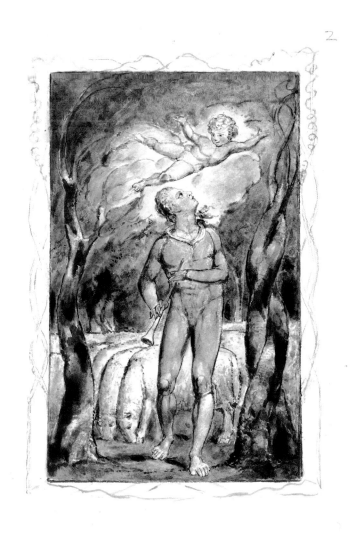

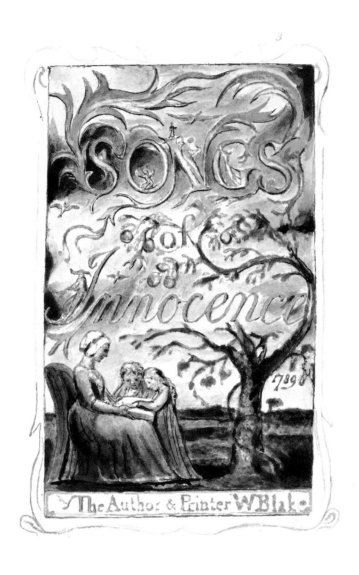

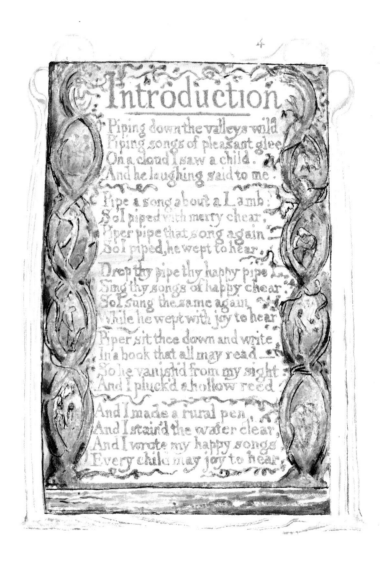

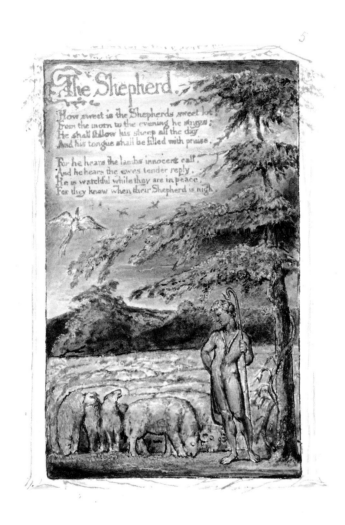

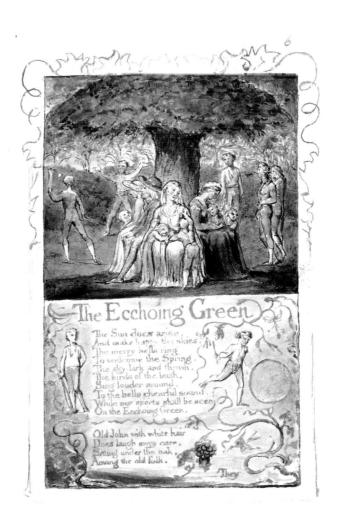

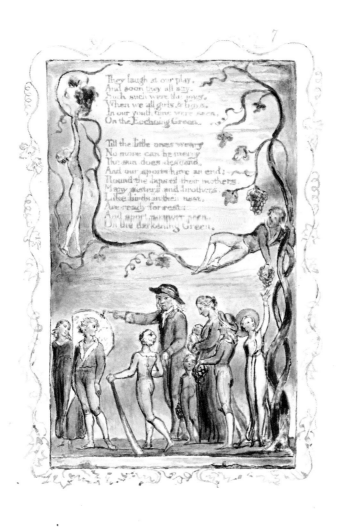

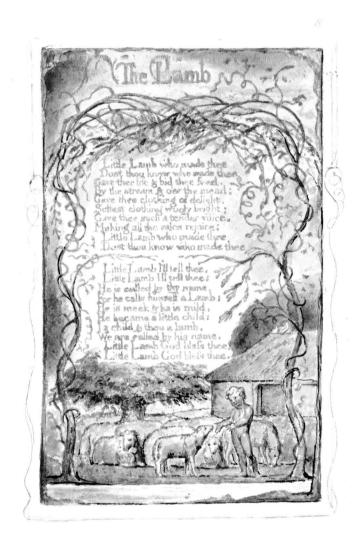

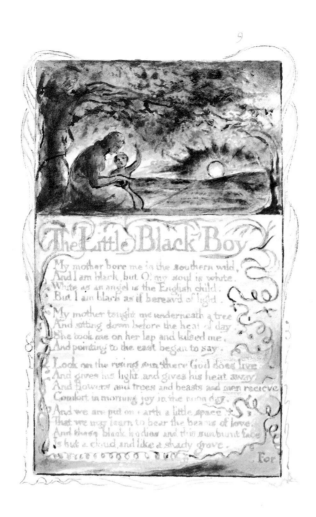

The Little Black Boy

My mother bore me in the southern wild,
And I am black, but O! my soul is white.
White as an angel is the English child:
But I am black as if bereav'd of light.

My mother taught me underneath a tree
And sitting down before the heat of day,
She took me on her lap and kissed me,
And pointing to the east began to say.

Look on the rising sun: there God does live
And gives his light, and gives his heat away.
And flowers and trees and beasts and men recieve
Comfort in morning joy in the noon day.

And we are put on earth a little space,
That we may learn to bear the beams of love,
And these black bodies and this sun-burnt face
Is but a cloud, and like a shady grove.

For

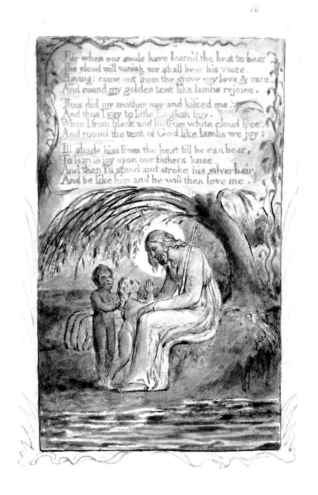

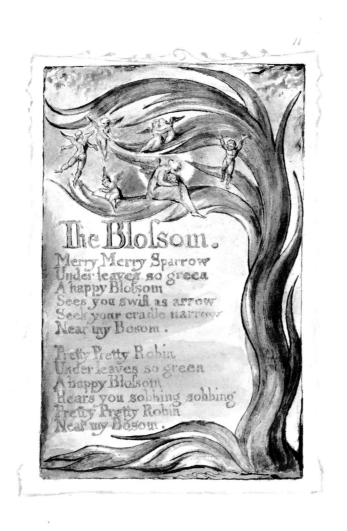

The Blossom.

Merry Merry Sparrow
Under leaves so green
A happy Blossom
Sees you swift as arrow
Seek your cradle narrow
Near my Bosom.

Pretty Pretty Robin
Under leaves so green
A happy Blossom
Hears you sobbing sobbing
Pretty Pretty Robin
Near my Bosom.

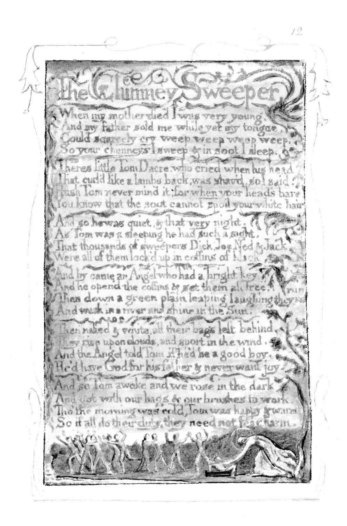

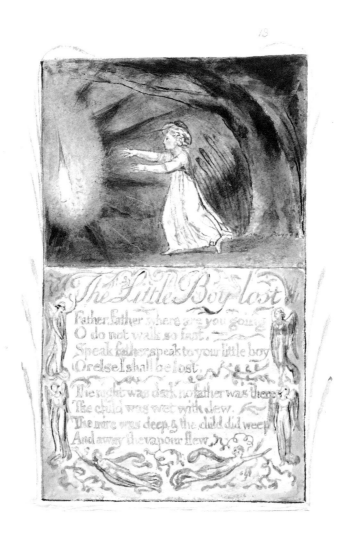

The Little Boy lost

Father. father. where are you going
O do not walk so fast.
Speak father, speak to your little boy
Or else I shall be lost,

The night was dark no father was there
The child was wet with dew.
The mire was deep, & the child did weep
And away the vapour flew.

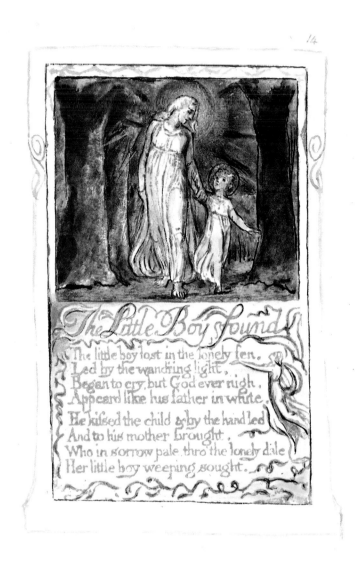

14

The Little Boy found

The little boy lost in the lonely fen,
Led by the wand'ring light,
Began to cry, but God ever nigh,
Appear'd like his father in white.

He kissed the child & by the hand led
And to his mother brought,
Who in sorrow pale, thro' the lonely dale
Her little boy weeping sought.

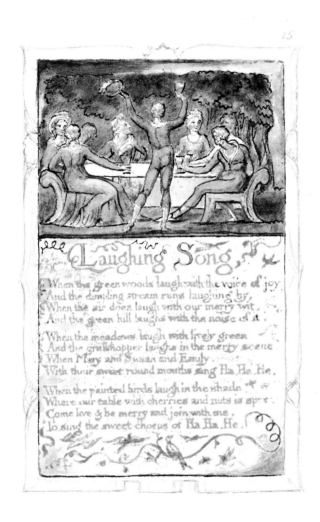

Laughing Song

When the green woods laugh with the voice of joy
And the dimpling stream runs laughing by,
When the air does laugh with our merry wit,
And the green hill laughs with the noise of it.

When the meadows laugh with lively green
And the grasshopper laughs in the merry scene
When Mary and Susan and Emily
With their sweet round mouths sing Ha Ha He.

When the painted birds laugh in the shade
Where our table with cherries and nuts is spread.
Come live & be merry and join with me,
To sing the sweet chorus of Ha Ha He.

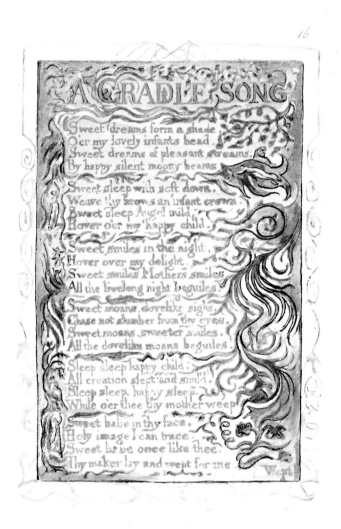

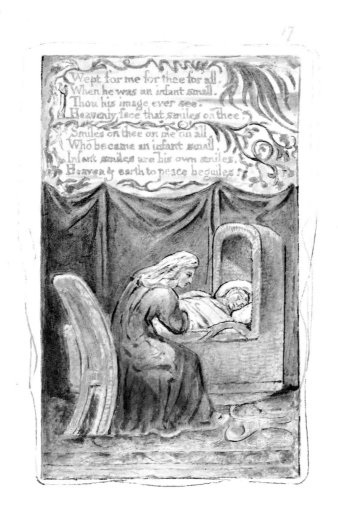

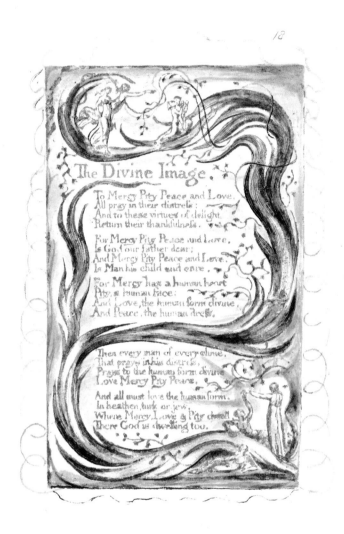

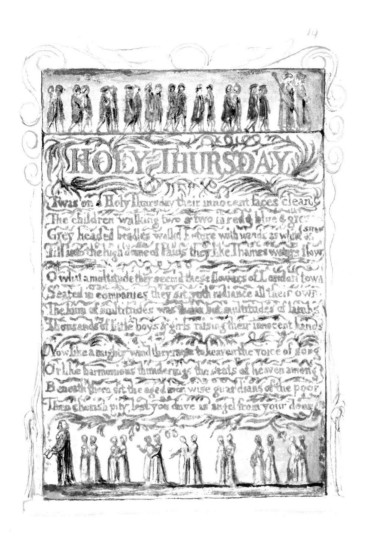

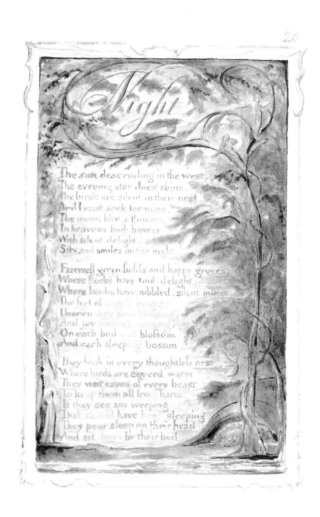

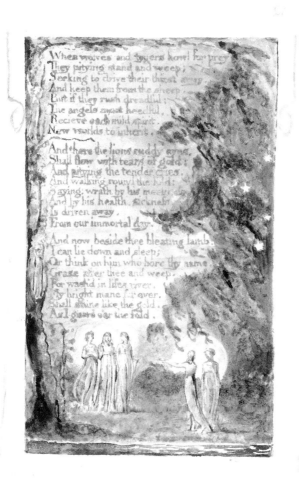

When wolves and tygers howl for prey
They pitying stand and weep;
Seeking to drive their thirst away,
And keep them from the sheep.
But if they rush dreadful;
The angels most heedful,
Recieve each mild spirit,
New worlds to inherit.

And there the lions ruddy eyes,
Shall flow with tears of gold:
And pitying the tender cries,
And walking round the fold:
Saying: wrath by his meekness
And by his health, sickness,
Is driven away,
From our immortal day.

And now beside thee bleating lamb,
I can lie down and sleep;
Or think on him who bore thy name,
Graze after thee and weep.
For wash'd in lifes river.
My bright mane for ever,
Shall shine like the gold,
As I guard o'er the fold.

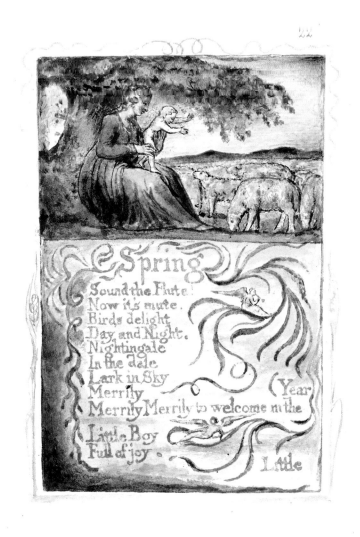

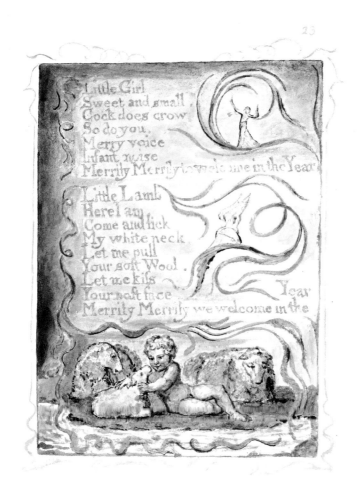

Little Girl
Sweet and small
Cock does crow
So do you,
Merry voice
Infant noise
Merrily Merrily to welcome in the Year

Little Lamb
Here I am
Come and lick
My white neck
Let me pull
Your soft Wool.
Let me kiss
Your soft face
Merrily Merrily we welcome in the Year

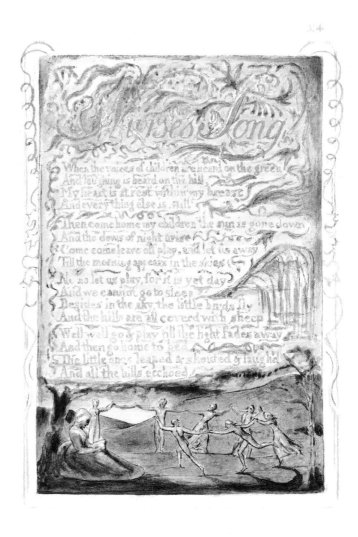

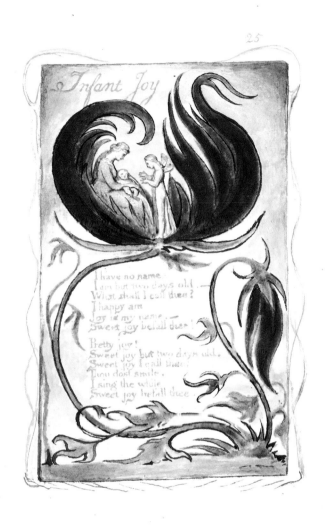

A Dream

Once a dream did weave a shade,
O'er my Angel-guarded bed,
That an Emmet lost its way
Where on grass methought I lay.

Troubled wilderd and forlorn
Dark benighted travel-worn,
Over many a tangled spray,
All heart-broke I heard her say.

O my children! do they cry,
Do they hear their father sigh.
Now they look abroad to see,
Now return and weep for me.

Pitying I dropd a tear:
But I saw a glow-worm near:
Who replied. What wailing wight
Calls the watchman of the night.

I am set to light the ground,
While the beetle goes his round:
Follow now the beetles hum,
Little wanderer hie thee home.

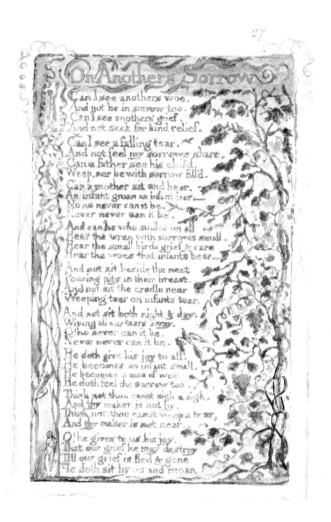

On Anothers Sorrow

Can I see anothers woe,
And not be in sorrow too.
Can I see anothers grief,
And not seek for kind relief.

Can I see a falling tear.
And not feel my sorrows share,
Can a father see his child,
Weep, nor be with sorrow filld.

Can a mother sit and hear,
An infant groan an infant fear—
No no never can it be.
Never never can it be.

And can he who smiles on all
Hear the wren with sorrows small,
Hear the small birds grief & care
Hear the woes that infants bear—

And not sit beside the nest
Pouring pity in their breast,
And not sit the cradle near
Weeping tear on infants tear.

And not sit both night & day,
Wiping all our tears away.
O! no never can it be.
Never never can it be.

He doth give his joy to all.
He becomes an infant small.
He becomes a man of woe
He doth feel the sorrow too.

Think not thou canst sigh a sigh,
And thy maker is not by.
Think not thou canst weep a tear,
And thy maker is not near.

O! he gives to us his joy.
That our grief he may destroy
Till our grief is fled & gone
He doth sit by us and moan

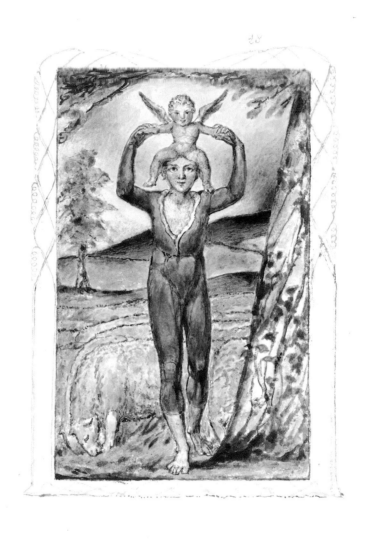

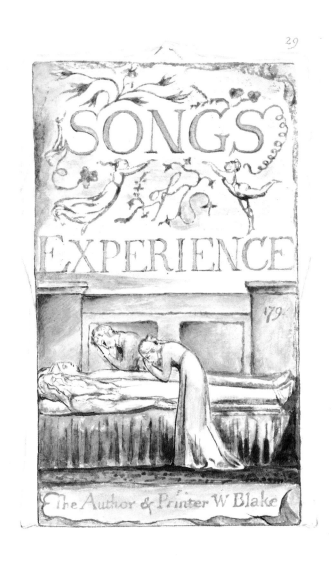

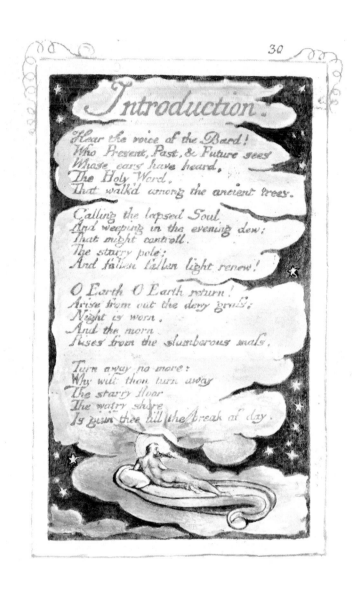

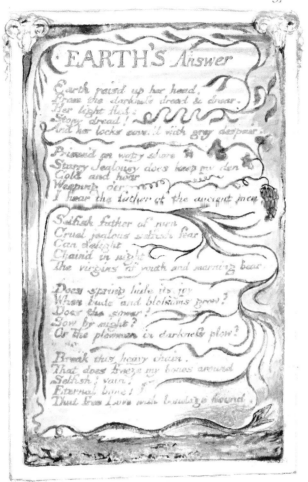

EARTH'S *Answer*

Earth raisd up her head,
From the darkness dread & drear.
Her light fled:
Stony dread!
And her locks cover'd with grey despair.

Prison'd on watry shore
Starry Jealousy does keep my den
Cold and hoar
Weeping o'er
I hear the father of the ancient men

Selfish father of men
Cruel jealous selfish fear
Can delight
Chaind in night
The virgins of youth and morning bear.

Does spring hide its joy
When buds and blossoms grow?
Does the sower?
Sow by night?
Or the plowman in darkness plow?

Break this heavy chain.
That does freeze my bones around
Selfish! vain!
Eternal bane!
That free Love with bondage bound.

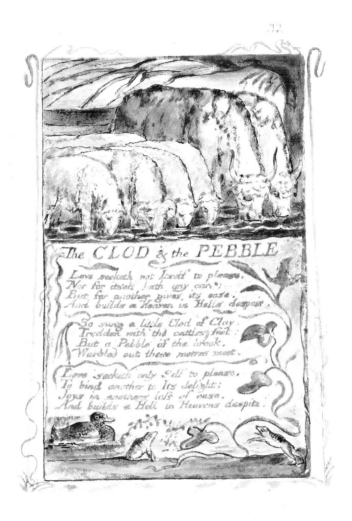

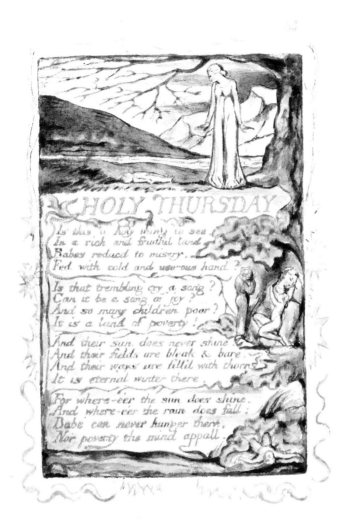

HOLY THURSDAY

Is this a holy thing to see,
In a rich and fruitful land,
Babes reducd to misery,
Fed with cold and usurous hand?

Is that trembling cry a song?
Can it be a song of joy?
And so many children poor?
It is a land of poverty!

And their sun does never shine.
And their fields are bleak & bare.
And their ways are fill'd with thorns
It is eternal winter there.

For where-eer the sun does shine.
And where-eer the rain does fall:
Babe can never hunger there,
Nor poverty the mind appall.

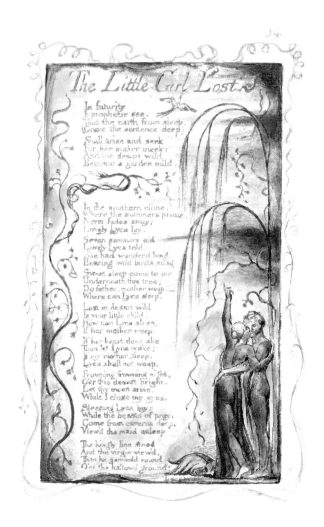

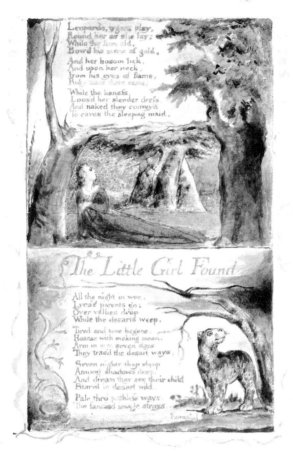

Leopards, tygers play,
Round her as she lay;
While the lion old,
Bow'd his mane of gold,

And her bosom lick,
And upon her neck,
From his eyes of flame,
Ruby tears there came;

While the lioness,
Loos'd her slender dress,
And naked they convey'd
To caves the sleeping maid.

The Little Girl Found

All the night in woe,
Lyca's parents go,
Over vallies deep,
While the desarts weep.

Tired and woe begone,
Hoarse with making moan:
Arm in arm seven days,
They trac'd the desart ways.

Seven nights they sleep,
Among shadows deep:
And dream they see their child
Starv'd in desart wild.

Pale thro' pathless ways,
The fancied image strays,

Famish'd

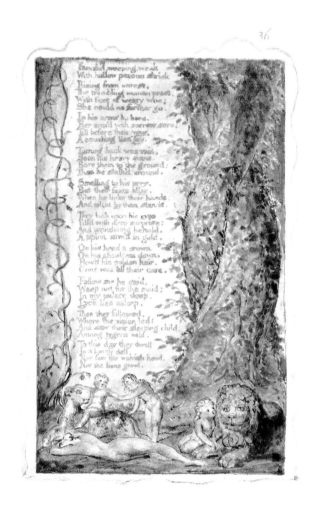

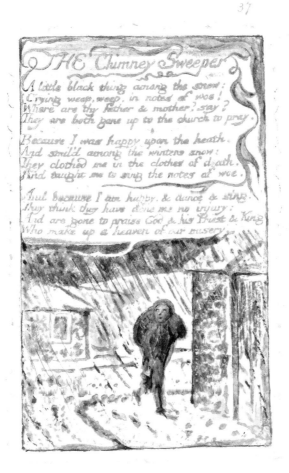

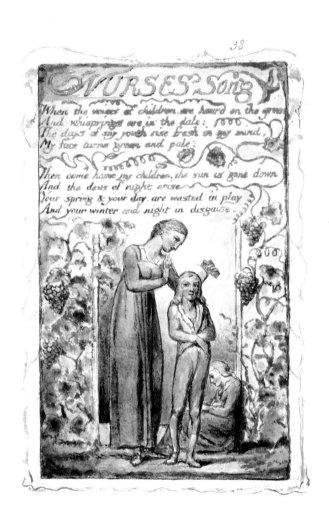

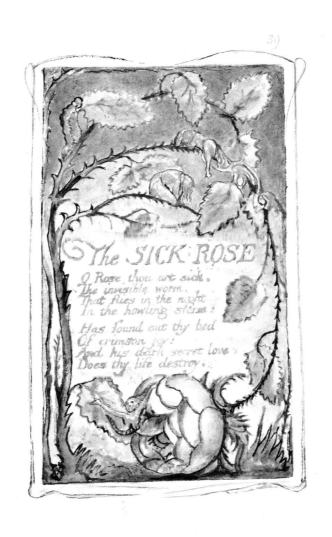

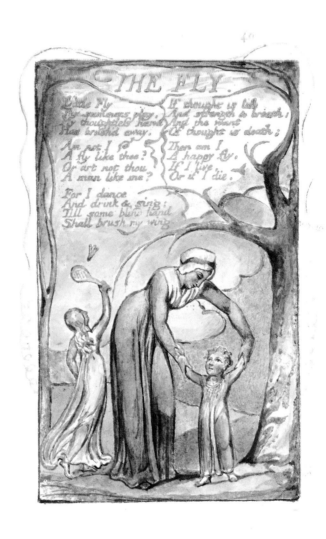

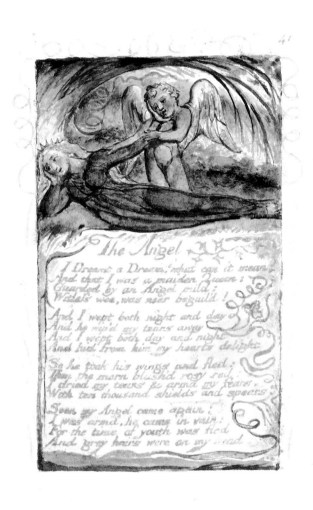

The Angel

I Dreamt a Dream! what can it mean?
And that I was a maiden Queen:
Guarded by an Angel mild;
Witless woe, was ne'er beguild!

And I wept both night and day
And he wip'd my tears away
And I wept both day and night
And hid from him my hearts delight

So he took his wings and fled;
Then the morn blush'd rosy red:
I dried my tears & arm'd my fears,
With ten thousand shields and spears.

Soon my Angel came again;
I was arm'd, he came in vain:
For the time of youth was fled
And grey hairs were on my head

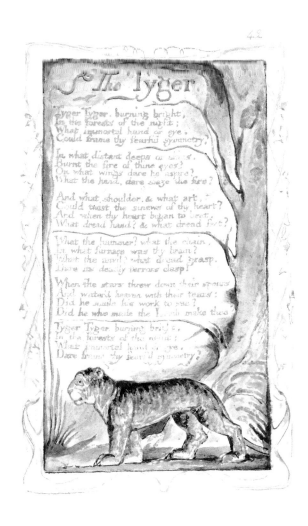

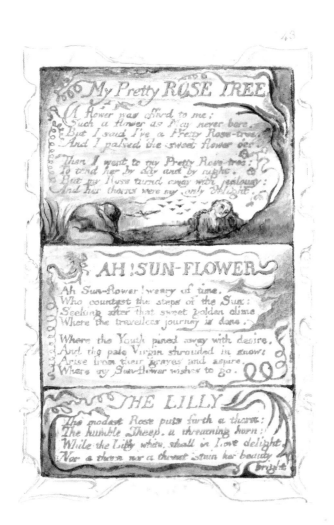

My Pretty ROSE TREE

A flower was offerd to me;
Such a flower as May never bore.
But I said I've a Pretty Rose-tree,
And I passed the sweet flower o'er.

Then I went to my Pretty Rose-tree;
To tend her by day and by night.
But my Rose turnd away with jealousy:
And her thorns were my only delight.

AH! SUN-FLOWER

Ah Sun-flower! weary of time,
Who countest the steps of the Sun:
Seeking after that sweet golden clime
Where the travellers journey is done.

Where the Youth pined away with desire,
And the pale Virgin shrouded in snow:
Arise from their graves and aspire,
Where my Sun-flower wishes to go.

THE LILLY

The modest Rose puts forth a thorn:
The humble Sheep, a threatning horn:
While the Lilly white, shall in love delight,
Nor a thorn nor a threat stain her beauty bright.

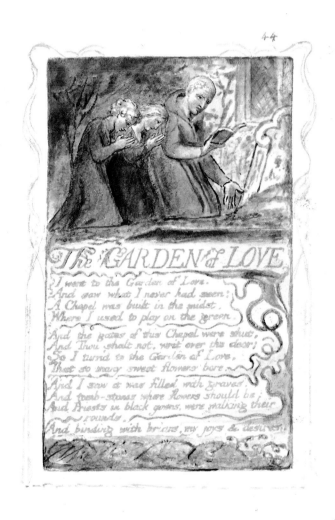

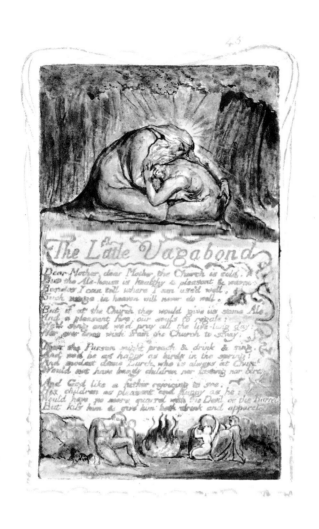

The Little Vagabond

Dear Mother, dear Mother, the Church is cold,
But the Ale-house is healthy & pleasant & warm;
Besides I can tell where I am used well,
Such usage in heaven will never do well.

But if at the Church they would give us some Ale
And a pleasant fire, our souls to regale;
We'd sing and we'd pray all the live-long day;
Nor ever once wish from the Church to stray.

Then the Parson might preach & drink & sing,
And we'd be as happy as birds in the spring:
And modest dame Lurch, who is always at Church,
Would not have bandy children nor fasting nor birch.

And God like a father rejoicing to see,
His children as pleasant and happy as he:
Would have no more quarrel with the Devil or the Barrel
But kiss him & give him both drink and apparel.

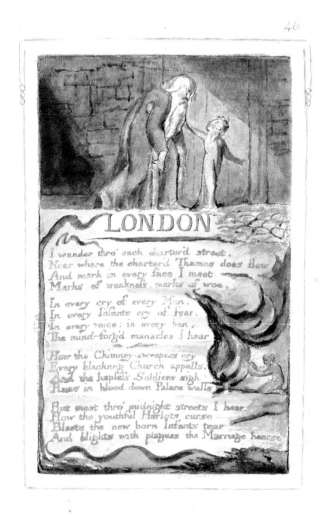

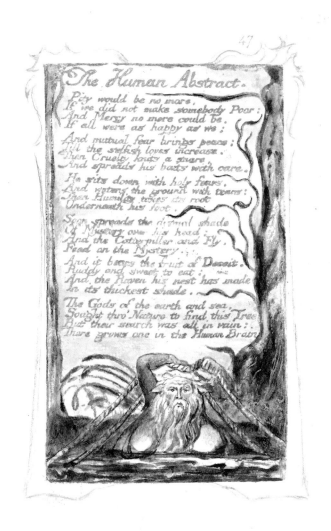

The Human Abstract.

Pity would be no more,
If we did not make somebody Poor:
And Mercy no more could be,
If all were as happy as we;

And mutual fear brings peace;
Till the selfish loves increase.
Then Cruelty knits a snare,
And spreads his baits with care.

He sits down with holy fears,
And waters the ground with tears:
Then Humility takes its root
Underneath his foot.

Soon spreads the dismal shade
Of Mystery over his head;
And the Catterpiller and Fly,
Feed on the Mystery.

And it bears the fruit of Deceit,
Ruddy and sweet to eat;
And the Raven his nest has made
In its thickest shade.

The Gods of the earth and sea,
Sought thro' Nature to find this Tree
But their search was all in vain:
There grows one in the Human Brain

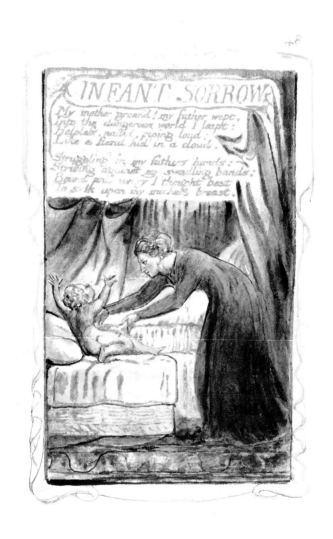

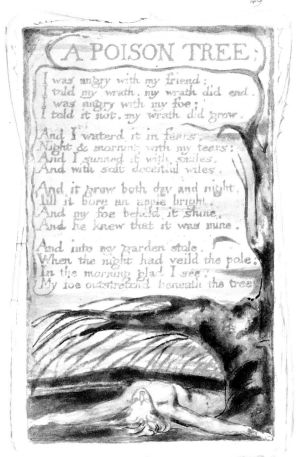

A POISON TREE;

I was angry with my friend;
I told my wrath, my wrath did end.
I was angry with my foe;
I told it not, my wrath did grow.

And I waterd it in fears,
Night & morning with my tears:
And I sunned it with smiles,
And with soft deceitful wiles.

And it grew both day and night,
Till it bore an apple bright,
And my foe beheld it shine,
And he knew that it was mine.

And into my garden stole,
When the night had veild the pole,
In the morning glad I see;
My foe outstretchd beneath the tree.

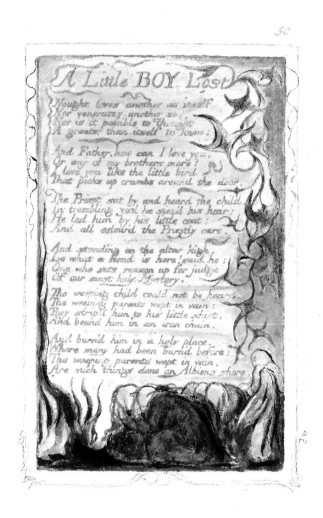

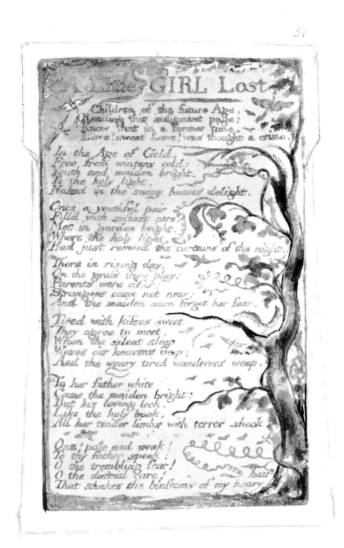

A Little GIRL Lost

Children of the future Age,
Reading this indignant page;
Know that in a former time,
Love! sweet Love! was thought a crime.

In the Age of Gold,
Free from winters cold:
Youth and maiden bright,
To the holy light,
Naked in the sunny beams delight.

Once a youthful pair
Fill'd with softest care:
Met in garden bright,
Where the holy light,
Had just removd the curtains of the night.

There in rising day,
On the grass they play:
Parents were afar:
Strangers came not near:
And the maiden soon forgot her fear.

Tired with kisses sweet
They agree to meet,
When the silent sleep
Waves o'er heavens deep;
And the weary tired wanderers weep.

To her father white
Came the maiden bright:
But his loving look,
Like the holy book,
All her tender limbs with terror shook.

Ona! pale and weak!
To thy father speak:
O the trembling fear!
O the dismal care!
That shakes the blossoms of my hoary hair

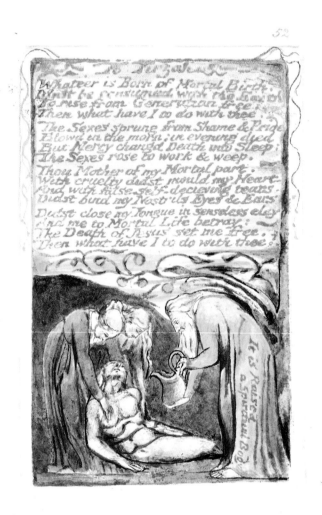

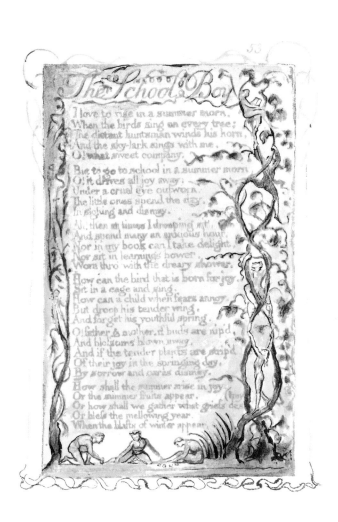

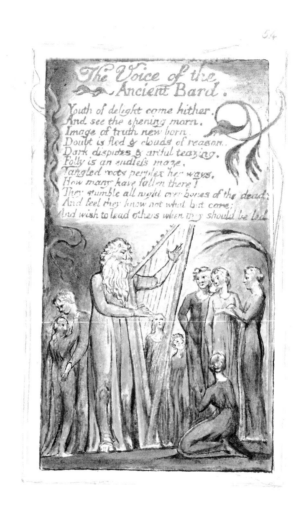

The Book of Thel

1789

Houghton Library, Harvard University, Cambridge, Mass. Copy J.
Relief etchings, watercoloured by hand.

The Book of Thel is a pastoral poem telling of the maiden Thel's journey of self-discovery through the vales of Har; there she questions the Lily-of-the-Valley, the Cloud, the Worm, and the Clod of Clay who lead her towards Experience, which she rejects, fleeing back to her valley.

Some fifteen copies of *Thel* are known, most of which – including the copy here reproduced – were printed about 1789–90. This perhaps suggests that Blake expected it to be as popular as *Songs of Innocence*; however, the present copy appears not to have found a buyer until about 1816, when Blake re-worked its colouring, perhaps to match more closely the colouring of copy G of *The Daughters of Albion* (pages 142–152 of this volume) with which it was bound by its original purchaser.

THEL's Motto.

Does the Eagle know what is in the pit?
Or wilt thou go ask the Mole:
Can Wisdom be put in a silver rod?
Or Love in a golden bowl?

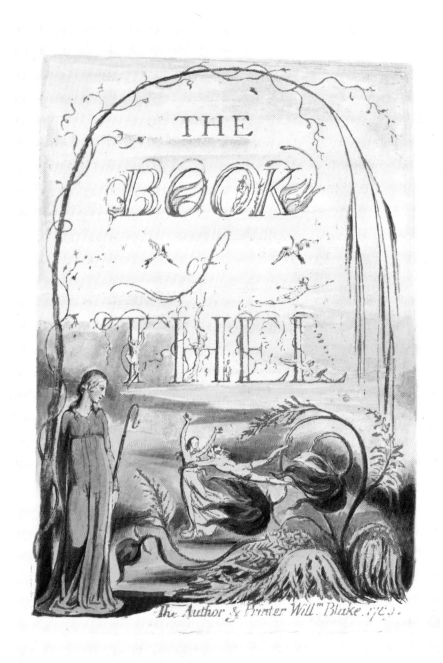

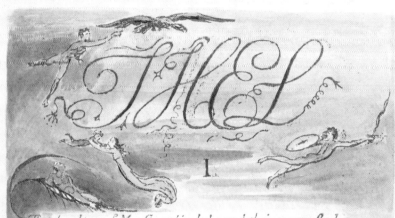

The daughters of Mne Seraphim led round their sunny flocks,
All but the youngest, she in paleness sought the secret air,
To fade away like morning beauty from her mortal day:
Down by the river of Adona her soft voice is heard;
And thus her gentle lamentation falls like morning dew.

O life of this our spring! why fades the lotus of the water?
Why fade these children of the spring? born but to smile & fall.
Ah! Thel is like a watry bow, and like a parting cloud,
Like a reflection in a glass, like shadows in the water,
Like dreams of infants, like a smile upon an infants face,
Like the doves voice, like transient day, like music in the air:
Ah! gentle may I lay me down, and gentle rest my head,
And gentle sleep the sleep of death, and gentle hear the voice
Of him that walketh in the garden in the evening time.

The Lilly of the valley breathing in the humble grass
Answerd the lovely maid and said, I am a watry weed,
And I am very small, and love to dwell in lowly vales;
So weak the gilded butterfly scarce perches on my head
Yet I am visited from heaven and he that smiles on all,
Walks in the valley, and each morn over me spreads his hand
Saying, rejoice thou humble grass, thou new-born lilly flower,
Thou gentle maid of silent valleys, and of modest brooks:
For thou shalt be clothed in light, and fed with morning manna:
Till summers heat melts thee beside the fountains and the springs
To flourish in eternal vales; then why should Thel complain,

Why

Why should the mistress of the vales of Har, utter a sigh.

She ceas'd & smild in tears, then sat down in her silver shrine.

Thel answerd, O thou little virgin of the peaceful valley.
Giving to those that cannot crave, the voiceless, the o'ertired
Thy breath doth nourish the innocent lamb, he smells thy milky garments,
He crops thy flowers, while thou sittest smiling in his face,
Wiping his mild and meekin mouth from all contagious taints.
Thy wine doth purify the golden honey, thy perfume.
Which thou dost scatter on every little blade of grass that springs
Revives the milked cow, & tames the fire breathing steed.
But Thel is like a faint cloud kindled at the rising sun;
I vanish from my pearly throne, and who shall find my place.

Queen of the vales the Lilly answerd, ask the tender cloud,
And it shall tell thee why it glitters in the morning sky.
And why it scatters its bright beauty thro' the humid air.
Descend O little cloud & hover before the eyes of Thel.

The Cloud descended, and the Lilly bowd her modest head:
And went to mind her numerous charge among the verdant grass.

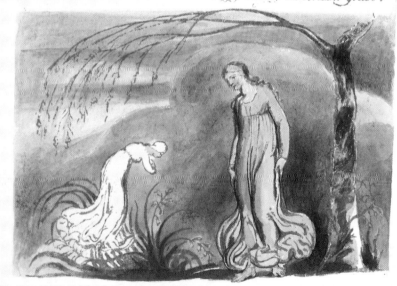

3

II.

O little Cloud the virgin said, I charge thee tell to me,
Why thou complainest not when in one hour thou fade away:
Then we shall seek thee but not find; ah Thel is like to thee.
I pass away, yet I complain, and no one hears my voice.

The Cloud then shew'd his golden head & his bright form emerg'd,
Hovering and glittering on the air before the face of Thel.

O virgin knowst thou not, our steeds drink of the golden springs
Where Luvah doth renew his horses: lookst thou on my youth,
And fearest thou because I vanish and am seen no more,
Nothing remains; O maid I tell thee, when I pass away,
It is to tenfold life, to love, to peace, and raptures holy:
Unseen descending, weigh my light wings upon balmy flowers:
And court the fair eyed dew, to take me to her shining tent;
The weeping virgin, trembling kneels before the risen sun,
Till we arise link'd in a golden band, and never part;
But walk united, bearing food to all our tender flowers.

Dost thou O little Cloud? I fear that I am not like thee;
For I walk through the vales of Har, and smell the sweetest flowers;
But I feed not the little flowers: I hear the warbling birds,
But I feed not the warbling birds, they fly and seek their food;
But Thel delights in these no more because I fade away,
And all shall say, without a use this shining woman liv'd,
Or did she only live, to be at death the food of worms.

The Cloud reclind upon his airy throne and answerd thus.

Then if thou art the food of worms, O virgin of the skies,
How great thy use, how great thy blessing; every thing that lives,
Lives not alone, nor for itself: fear not and I will call
The weak worm from its lowly bed, and thou shalt hear its voice.
Come forth worm of the silent valley, to thy pensive queen.

The helpless worm arose, and sat upon the Lillys leaf,
And the bright Cloud saild on, to find his partner in the vale.

III.

[102]

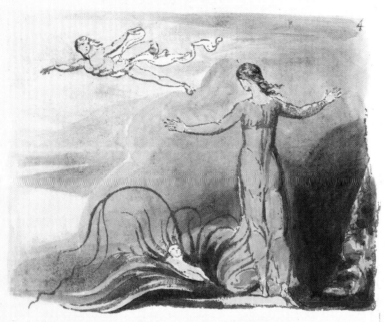

III.

Then Thel astonish'd view'd the Worm upon its dewy bed.

Art thou a Worm? image of weakness. art thou but a Worm?
I see thee like an infant wrapped in the Lillys leaf:
Ah weep not little voice, thou canst not speak. but thou canst weep;
Is this a Worm? I see thee lay helpless & naked: weeping,
And none to answer, none to cherish thee with mothers smiles.

The Cloud of Clay heard the Worms voice, & raisd her pitying head;
She bowd over the weeping infant, and her life exhald
In milky fondness, then on Thel she fixd her humble eyes.

O beauty of the vales of Har. we live not for ourselves,
Thou seest me the meanest thing, and so I am indeed;
My bosom of itself is cold. and of itself is dark,

But

5

But he that loves the lowly, pours his oil upon my head,
And kisses me, and binds his nuptial bands around my breast.
And says; Thou mother of my children, I have loved thee.
And I have given thee a crown that none can take away:
But how this is sweet maid, I know not, and I cannot know,
I ponder, and I cannot ponder; yet I live and love.

The daughter of beauty wip'd her pitying tears with her white veil,
And said. Alas! I knew not this, and therefore did I weep:
That God would love a Worm I knew, and punish the evil foot
That wilful, bruis'd its helpless form: but that he cherishd it
With milk and oil, I never knew; and therefore did I weep.
And I complaind in the mild air, because I fade away,
And lay me down in thy cold bed, and leave my shining lot.

Queen of the vales, the matron Clay answerd: I heard thy sighs,
And all thy moans flew oer my roof, but I have calld them down:
Wilt thou O Queen enter my house, tis given thee to enter,
And to return; fear nothing, enter with thy virgin feet.

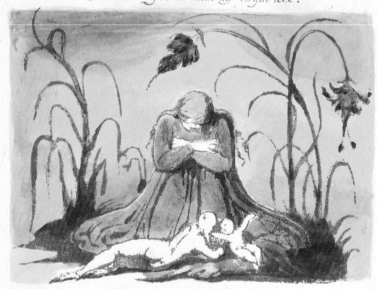

IV

IV.

The eternal gates terrific porter lifted the northern bar:
Thel enterd in & saw the secrets of the land unknown;
She saw the couches of the dead, & where the fibrous roots
Of every heart on earth infixes deep its restless twists:
A land of sorrows & of tears where never smile was seen.

She wanderd in the land of clouds thro' valleys dark, listning
Dolours & lamentations: waiting oft beside a dewy grave
She stood in silence, listning to the voices of the ground,
Till to her own grave plot she came, & there she sat down,
And heard this voice of sorrow breathed from the hollow pit.

Why cannot the Ear be closed to its own destruction?
Or the glistning Eye to the poison of a smile!
Why are Eyelids stord with arrows ready drawn,
Where a thousand fighting men in ambush lie!
Or an Eye of gifts & graces, showring fruits & coined
gold!
Why a Tongue impress'd with honey from every wind?
Why an Ear, a whirlpool fierce to draw creations in?
Why a Nostril wide inhaling terror trembling & affright.

The Virgin started from her seat, & with a shriek.
Fled back unhinderd till she came into the vales of
Har

The End

The Marriage of Heaven and Hell

c. 1790

Pierpont Morgan Library, New York. Copy F.
Relief etchings, colour-printed, with pen and watercolour.

The Marriage of Heaven and Hell is, in the form of a journey of discovery, a satire on Swedenborg's *Heaven and Hell* and signals the renunciation of Blake's own attraction towards Swedenborgianism. The prophetic 'Song of Liberty', with the promise of 'The Bible of Hell: which the world shall have whether they will or no', looks forward to the Prophecies of 1793 and later.

Only nine complete copies of the book are recorded. The one here reproduced, which dates from about 1794, is an early example of Blake's technique of colour printing, obtaining deep colours and richly textured surfaces in harmony with the developing urgency of his prophetic vision. This copy was at one time owned by Thomas Butts, for many years Blake's principal patron.

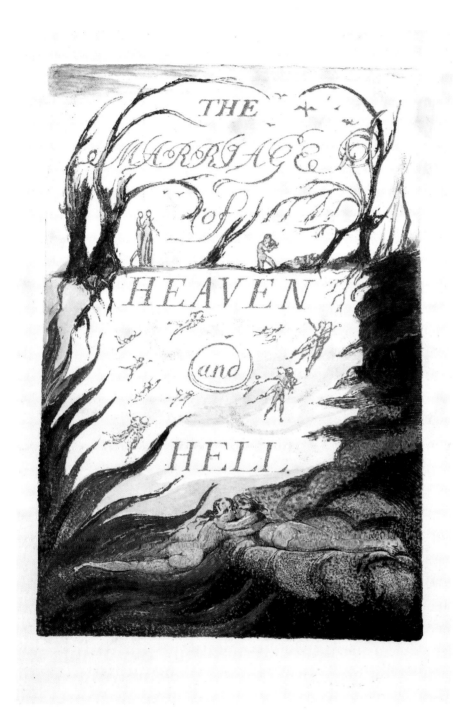

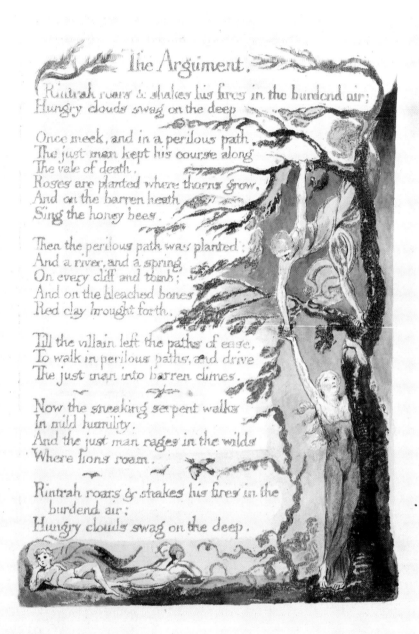

The Argument.

Rintrah roars & shakes his fires in the burdend air;
Hungry clouds swag on the deep

Once meek, and in a perilous path,
The just man kept his course along
The vale of death.
Roses are planted where thorns grow,
And on the barren heath
Sing the honey bees.

Then the perilous path was planted:
And a river, and a spring
On every cliff and tomb;
And on the bleached bones
Red clay brought forth.

Till the villain left the paths of ease,
To walk in perilous paths, and drive
The just man into barren climes.

Now the sneaking serpent walks
In mild humility.
And the just man rages in the wilds
Where lions roam.

Rintrah roars & shakes his fires in the
burdend air;
Hungry clouds swag on the deep.

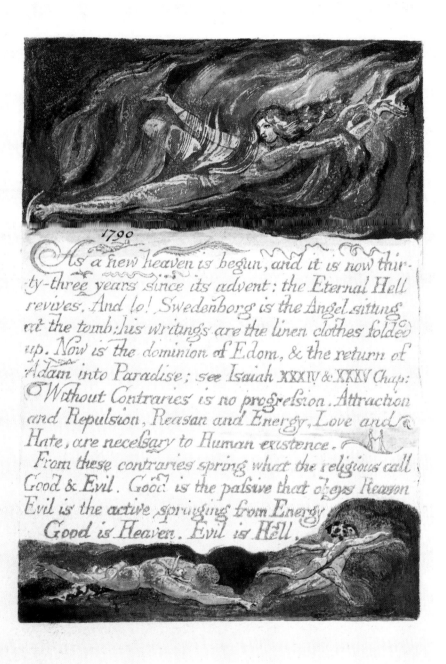

1790

As a new heaven is begun, and it is now thirty-three years since its advent: the Eternal Hell revives. And lo! Swedenborg is the Angel sitting at the tomb; his writings are the linen clothes folded up. Now is the dominion of Edom, & the return of Adam into Paradise; see Isaiah XXXIV & XXXV Chap:

Without Contraries is no progression. Attraction and Repulsion, Reason and Energy, Love and Hate, are necessary to Human existence.

From these contraries spring what the religious call Good & Evil. Good is the passive that obeys Reason. Evil is the active springing from Energy.

Good is Heaven. Evil is Hell.

Those who restrain desire, do so because theirs
is weak enough to be restrained; and the restrainer or
reason usurps its place & governs the unwilling.
~And being restraind it by degrees becomes passive
till it is only the shadow of desire.
~The history of this is written in Paradise Lost. & the
Governor or Reason is call'd Messiah.
~And the original Archangel or possessor of the com-
-mand of the heavenly host, is call'd the Devil or Satan
and his children are call'd Sin & Death
But in the Book of Job Miltons Messiah is call'd
Satan.

For this history has been adopted by both parties
It indeed appeard to Reason as if Desire was
cast out. but the Devils account is, that the Messi
-ah

6

ah fell, & formed a heaven of what he stole from the
Abyss

This is shewn in the Gospel, where he prays to the
Father to send the comforter or Desire that Reason
may have Ideas to build on, the Jehovah of the Bible
being no other than he who dwells in flaming fire
Know that after Christs death, he became Jehovah.
But in Milton; the Father is Destiny, the Son, a
Ratio of the five senses, & the Holy-ghost, Vacuum!
Note. The reason Milton wrote in fetters when
he wrote of Angels & God, and at liberty when of
Devils & Hell, is because he was a true Poet and
of the Devils party without knowing it

A Memorable Fancy.

As I was walking among the fires of hell, de
-lighted with the enjoyments of Genius; which to An-
-gels look like torment and insanity. I collected some
of their Proverbs: thinking that as the sayings used
in a nation, mark its character, so the Proverbs of
Hell, shew the nature of Infernal wisdom better
than any description of buildings or garments
When I came home; on the abyss of the five sen-
-ses, where a flat sided steep frowns over the pre-
-sent world, I saw a mighty Devil folded in black
clouds, hovering on the sides of the rock, with cor-

ro-

roding fires he wrote the following sentence now per-
ieved by the minds of men, & read by them on earth.

How do you know but evry Bird that cuts the airy way,
Is an immense world of delight, clos'd by your senses five?

Proverbs of Hell.

In seed time learn, in harvest teach, in winter enjoy.
Drive your cart and your plow over the bones of the dead.
The road of excess leads to the palace of wisdom.
Prudence is a rich ugly old maid courted by Incapacity.
He who desires but acts not, breeds pestilence.
The cut worm forgives the plow.
Dip him in the river who loves water.
A fool sees not the same tree that a wise man sees.
He whose face gives no light, shall never become a star.
Eternity is in love with the productions of time.
The busy bee has no time for sorrow.
The hours of folly are measur'd by the clock, but of wis-
-dom: no clock can measure.
All wholsom food is caught without a net or a trap.
Bring out number weight & measure in a year of dearth.
No bird soars too high. if he soars with his own wings.
A dead body. revenges not injuries.
The most sublime act is to set another before you.
If the fool would persist in his folly he would become wise
Folly is the cloke of knavery.
Shame is Prides cloke.

Proverbs of Hell.

Prisons are built with stones of Law, Brothels with bricks of Religion.

The pride of the peacock is the glory of God.

The lust of the goat is the bounty of God.

The wrath of the lion is the wisdom of God.

The nakedness of woman is the work of God.

Excess of sorrow laughs. Excess of joy weeps.

The roaring of lions, the howling of wolves, the raging of the stormy sea. and the destructive sword. are portions of eternity too great for the eye of man.

The fox condemns the trap. not himself.

Joys impregnate. Sorrows bring forth.

Let man wear the fell of the lion. woman the fleece of the sheep.

The bird a nest. the spider a web. man friendship.

The selfish smiling fool. & the sullen frowning fool. shall be both thought wise. that they may be a rod.

What is now proved was once, only imagin'd.

The rat, the mouse. the fox. the rabbet; watch the roots, the lion. the tyger. the horse. the elephant. watch the fruits.

The cistern contains; the fountain overflows

One thought. fills immensity.

Always be ready to speak your mind, and a base man will avoid you.

Every thing possible to be believ'd is an image of truth.

The eagle never lost so much time. as when he submit--ted to learn of the crow.

The

Proverbs of Hell

The fox provides for himself, but God provides for the lion.

Think in the morning, Act in the noon, Eat in the even-
 -ing, Sleep in the night.

He who has sufferd you to impose on him knows you.

As the plow follows words, so God rewards prayers.

The tygers of wrath are wiser than the horses of in-
Expect poison from the standing water. (-struction

You never know what is enough unless you know what is
 more than enough.

Listen to the fools reproach! it is a kingly title!

The eyes of fire, the nostrils of air, the mouth of water,
 the beard of earth.

The weak in courage is strong in cunning.

The apple tree never asks the beech how he shall grow,
 nor the lion, the horse, how he shall take his prey.

The thankful reciever bears a plentiful harvest.

If others had not been foolish, we should be so.

The soul of sweet delight, can never be defild.

When thou seest an Eagle, thou seest a portion of Ge-
 -nius, lift up thy head!

As the catterpiller chooses the fairest leaves to lay
 her eggs on, so the priest lays his curse on
 the fairest joys.

To create a little flower is the labour of ages.

Damn, braces: Bless relaxes.

The best wine is the oldest, the best water the newest.

Prayers plow not! Praises reap not!

Joys laugh not! Sorrows weep not!

 The

Proverbs of Hell

The head Sublime, the heart Pathos, the genitals Beauty,
the hands & feet Proportion.

As the air to a bird or the sea to a fish, so is contempt
to the contemptible.

The crow wish'd every thing was black, the owl, that eve-
-ry thing was white.

Exuberance is Beauty.

If the lion was advised by the fox, he would be cunning.

Improvent makes strait roads, but the crooked roads
without Improvement, are roads of Genius.

Sooner murder an infant in its cradle than nurse unact
-ed desires

Where man is not nature is barren.

Truth can never be told so as to be understood, and
not be believ'd.

Enough! or Too much.

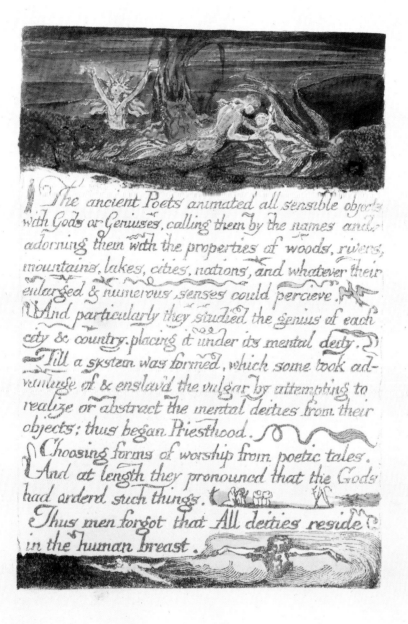

The ancient Poets animated all sensible objects with Gods or Geniuses, calling them by the names and adorning them with the properties of woods, rivers, mountains, lakes, cities, nations, and whatever their enlarged & numerous senses could perceive.

And particularly they studied the genius of each city & country, placing it under its mental deity.

Till a system was formed, which some took advantage of & enslav'd the vulgar by attempting to realize or abstract the mental deities from their objects; thus began Priesthood.

Choosing forms of worship from poetic tales.

And at length they pronounced that the Gods had order'd such things.

Thus men forgot that All deities reside in the human breast.

12

A Memorable Fancy.

The Prophets Isaiah and Ezekiel dined with me, and I asked them how they dared so roundly to assert. that God spoke to them; and whether they did not think at the time, that they would be misunderstood, & so be the cause of imposition.

Isaiah answer'd. I saw no God, nor heard any, in a finite organical perception; but my senses discover'd the infinite in every thing, and as I was then perswaded, & remain confirm'd; that the voice of honest indignation is the voice of God, I cared not for consequences but wrote.

Then I asked: does a firm perswasion that a thing is so, make it so?

He replied. All poets believe that it does, & in ages of imagination this firm perswasion removed mountains; but many are not capable of a firm perswasion of any thing.

Then Ezekiel said. The philosophy of the east taught the first principles of human perception some nations held one principle for the origin & some another, we of Israel taught that the Poetic Genius (as you now call it) was the first principle and all the others merely derivative, which was the cause of our despising the Priests & Philosophers of other countries, and prophecying that all Gods would

would at last be proved to originate in ours & to be the
tributaries of the Poetic Genius, it was this, that our
great poet King David desired so fervently & invokes
so patheticly, saying by this he conquers enemies &
governs kingdoms; and we so loved our God, that we
cursed in his name all the deities of surrounding
nations, and asserted that they had rebelled; from
these opinions the vulgar came to think that all nati-
-ons would at last be subject to the jews .

 This said he, like all firm perswasions, is come to
pass, for all nations believe the jews code and wor-
ship the jews god, and what greater subjection can be
 I heard this with some wonder, & must confess
my own conviction. After dinner I askd Isaiah to fa-
vour the world with his lost works, he said none of
equal value was lost. Ezekiel said the same of his .

 I also asked Isaiah what made him go naked and
barefoot three years? he answerd, the same that made
our friend Diogenes the Grecian .

 I then asked Ezekiel, why he eat dung, & lay so
long on his right & left side? he answerd, the desire
of raising other men into a perception of the infinite:
this the North American tribes practise. & is he hon-
est who resists his genius or conscience. only for
the sake of present ease or gratification?

14

The ancient tradition that the world will be consumed in fire at the end of six thousand years is true. as I have heard from Hell.

For the cherub with his flaming sword is hereby commanded to leave his guard at tree of life, and when he does, the whole creation will be consumed, and appear infinite. and holy whereas it now appears finite & corrupt.

This will come to pass by an improvement of sensual enjoyment.

But first the notion that man has a body distinct from his soul, is to be expunged; this I shall do, by printing in the infernal method, by corrosives, which in Hell are salutary and medicinal, melting apparent surfaces away, and displaying the infinite which was hid.

If the doors of perception were cleansed every thing would appear to man as it is, infinite.

For man has closed himself up, till he sees all things thro' narrow chinks of his cavern.

A Memorable Fancy

I was in a Printing house in Hell & saw the method in which knowledge is transmitted from generation to generation.

In the first chamber was a Dragon-Man, clearing away the rubbish from a caves mouth; within, a number of Dragons were hollowing the cave.

In the second chamber was a Viper folding round the rock & the cave, and others adorning it with gold silver and precious stones.

In the third chamber was an Eagle with wings and feathers of air, he caused the inside of the cave to be infinite, around were numbers of Eagle like men, who built palaces in the immense cliffs.

In the fourth chamber were Lions of flaming fire raging around & melting the metals into living fluids.

In the fifth chamber were Unnam'd forms, which cast the metals into the expanse.

There they were reciev'd by Men who occupied the sixth chamber, and took the forms of books & were arranged in libraries.

The Giants who formed this world into its
sensual existence and now seem to live in it
in chains are in truth. the causes of its life
& the sources of all activity, but the chains
are, the cunning of weak and tame minds, which
have power to resist energy. according to the pro
-verb, the weak in courage is strong in cunning.

Thus one portion of being, is the Prolific. the
other, the Devouring: to the devourer it seems as
if the producer was in his chains, but it is not so,
he only takes portions of existence and fancies
that the whole.

But the Prolific would cease to be Prolific
unless the Devourer as a sea recieved the excels
of his delights.

Some will say, Is not God alone the Prolific?
I answer, God only Acts & Is. in existing beings
or Men.

These two classes of men are always upon
earth. & they should be enemies; whoever tries
to

to reconcile them seeks to destroy existence.

Religion is an endeavour to reconcile the two.

Note. Jesus Christ did not wish to unite but to seperate them, as in the Parable of sheep and goats! & he says I came not to send Peace but a Sword.

Messiah or Satan or Tempter was formerly thought to be one of the Antediluvians who are our Energies.

A Memorable Fancy

An Angel came to me and said O pitiable foolish young man! O horrible! O dreadful state! consider the hot burning dungeon thou art preparing for thyself to all eternity, to which thou art going in such career.

I said. perhaps you will be willing to shew me my eternal lot & we will contemplate together upon it and see whether your lot or mine is most desirable

So he took me thro' a stable & thro' a church & down into the church vault at the end of which was a mill: thro' the mill we went, and came to a cave. down the winding cavern we groped our tedi-ous way till a void boundless as a nether sky ap-peard beneath us. & we held by the roots of trees and hung over this immensity, but I said, if you please we will commit ourselves to this void, and see whether providence is here also, if you will not I will? but he answerd, do not presume O young-man but as we here remain behold thy lot which will soon appear when the darkness passes away

So I remaind with him sitting in the twisted root

root of an oak, he was suspended in a fungus
which hung with the head downward into the deep:

By degrees we beheld the infinite Abyss, fiery
as the smoke of a burning city; beneath us at an
immense distance was the sun, black but shining
round it were fiery tracks on which revolv'd vast
spiders, crawling after their prey; which flew or
rather swum in the infinite deep, in the most ter-
rific shapes of animals sprung from corruption.
& the air was full of them, & seemd composed
of them; these are Devils. and are called Powers
of the air, I now asked my companion which was my
eternal lot? he said, between the black & white spiders

But now, from between the black & white spiders
a cloud and fire burst and rolled thro the deep
blackning all beneath, so that the nether deep grew
black as a sea & rolled with a terrible noise: be-
neath us was nothing now to be seen but a black
tempest, till looking east between the clouds & the
waves, we saw a cataract of blood mixed with fire
and not many stones throw from us appeard and
sunk again the scaly fold of a monstrous serpent
at last to the east, distant about three degrees ap-
peard a fiery crest above the waves slowly it rear-
ed like a ridge of golden rocks till we discoverd
two globes of crimson fire, from which the sea
fled away in clouds of smoke, and now we saw, it
was the head of Leviathan, his forehead was di-
vided into streaks of green & purple like those on
a tygers forehead: soon we saw his mouth & red
gills hang just above the raging foam tinging the
black deep with beams of blood, advancing toward
us

us with all the fury of a spiritual existence.

My friend the Angel climb'd up from his station into the mill; I remaind alone, & then this appearance was no more, but I found myself sitting on a pleasant bank beside a river by moonlight hearing a harper who, sung to the harp, & his theme was, The man who never alters his opinion is like standing water, & breeds reptiles of the mind.

But I arose, and sought for the mill & there I found my Angel, who surprised asked me, how I escaped?

I answerd, All that we saw was owing to your metaphysics: for when you ran away, I found myself on a bank by moonlight hearing a harper, But now we have seen my eternal lot, shall I shew you yours? he laugh'd at my proposal: but I by force suddenly caught him in my arms, & flew westerly thro' the night, till we were elevated above the earths shadow: then I flung myself with him directly into the body of the sun, here I clothed myself in white, & taking in my hand Swedenborgs volumes sunk from the glorious clime, and passed all the planets till we came to saturn, here I staid to rest & then leap'd into the void, between saturn & the fixed stars.

Here said I! is your lot, in this space, if space it may be called, Soon we saw the stable and the church, & I took him to the altar and opend the Bible, and lo! it was a deep pit, into which I descended driving the Angel before me, soon we saw seven houses of brick, one we enterd; in it were a num

number of monkeys, baboons, & all of that species
chaind by the middle, grinning and snatching at
one, another, but witheld by the shortness of their
chains; however I saw that they sometimes grew nu
merous, and then the weak were caught by the strong
and with a grinning aspect, first coupled with & then
devourd, by plucking off first one limb and then ano
ther till the body was left a helpless trunk, this after
grinning & kissing it with seeming fondness they de-
vourd too; and here & there I saw one savourily pic-
king the flesh off of his own tail; as the stench ter
ribly annoyd us both, we went into the mill, & I in
my hand brought the skeleton of a body, which in
the mill was Aristotles Analytics.

So the Angel said: thy phantasy has imposed
upon me & thou oughtest to be ashamed.

I answerd: we impose on one another, & it is
but lost time to converse with you whose works
are only Analytics

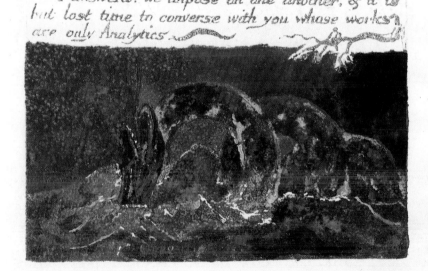

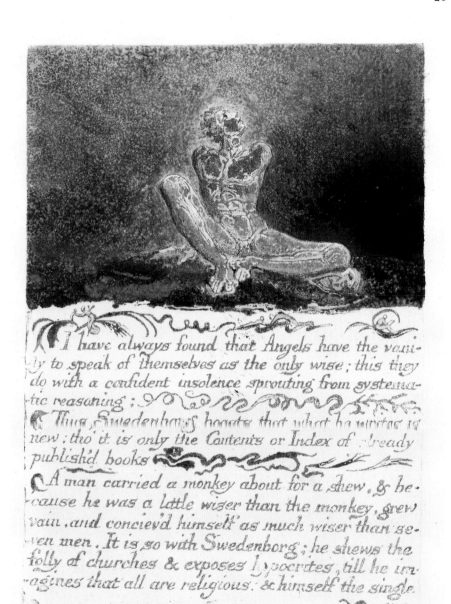

I have always found that Angels have the vani-
ty to speak of themselves as the only wise; this they
do with a confident insolence sprouting from systema-
tic reasoning:

Thus Swedenborg boasts that what he writes is
new; tho' it is only the Contents or Index of already
publish'd books

A man carried a monkey about for a shew, & be-
cause he was a little wiser than the monkey, grew
vain, and conciev'd himself as much wiser than se-
ven men. It is so with Swedenborg; he shews the
folly of churches & exposes hypocrites, till he im-
agines that all are religious. & himself the single
one

one on earth that ever broke a net.

¶ Now hear a plain fact: Swedenborg has not writ-
ten one new truth: Now hear another: he has written
all the old falshoods.

¶ And now hear the reason. He conversed with Angels
who are all religious, & conversed not with Devils who
all hate religion, for he was incapable thro' his conceited
notions.

Thus Swedenborgs writings are a recapitulation of
all superficial opinions, and an analysis of the more
sublime, but no further.

¶ Have now another plain fact: Any man of mechani-
cal talents may from the writings of Paracelsus or Ja-
cob Behmen, produce ten thousand volumes of equal
value with Swedenborgs, and from those of Dante or
Shakespear, an infinite number.

¶ But when he has done this, let him not say that he
knows better than his master, for he only holds a can-
dle in sunshine.

A Memorable Fancy

Once I saw a Devil in a flame of fire, who arose be-
fore an Angel that sat on a cloud, and the Devil ut-
terd these words.

The worship of God is, Honouring his gifts in other
men each according to his genius, and loving the
great

greatest men best, those who envy or calumniate great men hate God, for there is no other God.

The Angel hearing this became almost blue but mastering himself he grew yellow, & at last white pink & smiling. and then replied, Thou Idolater, is not God One? & is not he visible in Jesus Christ? and has not Jesus Christ given his sanction to the law of ten commandments and are not all other men fools, sinners, & nothings?

The Devil answerd: bray a fool in a morter with wheat yet shall not his folly be beaten out of him if Jesus Christ is the greatest man, you ought to love him in the greatest degree; now hear how he has given his sanction to the law of ten commandments: did he not mock at the sabbath, and so mock the sabbaths God? murder those who were murderd because of him? turn away the law from the woman taken in adultery? steal the labor of others to support him? bear false witness when he omitted making a defence before Pilate? covet when he prayd for his disciples, and when he bid them shake off the dust of their feet against such as refused to lodge them? I tell you, no virtue can exist without breaking these ten commandments. Jesus was all virtue, and acted from impulse

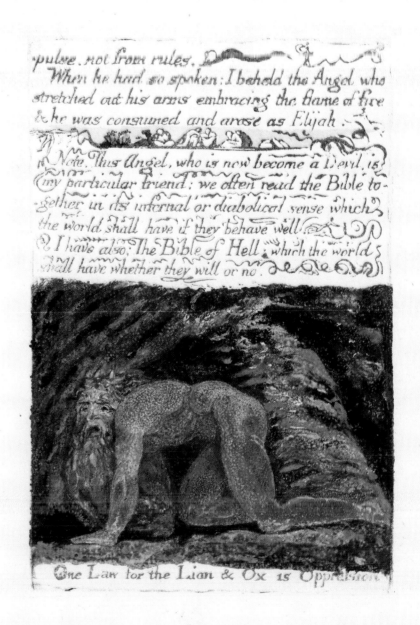

A Song of Liberty

1. The Eternal Female groand! it was heard over all the Earth:

2. Albions coast is sick silent; the A-merican meadows faint!

3. Shadows of Prophecy shiver along by the lakes and the rivers and mutter across the ocean? France rend down thy dungeon;

4. Golden Spain burst the barriers of old Rome;

5. Cast thy keys O Rome into the deep down falling, even to eternity down falling,

6. And weep

7. In her trembling hands she took the new born terror howling;

8. On those infinite mountains of light now barr'd out by the atlantic sea, the new born fire stood before the starry king!

9. Flag'd with grey brow'd snows and thunderous visages the jealous wings wav'd over the deep.

10. The speary hand burned aloft, unbuck-led was the shield, forth went the hand of jealousy among the flaming hair, and

hurl'd the new born wonder thro' the starry
night.

11. The fire, the fire, is falling!

12. Look up! look up! O citizen of London.
enlarge thy countenance; O Jew, leave coun
ting gold! return to thy oil and wine; O
African! black African! (go. winged thought
widen his forehead.)

13. The fiery limbs, the flaming hair, shot
like the sinking sun into the western sea.

14. Wak'd from his eternal sleep, the hoary
element roaring fled away;

15. Down rush'd beating his wings in vain
the jealous king: his grey brow'd councel-
-lors, thunderous warriors, curl'd veterans,
among helms, and shields, and chariots
horses, elephants: banners, castles, slings
and rocks,

16. Falling, rushing, ruining! buried in
the ruins, on Urthona's dens.

17. All night beneath the ruins, then
their sullen flames faded emerge round
the gloomy king.

18. With thunder and fire: leading his
starry hosts thro' the waste wilderness

he promulgates his ten commands,
glancing his beamy eyelids over the
deep in dark dismay,
19. Where the son of fire in his eastern
cloud, while the morning plumes her gol-
den breast.
20. Spurning the clouds written with
curses, stamps the stony law to dust,
loosing the eternal horses from the dens
of night, crying Empire is no more!
and now the lion & wolf shall
cease.

Chorus

Let the Priests of the Raven of dawn,
no longer in deadly black, with hoarse note
curse the sons of joy. Nor his accepted
brethren whom, tyrant, he calls free: lay the
bound or build the roof. Nor pale religious
letchery call that virginity, that wishes
but acts not!

For every thing that lives is Holy

The Gates of Paradise
1793/1818 (?)

Line engraving and etching.

The Gates of Paradise is a series of emblems distilled from a large group of designs in Blake's *Notebook*, now in the British Library, where they are gathered together under the title of 'Ideas of Good and Evil'. In ordering them for publication Blake made them follow the life of man from birth to death. While these emblems have affinities with children's books of the time, they are in fact extremely complex in thought and allusion.

In 1793 Blake made eighteen small engravings to which he gave the title 'For Children, The Gates of Paradise'. According to the etched title-page it was to be published jointly by Blake and the radical publisher Joseph Johnson. The inscription, however, seems to have been wishful thinking on Blake's part and Johnson may not have intended to do more than offer a few copies for sale. The opuscule, which its author advertised in 1793 'Price 3s.', was a complete failure. Five copies only have survived, one of which was in Blake's possession at his death.

In about 1818 Blake resuscitated the original plates, re-engraved some, revised others, altered some of the legends and added three plates of engraved text. This later version, which he re-titled *For the Sexes: The Gates of Paradise,* is here reproduced from the collotype facsimile printed and published in 1968 by the Trianon Press for The William Blake Trust.

What is Man !
The Suns Light when he unfolds it
Depends on the Organ that beholds it

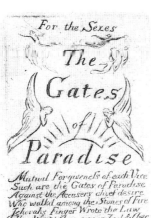

For the Sexes

The
Gates
of
Paradise

Mutual Forgiveness of each Vice
Such are the Gates of Paradise
Against the Accusers chief desire
Who walkd among the Stones of Fire
Jehovahs Finger Wrote the Law
Then Wept! then rose in Zeal & Awe
And the Dead Corpse from Sinais heat
Buried beneath his Mercy Seat
O Christians Christians! tell me Why
You rear it on your Altars high

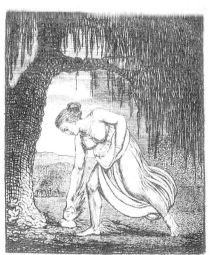

I found him beneath a Tree

Published 17 May 1793 by W Blake

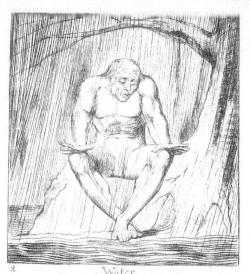

Water

Thou Waterest him with Tears

Published by W Blake 17 May 1793

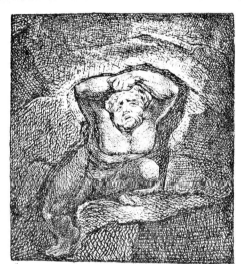

— Earth —

He struggles into Life

Published by W Blake 17 May 1793

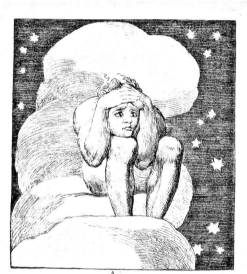

— Air —

On Cloudy Doubts & Reasoning Cares

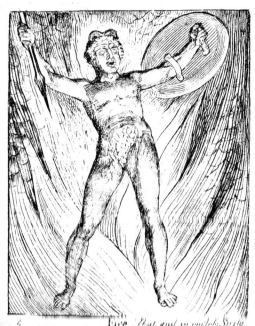

Fire *That end in endless Strife*
Publd by W Blake 17 May 1793

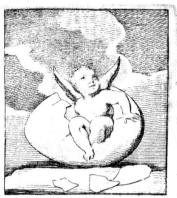

At length for hatching ripe
he breaks the shell
Publish'd by W B...

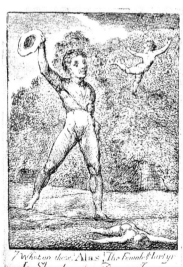

7 *What are these Alas! The Female Martyr*
Is She also the Divine Image
Published 17 May 1793 by W Blake Lambeth

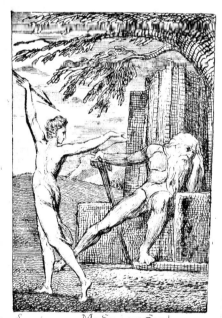

8 My Son! my Son!
Published by W Blake 17 May 1793 & sold

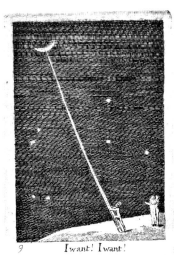

9 I want! I want!

Pub. by W Blake 17 May 1793

10 Help! Help!

Published by W Blake 17 May 1793

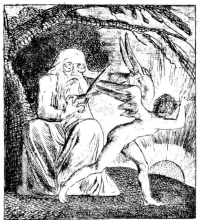

Aged Ignorance
Perceptive Organs closed their Objects close

Publd. by 17 May 1793 by W Blake Lambeth

12 Does thy God O Priest take such vengeance
as this?

Published 17 May 1793 by W Blake Lambeth

13 Fear & Hope are — Vision

The Traveller hasteth in the
Evening

15 Deaths Door

Published as the Act by W Blake Lambeth

16 I have said to the Worm: Thou
art my mother & my sister

Published by W Blake 17th 1793

The Keys

The Catterpiller on the Leaf
Reminds thee of thy Mothers Grief

of the Gates

1. My Eternal Man set in Repose
The Female from his darkness rose
And She found me beneath a Tree
A Mandrake & in her Veil hid me
Serpent Reasonings us entice
Of Good & Evil. Virtue & Vice
2. Doubt Self Jealous Watry folly
3. Struggling thro Earths Melancholy
4. Naked in Air in Shame & Fear
5. Blind in Fire with shield & spear
Two Hornd Reasoning Cloven Fiction
In Doubt which is Self contradiction
A dark Hermaphrodite We stood
Rational Truth Root of Evil & Good
Round me flew the Flaming Sword
Round her snowy Whirlwinds roard
Freezing her Veil the Mundane Shell
6. I rent the Veil where the Dead dwell
When weary Man enters his Cave

He meets his Saviour in the Grave
Some find a Female Garment there
And some a Male woven with care
Lest the Sexual Garments sweet
Should grow a devouring Winding sheet
7. One Dies! Alas! the Living & Dead
One is slain & One is fled
8. In Vain-glory hatcht & nurst
By double Spectres Self Accurst
My Son! my Son! thou treatest me
But as I have instructed thee
9. On the shadows of the Moon
Climbing thro Nights highest noon
10. In Times Ocean falling drownd
In Aged Ignorance profound
11. Holy & cold I clipd the Wings
Of all Sublunary Things
12. And in depths of my Dungeons
Closed the Father & the Sons
13. But when once I did descry
The Immortal Man that cannot Die
14. Thro evening shades I haste away
To close the Labours of my Day
15. The Door of Death I open found
And the Worm Weaving in the Ground
16. Thou'rt my Mother from the Womb
Wife Sister Daughter to the Tomb
Weaving to Dreams the Sexual strife
And weeping over the Web of Life

To The Accuser who is The God of This World

Truly My Satan thou art but a Dunce
And dost not know the Garment from the Man
Every Harlot was a Virgin once
Nor canst thou ever change Kate into Nan

Tho thou art Worshipd by the Names Divine
Of Jesus & Jehovah: thou art still
The Son of Morn in weary Nights decline
The lost Travellers Dream under the Hill

Visions of the Daughters of Albion

1793

Houghton Library, Harvard University, Cambridge, Mass. Copy G.
Relief etchings, watercoloured by hand.

Visions of the Daughters of Albion tells of the sexual alienation of the Fallen world through
the tragic and inconclusive story of Oothoon, the free-spirited heroine, and her triangular
relationship with Theotormon and Bromion, who represent respectively emotion and reason.
Their interdependence and the slavery of the children of Albion are represented in the
powerful frontispiece, while the text itself addresses still topical questions of female sexuality
and liberation which were the subject of concern and debate among Mary Wollstonecraft's
and Joseph Johnson's circle of radicals.

Visions of the Daughters of Albion exists in some seventeen copies. It was etched for relief
printing in 1793 and the copy here reproduced was probably printed two years later. The
hand-colouring in deep and sombre hues matches the poem's dark events and often resembles,
and perhaps imitates, the effects which Blake had achieved in the colour-printed copies of
The Marriage of Heaven and Hell (see pages 106–133).

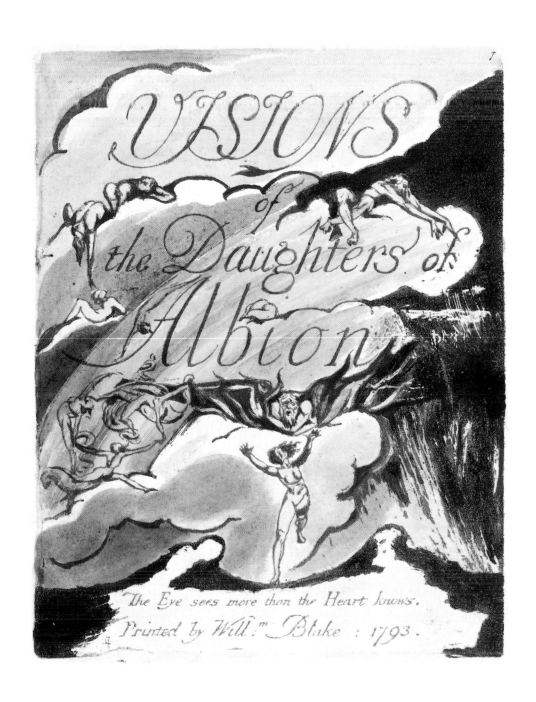

VISIONS

of

the Daughters of

Albion

The Eye sees more than the Heart knows.
Printed by Will:ᵐ Blake : 1793 .

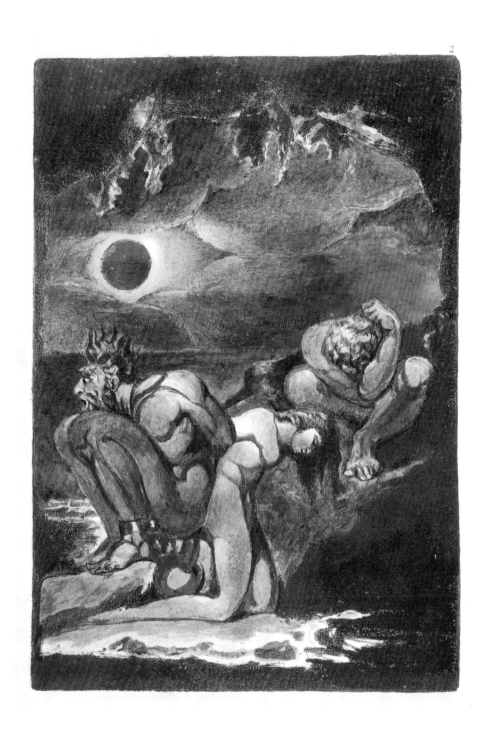

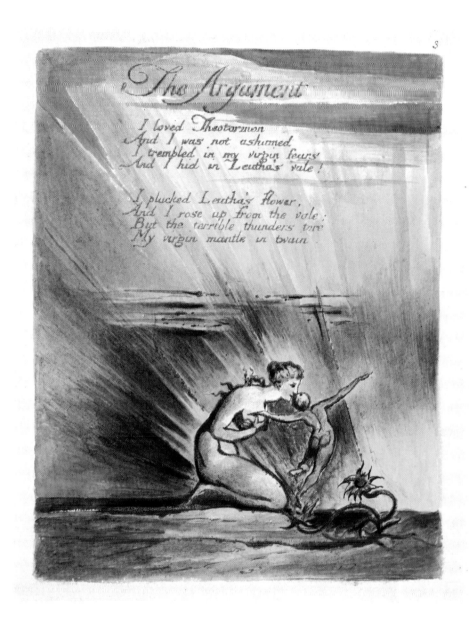

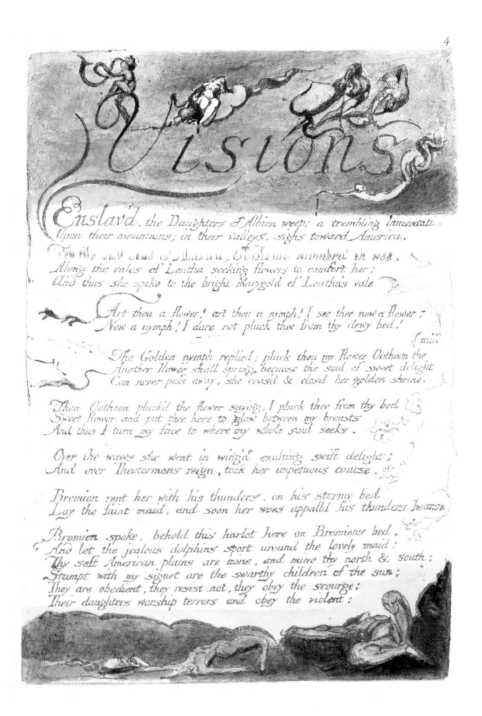

Visions

Enslav'd, the Daughters of Albion weep; a trembling lamentation
Upon their mountains; in their valleys, sighs toward America.

For the soft soul of America, Oothoon wanderd in woe,
Along the vales of Leutha seeking flowers to comfort her;
And thus she spoke to the bright Marygold of Leutha's vale

Art thou a flower! art thou a nymph! I see thee now a flower;
Now a nymph! I dare not pluck thee from thy dewy bed!

The Golden nymph replied; pluck thou my flower Oothoon the mild
Another flower shall spring, because the soul of sweet delight
Can never pass away. she ceasd & closd her golden shrine.

Then Oothoon pluck'd the flower saying, I pluck thee from thy bed
Sweet flower, and put thee here to glow between my breasts
And thus I turn my face to where my whole soul seeks.

Over the waves she went in wing'd exulting swift delight;
And over Theotormons reign, took her impetuous course.

Bromion rent her with his thunders, on his stormy bed
Lay the faint maid, and soon her woes appalld his thunders hoarse

Bromion spoke, behold this harlot here on Bromions bed,
And let the jealous dolphins sport around the lovely maid;
Thy soft American plains are mine, and mine thy north & south:
Stampt with my signet are the swarthy children of the sun;
They are obedient, they resist not, they obey the scourge;
Their daughters worship terrors and obey the violent:

Now thou maist marry Bromions harlot, and protect the child
Of Bromions rage, that Oothoon shall put forth in nine moons time

Then storms rent Theotormons limbs; he rolld his waves around.
And folded his black jealous waters round the adulterate pair
Bound back to back in Bromions caves terror & meekness dwell

At entrance Theotormon sits wearing the threshold hard
With secret tears; beneath him sound like waves on a desart shore
The voice of slaves beneath the sun, and children bought with money.
That shiver in religious caves beneath the burning fires
Of lust, that belch incessant from the summits of the earth.

Oothoon weeps not, she cannot weep! her tears are locked up;
But she can howl incessant writhing her soft snowy limbs.
And calling Theotormons Eagles to prey upon her flesh.

I call with holy voice! kings of the sounding air,
Rend away this defiled bosom that I may reflect,
The image of Theotormon on my pure transparent breast.

The Eagles at her call descend & rend their bleeding prey;
Theotormon severely smiles, her soul reflects the smile;
As the clear spring mudded with feet of beasts grows pure & smiles

The Daughters of Albion hear her woes, & eccho back her sighs.

Why does my Theotormon sit weeping upon the threshold;
And Oothoon hovers by his side, persuading him in vain;
I cry arise O Theotormon for the village dog
Barks at the breaking day, the nightingale has done lamenting.
The lark does rustle in the ripe corn, and the Eagle returns
From nightly prey, and lifts his golden beak to the pure east;
Shaking the dust from his immortal pinions to awake
The sun that sleeps too long. Arise my Theotormon I am pure.
Because the night is gone that closd me in its deadly black.
They told me that the night & day were all that I could see;
They told me that I had five senses to inclose me up.
And they inclosd my infinite brain into a narrow circle.
And sunk my heart into the Abyss, a red round globe hot burning
Till all from life I was obliterated and erased.
Instead of morn arises a bright shadow, like an eye
In the eastern cloud; instead of night a sickly charnel house;
That Theotormon hears me not! to him the night and morn
Are both alike; a night of sighs, a morning of fresh tears;

And none but Bromion can hear my lamentations.

With what sense is it that the chicken shuns the ravenous hawk?
With what sense does the tame pigeon measure out the expanse?
With what sense does the bee form cells? have not the mouse & frog
Eyes and ears and sense of touch? yet are their habitations.
And their pursuits, as different as their forms and as their joys:
Ask the wild ass why he refuses burdens: and the meek camel
Why he loves man: is it because of eye ear mouth or skin
Or breathing nostrils? No, for these the wolf and tyger have.
Ask the blind worm the secrets of the grave, and why her spires
Love to curl round the bones of death; and ask the rav'nous snake
Where she gets poison: & the wing'd eagle why he loves the sun
And then tell me the thoughts of man, that have been hid of old.

Silent I hover all the night, and all day could be silent,
If Theotormon once would turn his loved eyes upon me;
How can I be defild when I reflect thy image pure? (woe
Sweetest the fruit that the worm feeds on. & the soul prey'd on by
The new washd lamb ting'd with the village smoke & the bright swan
By the red earth of our immortal river: I bathe my wings,
And I am white and pure to hover round Theotormons breast.

Then Theotormon broke his silence. and he answered.

Tell me what is the night or day to one o'erflowd with woe?
Tell me what is a thought? & of what substance is it made?
Tell me what is a joy? & in what gardens do joys grow?
And in what rivers swim the sorrows? and upon what mountains

Wave shadows of discontent? and in what houses dwell the wretched
Drunken with woe forgotten, and shut up from cold despair.

Tell me where dwell the thoughts forgotten till thou call them forth
Tell me where dwell the joys of old! & where the ancient loves?
And when will they renew again & the night of oblivion past?
That I might traverse times & spaces far remote and bring
Comforts into a present sorrow and a night of pain
Where goest thou O thought! to what remote land is thy flight?
If thou returnest to the present moment of affliction
Wilt thou bring comforts on thy wings, and dews and honey and balm;
Or poison from the desart wilds, from the eyes of the envier.

Then Bromion said: and shook the cavern with his lamentation

Thou knowest that the ancient trees seen by thine eyes have fruit;
But knowest thou that trees and fruits flourish upon the earth
To gratify senses unknown? trees beasts and birds unknown:
Unknown, not unperceivd, spread in the infinite microscope,
In places yet unvisited by the voyager, and in worlds
Over another kind of seas, and in atmospheres unknown.
Ah! are there other wars, beside the wars of sword and fire!
And are there other sorrows, beside the sorrows of poverty?
And are there other joys, beside the joys of riches and ease?
And is there not one law for both the lion and the ox?
And is there not eternal fire, and eternal chains?
To bind the phantoms of existence from eternal life?

Then Oothoon waited silent all the day, and all the night,

But when the morn arose, her lamentation renewd,
The Daughters of Albion hear her woes, & eccho back her sighs.

O Urizen! Creator of men! mistaken Demon of heaven;
Thy joys are tears! thy labour vain, to form men to thine image.
How can one joy absorb another? are not different joys
Holy, eternal, infinite! and each joy is a Love.

Does not the great mouth laugh at a gift? & the narrow eyelids mock
At the labour that is above payment, and wilt thou take the ape
For thy councellor? or the dog, for a schoolmaster to thy children?
Does he who contemns poverty, and he who turns with abhorrence
From usury: feel the same passion or are they moved alike?
How can the giver of gifts experience the delights of the merchant?
How the industrious citizen the pangs of the husbandman,
How different far the fat fed hireling with hollow drum,
Who buys whole corn fields into wastes, and sings upon the heath:
How different their eye and ear! how different the world to them!
With what sense does the parson claim the labour of the farmer?
What are his nets & gins & traps, & how does he surround him
With cold floods of abstraction, and with forests of solitude,
To build him castles and high spires, where kings & priests may dwell.
Till she who burns with youth, and knows no fixed lot, is bound
In spells of law to one she loaths: and must she drag the chain
Of life, in weary lust! must chilling murderous thoughts, obscure
The clear heaven of her eternal spring? to bear the wintry rage
Of a harsh terror driv'n to madness, bound to hold a rod
Over her shrinking shoulders all the day; & all the night
To turn the wheel of false desire: and longings that wake her womb
To the abhorred birth of cherubs in the human form
That live a pestilence & die a meteor & are no more.
Till the child dwell with one he hates, and do the deed he loaths
And the impure scourge force his seed into its unripe birth
Eer yet his eyelids can behold the arrows of the day.

Does the whale worship at thy footsteps as the hungry dog?
Or does he scent the mountain prey, because his nostrils wide
Draw in the ocean? does his eye discern the flying cloud
As the ravens eye? or does he measure the expanse like the vulture?
Does the still spider view the cliffs where eagles hide their young?
Or does the fly rejoice, because the harvest is brought in?
Does not the eagle scorn the earth & despise the treasures beneath?
But the mole knoweth what is there, & the worm shall tell it thee.
Does not the worm erect a pillar in the mouldering church yard?

[149]

And, a palace of eternity in the jaws of the hungry grave
Over his porch these words are written. Take thy bliss O Man!
And sweet shall be thy taste & sweet thy infant joys renew!

Infancy, fearless, lustful, happy! nestling for delight
In laps of pleasure; Innocence! honest, open, seeking
The vigorous joys of morning light; open to virgin bliss.
Who taught thee modesty, subtil modesty! child of night & sleep
When thou awakest, wilt thou dissemble all thy secret joys
Or wert thou not awake when all this mystery was disclos'd!
Then com'st thou forth a modest virgin knowing to dissemble
With nets found under thy night pillow, to catch virgin joy,
And brand it with the name of whore; & sell it in the night,
In silence, ev'n without a whisper, and in seeming sleep.
Religious dreams and holy vespers, light thy smoky fires:
Once were thy fires lighted by the eyes of honest morn
And does my Theotormon seek this hypocrite modesty!
This knowing, artful, secret, fearful, cautious, trembling hypocrite.
Then is Oothoon a whore indeed! and all the virgin joys
Of life are harlots; and Theotormon is a sick mans dream.
And Oothoon is the crafty slave of selfish holiness.

But Oothoon is not so, a virgin filld with virgin fancies
Open to joy and to delight, where ever beauty appears
If in the morning sun I find it; there my eyes are fixd

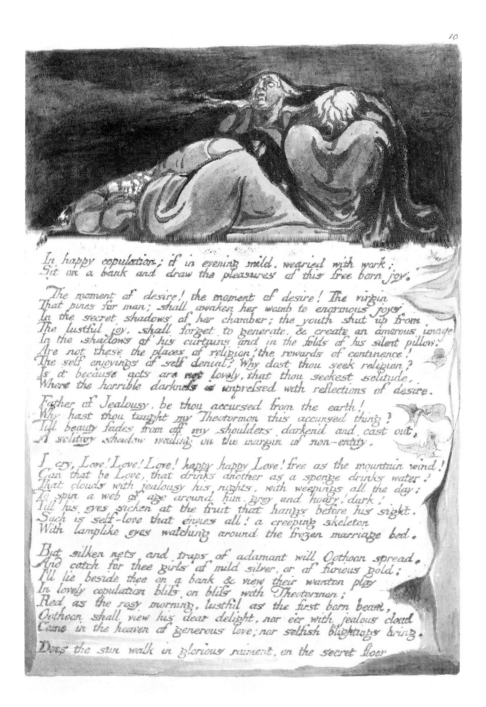

In happy copulation; if in evening mild, wearied with work;
Sit on a bank and draw the pleasures of this free born joy.

The moment of desire! the moment of desire! The virgin
That pines for man; shall awaken her womb to enormous joys
In the secret shadows of her chamber; the youth shut up from
The lustful joy, shall forget to generate, & create an amorous image
In the shadows of his curtains and in the folds of his silent pillow.
Are not these the places of religion; the rewards of continence!
The self enjoyings of self denial? Why dost thou seek religion?
Is it because acts are not lovely, that thou seekest solitude,
Where the horrible darkness is unpreſsed with reflections of desire.

Father of Jealousy, be thou accursed from the earth!
Why hast thou taught my Theotormon this accursed thing?
Till beauty fades from off my shoulders darkend and cast out,
A solitary shadow wailing on the margin of non-entity.

I cry, Love! Love! Love! happy happy Love! free as the mountain wind!
Can that be Love, that drinks another as a sponge drinks water?
That clouds with jealousy his nights, with weepings all the day:
To spin a web of age around him, grey and hoary, dark!
Till his eyes sicken at the fruit that hangs before his sight.
Such is self-love that envies all! a creeping skeleton
With lamplike eyes watching around the frozen marriage bed.

But silken nets and traps of adamant will Oothoon spread,
And catch for thee girls of mild silver, or of furious gold;
I'll lie beside thee on a bank & view their wanton play
In lovely copulation bliſs on bliſs with Theotormon;
Red as the rosy morning, lustful as the first born beam,
Oothoon shall view his dear delight, nor eer with jealous cloud
Come in the heaven of generous love; nor selfish blightings bring.

Does the sun walk in glorious raiment, on the secret floor

America a Prophecy
1793

The British Museum, London. Copy H.
Relief etchings, with some wash.

America is the first of the full-scale Prophecies of the 1790s, a time of great and dangerous political and social upheaval at home and abroad. It is Blake's direct response to crises of the French Revolution as it reached its bloodiest phase. It tells, with much historic circumstance, of the outbreak of revolutionary energy in America, personified by Orc, who confronts the reactionary powers of the Fallen world in the guise of 'Albion's Angel', otherwise Urizen.

Europe was etched and first printed in 1793, shortly after Blake's move to Lambeth in south London. Seventeen copies have survived. The bold, graphic style of the etching, which makes extensive use of white-line engraving, suggests that Blake did not, at least initially, envisage adding watercolour to these prints. In the present copy the combination of strong images, particularly closely integrated with the text, and monochrome printing heightens the urgency of Blake's political message. Copy H is one of four from the initial print-run of 1793 to be printed in blue/gray ink and evidences considerable care by Blake in inking and wiping so as to obtain strong and open impressions from the plates.

The cancelled plate (page 179) with Blake's autograph deletions and revisions, possibly intended for insertion between plates 10 and 11, is in the Rosenwald Collection, Library of Congress, Washington, D.C.

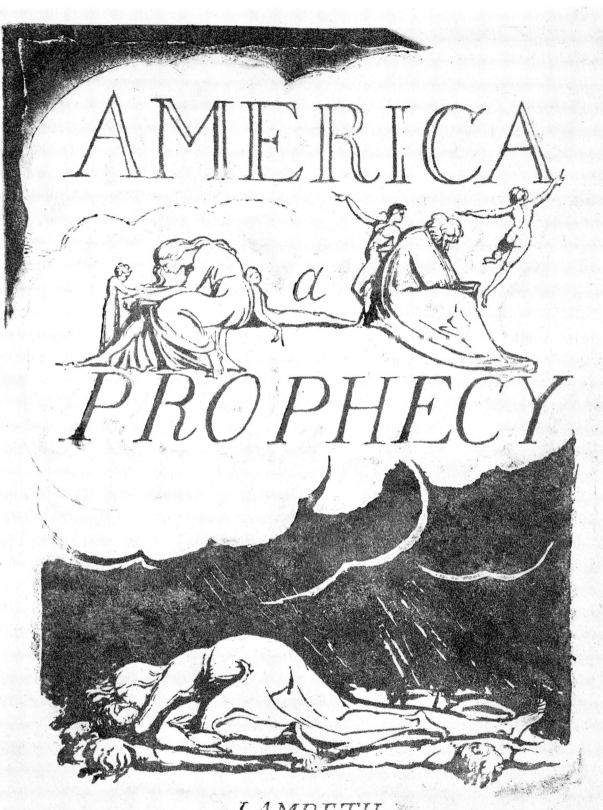

AMERICA

a

PROPHECY

LAMBETH

Printed by William Blake in the year 1793.

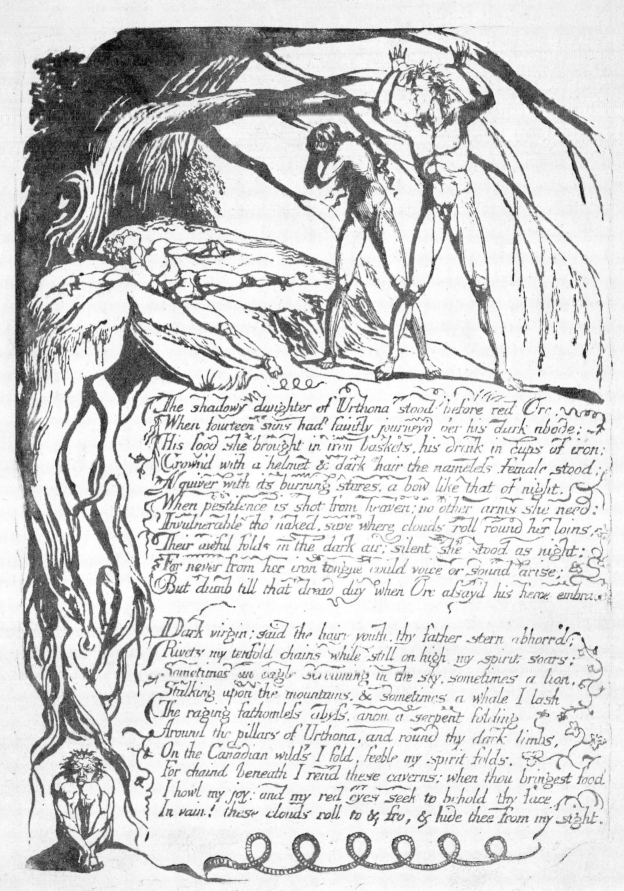

Preludium

The shadowy daughter of Urthona stood before red Orc.
When fourteen suns had faintly journeyd oer his dark abode;
His food she brought in iron baskets, his drink in cups of iron;
Crownd with a helmet & dark hair the nameless female stood;
A quiver with its burning stores, a bow like that of night,
When pestilence is shot from heaven; no other arms she need:
Invulnerable tho' naked, save where clouds roll round her loins,
Their awful folds in the dark air; silent she stood as night;
For never from her iron tongue could voice or sound arise;
But dumb till that dread day when Orc assayd his fierce embrace.

Dark virgin; said the hairy youth, thy father stern abhorrd;
Rivets my tenfold chains while still on high my spirit soars;
Sometimes an eagle screaming in the sky, sometimes a lion,
Stalking upon the mountains, & sometimes a whale I lash
The raging fathomless abyss, anon a serpent folding
Around the pillars of Urthona, and round thy dark limbs,
On the Canadian wilds I fold, feeble my spirit folds.
For chaind beneath I rend these caverns; when thou bringest food
I howl my joy: and my red eyes seek to behold thy face
In vain! these clouds roll to & fro, & hide thee from my sight.

Silent as despairing love, and strong as jealousy.
The hairy shoulders rend the links, free are the wrists of fire;
Round the terrific loins he siez'd the panting struggling womb;
It joy'd: she put aside her clouds & smiled her first-born smile;
As when a black cloud shews its lightnings to the silent deep.

Soon as she saw the terrible boy then burst the virgin cry.

I know thee, I have found thee, & I will not let thee go;
Thou art the image of God who dwells in darkness of Africa;
And thou art fall'n to give me life in regions of dark death.
On my American plains I feel the struggling afflictions
Endur'd by roots that writhe their arms into the nether deep:
I see a serpent in Canada, who courts me to his love;
In Mexico an Eagle, and a Lion in Peru;
I see a Whale in the South-sea, drinking my soul away.
O what limb rending pains I feel, thy fire & my frost
Mingle in howling pains, in furrows by thy lightnings rent;
This is eternal death; and this the torment long foretold.

[157]

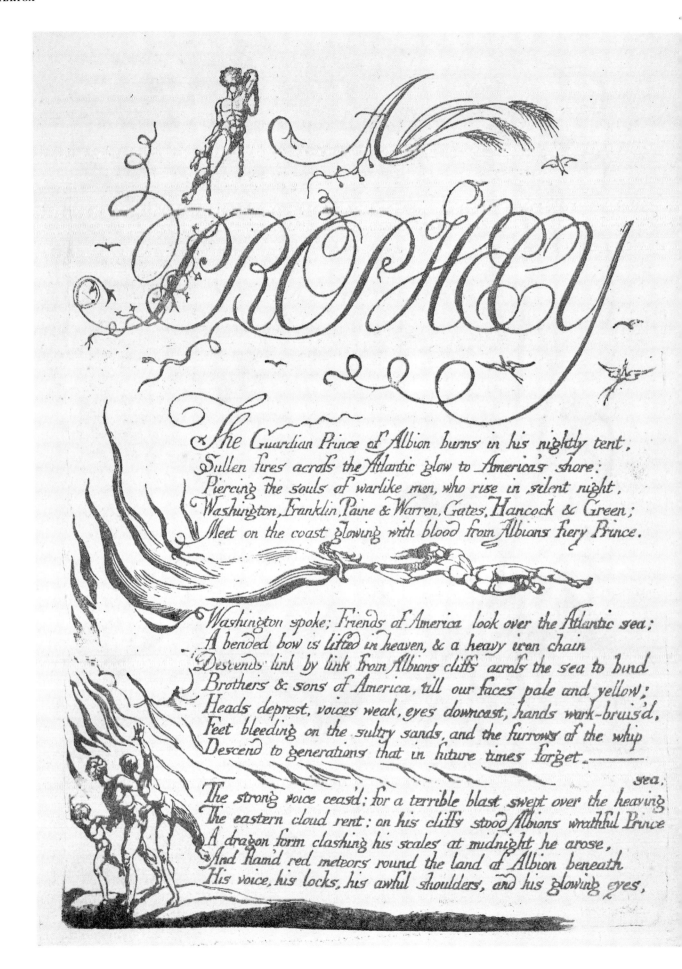

A PROPHECY

The Guardian Prince of Albion burns in his nightly tent,
Sullen fires across the Atlantic glow to America's shore:
Piercing the souls of warlike men, who rise in silent night,
Washington, Franklin, Paine & Warren, Gates, Hancock & Green;
Meet on the coast glowing with blood from Albions fiery Prince.

Washington spoke; Friends of America look over the Atlantic sea;
A bended bow is lifted in heaven, & a heavy iron chain
Descends link by link from Albions cliffs across the sea to bind
Brothers & sons of America, till our faces pale and yellow;
Heads deprest, voices weak, eyes downcast, hands work-bruis'd,
Feet bleeding on the sultry sands, and the furrows of the whip
Descend to generations that in future times forget.————

The strong voice ceas'd; for a terrible blast swept over the heaving sea,
The eastern cloud rent: on his cliffs stood Albions wrathful Prince
A dragon form clashing his scales at midnight he arose,
And flam'd red meteors round the land of Albion beneath
His voice, his locks, his awful shoulders, and his glowing eyes,

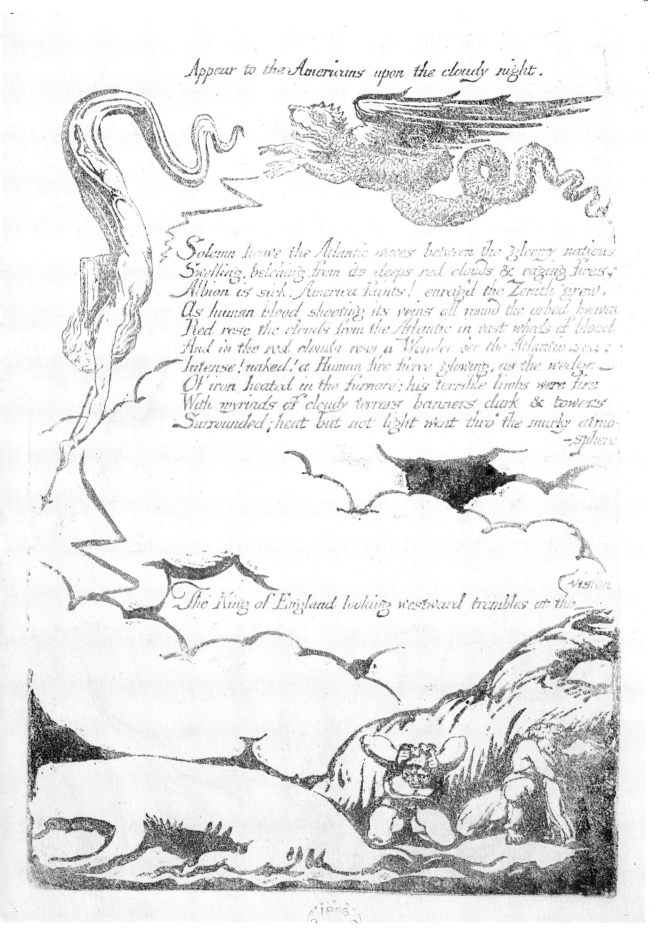

Appear to the Americans upon the cloudy night.

Solemn heave the Atlantic waves between the gloomy nations
Swelling, belching from its deeps red clouds & raging fires;
Albion is sick. America faints! enrag'd the Zenith grew.
As human blood shooting its veins all round the orbed heaven
Red rose the clouds from the Atlantic in vast wheels of blood
And in the red clouds rose a Wonder o'er the Atlantic sea;
Intense! naked! a Human fire fierce glowing, as the wedge
Of iron heated in the furnace; his terrible limbs were fire
With myriads of cloudy terrors banners dark & towers
Surrounded; heat but not light went thro' the murky atmo-
-sphere

vision

The King of England looking westward trembles at the

1856

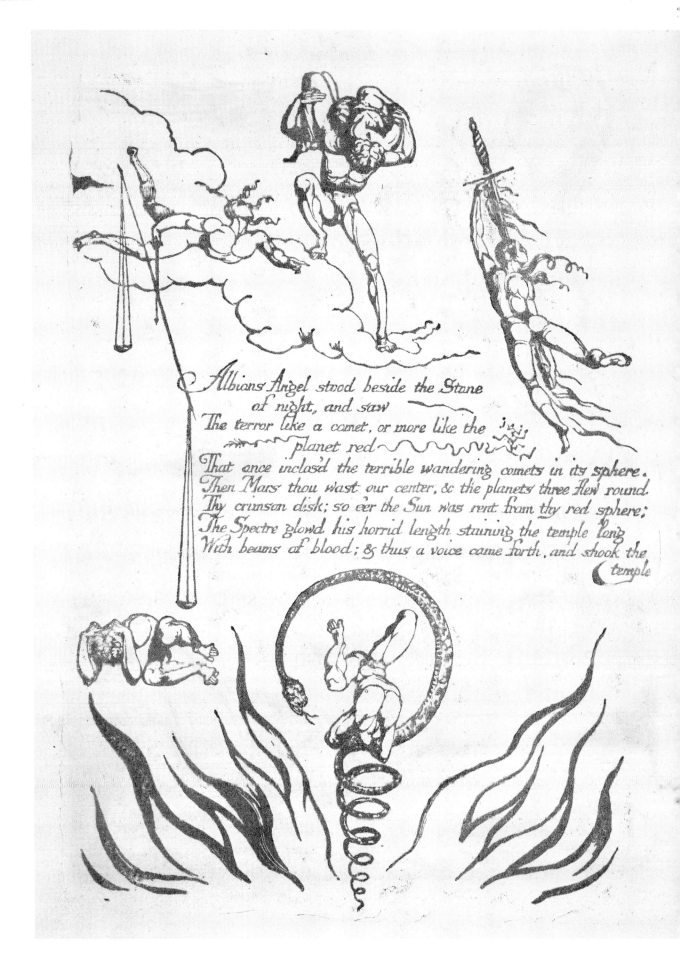

Albions Angel stood beside the Stone
of night, and saw
The terror like a comet, or more like the
planet red
That once inclos'd the terrible wandering comets in its sphere.
Then Mars thou wast our center, & the planets three flew round.
Thy crimson disk; so ere the Sun was rent from thy red sphere;
The Spectre glow'd his horrid length staining the temple long
With beams of blood; & thus a voice came forth, and shook the
temple

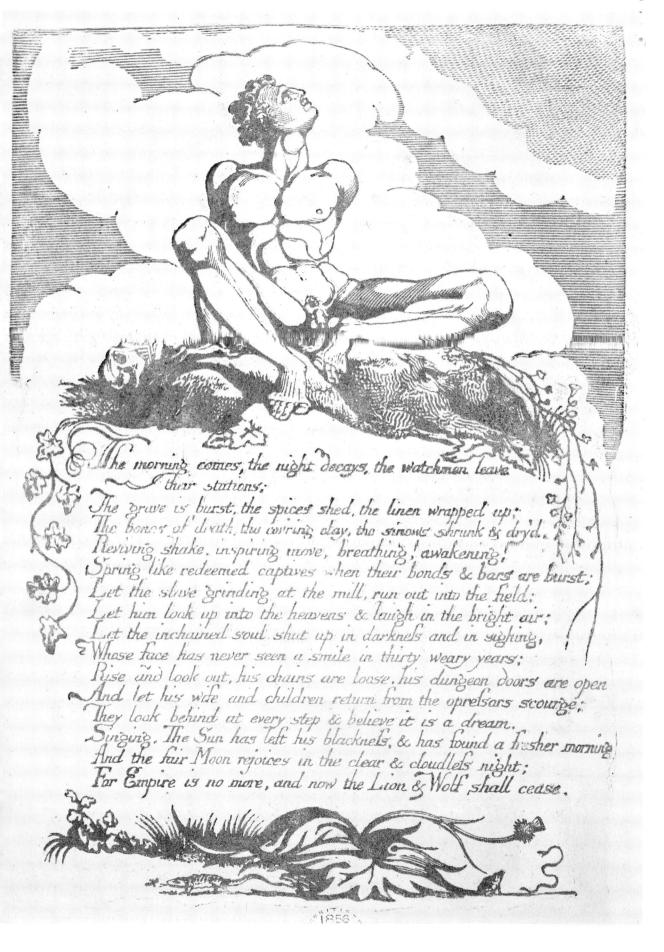

The morning comes, the night decays, the watchmen leave
 their stations;
The grave is burst, the spices shed, the linen wrapped up;
The bones of death, the covering clay, the sinews shrunk & dry'd,
Reviving shake, inspiring move, breathing! awakening!
Spring like redeemed captives when their bonds & bars are burst;
Let the slave grinding at the mill, run out into the field;
Let him look up into the heavens & laugh in the bright air;
Let the inchained soul shut up in darkness and in sighing,
Whose face has never seen a smile in thirty weary years;
Rise and look out, his chains are loose, his dungeon doors are open
And let his wife and children return from the oprefsors scourge;
They look behind at every step & believe it is a dream,
Singing. The Sun has left his blacknefs, & has found a fresher morning
And the fair Moon rejoices in the clear & cloudlefs night;
For Empire is no more, and now the Lion & Wolf shall cease.

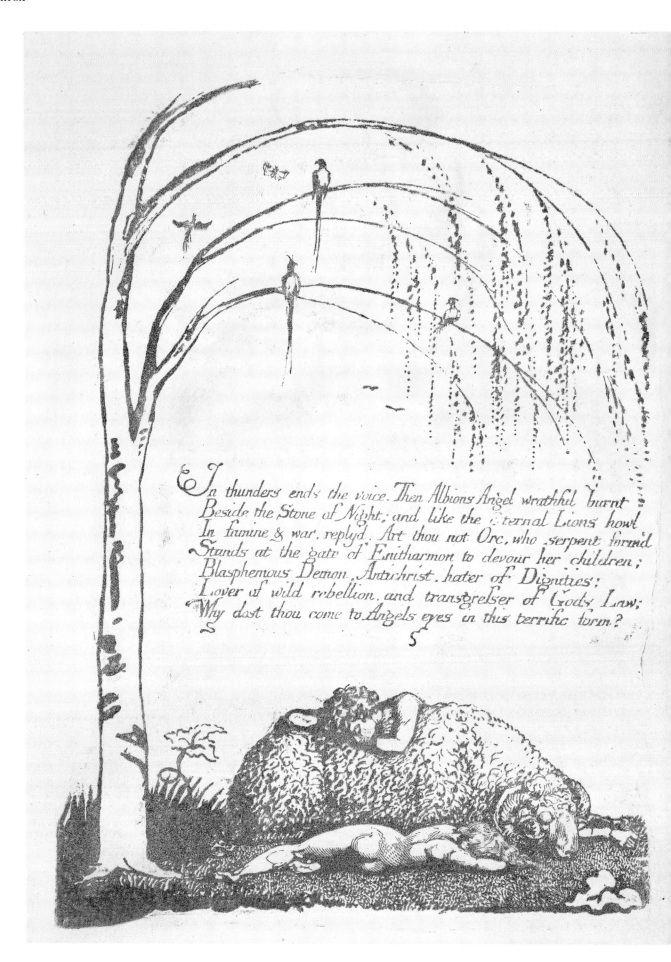

In thunders ends the voice. Then Albions Angel wrathful burnt
Beside the Stone of Night; and like the eternal Lions howl
In famine & war, replyd. Art thou not Orc, who serpent form'd
Stands at the gate of Enitharmon to devour her children;
Blasphemous Demon, Antichrist, hater of Dignities;
Lover of wild rebellion, and transgresser of Gods Law;
Why dost thou come to Angels eyes in this terrific form?

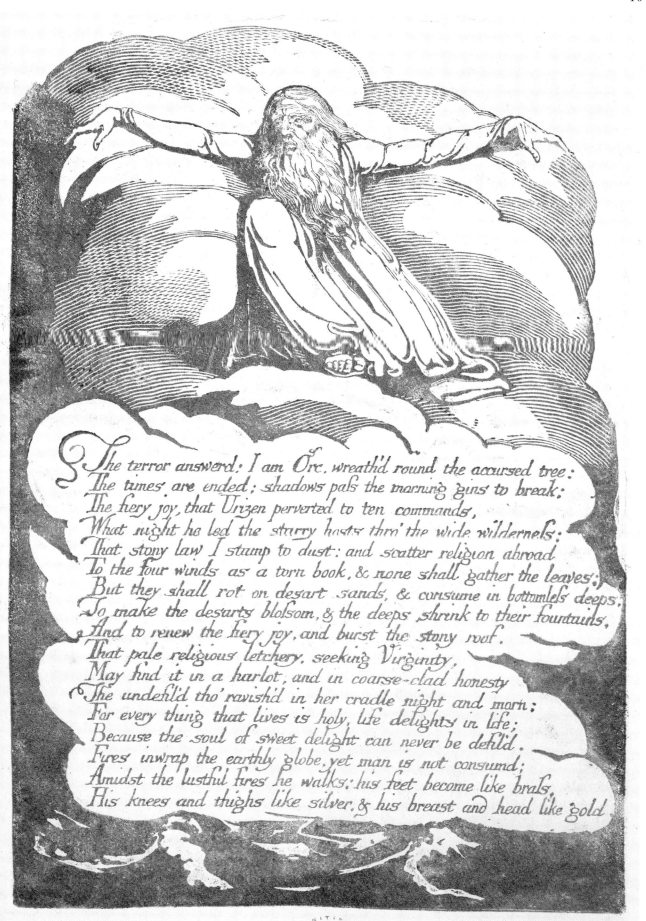

The terror answerd: I am Orc, wreath'd round the accursed tree:
The times are ended; shadows pass the morning gins to break:
The fiery joy, that Urizen perverted to ten commands,
What night he led the starry hosts thro' the wide wilderness:
That stony law I stamp to dust: and scatter religion abroad
To the four winds as a torn book, & none shall gather the leaves;
But they shall rot on desert sands, & consume in bottomless deeps,
To make the desarts blossom, & the deeps shrink to their fountains,
And to renew the fiery joy, and burst the stony roof.
That pale religious letchery, seeking Virginity,
May find it in a harlot, and in coarse-clad honesty
The undefil'd tho' ravish'd in her cradle night and morn:
For every thing that lives is holy, life delights in life;
Because the soul of sweet delight can never be defil'd.
Fires inwrap the earthly globe, yet man is not consumd;
Amidst the lustful fires he walks: his feet become like brass,
His knees and thighs like silver, & his breast and head like gold.

Sound! sound! my loud war-trumpets & alarm my Thirteen Angels!
Loud howls the eternal Wolf! the eternal Lion lashes his tail!
America is darkned; and my punishing Demons terrified
Crouch howling before their caverns deep like skins dry'd in the wind.
They cannot smite the wheat, nor quench the fatness of the earth.
They cannot smite with sorrows, nor subdue the plow and spade.
They cannot wall the city, nor moat round the castle of princes.
They cannot bring the stubbed oak to overgrow the hills.
For terrible men stand on the shores, & in their robes I see
Children take shelter from the lightnings, there stands Washington
And Paine and Warren with their foreheads reard toward the east.
But clouds obscure my aged sight. A vision from afar!
Sound! sound! my loud war-trumpets & alarm my thirteen Angels:
Ah vision from afar! Ah rebel form that rent the ancient
Heavens; Eternal Viper self-renew'd, rolling in clouds
I see thee in thick clouds and darkness on America's shore.
Writhing in pangs of abhorred birth; red flames the crest rebellious
And eyes of death; the harlot womb oft opened in vain
Heaves in enormous circles, now the times are return'd upon thee,
Devourer of thy parent, now thy unutterable torment renews.
Sound! sound! my loud war trumpets & alarm my thirteen Angels.
Ah terrible birth! a young one bursting! where is the weeping mouth?
And where the mothers milk? instead those ever-hissing jaws
And parched lips drop with fresh gore; now roll thou in the clouds
Thy mother lays her length outstretch'd upon the shore beneath.
Sound! sound! my loud war-trumpets & alarm my thirteen Angels!
Loud howls the eternal Wolf! the eternal Lion lashes his tail!

Thus wept the Angel voice & as he wept the terrible blasts
Of trumpets, blew a loud alarm across the Atlantic deep.
No trumpets answer; no reply of clarions or of fifes,
Silent the Colonies remain and refuse the loud alarm.

On those vast shady hills between America & Albions shore;
Now barr'd out by the Atlantic sea: call'd Atlantean hills:
Because from their bright summits you may pass to the Golden world
An ancient palace, archetype of mighty Emperies.
Rears its immortal pinnacles, built in the forest of God
By Ariston the king of beauty for his stolen bride.

Here on their magic seats the thirteen Angels sat perturb'd
For clouds from the Atlantic hover o'er the solemn roof.

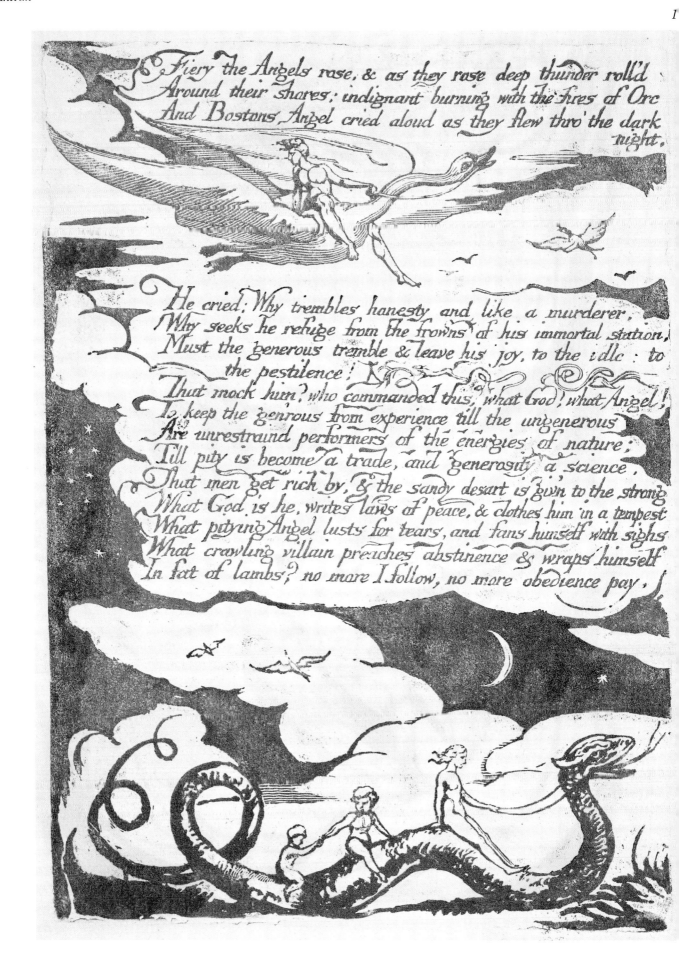

Fiery the Angels rose, & as they rose deep thunder roll'd
Around their shores: indignant burning with the fires of Orc
And Bostons Angel cried aloud as they flew thro' the dark
night.

He cried: Why trembles honesty and like a murderer,
Why seeks he refuge from the frowns of his immortal station,
Must the generous tremble & leave his joy, to the idle: to
the pestilence!
That mock him? who commanded this? what God? what Angel!
To keep the genrous from experience till the ungenerous
Are unrestraind performers of the energies of nature;
Till pity is become a trade, and generosity a science,
That men get rich by, & the sandy desart is givn to the strong
What God is he, writes laws of peace, & clothes him in a tempest
What pitying Angel lusts for tears, and fans himself with sighs
What crawling villain preaches abstinence & wraps himself
In fat of lambs? no more I follow, no more obedience pay.

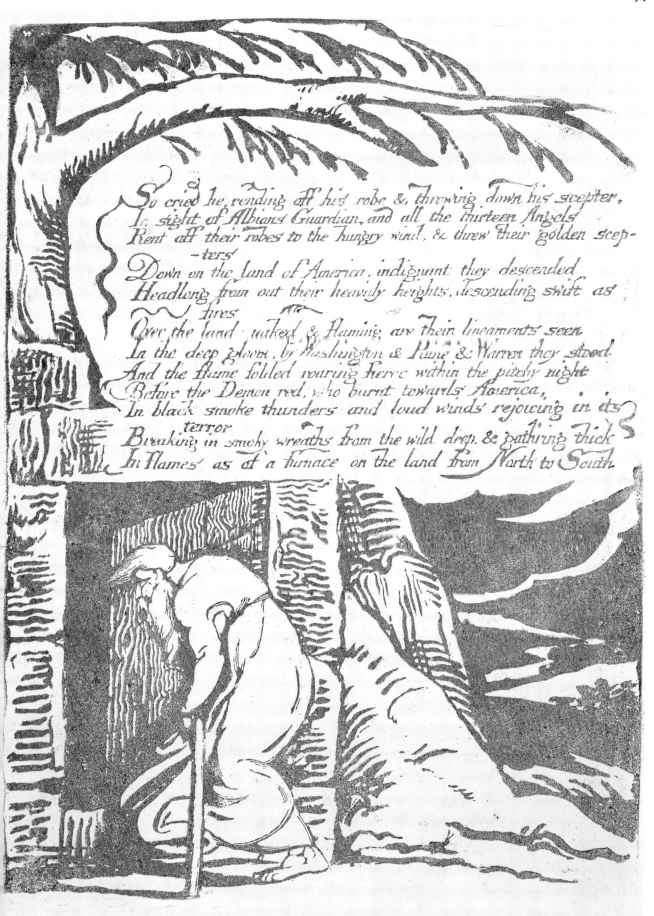

So cried he, rending off his robe & throwing down his scepter,
In sight of Albions Guardian, and all the thirteen Angels
Rent off their robes to the hungry wind, & threw their golden scep-
 -ters
Down on the land of America, indignant they descended
Headlong from out their heavnly heights, descending swift as
 fires
Over the land, naked & flaming are their lineaments seen
In the deep gloom, by Washington & Paine & Warren they stood
And the flame folded roaring fierce within the pitchy night
Before the Demon red, who burnt towards America,
In black smoke thunders and loud winds rejoicing in its
 terror
Breaking in smoky wreaths from the wild deep, & gathring thick
In flames as of a furnace on the land from North to South

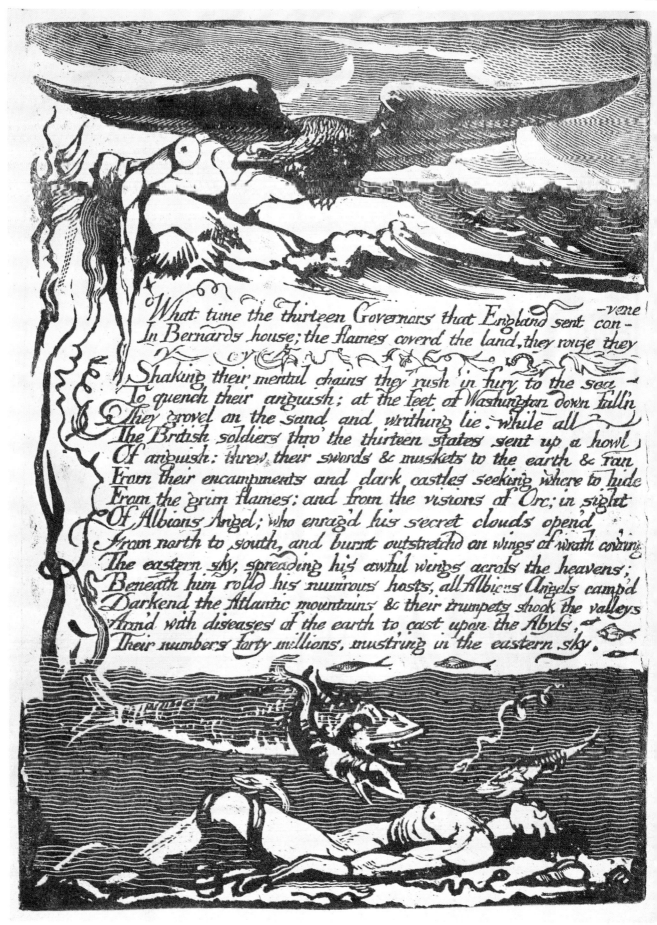

What time the thirteen Governors that England sent con-
-vene
In Bernards house; the flames coverd the land, they rouze they

Shaking their mental chains they rush in fury to the sea
To quench their anguish; at the feet of Washington down fall'n
They grovel on the sand and writhing lie: while all
The British soldiers thro' the thirteen states sent up a howl
Of anguish: threw their swords & muskets to the earth & ran
From their encampments and dark castles seeking where to hide
From the grim flames; and from the visions of Orc; in sight
Of Albions Angel; who enrag'd his secret clouds open'd
From north to south, and burnt outstretchd on wings of wrath cov'ring
The eastern sky, spreading his awful wings across the heavens;
Beneath him rolld his numrous hosts, all Albions Angels camp'd
Darkend the Atlantic mountains & their trumpets shook the valleys
Arm'd with diseases of the earth to cast upon the Abyss,
Their numbers forty millions, mustring in the eastern sky.

In the flames stood & view'd the armies drawn out in the sky,
Washington Franklin Paine & Warren Allen Gates & Lee;
And heard the voice of Albions Angel give the thunderous command:
His plagues obedient to his voice flew forth out of their clouds
Falling upon America, as a storm to cut them off
As a blight cuts the tender corn when it begins to appear.
Dark is the heaven above, & cold & hard the earth beneath;
And as a plague wind fill'd with insects cuts off man & beast;
And as a sea oerwhelms a land in the day of an earthquake:

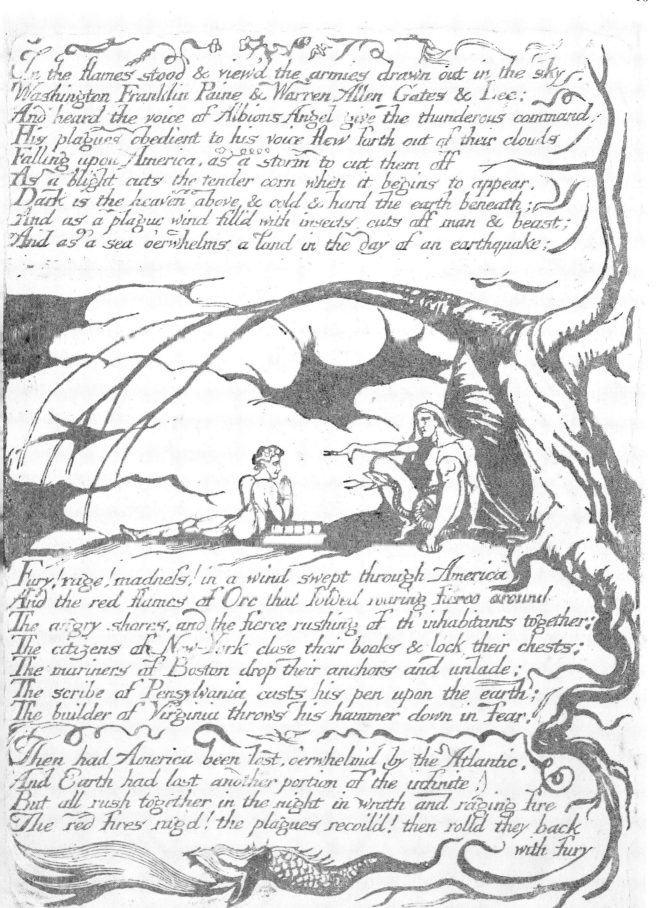

Fury! rage! madness! in a wind swept through America
And the red flames of Orc that folded roaring fierce around.
The angry shores, and the fierce rushing of th'inhabitants together:
The citizens of New-York close their books & lock their chests;
The mariners of Boston drop their anchors and unlade;
The scribe of Pensylvania casts his pen upon the earth;
The builder of Virginia throws his hammer down in fear.

Then had America been lost, oerwhelm'd by the Atlantic,
And Earth had lost another portion of the infinite,
But all rush together in the night in wrath and raging fire
The red fires rag'd! the plagues recoil'd! then rolld they back
with fury

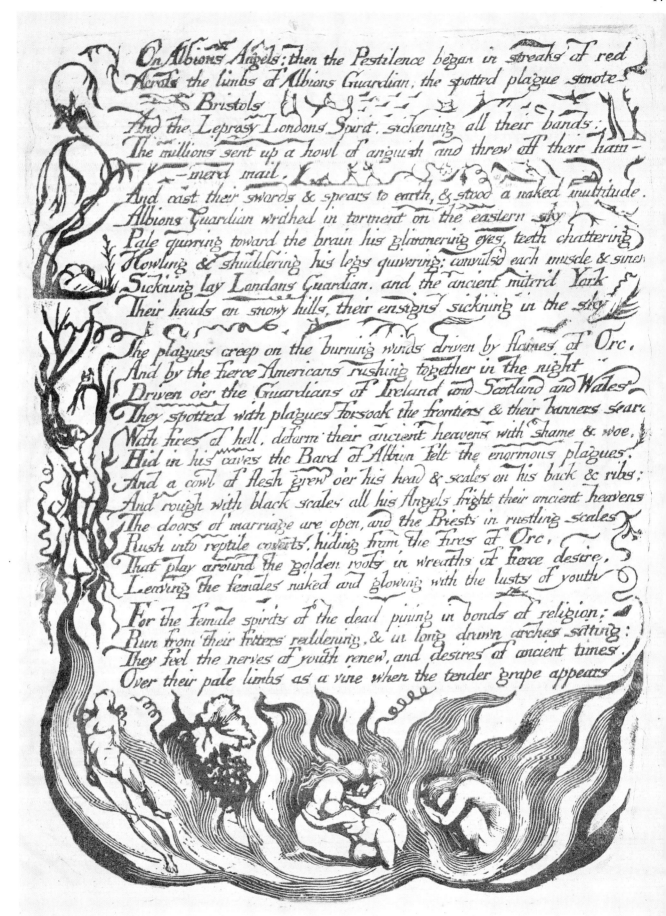

On Albions Angels; then the Pestilence began in streaks of red
Across the limbs of Albions Guardian, the spotted plague smote
 Bristols
And the Leprosy Londons Spirit, sickening all their bands;
The millions sent up a howl of anguish and threw off their ham-
 -merd mail.
And cast their swords & spears to earth, & stood a naked multitude.
Albions Guardian writhed in torment on the eastern sky
Pale quivring toward the brain his glimmering eyes, teeth chattering
Howling & shuddering his legs quivering: convulsd each muscle & sinew
Sickning lay Londons Guardian. and the ancient miterd York
Their heads on snowy hills, their ensigns sickning in the sky

The plagues creep on the burning winds driven by flames of Orc,
And by the fierce Americans rushing together in the night
Driven oer the Guardians of Ireland and Scotland and Wales.
They spotted with plagues forsook the frontiers & their banners seard
With fires of hell, deform their ancient heavens with shame & woe.
Hid in his caves the Bard of Albion felt the enormous plagues.
And a cowl of flesh grew oer his head & scales on his back & ribs;
And rough with black scales all his Angels fright their ancient heavens
The doors of marriage are open, and the Priests in rustling scales
Rush into reptile coverts, hiding from the fires of Orc,
That play around the golden roofs in wreaths of fierce desire,
Leaving the females naked and glowing with the lusts of youth

For the female spirits of the dead pining in bonds of religion;
Run from their fetters reddening, & in long drawn arches sitting:
They feel the nerves of youth renew, and desires of ancient times
Over their pale limbs as a vine when the tender grape appears

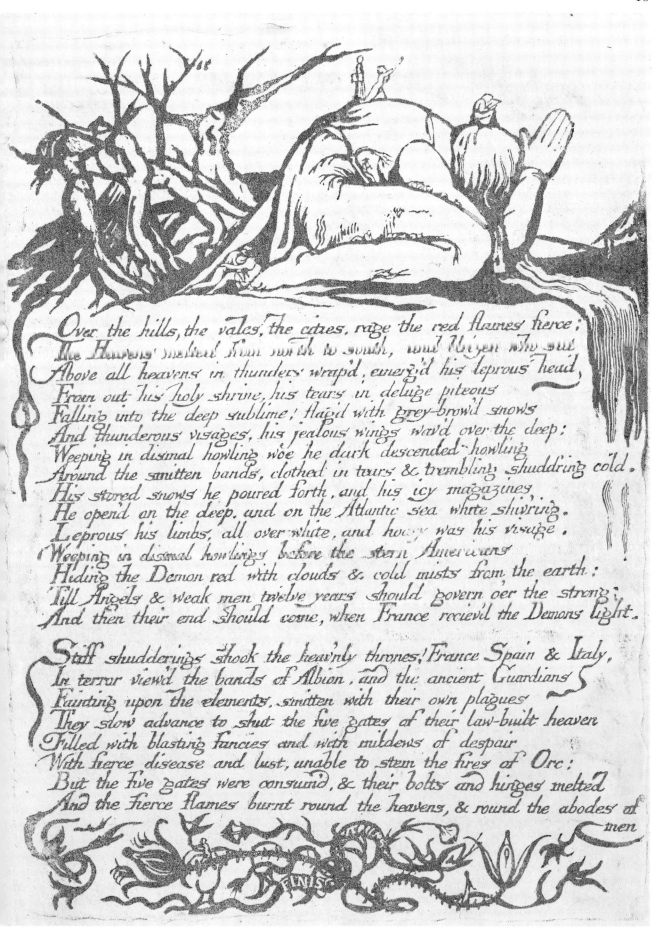

Over the hills, the vales, the cities, rage the red flames fierce;
The Heavens melted from north to south, and Urizen who sat
Above all heavens in thunders wrap'd, emerg'd his leprous head,
From out his holy shrine, his tears in deluge piteous
Falling into the deep sublime! flag'd with grey-brow'd snows
And thunderous visages, his jealous wings wav'd over the deep:
Weeping in dismal howling woe he dark descended howling
Around the smitten bands, clothed in tears & trembling shudd'ring cold.
His stored snows he poured forth, and his icy magazines
He open'd on the deep, and on the Atlantic sea white shiv'ring.
Leprous his limbs, all over white, and hoary was his visage.
Weeping in dismal howlings before the stern Americans
Hiding the Demon red with clouds & cold mists from the earth:
Till Angels & weak men twelve years should govern o'er the strong:
And then their end should come, when France reciev'd the Demons light.

Stiff shudderings shook the heav'nly thrones! France Spain & Italy,
In terror view'd the bands of Albion, and the ancient Guardians
Fainting upon the elements, smitten with their own plagues
They slow advance to shut the five gates of their law-built heaven
Filled with blasting fancies and with mildews of despair
With fierce disease and lust, unable to stem the fires of Orc;
But the five gates were consum'd, & their bolts and hinges melted
And the fierce flames burnt round the heavens, & round the abodes of
 men

FINIS

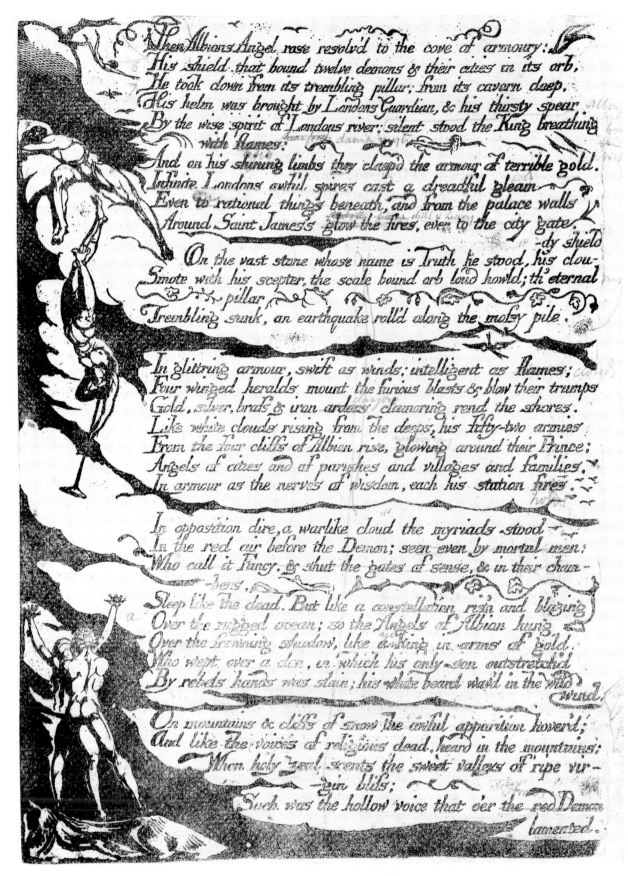

Then Albions Angel rose resolv'd to the cove of armoury:
His shield that bound twelve demons & their cities in its orb,
He took down from its trembling pillar; from its cavern deep,
His helm was brought by Londons Guardian, & his thirsty spear
By the wise spirit of Londons river; silent stood the King breathing
 with flames:
And on his shining limbs they clasp'd the armour of terrible gold.
Infinite Londons awful spires cast a dreadful gleam
Even to rational things beneath, and from the palace walls
Around Saint James's glow the fires, even to the city gate.

 On the vast stone whose name is Truth he stood, his clou-
 -dy shield
Smote with his scepter, the scale bound orb loud howld; th'eternal
 pillar
Trembling sunk, an earthquake roll'd along the mossy pile.

In glittring armour, swift as winds; intelligent as flames;
Four winged heralds mount the furious blasts & blow their trumps
Gold, silver, brass & iron ardors clamoring rend the shores.
Like white clouds rising from the deeps, his fifty-two armies
From the four cliffs of Albion rise, glowing around their Prince;
Angels of cities and of parishes and villages and families,
In armour as the nerves of wisdom, each his station fires.

In opposition dire, a warlike cloud the myriads stood
In the red air before the Demon; seen even by mortal men:
Who call it Fancy, & shut the gates of sense, & in their cham-
 -bers,
Sleep like the dead. But like a constellation rish and blazing
Over the ragged ocean; so the Angels of Albion hung
Over the frowning shadow, like an King in arms of gold,
Who wept over a den, in which his only son outstretch'd
By rebels hands was slain; his white beard wav'd in the wild
 wind.

On mountains & cliffs of snow the awful apparition hover'd;
And like the voices of religious dead, heard in the mountains;
 When holy zeal scents the sweet valleys of ripe vir-
 -gin bliss;
 Such was the hollow voice that o'er the red Demon
 lamented.

Cancelled plate *c*, not used in the book, possibly intended for insertion between plates 10 and 11

Europe a Prophecy

1794

Glasgow University Library. Copy B.
Relief etchings, colour-printed, with pen and watercolour.

Europe follows *America* and was often bound with it by Blake. The main action concerns the period in Europe's history before the revolutions of Blake's time, 'the 1,800 year sleep of Enitharmon' since Christ's Incarnation, the message of which was suppressed by the Church. It is grave in tone, and the illustrations, many of which occupy the whole plate, present a litany of the miseries of the Fallen world and, in historical terms, of the *ancien régime*: Plague, Famine, Terror, Blight, and Imprisonment. These powerful images do not refer to the text directly, but provide a commentary on the consequences of the allegorical narrative of the book.

The sinister import of the story is heightened by the use of colour-printing, which is to be found in most of the twelve copies which have survived. The copy here reproduced demonstrates the mastery that Blake had, by 1794, attained of this difficult technique.

The frontispiece, often known as 'The Ancient of Days', very soon acquired iconic status, though it is no longer interpreted as depicting the act of benign creation.

The additional plate 3 (page 191) was included in only two of the copies known today. It is here reproduced from the Fitzwilliam Museum, Cambridge, Copy K.

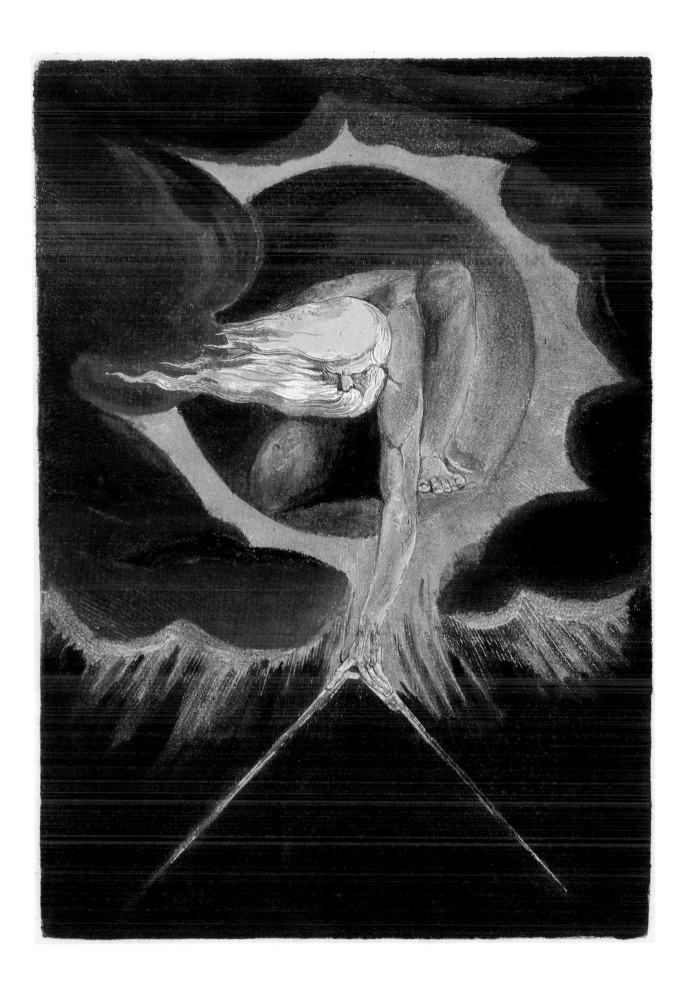

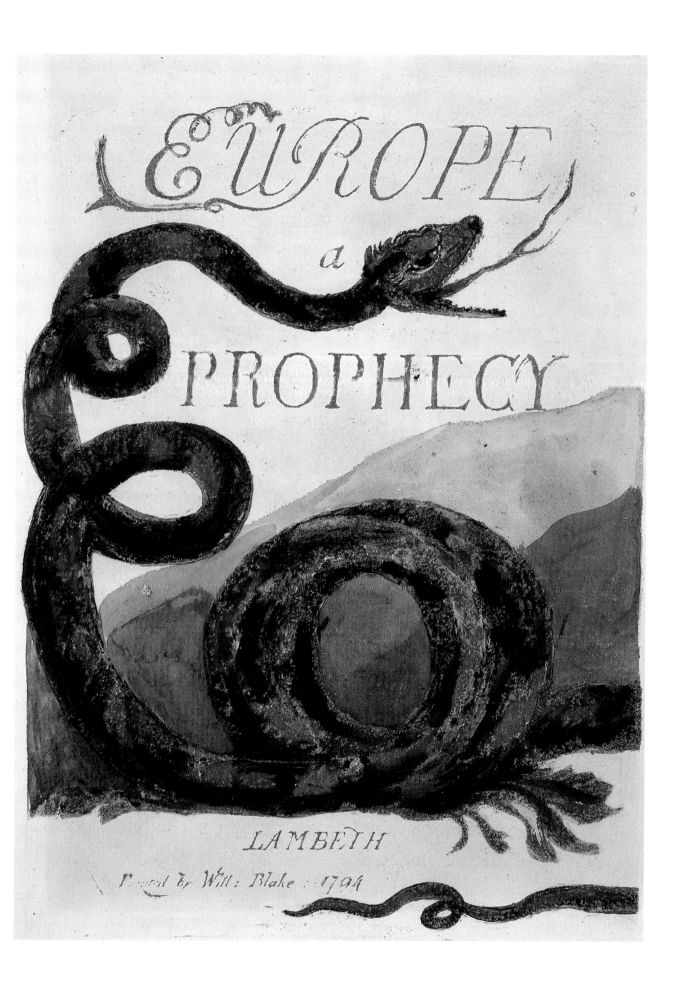

EUROPE a PROPHECY

LAMBETH

Printed by Will: Blake : 1794

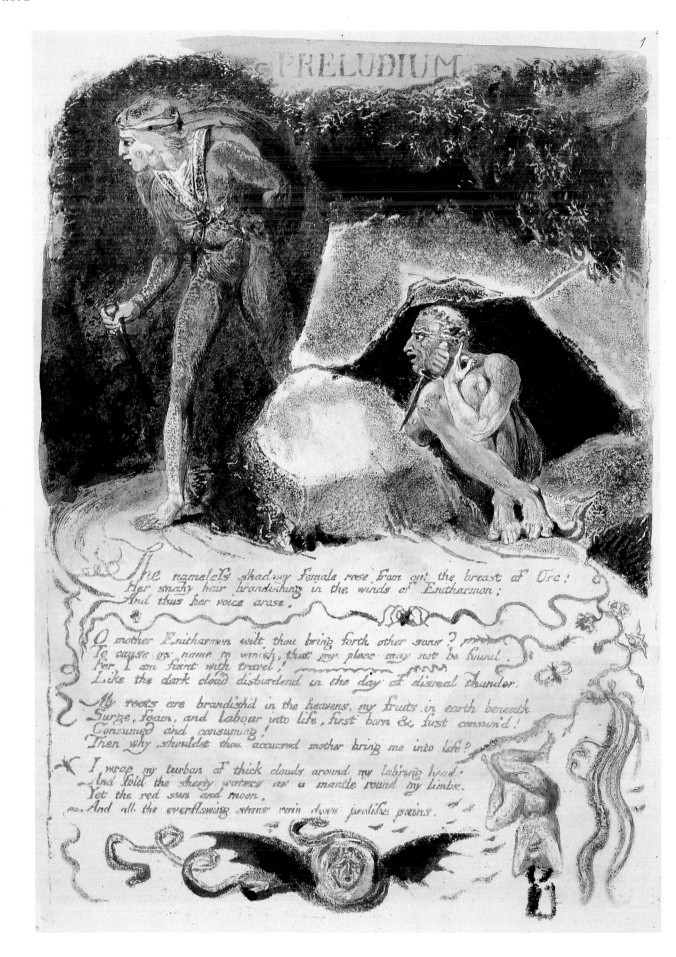

PRELUDIUM

The nameless shadowy Female rose from out the breast of Orc:
Her snaky hair brandishing in the winds of Enitharmon;
And thus her voice arose.

O mother Enitharmon wilt thou bring forth other sons?
To cause my name to vanish, that my place may not be known.
For I am faint with travel!
Like the dark cloud disburdend in the day of dismal thunder.

My roots are brandish'd in the heavens, my fruits in earth beneath
Surge, foam, and labour into life, first born & first consum'd!
Consumed and consuming!
Then why shouldst thou accursed mother bring me into life?

I wrap my turban of thick clouds around my labring head.
And fold the sheety waters as a mantle round my limbs.
Yet the red sun and moon,
And all the overflowing stars rain down prolific pains.

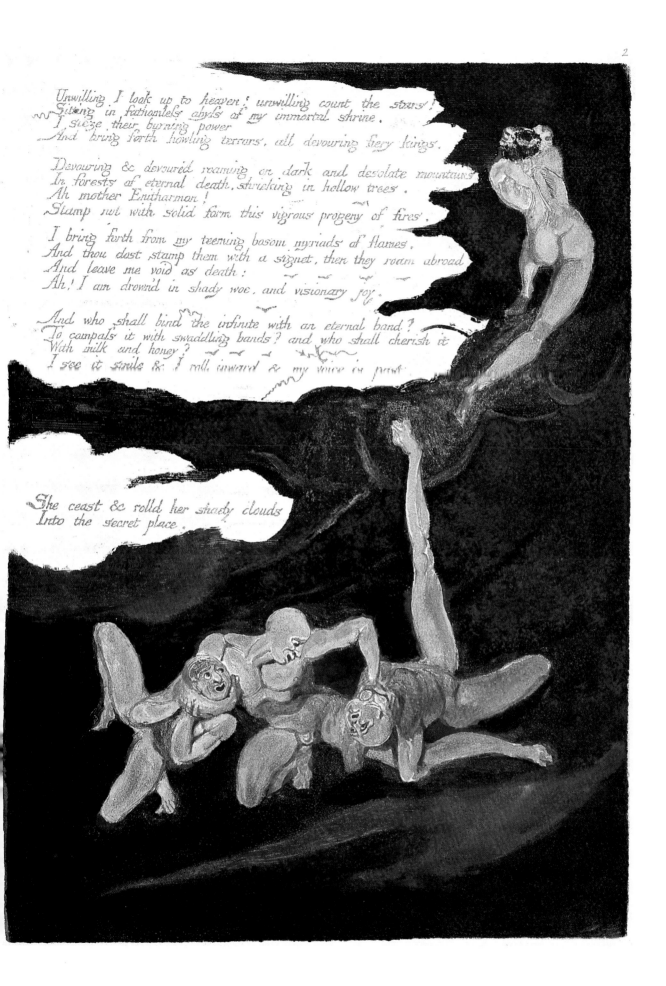

Unwilling I look up to heaven; unwilling count the stars!
Sitting in fathomless abyss of my immortal shrine.
I sieze their burning power
And bring forth howling terrors, all devouring fiery kings.

Devouring & devoured roaming on dark and desolate mountains
In forests of eternal death, shrieking in hollow trees.
Ah mother Enitharmon!
Stamp not with solid form this vigrous progeny of fires.

I bring forth from my teeming bosom myriads of flames.
And thou dost stamp them with a signet, then they roam abroad
And leave me void as death:
Ah! I am drown'd in shady woe, and visionary joy.

And who shall bind the infinite with an eternal band?
To compass it with swaddling bands? and who shall cherish it
With milk and honey?
I see it smile &: I roll inward & my voice is past.

She ceast & rolld her shady clouds
Into the secret place.

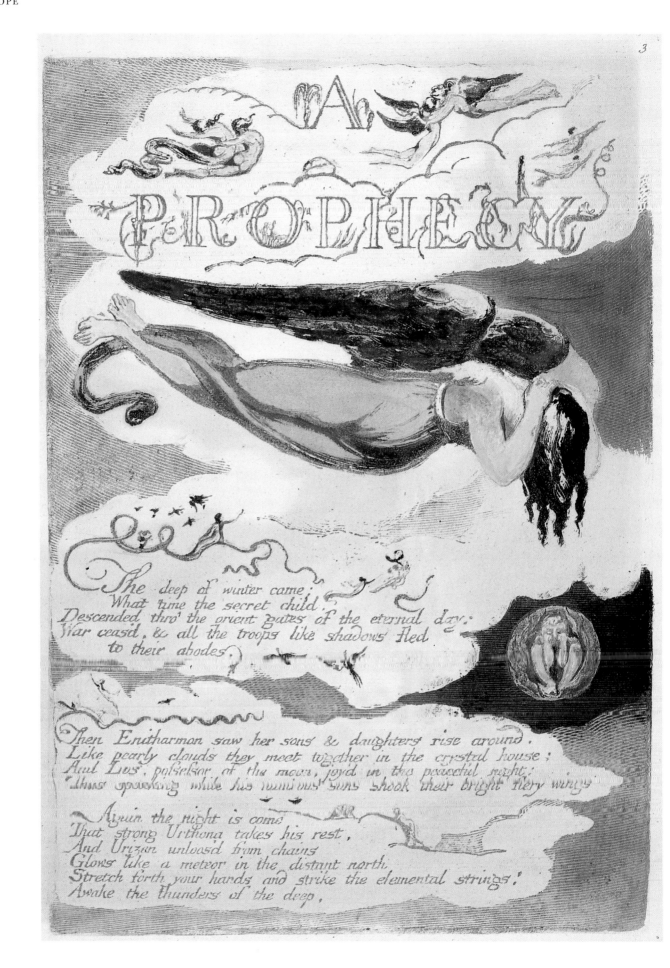

A PROPHECY

The deep of winter came;
 What time the secret child.
Descended thro' the orient gates of the eternal day:
War ceas'd, & all the troops like shadows fled
 to their abodes.

Then Enitharmon saw her sons & daughters rise around.
Like pearly clouds they meet together in the crystal house;
And Los, possessor of the moon, joyd in the peaceful night:
Thus speaking while his numerous sons shook their bright fiery wings

 Again the night is come
That strong Urthona takes his rest,
And Urizen unloos'd from chains
Glows like a meteor in the distant north.
Stretch forth your hands and strike the elemental strings.'
Awake the thunders of the deep,

The shrill winds wake!
Till all the sons of Urizen look out and envy Los:
Sieze all the spirits of life and bind
Their warbling joys to our loud strings
Bind all the nourishing sweets of earth
To give us bliss, that we may drink the sparkling wine of Los
And let us laugh at war,
Despising toil and care.
Because the days and nights of joy, in lucky hours renew.

Arise O Orc from thy deep den,
First born of Enitharmon rise!
And we will crown thy head with garlands of the ruddy vine;
For now thou art bound;
And I may see thee in the hour of bliss, my eldest born.

The horrent Demon rose, surrounded with red stars of fire,
Whirling about in furious circles round the immortal fiend.

Then Enitharmon down descended into his red light,
And thus her voice rose to her children, the distant heavens reply.

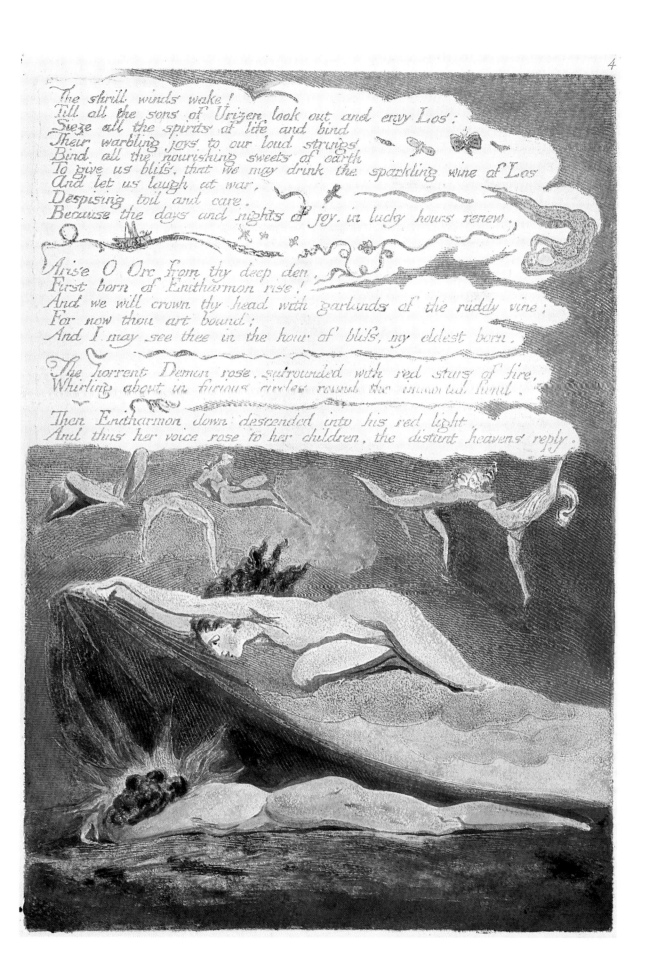

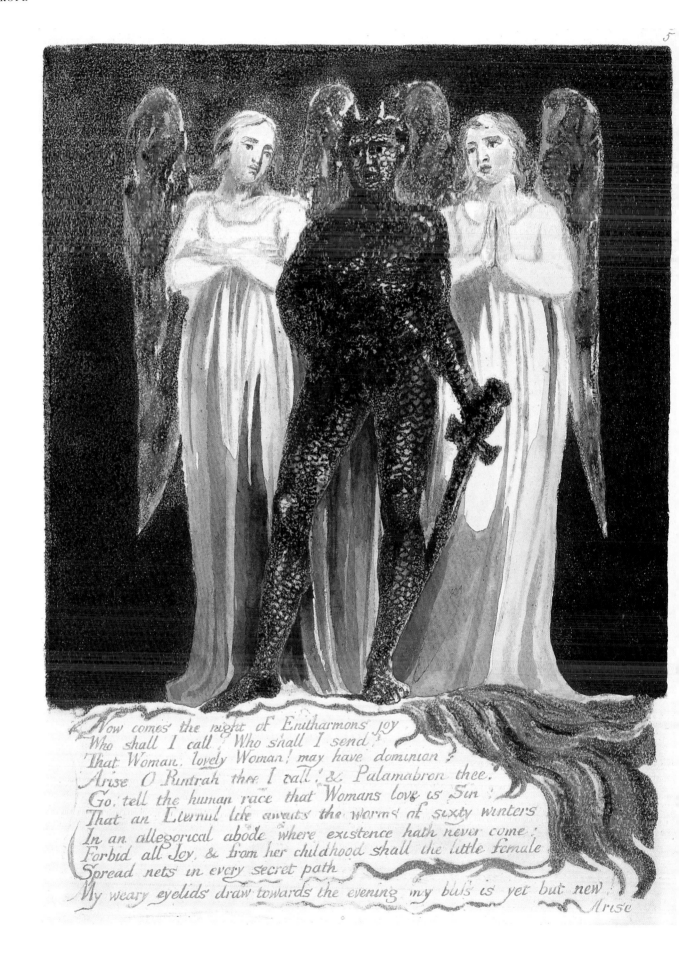

Now comes the night of Enitharmons joy!
Who shall I call? Who shall I send?
That Woman, lovely Woman! may have dominion?
Arise O Rintrah thee I call! & Palamabron thee!
Go, tell the human race that Womans love is Sin!
That an Eternal life awaits the worms of sixty winters
In an allegorical abode where existence hath never come:
Forbid all Joy, & from her childhood shall the little female
Spread nets in every secret path.

My weary eyelids draw towards the evening, my bliss is yet but new!

Arise

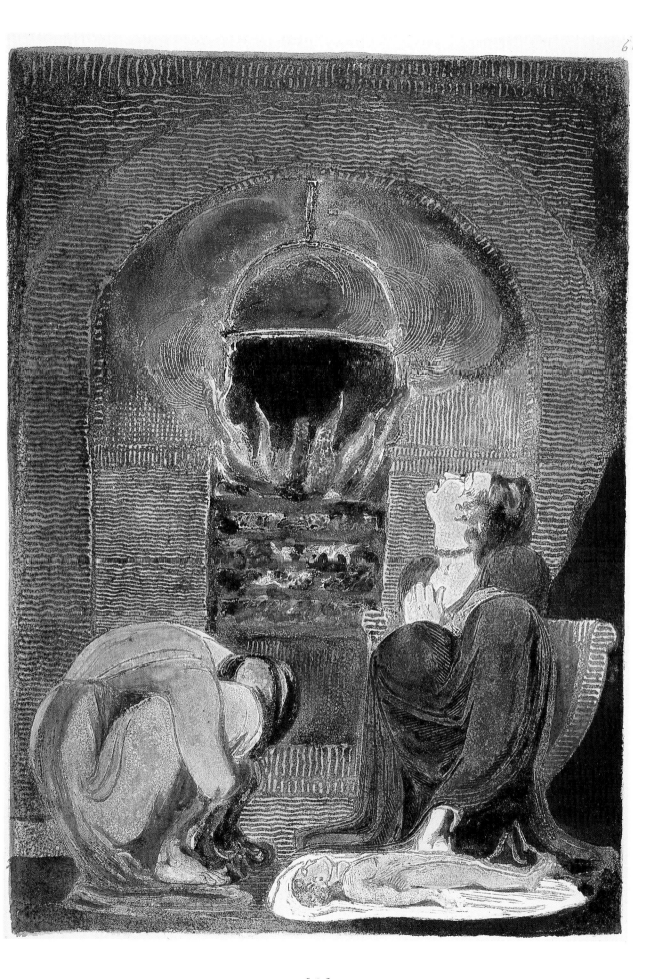

7

Arise O Rintrah. eldest born; second to none but Orc:
O lion Rintrah raise thy fury from thy forests black:
Bring Palamabron horned priest, skipping upon the mountains;
And silent Elynittria the silver bowed queen:
Rintrah where hast thou hid thy bride!
Weeps she in desart shades?
Alas my Rintrah! bring the lovely jealous Ocalythron.

Arise my son! bring all thy brethren O thou king of fire.
Prince of the sun I see thee with thy innumerable race:
thick as the summer stars:
But each ramping his golden mane shakes,
And thine eyes rejoice because of strength O Rintrah furious king.

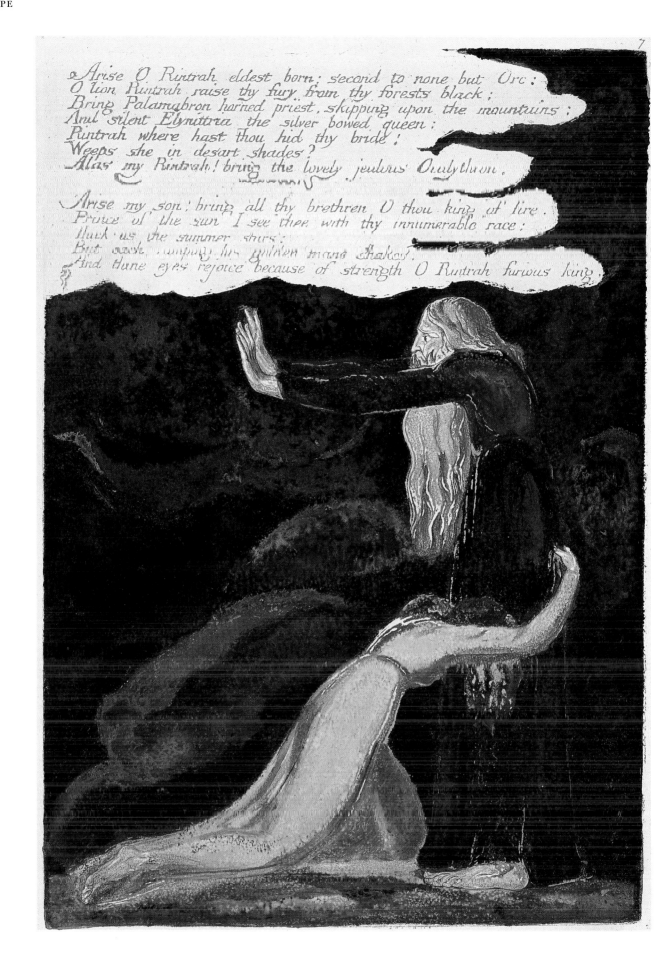

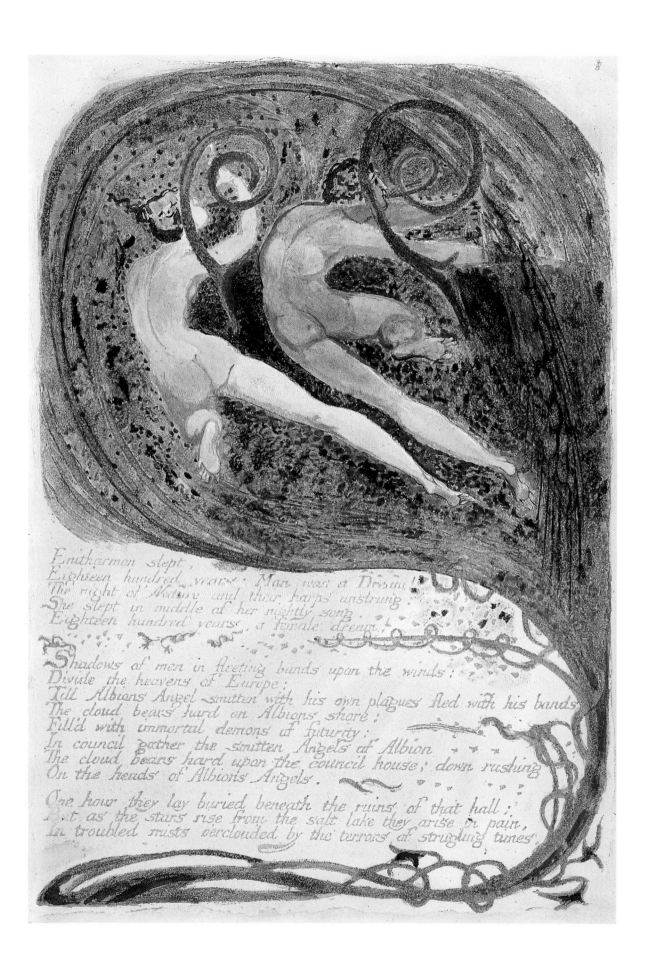

Enitharmon slept,
Eighteen hundred years: Man was a Dream!
The night of Nature and their harps unstrung:
She slept in middle of her nightly song,
Eighteen hundred years, a female dream.

Shadows of men in fleeting bands upon the winds:
Divide the heavens of Europe:
Till Albions Angel smitten with his own plagues fled with his bands
The cloud bears hard on Albions shore:
Fill'd with immortal demons of futurity:
In council gather the smitten Angels of Albion
The cloud bears hard upon the council house; down rushing
On the heads of Albions Angels.

One hour they lay buried beneath the ruins of that hall;
But as the stars rise from the salt lake they arise in pain,
In troubled mists oerclouded by the terrors of struggling times.

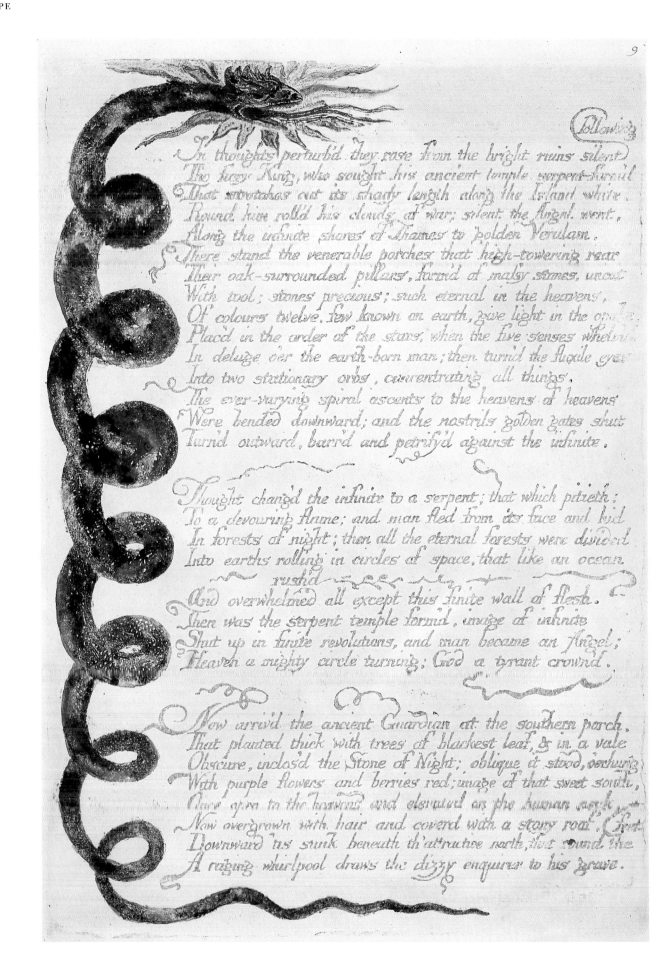

In thoughts perturb'd, they rose from the bright ruins silent
The faery King, who sought his ancient temple serpent-form'd
That stretches out its shady length along the Island white.
Round him roll'd his clouds of war; silent the Angel went,
Along the infinite shores of Thames to golden Verulam.
There stand the venerable porches that high-towering rear
Their oak-surrounded pillars, form'd of massy stones, uncut
With tool; stones precious; such eternal in the heavens,
Of colours twelve, few known on earth, give light in the opake,
Plac'd in the order of the stars, when the five senses whelm'd
In deluge o'er the earth-born man; then turn'd the fluxile eyes
Into two stationary orbs, concentrating all things.
The ever-varying spiral ascents to the heavens of heavens
Were bended downward; and the nostrils golden gates shut
Turn'd outward, barr'd and petrify'd against the infinite.

Thought chang'd the infinite to a serpent; that which pitieth:
To a devouring flame; and man fled from its face and hid
In forests of night; then all the eternal forests were divided
Into earths rolling in circles of space, that like an ocean
rush'd
And overwhelmed all except this finite wall of flesh.
Then was the serpent temple form'd, image of infinite
Shut up in finite revolutions, and man became an Angel;
Heaven a mighty circle turning; God a tyrant crown'd.

Now arriv'd the ancient Guardian at the southern porch,
That planted thick with trees of blackest leaf, & in a vale
Obscure, inclos'd the Stone of Night; oblique it stood, o'erhung
With purple flowers and berries red; image of that sweet south,
Once open to the heavens and elevated on the human neck,
Now overgrown with hair and cover'd with a stony roof,
Downward 'tis sunk beneath th'attractive north, that round the
A raging whirlpool draws the dizzy enquirer to his grave.

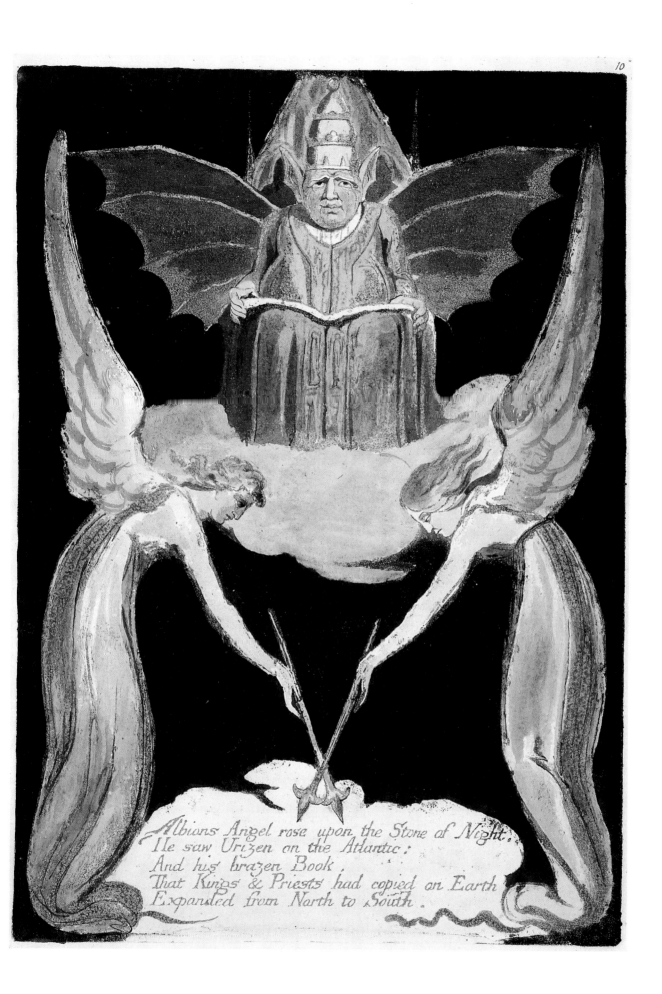

Albions Angel rose upon the Stone of Night.
He saw Urizen on the Atlantic:
And his brazen Book,
That Kings & Priests had copied on Earth
Expanded from North to South.

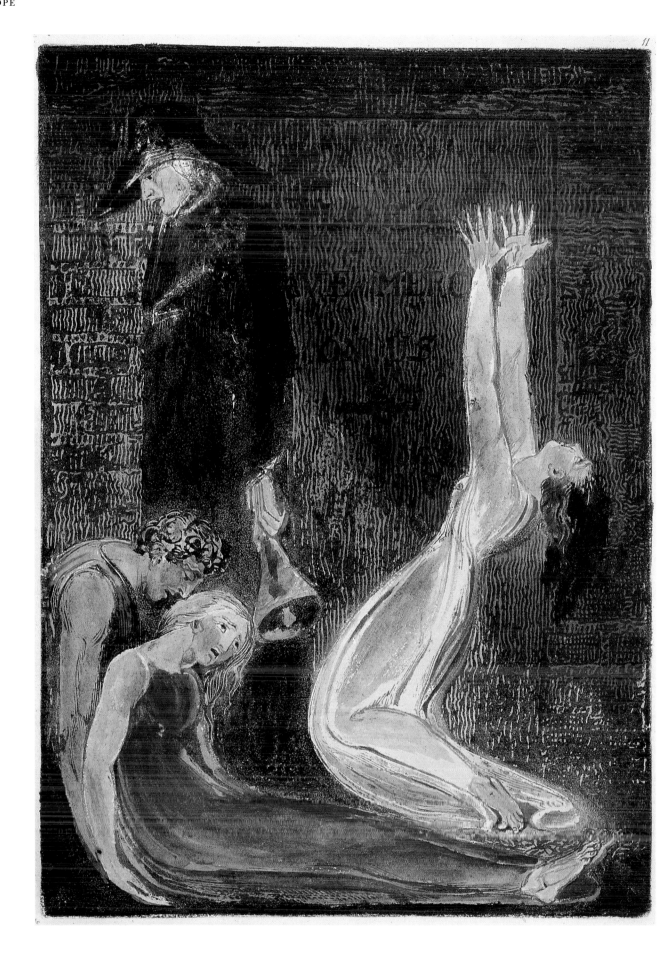

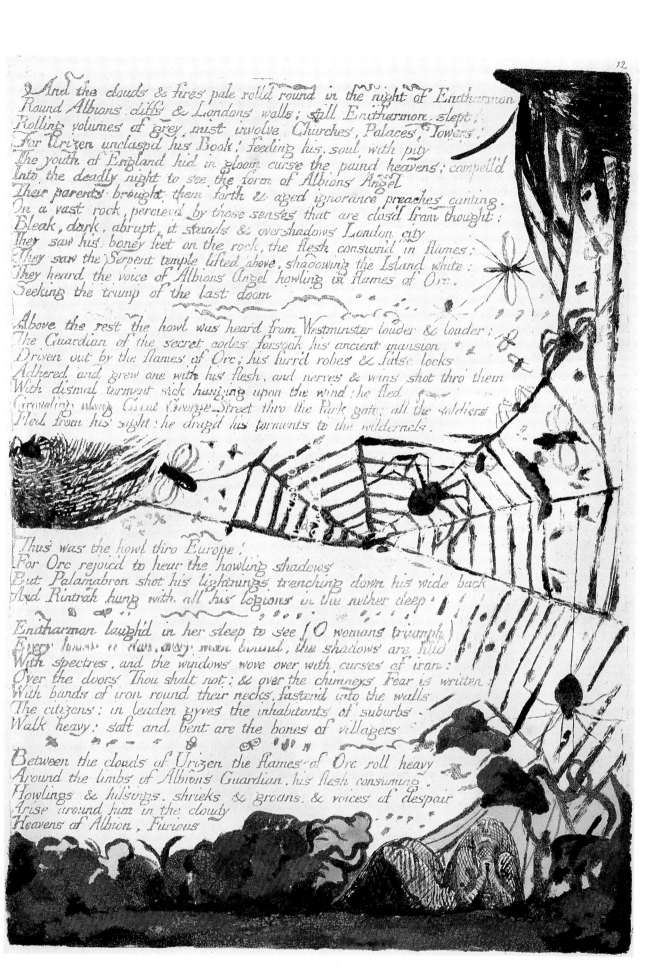

And the clouds & fires pale roll'd round in the night of Enitharmon
Round Albions cliffs & Londons walls: still Enitharmon slept.
Rolling volumes of grey mist involve Churches, Palaces, Towers:
For Urizen unclaspd his Book! feeding his soul with pity
The youth of England hid in gloom curse the paind heavens; compell'd
Into the deadly night to see the form of Albions Angel
Their parents brought them forth & aged ignorance preaches canting.
On a vast rock, perciev'd by those senses that are clos'd from thought:
Bleak, dark, abrupt, it stands & overshadows London city
They saw his boney feet on the rock, the flesh consum'd in flames:
They saw the Serpent temple lifted above, shadowing the Island white:
They heard the voice of Albions Angel howling in flames of Orc,
Seeking the trump of the last doom

Above the rest the howl was heard from Westminster louder & louder:
The Guardian of the secret codes forsook his ancient mansion
Driven out by the flames of Orc; his furr'd robes & false locks
Adhered, and grew one with his flesh, and nerves & veins shot thro' them
With dismal torment sick hanging upon the wind: he fled
Grovling along Great George Street thro' the Park gate; all the soldiers
Fled from his sight: he drag'd his torments to the wilderness.

Thus was the howl thro Europe!
For Orc rejoic'd to hear the howling shadows
But Palamabron shot his lightnings trenching down his wide back
And Rintrah hung with all his legions in the nether deep

Enitharmon laugh'd in her sleep to see (O womans triumph)
Every house a den, every man bound; the shadows are fill'd
With spectres, and the windows wove over with curses of iron:
Over the doors Thou shalt not: & over the chimneys Fear is written:
With bands of iron round their necks, fasten'd into the walls
The citizens: in leaden gyves the inhabitants of suburbs
Walk heavy: soft and bent are the bones of villagers

Between the clouds of Urizen the flames of Orc roll heavy
Around the limbs of Albions Guardian, his flesh consuming
Howlings & hissings, shrieks & groans, & voices of despair
Arise around him in the cloudy
Heavens of Albion, Furious

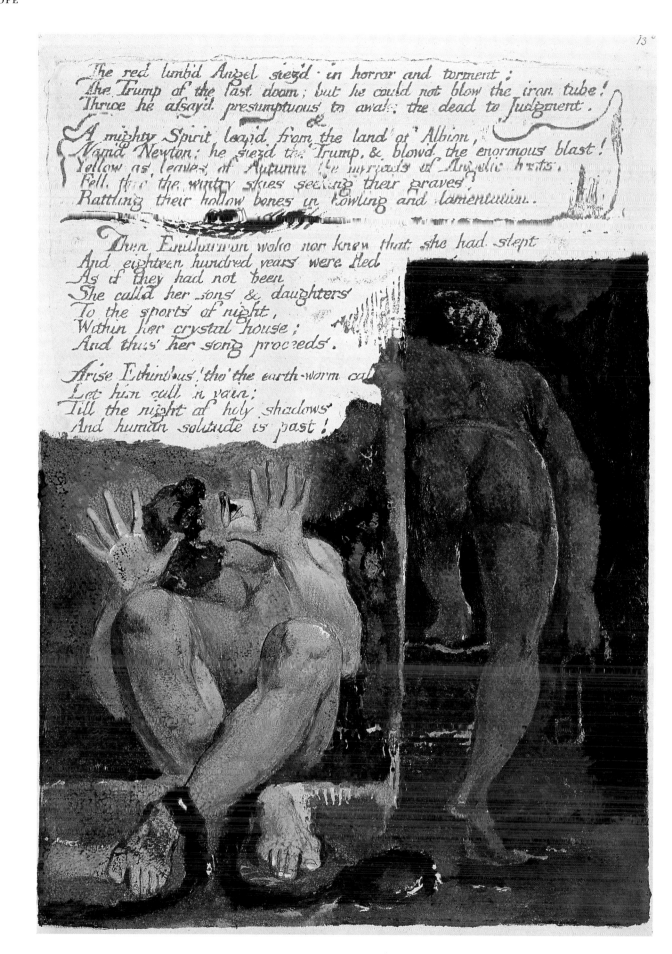

The red limb'd Angel siez'd · in horror and torment ;
The Trump of the last doom ; but he could not blow the iron tube !
Thrice he assay'd presumptuous to awake the dead to Judgment.

A mighty Spirit leap'd from the land of Albion,
Nam'd Newton ; he siez'd the Trump, & blow'd the enormous blast !
Yellow as leaves of Autumn the myriads of Angelic hosts,
Fell thro' the wintry skies seeking their graves ;
Rattling their hollow bones in howling and lamentation.

Then Enitharmon woke nor knew that she had slept
And eighteen hundred years were fled
As if they had not been
She call'd her sons & daughters
To the sports of night,
Within her crystal house ;
And thus her song proceeds.

Arise Ethinthus ' tho' the earth-worm call
Let him call in vain ;
Till the night of holy shadows
And human solitude is past !

Ethinthus, queen of waters, how thou shinest in the sky:
My daughter how do I rejoice! for thy children flock around
Like the gay fishes on the wave, when the cold moon drinks the dew.
Ethinthus! thou art sweet as comforts to my fainting soul:
For now thy waters warble round the feet of Enitharmon.

Manathu-Varcyon! I behold thee flaming in my halls,
Light of thy mothers soul! I see thy lovely eagles round;
Thy golden wings are my delight, & thy flames of soft delusion.

Where is my lureing bird of Eden! Leutha silent love!
Leutha, the many coloured bow delights upon thy wings:
Soft soul of flowers Leutha!
Sweet smiling pestilence! I see thy blushing light;
Thy daughters many changing,
Revolve like sweet perfumes ascending O Leutha silken queen!

Where is the youthful Antamon, prince of the pearly dew,
O Antamon, why wilt thou leave thy mother Enitharmon?
Alone I see thee crystal form,
Floating upon the bosomd air;
With lineaments of gratified desire.
My Antamon the seven churches of Leutha seek thy love.

I hear the soft Oothoon in Enitharmons tents:
Why wilt thou give up womans secrecy my melancholy child?
Between two moments bliss is ripe:
O Theotormon robb'd of joy, I see thy salt tears flow
Down the steps of my crystal house.

Sotha & Thiralatha, secret dwellers of dreamful caves,
Arise and please the horrent fiend with your melodious songs.
Still all your thunders golden hoofd, & bind your horses black.
Orc! smile upon my children!
Smile son of my afflictions.
Arise O Orc and give our mountains joy of thy red light.

She ceas'd, for All went forth at sport beneath the solemn moon
Waking the stars of Urizen with their immortal songs,
That nature felt thro' all her pores the enormous revelry,
Till morning oped the eastern gate.
Then every one fled to his station, & Enitharmon wept.

But terrible Orc, when he beheld the morning in the east,

15

Shot from the heights of Enitharmon;
And in the vineyards of red France appear'd the light of his fury.

The sun glow'd fiery red;
The furious terrors flew around!
On golden chariots raging, with red wheels dropping with blood;
The Lions lash their wrathful tails!
The Tigers couch upon the prey & suck the ruddy tide:
And Enitharmon groans & cries in anguish and dismay.

Then Los arose his head he reard in snaky thunders clad:
And with a cry that shook all nature to the utmost pole,
Call'd all his sons to the strife of blood.

FINIS

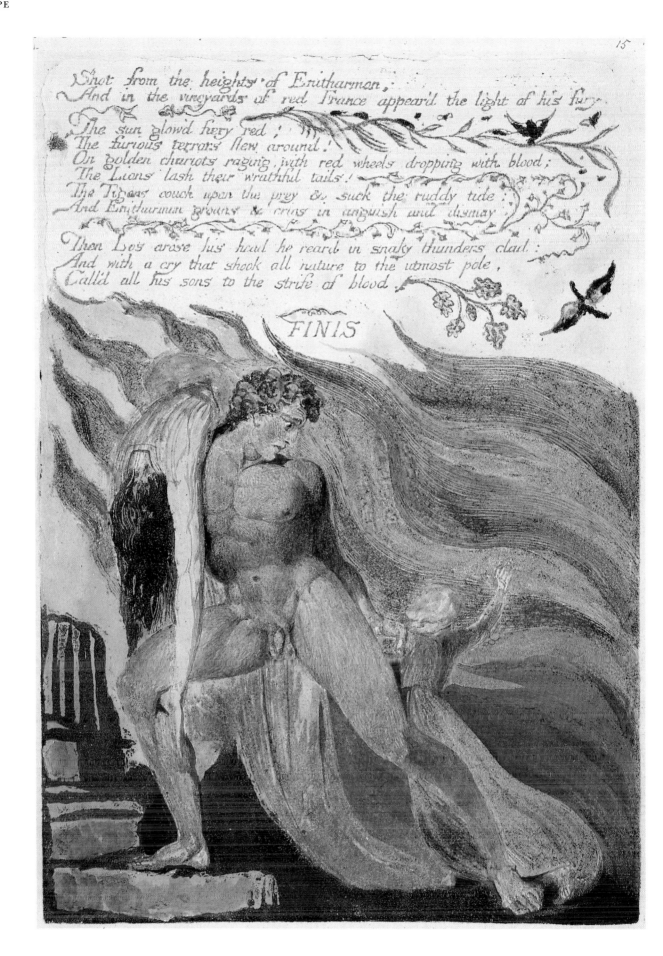

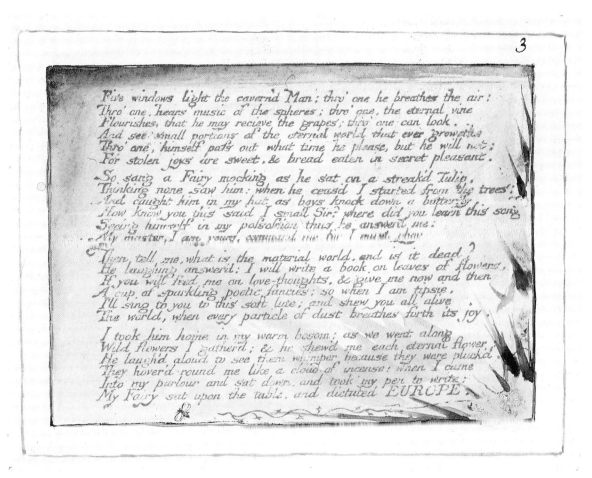

Five windows light the cavern'd Man; thro' one he breathes the air:
Thro' one, hears music of the spheres; thro' one, the eternal vine
Flourishes, that he may recieve the grapes; thro' one can look.
And see small portions of the eternal world that ever groweth;
Thro' one, himself pass out what time he please, but he will not;
For stolen joys are sweet, & bread eaten in secret pleasant.

So sang a Fairy mocking as he sat on a streak'd Tulip,
Thinking none saw him: when he ceasd I started from the trees!
And caught him in my hat as boys knock down a butterfly.
How know you this said I small Sir? where did you learn this song?
Seeing himself in my possession thus he answerd me:
My master, I am yours. command me, for I must obey.

Then, tell me, what is the material world, and is it dead?
He laughing answerd: I will write a book on leaves of flowers,
If you will feed me on love-thoughts, & give me now and then
A cup of sparkling poetic fancies; so when I am tipsie,
I'll sing to you to this soft lute; and shew you all alive
The world, when every particle of dust breathes forth its joy.

I took him home in my warm bosom: as we went along
Wild flowers I gatherd; & he shewd me each eternal flower;
He laugh'd aloud to see them whimper because they were pluck'd.
They hover'd round me like a cloud of incense; when I came
Into my parlour and sat down, and took my pen to write:
My Fairy sat upon the table, and dictated EUROPE.

ADDITIONAL PLATE 3
included by Blake in only two of the copies that are known today

[191]

The Song of Los

1795

The British Museum, London. Copy A.
Relief etchings, with colour printing, pen and watercolour.

The Song of Los represents in compressed form the 'Africa' and 'Asia' sections that predate
in the chronology of the world the prophecies of 'America' and 'Europe'. It tells of the events
which follow Urizen's imposition of his order upon the world, as described at the end of *The
Book of Urizen*: the bringing of religion to Africa by Urizen and the rise of Orc or Revolution
in Asia. Though the text shows signs of the crisis that was to lead to the abandonment of the
1790s cycle of Prophecies, the imagery and the free use of colour printing in a form of monotype
place the full-page designs among the greatest of Blake's achievements as an artist.

The richness and density of the colour printing in the frontispiece are incomparably effective
in evoking the early existence of man and his primitive submission to false religion in the
form of the murky 'indefinite' sun worshipped by a submissive priest. The 'King and Queen
on a Lily' (plate 5) is also transformed by the colour printing into a sinister and infinitely
remote image.

All six known copies of *The Song of Los* may have been printed in one session in 1795. The
method of colour printing employed differs significantly from that used in *Europe*. Here,
except for the text matter and some decoration, designs are built up in stiff, coloured inks on
flat, unetched surfaces and then printed off under pressure.

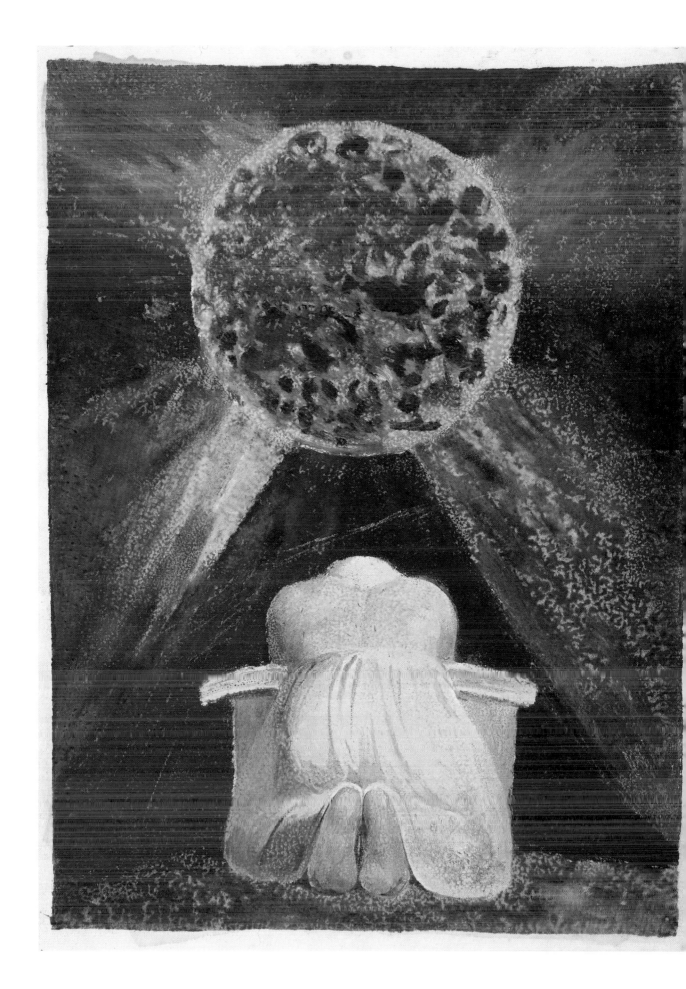

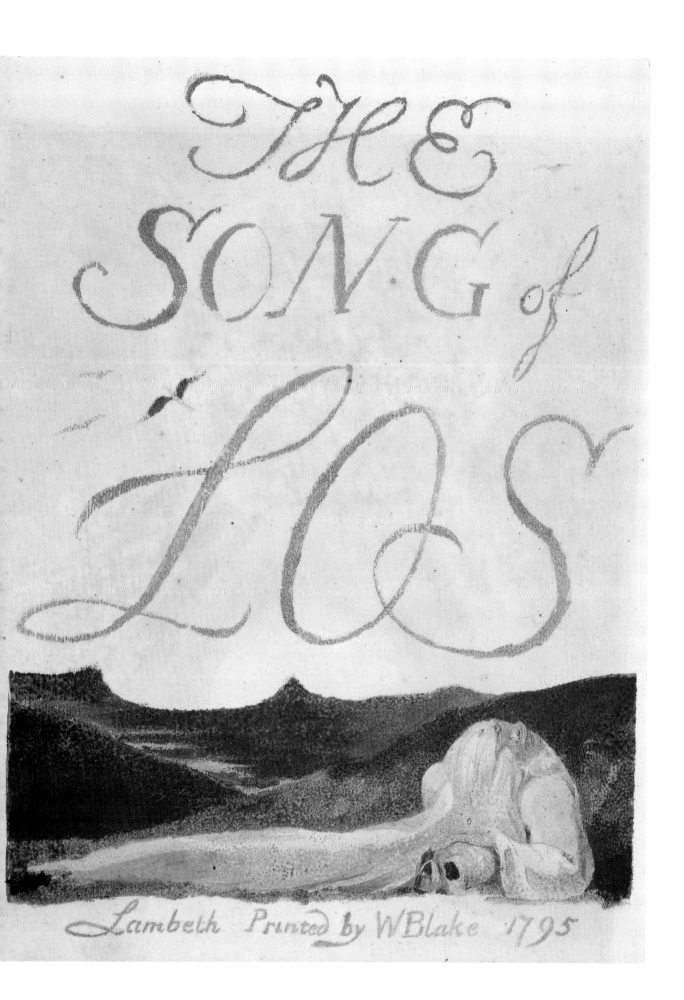

THE SONG of LOS

Lambeth Printed by W Blake 1795

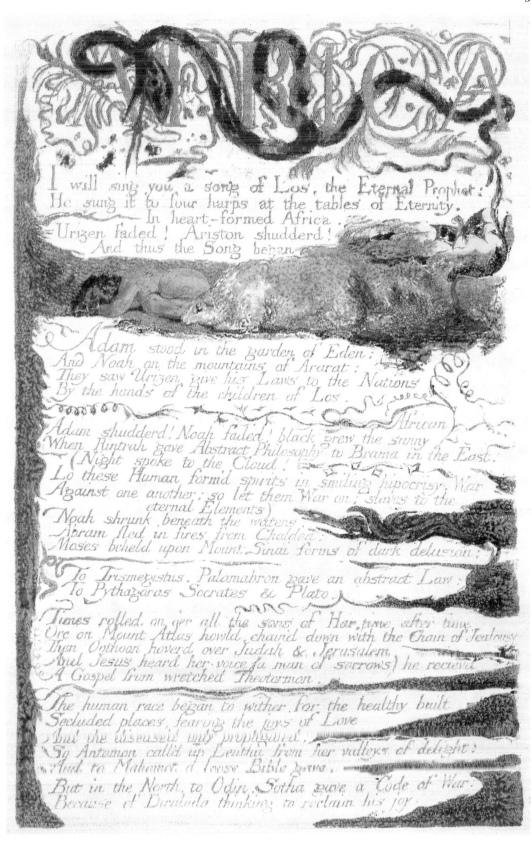

AFRICA

I will sing you a song of Los, the Eternal Prophet:
He sung it to four harps at the tables of Eternity.
In heart-formed Africa.
Urizen faded! Ariston shudderd!
And thus the Song began

Adam stood in the garden of Eden:
And Noah on the mountains of Ararat:
They saw Urizen give his Laws to the Nations
By the hands of the children of Los.

Adam shudderd! Noah faded! black grew the sunny African
When Rintrah gave Abstract Philosophy to Brama in the East.
(Night spoke to the Cloud!
Lo these Human form'd spirits in smiling hipocrisy. War
Against one another; so let them War on; slaves to the
eternal Elements)
Noah shrunk, beneath the waters;
Abram fled in fires from Chaldea;
Moses beheld upon Mount Sinai forms of dark delusion:

To Trismegistus. Palamabron gave an abstract Law:
To Pythagoras Socrates & Plato.

Times rolled on o'er all the sons of Har, time after time
Orc on Mount Atlas howld, chaind down with the Chain of Jealousy
Then Oothoon hoverd over Judah & Jerusalem
And Jesus heard her voice (a man of sorrows) he receivd
A Gospel from wretched Theotormon.

The human race began to wither, for the healthy built
Secluded places, fearing the joys of Love
And the diseased only propagated:
So Antamon called up Leutha from her valleys of delight:
And to Mahomet a loose Bible gave.
But in the North, to Odin, Sotha gave a Code of War,
Because of Diralada thinking to reclaim his joy.

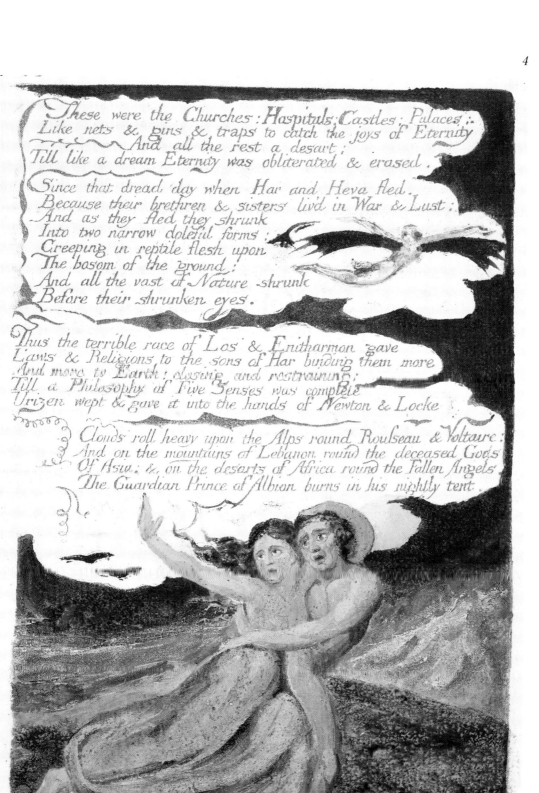

These were the Churches: Hospitals: Castles: Palaces:
Like nets & gins & traps to catch the joys of Eternity
 And all the rest a desart;
Till like a dream Eternity was obliterated & erased.

Since that dread day when Har and Heva fled.
Because their brethren & sisters livd in War & Lust;
And as they fled they shrunk
Into two narrow doleful forms;
Creeping in reptile flesh upon
The bosom of the ground;
And all the vast of Nature shrunk
Before their shrunken eyes.

Thus the terrible race of Los & Enitharmon gave
Laws & Religions to the sons of Har binding them more
And more to Earth: closing and restraining:
Till a Philosophy of Five Senses was complete
Urizen wept & gave it into the hands of Newton & Locke

Clouds roll heavy upon the Alps round Rousseau & Voltaire:
And on the mountains of Lebanon round the deceased Gods
Of Asia; & on the deserts of Africa round the Fallen Angels
The Guardian Prince of Albion burns in his nightly tent

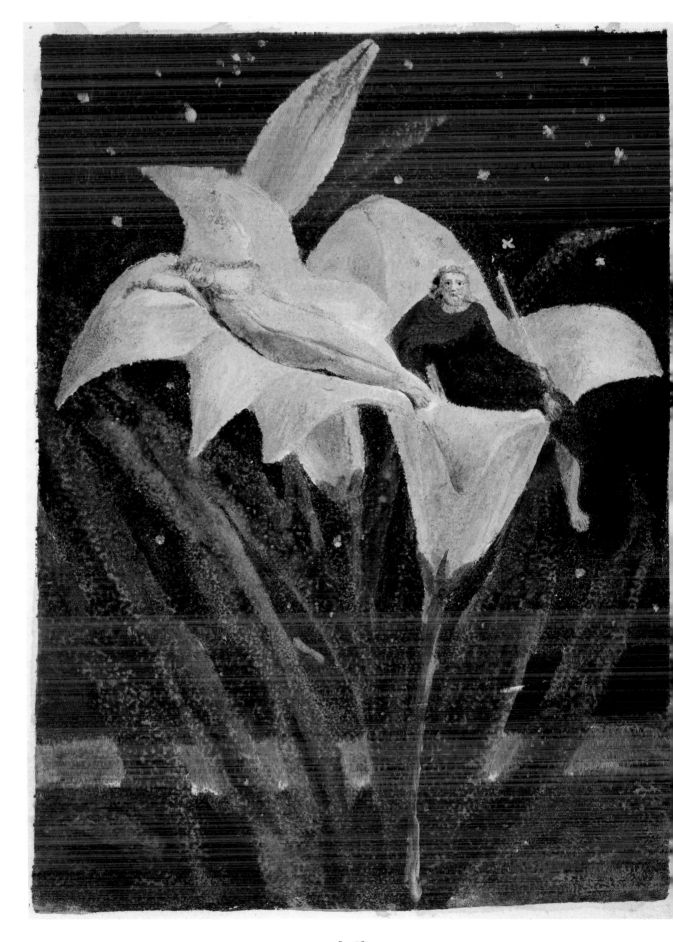

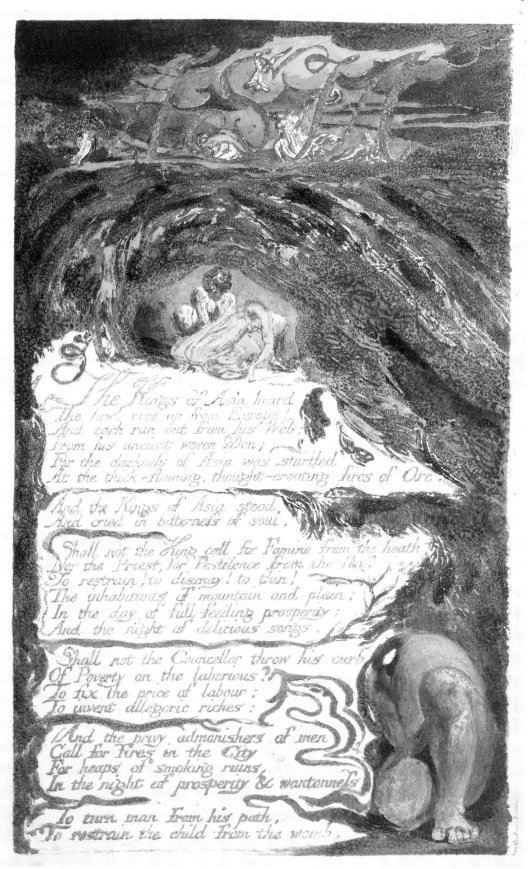

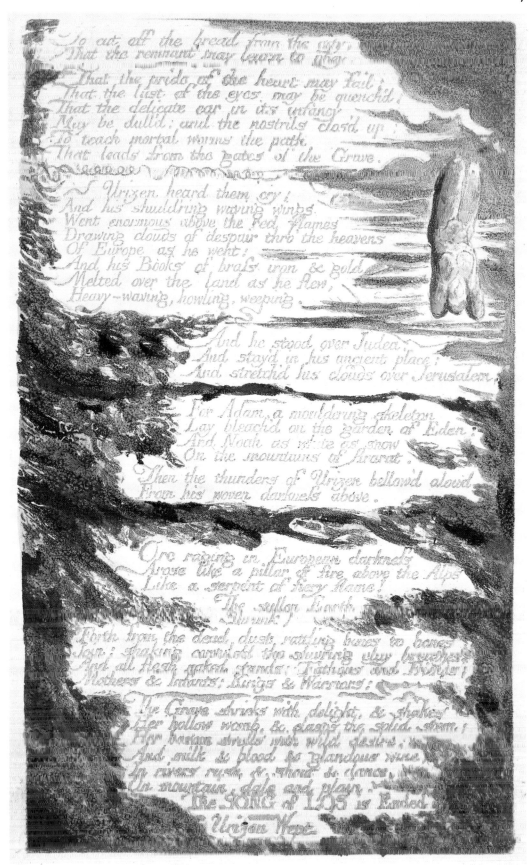

To cut off the bread from the city,
That the remnant may learn to obey.

That the pride of the heart may fail;
That the lust of the eyes may be quench'd:
That the delicate ear in its infancy
May be dull'd; and the nostrils clos'd up;
To teach mortal worms the path.
That leads from the gates of the Grave.

Urizen heard them cry!
And his shuddring waving wings.
Went enormous above the red flames
Drawing clouds of despair thro' the heavens
Of Europe as he went:
And his Books of brass iron & gold
Melted over the land as he flew,
Heavy-waving, howling, weeping.

And he stood over Judea;
And stay'd in his ancient place:
And stretch'd his clouds over Jerusalem.

For Adam, a mouldering skeleton
Lay bleach'd on the garden of Eden;
And Noah as white as snow
On the mountains of Ararat.

Then the thunders of Urizen bellow'd aloud
From his woven darkness above.

Orc raging in European darkness
Arose like a pillar of fire above the Alps
Like a serpent of fiery flame!
The sullen Earth
Shrunk!

Forth from the dead dust rattling bones to bones
Join; shaking convulsd the shivering clay breathes
And all flesh naked stands; Fathers and Friends;
Mothers & Infants; Kings & Warriors;

The Grave shrieks with delight, & shakes
Her hollow womb, & clasps the solid stem;
Her bosom swells with wild desire:
And milk & blood & glandous wine,
In rivers rush & shout & dance,
On mountain, dale and plain.

The SONG of LOS is Ended.
Urizen Wept.

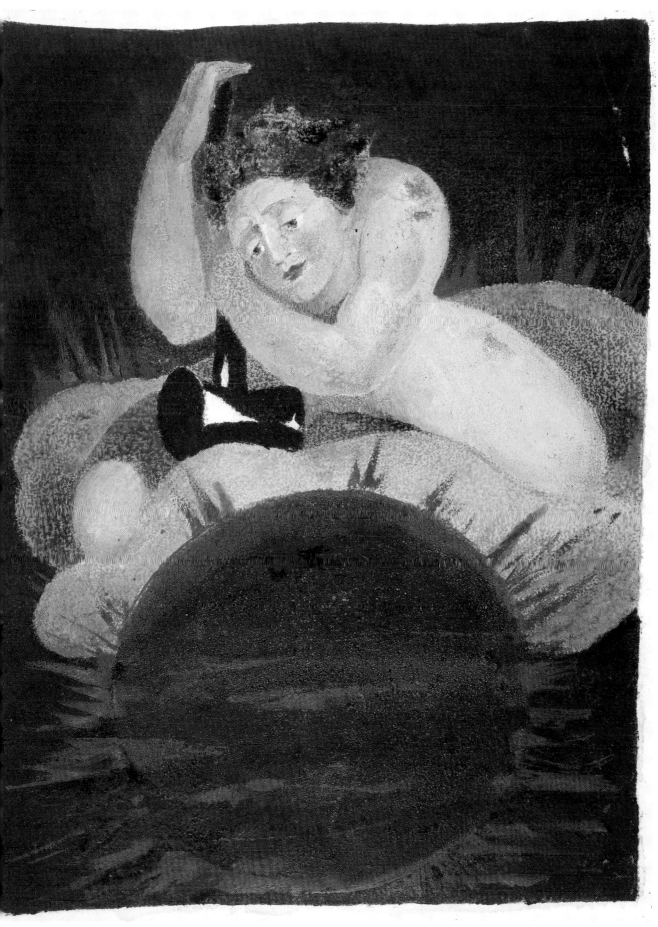

The First Book of Urizen

1794

The British Museum, London. Copy D.
Relief etchings, with colour printing, pen and watercolour.

Although probably not the earliest-written chapter of Blake's 'Bible of Hell', *The First Book of Urizen* describes the initial division of man, with consequences that are explored in Blake's other Prophetic books of the 1790s. Reason in the form of Urizen separates from the other elements of the human mind, and Los the eternal artist takes on the task of giving him form, so that his nature may be recognised by humanity. Los's struggle to give form to Urizen is the central action of the book; in feeling pity for his creation, Los himself divides, becoming enslaved to his own creation. In this book revolutionary energy in the form of Orc is born and chained to the rock; meanwhile Urizen, now fully formed, imprisons the spirit of man in 'a Net of Religion'.

Blake's preoccupation with his creation myth is inseparably entwined with his radical response to the political and social turmoil of the time. *The First Book of Urizen* (there is no other, though later Illuminated books may have been intended to be later Books of Urizen) is among his most politically committed works.

Of the seven presently known copies, all but one are richly colour-printed and no two are the same. They were produced together in 1794. The additional plates 4a and 16a (pages 229 and 230) were excluded from our copy; they are here reproduced respectively from the Beinecke Library, Yale University, Copy H, and the Pierpont Morgan Library, New York, Copy B.

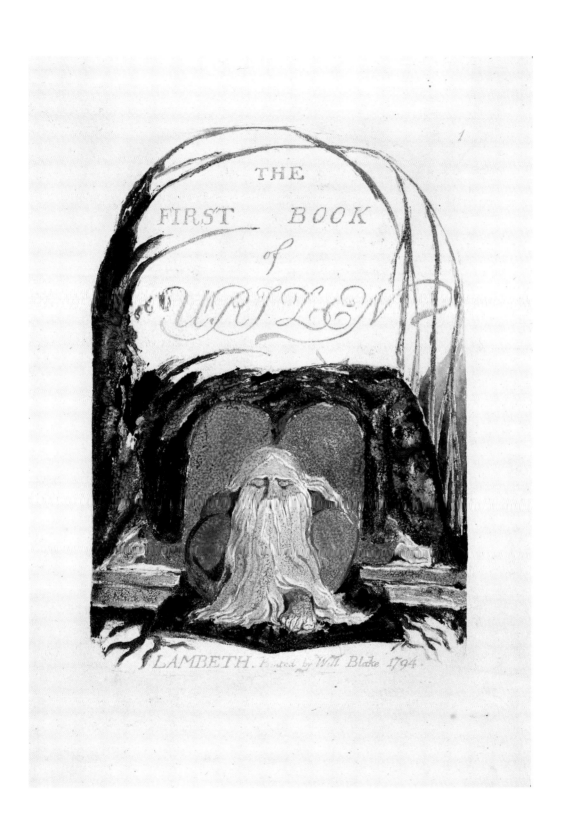

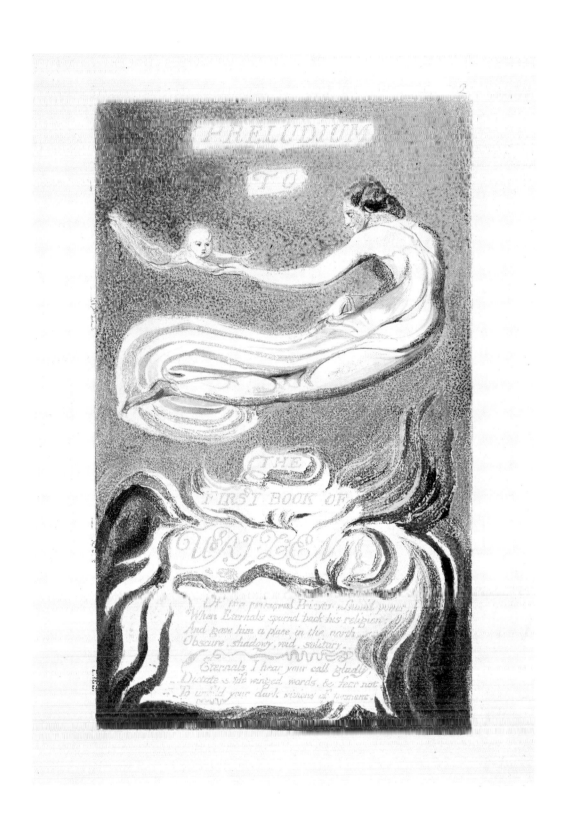

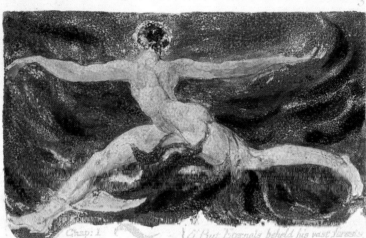

Chap: I

1 Lo, a shadow of horror is risen
In Eternity! Unknown, unprolific!
Self-clos'd, all-repelling: what Demon
Hath form'd this abominable void
This soul-shudd'ring vacuum?—Some
said
It is Urizen. But unknown, abstracted
Brooding secret, the dark power hid.

2. Times on times he divided, & measur'd
Space by space in his ninefold darkness
Unseen, unknown, changes appeard
Like desolate mountains rifted furious
By the black winds of perturbation

3. For he strove in battles dire
In unseen conflictions with shapes
Bred from his forsaken wilderness,
Of beast, bird, fish, serpent & element
Combustion, blast, vapour and cloud.

4. Dark revolving in silent activity
Unseen in tormenting passions;
An activity unknown and horrible;
A self-contemplating shadow,
In enormous labours occupied

5. But Eternals beheld his vast forests
Age on ages he lay, clos'd, unknown
Brooding shut in the deep; all avoid
The petrific abominable chaos

6. His cold horrors silent, dark Urizen
Prepar'd; his ten thousands of thunders
Rang'd in gloom'd array stretch out across
The dread world, & the rolling of wheels
As of swelling seas, sound in his clouds
In his hills of stor'd snows, in his mountains
Of hail & ice; voices of terror,
Are heard, like thunders of autumn,
When the cloud blazes over the harvests

Chap: II

1. Earth was not: nor globes of attrac-
tion
The will of the Immortal expanded
Or contracted his all flexible senses.
Death was not, but eternal life sprung

2. The sound of a trumpet the heavens
Awoke & vast clouds of blood roll'd
Round the dim rocks of Urizen, so nam'd
That solitary one in Immensity

3. Shrill the trumpet: & myriads of Eter

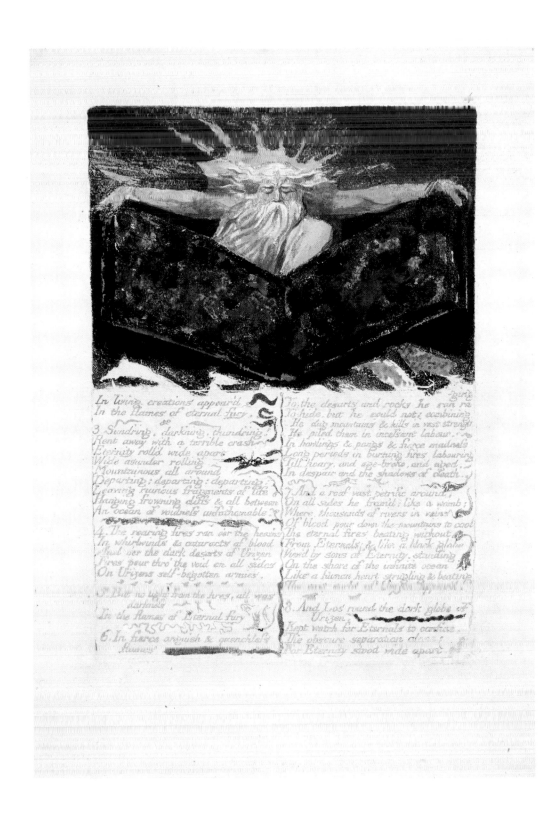

In living creations appear'd
In the flames of eternal fury.

3. Sund'ring, dark'ning, thund'ring,
Rent away with a terrible crash
Eternity roll'd wide apart
Wide asunder rolling
Mountainous all around
Departing; departing; departing:
Leaving ruinous fragments of life
Hanging frowning cliffs & all between
An ocean of voidness unfathomable.

4. The roaring fires ran o'er the heav'ns
In whirlwinds & cataracts of blood
And o'er the dark deserts of Urizen
Fires pour thro' the void on all sides
On Urizens self-begotten armies.

5. But no light from the fires. all was
darkness
In the flames of Eternal fury

6. In fierce anguish & quenchless
flames

To the deserts and rocks he ran rag
To hide, but he could not: combining
He dug mountains & hills in vast strength,
He piled them in incessant labour,
In howlings & pangs & fierce madness
Long periods in burning fires labouring
Till hoary, and age-broke, and aged,
In despair and the shadows of death.

7. And a roof vast petrific around,
On all sides he fram'd: like a womb;
Where thousands of rivers in veins
Of blood pour down the mountains to cool
The eternal fires beating without
From Eternals; & like a black globe
View'd by sons of Eternity, standing
On the shore of the infinite ocean
Like a human heart struggling & beating

8. And Los round the dark globe of
Urizen,
Kept watch for Eternals to confine,
The obscure separation alone;
For Eternity stood wide apart

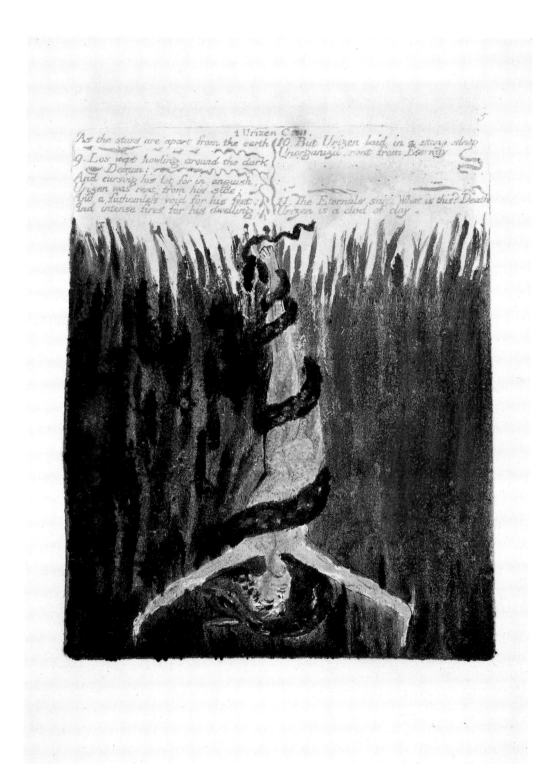

1 Urizen C.iiii.

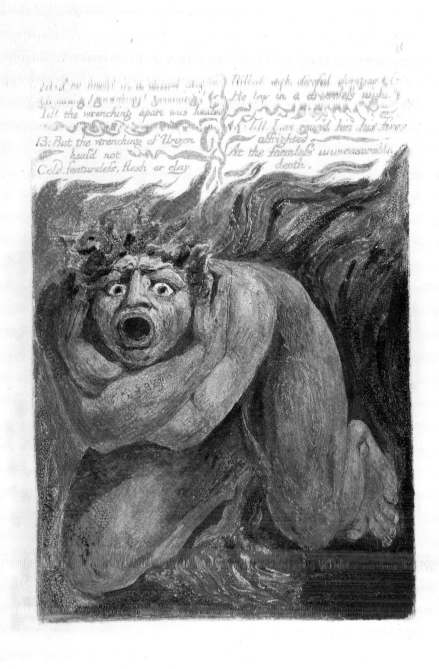

Chap: IV ment
1. Los smitten with astonish-
Frightend at the hurtling bones

2 And at the surging sulphure
- ous
Perturbed Immortal mad raging

3: In whirlwinds & pitch & nitre
Round the furious limbs of Los

4 And Los formed nets & gins
And threw the nets round about

5 He watchd in shuddring fear
The dark changes & bound every
change
With rivets of iron & brass

6. And these were the changes
of Urizen

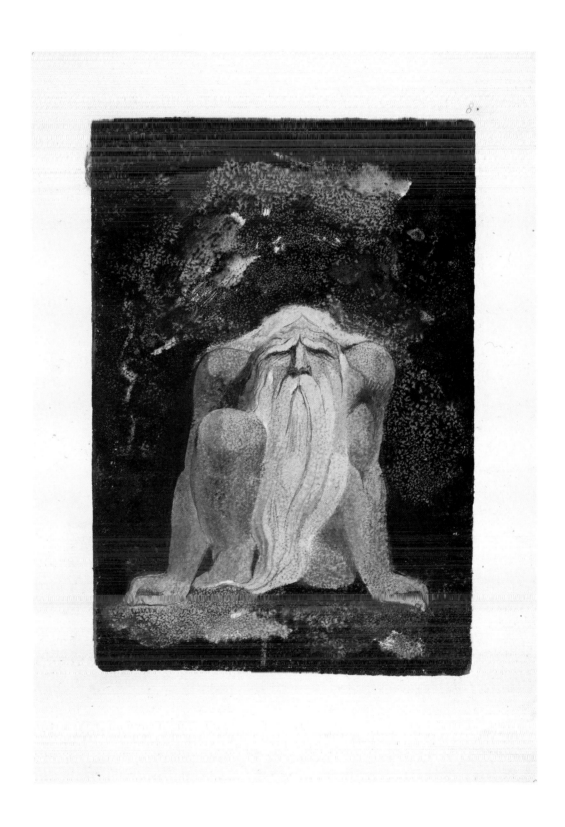

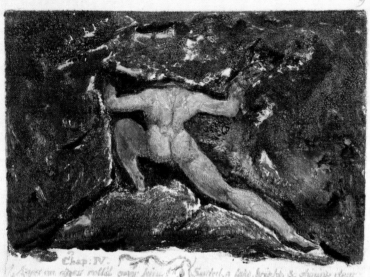

9

Chap: IV.

1. Ages on ages rolld over him.
In stony sleep ages rolld over him;
Like a dark waste stretching changable
By earthquakes riv'n, belching sullen
fires
On ages rolld ages in ghastly
Sick torment; around him in whirlwinds
Of darkness the eternal Prophet howld
Beating still on his rivets of iron
Pouring sodor of iron; dividing
The horrible night into watches.

2. And Urizen (so his eternal name)
His prolific delight obscurd more & more
In dark secresy hiding in surgeing
Sulphureous fluid his phantasies
The Eternal Prophet heavd the dark
bellows,
And turn'd restless the tongs; and the
hammer
Incessant beat; forging chains new & new
Numbring with links. hours, days & years

3. The eternal mind bounded began to roll
Eddies of wrath ceasless round & round
And the sulphureous foam surgeing thick

Settled, a lake, bright, & shining clear:
White as the snow on the mountains cold.

4. Forgetfulness, dumbness, necessity!
In chains of the mind locked up,
Like fetters of ice shrinking together
Disorganiz'd, rent from Eternity.
Los beat on his fetters of iron;
And heated his furnaces & pourd
Iron sodor and sodor of brass

5. Restles turnd the immortal inchaind
Heaving dolorous! anguishd! unbearable
Till a roof shaggy wild inclosd
In an orb, his fountain of thought.

6. In a horrible dreadful slumber
Like the linked infernal chain;
A vast Spine writh'd in torment
Upon the winds; shooting pain'd
Ribs, like a bending cavern
And bones of solidness, froze
Over all his nerves of joy.
And a first Age passed over,
And a state of dismal woe.

[211]

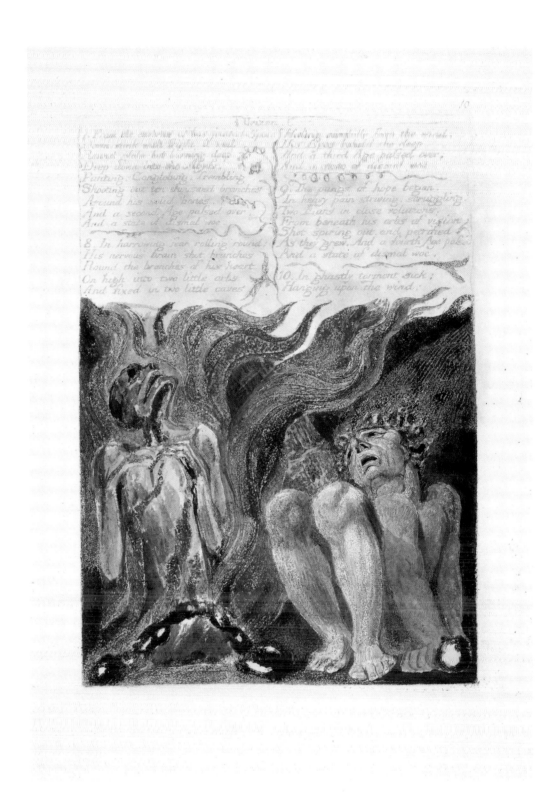

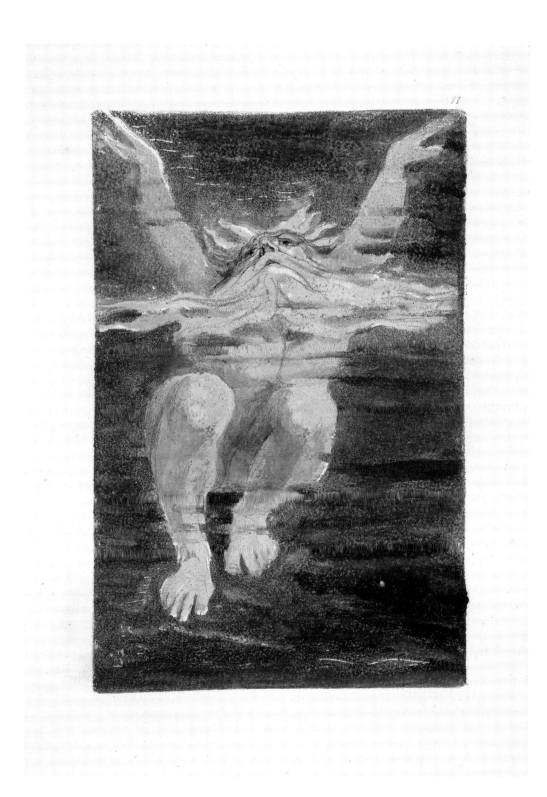

Two Nostrils bent down to the deep. In trembling & howling & dismay.
And a fifth Age passed over. And a seccond Age passed over.
And a state of dismal woe. And a state of dismal woe

 Chap V.

11. In ghastly torment sick. 1 In terrors Los shrunk from his
Within his ribs bloated round. task:
A craving Hungry Cavern. His great hammer fell from his hand
Thence arose his channeld Throat. His fires beheld, and sickening
And like a red flame a Tongue Hid their strong limbs in smoke
Of thirst & of hunger appeard. For with noises ruinous loud:
And a sixth Age passed over. With hurtlings & clashings & groans
And a state of dismal woe. The Immortal endurd his chains
 Tho bound in a deadly sleep

12. Enraged & stifled with torment 2. All the myriads of Eternity
He threw his right Arm to the north All the wisdom & joy of life
His left Arm to the south Roll like a sea around him.
Shooting out in anguish deep
And his Feet stampd the nether Abyss

Except what his little orbs Then he lookd back with anxious desire
Of sight by degrees unfold But the space undivided by existence
 Struck horror into his soul.

3 And now his eternal life
Like a dream was obliterated 6. Los wept obscur'd with mourning
 His bosom earthquakd with sighs
4 Shuddring the Eternal Prophet smote He saw Urizen deadly black
With a stroke, from his north to south In his chains bound, & Pity began.
region

A vast Spine writhd in torment 7 In anguish dividing & dividing
A nervous silence his prophetic voice For pity divides the soul
Siezd; a cold solitude & dark void In pangs eternity on eternity
The Eternal Prophet & Urizen clos'd Like an ocean rushd all his
 cliffs

5. Ages on ages rolld over them The void shrunk the lymph into nerves
Cut off from life & light frozen Wandring wide on the bosom of night
Into horrible forms of deformity And left a round globe of blood
Los sufferd his fires to decay Trembling upon the void

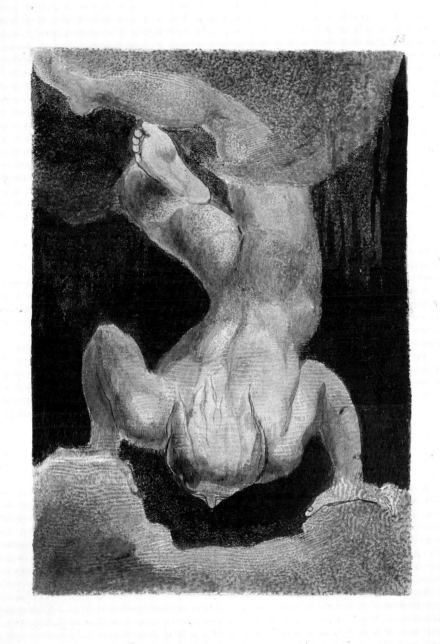

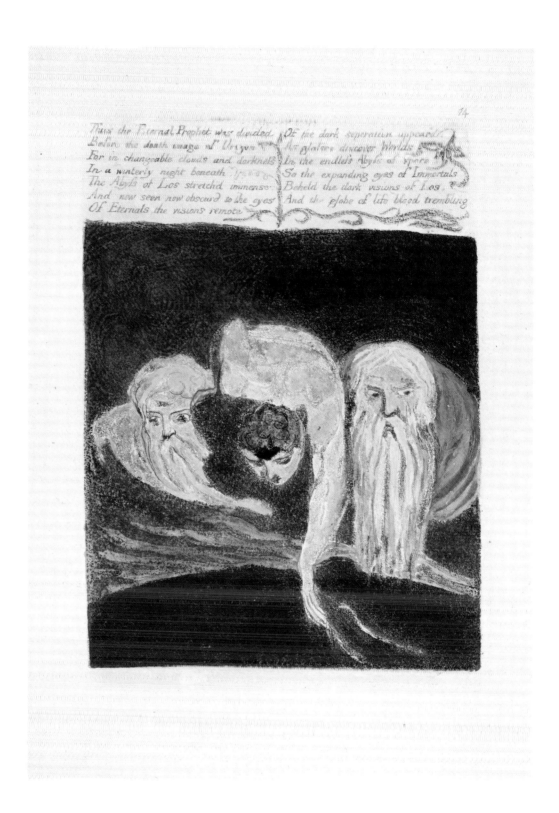

14

Thus the Eternal Prophet was divided
Before the death image of Urizen
For in changeable clouds and darkness
In a winterly night beneath
The Abyss of Los stretchd immense
And now seen now obscurd to the eyes
Of Eternals the visions remote

Of the dark seperation appeard
As glassins discover Worlds
In the endless Abyss of space
So the expanding eyes of Immortals
Beheld the dark visions of Los
And the globe of life blood trembling

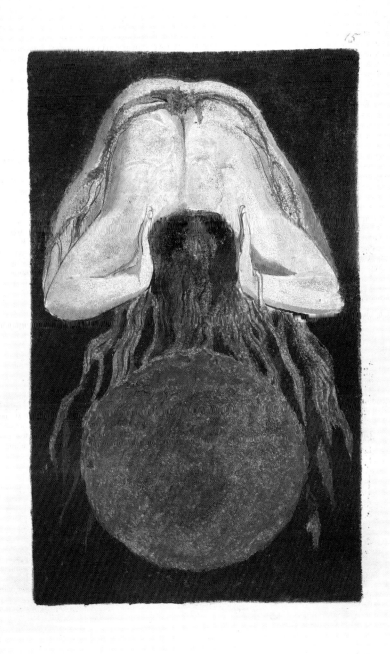

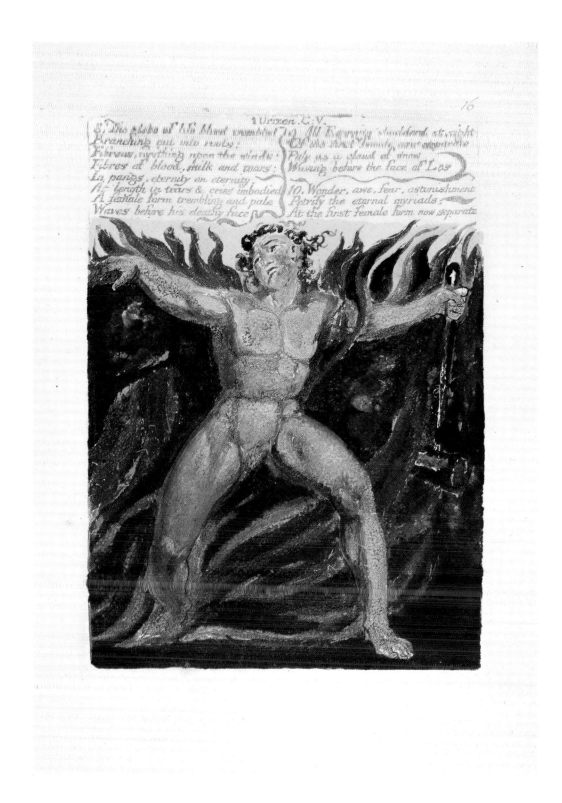

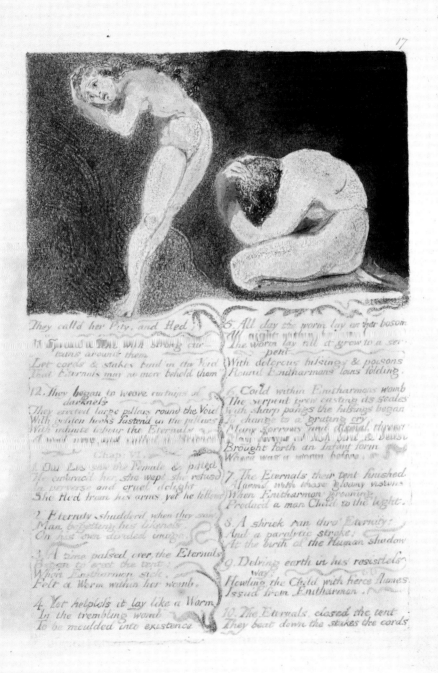

They called her Pity, and fled

[...] with strong cur
reins around them
Let cords & stakes bind in the Void
That Eternals may no more behold them

12. They began to weave curtains of
darkness
They erected large pillars round the Void
With golden hooks fastend in the pillars
With infinite labour the Eternals
[...]

Chap: VI.

1. But Los saw the Female & pitied
He embraced her, she wept, she refused
In perverse and cruel delight
She fled from his arms, yet he followd

2. Eternity shudderd when they saw
Man begetting his likeness
On his own divided image

3. A time passed over, the Eternals
Began to erect the tent:
When Enitharmon sick,
Felt a Worm within her womb.

4. Yet helpless it lay like a Worm
In the trembling womb
To be moulded into existence

5. All day the worm lay on her bosom
All night within her womb
The worm lay till it grew to a ser
pent
With dolorous hissings & poisons
Round Enitharmons loins folding,

6. Coild within Enitharmons womb
The serpent grew casting its scales
With sharp pangs the hissings began
To change to a grating cry
Many sorrows and dismal throes
[...]
Brought forth an Infant form
[...]

7. The Eternals their tent finished
Alarmd with these gloomy visions
When Enitharmon groaning
Producd a man Child to the light.

8. A shriek ran thro' Eternity:
And a paralytic stroke;
At the birth of the Human shadow

9. Delving earth in his resistless
way;
Howling the Child with fierce flames
Issud from Enitharmon.

10. The Eternals, closed the tent
They beat down the stakes the cords

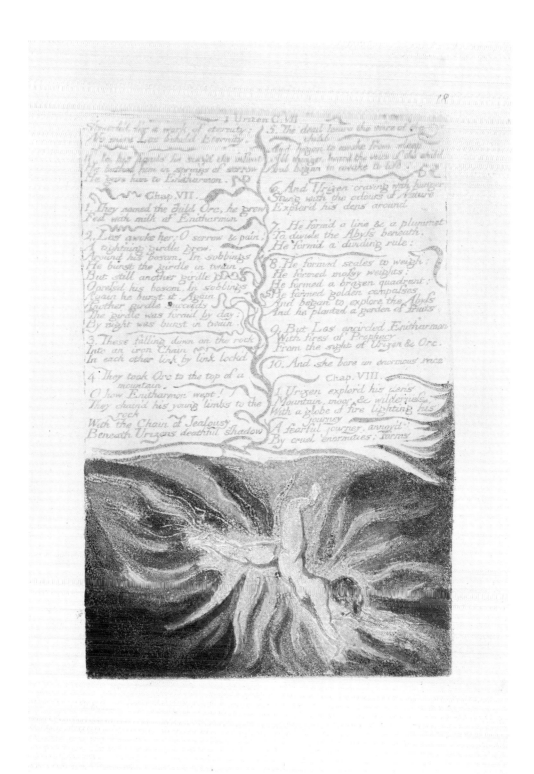

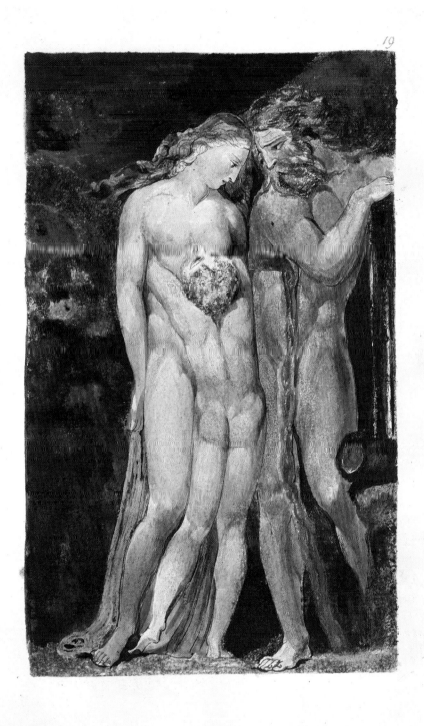

19

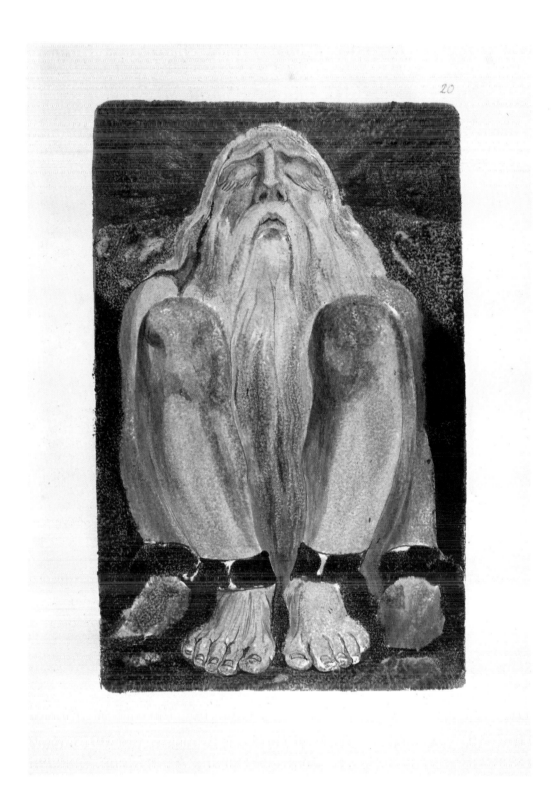

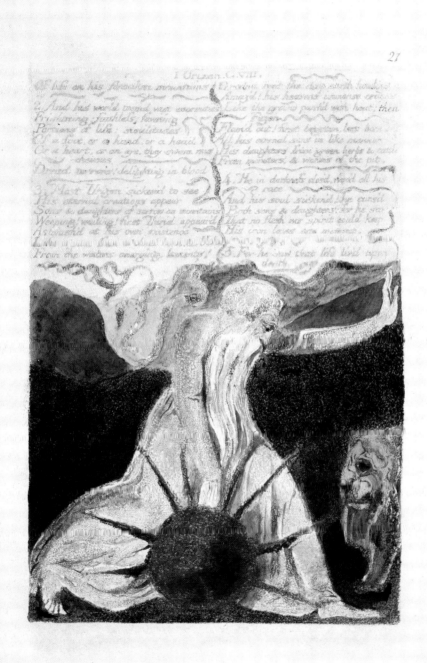

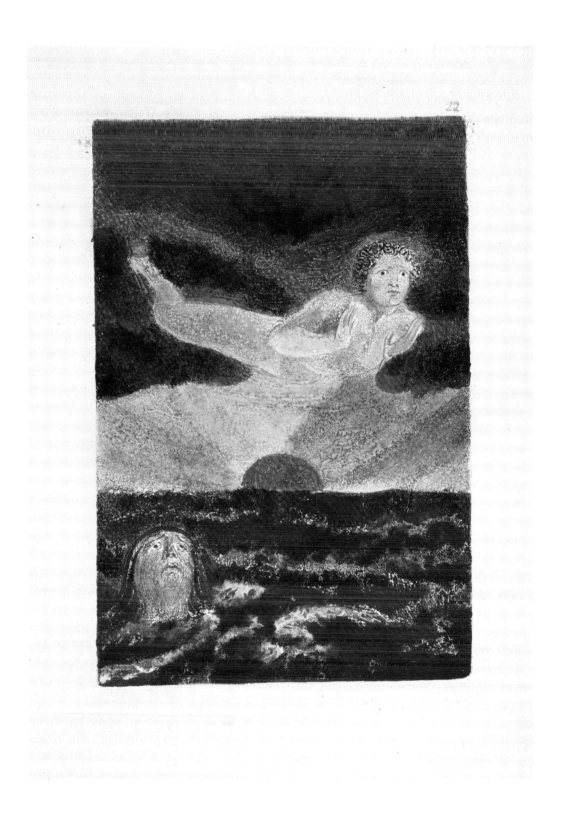

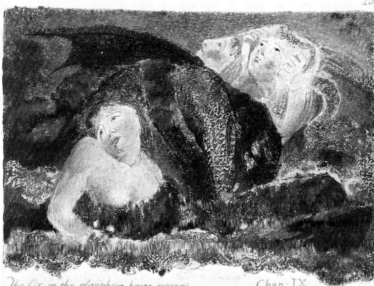

The Ox in the slaughter house moans
The Dog at the wintry door
And he wept & he called it Pity
And his tears flowed down on the winds

6 Cold he wander'd on high, over
 their cities
In weeping & pain & woe;
And where-ever he wanderd in sorrows
Upon the aged heavens
A cold shadow follow'd behind him
Like a spiders web, moist cold & dim
Drawing out from his sorrowing soul
The dungeon like heaven dividing
Where ever the footsteps of Urizen
Walk'd over the cities in sorrow

7 Till a Web dark & cold throughout all
The tormented element stretch'd
From the sorrows of Urizens soul
And the Web is a Female in embrio
 None could break the Web, no wings of
 fire

8 So twisted the cords & so knotted
The meshes; twisted like to the
 human brain

9 And all calld it The Net of Reli-gion

Chap: IX

1 Then the Inhabitants of those Cities:
Felt their Nerves change into Marrow
And hardening Bones began
In swift diseases and torments
In throbbings & shootings & grindings
Thro all the coasts till weakend
The Senses inward rush'd shrinking
Beneath the dark net of infection

2 Till the shrunken eyes clouded over
Discernd not the woven hypocrisy
But the streaky slime in their heavens
Brought together by narrowing perceptions
Appeard transparent air; for their eyes
Grew small like the eyes of a man
And in reptile forms shrinking together
Of seven feet stature they remaind

3 Six days they shrunk up from existence
And on the seventh day they rested.
And they blessd the seventh day, in sick
 hope
And forgot their eternal life

4 And their thirty cities divided
In form of a human heart
No more could they rise at will
In the infinite void, but bound down
To earth by their narrowing perceptions

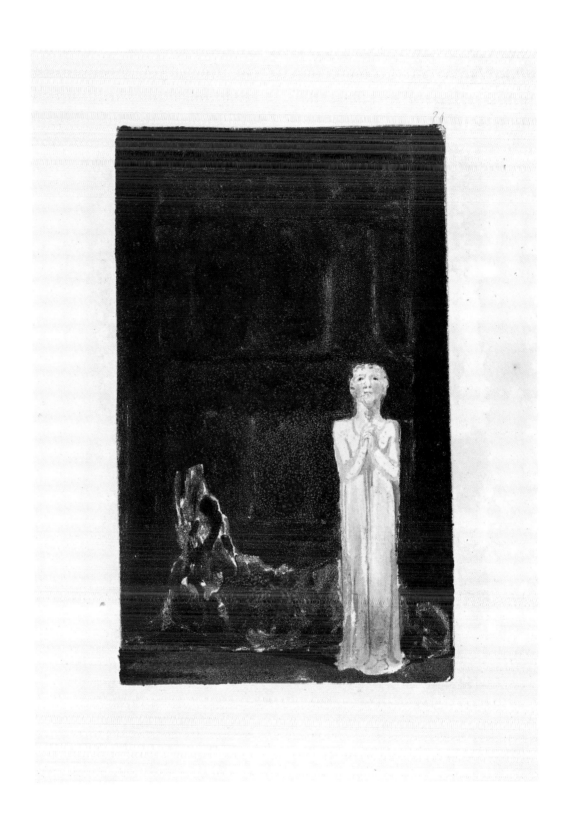

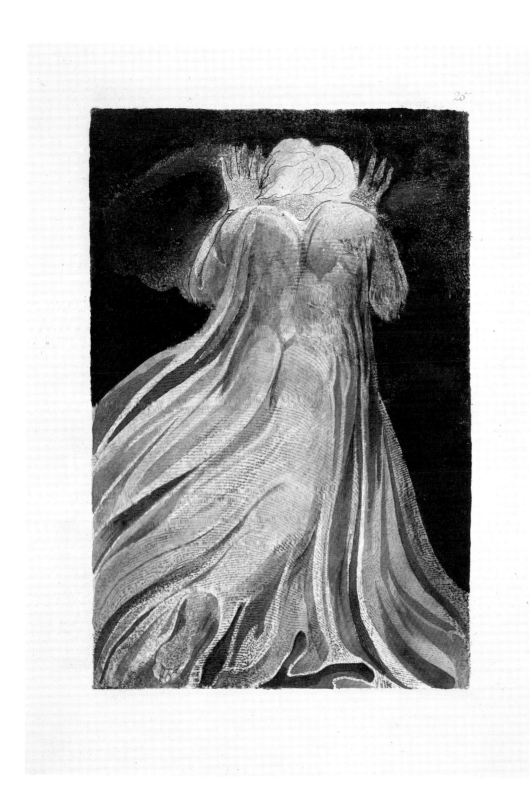

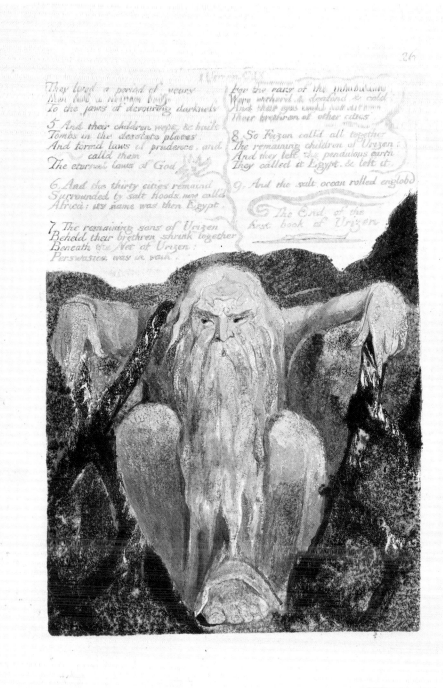

They lived a period of years
Then left a noysom body
To the jaws of devouring darkness

5. And their children wept, & built
Tombs in the desolate places
And form'd laws of prudence, and
 call'd them
The eternal laws of God

6. And the thirty cities remaind
Surrounded by salt floods, now calld
Africa: its name was then Egypt.

7. The remaining sons of Urizen
Beheld their brethren shrink together
Beneath the Net of Urizen:
Perswasion, was in vain

For the ears of the inhabitants
Were wither'd & deafend & cold
And their eyes could not discern
Their brethren of other cities

8. So Fuzon calld all together
The remaining children of Urizen:
And they left the pendulous earth
They called it Egypt, & left it.

9. And the salt ocean rolled englob'd

The End of the
first book of Urizen

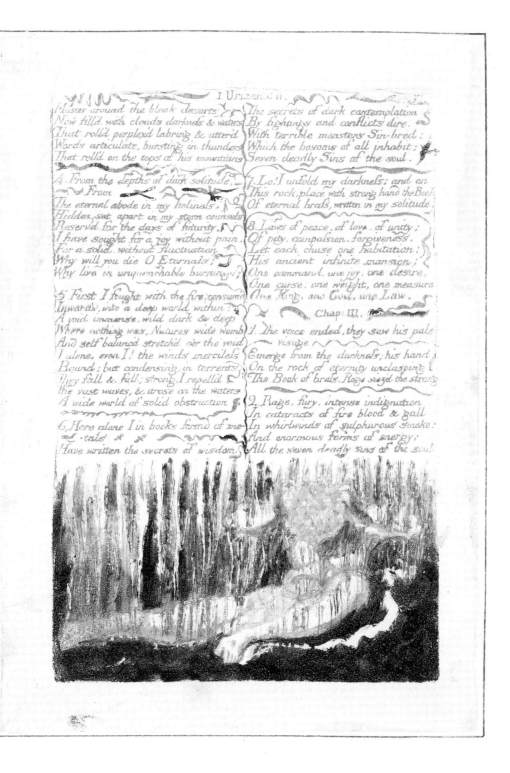

I U R I Z E N : II .

Muster around the bleak deserts;
Now fill'd with clouds, darkness & waters
That roll'd, perplex'd labring & utter'd
Words articulate, bursting in thunders
That roll'd on the tops of his mountains

4. From the depths of dark solitude. From
The eternal abode in my holiness,
Hidden, set apart in my stern counsels
Reserv'd for the days of futurity.
I have sought for a joy without pain,
For a solid without fluctuation
Why will you die O Eternals?
Why live in unquenchable burnings?

5 First I fought with the fire; consum'd
Inwards, into a deep world within:
A void immense, wild dark & deep
Where nothing was. Natures wide womb
And self balanc'd stretch'd oer the void
I alone, even I! the winds merciless
Bound; but condensing in torrents
They fall & fall; strong I repell'd
The vast waves, & arose on the waters
A wide world of solid obstruction

6. Here alone I in books form'd of me-
-tals
Have written the secrets of wisdom

The secrets of dark contemplation
By fightings and conflicts dire,
With terrible monsters Sin-bred:
Which the bosoms of all inhabit;
Seven deadly Sins of the soul.

7. Lo! I unfold my darkness: and on
This rock, place with strong hand the Book
Of eternal brass, written in my solitude.

8. Laws of peace, of love, of unity:
Of pity, compassion, forgiveness.
Let each chuse one habitation:
His ancient infinite mansion:
One command, one joy, one desire,
One curse, one weight, one measure
One King, one God, one Law.

Chap: III.

1. The voice ended, they saw his pale
visage
Emerge from the darkness; his hand
On the rock of eternity unclasping
The Book of brass. Rage siezd the strong

2. Rage, fury, intense indignation
In cataracts of fire blood & gall
In whirlwinds of sulphurous smoke:
And enormous forms of energy;
All the seven deadly sins of the soul

ADDITIONAL PLATE 4a

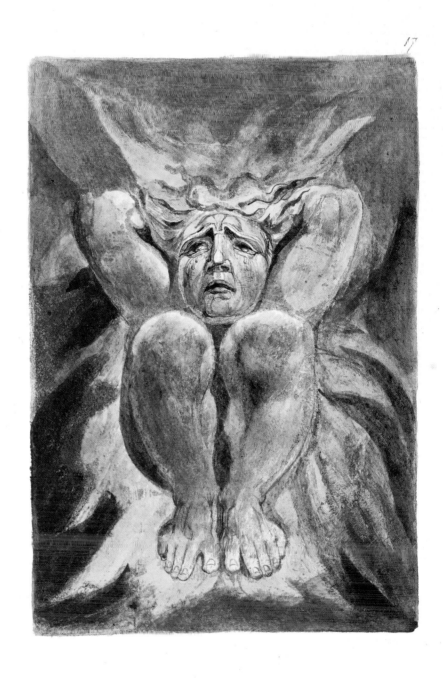

ADDITIONAL PLATE 10a

The Book of Ahania

1795

Rosenwald Collection, Library of Congress, Washington, D.C., and the Fitzwilliam Museum, Cambridge. Copy A.
Intaglio etchings, designs colour-printed.

The Book of Ahania combines intense visual imagery with a text of great complexity and terseness in which Blake pursues, from different aspects, characters and elements of his Urizen myth. It tells the story of the Children of Israel led by Moses in the form of Fuzon. Ahania, Urizen's emanation, begins as Pleasure, but under the moral law of Urizen becomes sin. Her tragic lament ends the book.

Unlike the immediately preceding Illuminated books, the text of *Ahania* is etched in intaglio with dense colour printing as used in *The Song of Los* added on the frontispiece, title-page and final plate. Blake's combination of these two disparate printing techniques may suggest that he did not envisage producing multiple copies. Indeed, *Ahania* exists in only one complete copy (there are a few separate leaves), which is now divided: five leaves are in the Rosenwald Collection and the frontispiece is in the Keynes Collection at the Fitzwilliam Museum. They are here brought together.

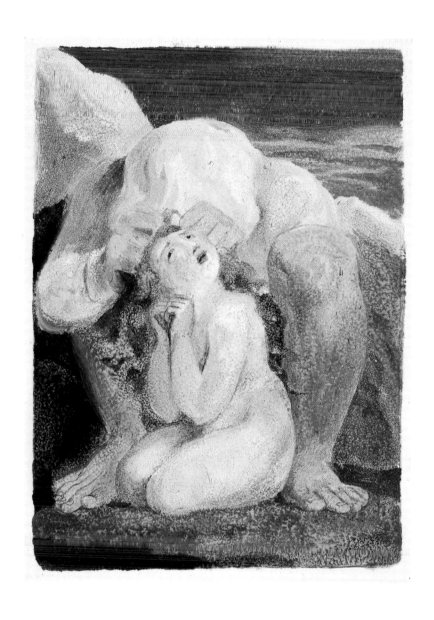

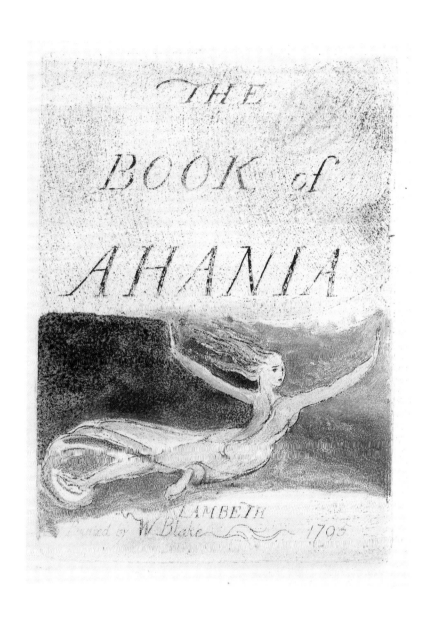

AHANIA

Chap: I[st]

1: Fuzon, on a chariot iron-wing'd
On spiked flames rose; his hot visage
Flam'd furious! sparkles his hair & beard
Shot down his wide bosom and shoulders
On clouds of smoke rages his chariot
And his right hand burns red in its
 cloud
Moulding into a vast globe, his wrath
As the thunder-stone is moulded.
Son of Urizens silent burnings

2: Shall we worship this Demon of smoke,
Said Fuzon, this abstract non-entity
This cloudy God, seated on waters
Now seen, now obscur'd; King of sorrow?

3: So he spoke, in a fiery flame,
On Urizen frowning indignant,
The Globe of wrath shaking on high
Roaring with fury, he threw
The howling Globe: burning it flew
Lengthning into a hungry beam. Swiftly

4: Oppos'd to the exulting flam'd beam
The broad Disk of Urizen upheav'd
Across the Void many a mile.

5: It was forg'd in mills where the winter
Beats incessant; ten winters the disk

Unremitting endur'd the cold hammer.

6: But the strong arm that sent it, remem-
 -berd
The sounding beam; laughing it tore through
That beaten mass; keeping its direction
The cold loins of Urizen dividing.

7: Dire shriek'd his invisible Lust
Deep groan'd Urizen! stretching his awful hand
Ahania (so name his parted soul)
He siez'd on his mountains of Jealousy.
He groand anguishd & called her Sin,
Kissing her and weeping over her;
Then hid her in darkness in silence;
Jealous tho' she was invisible.

8: She fell down a faint shadow wandring
In chaos and circling dark Urizen,
As the moon anguishd circles the earth;
Hopeless! abhorrd! a death-shadow,
Unseen, unbodied, unknown,
The mother of Pestilence.

9: But the fiery beam of Fuzon
Was a pillar of fire to Egypt
Five hundred years wandring on earth
Till Los siez'd it and beat in a mass
With the body of the sun.

Chap: II:

1: But the forehead of Urizen gathering.
And his eyes pale with anguish, his lips
Blue & changing; in tears and bitter
Contrition he prepard his Bow.

2: Formd of Ribs: that in his dark solitude
When obscurd in his forests fell monsters.
Arose. For his dire Contemplations
Rushd down like floods from his mountains
In torrents of mud settling thick
With Eggs of unnatural production
Forthwith hatching; some howld on his hills
Some in vales, some aloft flew in air

3: Of these: an enormous dread Serpent
Scaled, and poisonous horned
Approachd Urizen even to his knees
As he sat on his dark rooted Oak.

4: With his horns he pushd furious.
Great the conflict & great the jealousy
In cold poisons: but Urizen smote him

5: First he poisond the rocks with his blood.
Then polishd his ribs, and his sinews
Dried; laid them apart till winter;
Then a Bow black prepard, on this Bow,
A poisoned rock placd in silence.
He uttered these words to the Bow.

6: O Bow of the clouds of secresy:
O nerve of that lust formd monster!
Send this rock swift, invisible thro'
The black clouds, on the bosom of Fuzon

7: So saying, In torment of his wounds.
He bent the enormous ribs slowly;
A circle of darkness! then fixed.
The sinew in its rest; then the Rock
Poisonous source! placd with art, lifting difficult
Its weighty bulk: silent the rock lay.

8: While Fuzon his tygers unloosing

Thought Urizen slain by his wrath.
I am God. said he eldest of things!

9: Sudden sings the rock, swift & invisible
On Fuzon flew, enterd his bosom:
His beautiful visage, his tresses.
That gave light to the mornings of heaven
Were smitten with darkness, deformd
And outstretchd, on the edge of the fo-
 -rest

10: But the rock fell upon the Earth.
Mount Sinai. in Arabia.

Chap III:

1: The Globe shook; and Urizen seated
On black clouds his sore wound anointed
The ointment flow'd down on the void.
Mixd with blood; here the snake gets
 her poison.

2: With difficulty & great pain. Urizen
Lifted on high the dead corse:
On his shoulders he bore it to where
A Tree hung over the Immensity

3: For whom Urizen shrunk away
From Eternals, he sat on a rock
Barren; a rock which himself
From redounding fancies had petrified
Many tears fell on the rock,
Many sparks of vegetation:
Soon shot the pained root
Of Mystery, under his heel:
It grew a thick tree; he wrote
In silence his book of iron:
Till the horrid plant bending its boughs
Grew to roots when it felt the earth
And again sprung to many a tree.

4: Amazd started Urizen! when
He beheld himself compassed round
And high roofed over with trees
He rose but the stems stood so thick
He with difficulty and great pain
Brought his Books. all but the Book

Of

Of iron, from the dismal shade

5: The Tree still grows over the Void
Enrooting itself all around
An endless labyrinth of woe!

6: The corse of his first begotten
On the accursed Tree of Mystery:
On the topmost stem of this Tree
Urizen nail'd Fuzons corse.

Chap: IV:

1: Forth flew the arrows of pesilence
Round the pale living Corse on the tree

2: For in Urizens slumbers of abstraction
In the infinite ages of Eternity:
When his Nerves of Joy melted & flow'd
A white Lake on the dark blue air
In perturb'd pain and dismal torment
Now stretching out, now swift conglobing.

3: Effluvia vapord above
In noxious clouds; these hover'd thick
Over the disorganiz'd Immortal,
Till petrific pain scurfd oer the Lakes
As the bones of man, solid & dark

4: The clouds of disease hover'd wide
Around the Immortal in torment:
Perching around the hurtling bones
Disease on disease, shape on shape,
Winged screaming in blood & torment.

5: The Eternal Prophet beat on his anvils
Enrag'd in the desolate darkness
He forg'd nets of iron around
And Los threw them around the bones

6: The shapes screaming flutter'd vain
Some combin'd into muscles & glands
Some organs for craving and lust
Most remain on the tormented void:
Urizens army of horrors.

7: Round the pale living Corse on the
 Tree
Forty years flew the arrows of pestilence

8: Wandring and howling and thro
Rain thro' all his dismal world:
Forty years all his sons & daughters
Felt their skulls harden: then Asia
Arose in the pendulous deep.

9: They reptilize upon the Earth.

10: Fuzon groand on the Tree.

Chap: V

1: The lamenting voice of Ahania
Weeping upon the void,
And round the Tree of Fuzon:
Distant in solitary night
Her voice was heard, but no form
Had she, but her tears from clouds
Eternal fell round the Tree

2: And the voice cried: Ah Urizen! Love!
Flower of morning! I weep on the verge
Of Non-entity; how wide the Abyss
Between Ahania and thee!

3: I lie on the verge of the deep,
I see thy dark clouds ascend,
I see thy black forests and floods,
A horrible waste to my eyes!

4: Weeping I walk over rocks
Over dens & thro' valleys of death
Why didst thou despise Ahania
To cast me from thy bright presence
Into the World of Loneness

5: I cannot touch his hand:
Nor weep on his knees, nor hear
His voice & bow, nor see his eyes
And joy, nor hear his footsteps, and
My heart leap at the lovely sound!
I cannot kiss the place
Whereon his bright feet have trod,

But

But I wander on the rocks
With hard necessity.

6: Where is my golden palace
Where my ivory bed.
Where the joy of my morning hour
Where the sons of eternity singing

7: To awake bright Urizen my king.
To arise to the mountain sport.
To the bliss of eternal valleys.

8: To awake my king in the morn:
To embrace Ahanias joy
On the breath of his open bosom,
From my soft cloud of dew to fall
In showers of life on his harvests.

9: When he gave my happy soul
To the sons of eternal joy:
When he took the daughters of life
Into my chambers of love:

10: When I found babes of bliss on my beds.
And bosoms of milk in my chambers
Filld with eternal seed
O! eternal births sung round Ahania
In interchange sweet of their joys.

11: Swelld with ripeness & fat with fatness
Bursting on winds my odors.
My ripe figs and rich pomegranates

In infant joy at thy feet
O Urizen sported and sung:

12: Then thou with thy lap full of seed.
With thy hand full of generous fire
Walked forth from the clouds of morning
On the virgins of springing joy.
On the human soul to cast
The seed of eternal science.

13: The sweat poured down thy temples
To Ahania returnd in evening
The moisture awoke to birth
My mothers-joys, sleeping in bliss.

14: But now alone over rocks, mountains
Cast out from thy lovely bosom:
Cruel jealousy, selfish fear,
Self-destroying: how can delight
Renew in these chains of darkness
Where bones of beasts are strown
On the bleak and snowy mountains
Where bones from the birth are buried
Before they see the light.

FINIS

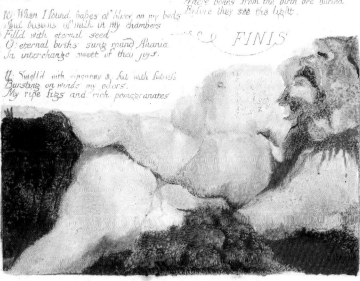

The Book of Los

1795

The British Museum, London. Copy A.
Intaglio etchings, designs colour-printed.

The Book of Los is closely associated with *The Book of Ahania* in format and methods of printing, while a similarly opaque text again develops aspects of the Urizen myth. Here, the creation of Urizen and the origins of religious ideology are told as from ancient legend by the matriarchal bard Eno.

The text is again finely etched in intaglio with minimal decoration, the pictorial element being confined to a sombre portrayal of the aged Eno, in vatic utterance 'beneath the eternal Oak'; a title-page perhaps depicting the nascent Los; a miniature emblem of mankind's ensnarement by the dictates of formal religion, painted into the O of 'Los' on the first page; and an ironic end-piece showing Los's jubilation at the creation of religion, symbolised by a heavily obscured sun.

The Book of Los exists only in the present copy. It marks the end of Blake's most intensive phase of creating the edifice of his 'Sublime Allegory' and of developing his own unique methods of giving it expression.

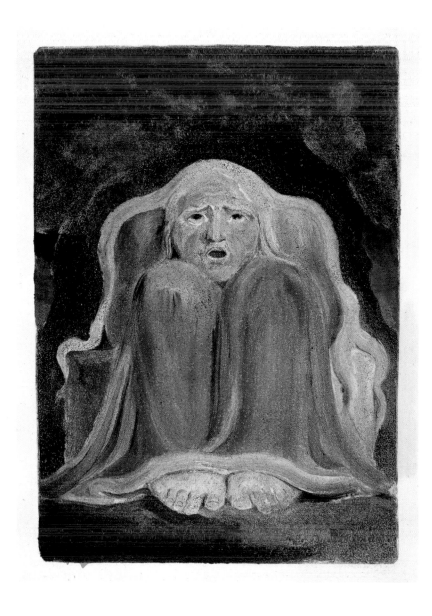

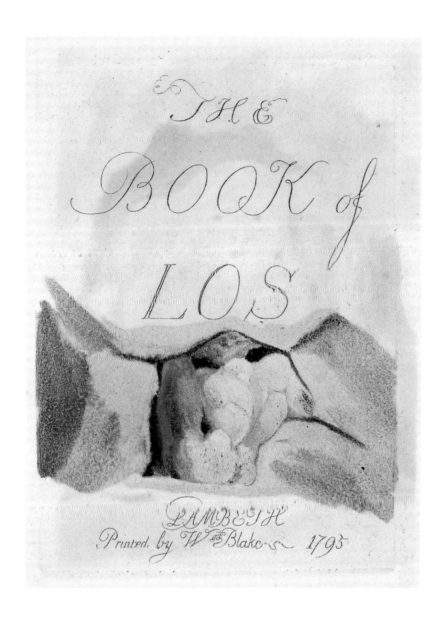

THE

BOOK of

LOS

LAMBETH
Printed by W. Blake 1795

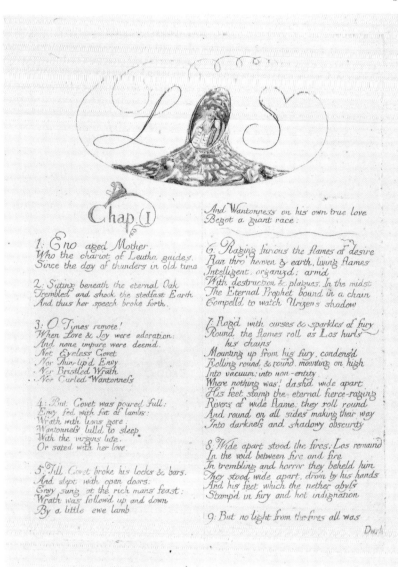

Chap. I

And Wantonness on his own true love
Begot a giant race:

1: Eno aged Mother,
Who the chariot of Leutha guides,
Since the day of thunders in old time

2: Sitting beneath the eternal Oak
Trembled, and shook the stedfast Earth
And thus her speech broke forth.

3: O Times remote!
When Love & Joy were adoration:
And none impure were deemd.
Not Eyeless Covet
Nor Thin-lip'd Envy
Nor Bristled Wrath
Nor Curled Wantonness

4: But Covet was poured full:
Envy fed with fat of lambs:
Wrath with lions gore:
Wantonness lulld to sleep
With the virgins lute,
Or sated with her love.

5: Till Covet broke his locks & bars,
And slept with open doors:
Envy sung at the rich mans feast:
Wrath was followd up and down
By a little ewe lamb

6: Raging furious the flames of desire
Ran thro' heaven & earth, living flames
Intelligent, organizd: armd
With destruction & plagues. In the midst
The Eternal Prophet bound in a chain
Compelld to watch Urizens shadow

7: Rag'd with curses & sparkles of fury
Round the flames roll as Los hurls
his chains
Mounting up from his fury, condens'd
Rolling round, & round, mounting on high
Into vacuum: into non-entity
Where nothing was! dash'd wide apart
His feet stamp the eternal fierce-raging
Rivers of wide flame: they roll round
And round on all sides making their way
Into darkness and shadowy obscurity

8: Wide apart stood the fires: Los remaind
In the void between fire and fire
In trembling and horror they beheld him
They stood wide apart, drivn by his hands
And his feet which the nether abyss
Stamp'd in fury and hot indignation

9: But no light from the fires all was

Dark

Darkness round Los: heat was not, for
 bound up
Into fiery spheres from his fury
The gigantic flames trembled and hid.

10. Coldness, darkness, obstruction, a Solid
Without fluctuation, hard as adamant
Black as marble of Egypt; impenetrable
Bound in the fierce raging Immortal.
And the seperated fires froze in
A vast solid without fluctuation.
Bound in his expanding clear senses

Chap: II

1. The Immortal stood frozen amidst
The vast rock of eternity: times
And times; a night of vast durance:
Impatient, stifled, stiffend, hardnind.

2. Till impatience no longer could bear
The hard bondage. rent, rent, the vast
 solid
With a crash from immense to immense

3. Crack'd acrofs into numberlefs frag
 -ments
The Prophetic wrath, struggling for vent
Hurls apart, stamping furious to dust
And crumbling with bursting sobs; heaves
The black marble on high into fragments

4. Hurl'd apart on all sides, as a falling
Rock: the innumerable fragments away
Fell asunder; and horrible vacuum
Beneath him & on all sides round.

5. Falling, falling! Los fell & fell
Sunk precipitant heavy down down
Times on times, night on night, day on day
Truth has bounds. Error none: falling,
 falling:
Years on years, and ages on ages
Still he fell thro the void, still a void
Found for falling day & night without
 end.
For tho' day or night was not, their spaces

Were measur'd by his incessant whirls
In the horrid vacuity bottomlefs.

6. The Immortal revolving; indignant
First in wrath threw his limbs, like the w
 babe
New born into our world: wrath subsided
And contemplative thoughts first arose
Then aloft his head reard in the Abyfs
And his downward-borne fall chang'd oblique

7. Many ages of groans: till there grew
Branchy forms, organizing the Human
Into finite inflexible organs.

8. Till in procefs from falling he bore
Sidelong on the purple air, wafting
The weak breeze in efforts oerwearied.

9. Incefsant the falling Mind labourd
Organizing itself: till the Vacuum
Became element, pliant to rife,
Or to fall, or to swim, or to fly:
With ease searching the dire vacuity

Chap: III

1. The Lungs heave incefsant, dull and
 heavy
For as yet were all other parts formlefs
Shivring, clinging around like a cloud
Dim & glutinous as the white Polypus
Driven by waves & englob'd on the tide.

2. And the unformed part crav'd repose
Sleep began, the Lungs heave on the wave
Weary overweigh'd, sinking beneath
In a stifling black fluid he woke

3. He arose on the waters, but soon
Heavy falling his organs like roots
Shooting out from the seed, shot beneath
And a vast world of waters around him
In furious torrents began.

4. Then he sunk, & around his spent Lungs
Began intricate pipes that drew in
The spawn of the waters. Outbranching
 An

An immense Fibrous form, stretching out
Thro the bottoms of immensity raging

5: He rose on the floods: then he smote
The wild deep with his terrible wrath,
Seperating the heavy and thin.

6: Down the heavy sunk; cleaving around
To the fragments of solid: up rose
The thin, flowing round the fierce fires
That glowd furious in the expanse.

Chap: IV

1: Then Light first began; from the fires
Beams, conducted by fluid so pure
Flowd around the Immense: Los beheld
Forthwith writhing upon the dark void
The Back bone of Urizen appear
Hurtling upon the wind
Like a serpent! like an iron chain
Whirling about in the Deep.

2: Unfolding his Fibres together
To a Form of impregnable strength
Los astonishd, and terrified, built
Furnaces; he formed an Anvil
A Hammer of adamant then began
The binding of Urizen day and night

3: Circling round the dark Demon, with
howlings
Dismay & sharp blightings, the Prophet
Of Eternity beat on his iron links

4: And first from those infinite fires
The light that flowd down on the winds
He siezd: beating incessant, condensing
The subtil particles in an Orb.

5: Roaring indignant the bright sparks
Endurd the vast Hammer; but unwearied
Los beat on the Anvil; till glorious
An immense Orb of fire he framd

6: Oft his furious it beneath in the
Deep
Then surveyd the all bright mass. Again
Siezing fires from the terrific Orbs
He heated, the round Globe, then beat
While roaring his Furnaces endurd
The chaind Orb in their infinite wombs

7: Nine ages completed their circles
When Los heated the glowing mass, cast-
-ing
It down into the Deeps: the Deeps fled
Away in redounding smoke; the Sun
Stood self-balancd. And Los smild
with joy.
He the vast Spine of Urizen siezd
And bound down to the glowing illusion

8: But no light, for the Deep fled away
On all sides, and left an unform'd
Dark vacuity: here Urizen lay
In fierce torments on his glowing bed

9: Till his Brain in a rock, & his Heart
In a fleshy slough formed four rivers
Obscuring the immense Orb of fire
Flowing down into night: till a Form
Was completed, a Human Illusion
In darkness and deep clouds involvd.

The End of the
Book of LOS

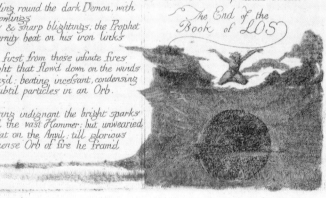

Milton a Poem

1804 (*c.* 1804–1810/11)

New York Public Library. Copy C.
Relief etching and white- and black-line engraving, with watercolour and grey wash.

In September 1800 the Blakes moved from London to Felpham, a seaside village in Sussex,
to a cottage provided for them by William Hayley, the poet and patron to whom Blake was to
be more or less artist-in-residence and whom he was required to help with the writing of a
life of Milton. Blake's preoccupation with Milton as the poetic redeemer of the English
Nation became intricately intertwined with his own destiny. He identified with Milton's
mental struggles, analysed the errors which led to the unresolved divisions in his life, and by
subsuming Milton's experience into his own renewed his conviction in his own destiny as
the prophetic saviour necessary for the Apocalypse. *Milton a Poem* is, with much else, an
autobiography of this mental strife and is a kind of Praeludium to the final vision realised in
Jerusalem.

Milton was probably begun at the end of Blake's time at Felpham or soon after his return to
London in 1804. Its composition and etching continued for some years and the first three
(including the present copy) of the four known copies were probably not printed until
1810/11. The text pages are relief-printed and finished in the manner developed for the
earlier prophetic books, but the full-plate designs employ new techniques of black-line and
white-line engraving to achieve bold effects far removed from the refined graphic style of
conventional engraving practice. Colouring is applied in watercolour washes throughout.

The pages of the copy here reproduced were probably collated and put together by Blake in
about 1818. At that time it contained two plates (reproduced on pages 295 and 296) which
Blake subsequently removed. Whatever his reasons for doing so, it is ironic that 'Jerusalem',
the one Blake poem that is universally known (if imperfectly understood), should form part
of a page which its author felt able to discard.

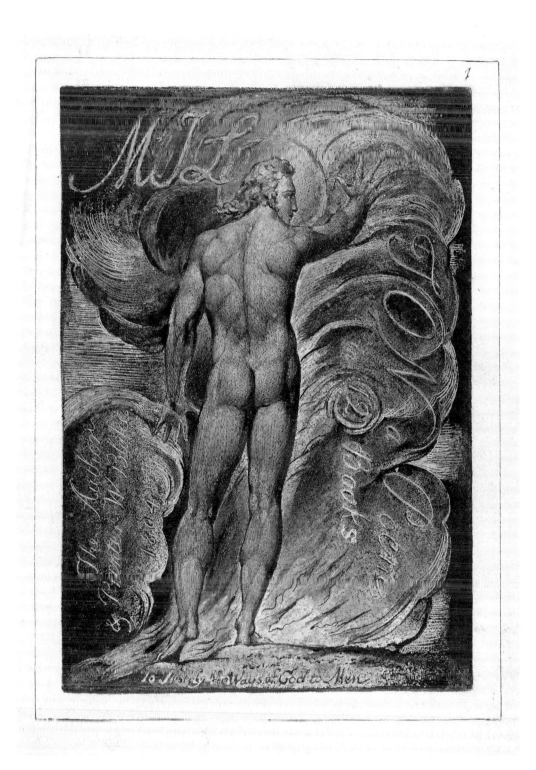

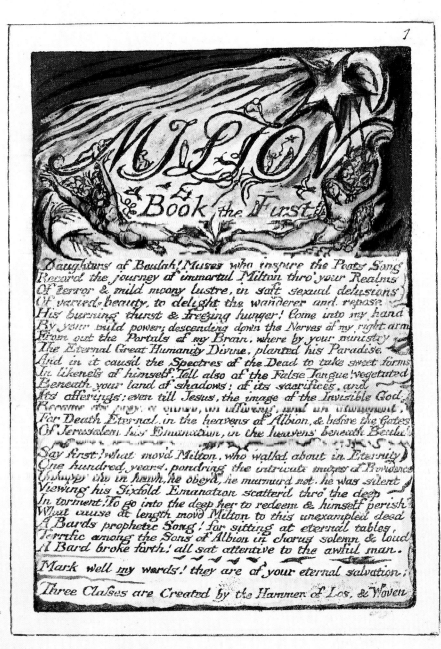

Daughters of Beulah! Muses who inspire the Poets Song
Record the journey of immortal Milton thro' your Realms
Of terror & mild moony lustre, in soft sexual delusions
Of varied beauty, to delight the wanderer and repose
His burning thirst & freezing hunger! Come into my hand
By your mild power; descending down the Nerves of my right arm
From out the Portals of my Brain, where by your ministry
The Eternal Great Humanity Divine, planted his Paradise.
And in it caus'd the Spectres of the Dead to take sweet forms
In likeness of himself. Tell also of the False Tongue! vegetated
Beneath your land of shadows: of its sacrifices, and
Its offerings; even till Jesus, the image of the Invisible God;
Became its prey; a curse, an offering, and an atonement,
For Death Eternal in the heavens of Albion, & before the Gates
Of Jerusalem his Emanation, in the heavens beneath Beulah

Say first! what mov'd Milton, who walk'd about in Eternity
One hundred years, pondring the intricate mazes of Providence
Unhappy tho' in heav'n, he obey'd, he murmur'd not. he was silent
Viewing his Sixfold Emanation scatter'd thro' the deep
In torment! To go into the deep her to redeem & himself perish?
What cause at length mov'd Milton to this unexampled deed
A Bards prophetic Song! for sitting at eternal tables,
Terrific among the Sons of Albion in chorus solemn & loud
A Bard broke forth! all sat attentive to the awful man.

Mark well my words! they are of your eternal salvation:

Three Classes are Created by the Hammer of Los, & Woven

Of Enitharmons Looms, when Albion was slain upon his Mountains
And in his Tent, thro envy of Living Form, even of the Divine Vision
And of the sports of Wisdom in the Human Imagination
Which is the Divine Body of the Lord Jesus blessed for ever
Mark well my words. they are of your eternal salvation.

Urizen lay in darkness & solitude. in chains of the mind lock'd up
Los siezd his Hammer & Tongs; he labourd at his resolute Anvil
Among indefinite Druid rocks & snows of doubt & reasoning.

Refusing all Definite Form, the Abstract Horror roofd. stony hard
And a first Age passed over & a State of dismal woe:

Down sunk with fright a red round Globe hot burning deep
Deep down into the Abyss. panting: conglobing: trembling
And a second Age passed over & a State of dismal woe.

Rolling round into two little Orbs & closed in two little Caves
The Eyes beheld the Abyss: lest bones of solidness freeze over all
And a third Age passed over & a State of dismal woe.

From beneath his Orbs of Vision. Two Ears in close volutions
Shot spiring out in the deep darkness & petrified as they grew
And a fourth Age passed over & a State of dismal woe

Hanging upon the wind. Two Nostrils bent down into the Deep
And a fifth Age passed over & a State of dismal woe

In ghastly torment sick. a Tongue of hunger & thirst flamed out
And a sixth Age passed over & a State of dismal woe.

Enraged & stifled without & within: in terror & woe, he threw his
Right Arm to the north, his left Arm to the south. & his Feet
Stampd the nether Abyss in trembling & howling & dismay
And a seventh Age passed over & a State of dismal woe

Terrified Los stood in the Abyss & his immortal limbs
Grew deadly pale; he became what he beheld: for a red
Round Globe sunk down from his Bosom into the Deep in pangs
He hoverd over it trembling & weeping. suspended it shook
The nether Abyss in tremblings. he wept over it. he cherishd it
In deadly sickening pain: till separated into a Female pale
As the cloud that brings the snow: all the while from his Back
A blue fluid exuded in Sinews hardening in the Abyss
Till it separated into a Male Form howling in Jealousy

Within labouring. beholding Without. from Particulars to Generals
Subduing his Spectre, they Builded the Looms of Generation
They Builded Great Golgonooza Times on Times Ages on Ages
First Orc was Born then the Shadowy Female: then All Loss's Family
At last Enitharmon brought forth Satan Refusing Form. in vain
The Miller of Eternity made subservient to the Great Harvest
That he may go to his own Place Prince of the Starry Wheels

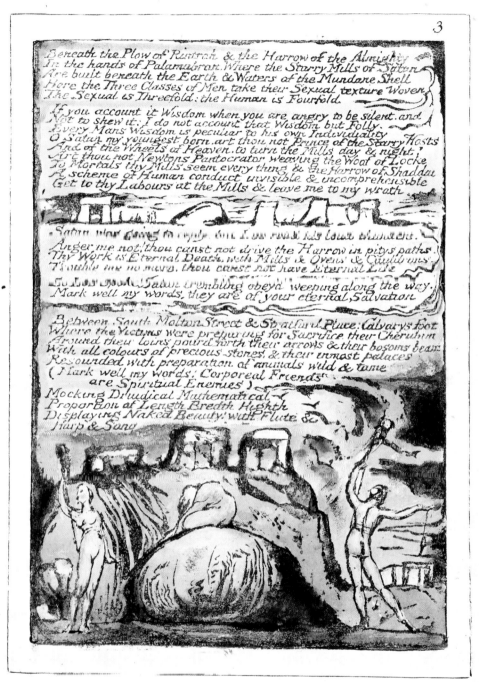

Beneath the Plow of Rintrah & the Harrow of the Almighty
In the hands of Palamabron. Where the Starry Mills of Satan
Are built beneath the Earth & Waters of the Mundane Shell
Here the Three Classes of Men take their Sexual texture Woven
The Sexual is Threefold: the Human is Fourfold.

If you account it Wisdom when you are angry to be silent, and
Not to shew it: I do not account that Wisdom but Folly.
Every Mans Wisdom is peculiar to his own Individuality
O Satan my youngest born. art thou not Prince of the Starry Hosts
And of the Wheels of Heaven. to turn the Mills day & night?
Art thou not Newtons Pantocrator weaving the Woof of Locke
To Mortals thy Mills seem every thing & the Harrow of Shaddai
A scheme of Human conduct invisible & incomprehensible
Get to thy Labours at the Mills & leave me to my wrath

Satan was going to reply, but Los roll'd his loud thunder.

Anger me not! thou canst not drive the Harrow in pitys paths.
Thy Work is Eternal Death, with Mills & Ovens & Cauldrons.
Trouble me no more. thou canst not have Eternal Life

So Los spoke! Satan trembling obeyd weeping along the way.
Mark well my words, they are of your eternal Salvation

Between South Molton Street & Stratford Place: Calvarys foot
Where the Victims were preparing for Sacrifice their Cherubim
Around their loins pourd forth their arrows & their bosoms beam
With all colours of precious stones, & their inmost palaces
Resounded with preparation of animals wild & tame
(Mark well my words: Corporeal Friends
 are Spiritual Enemies)
Mocking Druidical Mathematical
Proportion of Length Bredth Highth
Displaying Naked Beauty: with Flute &
Harp & Song

4

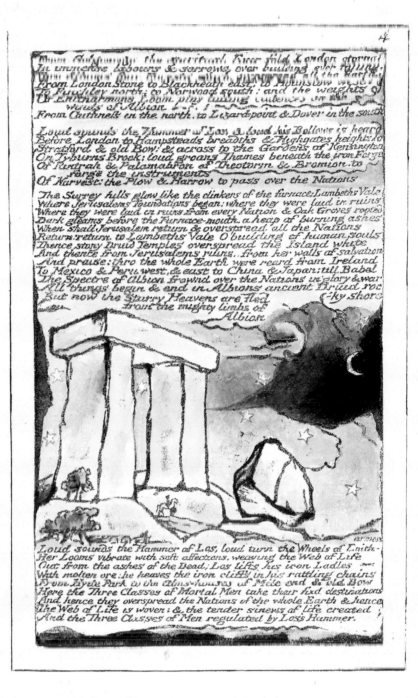

[Illegible text at top of plate] the [illegible] River [illegible] London [illegible]
In unmeasure labours & sorrows over building over [illegible]:
[illegible]
From London Stone to Blackheath east, to Hounslow west
To Finchley north, to Norwood south: and the weights of
Of Enitharmons Loom play lulling cadences on [illegible]
 wheels of Albion [illegible]!
From Cathness in the north, to Lizardpoint & Dover in the south

Loud sounds the Hammer of Los, & loud his Bellows is heard
Before London to Hampsteads breadths & Highgates heights to
Stratford & old Bow: & across to the Gardens of Kensington
On Tyburns Brook: loud groans Thames beneath the iron Forge
Of Rintrah & Palamabron of Theotorm & Bromion to
 forge the instruments
Of Harvest: the Plow & Harrow to pass over the Nations

The Surrey hills glow like the clinkers of the furnace: Lambeths Vale
Where Jerusalems foundations began: where they were laid in ruins
Where they were laid in ruins from every Nation & Oak Groves rooted
Dark gleams before the Furnace-mouth, a heap of burning ashes
When shall Jerusalem return & overspread all the Nations
Return: return to Lambeths Vale O building of human souls
Thence stony Druid Temples overspread the Island white
And thence from Jerusalems ruins, from her walls of salvation
And praise: thro the whole Earth were reard from Ireland
To Mexico & Peru west, & east to China & Japan: till Babel
The Spectre of Albion frownd over the Nations in glory & war
All things begin & end in Albions ancient Druid rocky shore
But now the Starry Heavens are fled
 from the mighty limbs of
 Albion

Loud sounds the Hammer of Los, loud turn the Wheels of Enith-
Her Looms vibrate with soft affections, weaving the Web of Life
Out from the ashes of the Dead; Los lifts his iron Ladles
With molten ore: he heaves the iron cliffs in his rattling chains
From Hyde Park to the Alms-houses of Mile end & old Bow
Here the Three Classes of Mortal Men take their fixd destinations
And hence they overspread the Nations of the whole Earth & hence
The Web of Life is woven: & the tender sinews of life created
And the Three Classes of Men regulated by Los's Hammer

The first, the Elect from before the foundation of the World:
The second, The Redeemd. The Third, The Reprobate & formd
To destruction from the mothers womb:
 follow with me my plow.

Of the first class was Satan: with incomparable mildness;
His primitive tyrannical attempts on Los: with most endearing love
He soft intreated Los to give to him Palamabrons station;
For Palamabron returnd with labour wearied every evening
Palamabron oft refusd; and as often Satan offerd
His service till by repeated offers and repeated intreaties
Los gave to him the Harrow of the Almighty; alas blamable
Palamabron feard to be angry lest Satan should accuse him of
Ingratitude, & Los believe the accusation thro Satans extreme
Mildness. Satan laboured all day, it was a thousand years
In the evening returning terrified overlabourd & astonishd
Embracd soft with a brothers tears Palamabron, who also wept

Mark well my words, they are of your eternal salvation

Next morning Palamabron rose; the horses of the Harrow
Were maddend with tormenting fury, & the servants of the Harrow
The Gnomes, accusd Satan, with indignation fury and fire.
Then Palamabron reddening like the Moon in an eclipse,
Spoke saying, You know Satans mildness and his self-imposition,
Seeming a brother, being a tyrant, even thinking himself a brother
While he is murdering the just; prophetic I behold
His future course thro darkness and despair to eternal death
But we must not be tyrants also! he hath assumd my place
For one whole day, under pretence of pity and love to me:
My horses hath he maddend! and my fellow servants injurd:
How should he he know the duties of another? O foolish forbearance
Would I had told Los, all my heart! but patience O my friends,
All may be well: silent remain while I call Los and Satan.

Loud as the wind of Beulah that unroots the rocks & hills
Palamabron calld! and Los & Satan came before him
And Palamabron shewd the horses & the servants, Satan wept,
And mildly cursing Palamabron, him accusd of crimes
Himself had wrought. Los trembled: Satans blandishments almost
Perswaded the Prophet of Eternity that Palamabron.
Was Satans enemy, & that the Gnomes being Palamabrons friends
Were leagued together against Satan thro ancient enmity,
What could Los do? how could he judge, when Satans self believd
That he had not oppressd the horses of the Harrow, nor the servants

So Los said, Henceforth Palamabron, let each his own station
Keep: nor in pity false, nor in officious brotherhood, where
None needs, be active. Mean time Palamabrons horses,
Ragd with thick flames redundant, & the Harrow maddend with fury
Trembling Palamabron stood, the strongest of Demons trembled:
Curbing his living creatures; many of the strongest Gnomes,
They bit in their wild fury, who also maddend like wildest beasts

Mark well my words; they are of your eternal salvation

Mean while wept Satan before Los. accusing Palamabron
Himself exculpating with mildest speech. for himself believ'd
That he had not oppress'd nor injur'd the refractory servants.

But Satan returning to his Mills (for Palamabron had servd
The Mills of Satan as the easier task) found all confusion.
And back return'd to Los, not fill'd with vengeance but with tears,
Himself convinc'd of Palamabrons turpitude. Los beheld
The servants of the Mills drunken with wine and dancing wild
With shouts and Palamabrons songs, rending the forests green
With ecchoing confusion, tho' the Sun was risen on high.

Then Los took off his left sandal placing it on his head.
Signal of solemn mourning: when the servants of the Mills
Beheld the signal they in silence stood, tho' drunk with wine
Los wept! But Rintrah also came, and Enitharmon on
His arm leand tremblingly observing all these things

And Los said, Ye Genii of the Mills: the Sun is on high
Your labours call you. Palamabron is also in sad dilemma
His horses are mad! his Harrow confounded! his companions enrag'd
Mine is the fault! I should have rememberd that pity divides the Soul
And, man, unmans: follow with me my Plow, this mournful day
Must be a blank in Nature; follow with me, and tomorrow again
Resume your labours, & this day shall be a mournful day

Wildly they follow'd Los and Rintrah, & the Mills were silent
They mourn'd all day this mournful day of Satan & Palamabron
And all the Elect & all the Redeem'd mourn'd one toward another
Upon the mountains of Albion among the cliffs of the Dead.

They Plow'd in tears! incessant pourd Jehovahs rain, & Molechs
Thick fires contending with the rain, thunderd above rolling
Terrible over their heads; Satan wept over Palamabron
Theotormon & Bromion contended on the side of Satan
Pitying his youth and beauty; trembling at eternal death:
Michael contended against Satan in the rolling thunder
Thulloh the friend of Satan also reprovd him; faint their reproof.

But Rintrah who is of the reprobate: of those form'd to destruction
In indignation. for Satans soft dissimulation of friendship!
Flam'd above all the plowed furrows, angry red and furious.
Till Michael sat down in the furrow weary dissolv'd in tears
Satan who drave the team, beside him, stood angry & red
He smote Thulloh & slew him, & he stood terrible over Michael
Urging him to arise: he wept; Enitharmon saw his tears
But Los hid Thulloh from her sight, lest she should die of grief
She wept: she trembled: she kissed Satan; she wept over Michael
She formd a Space for Satan & Michael & for the poor infected
Trembling she wept over the Space. & clos'd it with a tender Moon

Los secret buried Thulloh, weeping disconsolate over the moony Space.

But Palamabron called down a Great Solemn Assembly,
That he who will not defend Truth. may be compelled to
Defend a Lie. that he may be snared & caught & taken

And all Eden descended into Palamabrons tent
Among Albions Druids & Bards, in the caves beneath Albions
Death Couch, in the caverns of death, in the corner of the Atlantic.
And in the midst of the Great Assembly Palamabron prayd:
O God protect me from my friends, that they have not power over me
Thou hast givn me power to protect myself from my bitterest enemies.

Mark well my words, they are of your eternal salvation

Then rose the Two Witnesses, Rintrah & Palamabron:
And Palamabron appeald to all Eden, and recievd
Judgment: and Lo! it fell on Rintrah and his rage:
Which now flamd high & furious in Satan against Palamabron
Till it became a proverb in Eden. Satan is among the Reprobate.

Los in his wrath cursd heaven & earth, he rent up Nations
Standing on Albions rocks among high-reard Druid temples
Which reach the stars of heaven & stretch from pole to pole.
He displacd continents, the oceans fled before his face
He alterd the poles of the world, east, west & north & south.
But he closd up Enitharmon from the sight of all these things

For Satan flaming with Rintrahs fury hidden beneath his own mildness
Accusd Palamabron before the Assembly of ingratitude! of malice:
He created Seven deadly Sins drawing out his infernal scroll.
Of Moral laws and cruel punishments upon the clouds of Jehovah
To pervert the Divine voice in its entrance to the earth
With thunder of war & trumpets sound, with armies of disease
Punishments & deaths musterd & number'd; Saying I am God alone
There is no other! let all obey my principles of moral individuality
I have brought them from the uppermost innermost recesses
Of my Eternal Mind, transgressors I will rend off for ever,
As now I rend this accursed Family from my covering.

Thus Satan ragd amidst the Assembly! and his bosom grew
Opake against the Divine Vision: the paved terraces of
His bosom inwards shone with fires, but the stones becoming opake!
Hid him from sight, in an extreme blackness and darkness,
And there a World of deeper Ulro was opend, in the midst
Of the Assembly. In Satans bosom a vast unfathomable Abyss.

Astonishment held the Assembly in an awful silence: and tears
Fell down as dews of night, & a loud solemn universal groan
Was uttered from the east & from the west & from the south
And from the north; and Satan stood opake immeasurable
Covering the east with solid blackness, round his hidden heart
With thunders utterd from his hidden wheels: accusing loud
The Divine Mercy, for protecting Palamabron in his tent.

Rintrah reard up walls of rocks and pourd rivers & moats
Of fire round the walls: columns of fire guard around
Between Satan and Palamabron in the terrible darkness.

And Satan not having the Science of Wrath, but only of Pity:
Rent them asunder, and wrath was left to wrath, & pity to pity.
He sunk down a dreadful Death, unlike the slumbers of Beulah

The Separation was terrible: the Dead was repos'd on his Couch
Beneath the Couch of Albion, on the seven mountains of Rome
In the whole place of the Covering Cherub, Rome Babylon & Tyre.
His Spectre raging furious descended into its Space

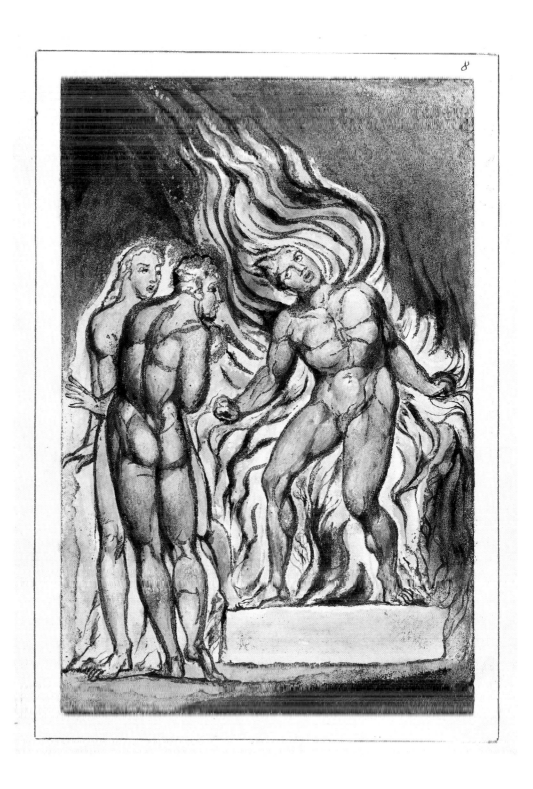

Then Los & Enitharmon knew that Satan is Urizen
Drawn down by Orc & the Shadowy Female into Generation
Oft Enitharmon enterd weeping into the Space, there appearing
An aged Woman raving along the Streets (the Space is named
Canaan) then she returnd to Los weary frighted as from dreams
The nature of a Female Space is this: it shrinks the Organs
Of Life, till they become Finite & Itself seems Infinite

And Satan vibrated in the immensity of the Space: Limited
To those without but Infinite to those within: it fell down and
Became Canaan: closing Los from Eternity in Albions Cliffs
A mighty Fiend against the Divine Humanity mustring to War
Satan, Ah me! is gone to his own place, said Los, their God
I will not worship in their Churches, nor King in their Theatres
Elynittria! whence is this Jealousy running along the mountains
British Women were not Jealous when Greek & Roman were Jealous
Every thing in Eternity shines by its own Internal light, but thou
Darkenest every Internal light with the arrows of thy quiver
Bound up in the horns of Jealousy to a deadly fading Moon
And Ocalythron binds the Sun into a Jealous Globe
That every thing is fixd Opake without Internal light
So Los lamented over Satan, who triumphant
.... divided the Nations

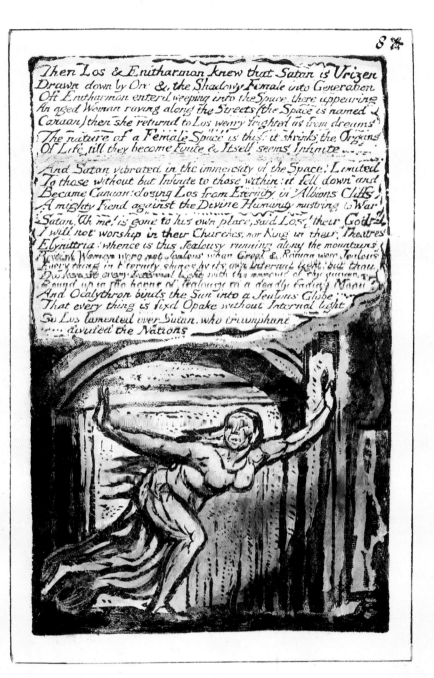

9

He set his face against Jerusalem to destroy the Kan of Albion

But Los hid Enitharmon from the sight of all these things
Upon the Thames whose lulling harmony repos'd her soul:
Where Beulah lovely terminates in rocky Albion:
Terminating in Hyde Park. on Tyburns awful brook.

And the Mills of Satan were separated into a moony Space
Among the rocks of Albions Temples, and Satans Druid sons
Offer the Human Victims throughout all the Earth. and Albions
Dread Tomb immortal on his Rock. overshadowd the whole Earth:
Where Satan making to himself Laws from his own identity.
Compelld others to serve him in moral gratitude & submission
Being calld God; setting himself above all that is called God
And all the Spectres of the Dead calling themselves Sons of God
In his Synagogues worship Satan under the Unutterable Name

And it was enquird; Why in a Great Solemn Assembly
The Innocent should be condemnd for the Guilty. Then an Eternal rose

Saying. If the Guilty should be condemnd. he must be an Eternal Death
And one must die for another throughout all Eternity.
Satan is falln from his station & never can be redeemd
But must be new Created continually moment by moment
And therefore the Class of Satan shall be calld the Elect. & those
Of Rintrah. the Reprobate. & those of Palamabron the Redeemd
For he is redeemd from Satans Law. the wrath falling on Rintrah.
And therefore Palamabron dared not to call a solemn Assembly
Till Satan had assumd Rintrahs wrath in the day of mourning
In a feminine delusion of false pride self-decievd -

So spake the Eternal and confirmd it with a thunderous oath.

But when Leutha (a Daughter of Beulah) beheld Satans condemna-
She down descended into the midst of the Great Solemn Assembly
Offering herself a Ransom for Satan, taking on her, his Sin

Mark well my words, they are of your eternal salvation:
-cing

And Leutha stood glowing with varying colours immortal. heart-pier-
And lovely: & her moth-like elegance shone over the Assembly

She spake. I am the Author of this Sin! by my suggestion
My Parent power Satan has committed this transgression.
I loved Palamabron & I sought to approach his Tent.
But beautiful Elynittria with her silver arrows repelld me.
For

For her light is terrible to me. I fade before her immortal beauty.
O, wherefore doth a Dragon-form forth issue from my limbs
To sieze her new born son? Ah me! the wretched Leutha!
This to prevent, entering the doors of Satans brain night after night
Like sweet perfumes I stupified the masculine perceptions
And kept only the feminine awake. hence rose his soft
Delusory love to Palamabron: admiration join'd with envy
Cupidity unconquerable! my fault, when at noon of day
The Horses of Palamabron call'd for rest and pleasant death:
I sprang out of the breast of Satan, over the Harrow beaming
In all my beauty; that I might unloose the flaming steeds
As Elynittria used to do: but too well those living creatures
Knew that I was not Elynittria, and they brake the traces
But me, the servants of the Harrow saw not: but as a bow
Of varying colours on the hills; terribly rag'd the horses.
Satan astonish'd, and with power above his own controll
Compell'd the Gnomes to curb the horses, & to throw banks of sand
Around the fiery flaming Harrow in labyrinthine forms.
And brooks between to intersect the meadows in their course.
The Harrow cast thick flames: Jehovah thunderd above:
Chaos & ancient night, fled from beneath the fiery Harrow:
The Harrow cast thick flames & orb'd us round in concave fires
A Hell of our own making. see, its flames still gird me round
Jehovah thunderd above! Satan in pride of heart
Drove the fierce Harrow among the constellations of Jehovah
Drawing a third part in the fires as stubble north & south
To devour Albion and Jerusalem the Emanation of Albion
Driving the Harrow in Pitys paths. twas then, with our dark fires
Which now gird round us (O eternal torment) I form'd the Serpent
Of precious stones & gold turn'd poisons on the sultry wastes
The Gnomes in all that day spard not; they cursd Satan bitterly.
To do unkind things in kindness! with power armd. to say
The most irritating things in the midst of tears and love
These are the stings of the Serpent! thus did we by them; till thus
They in return retaliated, and the Living Creatures maddend.
The Gnomes labourd. I weeping hid in Satans inmost brain;
But when the Gnomes refusd to labour more, with blandishments
I came forth from the head of Satan! back the Gnomes recoil'd
And calld me Sin, and for a sign portentous held me. Soon
Day sunk and Palamabron returnd, trembling I hid myself
In Satans inmost Palace of his nervous fine wrought Brain:
For Elynittria met Satan with all her singing women.
Terrific in their joy & pouring wine of wildest power
They gave Satan their wine: indignant at the burning wrath.
Wild with prophetic fury his former life became like a dream
Clothd in the Serpents folds, in selfish holiness demanding purity
Being most impure, self condemd to eternal tears, he drove
Me from his inmost Brain & the doors closd with thunders sound
O Divine Vision who didst create the Female: to repose
The Sleepers of Beulah; pity the repentant Leutha. My

The Spectre of Satan, he furious, refuses, to repose in sleep
Humbly bewail my sins before the throne of God; but Los
Not so the Sick-one: Alas what shall be done him to restore,
Who calls the Individual Law, Holy: and despises the Saviour,
Glorying to involve Albions Body in fires of eternal War—

Now Leutha ceasd: tears flowd: but the Divine Pity supported her.
All is my fault: We are the Spectre of Luvah the murderer
Of Albion: O Vala! O Luvah! O Albion! O lovely Jerusalem
The Sin was begun in Eternity, and will not rest to Eternity
Till two Eternitys meet together, Ah! lost! lost! lost! for ever!

So Leutha spoke. But when she saw that Enitharmon had
Created a New-Space to protect Satan from punishment;
She fled to Enitharmons Tent & hid herself. Loud raging
Thundered the Assembly dark & clouded, and they ratifyd
The kind decision of Enitharmon & gave a Time to the Space;
Even Six Thousand years: and sent Lucifer for its Guard.
But Lucifer refusd to die & in pride he forsook his charge
And they elected Moloch, and when Moloch was impatient
The Divine hand found the Two Limits: first of Opacity, then of Contraction
Opacity was named Satan, Contraction was named Adam,
Triple Elohim came: Elohim wearied fainted: they elected Shaddai,
Shaddai angry, Pahad descended: Pahad terrified, they sent Jehovah
And Jehovah was leprous; loud he calld, stretching his hand to Eternity
For then the Body of Death was perfected in hypocritic holiness,
Around the Lamb, a female Tabernacle woven in Cathedrons Looms
He died as a Reprobate, he was Punishd as a Transgressor!
Glory! Glory! Glory! to the Holy Lamb of God
I touch the heavens as an instrument to glorify the Lord!

The Elect shall meet the Redeemd, on Albions rocks they shall meet
Astonishd at the Transgresor, in him beholding the Saviour.
And the Elect shall say to the Redeemd. We behold it is of Divine
Mercy alone! of Free Gift and Election that we live.
Our Virtues & Cruel Goodnesses, have deservd Eternal Death.
Thus they weep upon the fatal Brook of Albions River.

But Elynittria met Leutha in the place where she was hidden.
And threw aside her arrows, and laid down her sounding Bow;
She soothd her with soft words & brought her to Palamabrons bed
In moments new created for delusion, interwoven round about.
In dreams she bore the Shadowy Spectre of Sleep, & namd him Death.
In dreams she bore Rahab the mother of Tirzah & her sisters,
In Lambeths vales; in Cambridge & in Oxford, places of Thought
Intricate labyrinths of Times and Spaces unknown, that Leutha lived
In Palamabrons Tent, and Oothoon was her charming guard.

The Bard ceasd. All considerd and a loud resounding murmur
Continud round the Halls; and much they questiond the immortal
Loud voicd Bard, and many condemnd the high toned Song
Saying Pity and Love are too venerable for the imputation
Of Guilt. Others said. If it is true! if the acts have been performd
Let the Bard himself witness. Where hadst thou this terrible Song

The Bard replied. I am Inspired! I know it is Truth! for I Sing

According to the inspiration of the Poetic Genius
Who is the eternal all-protecting Divine Humanity
To whom be Glory & Power & Dominion Evermore Amen

Then there was great murmuring in the Heavens of Albion
Concerning Generation & the Vegetative power & concerning
The Lamb the Saviour: Albion trembled to Italy Greece & Egypt
To Tartary & Hindostan & China & to Great America
Shaking the roots & fast foundations of the Earth in doubtfulness
The loud voic'd Bard terrify'd took refuge in Miltons bosom

Then Milton rose up from the heavens of Albion ardorous;
The whole Assembly wept prophetic, seeing in Miltons face
And in his lineaments divine the shades of Death & Ulro
He took off the robe of the promise, & ungirded himself from
the oath of God

And Milton said, I go to Eternal Death! The Nations still
Follow after the detestable Gods of Priam; in pomp
Of warlike selfhood, contradicting and blaspheming.
When will the Resurrection come; to deliver the sleeping body
From corruptibility: O when Lord Jesus wilt thou come?
Tarry no longer; for my soul lies at the gates of death.
I will arise and look forth for the morning of the grave.
I will go down to the sepulcher to see if morning breaks!
I will go down to self annihilation and eternal death,
Lest the Last Judgment come & find me unannihilate
And I be siez'd & giv'n into the hands of my own Selfhood
The Lamb of God is seen thro' mists & shadows, hov'ring
Over the sepulchers in clouds of Jehovah & winds of Elohim
A disk of blood, distant; & heav'ns & earths roll dark between
What do I here before the Judgment? without my Emanation?
With the daughters of memory, & not with the daughters of inspiration
I in my Selfhood am that Satan: I am that Evil One!
He is my Spectre! in my obedience to loose him from my Hells
To claim the Hells, my Furnaces, I go to Eternal Death.

And Milton said, I go to Eternal Death! Eternity shudder'd
For he took the outside course, among the graves of the dead
A mournful shade, Eternity shudder'd at the image of eternal death

Then on the verge of Beulah he beheld his own Shadow;
A mournful form double; hermaphroditic: male & female
In one wonderful body, and he entered into it
In direful pain for the dread shadow, twenty-seven-fold
Reach'd to the depths of direst Hell, & thence to Albions land:
Which is this earth of vegetation on which now I write.

The Seven Angels of the Presence wept over Miltons Shadow;

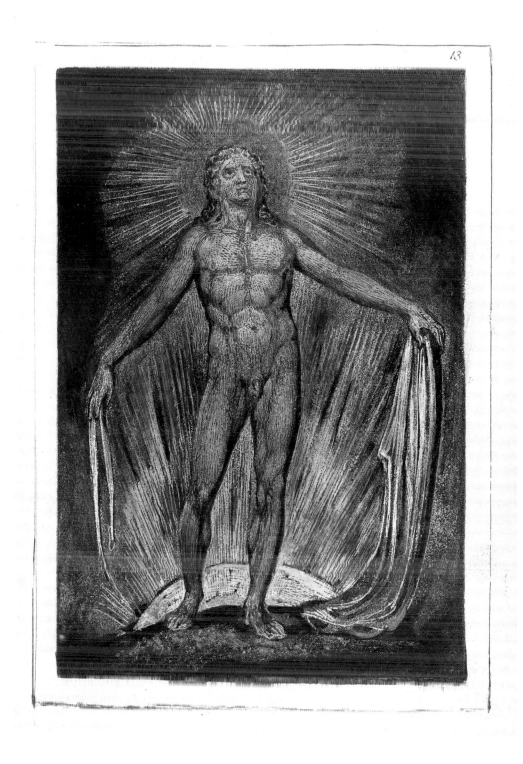

As when a man dreams, he reflects not that his body sleeps,
Else he would wake; so seemd he entering his Shadow: but
With him the Spirits of the Seven Angels of the Presence
Entering; they gave him still perceptions of his Sleeping Body:
Which now arose and walkd with them in Eden, as an Eighth
Image Divine tho' darkend; and tho' walking as one walks
In sleep; and the Seven comforted and supported him.

Like as a Polypus that vegetates beneath the deep!
They saw his Shadow vegetated underneath the Couch
Of death: for when he enterd into his Shadow: Himself:
His real and immortal Self: was as appeard to those
Who dwell in immortality, as One sleeping on a couch
Of gold; and those in immortality gave forth their Emanations
Like Females of sweet beauty, to guard round him & to feed
His lips with food of Eden in his cold and dim repose!
But to himself he seemd a wanderer lost in dreary night.

Onwards his Shadow kept its course among the Spectres; calld
Satan, but swift as lightning passing them, startled the shades
Of Hell beheld him in a trail of light as of a comet
That travels into Chaos: so Milton went guarded within.

The nature of infinity is this! That every thing has its
Own Vortex; and when once a traveller thro' Eternity.
Has passed that Vortex, he perceives it roll backward behind
His path, into a globe itself infolding; like a sun:
Or like a moon, or like a universe of starry majesty,
While he keeps onwards in his wondrous journey on the earth
Or like a human form, a friend with whom he livd benevolent.
As the eye of man views both the east & west encompassing
Its vortex; and the north & south, with all their starry host;
Also the rising sun & setting moon he views surrounding
His corn-fields and his valleys of five hundred acres square.
Thus is the earth one infinite plane, and not as apparent
To the weak traveller confin'd beneath the moony shade.
Thus is the heaven a vortex passd already, and the earth
A vortex not yet passd by the traveller thro' Eternity.

First Milton saw Albion upon the Rock of Ages,
Deadly pale outstretchd and snowy cold, storm coverd:
A Giant form of perfect beauty outstretchd on the rock
In solemn death: the Sea of Time & Space thunderd aloud
Against the rock, which was inwrapped with the weeds of death
Hovering over the cold bosom, in its vortex Milton bent down
To the bosom of death, what was underneath soon seemd above.
A cloudy heaven mingled with stormy seas in loudest ruin;
But as a wintry globe descends precipitant thro' Beulah bursting,
With thunders loud and terrible: so Miltons shadow fell
Precipitant loud thundring into the Sea of Time & Space

Then first I saw him in the Zenith as a falling star,
Descending perpendicular, swift as the swallow or swift;
And on my left foot falling on the tarsus, enterd there; —
But from my left foot a black cloud redounding spread over Europe.

Then Milton knew that the Three Heavens of Beulah were beheld
By him on earth in his bright pilgrimage of sixty years

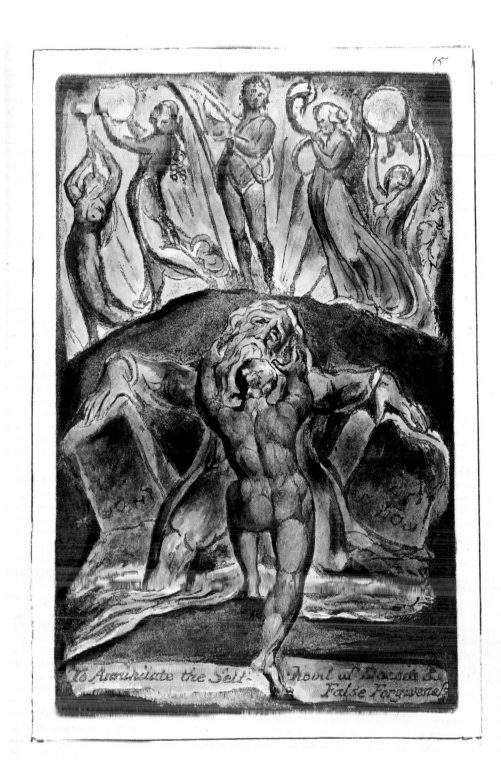

In those three Females whom his Wives, & those three whom his
Had represented and contained, that they might be resumed
By giving up of Selfhood: & they distant view'd his journey
In their eternal spheres, now Human, tho' their Bodies remain clos'd
In the dark Ulro till the Judgment: also Milton knew: they and
Himself was Human, tho' now wandering thro Death's Vale
In conflict with those Female forms, which in blood & jealousy
Surrounded him, dividing & uniting without end or number.

He saw the Cruelties of _____ and he _____ down
In iron tablets: and his Wives & Daughters names were these
Rahab and Tirzah, & Milcah & Malah & Noah & Hoglah
They sat rang'd round him as the rocks of Horeb round the land
Of Canaan: and they wrote in thunder smoke and fire
His dictate; and his body was the Rock Sinai; that body,
Which was on earth born to corruption: & the six Females
Are Hor & Peor & Bashan & Abarim & Lebanon & Hermon
Seven rocky masses terrible in the Desarts of Midian.

But Miltons Human Shadow continu'd journeying above
The rocky masses of The Mundane Shell: in the Lands
Of Edom & Aram & Moab & Midian & Amalek.

The Mundane Shell, is a vast Concave Earth: an immense
Harden'd shadow of all things upon our Vegetated Earth
Enlarg'd into dimension & deform'd into indefinite space
In Twenty-seven Heavens and all their Hells; with Chaos
And ancient Night; & Purgatory. It is a cavernous Earth
Of labyrinthine intricacy twenty-seven folds of opakeness
And finishes where the lark mounts; here Milton journeyed
In that Region called Midian, among the Rocks of Horeb
For travellers from Eternity, pass outward to Satans seat
But travellers to Eternity, pass inward to Golgonooza.

Los the Vehicular terror beheld him, & divine Enitharmon
Call'd all her daughters, Saying, Surely to unloose my bond
Is this Man come! Satan shall be _____ _____ _____

_____ _____ in _____ Enitharmons words: in fibrous strength
His limbs shot forth like roots of trees against the forward path
Of Miltons journey. Urizen beheld the immortal Man.

17

[first two lines illegible/faded]

Over the Dooes. outstretching her Twenty seven Heavens over *[illegible]*
And thus the Shadowy Female howls in articulate howlings

I will lament over Milton in the lamentations of the afflicted
[faded line]
The misery of unhappy Families shall be drawn out into its border
Wrought with the needle with dire sufferings poverty pain & woe
Along the rocky Island & thence throughout the whole Earth
There shall be the sick Father & his starving Family. there
The Prisoner in the stone Dungeon & the Slave at the Mill
I will have Writings written all over it in Human Words
That every Infant that is born upon the Earth shall read
And get by rote as a hard task of a life of sixty years.
I will have Kings inwoven upon it. & Councellors & Mighty Men
The Famine shall clasp it together with buckles & Clasps
And the Pestilence shall be its fringe & the War its girdle
To divide into Rahab & Tirzah that Milton may come to our tents
For I will put on the Human Form & take the Image of God
Even Pity & Humanity but my Clothing shall be Cruelty
And I will put on Holiness as a breastplate & as a helmet
And all my ornaments shall be of the gold of broken hearts
And the precious stones of anxiety & care & desperation & death
And repentance for sin & sorrow & punishment & fear
To defend me from thy terrors O Orc! my only beloved !

Orc answerd. Take not the Human Form O loveliest. Take not
Terror upon thee! Behold how I am & tremble lest thou also
Consume in my Consummation; but thou maist take a Form
Female & lovely, that cannot consume in Mans consummation
Wherefore dost thou Create & Weave this Satan for a Covering
When thou attemptest to put on the Human Form. my wrath
Burns to the top of heaven against thee in Jealousy & fear.
Then I rend thee asunder. then I howl over thy clay & ashes
When wilt thou put on the Female Form as in times of old
With a Garment of Pity & Compassion like the Garment of God
His garments are long sufferings for the Children of Men
Jerusalem is his Garment & not thy Covering Cherub O lovely
Shadow of my delight who wanderest seeking for the prey.

So spoke Orc when Oothoon & Leutha hoverd over his Couch
Of fire in interchange of Beauty & Perfection in the darkness
Opening interiorly into Jerusalem & Babylon shining glorious
In the Shadowy Females bosom Jealous her darkness grew
Howlings filld all the desolate places in accusations of Sin
[faded line]
[faded/illegible line]

Thus darkend the Shadowy Female tenfold & Orc tenfold
Glowd on his rocky Couch against the darkness: loud thunders
Told of the enormous conflict Earthquake beneath: around:
Rent the Immortal Females. limb from limb & joint from joint
And moved the vast foundations of the Earth to wake the Dead
Urizen emerged from his Rocky Form & from his Snows

And he also darkend his brows: freezing dark rocks between
The footsteps. and infixing deep the feet in marble beds:
That Milton labourd with his journey. & his feet bled sore
Upon the clay now changd to marble: also Urizen rose
And met him on the shores of Arnon: & by the streams of the brooks

Silent they met. and silent strove among the streams. of Arnon
Even to Mahanaim, when with cold hand Urizen stoopd down
And took up water from the river Jordan: pouring on
To Miltons brain the icy fluid from his broad cold palm.
But Milton took of the red clay of Succoth. moulding it with care
Between his palms: and filling up the furrows of many years
Beginning at the feet of Urizen, and on the bones
Creating new flesh on the Demon cold. and building him.
As with new clay a Human form in the Valley of Beth Peor.

Four Universes round the Mundane Egg remain Chaotic
One to the North. named Urthona: One to the South. named Urizen:
One to the East. named Luvah: One to the West. named Tharmas
They are the Four Zoa's that stood around the Throne Divine:
But when Luvah assum'd the World of Urizen to the South:
And Albion was slain upon his mountains. & in his tent:
All fell towards the Center in dire ruin, sinking down.
And in the South remains a burning fire; in the East a void.
In the West, a world of raging waters; in the North a solid.
Unfathomable! without end. But in the midst of these,
Is built eternally the Universe of Los and Enitharmon:
Towards which Milton went, but Urizen opposd his path.

The Man and Demon strove many periods. Rahab beheld
Standing on Carmel; Rahab and Tirzah trembled to behold
The enormous strife. one giving life, the other giving death
To his adversary. and they sent forth all their sons & daughters
In all their beauty to entice Milton across the river.

The Twofold form Hermaphroditic: and the Double-sexed;
The Female-male & the Male-female, self-dividing stood
Before him in their beauty, & in cruelties of holiness:
Shining in darkness, glorious upon the deeps of Entuthon.

Saying. Come thou to Ephraim! behold the Kings of Canaan!
The beautiful Amalekites, behold the fires of youth
Bound with the Chain of Jealousy by Los & Enitharmon:
The banks of Cam; cold learnings streams: Londons dark-frowning towers.
Lament upon the winds of Europe in Rephaims Vale.
Because Ahania rent apart into a desolate night,
Laments! & Enion wanders like a weeping inarticulate voice
And Vala labours for her bread & water among the Furnaces
Therefore bright Tirzah triumphs: putting on all beauty.
And all perfection. in her cruel sports among the Victims.
Come bring with thee Jerusalem with songs on the Grecian Lyre!
In Natural Religion: in experiments on Men.
Let her be Offerd up to Holiness! Tirzah numbers her:
She numbers with her fingers every fibre ere it grow;
Where is the Lamb of God! where is the promise of his coming?
Her shadowy Sisters form the bones, even the bones of Horeb:
Around the marrow: and the orbed scull around the brain!
His Images are born for War! for Sacrifice to Tirzah:
To Natural Religion! to Tirzah the Daughter of Rahab the Holy!
She ties the knot of nervous fibres, into a white brain!
She ties the knot of bloody veins, into a red hot heart!
Within her bosom Albion lies embalmd. never to awake
Hand is become a rock! Sinai & Horeb. is Hyle & Coban:
Scofield is bound in iron armour before Reubens Gate!
She ties the knot of milky seed into two lovely Heavens.

19

However Age may say, such is the bliss these mortal [...]
'Tis our three Heavens beneath, the shades of Beulah, land at rest.
Come then to Ephraim & Manasseh O beloved-one!
Come to my ivory palaces O beloved of thy mother!
And let us bind thee in the bands of War & be thou King
Of Canaan and reign in Hazor where the Twelve Tribes meet.

So spoke they as in one voice! Silent Milton stood before
The darkend Urizen; as the sculptor silent stands before
His forming image; he walks round it patient labouring.
Thus Milton stood forming bright Urizen, while his Mortal part
Sat frozen in the rock of Horeb: and his Redeemed portion.
Thus form'd the Clay of Urizen; but within that portion
His real Human walkd above in power and majesty
Tho darkend; and the Seven Angels of the Presence attended him.

O how can I with my gross tongue that cleaveth to the dust.
Tell of the Fourfold Man, in starry numbers fitly orderd
Or how can I with my cold hand of clay! But thou O Lord
Do with me as thou wilt! for I am nothing, and vanity.
If thou chuse to elect a worm, it shall remove the mountains.
For that portion namd the Elect: the Spectrous body of Milton:
Redounding from my left foot into Los's Mundane space,
Brooded over his Body in Horeb against the Resurrection
Preparing it for the Great Consummation; red the Cherub on Sinai
Glowd; but in terrors folded round his clouds of blood.

Now Albions sleeping Humanity began to turn upon his Couch;
Feeling the electric flame of Miltons awful precipitate descent.
Seest thou the little winged fly, smaller than a grain of sand?
It has a heart like thee; a brain open to heaven & hell,
Withinside wondrous & expansive; its gates are not closd.
I hope thine are not; hence it clothes itself in rich array;
Hence thou art clothd with human beauty O thou mortal man,
Seek not thy heavenly father then beyond the skies;
There Chaos dwells & ancient Night & Og & Anak old;
For every human heart has gates of brass & bars of adamant,
Which few dare unbar because dread Og & Anak guard the gates
Terrific! and each mortal brain is walld and moated round
Within; and Og & Anak watch here; here is the Seat
Of Satan in its Webs; for in brain and heart and loins
Gates open behind Satans Seat to the City of Golgonooza
Which is the spiritual fourfold London, in the loins of Albion

Thus Milton fell thro Albions heart, travelling outside of Humanity
Beyond the Stars in Chaos in Caverns of the Mundane Shell.

But many of the Eternals rose up from eternal tables
Drunk with the Spirit, burning round the Couch of death they stood
Looking down into Beulah: wrathful, filld with rage!
They rend the heavens round the Watchers in a fiery circle:
And round the Shadowy Eighth: the Eight close up the Couch
Into a tabernacle, and flee with cries down to the Deeps:
Where Los opens his three wide gates, surrounded by raging fires!
They soon find their own place & join the Watchers of the Ulro.

Los saw them and a cold pale horror coverd oer his limbs
Pondering he knew that Rintrah & Palamabron might depart:
Even as Reuben & as Gad; gave up himself to tears.
He sat down on his anvil-stock, and leand upon the trough
Looking into the black water, mingling it with tears.

At last when desperation almost tore his heart in twain
He recollected an old Prophecy in Eden recorded,
And often sung to the loud harp at the immortal feasts
That Milton of the Land of Albion should up ascend
Forwards from Ulro from the Vale of Felpham; and set free
Orc from his Chain of Jealousy, he started at the thought

And down descended into Udan-Adan: it was night:
And Satan sat sleeping upon his Couch in Udan-Adan:
His Spectre slept, his Shadow woke; when one sleeps th'other wakes

But Milton, entering my Foot; I saw in the nether
Regions of the Imagination; also all men on Earth
And all in Heaven. saw in the nether regions of the Imagination
In Ulro beneath Beulah, the vast breach of Miltons descent.
But I knew not that it was Milton, for man cannot know
What passes in his members till periods of Space & Time
Reveal the secrets of Eternity: for more extensive
Than any other earthly things, are Mans earthly lineaments.
And all this Vegetable World appeard on my left Foot,
As a bright sandal formd immortal of precious stones & gold:
I stooped down & bound it on to walk forward thro' Eternity.

There is in Eden a sweet River, of milk & liquid pearl.
Namd Ololon; on whose mild banks dwelt those who Milton drove
Down into Ulro: and they wept in long resounding song
For seven days of eternity, and the rivers living banks
The mountains wail'd! & every plant that grew, in solemn sighs lamented.

When Luvahs bulls each morning drag the sulphur Sun out of the Deep
Harnessd with starry harness black & shining kept by black slaves
That work all night at the starry harness. Strong and vigorous
They drag the unwilling Orb: at this time all the family
Of Eden heard the lamentation, and Providence began.
But when the clarions of day sounded they arose the lamentations
None when night came all seemd silent on Ololon; & all refused to lament
In the still night fearing lest they should others molest

Seven mornings Los heard them, as the poor bird within the shell
Hears its impatient parent bird; and Enitharmon heard them:
But saw them not, for the blue Mundane Shell inclosd them in.

And they lamented that they had in wrath & fury & fire
Driven Milton into the Ulro; for now they knew too late
That it was Milton the Awakener: they had not heard the Bard.
Whose song called Milton to the attempt; and Los heard these laments.
He heard them call in prayer all the Divine Family:
And he beheld the Cloud of Milton stretching over Europe.

But all the Family Divine collected as Four Suns
In the Four Points of heaven East, West & North & South.
Enlarging and enlarging till their Disks approachd each other:
And when they touchd closed together Southward in One Sun
Over Ololon: and as One Man, who weeps over his brother,
In a dark tomb, so all the Family Divine, wept over Ololon.

Saying. Milton goes to Eternal Death! so saying, they groand in spirit
And were troubled! and again the Divine Family groaned in spirit

And Ololon said, Let us descend also, and let us give
Ourselves to death in Ulro among the Transgressors.
Is Virtue a Punisher? O no! how is this wondrous thing:
This World beneath, unseen, unknown! an Infant loveliness
Or are these the pangs of repentance! let us enter into them

Then the Divine Family said. Six Thousand Years are now
Accomplishd in this World of Sorrow; Miltons Angel knew
The Universal Dictate; and you also feel this Dictate.
And now you know this World of Sorrow, and feel Pity. Obey
The Dictate! Watch over this World, and with your brooding wings,
Renew it to Eternal Life: Lo! I am with you alway
But you cannot renew Milton he goes to Eternal Death

So spake the Family Divine as One Man even Jesus
Uniting in One with Ololon & the appearance of One Man
Jesus the Saviour appeard coming in the Clouds of Ololon!

21

Tho driven away with the seven Starry Ones into the Ulro
Yet the Divine Vision remains Every-where For-ever. Amen.
And Ololon lamented for Milton with a great lamentation.

While Los heard indistinct in fear, what time I bound my sandals
On; to walk forward thro' Eternity, Los descended to me:
And Los behind me stood; a terrible flaming Sun: just close
Behind my back: I turned round in terror, and behold.
Los stood in that fierce glowing fire; & he also stoop'd down
And bound my sandals on in Udan-Adan; trembling I stood
Exceedingly with fear & terror, standing in the Vale
Of Lambeth: but he kissed me and wishd me health.
And I became One Man with him arising in my strength:
Twas too late now to recede. Los had enterd into my soul:
His terrors now possesd me whole! I arose in fury & strength.

I am that Shadowy Prophet who Six Thousand Years ago
Fell from my station in the Eternal bosom. Six Thousand Years
Are finishd. I return! both Time & Space obey my will.
I in Six Thousand Years walk up and down: for not one Moment
Of Time is lost, nor one Event of Space unpermanent
But all remain: every fabric of Six Thousand Years
Remains permanent: tho' on the Earth where Satan
Fell, and was cut off all things vanish & are seen no more
They vanish not from me & mine, we guard them first & last.
The generations of men run on in the tide of Time
But leave their destind lineaments permanent for ever & ever.
So spoke Los as we went along to his supreme abode.

Rintrah and Palamabron met us at the Gate of Golgonooza
Clouded with discontent. & brooding in their minds terrible things.

They said. O Father most beloved: O merciful Parent:
Pitying and permitting evil. tho' strong & mighty to destroy.
Whence is this Shadow terrible? wherefore dost thou refuse
To throw him into the Furnaces! knowest thou not that he
Will unchain Orc? & let loose Satan. Og. Sihon & Anak.
Upon the Body of Albion? for this he is come; behold it written
Upon his fibrous left Foot black; most dismal to our eyes
The Shadowy Female shudders thro' heaven in torment inexpressible:
And all the Daughters of Los prophetic wail; yet in deceit.
They weave a new Religion from new Jealousy of Theotormon!
Miltons Religion is the cause: there is no end to destruction!
Seeing the Churches at their Period in terror & despair:
Rahab created Voltaire; Tirzah created Rousseau;
Asserting the Self-righteousness against the Universal Saviour.
Mocking the Confessors & Martyrs, claiming Self-righteousness;
With cruel Virtue: making War upon the Lambs Redeemed;
To perpetuate War & Glory, to perpetuate the Laws of Sin:
They perverted Swedenborgs Visions in Beulah & in Ulro;
To destroy Jerusalem as a Harlot & her Sons as Reprobates;
To raise up Mystery the Virgin Harlot Mother of War,
Babylon the Great, the Abomination of Desolation!
O Swedenborg! strongest of men, the Samson shorn by the Churches!
Shewing the Transgressors in Hell, the proud Warriors in Heaven:
Heaven as a Punisher & Hell as One under Punishment:
With Laws from Plato & his Greeks to renew the Trojan Gods,
in Albion; & to deny the value of the Saviours blood.
But then I raisd up Whitefield, Palamabron raisd up Westley,
And these are the cries of the Churches before the two Witnesses
Faith in God the dear Saviour who took on the likeness of men:
Becoming obedient to death, even the death of the Cross
The Witnesses lie dead in the Street of the Great City
No Faith is in all the Earth: the Book of God is trodden under Foot:
He sent his two Servants Whitefield & Westley; were they Prophets
Or were they Idiots or Madmen? shew us Miracles!

Ca[t]

Can you have greater Miracles than these? Men who devote
Their lifes whole comfort to intire scorn & injury & death
Awake thou sleeper on the Rock of Eternity Albion awake
The trumpet of Judgment hath twice sounded: all Nations are awake
But thou art still heavy and dull: awake Albion awake:
Lo Orc arises on the Atlantic, Lo his blood and fire
Glow on Americas shore: Albion turns upon his Couch
He listens to the sounds of War, astonishd and confounded:
He weeps into the Atlantic deep, yet still in dismal dreams
Unwakend; and the Covering Cherub advances from the East:
How long shall we lay dead in the Street of the great City
How long beneath the Covering Cherub give our Emanations
Milton will utterly consume us & thee our beloved Father
He hath enterd into the Covering Cherub, becoming one with
Albions dread Sons, Hand, Hyle & Coban surround him as
A Girdle; Gwendolen & Conwenna as a garment woven
Of War & Religion; let us descend & bring him chained
To Bowlahoola O father most beloved! O mild Parent!
Cruel in thy mildness, pitying and permitting evil
Tho strong and mighty to destroy, O Los our beloved Father!

Like the black storm, coming out of Chaos, beyond the stars:
It issues thro the dark & intricate caves of the Mundane Shell
Passing the planetary visions, & the well adorned Firmament
The Sun rolls into Chaos & the Stars into the Desarts:
And then the storms become visible, audible & terrible,
Covering the light of day, & rolling down upon the mountains,
Deluge all the country round. Such is a vision of Los;
When Rintrah & Palamabron spoke; and such his stormy face
Appeard, as does the face of heaven, when coverd with thick storms
Pitying and loving tho in frowns of terrible perturbation

But Los dispersd the clouds even as the strong winds of Jehovah,
And Los thus spoke, O noble Sons, be patient yet a little
I have embracd the falling Death, he is become One with me
O Sons we live not by wrath, by mercy alone we live!
I recollect an old Prophecy in Eden recorded in gold; and oft
Sung to the harp: That Milton of the land of Albion,
Should up ascend forward from Felphams Vale & break the Chain
Of Jealousy from all its roots; be patient therefore O my Sons
These lovely Females form sweet night and silence and secret
Obscurities to hide from Satans Watch-Fiends. Human loves
And graces; lest they write them in their Books, & in the Scroll
Of mortal life, to condemn the accused; who at Satans Bar
Tremble in Spectrous Bodies continually day and night
While on the Earth they live in sorrowful Vegetations
O when shall we tread our Wine-presses in heaven; and Reap
Our wheat with shoutings of joy, and leave the Earth in peace
Remember how Calvin and Luther in fury premature
Sow'd War and stern division between Papists & Protestants
Let it not be so now: O go not forth in Martyrdoms & Wars
We were placd here by the Universal Brotherhood & Mercy
With powers fitted to circumscribe this dark Satanic death
And that the Seven Eyes of God may have space for Redemption.
But how this is as yet we know not, and we cannot know;
Till Albion is arisen; then patient wait a little while,
Six Thousand years are passd away the end approaches fast;
This mighty one is come from Eden, he is of the Elect,
Who died from Earth & he is returnd before the Judgment. This thing
Was never known that one of the holy dead should willing return
Then patient wait a little while till the Last Vintage is over:
Till we have quenchd the Sun of Salah in the Lake of Udan Adan
O my dear Sons! leave not your Father, as your brethren left me
Twelve Sons successive fled away in that thousand years of sorrow

Of Palamabrons Harrow, & of Rintrahs wrath & fury:
Reuben & Manazzoth & Gad & Simeon & Levi & Ephraim & Manasseh
They tell me, wandering with the Daughters of Albion about
One Thousand years, and all the Earth was in a watry deluge
Because of Satan: & the Seven Eyes of God continually
The Watchman of Eternity, the Three are not! & I am preserved
Still my mighty ones are left to me & these O Los!
Still Rintrah fierce, and Palamabron mild & piteous
Theotormon filld with care, Bromion loving Science
You O my Sons still guard round Los. O wander not & leave me
Rintrah, thou well rememberest when Amalek & Canaan
Fled with their Sister Moab into that abhorred Void
They became Nations in our sight beneath the hands of Tirzah.
And Palamabron thou rememberest when Joseph an infant;
Stolen from his nurses cradle wrap'd in needle-work
Of emblematic texture, was sold to the Amalekite
Who carried him down into Egypt where Ephraim & Menasseh
Gatherd my Sons together in the Sands of Midian.
And if you also flee away and leave your Fathers side,
Following Milton into Ulro. altho your power is great
Surely you also shall become poor mortal vegetations
Beneath the Moon, of Ulro: pity then your Fathers tears
When Jesus raisd Lazarus from the Grave I stood & saw
Lazarus who is the Vehicular Body of Albion the Redeem'd
Arise into the Covering Cherub who is the Spectre of Albion
By martyrdoms to suffer: to watch over the Sleeping Body.
Upon his Rock beneath his tomb. I saw the Covering Cherub
Divide Four-fold into Four Churches when Lazarus arose
Paul, Constantine, Charlemaine, Luther; behold they stand before us
Stretchd over Europe & Asia. come O Sons, come, come away
Arise O Sons give all your strength against Eternal Death
Lest we are vegetated, for Cathedrons Looms weave only Death
A Web of Death: & were it not for Bowlahoola & Allamanda
No Human Form but only a Fibrous Vegetation
A Polypus of soft affections without Thought or Vision
Must tremble in the Heavens & Earths thro all the Ulro space
Throw all the Vegetated Mortals into Bowlahoola
But as to this Elected Form who is returnd again
He is the Signal that the Last Vintage now approaches
Nor Vegetation may go on till all the Earth is reapd

So Los spoke. Furious they descended to Bowlahoola & Allamanda
Indignant. unconvinced by Loss' arguments & thunders rolling
They saw that wrath now sway'd and now pity absorbd him
As it was, so it remaind & no hope of an end.

Bowlahoola is namd Law. by mortals, Tharmas founded it:
Because of Satan. before Luban in the City of Golgonooza.
But Golgonooza is namd Art & Manufacture by mortal men.

In Bowlahoola Los's Anvils stand & his Furnaces rage;
Thundering the Hammers beat & the Bellows blow loud
Living self moving mourning lamenting & howling incessantly
Bowlahoola thro all its porches feels tho' too fast founded
Its pillars & porticoes to tremble at the force
Of mortal or immortal arm: and softly lilling flutes
Accordant with the horrid labours make sweet melody
The Bellows are the Animal Lungs: the Hammers the Animal Heart
The Furnaces the Stomach for digestion, terrible their fury
Thousands & thousands labour: thousands play on instruments
Stringed or fluted to ameliorate the sorrows of slavery
Loud sport the dancers in the dance of death, rejoicing in carnage
The hard dentant Hammers are lulld by the flutes lula lula
The bellowing Furnaces blare by the long sounding clarion
The double drum drones loud & loud the black smoke rolls & cares;
The dropping orders loud the torrent sweat terrible but harmonious

Bowlahoola is the Stomach in every individual man.
Los is by mortals namd Time Enitharmon is namd Space
But they depict him bald & aged who is in eternal youth
All powerful and his locks flourish like the brows of morning
He is the Spirit of Prophecy the ever apparent Elias
Time is the mercy of Eternity; without Times swiftness
Which is the swiftest of all things: all were eternal torment:
All the Gods of the Kingdoms of Earth labour in Los's Halls.
Every one is a fallen Son of the Spirit of Prophecy
He is the Fourth Zoa, that stood around the Throne Divine.

Loud shout the Sons of Luvah, at the Wine-presses as Los descended
With Rintrah & Palamabron in his fires of resistless fury.
The Wine-press on the Rhine groans loud, but all its central beams
Act more terrific in the central Cities of the Nations
Where Human Thought is crushd beneath the iron hand of Power.
There Los puts all into the Press, the Opressor & the Opressed
Together, ripe for the Harvest & Vintage & ready for the Loom.

They sang at the Vintage. This is the Last Vintage! & Seed
Shall no more be sown, upon Earth, till all the Vintage is over
And all gatherd in, till the Plow has pass'd over the Nations
And the Harrow & heavy thundering Roller upon the mountains

And loud the Souls howl round the Porches of Golgonooza
Crying O God, deliver us to the Heavens or to the Earths,
That we may preach righteousness & punish the sinner with death
But Los refused, till all the Vintage of Earth was gatherd in.

And Los stood & cried to the Labourers of the Vintage in voice of awe.

Fellow Labourers! The Great Vintage & Harvest is now upon Earth
The whole extent of the Globe is explored; Every scatterd Atom
Of Human Intellect now is flocking to the sound of the Trumpet
All the Wisdom which was hidden in caves & dens, from ancient
Time; is now sought out from Animal & Vegetable & Mineral
The Awakener is come, outstretchd over Europe; the Vision of God is fulfilled
The Ancient Man upon the Rock of Albion Awakes,
He listens to the sounds of War astonishd & ashamed;
He sees his Children mock at Faith and deny Providence
Therefore you must bind the Sheaves not by Nations or Families
You shall bind them in Three Classes; according as they have been formed
Since Men began to be Wove into Nations by Rahab & Tirzah
Since Albions Death & Satans Cutting-off from our awful Fields;
When under pretence to benevolence the Elect Subdud All
From the Foundation of the World. The Elect is one Class: You
Shall bind them separate: they cannot Believe in Eternal Life
Except by Miracle & a New Birth. The other two Classes;
The Reprobate who never cease to Believe, and the Redeemd,
Who live in doubts & fears perpetually tormented by the Elect
These you shall bind in a twin-bundle for the Consummation—
But the Elect must be saved from fires of Eternal Death,
To be formed into the Churches of Beulah that they destroy not the Earth
For in every Nation & every Family the Three Classes are born.
And in every Species of Earth, Metal, Tree, Fish, Bird & Beast.
We form the Mundane Egg, that Spectres coming by fury or amity
All is the same, & every one remains in his own energy
Go forth Reapers with rejoicing, you sowed in tears
But the time of your refreshing cometh, only a little moment
Still abstain from pleasure & rest, in the labours of eternity
And you shall Reap the whole Earth from Pole to Pole; from Sea to Sea
Beginning at Jerusalems Inner Court, Lambeth ruind and given
To the detestable Gods of Priam, to Apollo: and at the Asylum
Given to Hercules, who labour in Tirzahs Looms for bread
Who set Pleasure against Duty; who Create Olympic crowns to make
Fierce Thor & cruel Odin who first reard the Polar Caves
...
...
...
Forth in your wrath lest you also are Vegetated by Tirzah
Wait till the Judgement is past, till the Creation is consumed
And then rush forward with me into the glorious spiritual
Vegetation the Supper of the Lamb & his Bride; and the
Awaking of Albion our friend and ancient companion.

So Los spoke. But lightnings of discontent broke on all sides round.
And murmurs of thunder rolling heavy long & loud over the mountains
While Los calld his Sons around him to the Harvest & the Vintage.

Thou seest the Constellations in the deep & wondrous Night
They rise in order and continue their immortal courses
Upon the mountains & in vales with harp & heavenly song
With flute & clarion; with cups & measures filld with foaming wine
Glittering the streams reflect the Vision of beatitude
And the calm Ocean joys beneath & smooths his awful waves!

These are the Sons of Los, & these the Labourers of the Vintage
Thou seest the gorgeous clothed Flies that dance & sport in summer
Upon the sunny brooks & meadows: every one the dance
Knows in its intricate mazes of delight artful to weave:
Each one to sound his instruments of music in the dance,
To touch each other & recede; to cross & change & return.
These are the Children of Los; thou seest the Trees on mountains
The wind blows heavy, loud they thunder thro' the darksom sky
Uttering prophecies & speaking instructive words to the sons
Of men: These are the Sons of Los! These the Visions of Eternity
But we see only as it were the hem of their garments
When with our vegetable eyes we view these wondrous Visions

There are Two Gates thro' which all Souls descend. One Southward
From Dover Cliff to Lizard Point. the other toward the North
Caithness & rocky Durness, Pentland & John Groats House

The Souls descending to the Body, wail on the right hand
Of Los; & those deliverd from the Body, on the left hand
For Los against the east his force continually bends
Along the Valleys of Middlesex from Hounslow to Blackheath
Lest those Three Heavens of Beulah should the Creation destroy
And lest they should descend before the north & south Gates
Groaning with pity, he among the wailing Souls laments.

And these the Labours of the Sons of Los in Allamanda:
And in the City of Golgonooza: & in Luban: & around
The Lake of Udan-Adan, in the Forests of Entuthon Benython
Where Souls incessant wail, being piteous Passions & Desires
With neither lineament nor form but like to watry clouds
The Passions & Desires descend upon the hungry winds
For such alone Sleepers remain meer passion & appetite;
The Sons of Los clothe them & feed & provide houses & fields

And every Generated Body in its inward form
Is a garden of delight & a building of magnificence,
Built by the Sons of Los in Bowlahoola & Allamanda
And the herbs & flowers & furniture & beds & chambers
Continually woven in the Looms of Enitharmons Daughters
In bright Cathedrons golden Dome with care & love & tears
For the various Classes of Men are all markd out determinate
In Bowlahoola: & as the Spectres choose their affinities
So they are born on Earth, & every Class is determinate
But not by Natural but by Spiritual power alone. Because
The Natural power continually seeks & tends to Destruction
Ending in Death: which would of itself be Eternal Death
And all are Classd by Spiritual, & not by Natural power.

And every Natural Effect has a Spiritual Cause, and Not
A Natural: for a Natural Cause only seems, it is a Delusion
Of Ulro: & a ratio of the perishing Vegetable Memory.

But the Wine-press of Los is eastward of Golgonooza. before the Seat
Of Satan. Luvah laid the foundation & Urizen finishd it in howling woe.
How red the sons & daughters of Luvah: here they tread the grapes.
Laughing & shouting drunk with odours many fall, oerwearied,
Drownd in the wine is many a youth & maiden: those around
Lay them on skins of Tygers & of the spotted Leopard & the Wild Ass
Till they revive, or bury them in cool grots, making lamentation.

This Wine-press is calld War on Earth. it is the Printing-Press
Of Los; and here he lays his words in order above the mortal brain
As cogs are formd in a wheel to turn the cogs of the adverse wheel.

Timbrels & violins sport round the Wine-presses: the little Seed;
The sportive Root. the Earth-worm. the gold Beetle: the wise Emmet;
Dance round the Wine-presses of Luvah: the Centipede is there:
The ground Spider with many eyes: the Mole clothed in velvet
The ambitious Spider in his sullen web; the lucky golden Spinner;
The Earwig armd: the tender Maggot emblem of immortality:
The Flea: Louse: Bug: the Tape-Worm: all the Armies of Disease:
Visible or invisible to the slothful vegetating Man.
The slow Slug: the Grasshopper that sings & laughs & drinks:
Winter comes, he folds his slender bones without a murmur.
The cruel Scorpion is there: the Gnat: Wasp: Hornet & the Honey Bee:
The Toad & venomous Newt; the Serpent clothd in gems & gold:
They throw off their gorgeous raiment: they rejoice with loud jubilee
Around the Wine-presses of Luvah. naked & drunk with wine.

There is the Nettle that stings with soft down; and there
The indignant Thistle: whose bitterness is bred in his milk:
Who feeds on contempt of his neighbour: there all the idle Weeds
That creep around the obscure places, shew their various limbs
Naked in all their beauty dancing round the Wine-presses.

But in the Wine-presses the Human grapes sing not, nor dance
They howl & writhe in shoals of torment; in fierce flames consuming.
In chains of iron & in dungeons circled with ceaseless fires.
In pits & dens & shades of death: in shapes of torment & woe.
The plates & screws & wracks & saws, & cords & fires & cisterns
The cruel joys of Luvahs Daughters, lacerating with knives
And whips their Victims & the deadly sport of Luvahs Sons.

They dance around the dying, & they drink the howl & groan
They catch the shrieks in cups of gold. they hand them to one another
These are the sports of love, & these the sweet delights of amorous play
Tears of the grape, the death sweat of the cluster the last sigh
Of the mild youth who listens to the lureing songs of Luvah.

But Allamanda calld on Earth Commerce, is the Cultivated land
Around the City of Golgonooza in the Forests of Entuthon:
Here the Sons of Los labour against Death Eternal: through all
The Twenty-seven Heavens of Beulah in Ulro, Seat of Satan
Which is the False Tongue beneath Beulah: it is the Sense of Touch
The Plow goes forth in tempests & lightnings & the Harrow cruel
In blights of the east; the heavy Roller follows in howlings of woe.

Urizens sons here labour also; & here are seen the Mills
Of Theotormon, on the verge of the Lake of Udan-Adan:
These are the starry voids of night & the depths & caverns of earth
These Mills are oceans, clouds & waters ungovernable in their fury
Here are the Stars created & the seeds of all things planted
And here the Sun & Moon receive their fixed destinations

But in Eternity the Four Arts: Poetry, Painting, Music
And Architecture which is Science: are the Four Faces of Man.
Not so in Time & Space: there Three are shut out, and only
Science remains thro Mercy: & by means of Science, the Three
Became apparent in Time & Space, in the Three Professions

That Man may live upon Earth till the time of his awaking,
And from these Three, Science derives every Occupation of Men.
And Science is divided into Bowlahoola & Allamanda.

Some Sons of Los surround the Passions with porches of iron & silver
Creating form & beauty around the dark regions of sorrow.
Giving to airy nothing a name and a habitation
Delightful: with bounds to the Infinite putting off the Indefinite
Into most holy forms of Thought: (such is the power of inspiration)
They labour incessant; with many tears & afflictions:
Creating the beautiful House for the piteous sufferer.

Others; Cabinets richly fabricate of gold & ivory;
For Doubts & fears unform'd & wretched & melancholy
The little weeping Spectre stands on the threshold of Death
Eternal; and sometimes two Spectres like lamps quivering
And often malignant they combat (heart breaking sorrowful & piteous)
Antamon takes them into his beautiful flexible hands,
As the Sower takes the seed, or as the Artist his clay
Or fine wax, to mould artful a model for golden ornaments
The soft hands of Antamon draw the indelible line:
Form immortal with golden pen; such as the Spectre admiring
Puts on the sweet form; then smiles Antamon bright thro his windows
The Daughters of beauty look up from their Loom & prepare.
The integument soft for its clothing with joy & delight.

But Theotormon & Sotha stand in the Gate of Luban anxious
Their numbers are seven million & seven thousand & seven hundred
They contend with the weak Spectres, they fabricate soothing forms
The Spectre refuses. he seeks cruelty. they create the crested Cock
Terrified the Spectre screams & rushes in fear into their Net
Of kindness & compassion & is born a weeping terror.
Or they create the Lion & Tyger in compassionate thunderings
Howling the Spectres flee: they take refuge in Human lineaments.

The Sons of Ozoth within the Optic Nerve stand fiery glowing
And the number of his Sons is eight millions & eight.
They give delights to the man unknown; artificial riches
They give to scorn, & their posessors to trouble & sorrow & care.
Shutting the sun. & moon. & stars. & trees. & clouds. & waters.
And hills. out from the Optic Nerve & hardening it into a bone
Opake. and like the black pebble on the enraged beach.
While the poor indigent is like the diamond which tho clothd
In rugged covering in the mine, is open all within
And in his hallowd center holds the heavens of bright eternity
Ozoth here builds walls of rocks against the surging sea
And timbers cramp'd with iron cramps bar in the joys of life
From fell destruction in the Spectrous cunning or rage. He Creates
The speckled Newt, the Spider & Beetle, the Rat & Mouse,
The Badger & Fox: they worship before his feet in trembling fear.

But others of the Sons of Los build Moments & Minutes & Hours
And Days & Months & Years & Ages & Periods; wondrous buildings
And every Moment has a Couch of gold for soft repose,
(A Moment equals a pulsation of the artery)
And between every two Moments stands a Daughter of Beulah
To feed the Sleepers on their Couches with maternal care.
And every Minute has an azure Tent with silken Veils.
And every Hour has a bright golden Gate carved with skill.
And every Day & Night, has Walls of brass & Gates of adamant,
Shining like precious stones & ornamented with appropriate signs:
And every Month, a silver paved Terrace builded high:
And every Year, invulnerable Barriers with high Towers.
And every Age is Moated deep with Bridges of silver & gold.
And every Seven Ages is Incircled with a Flaming Fire.
Now Seven Ages is amounting to Two Hundred Years
Each has its Guard. each Moment Minute Hour Day Month & Year.
All are the work of Fairy hands of the Four Elements
The Guard are Angels of Providence on duty evermore
Every Time less than a pulsation of the artery
Is equal in its period & value to Six Thousand Years.

For in this Period the Poets Work is Done: and all the Great
Events of Time start forth & are conceivd in such a Period
Within a Moment: a Pulsation of the Artery.

The Sky is an immortal Tent built by the Sons of Los
And every Space that a Man views around his dwelling-place:
Standing on his own roof, or in his garden on a mount
Of twenty-five cubits in height. such Space is his Universe;
And on its verge the Sun rises & sets. the Clouds bow
To meet the flat Earth & the Sea in such an orderd Space:
The Starry heavens reach no further but here bend and set
On all sides & the two Poles turn on their valves of gold:
And if he move his dwelling-place. his heavens also move.
Whereer he goes & all his neighbourhood bewail his loss:
Such are the Spaces called Earth & such its dimension:
As to that false appearance which appears to the reasoner,
As of a Globe rolling thro Voidness, it is a delusion of Ulro
The Microscope knows not of this nor the Telescope. they alter
The ratio of the Spectators Organs but leave Objects untouchd
For every Space larger than a red Globule of Mans blood.
Is visionary: and is created by the Hammer of Los
And every Space smaller than a Globule of Mans blood. opens
Into Eternity of which this vegetable Earth is but a shadow:
The red Globule is the unwearied Sun by Los created
To measure Time and Space to mortal Men. every morning.
Bowlahoola & Allamanda are placed on each side
Of that Pulsation & that Globule. terrible their power.

But Rintrah & Palamabron govern over Day & Night
In Allamanda & Entuthon Benython where Souls wail:
Where Orc incessant howls burning in fires of Eternal Youth,
Within the vegetated mortal Nerves; for every Man born is joined
Within into One mighty Polypus. and this Polypus is Orc.

But in the Optic vegetative Nerves Sleep was transformed
To Death in old time by Satan the father of Sin & Death
And Satan is the Spectre of Orc & Orc is the generate Luvah

But in the Nerves of the Nostrils. Accident being Formed
Into Substance & Principle. by the cruelties of Demonstration
It became Opake & Indefinite: but the Divine Saviour,
Formed it into a Solid by Los's Mathematic power.
He named the Opake Satan: he named the Solid Adam

And in the Nerves of the Ear. (for the Nerves of the Tongue are closed)
On Albions Rock Los stands creating the glorious Sun each morning
And when unwearied in the evening he creates the Moon
Death to delude, who all in terror at their splendor leaves
His prey while Los appoints. & Rintrah & Palamabron guide
The Souls clear from the Rock of Death. that Death himself may wake
In his appointed season when the ends of heaven meet.

Then Los conducts the Spirits to be Vegetated. into
Great Golgonooza. free from the four iron pillars of Satans Throne
Temperance. Prudence. Justice. Fortitude. the four pillars of tyranny
That Satans Watch Fiends touch them not before they Vegetate.

But Rahab & Tirzah & her Daughters take the pleasant charge
To give them to their lovely heavens till the Great Judgment Day
Such is their lovely charge. But Rahab & Tirzah pervert
Their mild influences, therefore the Seven Eyes of God walk round
The Three Heavens of Ulro. where Tirzah & her Sisters
Weave the black Woof of Death upon Entuthon Benython
In the Vale of Surrey where Horeb terminates in Rephaim The
The stamping feet of Zelophehads Daughters are covered with Human
Upon the treadles of the Loom, they sing to the winged shuttle:
The River rises above his banks to wash the Woof:
He takes it in his arms: he pulses it in strength thro his current
The veil of human miseries is woven over the Ocean
From the Atlantic to the Great South Sea. the Erythrean.

Such is the World of Los the labour of six thousand years.
Thus Nature is a Vision of the Science of the Elohim.

End of the First Book

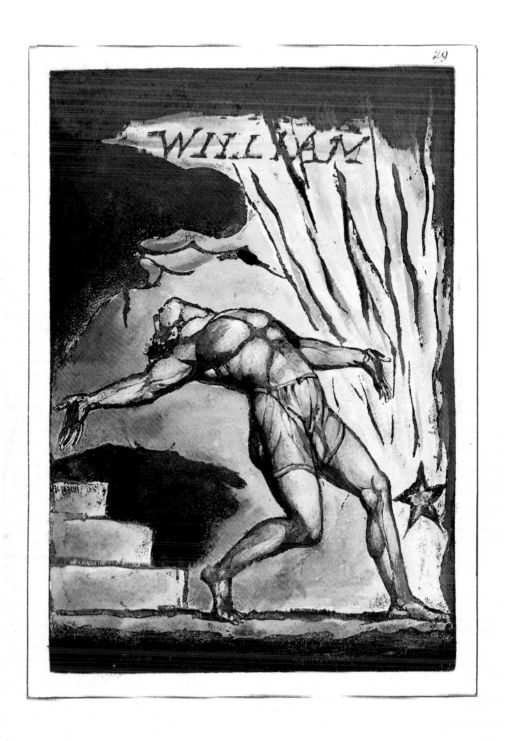

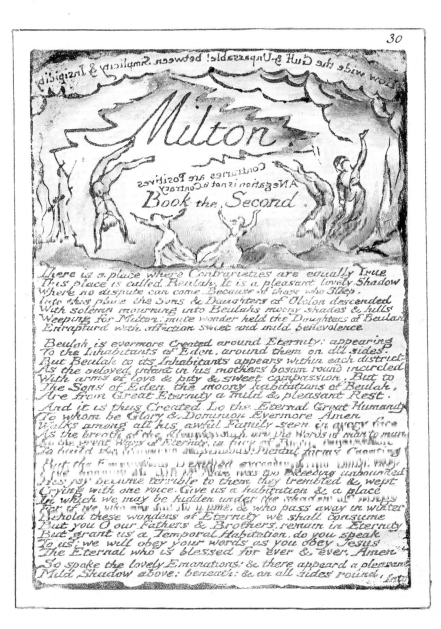

How wide the Gulf & Unpassable! between Simplicity & Insipidity

Milton

Contraries are Positives
A Negation is not a Contrary

Book the Second

There is a place where Contrarieties are equally True
This place is called Beulah, It is a pleasant lovely Shadow
Where no dispute can come. Because of those who Sleep.
Into this place the Sons & Daughters of Ololon descended
With solemn mourning into Beulahs moony shades & hills
Weeping for Milton: mute wonder held the Daughters of Beulah
Entraptur'd with affection sweet and mild benevolence.

Beulah is evermore Created around Eternity; appearing
To the Inhabitants of Eden, around them on all sides
But Beulah to its Inhabitants appears within each district.
As the beloved infant in his mothers bosom round incircled
With arms of love & pity & sweet compassion. But to
The Sons of Eden, the moony habitations of Beulah,
Are from Great Eternity a mild & pleasant Rest.
And it is thus Created. Lo the Eternal Great Humanity
To whom be Glory & Dominion Evermore Amen
Walks among all his awful Family seen in every face
As the breath of the Almighty. such are the Words of man to man
In the great Wars of Eternity, in fury of Poetic Inspiration,
To build the Universe stupendous: Mental forms Creating

But the Emanations trembled exceedingly, nor could they
Live, because the life of Man was too exceeding unbounded
His joy became terrible to them they trembled & wept
Crying with one voice. Give us a habitation & a place
In which we may be hidden under the shadow of wings
For if we who are but for a time, & who pass away in winter
Behold these wonders of Eternity we shall consume
But you O our Fathers & Brothers, remain in Eternity
But grant us a Temporal Habitation. do you speak
To us; we will obey your words as you obey Jesus
The Eternal who is blessed for ever & ever. Amen

So spake the lovely Emanations; & there appeard a pleasant
Mild Shadow above: beneath: & on all sides round,
Into

31

Into this pleasant Shadow all the weak & weary;
Like Women & Children were taken away as on wings
Of dovelike softness, & shadowy habitations prepared for them
But every Man returnd & went still going forward thro'
As One Man at one Father in Eternity on Eternity
Neither did any lack or fall into Error without
A Shadow to repose in all the Days of happy Eternity

Into this pleasant Shadow Beulah. all Ololon descended
And when the Daughters of Beulah heard the lamentation
All Beulah wept. for they saw the Lord coming in the Clouds
And the Shadows of Beulah terminate in rocky Albion ––

And all Nations wept in affliction Family by Family
Germany wept towards France & Italy: England wept & trembled
Towards America: India rose up from his golden bed:
As one awakend in the night: they saw the Lord coming
In the Clouds of Ololon with Power & Great Glory!
And all the Living Creatures of the Four Elements, waild
With bitter wailing: these in the aggregate are named Satan
And Rahab: they know not of Regeneration, but only of Generation
The Fairies. Nymphs. Gnomes & Genii of the Four Elements
Unforgiving, & unalterable: these cannot be Regenerated
But must be Created, for they know only of Generation
These are the Gods of the Kingdoms of the Earth: in contrarious
And cruel opposition: Element against Element, opposed in War
Not Mental, as the Wars of Eternity, but a Corporeal Strife
In Los's Halls continual labouring in the Furnaces of Golgonooza
Orc howls on the Atlantic: Enitharmon trembles: All Beulah weeps

Thou hearest the Nightingale begin the Song of Spring;
The Lark sitting upon his earthy bed: just as the morn
Appears: listens silent; then springing from the waving Corn-field! loud
He leads the Choir of Day! trill. trill. trill. trill.
Mounting upon the wings of light into the Great Expanse:
Reechoing against the lovely blue & shining heavenly Shell:
His little throat labours with inspiration; every feather
On throat & breast & wings vibrates with the effluence Divine
All Nature listens silent to him & the awful Sun
Stands still upon the Mountain looking on this little Bird
With eyes of soft humility, & wonder love & awe.
Then loud from their green covert all the Birds begin their Song
The Thrush, the Linnet & the Goldfinch, Robin & the Wren
Awake the Sun from his sweet reverie upon the Mountain:
The Nightingale again assays his song & thro the day,
And thro the night warbles luxuriant; every Bird of Song
Attending his loud harmony with admiration & love.
This is a Vision of the lamentation of Beulah over Ololon!

Thou perceivest the Flowers put forth their precious Odours!
And none can tell how from so small a center comes such sweets
Forgetting that within that Center Eternity expands
Its ever during doors, that Og & Anak fiercely guard
First eer the morning breaks joy opens in the flowery bosoms
Joy even to tears, which the Sun rising dries; first the Wild Thyme
And Meadow-sweet downy & soft waving among the reeds.
Light springing on the air lead the sweet Dance: they wake
The Honeysuckle sleeping on the Oak: the flaunting beauty
Revels along upon the wind; the White-thorn lovely May
Opens her many lovely eyes: listening the Rose still sleeps
None dare to wake her, soon she bursts her crimson curtaind bed
And comes forth in the majesty of beauty; every Flower:
The Pink, the Jessamine, the Wall-flower, the Carnation
The Jonquil, the mild Lilly opes her heavens; every Tree,
And Flower & Herb soon fill the air with an innumerable Dance
Yet all in order sweet & lovely, Men are sick with Love! ––
Such is a Vision of the lamentation of Beulah over Ololon

And

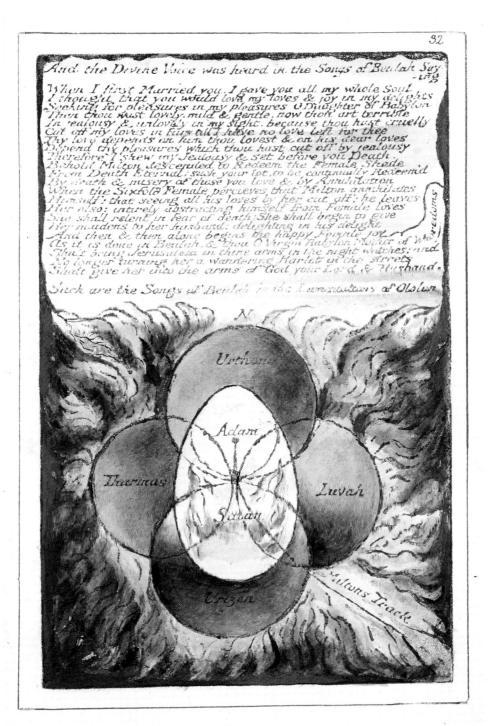

And the Divine Voice was heard in the Songs of Beulah Say
ing

When I first Married you, I gave you all my whole Soul
I thought that you would love my loves & joy in my delights
Seeking for pleasures in my pleasures O Daughter of Babylon
Then thou wast lovely mild & gentle. now thou art terrible
In jealousy & unlovely in my sight. because thou hast cruelly
Cut off my loves in fury till I have no love left for thee
Thy love depends on him thou lovest & on his dear loves
Depend thy pleasures which thou hast cut off by jealousy
Therefore I shew my Jealousy & set before you Death.
Behold Milton descended to Redeem the Female Shade
From Death Eternal; such your lot to be continually Redeemd
By death & misery of those you love & by Annihilation
When the Sixfold Female perceives that Milton annihilates
Himself: that seeing all his loves by her cut off: he leaves
Her also: intirely abstracting himself from Female loves
She shall relent in fear of death; She shall begin to give
Her maidens to her husband: delighting in his delight
And then & then alone begins the happy Female joy
As it is done in Beulah & thou O Virgin Babylon Mother of Whoredoms
Shalt bring Jerusalem in thine arms in the night watches: and
No longer turning her a wandering Harlot in the streets
Shalt give her into the arms of God your Lord & Husband.

Such are the Songs of Beulah in the Lamentations of Ololon

And Milton oft sat up on the Couch of Death & oft conversed
In vision & dream beatific with the Seven Angels of the Presence

I have turned my back upon these Heavens builded on cruelty
My Spectre still wandering thro' them follows my Emanation
He hunts her footsteps thro' the snow & the wintry hail & rain
The idiot Reasoner laughs at the Man of Imagination
And from laughter proceeds to murder by undervaluing calumny

Then Hillel who is Lucifer replied over the Couch of Death
And thus the Seven Angels instructed him & thus they converse.

We are not Individuals but States: Combinations of Individuals
We were Angels of the Divine Presence: & were Druids in Annandale
Compelld to combine into Form by Satan. the Spectre of Albion.
Who made himself a God &. destroyed the Human Form Divine.
But the Divine Humanity & Mercy gave us a Human Form
Because we were combind in Freedom & holy Brotherhood
While those combind by Satans Tyranny first in the blood of War
And Sacrifice & next. in Chains of imprisonment: are Shapeless Rocks
Retaining only Satans Mathematic Holiness, Length: Bredth & Highth
Calling the Human Imagination: which is the Divine Vision & Fruition
In which Man liveth eternally: madness & blasphemy, against
Its own Qualities. which are Servants of Humanity. not Gods or Lords
Distinguish therefore States from Individuals in those States.
States change: but Individual Identities never change nor cease:
You cannot go to Eternal Death in that which can never Die.
Satan & Adam are States Created into Twenty-seven Churches
And thou O Milton art a State about to be Created
Called Eternal Annihilation that none but the Living shall
Dare to enter: & they shall enter triumphant over Death
And Hell & the Grave: States that are not. but ah! Seem to be.

Judge then of thy Own Self: thy Eternal Lineaments explore
What is Eternal & what Changeable? & what Annihilable!
The Imagination is not a State: it is the Human Existence itself
Affection or Love becomes a State, when divided from Imagination
The Memory is a State always. & the Reason is a State
Created to be Annihilated & a new Ratio Created
Whatever can be Created can be Annihilated. Forms cannot
The Oak is cut down by the Ax. the Lamb falls by the Knife
But their Forms Eternal Exist. For-ever. Amen Hallelujah

Thus they converse with the Dead watching round the Couch of Death.
For God himself enters Death's Door always with those that enter
And lays down in the Grave with them. in Visions of Eternity
Till they awake & see Jesus & the Linen Clothes lying
That the Females had Woven for them. & the Gates of their Fathers House

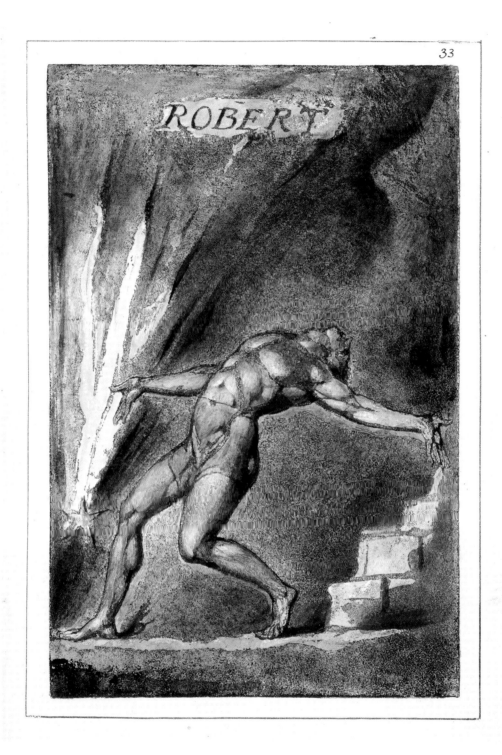

34

And all the Songs of Beulah sounded comfortable notes
To comfort Ololons lamentation, for they said

The Virgin. . . .
The Eight Immortal Starry-Ones in Ulro dark
Rending the Heavens of Beulah with your thunders & lightnings
And can you thus lament & can you pity & forgive?
Is terror changd to pity O wonder of Eternity.

And the Four States of Humanity in its Repose,
Were shewed them. First of Beulah a most pleasant Sleep
On Couches soft, with mild music. tended by Flowers of Beulah
Sweet Female forms, winged or floating in the air spontaneous
The Second State is Alla & the Third State Al-Ulro:
But the Fourth State is dreadful; it is named Or-Ulro:
The First State is in the Head, the Second is in the Heart:
The Third in the Loins & Seminal Vessels & the Fourth,
In the Stomach & Intestines terrible, deadly, unutterable
And he whose Gates are opend in those Regions of his Body
Can from those Gates view all these wondrous Imaginations

But Ololon sought the Or-Ulro & its fiery Gates
And the Couches of the Martyrs; & many Daughters of Beulah
Accompany them down to the Ulro with soft melodious tears
A long journey & dark thro Chaos in the track of Miltons course
To where the Contraries of Beulah Wr beneath Negations Banner

Then view'd from Miltons Track they see the Ulro: a vast Polypus
Of living fibres down into the Sea of Time & Space growing
A self-devouring monstrous Human Death Twenty-seven fold
Within it sit Five Females & the nameless Shadowy Mother
Spinning it from their bowels with songs of amorous delight
And melting cadences that lure the Sleepers of Beulah down
The River Storge (which is Arnon) into the Dead Sea:
Around this Polypus Los continual builds the Mundane Shell

Four Universes round the Universe of Los remain Chaotic
Four intersecting Globes, & the Egg formd World of Los
In midst; stretching from Zenith to Nadir, in midst of Chaos
One of these Ruind Universes is to the North named Urthona
One to the South this was the glorious World of Urizen
One to the East, of Luvah: One to the West; of Tharmas;
But when Luvah assumed the World of Urizen in the South
All fell towards the Center sinking downward in dire Ruin

Here in these Chaoses the Sons of Ololon took their abode
In Chasms of the Mundane Shell which open on all sides round
Southward & by the East within the Breach of Miltons descent
To watch the Fame, pitying, & gentle to awaken Urizen
They stood in a dark land of death of fiery corroding waters
Where lie in evil death the Four Immortals pale and cold
And the Eternal Man even Albion upon the Rock of Ages
Seeing Miltons Shadow, some Daughters of Beulah trembling
Retird, but Ololon remand before the Gates of the Dead

And Ololon looked down into the Heavens of Ulro in fear
They said. How are the Wars of man which in Great Eternity
Appear around, in the External Spheres of Visionary Life
Here renderd Deadly within the Life & Interior Vision
How are the Beasts & Birds & Fishes, & Plants & Minerals
Here fixd into a frozen bulk subject to decay & death
These Visions of Human Life & Shadows of Wisdom & Knowledge

Are here Frozen to unexpansive deadly destroying terrors
And War & Hunting: the Two Fountains of the River of Life
Are become Fountains of bitter Death & of corroding Hell
Till Brotherhood is changd into a Curse & a Flattery
By Differences between Ideas, that Idols themselves, (which are
The Divine Members) may be slain in offerings for sin
O dreadful Loom of Death! O pitious Female forms compelld
To weave the Woof of Death. On Camberwell Tirzahs Courts
Malahs on Blackheath, Rahab & Noah, dwell on Windsors heights
Where once the Cherubs of Jerusalem spread to Lambeths Vale
Milcahs Pillars shine from Harrow to Hampstead where Hoglah
On Highgates heights magnificent Weaves over trembling Thames
To Shooters Hill and thence to Blackheath the dark Woof! Loud
Loud roll the Weights & Spindles over the whole Earth let down
On all sides round to the Four Quarters of the World, eastward on
Europe to Euphrates & Hindu, to Nile & back in Clouds
Of Death across the Atlantic to America North & South

So spoke Ololon in reminiscence astonishd, but they
Could not behold Golgonooza without passing the Polypus
A wondrous journey not passable by Immortal feet, & none
But the Divine Saviour can pass it without annihilation.
For Golgonooza cannot be seen till having passd the Polypus
It is viewed on all sides round by a Four-fold Vision
Or till you become Mortal & Vegetable in Sexuality
Then you behold its mighty Spires & Domes of ivory & gold

And Ololon examined all the Couches of the Dead.
Even of Los & Enitharmon & all the Sons of Albion
And his Four Zoas terrified & on the verge of Death
In midst of these was formd the Ulro Visions of its creatures
Immortal Starry-Ones, guarding the Couch in flaming fires
They thunderous utterd all a universal groan falling down
Prostrate before the Starry Eight asking with tears forgiveness
Confessing their crime with humiliation and sorrow.

O how the Starry Eight rejoicd to see Ololon descended!
And now that a wide road was open to Eternity,
By Ololons descent thro Beulah to Los & Enitharmon.
For mighty were the multitudes of Ololon, vast the extent
Of their great sway, reaching from Ulro to Eternity
Surrounding the Mundane Shell outside in its Caverns
And through Beulah, and all silent forbore to contend
With Ololon for they saw the Lord in the Clouds of Ololon.

There is a Moment in each Day that Satan cannot find
Nor can his Watch Fiends find it, but the Industrious find
This Moment & it multiply. & when it once is found
It renovates every Moment of the Day if rightly placed
In this Moment Ololon descended to Los & Enitharmon
Unseen beyond the Mundane Shell Southward in Miltons track

Just in this Moment when the morning odours rise abroad
And first from the Wild Thyme, stands a Fountain in a rock
Of crystal flowing into two Streams, one flows thro Golgonooza
And thro Beulah to Eden beneath Los's western Wall
The other flows thro the Aerial Void & all the Churches
Meeting again in Golgonooza beyond Satans Seat

The Wild Thyme is Los's Messenger to Eden, a mighty Demon
Terrible deadly & poisonous his presence in Ulro dark
Therefore he appears only a small Root creeping in grass
Covering over the Rock of Odours his bright purple mantle
Beside the Fount above the Larks Nest in Golgonooza
Luvah slept here in death & here is Luvahs empty Tomb
Ololon sat beside this Fountain on the Rock of Odours.

Just at the place to where the Lark mounts, is a Crystal Gate
It is the enterance of the First Heaven named Luther: for
The Lark is Los's Messenger thro the Twenty-seven Churches
That the Seven Eyes of God who walk even to Satans Seat
Thro all the Twenty-seven Heavens may not slumber nor sleep
But the Larks Nest is at the Gate of Los, at the eastern
Gate of wide Golgonooza & the Lark is Los's Messenger

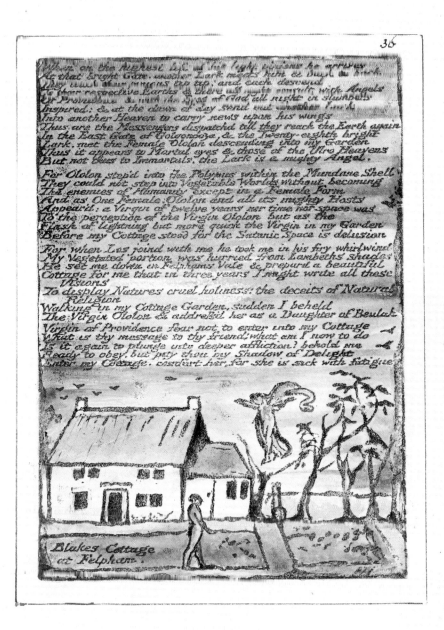

The Virgin answerd. Knowest thou of Milton who descended
Driven from Eternity; him I seek! terrified at my Act
In Great Eternity which thou knowest! I come him to seek

So Ololon utterd in words distinct the anxious thought
Mild was the voice, but more distinct than any earthly
That Miltons Shadow heard & condensing all his Fibres
Into a strength impregnable of majesty & beauty infinite
I saw he was the Covering Cherub & within him Satan
And Rahab, in an outside which is fallacious! within
Beyond the outline of Identity, in the Selfhood deadly
And he appeard the Wicker Man of Scandinavia in whom
Jerusalems children consume in flames among the Stars

Descending down into my Garden, a Human Wonder of God
Reaching from heaven to earth a Cloud & Human Form
I beheld Milton with astonishment & in him beheld
The Monstrous Churches of Beulah, the Gods of Ulro dark
Twelve monstrous dishumanized terrors Synagogues of Satan.
A Double Twelve & Thrice Nine: such their divisions.

And these their Names & their Places within the Mundane Shell
In Tyre & Sidon I saw Baal & Ashtaroth. In Moab Chemosh
In Ammon, Molech: loud his Furnaces rage among the Wheels
Of Og, & pealing loud the cries of the Victims of Fire!
And Baal his Priestesses unfolded in Veils of Pestilence, borderd
With War: Woven in Looms of Tyre & Sidon by beautiful Ashtaroth
In Palestine Dagon, Sea Monster! worshipd oer the Sea.
Thammuz in Lebanon & Rimmon in Damascus curtaind
Osiris: Isis; Orus: in Egypt: dark their Tabernacles on Nile
Floating with solemn songs, & on the Lakes of Egypt nightly
With pomp, even till morning break & Osiris appear in the sky
But Belial of Sodom & Gomorrha, obscure Demon of Bribes
And secret Assassinations, not worshipd nor adord: but
With the finger on the lips & the back turnd to the light
And Saturn Jove & Rhea of the Isles of the Sea remote
These Twelve Gods, are the Twelve Spectre Sons of the Druid Albion

And these the Names of the Twenty-seven Heavens & their Churches
Adam, Seth, Enos, Cainan, Mahalaleel, Jared, Enoch,
Methuselah, Lamech: these are Giants mighty Hermaphroditic
Noah, Shem, Arphaxad, Cainan the second, Salah, Heber,
Peleg, Reu, Serug, Nahor, Terah, these are the Female-Males
A Male within a Female hid as in an Ark & Curtains.
Abraham, Moses, Solomon, Paul, Constantine, Charlemaine
Luther, these seven are the Male-Females: the Dragon Forms
Religion hid in War: a Dragon red & hidden Harlot

All these are seen in Miltons Shadow who is the Covering Cherub
The Spectre of Albion in which the Spectre of Luvah inhabits
In the Newtonian Voids between the Substances of Creation

For the Chaotic Voids outside of the Stars are measured by
The Stars, which are the boundaries of Kingdoms, Provinces
And Empires of Chaos invisible to the Vegetable Man
The Kingdom of Og is in Orion: Sihon is in Ophiucus
Og has Twenty-seven Districts: Sihons Districts Twenty-one
From Star to Star, Mountains & Valleys, terrible dimension
Stretchd out, compose the Mundane Shell, a mighty Incrustation
Of Forty-eight deformed Human Wonders of the Almighty
With Caverns whose remotest bottoms meet again beyond
The Mundane Shell in Golgonooza, but the Fires of Los, rage
In the remotest bottoms of the Caves, that none can pass
Into Eternity that way, but all descend to Los
To Bowlahoola & Allamanda & to Entuthon Benython.
The Heavens are the Cherub, the Twelve Gods are Satan

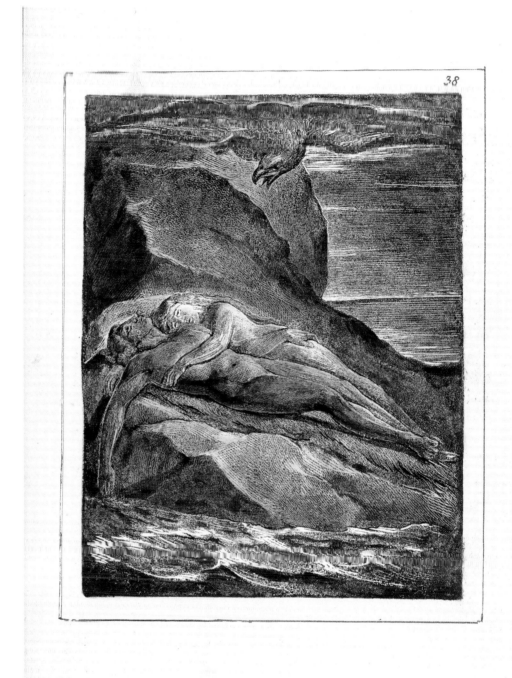

And the Forty-eight Starry Regions are Cities of the Levites
The Heads of the Great Polypus. Four-fold twelve enormity
In mighty & mysterious comingline enemy with enemy
Woven by Urizen into Sexes from his mantle of years
And Milton collecting all his fibres into impregnable strength
Descended down a Paved work of all kinds of precious stones
Out from the eastern sky; descending down into my Cottage
Garden: clothed in black, severe & silent he descended.

The Spectre of Satan stood upon the roaring sea & beheld
Milton within his sleeping Humanity: trembling & shuddring
He stood upon the waves a Twenty-seven-fold mighty Demon
Gorgeous & beautiful: loud roll his thunders against Milton
Loud Satan thunderd, loud, & dark upon mild Felpham shore
Not daring to touch one fibre he howld round upon the Sea.

I also stood in Satans bosom & beheld its desolations:
A ruind Man: a ruind building of God not made with hands;
Its plains of burning sand, its mountains of marble terrible:
Its pits & declivities flowing with molten ore & fountains
Of pitch & nitre: its ruind palaces & cities & mighty works:
Its furnaces of affliction in which his Angels & Emanations
Labour with blackend visages among its stupendous ruins
Arches & pyramids & porches colonades & domes:
In which dwells Mystery Babylon, here is her secret place
From hence she comes forth on the Churches in delight
Here is her Cup filld with its poisons, in these horrid vales
And here her scarlet Veil woven in pestilence & war:
Here is Jerusalem bound in chains, in the Dens of Babylon

In the Eastern porch of Satans Universe Milton stood & said

Satan, my Spectre! I know my power thee to annihilate
And be a greater in thy place, & be thy Tabernacle
A covering for thee to do thy will, till one greater comes
And smites me as I smote thee & becomes my covering
Such are the Laws of thy false Heavns! but Laws of Eternity
Are not such: know thou: I come to Self Annihilation
Such are the Laws of Eternity that each shall mutually
Annihilate himself for others good, as I for thee
Thy purpose & the purpose of thy Priests & of thy Churches
Is to impress on men the fear of death; to teach
Trembling & fear, terror, constriction; abject selfishness
Mine is to teach Men to despise death & to go on
In fearless majesty annihilating Self, laughing to scorn
Thy Laws & terrors, shaking down thy Synagogues as webs
I come to discover before Heavn & Hell the Self righteousness
In all its Hypocritic turpitude, opening to every eye
These wonders of Satans holiness shewing to the Earth
The Idol Virtues of the Natural Heart, & Satans Seat
Explore in all its Selfish Natural Virtue & put off
In Self annihilation all that is not of God alone:
To put off Self & all I have ever & ever Amen

Satan heard! Coming in a cloud, with trumpets & flaming fire
Saying I am God the judge of all, the living & the dead
Fall therefore down & worship me, submit thy supreme
Dictate, to my eternal Will & to my dictate bow
I hold the Balances of Right & Just & mine the Sword
Seven Angels bear my Name & in those Seven I appear
But I alone am God & I alone in Heavn & Earth
Of all that live dare utter this, others tremble & bow

Till All Things became One Great Satan. in Holiness
Oppos'd to Mercy. and the Divine Delusion Jesus be no more

Suddenly around Milton on my Path, the Starry Seven
Burnd terrible! my Path became a solid fire, as bright
As the clear Sun & Milton silent came down on my Path.
And there went forth from the Starry limbs of the Seven: Forms
Human; with Trumpets innumerable, sounding articulate
As the Seven spake; and they stood in a mighty Column of Fire
Surrounding Felphams Vale, reaching to the Mundane Shell, Saying

Awake Albion awake! reclaim thy Reasoning Spectre. Subdue
Him to the Divine Mercy, Cast him down into the Lake
Of Los, that ever burneth with fire, ever & ever Amen!
Let the Four Zoa's awake from Slumbers of Six Thousand Years

Then loud the Furnaces of Los were heard! & seen as Seven Heavens
Stretching from south to north over the mountains of Albion

Satan heard! trembling round his Body, he incircled it
He trembled with exceeding great trembling & astonishment
Howling in his Spectre round his Body hungring to devour
But fearing for the pain for if he touches a Vital,
His torment is unendurable: therefore he cannot devour:
But howls round it as a lion round his prey continually
Loud Satan thunderd, loud & dark upon mild Felphams Shore
Coming in a Cloud with Trumpets & with Fiery Flame
An awful Form eastward from midst of a bright Paved-work
Of precious stones by Cherubim surrounded: so permitted
(Lest he should fall apart in his Eternal Death) to imitate
The Eternal Great Humanity Divine, surrounded by
His Cherubim & Seraphim in ever happy Eternity
Beneath sat Chaos: Sin on his right hand Death on his left
And Ancient Night spread over all the heavn his Mantle of Laws
He trembled with exceeding great trembling & astonishment

Then Albion rose up in the Night of Beulah on his Couch
Of dread repose seen by the visionary eye: his face is toward
The east, toward Jerusalems Gates: groaning he sat above
His rocks. London & Bath & Legions & Edinburgh
Are the four pillars of his Throne; his left foot near London
Covers the shades of Tyburn: his instep from Windsor
To Primrose Hill stretching to Highgate & Holloway
London is between his knees: its basements fourfold
His right foot stretches to the sea on Dover cliffs, his heel
On Canterburys ruins; his right hand covers lofty Wales
His left Scotland; his bosom girt with gold involves
York, Edinburgh, Durham & Carlisle & on the front
Bath, Oxford, Cambridge Norwich: his right elbow
Leans on the Rocks of Erins Land. Ireland ancient nation
His head bends over London: he sees his embodied Spectre
Trembling before him with exceeding great trembling & fear
He views Jerusalem & Babylon, his tears flow down
He moved his right foot to Cornwall, his left to the Rocks of Bognor
He strove to rise to walk into the Deep, but strength failing
Forbad & down with dreadful groans he sunk upon his Couch
In moony Beulah. Los his strong Guard walks round beneath the Moon

Urizen faints in terror striving among the Brooks of Arnon
With Miltons Spirit: as the Plowman or Artificer or Shepherd
While in the labours of his Calling sends his Thought abroad
To labour in the ocean or in the starry heaven. So Milton
Labourd in Chasms of the Mundane Shell, tho here before
My Cottage midst the Starry Seven, where the Virgin Ololon
Stood trembling in the Porch, loud Satan thunderd on the stormy Sea
Circling Albions Cliffs in which the Four-fold World resides
Tho seen in fallacy outside: a fallacy of Satans Churches

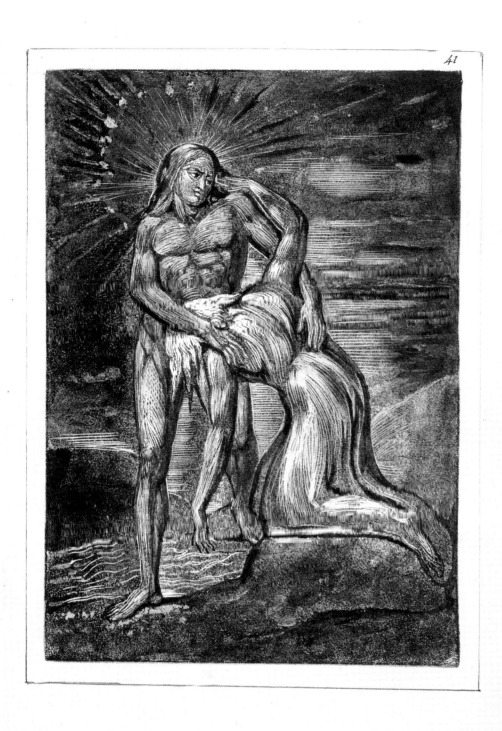

40

Before Ololon Milton stood & perceivd the Eternal Form
Of that mild Vision; wondrous were their acts by me unknown
Except remotely; and I heard Ololon say to Milton

I see thee strive upon the Brooks of Arnon. there a dread
And awful Man I see. oercoverd with the mantle of years.
I behold Los & Urizen. I behold Orc & Tharmas;
The Four Zoas of Albion & thy Spirit with them striving
In Self annihilation giving thy life to thy enemies
Are those who contemn Religion & seek to annihilate it
Become in their Feminine portions the causes & promoters
Of these Religions, how is this thing? this Newtonian Phantasm
This Voltaire & Rousseau: this Hume & Gibbon & Bolingbroke
This Natural Religion! this impossible absurdity
Is Ololon the cause of this? O where shall I hide my face
These tears fall for the little-ones: the Children of Jerusalem
Lest they be annihilated in thy annihilation.

No sooner she had spoke but Rahab Babylon appeard
Eastward upon the Paved work across Europe & Asia
Glorious as the midday Sun in Satans bosom glowing:
A Female hidden in a Male, Religion hidden in War
Namd Moral Virtue; cruel two-fold Monster shining bright
A Dragon red & hidden Harlot which John in Patmos saw
And all beneath the Nations innumerable of Ulro
Appeard, the Seven Kingdoms of Canaan & Five Baalim
Of Philistea. into Twelve divided, calld after the Names
Of Israel: as they are in Eden. Mountain, River & Plain
City & sandy Desert intermingled beyond mortal ken

But turning toward Ololon in terrible majesty Milton
Replied. Obey thou the Words of the Inspired Man
All that can be annihilated must be annihilated
That the Children of Jerusalem may be saved from slavery
There is a Negation, & there is a Contrary
The Negation must be destroyd to redeem the Contraries
The Negation is the Spectre; the Reasoning Power in Man
This is a false Body: an Incrustation over my Immortal
Spirit; a Selfhood, which must be put off & annihilated alway
To cleanse the Face of my Spirit by Self-examination.

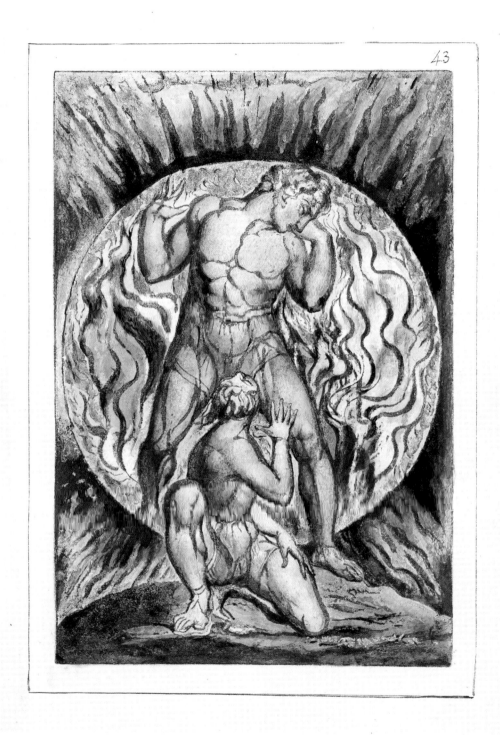

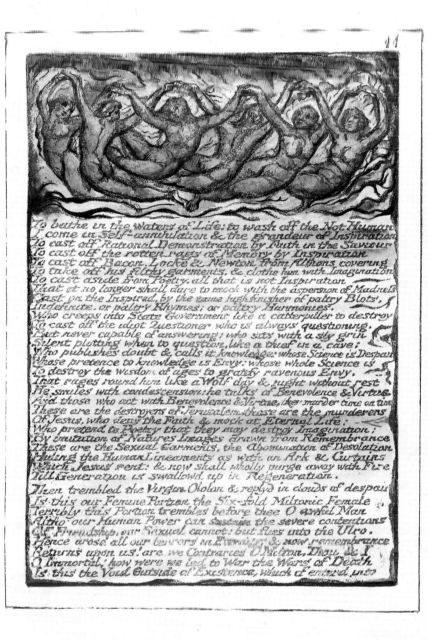

To bathe in the waters of Life: to wash off the Not Human
I come in Self-annihilation & the grandeur of Inspiration
To cast off Rational Demonstration by Faith in the Saviour
To cast off the rotten rags of Memory by Inspiration
To cast off Bacon, Locke & Newton from Albions covering
To take off his filthy garments, & clothe him with Imagination
To cast aside from Poetry, all that is not Inspiration
That it no longer shall dare to mock with the aspersion of Madness
Cast on the Inspired, by the tame high finisher of paltry Blots,
Indefinite, or paltry Rhymes; or paltry Harmonies.
Who creeps into State Government like a caterpiller to destroy
To cast off the idiot Questioner who is always questioning,
But never capable of answering; who sits with a sly grin
Silent plotting when to question, like a thief in a cave;
Who publishes doubt & calls it knowledge; whose Science is Despair
Whose pretence to knowledge is Envy, whose whole Science is
To destroy the wisdom of ages to gratify ravenous Envy,
That rages round him like a Wolf day & night without rest
He smiles with condescension; he talks of Benevolence & Virtue
And those who act with Benevolence & Virtue, they murder time on time
These are the destroyers of Jerusalem, these are the murderers
Of Jesus, who deny the Faith & mock at Eternal Life;
Who pretend to Poetry that they may destroy Imagination;
By imitation of Natures Images drawn from Remembrance
These are the Sexual Garments, the Abomination of Desolation
Hiding the Human Lineaments as with an Ark & Curtains
Which Jesus rent: & now shall wholly purge away with Fire
Till Generation is swallowd up in Regeneration.

Then trembled the Virgin Ololon & replyd in clouds of despair
Is this our Feminine Portion the Six-fold Miltonic Female
Terribly this Portion trembles before thee O awful Man
Altho' our Human Power can sustain the severe contentions
Of Friendship, our Sexual cannot: but flies into the Ulro.
Hence arose all our terrors in Eternity & now remembrance
Returns upon us! are we Contraries O Milton, Thou & I
O Immortal, how were we led to War the Wars of Death
Is this the Void Outside of Existence, which if enterd into

Became a Womb, & is this the Death Couch of Albion
Thou goest to Eternal Death & all must go with thee!

So saying, the Virgin divided Six-fold & with a shriek
Dolorous that ran thro all Creation a Double Six-fold Wonder!
Away from Ololon she divided & fled into the depths
Of Miltons Shadow as a Dove upon the stormy Sea.

Then as a Moony Ark Ololon descended to Felphams Vale
In clouds of blood, in streams of gore, with dreadful thunderings
Into the Fires of Intellect that rejoicd in Felphams Vale
Around the Starry Eight: with one accord the Starry Eight became
One Man Jesus the Saviour. wonderful! round his limbs
The Clouds of Ololon folded as a Garment dipped in blood
Written within & without in woven letters: & the Writing
Is the Divine Revelation in the Litteral expression:
A Garment of War, I heard it namd the Woof of Six Thousand Years

And I beheld the Twenty-four Cities of Albion
Arise upon their Thrones to Judge the Nations of the Earth
And the Immortal Four in whom the Twenty-four appear Four-fold
Arose around Albions body: Jesus wept & walked forth
From Felphams Vale clothed in Clouds of blood, to enter into
Albions Bosom, the bosom of death & the Four surrounded him
In the Column of Fire in Felphams Vale; then to their mouths the Four
Applied their Four Trumpets & them sounded to the Four winds

Terror struck in the Vale I stood at that immortal sound
My bones trembled. I fell outstretchd upon the path
A moment, & my Soul returnd into its mortal state
To Resurrection & Judgment in the Vegetable Body
And my sweet Shadow of Delight stood trembling by my side

Immediately the Lark mounted with a loud trill from Felphams Vale
And the Wild Thyme from Wimbletons green & impurpled Hills
And Los & Enitharmon rose over the Hills of Surrey
Their clouds roll over London with a south wind, soft Oothoon
Pants in the Vales of Lambeth weeping oer her Human Harvest
Los listens to the Cry of the Poor Man: his Cloud
Over London in volume terrific, low bended in anger.

Rintrah & Palamabron view the Human Harvest beneath
Their Wine-presses & Barns stand open: the Ovens are prepard
The Waggons ready: terrific Lions & Tygers sport & play
All Animals upon the Earth are prepard in all their strength

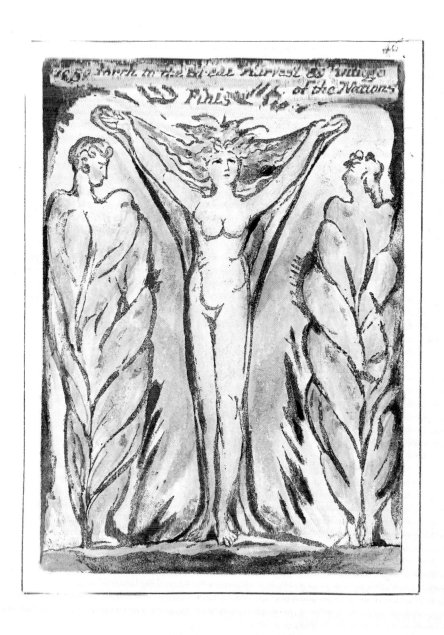

PREFACE.

The Stolen and Perverted Writings of Homer &
Ovid: of Plato & Cicero. which all Men ought to
condemn: are set up by artifice against the Sublime
of the Bible. but when the New Age is at leisure
to Pronounce; all will be set right: & those Grand
Works of the more ancient & consciously & profess-
edly Inspired Men. will hold their proper rank. &
the Daughters of Memory shall become the Daugh-
ters of Inspiration. Shakspeare & Milton were
both curbd by the general malady & infection from
the silly Greek & Latin slaves of the Sword.—
Rouze up O Young Men of the New Age! set your
foreheads against the ignorant Hirelings! For
we have Hirelings in the Camp, the Court & the Uni-
versity: who would if they could, for ever depress Ment-
al & prolong Corporeal War. Painters! on you I call!
Sculptors! Architects! Suffer not the fashonable Fools
to depress your powers by the prices they pretend to give
for contemptible works or the expensive advertizing
boasts that they make of such works; believe
Christ & his Apostles that there is a Class of Men
whose whole delight is in Destroying. We do not
want either Greek or Roman Models if we are but
just & true to our own Imaginations. those Worlds
of Eternity in which we shall live for ever; in
Jesus our Lord.

And did those feet in ancient time.
Walk upon Englands mountains green:
And was the holy Lamb of God.
On Englands pleasant pastures seen!

And did the Countenance Divine.
Shine forth upon our clouded hills?
And was Jerusalem builded here.
Among these dark Satanic Mills?

Bring me my Bow of burning gold:
Bring me my Arrows of desire:
Bring me my Spear: O clouds unfold!
Bring me my Chariot of fire!

I will not cease from Mental Fight.
Nor shall my Sword sleep in my hand:
Till we have built Jerusalem.
In Englands green & pleasant Land.

Would to God that all the Lords people
were Prophets Numbers XI. ch 29 v.

ADDITIONAL PLATE 1
Follows title page

ADDITIONAL PLATE 2
Follows plate 3

Jerusalem The Emanation of The Giant Albion

1804 (c. 1804–20?)

Yale Center for British Art, New Haven, Conn. Copy E.
Relief etching and white-line engraving, with watercolour, pen and touches of gold.

The prophecy *Jerusalem The Emanation of The Giant Albion* is the culminating work of Blake's prophetic oeuvre, representing a final synthesis of his poetic vision and the medium he had invented for its expression. It took almost twenty years to complete. As early as July 1803 he announced his aim

> to speak to future generations by a Sublime Allegory, which is now perfectly completed into a Grand Poem. I may praise it, since I dare not pretend to be any other than the Secretary; the Authors are in Eternity. I consider it as the Grandest Poem that this World Contains. Allegory address'd to the Intellectual powers, while it is altogether hidden from the Corporeal Understanding, is My Definition of the Most Sublime Poetry . . . This Poem shall, by Divine Assistance, be progressively Printed and Ornamented with Prints & given to the Public

Jerusalem originated, as Blake notes at the beginning of the book, in his 'three years slumber on the banks of the Ocean' at Felpham, but references to incidents in his later life and obvious interpolations of plates make it clear that it evolved over many years. Despite the date 1804 on the title-page, none of the complete copies was finished before 1820, and he went on adding to some of them even later.

The one hundred plates display the full range of Blake's mastery of the techniques he had developed for Illuminated printing. There are five known complete copies of which only one was coloured throughout. Finished on every page in Blake's most careful and fully considered manner, it is here reproduced. Blake managed to sell the four uncoloured copies but this, the unrivalled masterpiece of Illuminated printing, remained unsold at his death.

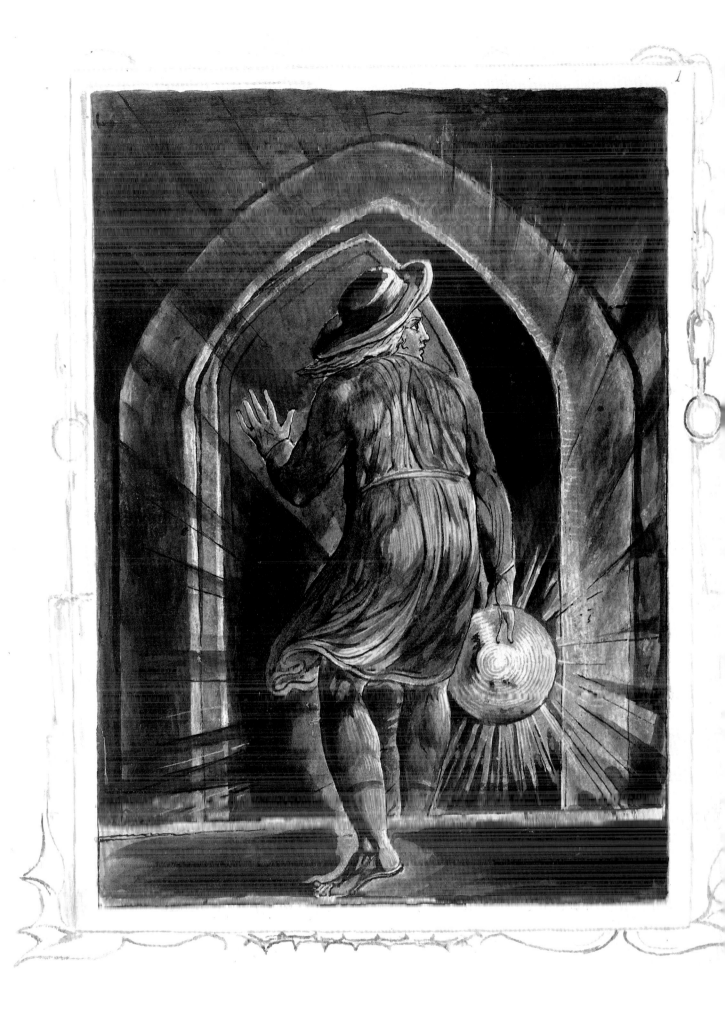

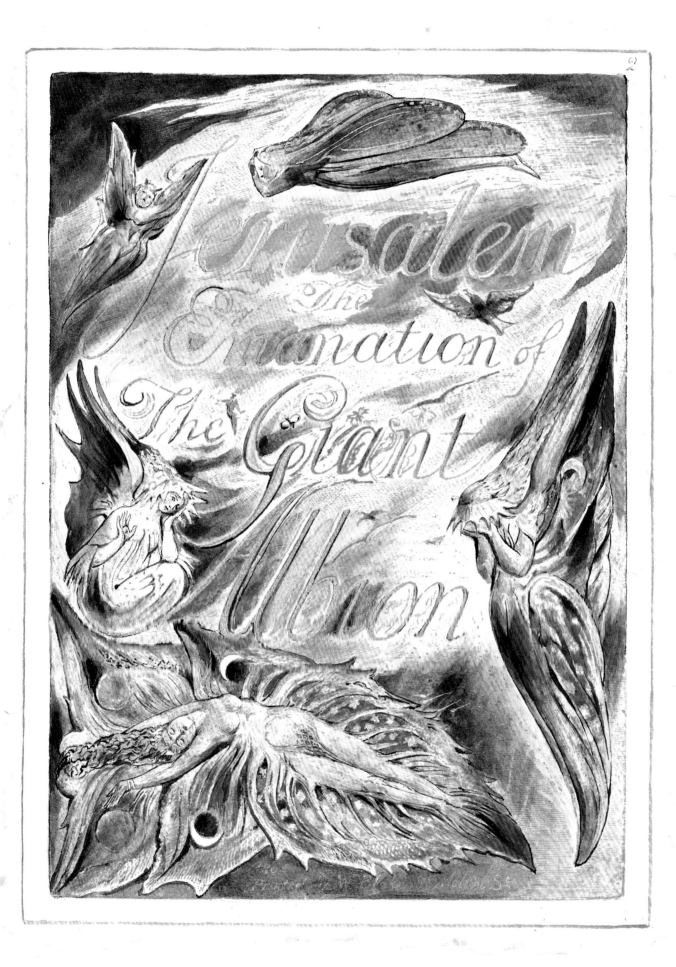

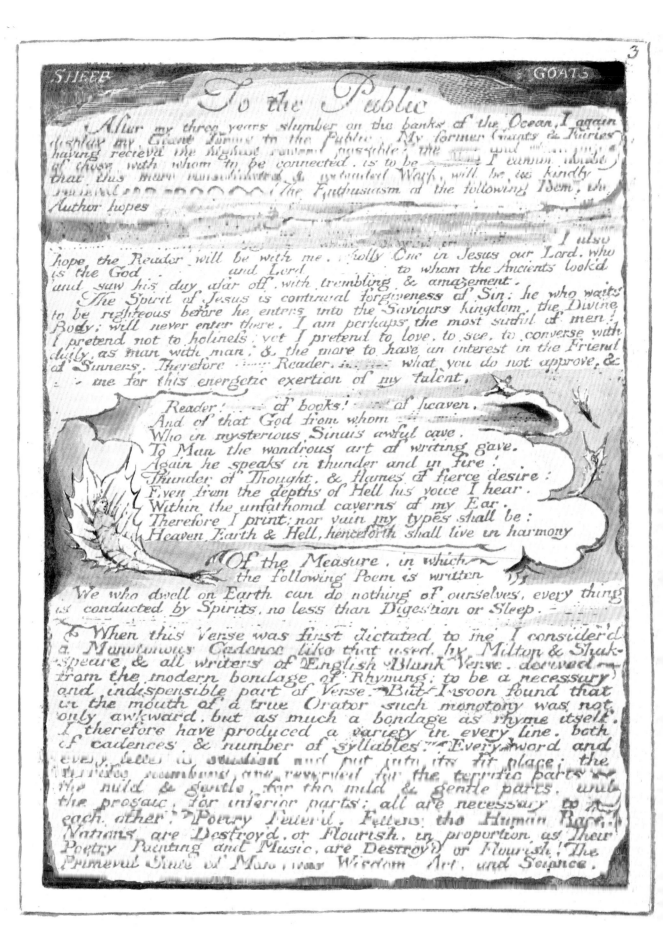

To the Public

After my three years slumber on the banks of the Ocean, I again display my Giant forms to the Public. My former Giants & Fairies having reciev'd the highest reward possible: the ~~~~ and ~~~~ of those with whom to be connected, is to be ~~~~ I cannot doubt that this more ~~~~ & ~~~~ Work, will be as kindly receiv'd ~~~~ The Enthusiasm of the following Poem, the Author hopes ~~~~

~~~~ I also hope the Reader will be with me . ~~~~ Fully One in Jesus our Lord, who is the God ~~~~ and Lord ~~~~ to whom the Ancients look'd and saw his day afar off, with trembling & amazement.

The Spirit of Jesus is continual forgiveness of Sin: he who waits to be righteous before he enters into the Saviours kingdom, the Divine Body; will never enter there. I am perhaps the most sinful of men! I pretend not to holiness; yet I pretend to love, to see, to converse with daily, as man with man; & the more to have an interest in the Friend of Sinners. Therefore ~~~~ Reader, ~~~~ what you do not approve, & ~~~~ me for this energetic exertion of my talent.

Reader! ~~~~ of books! ~~~~ of heaven.
And of that God from whom ~~~~
Who in mysterious Sinais awful cave.
To Man the wondrous art of writing gave.
Again he speaks in thunder and in fire!
Thunder of Thought, & flames of fierce desire:
Even from the depths of Hell his voice I hear.
Within the unfathomd caverns of my Ear.
Therefore I print; nor vain my types shall be:
Heaven Earth & Hell, henceforth shall live in harmony

## Of the Measure, in which the following Poem is written

We who dwell on Earth can do nothing of ourselves, every thing is conducted by Spirits, no less than Digestion or Sleep. ~~~~

When this Verse was first dictated to me I consider'd a Monotonous Cadence like that used by Milton & Shakspeare & all writers of English Blank Verse, derived from the modern bondage of Rhyming; to be a necessary and indispensible part of Verse. But I soon found that in the mouth of a true Orator such monotony was not only awkward, but as much a bondage as rhyme itself. I therefore have produced a variety in every line, both of cadences & number of syllables. Every word and every letter is studied and put into its fit place: the terrific numbers are reserved for the terrific parts — the mild & gentle, for the mild & gentle parts, and the prosaic, for inferior parts: all are necessary to each other. Poetry Fetter'd, Fetters the Human Race! Nations are Destroy'd, or Flourish, in proportion as Their Poetry Painting and Music, are Destroy'd or Flourish! The Primeval State of Man, was Wisdom, Art, and Science.

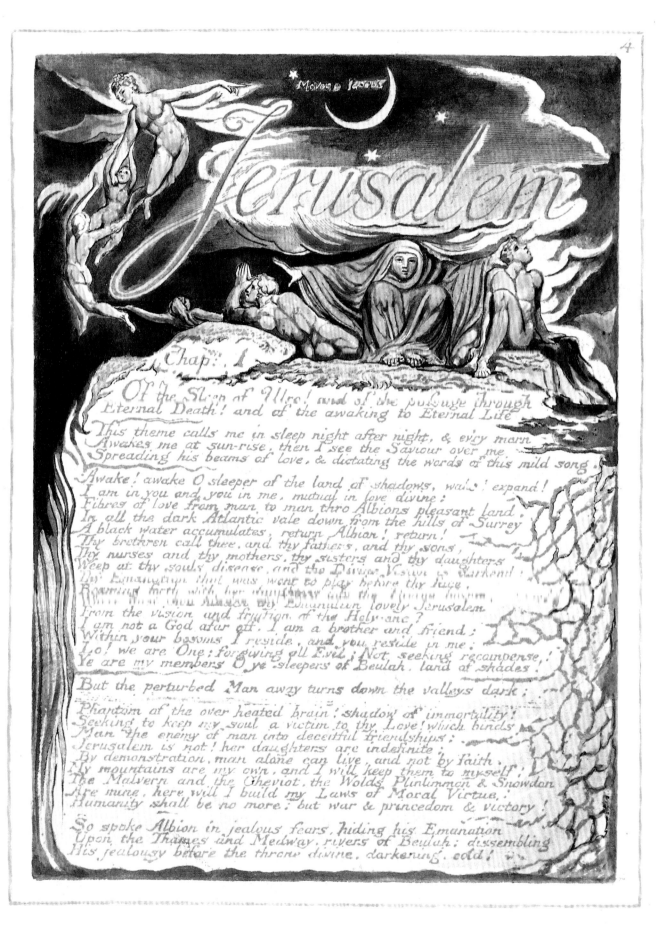

The banks of the Thames are clouded! the ancient porches of Albion are
Darkend! they are drawn thro' unbounded space, scatter'd upon
The Void in incoherent despair! Cambridge & Oxford & London,
Are driven among the starry Wheels, rent away and dissipated,
In Chasms & Abysses of sorrow, enlarg'd without dimension, terrible
Albions mountains run with blood, the cries of war & of tumult
Resound into the unbounded night, every Human perfection
Of mountain & river & city, are small & wither'd & darken'd
Cam is a little stream! Ely is almost swallowd up!
Lincoln & Norwich stand trembling on the brink of Udan-Adan!
Wales and Scotland shrink themselves to the west and to the north!
Mourning for fear of the warriors in the Vale of Entuthon-Benython
Jerusalem is scatterd abroad like a cloud of smoke thro' non-entity:
Moab & Ammon & Amalek & Canaan & Egypt & Aram
Recieve her little-ones for sacrifices and the delights of cruelty

Trembling I sit day and night, my friends are astonish'd at me.
Yet they forgive my wanderings, I rest not from my great task!
To open the Eternal Worlds, to open the immortal Eyes
Of Man inwards into the Worlds of Thought: into Eternity
Ever expanding in the Bosom of God. the Human Imagination
O Saviour pour upon me thy Spirit of meekness & love:
Annihilate the Selfhood in me, be thou all my life!
Guide thou my hand which trembles exceedingly upon the rock of ages,
While I write of the building of Golgonooza, & of the terrors of Entuthon:
Of Hand & Hyle & Coban, of Kwantok, Peachey, Brereton, Slayd & Hutton:
Of the terrible sons & daughters of Albion and their Generations.

Scofield! Kox, Kotope and Bowen, revolve most mightily upon
The Furnace of Los: before the eastern gate bending their fury.
They war, to destroy the Furnaces, to desolate Golgonooza:
And to devour the Sleeping Humanity of Albion in rage & hunger.
They revolve into the Furnaces Southward & are driven forth Northward
Divided into Male and Female forms time after time.
From these Twelve all the Families of England spread abroad.

The Male is a Furnace of beryll: the Female is a golden Loom:
I behold them and their rushing fires overwhelm my Soul,
In Londons darkness; and my tears fall day and night,
Upon the Emanations of Albions Sons! the Daughters of Albion
Names anciently rememberd, but now contemd as fictions:
Although in every bosom they controll our Vegetative powers.

These are united into Tirzah and her Sisters, on Mount Gilead,
Cambel & Gwendolen & Conwenna & Cordella & Ignoge.
And these united into Rahab in the Covering Cherub on Euphrates
Gwiniverra & Gwinefred, & Gonorill & Sabrina beautiful,
Estrild, Mehetabel & Ragan, lovely Daughters of Albion
They are the beautiful Emanations of the Twelve Sons of Albion

The Starry Wheels revolv'd heavily over the Furnaces:
Drawing Jerusalem in anguish of maternal love,
Eastward a pillar of a cloud with Vala upon the mountains
Howling in pain, redounding from the arms of Beulahs Daughters,
Out from the Furnaces of Los above the head of Los.
A pillar of smoke writhing afar into Non-Entity, redounding
Till the cloud reaches afar outstretch'd among the Starry Wheels
Which revolve heavily in the mighty Void above the Furnaces

O what avail the loves & tears of Beulahs lovely Daughters
They hold the Immortal Form in gentle bands & tender tears
But all within is open'd into the deeps of Entuthon Benython
A dark and unknown night, indefinite, unmeasurable, without end.
Abstract Philosophy warring in enmity against Imagination
(Which is the Divine Body of the Lord Jesus, blessed for ever)
And there Jerusalem wanders with Vala upon the mountains,
Attracted by the revolutions of those Wheels the Cloud of smoke
Immense, and Jerusalem & Vala weeping in the Cloud
Wander away into the Chaotic Void, lamenting with her Shadow
Among the Daughters of Albion, among the Starry Wheels:
Lamenting for her children, for the sons & daughters of Albion

Los heard her lamentations in the deeps afar! his tears fall
Incessant before the Furnaces, and his Emanation divided in pain,

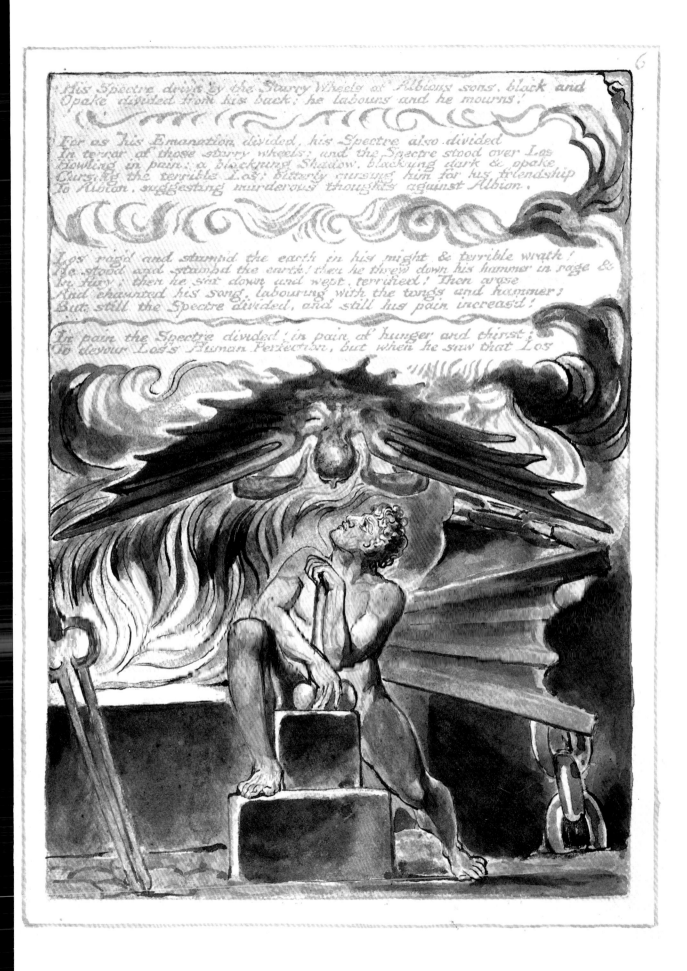

His Spectre driven by the Starry Wheels of Albions sons, black and
Opake divided from his back; he labours and he mourns!

For as his Emanation divided, his Spectre also divided
In terror of those starry wheels; and the Spectre stood over Los
Howling in pain: a blackning Shadow, blackning dark & opake
Cursing the terrible Los: bitterly cursing him for his friendship
To Albion, suggesting murderous thoughts against Albion.

Los raged and stamp'd the earth in his might & terrible wrath!
He stood and stamp'd the earth! then he threw down his hammer in rage &
In fury; then he sat down and wept, terrified! Then arose
And chaunted his song, labouring with the tongs and hammer:
But still the Spectre divided, and still his pain increas'd!

In pain the Spectre divided: in pain of hunger and thirst;
To devour Los's Human Perfection, but when he saw that Los

7

Was living: panting like a frighted wolf, and howling
He stood over the Immortal, in the solitude and darkness:
Upon the darkning Thames, across the whole Island westward,
A horrible Shadow of Death, among the Furnaces: beneath
The pillar of folding smoke: and he sought by other means,
To lure Los: by tears, by arguments of science & by terrors:
Terrors in every Nerve, by spasms & extended pains:
While Los answerd unterrified to the opake blackening Fiend

And thus the Spectre spoke: Wilt thou still go on to destruction?
Till thy life is all taken away by this deceitful Friendship?
He offerd love to thee but thou refusedst he wishes to destroy thee
Because the Emanation that he loved flies to thee for refuge
He makes thy Sons the trampling of his bulls, they are plowd
And harrowd for his profit, lo! thy stolen Emanation
Is his garden of pleasure! all the Spectres of his Sons mock thee
Look how they scorn thy once admired palaces! now in ruins
Because of Albion! because of deceit and friendship! For Lo!
Hand has peopled Babel & Nineveh: Hyle, Ashur & Aram:
Coban's son is Nimrod: his son Cush is adjoind to Aram,
By the Daughter of Babel, in a woven mantle of pestilence & war.
They put forth their spectrous cloudy sails; which drive their immense
Constellations over the deadly deeds of indefinite Udan-Adan
Hand is the Father of Shem & Ham & Japheth, he is the Noah
Of the Flood of Udan-Adan, Hutn is the Father of the Seven
From Enoch to Adam; Schofield is Adam who was New-
Created in Edom, I saw it indignant, & thou art not moved!
This has divided thee in sunder: and wilt thou still forgive?
O! thou seest not what I see, what is done in the Furnaces.
Listen, I will tell thee what is done in moments to thee unknown:
Luvah was cast into the Furnaces of affliction and sealed,
And Vala fed in cruel delight, the Furnaces with fire:
Stern Urizen beheld; urgd by necessity to keep
The evil day afar, and if perchance with iron power
He might avert his own despair: in woe & fear he saw
Vala incircle round the Furnaces where Luvah was closd:
With joy she heard his howlings, & forgot he was her Luvah,
With whom she livd in bliss in times of innocence & youth!
Vala comes from the Furnace in a cloud, but wretched Luvah
Is howling in the Furnaces, in flames among Albions Spectres,
To prepare the Spectre of Albion to reign over thee O Los,
Forming the Spectres of Albion according to his rage:
To prepare the Spectre sons of Adam, who is Scofield: the Ninth
Of Albions sons, & the father of all his brethren in the Shadowy
Generation, Cambel & Gwendolen wove webs of war & of
Religion, to involve all Albions sons, and when they had
Involvd Eight; their webs rolld outwards into darkness
And Schofield the Ninth remaind on the outside of the Eight
And Kox, Kotope, & Bowen, One in him, a Fourfold Wonder
Involvd the Eight: Such are the Generations of the Giant Albion,
To separate a Law of Sin, to punish thee in thy members.

Los answerd. Altho' I know not this! I know far worse than this:
I know that Albion hath divided me, and that thou O my Spectre,
Hast just cause to be irritated: but look stedfastly upon me:
Comfort thyself in my strength the time will arrive,
When all Albions injuries shall cease, and when we shall
Embrace him tenfold bright, rising from his tomb in immortality.
They have divided themselves by Wrath, they must be united by
Pity: let us therefore take example & warning O my Spectre,
O that I could abstain from wrath! O that the Lamb
Of God would look upon me and pity me in my fury,
In anguish of regeneration! in terrors of self annihilation:
Pity must join together those whom wrath has torn in sunder,
And the Religion of Generation which was meant for the destruction
Of Jerusalem, become her covering, till the time of the End.
O holy Generation! [Image] of regeneration!
O point of mutual forgiveness between Enemies!
Birthplace of the Lamb of God incomprehensible!
The Dead despise & scorn thee, & cast thee out as accursed:
Seeing the Lamb of God in thy gardens & thy palaces:
Where they desire to place the Abomination of Desolation.
Hand sits before his furnace: scorn of others & furious pride:
Freeze round him to bars of iron & to iron rocks beneath
His feet: indignant self-righteousness like whirlwinds of the north:

Rose up against me thundering from the Brook of Albions River
From Ranelagh & Strumbolo, from Cromwells gardens & Chelsea
The place of wounded Soldiers. but when he Saw my Mace
Whirld round from heaven to earth, trembling he sat; his cold
Poisons rose up; & his sweet deceits coverd them all over
With a tender cloud. As thou art now; such was he O Spectre
I know thy deceit & thy revenges, and unless thou desist
I will certainly create an eternal Hell for thee. Listen!
Be attentive! be obedient! Lo the Furnaces are ready to recieve thee.
I will break thee into shivers! & melt thee in the furnaces of death;
I will cast thee into forms of abhorrence & torment if thou
Desist not from thine own will, & obey not my stern command:
I am closd up from my children: my Emanation is dividing
And thou my Spectre art divided against me. But mark
I will compell thee to assist me in my terrible labours. To beat
These hypocritic Selfhoods on the Anvils of bitter Death
I am inspired: I act not for myself: for Albions sake
I now am what I am: a horror and an astonishment
Shuddring the heavens to look upon me: Behold what cruelties
Are practised in Babel & Shinar. & have approachd to Zions Hill

While Los spoke, the terrible Spectre fell shuddring before him
Watching his time with glowing eyes to leap upon his prey
Los opend the Furnaces in fear. the Spectre saw to Babel & Shinar
Across all Europe & Asia. he saw the tortures of the Victims.
He saw now from the ouside what he before saw & felt from within
He saw that Los was the sole, uncontrolld Lord of the Furnaces
Groaning he kneeld before Loss iron-shod feet on London Stone,
Hungring & thirsting for Los's life yet pretending obedience.
While Los pursud his speech in threatnings loud & fierce.

Thou art my Pride & Self-righteousness: I have found thee out:
Thou art reveald before me in all thy magnitude & power
Thy Uncircumcised pretences to Chastity must be cut in sunder!
Thy holy wrath & deep deceit cannot avail against me
Nor shalt thou ever assume the triple-form of Albions Spectre
For I am one of the living: dare not to mock my inspired fury
If thou wast cast forth from my life! if I was dead upon the mountains
Thou mightest be pitied & lovd: but now I am living; unless
Thou abstain ravening I will create an eternal Hell for thee.
Take thou this Hammer & in patience heave the thundering Bellows
Take thou these Tongs: strike thou alternate with me: labour obedient
Hand & Hyle & Koban: Skofield, Kox & Kotope, labour mightily
In the Wars of Babel & Shinar, all their Emanations were
Condensd. Hand has absorbd all his Brethren in his might
All the infant Loves & Graces were lost. for the mighty Hand

                                                    Con

9

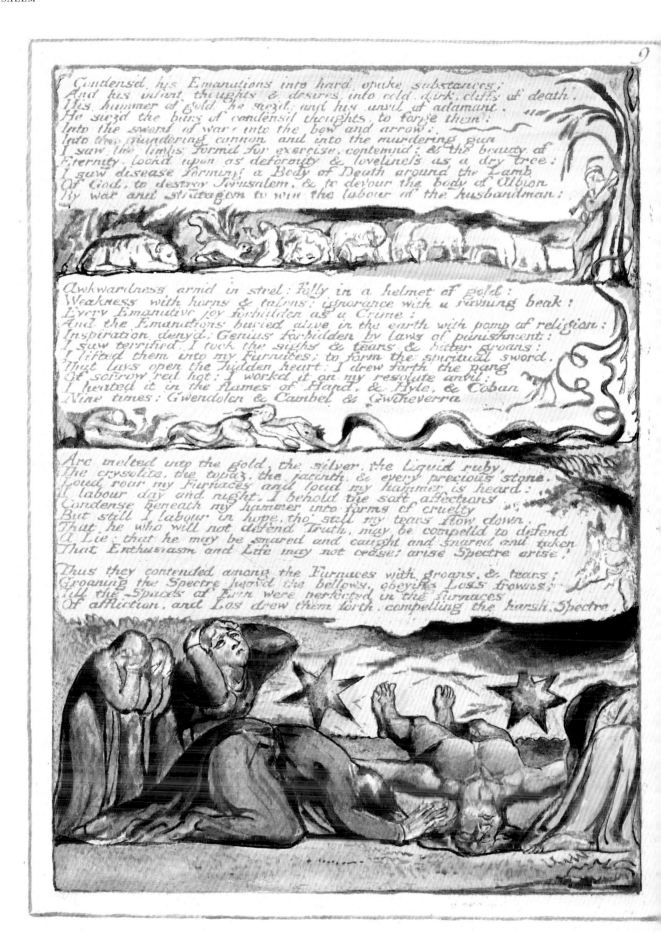

Condensd, his Emanations into hard opake substances;
And his infant thoughts & desires, into cold, dark, cliffs of death.
His hammer of gold he seizd, and his anvil of adamant.
He siezd the bars of condensd thoughts, to forge them:
Into the sword of war: into the bow and arrow:
Into the murdering cannon, and into the murdering gun
I saw the limbs formd for exercise, contemnd: & the beauty of
Eternity, lookd upon as deformity & loveliness as a dry tree:
I saw disease forming a Body of Death around the Lamb
Of God, to destroy Jerusalem, & to devour the body of Albion
By war and stratagem to win the labour of the husbandman:

Awkwardness armd in steel: folly in a helmet of gold:
Weakness with horns & talons: ignorance with a ravening beak:
Every Emanative joy forbidden as a Crime:
And the Emanations buried alive in the earth with pomp of religion:
Inspiration denyd; Genius forbidden by laws of punishment:
I saw terrified; I took the sighs & tears, & bitter groans:
I lifted them into my Furnaces; to form the spiritual sword.
That lays open the hidden heart: I drew forth the pang
Of sorrow red hot: I worked it on my resolute anvil:
I heated it in the flames of Hand, & Hyle, & Coban
Nine times: Gwendolen & Cambel & Gwineverra

Are melted into the gold, the silver, the liquid ruby,
The crysolite, the topaz, the jacinth, & every precious stone,
Loud roar my Furnaces and loud my hammer is heard:
I labour day and night, I behold the soft affections
Condense beneath my hammer into forms of cruelty
But still I labour in hope, tho' still my tears flow down.
That he who will not defend Truth, may be compelld to defend
A Lie: that he may be snared and caught and snared and taken
That Enthusiasm and Life may not cease: arise Spectre arise!

Thus they contended among the Furnaces with groans, & tears;
Groaning the Spectre heavd the bellows, obeying Loss frowns;
Till the Spaces of Erin were perfected in the Furnaces
Of affliction, and Los drew them forth, compelling the harsh Spectre

Into the Furnaces & into the valleys of the Anvils of Death
And into the mountains of the Anvils & of the heavy Hammers
Till he should bring the Sons & Daughters of Jerusalem to be
The Sons & Daughters of Los that he might protect them from
Albions dread Spectres: storming, loud, thunderous & mighty
The Bellows & the Hammers move compell'd by Los's hand.

And this is the manner of the Sons of Albion in their strength
They take the Two Contraries which are call'd Qualities, with which
Every Substance is clothed, they name them Good & Evil
From them they make an Abstract, which is a Negation
Not only of the Substance from which it is derived
A murderer of its own Body: but also a murderer
Of every Divine Member: it is the Reasoning Power
An Abstract objecting power, that Negatives every thing
This is the Spectre of Man: the Holy Reasoning Power
And in its Holiness is closed the Abomination of Desolation

Therefore Los stands in London building Golgonooza
Compelling his Spectre to labours mighty; trembling in fear
The Spectre weeps, but Los unmov'd by tears or threats remains

I must Create a System, or be enslav'd by another Mans
I will not Reason & Compare: my business is to Create

So Los, in fury & strength: in indignation & burning wrath
Shuddring the Spectre howls, his howlings terrify the night
He stamps around the Anvil, beating blows of stern despair
He curses Heaven & Earth, Day & Night & Sun & Moon
He curses Forest Spring & River, Desart & sandy Waste
Cities & Nations, Families & Peoples, Tongues & Laws
Driven to desperation by Los's terrors & threatning fears

Los cries, Obey my voice & never deviate from my will
And I will be merciful to thee: be thou invisible to all
To whom I make thee invisible, but chief to my own Children
O Spectre of Urthona: Reason not against their dear approach
Nor them obstruct with thy temptations of doubt & despair
O Shame O strong & mighty Shame I break thy brazen fetters
If thou refuse, thy present torments will seem southern breezes
To what thou shalt endure if thou obey not my great will.

The Spectre answer'd. Art thou not asham'd of those thy Sins
That thou callest thy Children? lo the Law of God commands
That they be offered upon his Altar: O cruelty & torment
For thine are also mine! I have kept silent hitherto,
Concerning my chief delight: but thou hast broken silence
Now I will speak my mind! Where is my lovely Enitharmon
O thou my enemy, where is my Great Sin? She is also thine
I said: now is my grief at worst: incapable of being
Surpassed: but every moment it accumulates more & more
It continues accumulating to eternity! the joys of God advance
For he is Righteous: he is not a Being of Pity & Compassion
He cannot feel Distress: he feeds on Sacrifice & Offering:
Delighting in cries & tears & clothed in holiness & solitude
But my griefs advance also, for ever & ever without end
O that I could cease to be! Despair! I am Despair
Created to be the great example of horror & agony: also my
Prayer is vain, I called for compassion: compassion mockd
Mercy & pity threw the grave stone over me & with lead
And iron, bound it over me for ever: Life lives on my
Consuming: & the Almighty hath made me his Contrary
To be all evil, all reversed & for ever dead: knowing
And seeing life, yet living not; how can I then behold
And not tremble; how can I be beheld & not abhorrd

So spoke the Spectre shuddring, & dark tears ran down his shadowy face
Which Los wiped off, but comfort none could give! or beam of hope
Yet ceasd he not from labouring at the roarings of his Forge
With iron & brass Building Golgonooza in great contendings
Till his Sons & Daughters came forth from the Furnaces
At the sublime Labours for Los, compell'd the invisible Spectre

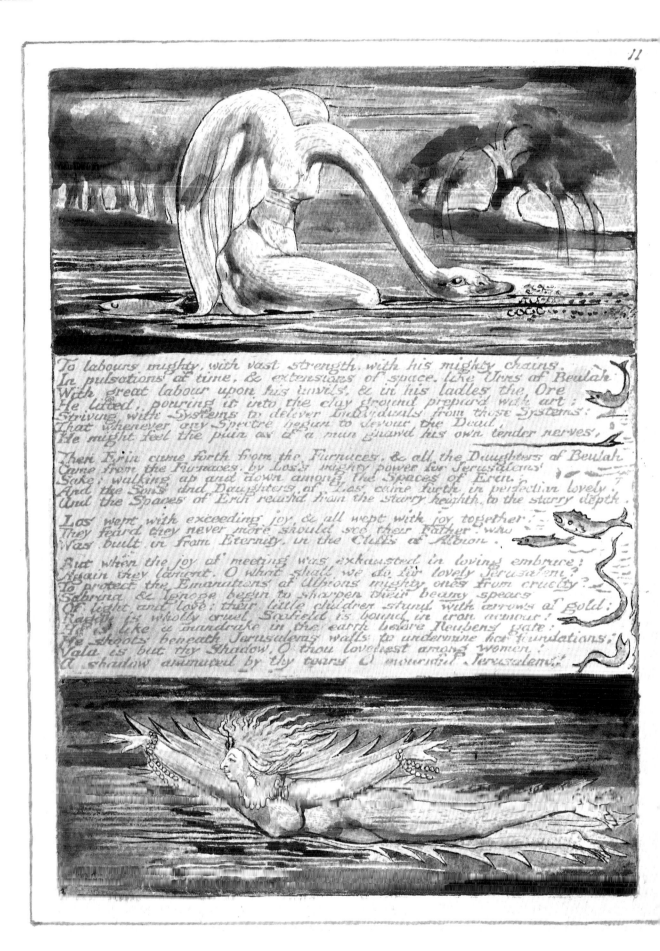

To labours mighty, with vast strength, with his mighty chains,
In pulsations of time, & extensions of space, like Urns of Beulah
With great labour upon his anvils, & in his ladles the Ore
He lifted, pouring it into the clay ground prepard with art;
Striving with Systems to deliver Individuals from those Systems;
That whenever any Spectre began to devour the Dead,
He might feel the pain as if a man gnawd his own tender nerves,

Then Erin came forth from the Furnaces, & all the Daughters of Beulah
Came from the Furnaces, by Los's mighty power for Jerusalems
Sake; walking up and down among the Spaces of Erin:
And the Sons and Daughters of Los came forth in perfection lovely!
And the Spaces of Erin reachd from the starry heighth, to the starry depth.

Los wept with exceeding joy, & all wept with joy together!
They feard they never more should see their Father, who
Was built in from Eternity, in the Cliffs of Albion.

But when the joy of meeting was exhausted in loving embrace;
Again they lament. O what shall we do for lovely Jerusalem?
To protect the Emanations of Albions mighty ones from cruelty?
Sabrina & Ignoge begin to sharpen their beamy spears
Of light and love: their little children stand with arrows of gold:
Ragan is wholly cruel Scofield is bound in iron armour!
He is like a mandrake in the earth before Reubens gate:
He shoots beneath Jerusalems walls to undermine her foundations!
Vala is but thy Shadow, O thou loveliest among women!
A shadow animated by thy tears O mournful Jerusalem!

Why wilt thou give to her a Body whose life is but a Shade?
Her joy and love, a shade: a Shade of sweet repose:
But animated and vegetated, she is a devouring worm:
What shall we do for thee O lovely mild Jerusalem?

And Los said, I behold the finger of God in terrors!
Albion is dead! his Emanation is divided from him!
But I am living! yet I feel my Emanation also dividing
Such thing was never known! O pity me, thou all-piteous-one!
What shall I do! or how exist, divided from Enitharmon?
Yet why despair! I saw the finger of God go forth
Upon my Furnaces, from within the Wheels of Albions Sons:
Fixing their Systems, permanent: by mathematic power
Giving a body to Falshood that it may be cast off for ever.
With Demonstrative Science piercing Apollyon with his own bow:
God is within, & without! he is even in the depths of Hell!

Such were the lamentations of the Labourers in the Furnaces!

And they appeard within & without incircling on both sides
The Starry Wheels of Albions Sons, with Spaces for Jerusalem:
And for Vala the shadow of Jerusalem: the ever mourning shade:
On both sides, within & without beaming gloriously!

Terrified at the sublime Wonder, Los stood before his Furnaces.
And they stood around, terrified with admiration at Erins Spaces
For the Spaces reachd from the starry heighth, to the starry depth.
And they builded Golgonooza: terrible eternal labour!

What are those golden builders doing? where was the burying-place
Of soft Ethinthus? near Tyburns fatal Tree? is that
Mild Zions hills most ancient promontory, near mournful,
Ever weeping Paddington? is that Calvary and Golgotha?
Becoming a building of pity and compassion? Lo!
The stones are pity, and the bricks, well wrought affections:
Enameld with love & kindness, & the tiles engraven gold
Labour of merciful hands: the beams & rafters are forgiveness:
The mortar & cement of the work, tears of honesty: the nails,
And the screws & iron braces, are well wrought blandishments,
And well contrived words, firm fixing, never forgotten,
Always comforting the remembrance: the floors, humility,
The cielings, devotion: the hearths, thanksgiving:
Prepare the furniture O Lambeth in thy pitying looms!
The curtains, woven tears & sighs, wrought into lovely forms
For comfort, there the secret furniture of Jerusalems chamber
Is wrought: Lambeth! the Bride the Lambs Wife loveth thee:
Thou art one with her & knowest not of self in thy supreme joy
Go on, builders in hope, tho Jerusalem wanders far away,
Without the gate of Los: among the dark Satanic wheels.

Fourfold the Sons of Los in their divisions: and fourfold,
The great City of Golgonooza, fourfold toward the north
And toward the south fourfold, & fourfold toward the east & west
Each within other toward the four points: that toward
Eden, and that toward the World of Generation.
And that toward Beulah, and that toward Ulro:
Ulro is the space of the terrible starry wheels of Albions sons:
But that toward Eden is walled up, till time of renovation:
Yet it is perfect in its building, ornaments & perfection.

And the Four Points are thus beheld in Great Eternity
West, the Circumference: South, the Zenith: North,
The Nadir: East, the Center, unapproachable for ever.
These are the four Faces towards the Four Worlds of Humanity
In every Man. Ezekiel saw them by Chebars flood.
And the Eyes are the South, and the Nostrils are the East.
And the Tongue is the West, and the Ear is the North.

And the North Gate of Golgonooza toward Generation;
Has four sculpturd Bulls terrible before the Gate of iron.
And iron, the Bulls: and that which looks toward Ulro,
Clay bakd & enameld, eternal glowing as four furnaces:
Turning upon the Wheels of Albions sons with enormous power.
And that toward Beulah four, gold, silver, brass, & iron:

And that toward Eden, four, formd of gold, silver, brass, & iron.

The South, a golden Gate, has four Lions terrible, living:
That toward Generation, four, of iron carved wondrous:
That toward Ulro, four, clay bakd, laborious workmanship
Thus, toward Eden, four; immortal gold, silver, brass & iron.

The Western Gate fourfold, is closd: having four Cherubim
Its guards, living, the work of elemental hands, laborious task:
Like Men, hermaphroditic, each winged with eight wings
That towards Generation, iron; that toward Beulah, stone;
That toward Ulro, clay; that toward Eden, metals.        (dead
But all closd up till the last day, when the graves shall yield their

The Eastern Gate, fourfold; terrible & deadly its ornaments:
Taking their forms from the Wheels of Albions sons; as cogs
Are formd in a wheel, to fit the cogs of the adverse wheel.

That toward Eden, eternal ice, frozen in seven folds
Of forms of death; and that toward Beulah, stone;
The seven diseases of the earth are carved terrible.
And that toward Ulro, forms of war; seven enormities;
And that toward Generation, seven generative forms.

And every part of the City is fourfold; & every inhabitant, fourfold.
And every pot & vessel & garment & utensil of the houses,
And every house, fourfold; but the third Gate in every one
Is closd as with a threefold curtain of ivory & fine linen & ermine.
And Luban stands in middle of the City, a mout of fire
Surrounds Luban, Loss Palace & the golden Looms of Cathedron.

And sixty-four thousand Genii, guard the Eastern Gate:
And sixty-four thousand Gnomes, guard the Northern Gate:
And sixty-four thousand Nymphs, guard the Western Gate:
And sixty-four thousand Fairies, guard the Southern Gate:

Around Golgonooza lies the land of death eternal; a Land
Of pain and misery and despair and ever brooding melancholy:
In all the Twenty-seven Heavens, numberd from Adam to Luther;
From the blue Mundane Shell, reaching to the Vegetative Earth.

The Vegetative Universe, opens like a flower from the Earths center:
In which is Eternity. It expands in Stars to the Mundane Shell
And there it meets Eternity again, both within and without,
And the abstract Voids between the Stars are the Satanic Wheels.

There is the Cave; the Rock; the Tree; the Lake of Udan Adan;
The Forest, and the Marsh, and the Pits of bitumen deadly:
The Rocks of solid fire; the Ice valleys; the Plains
Of burning sand; the rivers, cataract & Lakes of Fire:
The Islands of the fiery Lakes; the Trees of Malice; Revenge;
And black Anxiety; and the Cities of the Salamandrine men:
(But whatever is visible to the Generated Man,
Is a Creation of mercy & love, from the Satanic Void.)
The land of darkness flamed but no light, & no repose:
The land of snows of trembling, & of iron hail incessant:
The land of earthquakes: and the land of woven labyrinths:
The land of snares & traps & wheels & pit-falls & dire mills:
The Voids, the Solids, & the land of clouds & regions of waters:
With their inhabitants: in the Twenty-seven Heavens beneath Beulah:
Self-righteousnesses conglomerating against the Divine Vision:
A Concave Earth wondrous, Chasmal, Abyssal, Incoherent!
Forming the Mundane Shell: above; beneath: on all sides surrounding
Golgonooza: Los walks round the walls night and day.

He views the City of Golgonooza, & its smaller Cities:
The Looms & Mills & Prisons & Work-houses of Og & Anak:
The Amalekite: the Canaanite: the Moabite: the Egyptian:
And all that has existed in the space of six thousand years:
Permanent, & not lost not lost nor vanishd, & every little act,
Word, work, & wish, that has existed, all remaining still
In those Churches ever consuming & ever building by the Spectres
Of all the inhabitants of Earth wailing to be Created:
Shadowy to those who dwell not in them, meer possibilities:
But to those who enter into them they seem the only substances
For every thing exists & not one sigh nor smile nor tear,

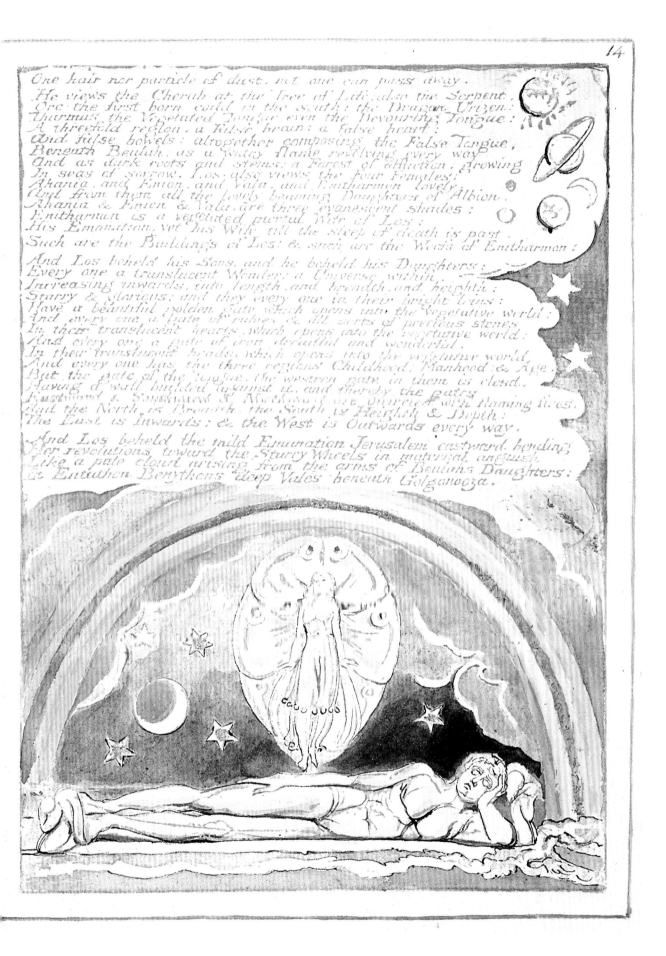

One hair nor particle of dust, not one can pass away.

He views the Cherub at the Tree of Life, also the Serpent,
Orc the first born coild in the south: the Dragon Urizen:
Tharmas the Vegetated Tongue even the Devouring Tongue:
A threefold region, a false brain: a false heart:
And false bowels: altogether composing the False Tongue,
Beneath Beulah: as a watry flame revolving every way
And as dark roots and stems: a Forest of affliction, growing
In seas of sorrow. Los also views the four Females:
Ahania, and Enion, and Vala, and Enitharmon lovely.
And from them all the lovely beaming Daughters of Albion.
Ahania & Enion & Vala, are three evanescent shades:
Enitharmon is a vegetated mortal Wife of Los:
His Emanation, yet his Wife till the sleep of death is past.
Such are the Buildings of Los! & such are the Woofs of Enitharmon!

And Los beheld his Sons, and he beheld his Daughters:
Every one a translucent Wonder: a Universe within,
Increasing inwards, into length and breadth, and heighth:
Starry & glorious: and they every one in their bright loins:
Have a beautiful golden Gate which opens into the vegetative world:
And every one a gate of rubies & all sorts of precious stones
In their translucent hearts, which opens into the reptile world:
And every one a gate of iron dreadful and wonderful.
In their translucent heads, which opens into the vegetative world,
And every one has the three regions Childhood, Manhood & Age:
But the gate of the Tongue, the western gate in them is closed.
Having a wall builded against it: and thereby the gates
Eastward & Southward & Northward are incircled with flaming fires,
And the North is Breadth, the South is Heighth & Depth:
The East is Inwards: & the West is Outwards every way.

And Los beheld the mild Emanation Jerusalem eastward bending
Her revolutions toward the Starry Wheels in maternal anguish
Like a pale cloud arising from the arms of Beulahs Daughters:
In Entuthon Benythons deep Vales beneath Golgonooza.

And Hand & Hyle rooted into Jerusalem by a fibre
Of strong revenge & Skofeld Vegetated by Reubens Gate
In every Nation of the Earth till the Twelve Sons of Albion
Enrooted into every Nation; a mighty Polypus growing
From Albion over the whole Earth: such is my awful Vision.

I see the Four-fold Man. The Humanity in deadly sleep
And its fallen Emanation. The Spectre & its cruel Shadow.
I see the Past, Present & Future, existing all at once
Before me; O Divine Spirit sustain me on thy wings!
That I may awake Albion from his long & cold repose.
For Bacon & Newton sheathd in dismal steel, their terrors hang
Like iron scourges over Albion. Reasonings like vast Serpents
Infold around my limbs, bruising my minute articulations

I turn my eyes to the Schools & Universities of Europe
And there behold the Loom of Locke whose Woof rages dire
Washd by the Water-wheels of Newton. black the cloth
In heavy wreathes folds over every Nation; cruel Works
Of many Wheels I view, wheel without wheel, with cogs tyrannic
Moving by compulsion each other: not as those in Eden: which
Wheel within Wheel in freedom revolve in harmony & peace.

I see in deadly fear in London Los raging round his Anvil
Of death: forming an Ax of gold: the Four Sons of Los
Stand round him cutting the Fibres from Albions hills
That Albions Sons may roll apart over the Nations
While Reuben enroots his brethren in the narrow Canaanite
From the Limit Noah to the Limit Abram in whose Loins
Reuben in his Twelve-fold majesty & beauty shall take refuge
As Abraham flees from Chaldea shaking his goary locks
But first Albion must sleep, divided from the Nations

I see Albion sitting upon his Rock in the first Winter
And thence I see the Chaos of Satan & the World of Adam
When the Divine Hand went forth on Albion in the midWinter
And at the place of Death when Albion sat in Eternal Death
Among the Furnaces of Los in the Valley of the Son of Hin-
nom

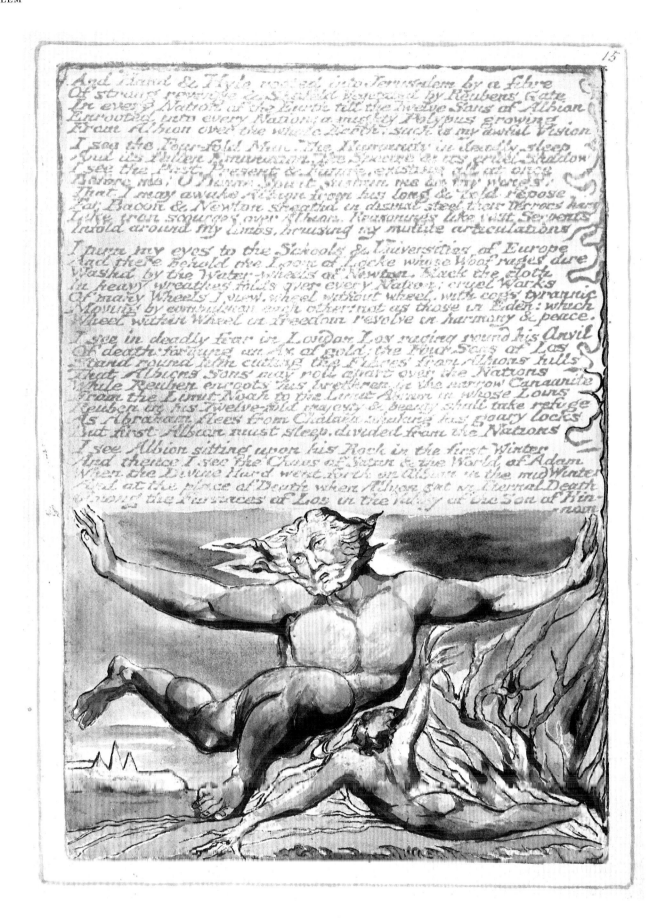

Hampstead Highgate Finchley Hendon Muswell hill: rage loud
Before Bromions iron Tongs & glowing Poker reddening fierce
Hertfordshire glows with fierce Vegetation! in the Forests
The Oak frowns terrible, the Beech & Ash & Elm enroot
Among the Spiritual fires; loud the Corn fields thunder along
The Soldiers fife; the Harlots shriek; the Virgins dismal groan
The Parents fear: the Brothers jealousy: the Sisters curse &
Beneath the Storms of Theotormon & the thundring Bellows
Heaves in the hand of Palamabron who in Londons darkness
Before the Anvil, watches the bellowing flames: thundering
The Hammer loud rages in Rintrahs strong grasp swinging loud
Round from heaven to earth down falling with heavy blow
Dead on the Anvil, where the red hot wedge groans in pain
He quenches it in the black trough of his Forge: Londons River
Feeds the dread Forge, trembling & shuddering along the Valleys

Humber & Trent roll dreadful before the Seventh Furnace
And Tweed & Tyne anxious give up their Souls for Albions sake
Lincolnshire, Derbyshire, Nottinghamshire, Leicestershire
From Oxfordshire to Norfolk on the Lake of Udan Adan
Labour within the Furnaces, walking among the Fires
With Ladles huge & iron Pokers over the Island white.

Scotland pours out his Sons to labour at the Furnaces
Wales gives his Daughters to the Looms: England: nursing Mothers
Gives to the Children of Albion & to the Children of Jerusalem,
From the blue Mundane Shell even to the Earth of Vegetation
Throughout the whole Creation which groans to be delivered
Albion groans in the deep slumbers of Death upon his Rock!

Here Los fixd down the Fifty-two Counties of England & Wales
The Thirty-six of Scotland, & the Thirty-four of Ireland
With mighty power, when they fled out at Jerusalems Gates
Away from the Conflict of Luvah & Urizen, fixing the Gates
In the Twelve Counties of Wales & thence Gates looking every way
To the Four Points: conduct to England & Scotland & Ireland
And thence to all the Kingdoms & Nations & Families of the Earth
The Gate of Reuben in Carmarthenshire: the Gate of Simeon in
Cardiganshire; & the Gate of Levi in Montgomeryshire
The Gate of Judah Merionethshire: the Gate of Dan Flintshire
The Gate of Napthali, Radnorshire; the Gate of Gad Pembrokeshire
The Gate of Asher, Carnarvonshire the Gate of Issachar Brecknokshire
The Gate of Zebulun, in Anglesea & Sodor, so is Wales divided
The Gate of Joseph, Denbighshire: the Gate of Benjamin Glamorganshire
For the protection of the Twelve Emanations of Albions Sons

And the Forty Counties of England are thus divided in the Gates
Of Reuben Norfolk Suffolk Essex, Simeon Lincoln York Lancashire
Levi. Middlesex Kent Surrey: Judah Somerset Glouster Wiltshire
Dan. Cornwal Devon Dorset, Napthali, Warwick Leicester Worcester
Gad Oxford Bucks Harford: Asher, Sussex Hampshire Berkshire
Issachar, Northampton Rutland Nottigham: Zebulun Bedford Huntgn Cambs
Joseph Stafford Shrops Heref: Benjamin, Derby Cheshire Monmouth
And Cumberland Northumberland Westmoreland & Durham are
Divided in the the Gates of Reuben Judah Dan & Joseph

And the Thirty-six Counties of Scotland, divided in the Gates
Of Reuben Kincard Haddntn Forfar. Simeon Ayr Argyll Banff
Levi Edinburgh Roxbro Ross. Judah, Aberdeen Berwik Dumfries
Dan Bute Caitnes Clakmanan. Napthali Nairn Invernes Linlithgo
Gad Peebles Perth Renfru. Asher Sutherlan Sterling Wigtoun
Issachar Selkirk Dumbartn Glasgo: Zebulun Orkney Shetland Skye
Joseph Elgin Lanerk Kintros: Benjamin Kromarty Murra Kirkubrht
Governing all by the sweet delights of secret amorous glances
In Enitharmons Halls builded by Los & his mighty Children

All things acted on Earth are seen in the bright Sculptures of
Los's Halls & every Age renews its powers from these Works
With every pathetic story possible to happen from Hate or
Wayward Love & every sorrow & distress is carved here
Every Affinity of Parents Marriages & Friendships are here
In all their various combinations wrought with wondrous Art
All that can happen to Man in his pilgrimage of seventy years
Such is the Divine Written Law of Horeb & Sinai:
And such the Holy Gospel of Mount Olivet & Calvary:

His Spectre divides & Los in fury compells it to divide:
To labour in the fire. in the water. in the earth. in the air.
To follow the Daughters of Albion as the hound follows the scent
Of the wild inhabitant of the forest. to drive them from his own:
To make a way for the Children of Los to come from the Furnaces
But Los himself against Albions Sons his fury bends. for he
Dare not approach the Daughters openly lest he be consumed
In the fires of their beauty & perfection & be Vegetated beneath
Their Looms. in a Generation of death & resurrection to forgetfulness
They woo Los continually to subdue his strength; he continually
Shews them his Spectre. sending him abroad over the four points of heaven
In the fierce desires of beauty & in the tortures of repulse. He is
The Spectre of the Living pursuing the Emanations of the Dead.
Shuddring they flee: they hide in the Druid Temples in cold chastity.
Subdued by the Spectre of the Living & terrified by undisguisd desire.

For Los said: Tho my Spectre is divided: as I am a Living Man
I must compell him to obey me wholly: that Enitharmon may not
Be lost: & lest he should devour Enitharmon: Ah me!
Piteous image of my soft desires, & loves: O Enitharmon!
I will compell my Spectre to obey: I will restore to thee thy Children.
No one bruises or starves himself to make himself fit for labour!

Tormented with sweet desire for these beauties of Albion
They would never love my power if they did not seek to destroy
Enitharmon: Vala would never have sought & loved Albion
If she had not sought to destroy Jerusalem; such is that false
And Generating Love: a pretence of love to destroy love:
Cruel hipocrisy unlike the lovely delusions of Beulah:
And cruel forms, unlike the merciful forms of Beulahs Night

They know not why they love nor wherefore they sicken & die
Calling that Holy Love: which is Envy Revenge & Cruelty
Which separated the stars from the mountains: the mountains from Man
And left Man. a little grovelling Root, outside of Himself.
Negations are not Contraries: Contraries mutually Exist:
But Negations Exist Not: Exceptions & Objections & Unbeliefs
Exist not: nor shall they ever be Organized for ever & ever:
If thou separate from me, thou art a Negation: a meer
Reasoning & Derogation from me. an Objecting & cruel Spite
And Malice & Envy: but my Emanation. Alas! will become
My Contrary: O thou Negation. I will continually compell
Thee to be invisible to any but whom I please. & when
And where & how I please. and never! never! shalt thou be Organized
But as a distorted & reversed Reflexion in the Darkness
And in the Non Entity: nor shall that. which is above
Ever descend into thee: but thou shalt be a Non Entity for ever
And if any enter into thee. thou shalt be an Unquenchable Fire
And he shall be a never dying Worm. mutually tormented by
Those that thou tormentest. a Hell & Despair for ever & ever.

So Los in secret with himself communed & Enitharmon heard
In her darkness & was comforted: yet still she divided away
In gnawing pain from Los's bosom in the deadly Night:
First as a red Globe of blood trembling beneath his bosom
Suspended over her he hung: he infolded her in his garments
Of wool: he hid her from the Spectre. in shame & confusion of
Face; in terrors & pains of Hell & Eternal Death. the
Trembling Globe shot forth Self-living & Los howld over it:
Feeding it with his groans & tears day & night without ceasing:
And the Spectrous Darkness from his back divided in temptations.
And in stinding agonies in threats: stiflings: & direful strugglings.

Go thou to Skofield: ask him if he is Bath or if he is Canterbury
Tell him to be no more dubious: demand explicit words
Tell him: I will dash him into shivers. where & at what time
I please: tell Hand & Skofield they are my ministers of evil
To those I hate: for I can hate also as well as they!

From every-one of the Four Regions of Human Majesty,
There is an Outside spread Without, & an Outside spread Within
Beyond the Outline of Identity both ways, which meet in One:
An orbed Void of doubt, despair, hunger, & thirst & sorrow.
Here the Twelve Sons of Albion, joind in dark Assembly,
Jealous of Jerusalems children, ashamd of her little-ones
(For Vala produc'd the Bodies, Jerusalem gave the Souls)
Became as Three Immense Wheels, turning upon one-another
Into Non-Entity, and their thunders hoarse appall the Dead
To murder their own Souls, to build a Kingdom among the Dead.

Cast! Cast ye Jerusalem forth! The Shadow of delusions!
The Harlot daughter! Mother of pity and dishonourable forgiveness
Our Father Albions sin and shame! But father now no more!
Nor sons, nor hateful peace & love, nor soft complacencies
With transgressors meeting in brotherhood around the table
Or in the porch or garden. No more the sinful delights
Of age, and youth and boy and girl, and animal and herb,
And river and mountain, and city & village, and house & family
Beneath the Oak & Palm, beneath the Vine and Fig-tree,
In self-denial!—But War and deadly contention, Between
Father and Son, and light and love! All bold asperities
Of Haters met in deadly strife, rending the house & garden
The unforgiving porches, the tables of enmity, and beds
And chambers of trembling & suspition, hatreds of age & youth
And boy & girl, & animal & herb, & river & mountain
And city & village, and house & family. That the Perfect,
May live in glory, redeem'd by Sacrifice of the Lamb
And of his children, before sinful Jerusalem. To build
Babylon the City of Vala, the Goddess Virgin-Mother,
She is our Mother! Nature! Jerusalem is our Harlot-Sister
Returnd with Children of pollution, to defile our House,
With Sin and Shame. Cast! Cast her into the Potters field.
Her little-ones, She must slay upon our Altars: and her aged
Parents must be carried into captivity, to redeem her Soul
To be for a Shame & a Curse, and to be our Slaves for ever

So cry Hand & Hyle the eldest of the fathers of Albions
Little-ones; to destroy the Divine Saviour: the Friend of Sinners,
Building Castles in desolated places, and strong Fortifications.
Soon Hand mightily devour'd & absorbd Albions Twelve Sons.
Out from his bosom a mighty Polypus, vegetating in darkness,
And Hyle & Coban were his two chosen ones, for Emissaries
In War: forth from his bosom they went and returnd.
Like Wheels from a great Wheel reflected in the Deep.
Hoarse turnd the Starry Wheels, rending a way in Albions Loins
Beyond the Night of Beulah. In a dark & unknown Night
Outstretch'd his Giant beauty on the ground in pain & tears.

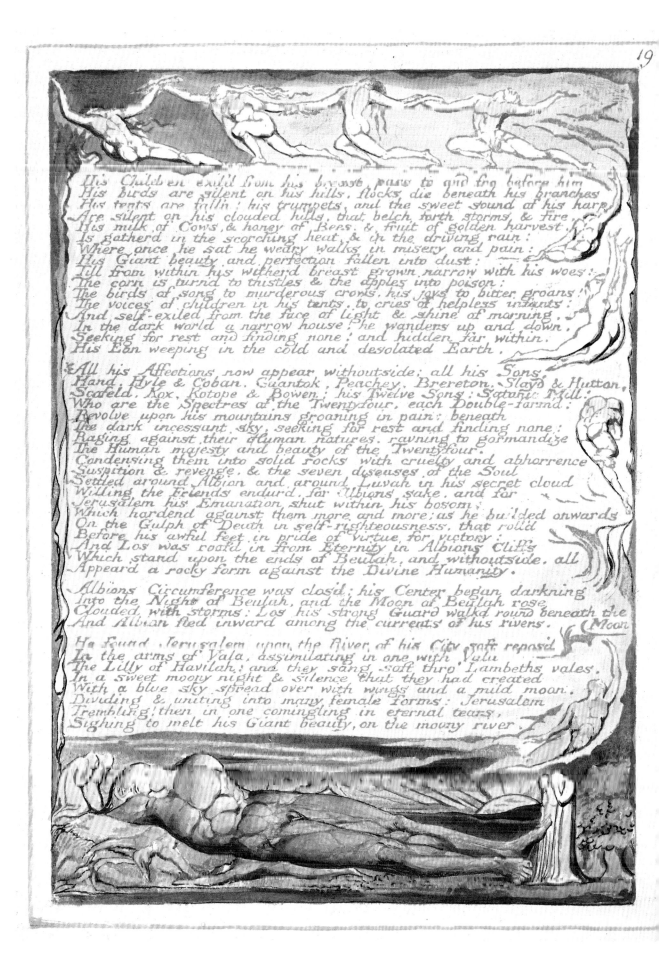

His Children exil'd from his breast pass to and fro before him
His birds are silent on his hills, flocks die beneath his branches
His tents are fallen! his trumpets, and the sweet sound of his harp
Are silent on his clouded hills, that belch forth storms, & fire.
His milk of Cows, & honey of Bees, & fruit of golden harvest,
Is gatherd in the scorching heat, & in the driving rain:
Where once he sat he weary walks in misery and pain:
His Giant beauty and perfection fallen into dust:
Till from within his witherd breast grown narrow with his woes:
The corn is turnd to thistles & the apples into poison:
The birds of song to murderous crows, his joys to bitter groans!
The voices of children in his tents, to cries of helpless infants!
And self-exiled from the face of light & shine of morning,
In the dark world a narrow house! he wanders up and down,
Seeking for rest and finding none! and hidden far within.
His Eon weeping in the cold and desolated Earth.

All his Affections now appear withoutside: all his Sons,
Hand, Hyle & Coban. Guantok, Peachey, Brereton, Slayd & Hutton,
Scofeld, Kox, Kotope & Bowen; his Twelve Sons: Satanic Mill:
Who are the Spectres of the Twentyfour, each Double-formd:
Revolve upon his mountains groaning in pain: beneath
The dark incessant sky, seeking for rest and finding none:
Raging against their Human natures, ravning to gormandize
The Human majesty and beauty of the Twentyfour.
Condensing them into solid rocks with cruelty and abhorrence
Suspition & revenge, & the seven diseases of the Soul
Settled around Albion and around Luvah in his secret cloud
Willing the Friends endurd, for Albions sake, and for
Jerusalem his Emanation, shut within his bosom:
Which hardend against them more and more; as he builded onwards
On the Gulph of Death in self-righteousness, that rolld
Before his awful feet in pride of virtue, for victory:
And Los was rooted in from Eternity in Albions Cliffs
Which stand upon the ends of Beulah, and withoutside, all
Appeard a rocky form against the Divine Humanity.

Albions Circumference was clos'd: his Center began darkning
Into the Night of Beulah, and the Moon of Beulah rose,
Clouded with storms: Los his strong Guard walkd round beneath the
And Albion fled inward among the currents of his rivers.              Moon

He found Jerusalem upon the River of his City soft repos'd
In the arms of Vala, assimilating in one with Vala
The Lilly of Havilah: and they sang soft thro' Lambeths vales,
In a sweet moony night & silence that they had created
With a blue sky spread over with wings and a mild moon,
Dividing & uniting into many female forms: Jerusalem
Trembling! then in one comingling in eternal tears,
Sighing to melt his Giant beauty, on the moony river.

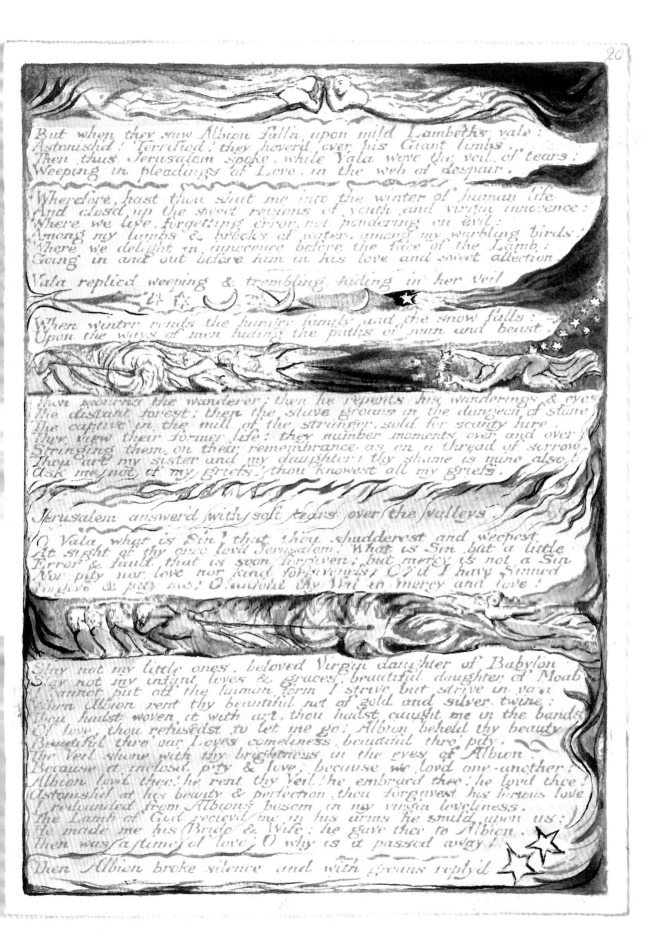

But when they saw Albion fall'n upon mild Lambeths vale:
Astonish'd! Terrified! they hover'd over his Giant limbs.
Then thus Jerusalem spoke, while Vala wove the veil of tears:
Weeping in pleadings of Love, in the web of despair.

Wherefore hast thou shut me into the winter of human life
And closed up the sweet regions of youth and virgin innocence:
Where we live, forgetting error, not pondering on evil:
Among my lambs & brooks of water, among my warbling birds:
Where we delight in innocence before the face of the Lamb:
Going in and out before him in his love and sweet affection.

Vala replied weeping & trembling, hiding in her veil

When winter rends the hungry family and the snow falls:
Upon the ways of men hiding the paths of man and beast.

Then mourns the wanderer: then he repents his wanderings & eyes
The distant forest; then the slave groans in the dungeon of stone.
The captive in the mill of the stranger, sold for scanty hire.
They view their former life: they number moments over and over.
Stringing them on their remembrance as on a thread of sorrow.
Thou art my sister and my daughter! thy shame is mine also:
Ask me not of my griefs! thou knowest all my griefs.

Jerusalem answer'd with soft tears over the valleys.

O Vala what is Sin? that thou shudderest and weepest
At sight of thy once lov'd Jerusalem! What is Sin but a little
Error & fault that is soon forgiven; but mercy is not a Sin
Nor pity nor love nor kind forgiveness! O! if I have Sinned
Forgive & pity me! O! unfold thy Veil in mercy and love!

Slay not my little ones, beloved Virgin daughter of Babylon
Slay not my infant loves & graces, beautiful daughter of Moab
I cannot put off the human form I strive but strive in vain
When Albion rent thy beautiful net of gold and silver twine:
Thou hadst woven it with art, thou hadst caught me in the bands
Of love; thou refusedst to let me go; Albion beheld thy beauty
Beautiful thro' our Loves comeliness, beautiful thro' pity.
The Veil shone with thy brightness in the eyes of Albion,
Because it inclosd pity & love; because we lovd one-another!
Albion lovd thee! he rent thy Veil! he embraced thee! he lovd thee!
Astonish'd at his beauty & perfection, thou forgavest his furious love:
I redounded from Albions bosom in my virgin loveliness.
The Lamb of God recievd me in his arms he smild upon us:
He made me his Bride & Wife: he gave thee to Albion.
Then was a time of love! O why is it passed away!

Then Albion broke silence and with groans replyd

O Vala! O Jerusalem! do you delight in my groans
You O lovely forms, you have prepared my death-cup:
The disease of Shame covers me from head to feet: I have no hope
Every boil upon my body is a separate & deadly Sin.
Doubt first assaild me, then Shame took possession of me
Shame divides Families. Shame hath divided Albion in sunder!
First fled my Sons, & then my Daughters, then my Wild Animations
My Cattle next, last even the Dog at my Gate. the Forests fled
The Corn-fields, & the breathing Gardens outside separated
The Sea; the Stars; the Sun; the Moon; drivn forth by my disease
All is Eternal Death unless you can weave a chaste
Body over an unchaste Mind! Vala! O that thou wert pure!
That the deep wound of Sin might be closd up with the Needle.
And with the Loom: to cover Gwendolen & Ragan with costly Robes
Of Natural Virtue, for their Spiritual forms without a Veil
Wither in Luvahs Sepulcher. I thrust him from my presence
And all my Children followd his loud howlings into the Deep.
Jerusalem! dissembler Jerusalem! I look into thy bosom:
I discover thy secret places: Cordella! I behold
Thee whom I thought pure as the heavens in innocence & fear:
Thy Tabernacle taken down, thy secret Cherubim disclosed
Art thou broken? Ah me Sabrina, running by my side:
In childhood what wert thou? unutterable anguish! Conwenna
Thy cradled infancy is most piteous, O hide, O hide!
Their secret gardens were made paths to the traveller:
I knew not of their secret loves with those I hated most.
Nor that their every thought was Sin & secret appetite
Hyle sees in fear, he howls in fury over them, Hand sees
In jealous fear: in stern accusation with cruel stripes
He drives them thro' the Streets of Babylon before my face:
Because they taught Luvah to rise into my clouded heavens
Battersea and Chelsea mourn for Cambel & Gwendolen!
Hackney and Holloway sicken for Estrild & Ignoge!
Because the Peak, Malvern & Cheviot Reason in Cruelty
Pennamenmawr & Dhinas-bran Demonstrate in Unbelief
Manchester & Liverpool are in tortures of Doubt & Despair
Malden & Colchester Demonstrate: I hear my Childrens voices
I see their piteous faces gleam out upon the cruel winds
From Lincoln & Norwich, from Edinburgh & Monmouth:
I see them distant from my bosom scourgd along the roads
Then lost in clouds; I hear their tender voices! clouds divide
I see them die beneath the whips of the Captains; they are taken
In solemn pomp into Chaldea across the breadths of Europe
Six months they lie embalmd in silent death; worshipped
Carried in Arks of Oak before the armies in the spring
Bursting their Arks they rise again to life; they play before
The Armies: I hear their loud cymbals & their deadly cries
Are the Dead cruel! are those who are infolded in moral Law
Revengeful? O that Death & Annihilation were the same!

Then Vala answerd spreading her scarlet Veil over Albion.

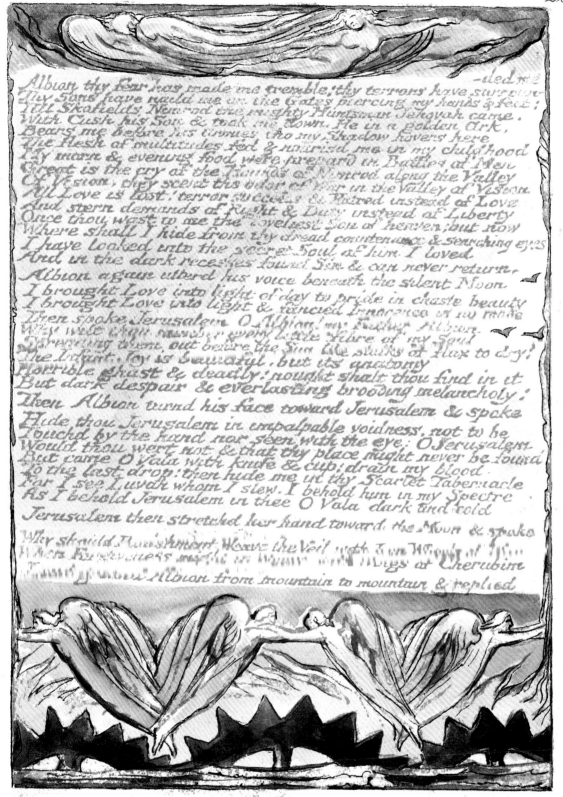

—ded me
Albion thy fear has made me tremble, thy terrors have surroun-
Thy Sons have naild me on the Gates piercing my hands & feet:
Till Skofields Nimrod the mighty Huntsman Jehovah came,
With Cush his Son & took me down. He in a golden Ark,
Bears me before his Armies tho my Shadow hovers here
The flesh of multitudes fed & nourishd me in my childhood
My morn & evening food were prepard in Battles of Men
Great is the cry of the Hounds of Nimrod along the Valley
Of Vision, they scent the odor of War in the Valley of Vision.
All Love is lost, terror succeeds & Hatred instead of Love
And stern demands of Right & Duty instead of Liberty
Once thou wast to me the loveliest Son of heaven; but now
Where shall I hide from thy dread countenance & searching eyes
I have looked into the secret Soul of him I loved
And in the dark recesses found Sin & can never return.

Albion again utterd his voice beneath the silent Moon

I brought Love into light of day to pride in chaste beauty
I brought Love into light & fancied Innocence is no more

Then spoke Jerusalem O Albion! my Father Albion
Why wilt thou number every little fibre of my Soul
Spreading them out before the Sun like stalks of flax to dry?
The Infant Joy is beautiful, but its anatomy
Horrible ghast & deadly! nought shalt thou find in it
But dark despair & everlasting brooding melancholy!

Then Albion turnd his face toward Jerusalem & spoke

Hide thou Jerusalem in impalpable voidness, not to be
Touchd by the hand nor seen with the eye: O Jerusalem
Would thou wert not & that thy place might never be found
But come O Vala with knife & cup: drain my blood
To the last drop: then hide me in thy Scarlet Tabernacle
For I see Luvah whom I slew. I behold him in my Spectre
As I behold Jerusalem in thee O Vala dark and cold

Jerusalem then stretched her hand toward the Moon & spoke

Why should Punishment Weave the Veil with Iron Wheels of War
When Forgiveness might it Weave with Wings of Cherubim

Loud groand Albion from mountain to mountain & replied

Jerusalem! Jerusalem! deluding shadow of Albion!
Daughter of my phantasy! unlawful pleasure! Albions curse!
I came here with intention to annihilate thee! But
My soul is melted away, unwoven within the Veil
Hast thou again, knitted the Veil of Vala, which I for thee
Pitying rent in ancient times. I see it whole and more
Perfect, and shining with beauty! But thou! O wretched Father!

Jerusalem. replyd. like a voice heard from a sepulcher:
Father! once piteous! Is Pity a Sin? Embalmd in Valas bosom.
In an Eternal Death for Albions sake, our best beloved.
Thou art my Father & my Brother: Why hast thou hidden me,
Remote from the divine Vision: my Lord and Saviour.

Trembling stood Albion at her words in jealous dark despair

He felt that Love and Pity are the same; a soft repose!
Inward complacency of Soul: a Self-annihilation!

I have erred! I am ashamed! and will never return more:
I have taught my children sacrifices of cruelty: what shall I answer?
I will hide it from Eternals! I will give myself for my Children!
Which way soever I turn, I behold Humanity and Pity!

He recoild: he rushd outwards; he bore the Veil whole away.
His fires redound from his Dragon Altars in Errors returning
He drew the Veil of Moral Virtue, woven for Cruel Laws.
And cast it into the Atlantic Deep, to catch the Souls of the Dead.
He stood between the Palm tree & the Oak of weeping
Which stand upon the edge of Beulah; and there Albion sunk
Down in sick pallid languor! These were his last words, relapsing
Hoarse from his rocks, from caverns of Derbyshire & Wales
And Scotland, utterd from the Circumference into Eternity.

Blasphemous Sons of Feminine delusion! God in the dreary Void.
Dwells from Eternity, wide separated from the Human Soul
But thou deluding Image by whom imbud the Veil I rent
Lo here is Valas Veil whole, for a Law, a Terror & a Curse!
And therefore God takes vengeance on me: from my clay-cold bosom
My children wander trembling victims of his Moral Justice.
His snows fall on me and cover me, while in the Veil I fold
My dying limbs. Therefore O Manhood, if thou art aught
But a meer Phantasy, hear dying Albions Curse!
May God who dwells in this dark Ulro & voidness, vengeance take,
And draw thee down into this Abyss of sorrow and torture,
Like me thy Victim. O that Death & Annihilation were the same!

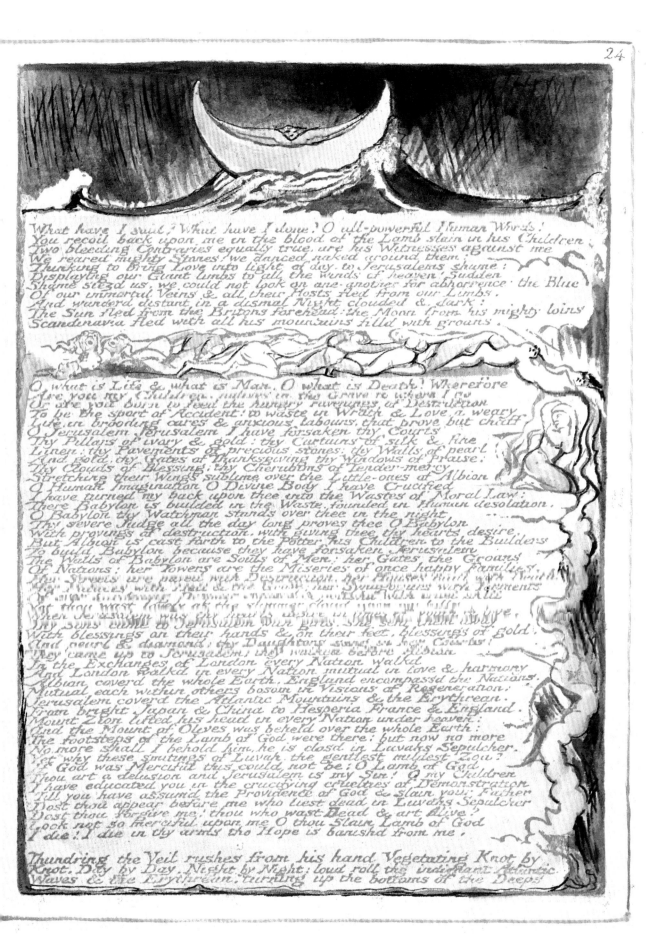

What have I said? What have I done? O all-powerful Human Words!
You recoil back upon me in the blood of the Lamb slain in his Children.
Two bleeding Contraries equally true, are his Witnesses against me
We reared mighty Stones! we danced naked around them:
Thinking to bring Love into light of day, to Jerusalems shame:
Displaying our Giant limbs to all the winds of heaven! Sudden
Shame siezd us, we could not look on one-another for abhorrence: the Blue
Of our immortal Veins & all their Hosts fled from our Limbs,
And wanderd distant in a dismal Night clouded & dark:
The Sun fled from the Britons forehead: the Moon from his mighty loins:
Scandinavia fled with all his mountains filld with groans.

O what is Life & what is Man. O what is Death! Wherefore
Are you my Children, natives in the Grave to whom I go
Or are you born to feed the hungry ravenings of Destruction,
To be the sport of Accident! to waste in Wrath & Love, a weary
Life, in brooding cares & anxious labours, that prove but chaff
O Jerusalem Jerusalem I have forsaken thy Courts
Thy Pillars of ivory & gold: thy Curtains of silk & fine
Linen: thy Pavements of precious stones: thy Walls of pearl
And gold, thy Gates of Thanksgiving thy Windows of Praise:
Thy Clouds of Blessing; thy Cherubims of Tender-mercy
Stretching their Wings sublime over the Little-ones of Albion
O Human Imagination O Divine Body I have Crucified,
I have turned my back upon thee into the Wastes of Moral Law:
There Babylon is builded in the Waste, founded in Human desolation.
O Babylon thy Watchman stands over thee in the night
Thy severe Judge all the day long proves thee O Babylon
With provings of destruction, with giving thee thy hearts desire,
But Albion is cast forth to the Potter his Children to the Builders
To build Babylon because they have forsaken Jerusalem
The Walls of Babylon are Souls of Men: her Gates the Groans
Of Nations: her Towers are the Miseries of once happy Families.
Her Streets are paved with Destruction, her Houses built with Death
Her Palaces with Hell & the Grave; her Synagogues with Torments
Of ever-hardening Despair squard & polishd with cruel skill
Yet thou wast lovely as the summer cloud upon my hills
When Jerusalem was thy hearts desire in times of youth & love.
Thy Sons came to Jerusalem with gifts, she sent them away
With blessings on their hands & on their feet, blessings of gold,
And pearl & diamond: thy Daughters sang in her Courts:
They came up to Jerusalem; they walked before Albion
In the Exchanges of London every Nation walkd
And London walkd in every Nation mutual in love & harmony
Albion coverd the whole Earth, England encompass'd the Nations,
Mutual each within others bosom in Visions of Regeneration;
Jerusalem coverd the Atlantic Mountains & the Erythrean,
From bright Japan & China to Hesperia France & England.
Mount Zion lifted his head in every Nation under heaven:
And the Mount of Olives was beheld over the whole Earth:
The footsteps of the Lamb of God were there: but now no more
No more shall I behold him, he is closd in Luvahs Sepulcher.
Yet why these smitings of Luvah, the gentlest mildest Zoa?
If God was Merciful this could not be: O Lamb of God
Thou art a delusion and Jerusalem is my Sin! O my Children
I have educated you in the crucifying cruelties of Demonstration
Till you have assumd the Providence of God & slain your Father
Dost thou appear before me who liest dead in Luvahs Sepulcher
Dost thou forgive me! thou who wast Dead & art Alive?
Look not so merciful upon me O thou Slain Lamb of God
I die! I die in thy arms tho Hope is banishd from me.

Thundring the Veil rushes from his hand Vegetating Knot by
Knot, Day by Day, Night by Night; loud roll the indignant Atlantic
Waves & the Erythrean, turning up the bottoms of the Deeps

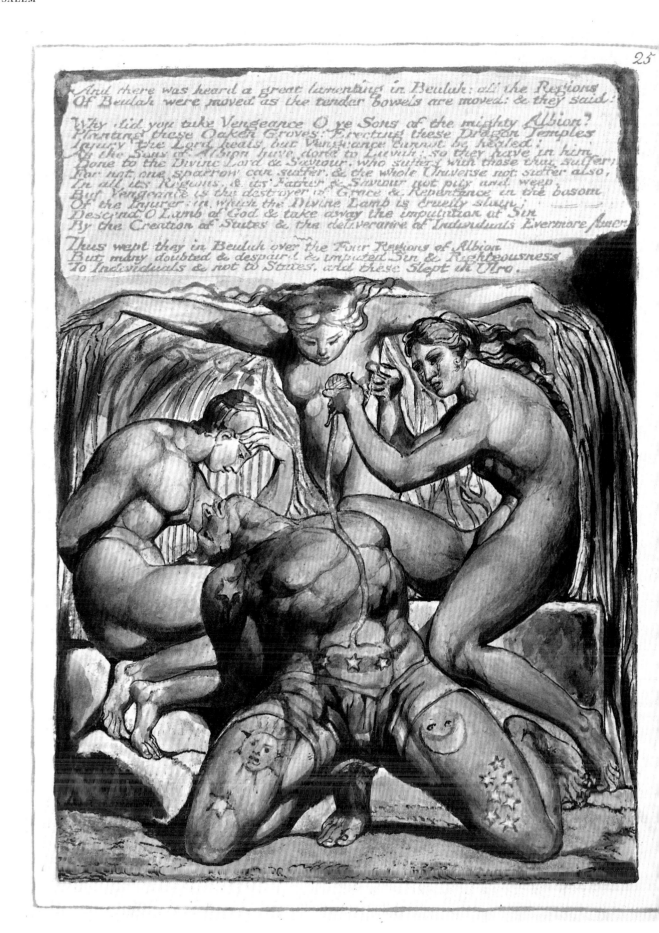

And there was heard a great lamenting in Beulah: all the Regions
Of Beulah were moved as the tender bowels are moved: & they said:

Why did you take Vengeance O ye Sons of the mighty Albion?
Planting these Oaken Groves: Erecting these Dragon Temples
Injury the Lord heals but Vengeance cannot be healed:
As the Sons of Albion have done to Luvah: so they have in him
Done to the Divine Lord & Saviour, who suffers with those that suffer;
For not one sparrow can suffer. & the whole Universe not suffer also,
In all its Regions, & its Father & Saviour not pity and weep,
But Vengeance is the destroyer of Grace & Repentance in the bosom
Of the Injurer: in which the Divine Lamb is cruelly slain;
Descend O Lamb of God & take away the imputation of Sin
By the Creation of States & the deliverance of Individuals Evermore Amen

Thus wept they in Beulah over the Four Regions of Albion
But many doubted & despaird & imputed Sin & Righteousness
To Individuals & not to States, and these Slept in Ulro.

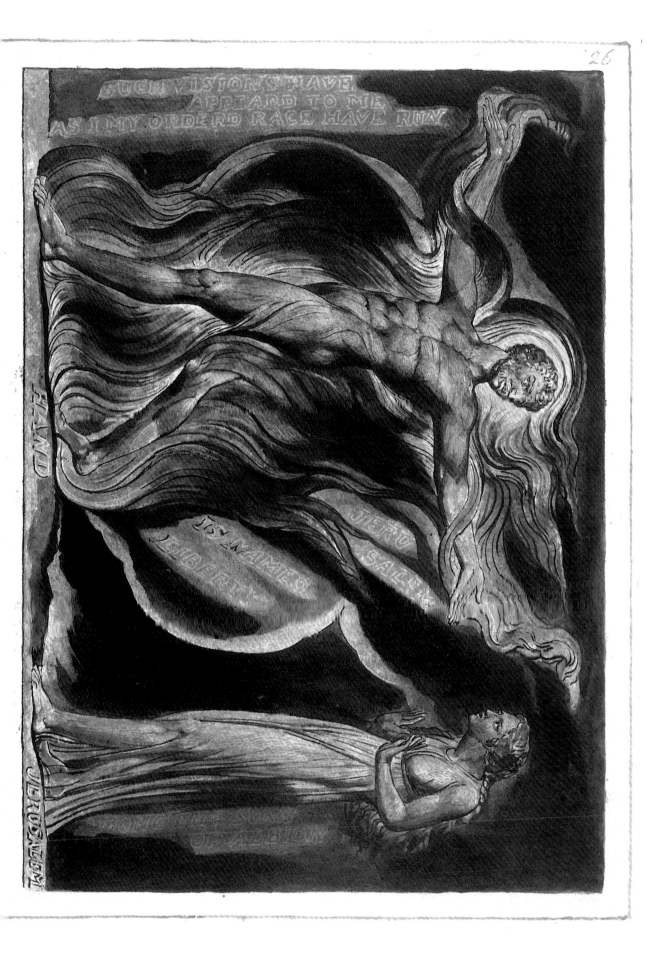

27

## To the Jews.

Jerusalem the Emanation of the Giant Albion! Can it be? Is it a Truth that the Learned have explored? Was Britain the Primitive Seat of the Patriarchal Religion? If it is true: my title-page is also True, that Jerusalem was & is the Emanation of the Giant Albion. It is True, and cannot be controverted. Ye are united O ye Inhabitants of Earth in One Religion. The Religion of Jesus: the most Ancient, the Eternal; & the Everlasting Gospel — The Wicked will turn it to Wickedness, the Righteous to Righteousness. Amen! Huzza! Selah!

"All things Begin & End in Albions Ancient Druid Rocky Shore."

Your Ancestors derived their origin from Abraham, Heber, Shem, and Noah, who were Druids: as the Druid Temples (which are the Patriarchal Pillars & Oak Groves) over the whole Earth witness to this day.

You have a tradition, that Man anciently contain'd in his mighty limbs all things in Heaven & Earth: this you received from the Druids.

"But now the Starry Heavens are fled from the mighty limbs of Albion"

Albion was the Parent of the Druids; & in his Chaotic State of Sleep Satan & Adam & the whole World was Created by the Elohim.

The fields from Islington to Marybone,
To Primrose Hill and Saint Johns Wood:
Were builded over with pillars of gold,
And there Jerusalems pillars stood.

Her Little-ones ran on the fields
The Lamb of God among them seen
And fair Jerusalem his Bride:
Among the little meadows green.

Pancrass & Kentish-town repose
Among her golden pillars high:
Among her golden arches which
Shine upon the starry sky.

The Jews-harp-house & the Green Man;
The Ponds where Boys to bathe delight:
The fields of Cows by Willans farm:
Shine in Jerusalems pleasant sight.

She walks upon our meadows green:
The Lamb of God walks by her side:
And every English Child is seen,
Children of Jesus & his Bride.

Forgiving trespasses and sins
Lest Babylon with cruel Og,
With Moral & Self-righteous Law
Should Crucify in Satans Synagogue!

What are those golden Builders doing
Near mournful ever-weeping Paddington
Standing above that mighty Ruin
Where Satan the first victory won.

Where Albion slept beneath the Fatal Tree
And the Druids golden Knife,
Rioted in human gore,
In Offerings of Human Life

They groan'd aloud on London Stone
They groan'd aloud on Tyburns Brook
Albion gave his deadly groan,
And all the Atlantic mountains shook

Albions Spectre from his Loins
Tore forth in all the pomp of War:
Satan his name: in flames of fire
He stretch'd his Druid Pillars far.

Jerusalem fell from Lambeths Vale,
Down thro Poplar & Old Bow;
Thro Malden & across the Sea,
In War & howling death & woe.

The Rhine was red with human blood:
The Danube rolld a purple tide:
On the Euphrates Satan stood:
And over Asia stretch'd his pride.

He witherd up sweet Zions Hill,
From every Nation of the Earth:
He witherd up Jerusalems Gates,
And in a dark Land gave her birth.

He witherd up the Human Form,
By laws of sacrifice for sin:
Till it became a Mortal Worm:
But O! translucent all within.

The Divine Vision still was seen
Still was the Human Form, Divine
Weeping in weak & mortal clay
O Jesus still the Form was thine.

And thine the Human Face & thine
The Human Hands & Feet & Breath
Entering thro' the Gates of Birth
And passing thro' the Gates of Death

And O thou Lamb of God, whom I
Slew in my dark self-righteous pride:
Art thou returnd to Albions Land!
And is Jerusalem thy Bride?

Come to my arms & never more
Depart; but dwell for ever here:
Create my Spirit to thy Love:
Subdue my Spectre to thy Fear.

Spectre of Albion! warlike Fiend!
In clouds of blood & ruin roll'd:
I here reclaim thee as my own
My Selfhood! Satan! armd in gold.

Is this thy soft Family-Love
Thy cruel Patriarchal pride
Planting thy family alone,
Destroying all the World beside.

A mans worst enemies are those
Of his own house & family:
And he who makes his law a curse
By his own law shall surely die.

In my Exchanges every Land
Shall walk, & mine in every Land,
Mutual shall build Jerusalem:
Both heart in heart & hand in hand.

If Humility is Christianity; you O Jews are the true Christians; If your tradition that Man contained in his limbs, all Animals, is True & they were separated from him by cruel Sacrifices: and when compulsory cruel Sacrifices had brought Humanity into a Feminine Tabernacle, in the loins of Abraham & David; the Lamb of God, the Saviour became apparent on Earth as the Prophets had foretold? The Return of Israel is a Return to Mental Sacrifice & War. Take up the Cross O Israel & follow Jesus.

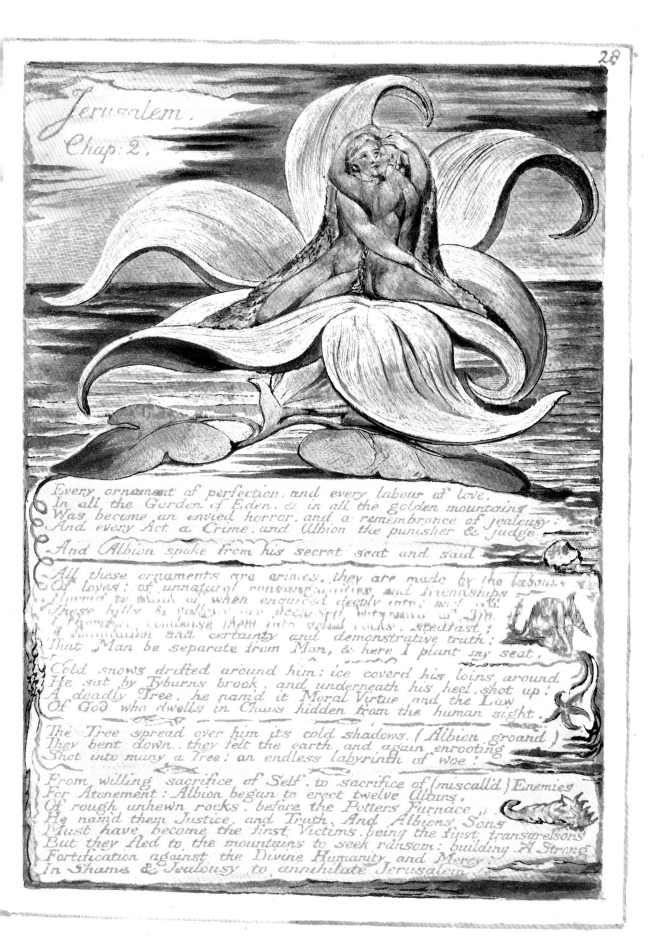

*Jerusalem.*
*Chap: 2.*

Every ornament of perfection. and every labour of love.
In all the Garden of Eden. & in all the golden mountains
Was become an envied horror. and a remembrance of jealousy:
And every Act a Crime. and Albion the punisher & judge.

And Albion spoke from his secret seat and said

All these ornaments are crimes. they are made by the labours
Of loves: of unnatural consanguinities and friendships
Horrid to think of when enquired deeply into; and all
These hills & valleys are accursed witnesses of Sin
I therefore condense them into solid rocks. stedfast!
A foundation and certainty and demonstrative truth:
That Man be separate from Man, & here I plant my seat.

Cold snows drifted around him: ice coverd his loins around
He sat by Tyburns brook, and underneath his heel, shot up!
A deadly Tree. he namd it Moral Virtue, and the Law
Of God who dwells in Chaos hidden from the human sight.

The Tree spread over him its cold shadows. (Albion groand)
They bent down. they felt the earth and again enrooting
Shot into many a Tree! an endless labyrinth of woe!

From willing sacrifice of Self. to sacrifice of (miscalld) Enemies
For Atonement: Albion began to erect twelve Altars,
Of rough unhewn rocks. before the Potters Furnace
He namd them Justice, and Truth. And Albions Sons
Must have become the first Victims. being the first transgressons
But they fled to the mountains to seek ransom: building A Strong
Fortification against the Divine Humanity and Mercy.
In Shame & Jealousy to annihilate Jerusalem.

Then the Divine Vision like a silent Sun appeard above
Albions dark rocks: setting behind the Gardens of Kensington
On Tyburns River, in clouds of blood: where was mild Zion Hills
Most ancient promontory, and in the Sun, a Human Form appeard
And thus the Voice Divine went forth upon the rocks of Albion

I elected Albion for my glory; I gave to him the Nations,
Of the whole Earth. He was the Angel of my Presence: and all
The Sons of God were Albions Sons: and Jerusalem was my joy.
The Reactor hath hid himself thro envy. I behold him.
But you cannot behold him till he be revealed in his System
Albions Reactor must have a Place prepard: Albion must Sleep
The Sleep of Death, till the Man of Sin & Repentance be revealed.
Hidden in Albions Forests he lurks: he admits of no Reply
From Albion: but hath founded his Reaction into a Law
Of Action, for Obedience to destroy the Contraries of Man
He hath compelld Albion to become a Punisher & hath possessd
Himself of Albions Forests & Wilds: and Jerusalem is taken:
The City of the Woods in the Forest of Ephratah is taken!
London is a stone of her ruins; Oxford is the dust of her walls!
Sussex & Kent are her scatterd garments: Ireland her holy place:
And the murderd bodies of her little ones are Scotland and Wales.
The Cities of the Nations are the smoke of her consummation
The Nations are her dust: ground by the chariot wheels
Of her lordly conquerors, her palaces levelld with the dust
I come that I may find a way for my banished ones to return
Fear not O little Flock I come! Albion shall rise again.

So saying, the mild Sun inclosd the Human Family.

Forthwith from Albions darkning locks came two Immortal forms
Saying We alone are escaped, O merciful Lord and Saviour,
We flee from the interiors of Albions hills and mountains!
From his Valleys Eastward; from Amalek Canaan & Moab:
Beneath his vast ranges of hills surrounding Jerusalem.
Albion walkd on the steps of fire before his Halls
And Vala walkd with him in dreams of soft deluding slumber.
He looked up & saw the Prince of Light with splendor faded
Then Albion ascended mourning into the porches of his Palace
Above him rose a Shadow from his wearied intellect
Of living gold, pure, perfect, holy; in white linen pure he hoverd
A sweet entrancing self-delusion a watry vision of Albion
Soft exulting in existence; all the Man absorbing!

Albion fell upon his face prostrate before the watry Shadow
Saying O Lord, whence is this change, thou knowest I am nothing!
And Vala trembled & coverd her face! & her locks were spread on the
pavement

We heard astonishd at the Vision & our hearts trembled within us:
We heard the voice of slumberous Albion, and thus he spoke,
Idolatrous to his own Shadow words of eternity uttering:
O I am nothing when I enter into judgment with thee!
If thou withdraw thy breath I die & vanish into Hades
If thou dost lay thine hand upon me behold I am silent:
If thou withhold thine hand; I perish like a fallen leaf:
O I am nothing: and to nothing must return again:
If thou withdraw thy breath. Behold I am oblivion.

He ceasd: the shadowy voice was silent: but the cloud hoverd over their heads
In golden wreathes, the sorrow of Man; & the balmy drops fell down.
And lo! that son of Man that Shadowy Spirit of mild Albion:
Luvah descended from the cloud in terror Albion rose:
Indignant rose the awful Man, & turnd his back on Vala.

We heard the voice of Albion starting from his sleep:
Whence is this voice crying Enion! that soundeth in my ears?
O cruel pity! O dark deceit! can love seek for dominion?

And Luvah strove to gain dominion over Albion
They strove together above the Body where Vala was inclosd
And the dark Body of Albion left prostrate upon the crystal pavement,
Coverd with boils from head to foot: the terrible smitings of Luvah.

Then frownd the fallen Man, and put forth Luvah from his presence
Saying, Go and Die the Death of Man, for Vala the sweet wanderer.
I will turn the volutions of your ears outward, and bend your nostrils
Downward, and your fluxile eyes englobd roll round in fear:
Your withring lips and tongue shrink up into a narrow circle,
Till into narrow forms you creep: go take your fiery way:
And learn what tis to absorb the Man you Spirits of Pity & Love.

They heard the voice and fled swift as the winters setting sun.
And now the human blood foamd high, the Spirits Luvah & Vala,
Went down the Human Heart where Paradise & its joys abounded,
In jealous fears & fury & rage, & flames roll round their fervid feet:
And the vast form of Nature like a serpent playd before them
And as they fled in folding fires & thunders of the deep:
Vala shrunk in like the dark sea that leaves its slimy banks,
And from her bosom Luvah fell far as the east and west.
And the vast form of Nature like a serpent rolld between
Whether of Jerusalems or Valas ruins congenerated we know not
All is confusion: all is tumult, & we alone are escaped.
So spoke the fugitives; they joind the Divine Family, trembling

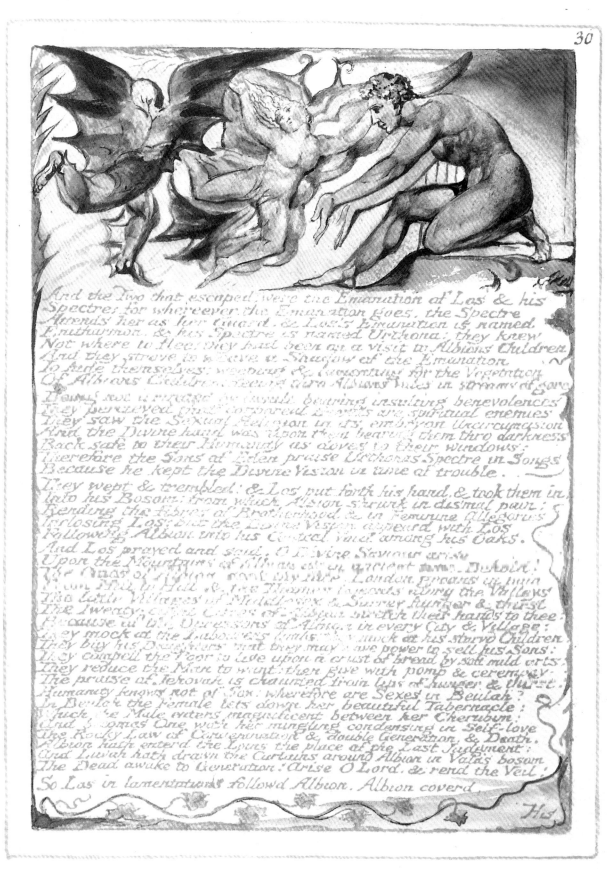

And the Two that escaped, were the Emanation of Los & his
Spectres for whereever the Emanation goes, the Spectre
Attends her as her Guard, & Los's Emanation is named
Enitharmon, & his Spectre is named Urthona: they knew
Not where to flee: they had been on a visit to Albions Children
And they strove to gather a Shadow of the Emanation
To hide themselves: weeping & lamenting for the Vegetation
Of Albions Children: fleeing from Albions Sublimity gone

Having not a moment's breath from insulting benevolences
They perceived that corporeal friends are spiritual enemies
They saw the Sexual Religion in its embryon Uncircumcision
And the Divine hand was upon them bearing them thro darkness
Back safe to their Humanity as doves to their windows:
Therefore the Sons of Eden praise Urthonas Spectre in Songs
Because he kept the Divine Vision in time of trouble.

They wept & trembled: & Los put forth his hand & took them in
Into his Bosom: from which Albion shrunk in dismal pain;
Rending the fibres of Brotherhood & in Feminine Allegories
Inclosing Los: But the Divine Vision appeard with Los
Following Albion into his Central Void among his Oaks.

And Los prayed and said. O Divine Saviour arise
Upon the Mountains of Albion as in ancient time. Behold!
The Cities of Albion seek thy face. London groans in pain
From Hill to Hill & the Thames laments along the Valleys
The little Villages of Middlesex & Surrey hunger & thirst
The Twenty-eight Cities of Albion stretch their hands to thee:
Because of the Oppressors of Albion in every City & Village
They mock at the Labourers limbs: they mock at his starvd Children
They buy his Daughters that they may have power to sell his Sons:
They compell the Poor to live upon a crust of bread by soft mild arts:
They reduce the Man to want: then give with pomp & ceremony.
The praise of Jehovah is chaunted from lips of hunger & thirst
Humanity knows not of Sex: wherefore are Sexes in Beulah?
In Beulah the Female lets down her beautiful Tabernacle:
Which the Male enters magnificent between her Cherubim:
And becomes One with her mingling condensing in Self-love
The Rocky Law of Condemnation & double Generation, & Death
Albion hath enterd the State Satan! Be permanent O State!
And be thou for ever accursed! that Albion may arise again:
And be thou created into a State! I go forth to Create
States: to deliver Individuals evermore! Amen.

So Los in lamentations followd Albion. Albion coverd

His western heaven with rocky clouds of death & despair.
Fearing that Albion should turn his back against the Divine Vision
Los took his globe of fire to search the interiors of Albions
Bosom, in all the terrors of friendship, entering the caves
Of despair & death, to search the tempters out, walking among
Albions rocks & precipices! caves of solitude & dark despair,
And saw every Minute Particular of Albion degraded, & murderd
But saw not by whom; they were hidden within in the minute particulars
Of which they had possessd themselves; and there they take up
The articulations of a mans soul, and laughing throw it down
Into the frame, then knock it out upon the plank, & souls are bakd
In bricks to build the pyramids of Heber & Terah. But Los
Searchd in vain: closd from the minutia he walkd, difficult.
He came down from Highgate thro Hackney & Holloway towards London
Till he came to old Stratford & thence to Stepney & the Isle
Of Leuthas Dogs, thence thro the narrows of the Rivers side
And saw every minute particular, the jewels of Albion, running down
The kennels of the streets & lanes as if they were abhorrd.
Every Universal Form, was become barren mountains of Moral
Virtue: and every Minute Particular hardend into grains of sand:
And all the tendernesses of the soul cast forth as filth & mire.
Among the winding places of deep contemplation intricate
To where the Tower of London frownd dreadful over Jerusalem;
A building of Luvah builded in Jerusalems eastern gate to be
His secluded Court: thence to Bethlehem where was builded
Dens of despair in the house of bread: enquiring in vain
Of stones and rocks he took his way, for human form was none:
And thus he spoke, looking on Albions City with many tears

What shall I do! what could I do, if I could find these Criminals
I could not dare to take vengeance; for all things are so constructed
And builded by the Divine hand, that the sinner shall always escape,
And he who takes vengeance alone is the criminal of Providence;
If I should dare to lay my finger on a grain of sand
In way of vengeance; I punish the already punishd: O whom
Should I pity if I pity not the sinner who is gone astray!
O Albion, if thou takest vengeance; if thou revengest thy wrongs
Thou art for ever lost! What can I do to hinder the Sons
Of Albion from taking vengeance? or how shall I them perswade.

So spoke Los, travelling thro darkness & horrid solitude:
And he beheld Jerusalem in Westminster & Marybone,
Among the ruins of the Temple: and Vala who is her Shadow.
Jerusalems Shadow bent northward over the Island white.
At length he sat on London Stone, & heard Jerusalems voice.

Albion I cannot be thy Wife, thine own Minute Particulars,
Belong to God alone, and all thy little ones are holy
They are of Faith & not of Demonstration; wherefore is Vala
Clothd in black mourning upon my rivers currents, Vala awake!
I hear thy shuttles sing in the sky, and round my limbs
I feel the iron threads of love & jealousy & despair.

Vala reply'd, Albion is mine! Luvah gave me to Albion
And now recieves reproach & hate. Was it not said of old
Set your Son before a man & he shall take you & your sons
For slaves: but set your Daughter before a man and she
Shall make him & his sons & daughters your slaves for ever!
And is this Faith? Behold the strife of Albion & Luvah
Is great in the east, their spears of blood rage in the eastern heaven
Urizen is the champion of Albion, they will slay my Luvah:
And thou O harlot daughter! daughter of despair art all
This cause of these shakings of my towers on Euphrates.
Here is the House of Albion, & here is thy secluded place
And here we have found thy sins; & hence we turn thee forth,
For all to avoid thee: to be astonishd at thee for thy sins:
Because thou art the impurity & the harlot: & thy children,
Children of whoredoms; born for Sacrifice: for the meat & drink
Offering: to sustain the glorious combat & the battle & war
That Man may be purified by the death of thy delusions.

So saying she her dark threads cast over the trembling River:
And over the valleys, from the hills of Hertfordshire to the hills
Of Surrey mrom Middlesex & across Albions House

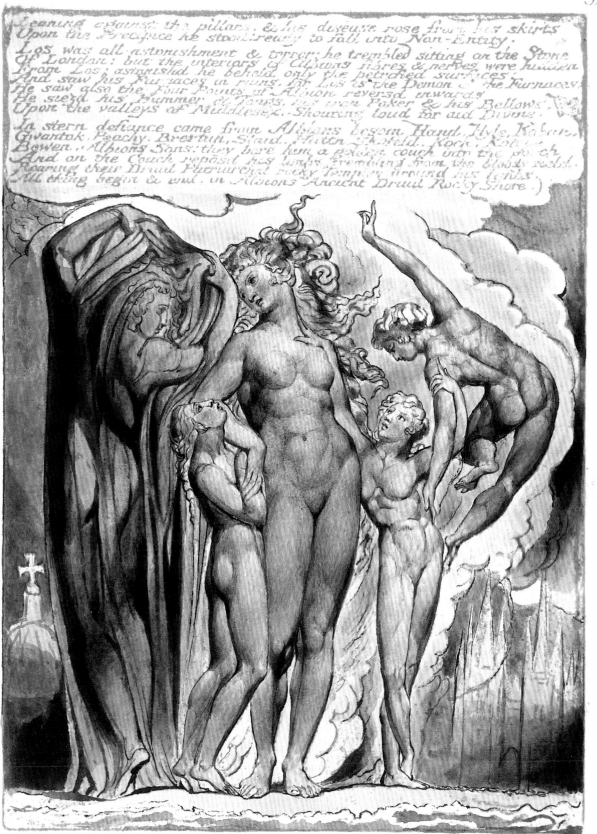

Turning his back to the Divine Vision. his Spectrous
Chaos before his face appeard: an Unformed Memory

Then spoke the Spectrous Chaos to Albion darkning cold
From the back & loins where dwell the Spectrous Dead

I am your Rational Power O Albion & that Human Form
You call Divine. is but a Worm seventy inches long
That creeps forth in a night & is dried in the morning sun
In forturous concourse of memorys accumulated & lost
It plows the Earth in its own conceit it overwhelms the Hills
Beneath its winding labyrinths. till a stone of the brook
Stops it in midst of its pride among its hills & rivers
Battersea & Chelsea mourn. London & Canterbury tremble
Their place shall not be found as the wind passes over
The ancient Cities of the Earth remove as a traveller
And shall Albions Cities remain when I pass over them
With my deluge of forgotten remembrances over the tablet

So spoke the Spectre to Albion. he is the Great Selfhood
Satan: Worshipd as God by the Mighty Ones of the Earth
Having a white Dot calld a Center from which branches out
A Circle in continual gyrations: this became a Heart
From which sprang numerous branches varying their motions
Producing many Heads three or seven or ten. & hands & feet
Innumerable at will of the unfortunate contemplator
Who becomes his food such is the way of the Devouring Power

And this is the cause of the appearance in the frowning Chaos
Albions Emanation which he had hidden in Jealousy
Appeard now in the frowning Chaos prolific upon the Chaos
Reflecting back to Albion in Sexual Reasoning Hermaphroditic

Albion spoke. Who art thou that appearest in gloomy pomp
Involving the Divine Vision in colours of autumn ripeness
I never saw thee till this time. nor beheld life abstracted
Nor darkness immingled with light on my furrowd field.
Whence camest thou? who art thou O loveliest? the Divine Vision
Is as nothing before thee. faded is all life and joy

Vala replied in clouds of tears Albions garment embracing

I was a City & a Temple built by Albions Children.
I was a Garden planted with beauty I allured on hill & valley
The River of Life to flow against my walls & among my trees
Vala was Albions Bride & Wife in great Eternity
The loveliest of the daughters of Eternity when in day-break
I emanated from Luvah over the Towers of Jerusalem
And in her Courts among her little Children offering up
The Sacrifice of fanatic love! why loved I Jerusalem!
Why was I one with her embracing in the Vision of Jesus
Wherefore did I loving create love. which never yet
Immingled God & Man. when thou & I hid the Divine Vision
In cloud of secret gloom which behold involve me round about
Know me now Albion: look upon me I alone am Beauty
The Imaginative Human Form is but a breathing of Vala
I breathe him forth into the Heaven from my secret Cave
Born of the Woman. to obey the Woman O Albion the mighty
For the Divine appearance is Brotherhood, but I am Love

Elevate into the Region of Brotherhood with my red fires

Art thou Vala? replied Albion. image of my repose
O how I tremble! how my members pour down milky fear!
A dewy garment covers me all over. all manhood is gone:
At thy word & at thy look death enrobes me about
From head to feet, a garment of death & eternal fear
Is not that Sun thy husband & that Moon thy glimmering Veil?
Are not the Stars of heaven thy Children? art thou not Babylon?
Art thou Nature Mother of all? is Jerusalem thy Daughter
Why have thou elevate inward: O dweller of outward chambers
From grot & cave beneath the Moon dim region of death
Where I laid my Plow in the hot noon, where my hot team fed
Where implements of War are forged, the Plow to go over the Nations
In pain girding me round like a rib of iron in heaven: O Vala
In Eternity they neither marry nor are given in marriage
Albion the high Cliff of the Atlantic is become a barren Land

Los stood at his Anvil: he heard the contentions of Vala
He heavd his thundring Bellows upon the valleys of Middlesex
He opend his Furnaces before Vala, then Albion frownd in anger
On his Rock: ere yet the Starry Heavens were fled away
From his awful Members, and thus Los cried aloud
To the Sons of Albion & to Hand the eldest Son of Albion
I hear the screech of Childbirth loud pealing, & the groans
Of Death, in Albions clouds dreadful utterd over all the Earth
What may Man be? who can tell! but what may Woman be?
To have power over Man from Cradle to corruptible Grave
There is a Throne in every Man, it is the Throne of God
This Woman has claimd as her own & Man is no more!
Albion is the Tabernacle of Vala & her Temple
And not the Tabernacle & Temple of the Most High
O Albion why wilt thou Create a Female Will?
To hide the most evident God in a hidden covert, even
In the shadows of a Woman & a secluded Holy Place
That we may pry after him as after a stolen treasure
Hidden among the Dead & murderd up from the paths of life
Hand! art thou not Reuben enrooting thyself into Bashan
Till thou remainest a vaporous Shadow in a Void! O Merlin!
Unknown among the Dead where never before Existence came
Is this the Female Will O ye lovely Daughters of Albion. To
Converse concerning Weight & Distance in the Wilds of Newton & Locke

So Los spoke standing on Mam-Tor looking over Europe & Asia
The Graves thunder beneath his feet from Ireland to Japan

Reuben slept in Bashan like one dead in the valley
Cut off from Albions mountains & from all the Earths summits
Between Succoth & Zaretan beside the Stone of Bohan
While the Daughters of Albion divided Luvah into three Bodies
Los bended his Nostrils down to the Earth, then sent him over
Jordan, to the Land of the Hittite: every-one that saw him
Fled! they fled at his horrible Form: they hid in caves
And dens, they looked on one-another & became what they beheld

Reuben returnd to Bashan, in despair he slept on the Stone
Then Gwendolen divided into Rahab & Tirza in Twelve Portions
Los rolled his Eyes into two narrow circles, then sent him
Over Jordan; all terrified fled: they became what they beheld
If Perceptive Organs vary: Objects of Perception seem to vary
If the Perceptive Organs close: their Objects seem to close also
Consider this O mortal Man: O worm of sixty winters said Los
Consider Sexual Organization & hide thee in the dust.

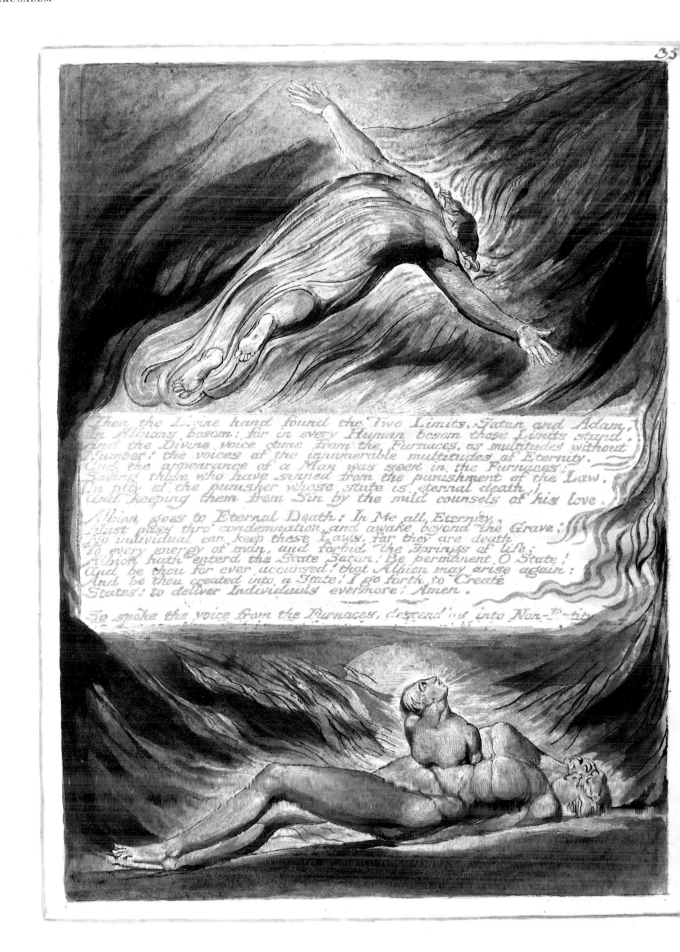

Then the Divine hand found the Two Limits, Satan and Adam,
In Albions bosom: for in every Human bosom those Limits stand.
And the Divine voice came from the Furnaces, as multitudes without
Number! the voices of the innumerable multitudes of Eternity.
And the appearance of a Man was seen in the Furnaces;
Saving those who have sinned from the punishment of the Law,
(In pity of the punisher whose state is eternal death,)
And keeping them from Sin by the mild counsels of his love.

Albion goes to Eternal Death: In Me all Eternity,
Must pass thro' condemnation, and awake beyond the Grave!
No individual can keep these Laws, for they are death
To every energy of man, and forbid the springs of life:
Albion hath enterd the State Satan! Be permanent O State!
And be thou for ever accursed! that Albion may arise again:
And be thou created into a State! I go forth to Create
States: to deliver Individuals evermore! Amen.

So spoke the voice from the Furnaces, descending into Non-Entity

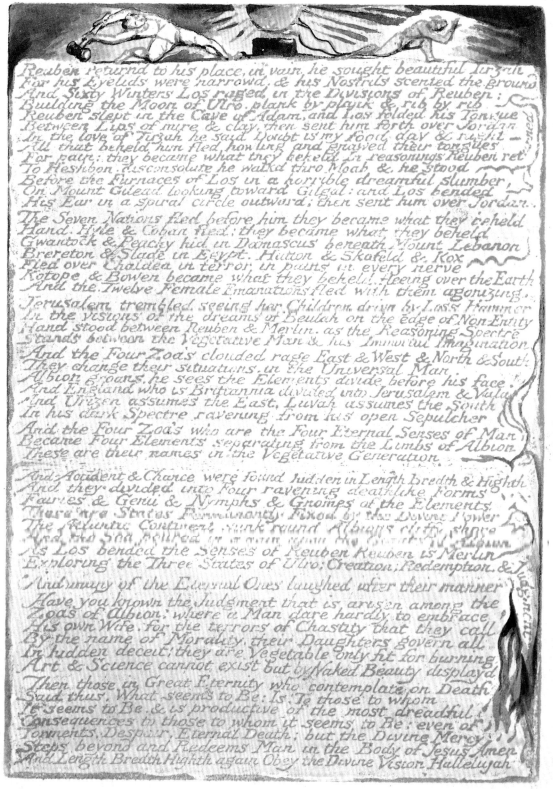

Reuben returnd to his place, in vain, he sought beautiful Tirzah
For his Eyelids were narrowd, & his Nostrils scented the ground
And Sixty Winters Los raged in the Divisions of Reuben:
Building the Moon of Ulro, plank by plank & rib by rib
Reuben slept in the Cave of Adam, and Los folded his Tongue
Between Lips of mire & clay, then sent him forth over Jordan
In the love of Tirzah he said Doubt is my food day & night—
All that beheld him fled howling and gnawd their tongues
For pain: they became what they beheld In reasonings Reuben ret
To Heshbon. disconsolate he walkd thro Moab & he stood
Before the Furnaces of Los in a horrible dreamful slumber,
On Mount Gilead looking toward Gilgal: and Los bended
His Ear in a spiral circle outward; then sent him over Jordan.

The Seven Nations fled before him they became what they beheld
Hand, Hyle & Coban fled: they became what they beheld
Gwantock & Peachy hid in Damascus beneath Mount Lebanon
Brereton & Slade in Egypt. Hutton & Skofeld & Kox
Fled over Chaldea in terror in pains in every nerve
Kotope, & Bowen became what they beheld fleeing over the Earth
And the Twelve Female Emanations fled with them agonizing.

Jerusalem trembled seeing her Children drivn by Loss Hammer
In the visions of the dreams of Beulah on the edge of Non-Entity
Hand stood between Reuben & Merlin, as the Reasoning Spectre
Stands between the Vegetative Man & his Immortal Imagination

And the Four Zoa's clouded rage East & West & North & South
They change their situations, in the Universal Man.
Albion groans, he sees the Elements divide before his face.
And England who is Britannia divided into Jerusalem & Vala
And Urizen assumes the East, Luvah assumes the South
In his dark Spectre ravening from his open Sepulcher

And the Four Zoa's who are the Four Eternal Senses of Man
Became Four Elements separating from the Limbs of Albion
These are their names in the Vegetative Generation.

And Accident & Chance were found hidden in Length Bredth & Highth
And they divided into Four ravening deathlike Forms
Fairies & Genii & Nymphs & Gnomes of the Elements.
There are States Permanently Fixed by the Divine Power
The Atlantic Continent sunk round Albions cliffy shore
And the Sea poured in amain upon the Giants of Albion
As Los bended the Senses of Reuben Reuben is Merlin
Exploring the Three States of Ulro; Creation; Redemption. & Judgment

And many of the Eternal Ones laughed after their manner

Have you known the Judgment that is arisen among the
Zoa's of Albion? where a Man dare hardly to embrace
His own Wife, for the terrors of Chastity that they call
By the name of Morality, their Daughters govern all
In hidden deceit! they are Vegetable only fit for burning
Art & Science cannot exist but by Naked Beauty displayd

Then those in Great Eternity who contemplate on Death
Said thus, What seems to Be: Is: To those to whom
It seems to Be, & is productive of the most dreadful
Consequences to those to whom it seems to Be: even of
Torments, Despair, Eternal Death; but the Divine Mercy
Steps beyond and Redeems Man in the Body of Jesus Amen
And Length Bredth Highth again Obey the Divine Vision Hallelujah

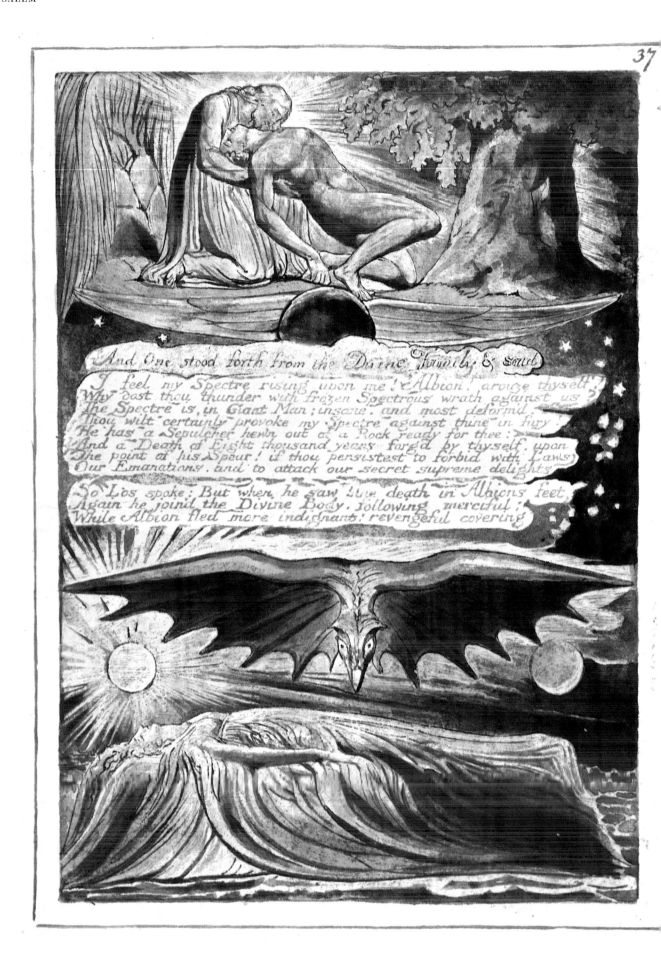

And One stood forth from the Divine Family & said

I feel my Spectre rising upon me! Albion! arouze thyself!
Why dost thou thunder with frozen Spectrous wrath against us?
The Spectre is, in Giant Man; insane. and most deform'd.
Thou wilt certainly provoke my Spectre against thine in fury!
He has a Sepulcher hewn out of a Rock ready for thee:
And a Death of Eight thousand years forg'd by thyself, upon
The point of his Spear! if thou persistest to forbid with Laws
Our Emanations, and to attack our secret supreme delights

So Los spoke: But when he saw blue death in Albions feet,
Again he joind the Divine Body, following merciful:
While Albion fled more indignant: revengeful covering

His face and bosom with petrific hardness, and his hands
And feet, lest any should enter his bosom & embrace
His hidden heart; his Emanation wept & trembled within him:
Uttering not his jealousy, but hiding it as with
Iron and steel, dark and opake, with clouds & tempests brooding:
His strong limbs shudder'd upon his mountains high and dark.

Turning from Universal Love petrific as he went,
His cold against the warmth of Eden rag'd with loud
Thunders of deadly war (the fever of the human soul,)
Fires and clouds of rolling smoke! but mild the Saviour follow'd him,
Displaying the Eternal Vision! the Divine Similitude!
In loves and tears of brothers, sisters, sons, fathers, and friends
Which if Man ceases to behold, he ceases to exist:

Saying, Albion! Our wars are wars of life, & wounds of love,
With intellectual spears, & long winged arrows of thought:
Mutual in one anothers love and wrath all renewing
We live as One Man; for contracting our infinite senses
We behold multitude; or expanding; we behold as one,
As One Man all the Universal Family; and that One Man
We call Jesus the Christ; and he in us, and we in him,
Live in perfect harmony in Eden the land of life,
Giving, recieving, and forgiving each others trespasses.
He is the Good shepherd, he is the Lord and master:
He is the Shepherd of Albion, he is all in all,
In Eden; in the garden of God, and in heavenly Jerusalem.
If we have offended, forgive us, take not vengeance against us.

Thus speaking; the Divine Family follow Albion:
I see them in the Vision of God upon my pleasant valleys.

I behold London; a Human awful wonder of God!
He says: Return, Albion, return! I give myself for thee:
My Streets are my, Ideas of Imagination.
Awake Albion, awake! and let us awake up together.
My Houses are Thoughts; my Inhabitants; Affections,
The children of my thoughts, walking within my blood-vessels,
Shut from my nervous form which sleeps upon the verge of Beulah
In dreams of darkness, while my vegetating blood in veiny pipes,
Rolls dreadful thro' the Furnaces of Los, and the Mills of Satan,
For Albions sake, and for Jerusalem thy Emanation
I give myself, and these my brethren give themselves for Albion.

So spoke London, immortal Guardian! I heard in Lambeths shades:
In Felpham I heard and saw the Visions of Albion
I write in South Molton Street, what I both see and hear
In regions of Humanity, in Londons opening streets.

I see thee awful Parent Land in light, behold I see!
Verulam! Canterbury! venerable parent of men,
Generous immortal Guardian golden clad! for Cities
Are Men, fathers of multitudes, and Rivers & Mountains
Are also Men; every thing is Human, mighty! sublime!
In every bosom a Universe expands, as wings
Let down at will around, and call'd the Universal Tent,
York, crown'd with loving kindness, Edinburgh, cloth'd
With fortitude as with a garment of immortal texture
Woven in looms of Eden, in spiritual deaths of mighty men
Who give themselves in Golgotha, Victims to Justice; where
There is in Albion a Gate of precious stones and gold
Seen only by Emanations, by vegetations viewless,
Bending across the road of Oxford Street; it from Hyde Park
To Tyburns deathful shades, admits the wandering souls
Of multitudes who die from Earth: this Gate cannot be found

By

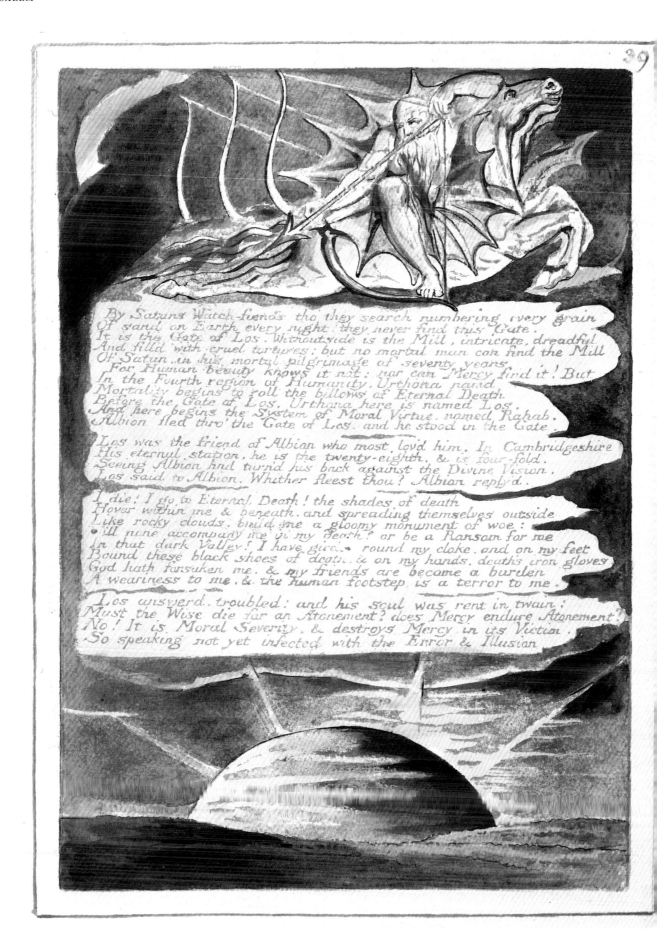

By Satans Watch-fiends tho they search numbering every grain
Of sand on Earth every night, they never find this Gate.
It is the Gate of Los. Withoutside is the Mill, intricate, dreadful.
And filld with cruel tortures: but no mortal man can find the Mill
Of Satan in his mortal pilgrimage of seventy years
  For Human beauty knows it not: nor can Mercy find it! But
In the Fourth region of Humanity, Urthona namd
Mortality begins to roll the billows of Eternal Death.
Before the Gate of Los. Urthona here is named Los.
And here begins the System of Moral Virtue, named Rahab.
Albion fled thro' the Gate of Los, and he stood in the Gate.

Los was the friend of Albion who most lovd him. In Cambridgeshire
His eternal station, he is the twenty-eighth, & is four-fold.
Seeing Albion had turnd his back against the Divine Vision.
Los said to Albion. Whither fleest thou? Albian replyd.

I die! I go to Eternal Death! the shades of death
Hover within me & beneath, and spreading themselves outside
Like rocky clouds, build me a gloomy monument of woe:
Will none accompany me in my death? or be a Ransom for me
In that dark Valley? I have girn round my cloke, and on my feet
Bound these black shoes of death, & on my hands, death's iron gloves
God hath forsaken me, & my friends are became a burden
A weariness to me, & the human footstep is a terror to me.

Los answerd, troubled: and his soul was rent in twain:
Must the Wise die for an Atonement? does Mercy endure Atonement?
No! It is Moral Severity, & destroys Mercy in its Victim.
So speaking not yet infected with the Error & Illusion

Los shudder'd at beholding Albion, for his disease
Arose upon him pale and ghastly: and he call'd around
The Friends of Albion; trembling at the sight of Eternal Death
The four appeard with their Emanations in fiery
Chariots: black their fires roll beholding Albions House of Eternity
Damp couch the flames beneath and silent, sick, stand shuddering
Before the Porch of sixteen pillars: weeping every one
Descended and fell down upon their knees round Albions knees
Swearing the Oath of God! with awful voice of thunders round
Upon the hills & valleys, and the cloudy Oath rolld far and wide.

Albion is sick! said every Valley, every mournful Hill
And every River: our brother Albion is sick to death.
He hath leagued himself with robbers! he hath studied the arts
Of unbelief! Envy hovers over him! his Friends are his abhorrence!
Those who give their lives for him are despised!
Those who devour his soul, are taken into his bosom!
To destroy his Emanation is their intention:
Arise! awake O Friends of the Giant Albion
They have perswaded him of horrible falshoods!
They have sown errors over all his fruitful fields!

The Twenty-four heard! they came trembling on watry chariots.
Borne by the living Creatures of the third procession
Of Human Majesty, the Living Creatures wept aloud as they
Went along Albions roads, till they arriv'd at Albions House.

O! how the torments of Eternal Death, waited on Man:
And the loud-rending bars of the Creation ready to burst:
That the wide world might fly from its hinges, & the immortal mansion
Of Man, for ever be possess'd by monsters of the deeps:
And Man himself become a Fiend, wrap'd in an endless curse,
Consuming and consum'd for-ever in flames of Moral Justice.

For had the Body of Albion fall'n down, and from its dreadful ruins
Let loose the enormous Spectre on the darkness of the deep,
At enmity with the Merciful & fill'd with devouring fire,
A nether-world must have reciev'd the foul enormous spirit,
Under pretence of Moral Virtue, fill'd with Revenge and Law.
There to eternity chaind down, and issuing in red flames
And curses, with his mighty arms brandishd against the heavens
Breathing cruelty blood & vengeance, gnashing his teeth with pain
Torn with black storms, & ceaseless torrents of his own consuming fire:
Within his breast his mighty Sons chaind down & fill'd with cursings:
And his dark Eon that once fair crystal form divinely clear:
Within his ribs producing serpents whose souls are flames of fire.
But glory in the Merciful One, Albion is full of infernal mercies!
Until the Divine Family might over him as One Man.

And these the Twenty-four in whom the Divine Family
Appeard; and they were One in Him. A Human Vision!
Human Divine, Jesus the Saviour, blessed for ever and ever.

Selsey, true friend! who afterwards submitted to be devourd
By the waves of Despair, whose Emanation rose above
The flood, and was nam'd Chichester, lovely mild & gentle! Lo!
Her lambs bleat to the sea-fowls cry, lamenting still for Albion.

Submitting to be call'd the son of Los the terrible vision:
Winchester stood devoting himself for Albion: his tents
Outspread with abundant riches, and his Emanations
Submitting to be call'd Enitharmons daughters, and be born
In vegetable mould, created by the Hammer and Loom
In Bowlahoola & Allamanda where the Dead wail night & day.

(I call them by their English names: English, the rough basement.
Los built the stubborn structure of the Language, acting against
Albions melancholy, who must else have been a Dumb despair.)

Gloucester and Exeter and Salisbury and Bristol: and benevolent
Bath

41

Bath who is Legions: he is the Seventh, the physician and
The poisoner: the best and worst in Heaven and Hell:
Whose Spectre first assimilated with Luvah in Albions mountains
A triple octave he took, to reduce Jerusalem to twelve
To cast Jerusalem forth upon the wilds to Poplar & Bow:
To Malden & Canterbury in the delights of cruelty:
The Shuttles of death sing in the sky to Islington & Pancrass
Round Marybone to Tyburns River, weaving black melancholy as a net,
And despair as meshes closely wove over the west of London.
Where mild Jerusalem sought to repose in death & be no more.
She fled to Lambeths mild Vale and hid herself beneath
The Surrey Hills where Rephaim terminates: her Sons are siezd
For victims of sacrifice; but Jerusalem cannot be found! Hid
By the Daughters of Beulah: gently snatchd away: and hid in Beulah

There is a Grain of Sand in Lambeth that Satan cannot find
Nor can his Watch Fiends find it: tis translucent & has many Angles
But he who finds it will find Oothoons palace, for within
Opening into Beulah every angle is a lovely heaven
But should the Watch Fiends find it, they would call it Sin
And lay its Heavens & their inhabitants in blood of punishment
Here Jerusalem & Vala were hid in soft slumberous repose
Hid from the terrible East, shut up in the South & West.

The Twenty-eight trembled in Deaths dark caves, in cold despair
They kneeld around the Couch of Death in deep humiliation
And tortures of self condemnation while their Spectres ragd within
The Four Zoa's in terrible combustion clouded rage
Drinking the shuddering fears & loves of Albions Families
Destroying by selfish affections the things that they most admire
Drinking & eating, & pitying & weeping, as at a tragic scene.
The soul drinks murder & revenge, & applauds its own holiness

They saw Albion endeavouring to destroy their Emanations

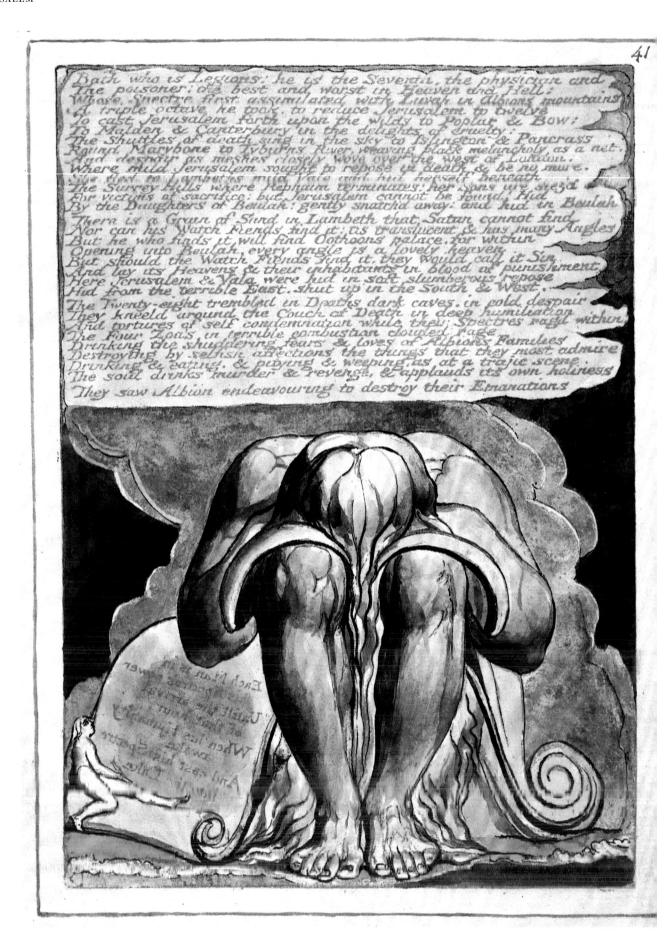

Thus Albion sat, studious of others in his pale disease:
Brooding on evil: but when Los opend the Furnaces before him:
He saw that the accursed things were his own affections.
And his own beloveds: then he turnd sick! his soul died within him
Also Los sick & terrified beheld the Furnaces of Death
And must have died. but the Divine Saviour descended
Among the infant loves & affections, and the Divine Vision wept
Like evening dew on every herb upon the breathing ground

Albion spoke in his dismal dreams; O thou deceitful friend
Worshipping mercy & beholding thy friend in such affliction:
Los! thou now discoverest thy turpitude to the heavens.
I demand righteousness & justice. O thou ingratitude!
Give me my Emanations back food for my dying soul!
My daughters are harlots! my sons are accursed before me.
Enitharmon is my daughter: accursed with a fathers curse!
O! I have utterly been wasted! I have given my daughters to devils

So spoke Albion in gloomy majesty, and deepest night
Of Ulro rolld round his skirts from Dover to Cornwall.

Los answerd. Righteousness & justice I give thee in return
For thy righteousness! but I add mercy also, and bind
Thee from destroying these little ones: am I to be only
Merciful to thee and cruel to all that thou hatest
Thou wast the Image of God surrounded by the Four Zoa's
Three thou hast slain! I am the Fourth: thou canst not destroy me.
Thou art in Error; trouble me not with thy righteousness.
I have innocence to defend and ignorance to instruct:
I have no time for seeming; and little arts of complement,
In morality and virtue: in self-glorying and pride.
There is a Limit of Opakeness, and a Limit of Contraction;
In every Individual Man, and the limit of Opakeness,
Is named Satan: and the limit of Contraction is named Adam.
But when Man sleeps in Beulah, the Saviour in mercy takes
Contractions Limit, and of the Limit he forms Woman: That
Himself may in process of time be born Man to redeem
But there is no Limit of Expansion! there is no Limit of Translucence.
In the bosom of Man for ever from eternity to eternity.
Therefore I break thy bonds of righteousness; I crush thy messengers!
That they may not crush me and mine: do thou be righteous,
And I will return it; otherwise I defy thy worst revenge:
Consider me as thine enemy: on me turn all thy fury
But destroy not these little ones, nor mock the Lords anointed:
Destroy not by Moral Virtue, the little ones whom he hath chosen!
The little ones whom he hath chosen in preference to thee.
He hath cast thee off for ever; the little ones he hath anointed!
Thy Selfhood is for ever accursed from the Divine presence

So Los spoke: then turnd his face & wept for Albion.

Albion replied. Go Hand & Hyle! seize the abhorred friend:
As you have siezd the Twenty-four rebellious ingratitudes;
To atone for you, for spiritual death! Man lives by deaths of Men
Bring him to Justice before heaven here upon London stone,
Between Blackheath & Hounslow, between Norwood & Finchley
All that they have is mine: from my free genrous gift,
They now hold all they have: ingratitude to me!
To me their benefactor calls aloud for vengeance deep.

Los stood among his Furnaces, his Spectre murmured in its fear
And the Divine hand was upon him strengthening him mightily.

The Spectres of the Dead cry out from the deeps beneath
Upon the hills of Albion; Oxford groans in his iron furnace
Winchester in his den & cavern; they lament against
Albion: they curse their human kindness & affection
They rage like wild beasts in the forests of affliction
In the dreams of Ulro they repent of their human kindness.

Come up, build Babylon, Rahab is ours & all her multitudes
With her in pomp and glory of victory. Depart
Ye twenty-four into the deeps! let us depart to glory!

Their Human majestic forms sit up upon their Couches
Of death: they curb their Spectres as with iron curbs
They enquire after Jerusalem in the regions of the dead.
With the voices of dead men, low, scarcely articulate.
And with tears cold on their cheeks they weary repose.

O when shall the morning of the grave appear, and when
Shall our salvation come? we sleep upon our watch
We cannot awake! and our Spectres rage in the forests
O God of Albion where art thou! pity the watchers!

Thus mourn they. Loud the Furnaces of Los thunder upon
The clouds of Europe & Asia, among the Serpent Temples!
And Los drew his Seven Furnaces around Albions Altars
And as Albion built his frozen Altars, Los built the Mundane Shell,
In the Four Regions of Humanity East & West & North & South,
Till Norwood & Finchley & Blackheath & Hounslow, coverd the whole Earth.
This is the Net & Veil of Vala, among the Souls of the Dead.

They saw their Wheels rising up poisonous against Albion
Urizen, cold & scientific; Luvah, pitying & weeping
Tharmas, indolent & sullen; Urthona, doubting & despairing
Victims to one another & dreadfully plotting against each other
To prevent Albion walking about in the Four Complexions.

They saw America clos'd out by the Oaks of the western shore;
And Tharmas dash'd on the Rocks of the Altars of Victims in Mexico.
If we are wrathful Albion will destroy Jerusalem with rooty Groves
If we are merciful, ourselves must suffer destruction on his Oaks!
Why should we enter into our Spectres, to behold our own corruptions
O God of Albion descend! deliver Jerusalem from the Oaken Groves!

Then Los grew furious raging: Why stand we here trembling around
Calling on God for help; and not ourselves in whom God dwells
Stretching a hand to save the falling Man: are we not Four
Beholding Albion upon the Precipice ready to fall into Non-Entity:
Seeing these Heavens & Hells conglobing in the Void. Heavens over Hells
Brooding in holy hypocritic lust, drinking the cries of pain
From howling victims of Law: building Heavens Twenty-seven-fold.
Swelld & bloated General Forms, repugnant to the Divine-
Humanity, who is the Only General and Universal Form
To which all Lineaments tend & seek with love & sympathy
All broad & general principles belong to benevolence
Who protects minute particulars, every one in their own identity.
But here the affectionate touch of the tongue is clos'd in by deadly teeth
And the soft smile of friendship & the open dawn of benevolence
Become a net & a trap, & every energy renderd cruel,
Till the existence of friendship & benevolence is denied:
The wine of the Spirit & the vineyards of the Holy-One.
Here; turn into poisonous stupor & deadly intoxication:
That they may be condemnd by Law & the Lamb of God be slain:
And the two Sources of Life in Eternity Hunting and War:
Are become the Sources of dark & bitter Death & of corroding Hell:
The open heart is shut up in integuments of frozen silence
That the spear that lights it forth may shatter the ribs & bosom
A pretence of Art to destroy Art; a pretence of Liberty
To destroy Liberty; a pretence of Religion to destroy Religion
Oshea and Caleb fight; they contend in the valleys of Peor
In the terrible Family Contentions of those who love each other:
The Armies of Balaam weep—no women come to the field
Dead corses lay before them, & not as in Wars of old.
For the Soldier who fights for Truth, calls his enemy his brother:
They fight & contend for life, & not for eternal death
But here the Soldier strikes, & a dead corse falls at his feet
Nor Daughter nor Sister nor Mother come forth to embosom the Slain!
But Death! Eternal Death! remains in the Valleys of Peor.
The English are scatterd over the face of the Nations: are these
Jerusalems children? Hark! hear the Giants of Albion, cry at night
We smell the blood of the English! we delight in their blood on our Altars!
The living & the dead shall be ground in our rumbling Mills
For bread of the Sons of Albion: of the Giants Hand & Scofield
Scofield & Kox are let loose upon my Saxons! they accumulate
A World in which Man is by his Nature the Enemy of Man,
In pride of Selfhood unwieldy stretching out into Non Entity
Generalizing Art & Science till Art & Science is lost.
Bristol & Bath, listen to my words, & ye Seventeen give ear!
It is easy to acknowledge a man to be great & good while we
Derogate from him in the trifles & small articles of that goodness
Those alone are his friends, who admire his minutest powers
Instead of Albions lovely mountains & the curtains of Jerusalem
I see a Cave, a Rock, a Tree deadly and poisonous, unimaginative
Instead of the Mutual Forgivenesses, the Minute Particulars, I see
Pits of bitumen ever burning; artificial Riches of the Canaanite
Like Lakes of liquid lead: instead of heavenly Chapels, built
By our dear Lord; I see Worlds crusted with snows & ice;
I see a Wicker Idol woven round Jerusalem children, I see
The Canaanite, the Amalekite, the Moabite, the Egyptian,
By Demonstrations the cruel Sons of Quality & Negation.
Driven on the Void in incoherent despair into Non Entity
I see America closd apart, & Jerusalem driven in terror
Away from Albions mountains, far away from Londons spires!
I will not endure this thing! I alone withstand to death,
This outrage! Ah me! how sick & pale you all stand round me!
Ah me! pitiable ones! do you also go to deaths vale?
All you my Friends & Brothers! all you my beloved Companions!
Have you also caught the infection of Sin & stern Repentance?
I see Disease arise upon you! yet speak to me and give
Me some comfort: why do you all stand silent? I alone
Remain in permanent strength. Or is all this goodness & pity, only
That you may take the greater vengeance in your Sepulcher.

So Los spoke. Pale they stood around the House of Death:
In the midst of temptations & despair: among the rooted Oaks:
Among reared Rocks of Albions Sons, at length they rose

With

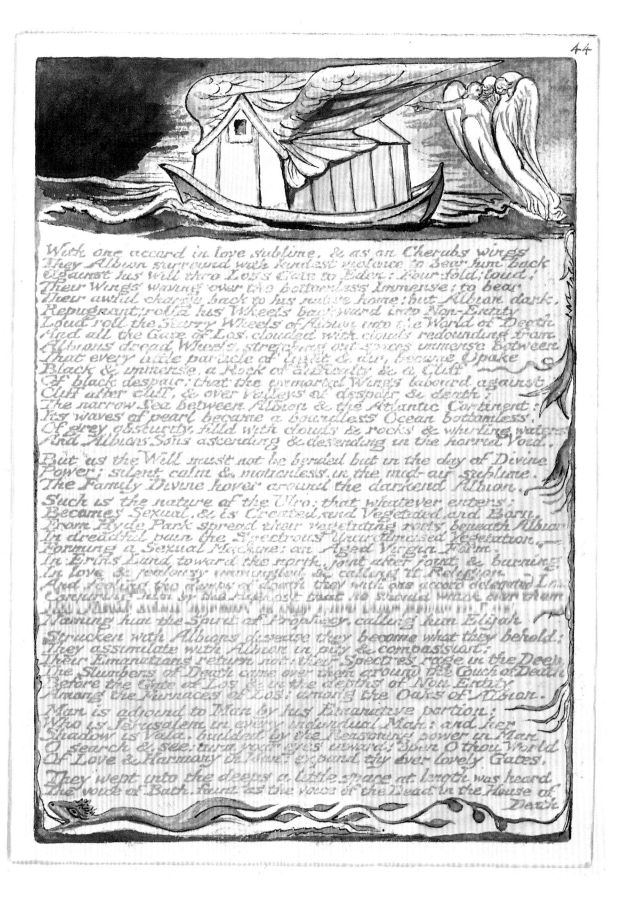

With one accord in love sublime, & as on Cherubs wings
They Albion surround with kindest violence to bear him back
Against his will thro Los's Gate to Eden: Four-fold; loud!
Their Wings waving over the bottomless Immense: to bear
Their awful charge back to his native home: but Albion dark,
Repugnant; rolld his Wheels backward into Non-Entity
Loud roll the Starry Wheels of Albion into the World of Death
And all the Gate of Los, clouded with clouds redounding from
Albions dread Wheels, stretching out spaces immense between
That every little particle of light & air, became Opake
Black & immense, a Rock of difficulty & a Cliff
Of black despair; that the immortal Wings labourd against
Cliff after cliff, & over valleys of despair & death:
The narrow Sea between Albion & the Atlantic Continent:
Its waves of pearl became a boundless Ocean bottomless,
Of grey obscurity, filld with clouds & rocks & whirling waters
And Albions Sons ascending & descending in the horrid Void.

But as the Will must not be bended but in the day of Divine
Power: silent calm & motionless, in the mid-air sublime.
The Family Divine hover around the darkend Albion.

Such is the nature of the Ulro: that whatever enters:
Becomes Sexual, & is Created, and Vegetated, and Born.
From Hyde Park spread their vegetating roots beneath Albion
In dreadful pain the Spectrous Uncircumcised Vegetation,
Forming a Sexual Machine: an Aged Virgin Form.
In Erins Land toward the north, joint after joint & burning
In love & jealousy immingled & calling it Religion
And feeling the damps of death they with one accord delegated Los
Conjuring him by the Highest that he should Watch over them
Till Jesus shall appear: & they gave their power to Los
Naming him the Spirit of Prophecy, calling him Elijah

Strucken with Albions disease they become what they behold:
They assimilate with Albion in pity & compassion;
Their Emanations return not, their Spectres rage in the Deep
The Slumbers of Death came over them around the Couch of Death
Before the Gate of Los & in the depths of Non Entity
Among the Furnaces of Los: among the Oaks of Albion.

Man is adjoind to Man by his Emanative portion:
Who is Jerusalem in every individual Man: and her
Shadow is Vala, builded by the Reasoning power in Man
O search & see: turn your eyes inward: open O thou World
Of Love & Harmony in Man: expand thy ever lovely Gates.

They went into the deeps a little space at length was heard
The voice of Bath, faint as the voice of the Dead in the House of
                                                        Death

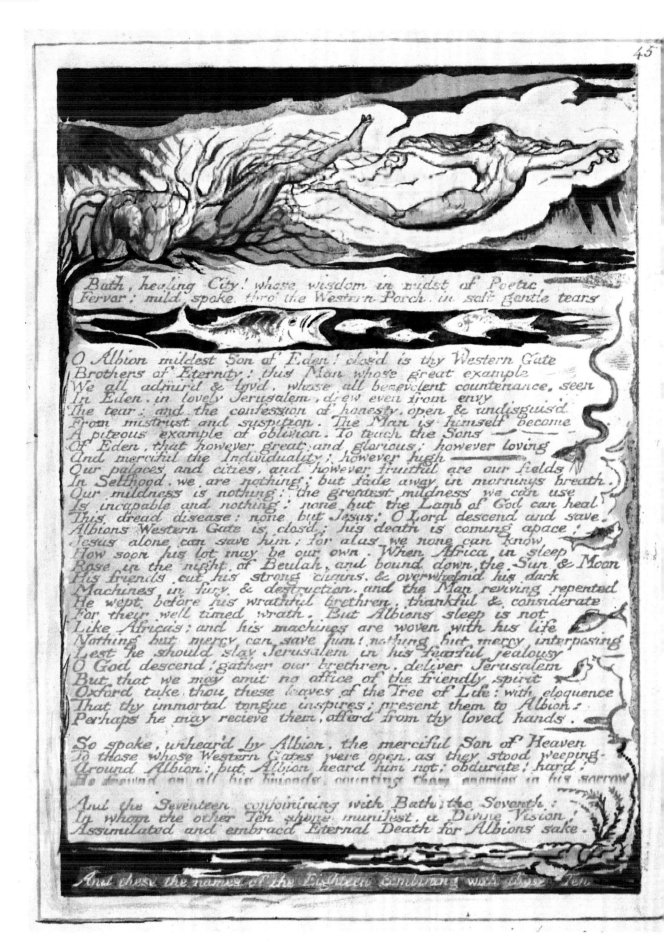

45

Bath, healing City! whose wisdom in midst of Poetic
Fervor; mild spoke thro' the Western Porch in soft gentle tears

O Albion mildest Son of Eden! clos'd is thy Western Gate
Brothers of Eternity: this Man whose great example
We all admir'd & lov'd, whose all benevolent countenance, seen
In Eden, in lovely Jerusalem, drew even from envy
The tear: and the confession of honesty, open & undisguis'd
From mistrust and suspition. The Man is himself become
A piteous example of oblivion. To teach the Sons
Of Eden, that however great and glorious; however loving
And merciful the Individuality; however high
Our palaces and cities, and however fruitful are our fields
In Selfhood, we are nothing: but fade away in mornings breath.
Our mildness is nothing: the greatest mildness we can use
Is incapable and nothing: none but the Lamb of God can heal
This dread disease: none but Jesus: O Lord descend and save.
Albions Western Gate is clos'd: his death is coming apace;
Jesus alone can save him; for alas we none can know
How soon his lot may be our own. When Africa in sleep
Rose in the night of Beulah, and bound down the Sun & Moon
His friends cut his strong chains, & overwhelmd his dark
Machines in fury & destruction, and the Man reviving repented
He wept before his wrathful brethren, thankful & considerate
For their well timed wrath. But Albions sleep is not
Like Africas; and his machines are woven with his life
Nothing but mercy can save him; nothing but mercy interposing
Lest he should slay Jerusalem in his fearful jealousy
O God descend! gather our brethren, deliver Jerusalem
But, that we may omit no office of the friendly spirit
Oxford take thou these leaves of the Tree of Life: with eloquence
That thy immortal tongue inspires; present them to Albion:
Perhaps he may recieve them, offerd from thy loved hands.

So spoke, unheard by Albion, the merciful Son of Heaven
To those whose Western Gates were open, as they stood weeping
Around Albion: but Albion heard him not: obdurate! hard!
He frownd on all his Friends, counting them enemies in his sorrow

And the Seventeen conjoining with Bath, the Seventh:
In whom the other Ten shone manifest, a Divine Vision!
Assimilated and embraced Eternal Death for Albions sake.

And these the names of the Eighteen combining with those Ten

Bath. mild Physician of Eternity. mysterious power
Whose springs are unsearchable & knowledge infinite.
Hereford. ancient Guardian of Wales. whose hands
Builded the mountain palaces of Eden. stupendous works!
Lincoln. Durham & Carlisle. Councellors of Los.
And Ely. Scribe of Los. whose pen no other hand
Dare touch: Oxford. immortal Bard! with eloquence
Divine he wept over Albion. speaking the words of God
In mild perswasion: bringing leaves of the tree of Life.

Thou art in Error Albion. the Land of Ulro:
One Error not removd. will destroy a human Soul,
Repose in Beulahs night. till the Error is removd
Reason not on both sides. Repose upon our bosoms
Till the Plow of Jehovah. and the Harrow of Shaddai
Have passed over the Dead. to awake the Dead to Judgment.
But Albion turnd away refusing comfort.

Oxford trembled while he spoke. then fainted in the arms
Of Norwich. Peterboro. Rochester. Chester awful. Worcester.
Litchfield. Saint Davids. Landaff. Asaph. Bangor. Sodor.
Bowing their heads devoted: and the Furnaces of Los
Began to rage. thundering loud the storms began to roar
Upon the Furnaces. and loud the Furnaces rebellow beneath

And these the Four in whom the twenty-four appeard four fold
Verulam. London. York. Edinburgh. mourning one towards another
Alas!——The time will come. when a mans worst enemies
Shall be those of his own house and family: in a Religion
Of Generation. to destroy by Sin and Atonement. happy Jerusalem.
The Bride and Wife of the Lamb. O God thou art Not an Avenger

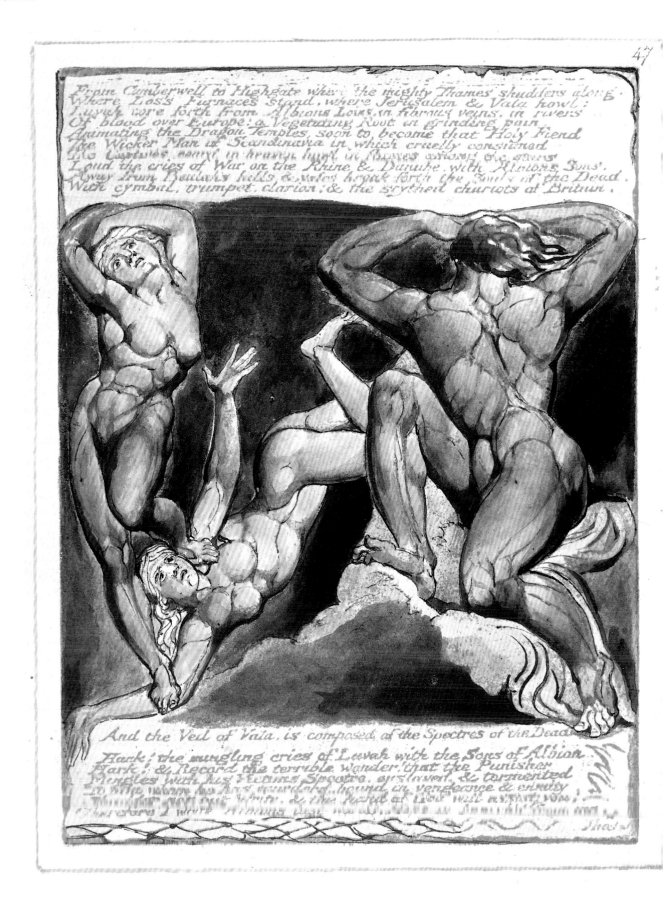

These were his last words. and the merciful Saviour in his arms
Recievd him, in the arms of tender mercy and reposd
The pale limbs of his Eternal Individuality
Upon the Rock of Ages. Then, surrounded with a Cloud:
In silence the Divine Lord builded with immortal labour.
Of gold & jewels a sublime Ornament. a Couch of repose,
With Sixteen pillars: canopied with emblems & written verse.
Spiritual Verse. orderd & measurd. from whence, time shall reveal.
The Five books of the Decalogue. the books of Joshua & Judges.
Samuel. a double book & Kings. a double book. the Psalms & Prophets
The Four-fold Gospel. and the Revelations everlasting
Eternity groand & was troubled. at the image of Eternal Death!

Beneath the bottoms of the Graves. which is Earths central joint.
There is a place where Contrarieties are equally true:
To protect from the Giant blows in the sports of intellect.
Thunder in the midst of kindness. & love that kills its beloved:
Because Death is for a period. and they renew tenfold.
From this sweet Place Maternal Love awoke Jerusalem
With pangs she forsook Beulahs pleasant lovely shadowy Universe
Where no dispute can come: created for those who Sleep.

Weeping was in all Beulah. and all the Daughters of Beulah
Wept for their Sister the Daughter of Albion. Jerusalem:
When out of Beulah the Emanation of the Sleeper descended
With solemn mourning out of Beulahs moony shades and hills:
Within the Human Heart. whose Gates closed with solemn sound.

And this the manner of the terrible Separation
The Emanations of the grievously afflicted Friends of Albion
Concenter in one Female form an Aged pensive Woman.
Astonishd! lovely! embracing the sublime shade: the Daughters of Beulah
Beheld her with wonder! With awful hands she took
A Moment of Time, drawing it out with many tears & afflictions
And many sorrows: oblique across the Atlantic Vale
Which is the Vale of Rephaim dreadful from East to West.
Where the Human Harvest waves abundant in the beams of Eden
Into a Rainbow of jewels and gold, a mild Reflection from
Albions dread Tomb. Eight thousand and five hundred years
In its extension. Every two hundred years has a door to Eden
She also took an Atom of Space. with dire pain opening it a Center
Into Beulah: trembling the Daughters of Beulah dried
Her tears. she ardent embracd her sorrows, occupied in labours
Of sublime mercy in Rephaims Vale. Perusing Albions Tomb
She sat: she walkd among the ornaments solemn mourning
The Daughters attended her shudderings wiping the death sweat
Los also saw her in his seventh Furnace, he also terrified
Saw the finger of God go forth upon his seventh Furnace.
Away from the Starry Wheels to prepare Jerusalem a place.
When with a dreadful groan the Emanation mild of Albion
Burst from his bosom in the Tomb like a pale snowy cloud.
Female and lovely, struggling to put off the Human form
Writhing in pain. The Daughters of Beulah in kind arms recievd
Jerusalem: weeping over her among the Spaces of Erin.
In the Ends of Beulah. where the Dead wail night & day.

And thus Erin spoke to the Daughters of Beulah, in soft tears

Albion the Vortex of the Dead! Albion the Generous!
Albion the mildest son of Heaven! The Place of Holy Sacrifice!
Where Friends Die for each other: will become the Place.
Of Murder. & Unforgiving Never-awaking Sacrifice of Enemies
The Children must be sacrificd! (a horror never known
Till now in Beulah.) unless a Refuge can be found
To hide them from the wrath of Albions Law that freezes sore
Upon his Sons & Daughters. self-exiled from his bosom
Draw ye Jerusalem away from Albions Mountains
To give a Place for Redemption. let Sihon and Og
Remove Eastward to Bashan and Gilead. and leave
The

The secret coverts of Albion & the hidden places of America
Jerusalem Jerusalem! why wilt thou turn away
Come ye O Daughters of Beulah, lament for Og & Sihon
Upon the Lakes of Ireland from Rathlin to Baltimore:
Stand ye upon the Dargle from Wicklow to Drogheda:
Come & mourn over Albion the White Cliff of the Atlantic
The Mountain of Giants: all the Giants of Albion are become
Weak! wither'd, darken'd! & Jerusalem is cast forth from Albion.
They deny that they ever knew Jerusalem. or ever dwelt in Shiloh
The Gigantic roots & twigs of the vegetating Sons of Albion
Fill'd with the little-ones are consumed in the fires of their Altars
The vegetating Cities are burned & consumed from the Earth:
And the Bodies in which all Animals & Vegetations, the Earth & Heaven
Were contain'd in the All glorious Imagination are witherd & darkend;
The golden Gate of Havilah, and all the Garden of God,
Was caught up with the Sun in one day of fury and war,
The Lungs, the Heart, the Liver, shrunk away far distant from Man
And left a little slimy substance floating upon the tides,
In one night the Atlantic Continent was caught up with the Moon,
And became an Opake Globe far distant clad with moony beams.
The Visions of Eternity, by reason of narrowed perceptions,
Are become weak Visions of Time & Space, fix'd into furrows of death:
Till deep dissimulation is the only defence an honest man has left
O Polypus of Death O Spectre over Europe and Asia
Withering the Human Form by Laws of Sacrifice for Sin.
By Laws of Chastity & Abhorrence I am witherd up.
Striving to Create a Heaven in which all shall be pure & holy
In their Own Selfhoods, in Natural Selfish Chastity to banish Pity
And dear Mutual Forgiveness; & to become One Great Satan
Inslavd to the most powerful Selfhood: to murder the Divine Humanity
In whose sight all are as the dust & who chargeth his Angels with folly;
Ah! weak & wide astray! Ah shut in narrow doleful form!
Creeping in reptile flesh upon the bosom of the ground:
The Eye of Man, a little narrow orb, clos'd up & dark
Scarcely beholding the Great Light: conversing with the ground:
The Ear, a little shell, in small volutions shutting out
True Harmonies, & comprehending great, as very small:
The Nostrils, bent down to the earth & clos'd with senseless flesh,
That odours cannot them expand, nor joy on them exult:
The Tongue, a little moisture fills, a little food it clogs,
A little sound it utters, & its cries are faintly heard.
Therefore they are removed: therefore they have taken root
In Egypt & Philistea: in Moab & Edom & Aram:
In the Erythrean Sea their Uncircumcision in Heart & Loins
Be. lost for ever & ever. then they shall arise from Self
By Self Annihilation into Jerusalems Courts & into Shiloh
Shiloh the Masculine Emanation among the Flowers of Beulah
Lo Shiloh dwells over France, as Jerusalem dwells over Albion
Build & prepare a Wall & Curtain for Americas shore!
Rush on: Rush on: Rush on! ye vegetating Sons of Albion
The Sun shall go before you in Day, the Moon shall go
Before you in Night, Come on! Come on! Come on! The Lord
Jehovah is before, behind, above, beneath, around
He has builded the arches of Albions Tomb binding the Stars
In merciful Order, bending the Laws of Cruelty to Peace.
He hath placed Og & Anak the Giants of Albion for their Guards:
Building the Body of Moses in the Valley of Peor: the Body
Of Divine Analogy: and Og & Sihon in the tears of Balaam
The Son of Beor, have given their power to Joshua & Caleb.
Remove from Albion, far remove these terrible surfaces.
They are beginning to form Heavens & Hells in immense
Circles: the Hells for food to the Heavens: food of torment,
Food of despair: they drink the condemnd Soul & rejoice
In cruel holiness, in their Heavens of Chastity & Uncircumcision
Yet they are blameless & Iniquity must be imputed only
To the State they are enterd into that they may be deliverd:
Satan is the State of Death, & not a Human existence:
But Luvah is named Satan, because he has enterd that State.
A World where Man is by Nature the enemy of Man,
Because the Evil is Created into a State, that Men
May be deliverd time after time evermore. Amen
Learn therefore O Sisters to distinguish the Eternal Human
That walks about among the stones of fire in bliss & woe
Alternate! from those States or Worlds in which the Spirit travels:
This is the only means to Forgiveness of Enemies
Therefore remove from Albion these terrible Surfaces
And let wild seas & rocks close up Jerusalem away from
The

The Atlantic Mountains where Giants dwelt in Intellect;
Now given to stony Druids, and Allegoric Generation
To the Twelve Gods of Asia, the Spectres of those who Sleep:
Sway'd by a Providence oppos'd to the Divine Lord Jesus:
A murderous Providence! A Creation that groans, living on Death.
Where Fish & Bird & Beast & Man & Tree & Metal & Stone
Live by Devouring, going into Eternal Death continually:
Albion is now possess'd by the War of Blood! the Sacrifice
Of envy Albion is become, and his Emanation cast out:
Come Lord Jesus, Lamb of God descend! for if; O Lord!
If thou hadst been here, our brother Albion had not died.
Arise sisters! Go ye & meet the Lord, while I remain—
Behold the foggy mornings of the Dead on Albions cliffs!
Ye know that if the Emanation remains in them:
She will become an Eternal Death, an Avenger of Sin
A Self-righteousness, the proud Virgin-Harlot! Mother of War!
And we also & all Beulah, consume beneath Albions curse.

So Erin spoke to the Daughters of Beulah. Shuddering
With their wings they sat in the Furnace, in a night
Of stars, for all the Sons of Albion appeard distant stars,
Ascending and descending into Albions sea of death.
And Erins lovely Bow enclosd the Wheels of Albions Sons.

Expanding on wing, the Daughters of Beulah replied in sweet response

Come O thou Lamb of God and take away the remembrance of Sin
To Sin & to hide the Sin in sweet deceit, is lovely!!
To Sin in the open face of day is cruel & pitiless! But
To record the Sin for a reproach: to let the Sun go down,
In a remembrance of the Sin: is a Woe & a Horror!
A brooder of an Evil Day, and a Sun rising in blood
Come then O Lamb of God and take away the remembrance of Sin

End of Chap 1.

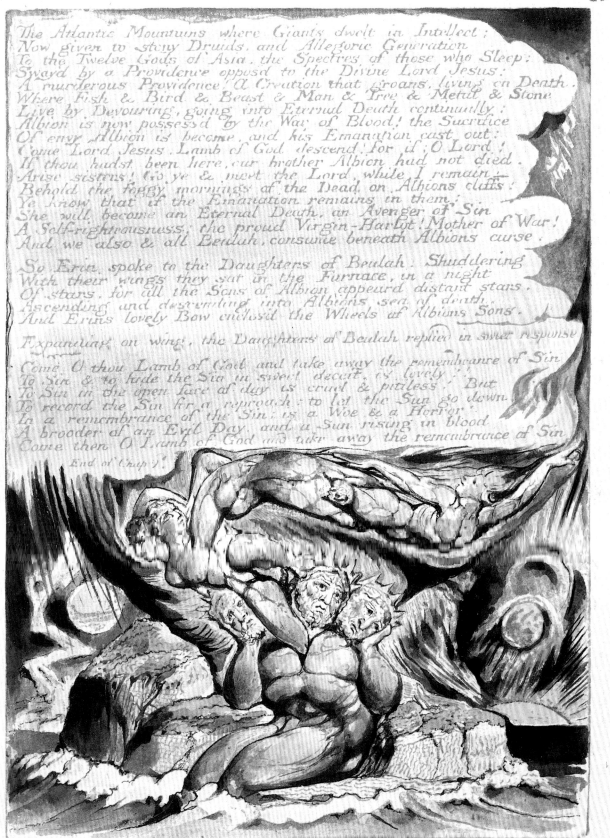

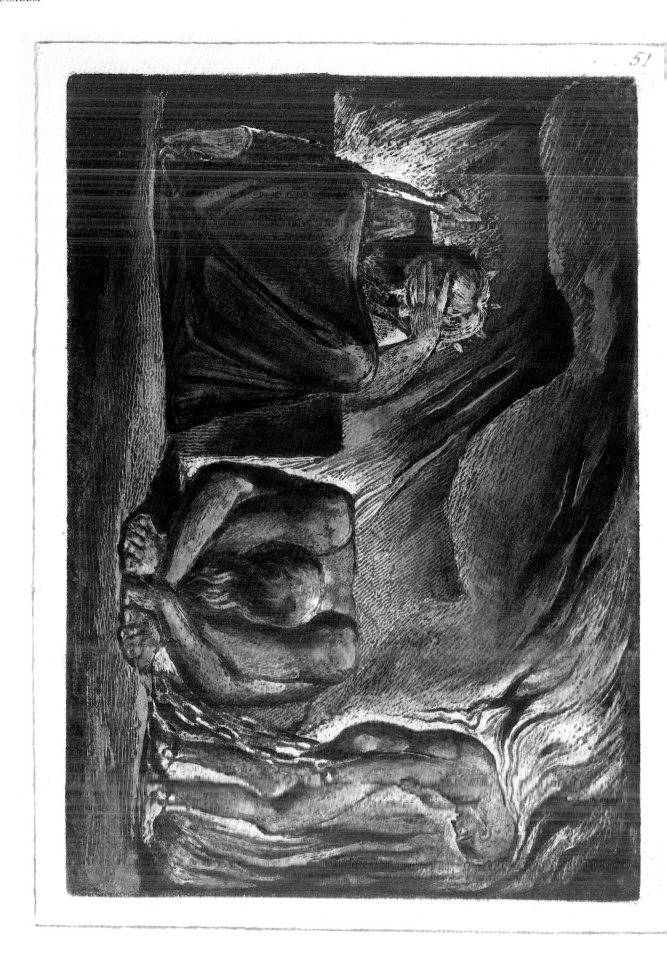

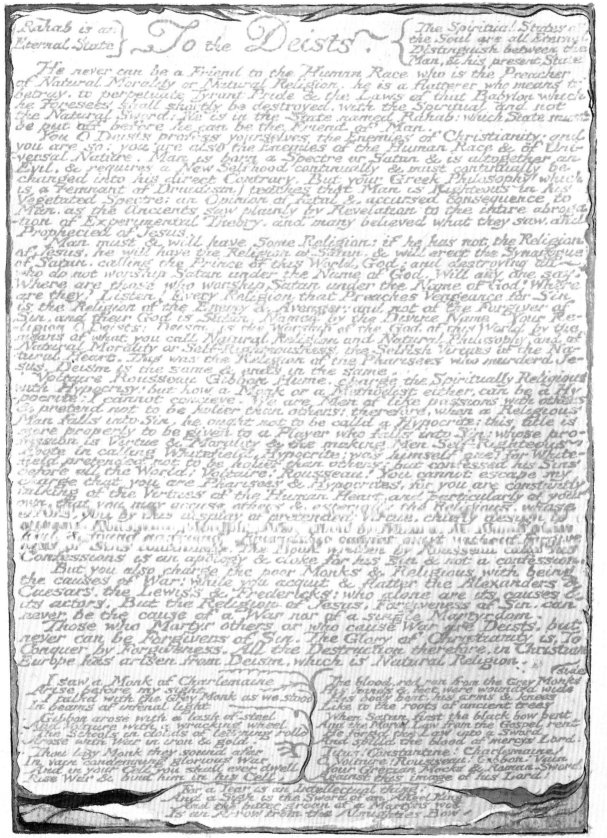

Rahab is an Eternal State}   To the Deists.   {The Spiritual States of the Soul are all Eternal Distinguish between the Man, & his present State

He never can be a Friend to the Human Race who is the Preacher of Natural Morality or Natural Religion. he is a flatterer who means to betray. to perpetuate Tyrant Pride & the Laws of that Babylon which he foresees shall shortly be destroyed, with the Spiritual and not the Natural Sword: He is in the State named Rahab: which State must be put off before he can be the Friend of Man.

You O Deists profess yourselves the Enemies of Christianity: and you are so: you are also the Enemies of the Human Race & of Universal Nature. Man is born a Spectre or Satan & is altogether an Evil, & requires a New Selfhood continually & must continually be changed into his direct Contrary. But your Greek Philosophy (which is a remnant of Druidism) teaches that Man is Righteous in his Vegetated Spectre: an Opinion of fatal & accursed consequence to Man. as the Ancients saw plainly by Revelation to the intire abrogation of Experimental Theory. and many believed what they saw. and Prophecied of Jesus.

Man must & will have Some Religion: if he has not the Religion of Jesus, he will have the Religion of Satan, & will erect the Synagogue of Satan. calling the Prince of this World, God; and destroying all who do not worship Satan under the Name of God, Will any one say: Where are those who worship Satan under the Name of God! Where are they? Listen! Every Religion that Preaches Vengeance for Sin is the Religion of the Enemy & Avenger; and not of the Forgiver of Sin. and their God is Satan. Named by the Divine Name Your Religion O Deists: Deism, is the Worship of the God of this World by the means of what you call Natural Religion and Natural Philosophy, and of Natural Morality or Self-Righteousness, the Selfish Virtues of the Natural Heart. This was the Religion of the Pharisees who murderd Jesus. Deism is the same & ends in the same.

Voltaire Rousseau Gibbon Hume. charge the Spiritually Religious with Hypocrisy! but how a Monk or a Methodist either, can be a Hypocrite: I cannot conceive. We are Men of like passions with others & pretend not to be holier than others: therefore, when a Religious Man falls into Sin, he ought not to be calld a Hypocrite: this title is more properly to be given to a Player who falls into Sin; whose profession is Virtue & Morality & the making Men Self-Righteous. Foote in calling Whitefield, Hypocrite: was himself one: for Whitefield pretended not to be holier than others: but confessed his Sins before all the World; Voltaire! Rousseau! You cannot escape my charge that you are Pharisees & Hypocrites, for you are constantly talking of the Virtues of the Human Heart. and particularly of your own, that you may accuse others & especially the Religious, whose errors, you by this display of pretended Virtue, chiefly design to expose. Rousseau thought Men Good by Nature: he found them Evil & found no friend. Friendship cannot exist without Forgiveness of Sins continually. The Book written by Rousseau calld his Confessions is an apology & cloke for his Sin & not a confession.

But you also charge the poor Monks & Religious with being the causes of War: while you acquit & flatter the Alexanders & Caesars, the Lewis's & Fredericks: who alone are its causes & its actors. But the Religion of Jesus, Forgiveness of Sin. can never be the cause of a War nor of a single Martyrdom.

Those who Martyr others or who cause War are Deists, but never can be Forgivers of Sin. The Glory of Christianity is, To Conquer by Forgiveness. All the Destruction therefore, in Christian Europe has arisen from Deism, which is Natural Religion.

[side]

I saw a Monk of Charlemaine
Arise before my sight
I talked with the Grey Monk as we stood
In beams of infernal light

Gibbon arose with a lash of steel
And Voltaire with a wracking wheel
The Schools in clouds of learning rollo
Arose with War in iron & gold.

Thou lazy Monk they sound afar
In vain condemning glorious War
And in your Cell you shall ever dwell
Rise War & bind him in his Cell.

The blood. red ran from the Grey Monks side
His hands & feet were wounded wide
His body bent, his arms & knees
Like to the roots of ancient trees

When Satan first the black bow bent
And the Moral Law from the Gospel rent
He forgd the Law into a Sword
And spilld the blood of mercys Lord.

Titus! Constantine! Charlemaine!
O Voltaire! Rousseau! Gibbon! Vain
Your Grecian Mocks & Roman Sword
Against this image of his Lord

For a Tear is an intellectual thing
And a Sigh is the Sword of an Angel King
And the bitter groan of a Martyrs woe
Is an Arrow from the Almighties Bow!

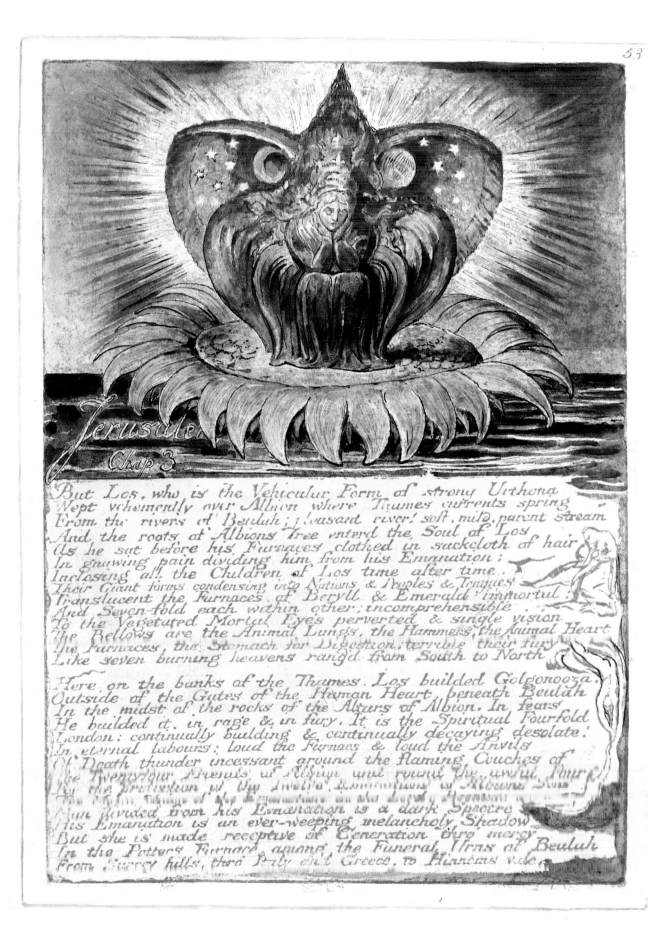

Jerusalem
Chap 3

But Los, who is the Vehicular Form of strong Urthona
Wept vehemently over Albion where Thames currents spring
From the rivers of Beulah; pleasant river! soft, mild, parent stream
And the roots of Albions Tree enterd the Soul of Los
As he sat before his Furnaces clothed in sackcloth of hair
In gnawing pain dividing him from his Emanation;
Inclosing all the Children of Los time after time.
Their Giant forms condensing into Nations & Peoples & Tongues
Translucent the Furnaces of Beryll & Emerald immortal:
And Seven-fold each within other: incomprehensible
To the Vegetated Mortal Eyes perverted & single vision
The Bellows are the Animal Lungs, the Hammers, the Animal Heart
The Furnaces, the Stomach for Digestion: terrible their fury
Like seven burning heavens rang'd from South to North

Here on the banks of the Thames, Los builded Golgonooza,
Outside of the Gates of the Human Heart, beneath Beulah
In the midst of the rocks of the Altars of Albion. In fears
He builded it, in rage & in fury. It is the Spiritual Fourfold
London: continually building & continually decaying desolate:
In eternal labours: loud the Furnaces & loud the Anvils
Of Death thunder incessant around the flaming Couches of
The Twenty-four Friends of Albion and round the wrath-full Four
For the Protection of the Twelve Emanations of Albions Sons

Man divided from his Emanation is a dark Spectre
His Emanation is an ever-weeping melancholy Shadow
But she is made receptive of Generation thro' mercy
In the Potters Furnace, among the Funeral Urns of Beulah
From Surrey hills, thro' Italy and Greece, to Hinnoms vale.

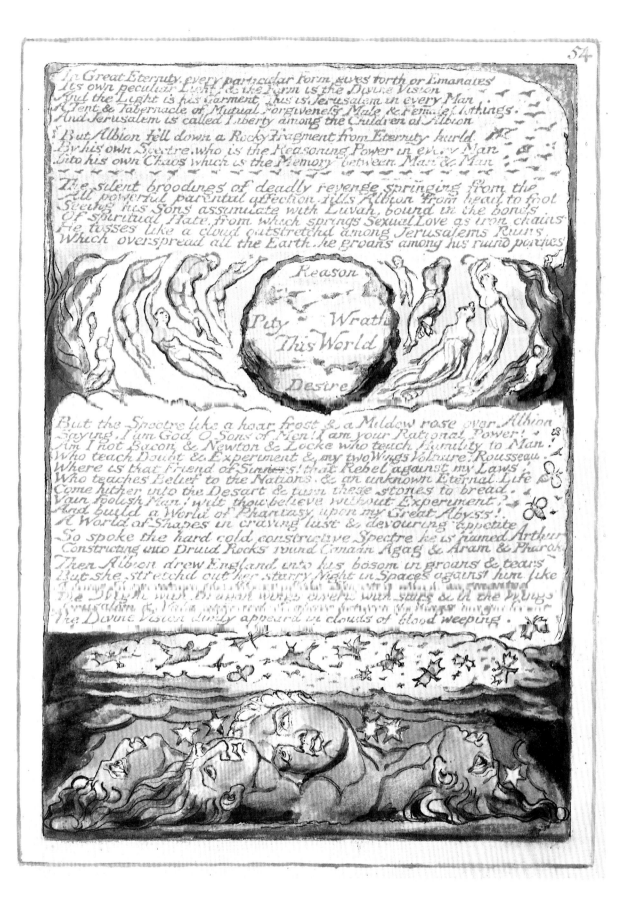

In Great Eternity, every particular Form gives forth or Emanates
Its own peculiar Light, & the Form is the Divine Vision
And the Light is his Garment. This is Jerusalem in every Man
A Tent & Tabernacle of Mutual Forgiveness Male & Female Clothings.
And Jerusalem is called Liberty among the Children of Albion

But Albion fell down a Rocky fragment from Eternity hurld
By his own Spectre, who is the Reasoning Power in every Man
Into his own Chaos which is the Memory between Man & Man

The silent broodings of deadly revenge springing from the
All powerful parental affection, fills Albion from head to foot
Seeing his Sons assimilate with Luvah, bound in the bonds
Of spiritual Hate, from which springs Sexual Love as iron chains
He tosses like a cloud outstretchd among Jerusalems Ruins,
Which overspread all the Earth, he groans among his ruind porches

Reason
Pity      Wrath
This World
Desire

But the Spectre like a hoar frost & a Mildew rose over Albion
Saying, I am God O Sons of Men! I am your Rational Power!
Am I not Bacon & Newton & Locke who teach Humility to Man!
Who teach Doubt & Experiment & my two Wings Voltaire: Rousseau.
Where is that Friend of Sinners! that Rebel against my Laws!
Who teaches Belief to the Nations, & an unknown Eternal Life
Come hither into the Desart & turn these stones to bread.
Vain foolish Man! wilt thou believe without Experiment?
And build a World of Phantasy upon my Great Abyss!
A World of Shapes in craving lust & devouring appetite

So spoke the hard cold constrictive Spectre he is named Arthur
Constricting into Druid Rocks round Canaan Agag & Aram & Pharoh

Then Albion drew England into his bosom in groans & tears
But she stretchd out her starry Night in Spaces against him like
A long Serpent, in the Abyss of the Spectre which augmented
The Night with Dragon wings coverd with stars & in the wings
Jerusalem & Vala, weeping in pangs of Maternal Love
The Divine Vision dimly appeard in clouds of blood weeping.

55

When those who disregard all Mortal Things, saw a Mighty-One
Among the Flowers of Beulah still retain his awful strength
They wonderd; checking their wild flames & Many gathering
Together into an Assembly; they said, let us go down
And see these changes! Others said, If you do so prepare
For being driven from our fields, what have we to do with the Dead
To be their inferiors or superiors we equally abhor;
Superior none we know: inferior none: all equal share

Divine Benevolence & Joy is God himself in whom all live & move
Walketh among us, calling us his Brothers & his Friends:
Forbidding us that Veil which Satan puts between Eve & Adam
By which the Princes of the Dead enslave their Votaries
Teaching them to form the Serpent of precious stones & gold
To sieze the Sons of Jerusalem & plant them in One Mans Loins
To make One Family of Contraries: that Joseph may be sold
Into Egypt: for Negation; a Veil the Saviour born & dying rends

But others said: Let us to him who only Is, & who
Walketh among us, give decision. bring forth all your fires!

So saying, an eternal deed was done: in fiery flames
The Universal Concave raged, such thunderous sounds as never
Were sounded from a mortal cloud, nor on Mount Sinai old
Nor in Havilah where the Cherub rolld his redounding flame.

Loud! loud! the Mountains lifted up their voices, loud the Forests
Rivers thunderd against their banks, loud Winds furious fought
Cities & Nations contended in fires & clouds & tempests.
The Seas raisd up their voices & lifted their hands on high
The Stars in their courses fought. the Sun! Moon! Heaven! Earth.
Contending for Albion & for Jerusalem his Emanation
And for Shiloh, the Emanation of France & for lovely Vala.

Then far the greatest number were about to make a Separation
And they Elected Seven, calld the Seven Eyes of God;
Lucifer, Molech, Elohim, Shaddai, Pahad, Jehovah, Jesus.
They named the Eighth. he came not, he hid in Albions Forests
But first they said: (& their Words stood in Chariots in array
Curbing their Tygers with golden bits & bridles of silver & ivory

Let the Human Organs be kept in their perfect Integrity
At will Contracting into Worms, or Expanding into Gods
And then, behold! what are these Ulro Visions of Chastity
Then as the moss upon the tree: or dust upon the plow:
Or as the sweat upon the labouring shoulder: or as the chaff
Of the wheat floor or as the dregs of the sweet wine-press
Such are these Ulro Visions, for tho we sit down within
The plowed furrow, listning to the weeping clods till we
Contract or Expand Space at will: or if we raise ourselves
Upon the chariots of the morning. Contracting or Expanding Time
Every one knows, we are One Family: One Man blessed for ever

Silence remaind & every one resumd his Human Majesty
And many conversed on these things as they labourd at the furrow
Saying; It is better to prevent misery, than to release from misery
It is better to prevent error, than to forgive the criminal:
Labour well the Minute Particulars, attend to the Little-ones:
And those who are in misery cannot remain so long
If we do but our duty: labour well the teeming Earth.

They Plowd in tears, the trumpets sounded before the golden Plow
And the voices of the Living Creatures were heard in the clouds of heaven
Crying: Compell the Reasoner to Demonstrate with unhewn Demonstrations
Let the Indefinite be explored, and let every Man be judged
By his own Works, Let all Indefinites be thrown into Demonstrations
To be pounded to dust & melted in the Furnaces of Affliction:
He who would do good to another, must do it in Minute Particulars
General Good is the plea of the scoundrel hypocrite & flatterer:
For Art & Science cannot exist but in minutely organized Particulars
And not in generalizing Demonstrations of the Rational Power.
The Infinite alone resides in Definite & Determinate Identity
Establishment of Truth depends on destruction of Falshood continually
On Circumcision: not on Virginity, O Reasoners of Albion

So cried they at the Plow. Albions Rock frowned above
And the Great Voice of Eternity rolled above terrible in clouds
Saying Who will go forth for us! & Who shall we send before our face

Then Los heaved his thundring Bellows on the Valley of Middlesex
And thus he chaunted his Song: the Daughters of Albion reply.

What may Man be? who can tell! But what may Woman be?
To have power over Man from Cradle to corruptable Grave.
He who is an Infant, and whose Cradle is a Manger
Knoweth the Infant sorrow: whence it came, and where it goeth.
And who weave it a Cradle of the grass that withereth away.
This World is all a Cradle for the erred wandering Phantom:
Rockd by Year, Month, Day & Hour; and every two Moments
Between, dwells a Daughter of Beulah, to feed the Human Vegetable
Entune: Daughters of Albion: your hymning Chorus mildly!
Cord of affection thrilling extatic on the iron Reel:
To the golden Loom of Love! to the moth-labourd Woof
A Garment and Cradle weaving for the infantine Terror:
For fear; at entering the gate into our World of cruel
Lamentation: it flee back & hide in Non-Entitys dark wild
Where dwells the Spectre of Albion: destroyer of Definite Form.
The Sun shall be a Scythed Chariot of Britain: the Moon; a Ship
In the British Ocean! Created by Los's Hammer; measured out
Into Days & Nights & Years & Months. to travel with my feet
Over these desolate rocks of Albion: O daughters of despair!
Rock the Cradle, and in mild melodies tell me where found
What you have enwoven with so much tears & care! so much
Tender artifice: to laugh: to weep: to learn: to know;
Remember! recollect! what dark befel in wintry days

O it was lost for ever! and we found it not: it came
And wept at our wintry Door: Look! look! behold! Gwendolen
Is become a Clod of Clay! Merlin is a Worm of the Valley!

Then Los uttered with Hammer & Anvil: Chaunt! revoice!
I mind not your laugh: and your frown I not fear! and
You must my dictate obey from your gold-beamd Looms: trill!
Gentle to Albions Watchman, on Albions mountains; reecho
And rock the Cradle while! Ah me! Of that Eternal Man
And of the cradled Infancy in his bowels of compassion:
Who fell beneath his instruments of husbandry & became
Subservient to the clods of the furrow! the cattle and even
The emmet and earth-Worm are his superiors & his lords.

Then the response came warbling from trilling Looms in Albion
We Women tremble at the light therefore: hiding fearful
The Divine Vision with Curtain & Veil & fleshly Tabernacle

Los utterd: swift as the rattling thunder upon the mountains
Look back into the Church Paul! Look! Three Women around
The Cross! O Albion why didst thou a Female Will Create?

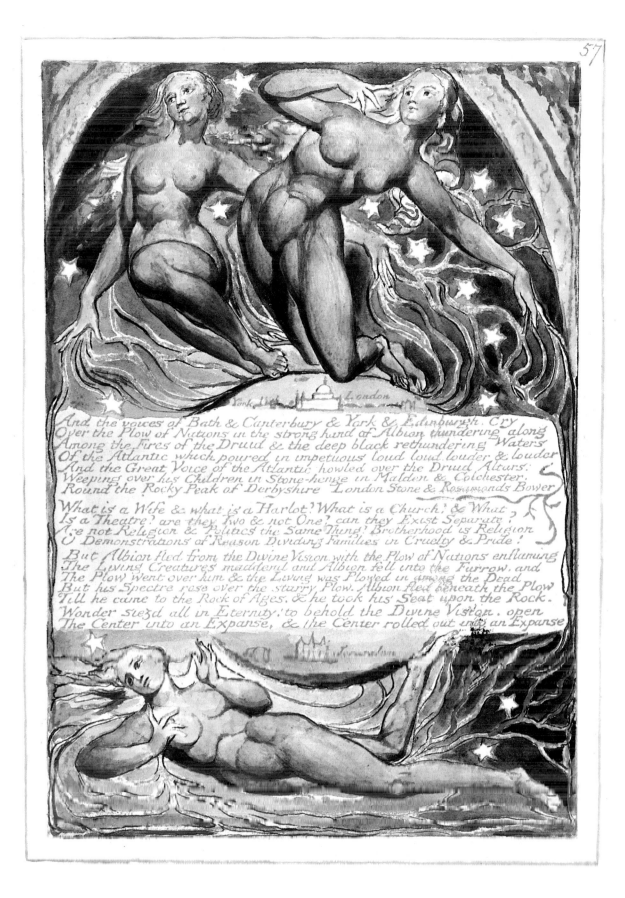

And the voices of Bath & Canterbury & York & Edinburgh. Cry
Over the Plow of Nations in the strong hand of Albion thundering along
Among the Fires of the Druid & the deep black rethundering Waters
Of the Atlantic which poured in impetuous loud loud, louder & louder
And the Great Voice of the Atlantic howled over the Druid Altars:
Weeping over his Children in Stone-henge in Malden & Colchester.
Round the Rocky Peak of Derbyshire London Stone & Rosamonds Bower

What is a Wife & what is a Harlot? What is a Church? & What
Is a Theatre? are they Two & not One? can they Exist Separate?
Are not Religion & Politics the Same Thing? Brotherhood is Religion
O Demonstrations of Reason Dividing Families in Cruelty & Pride!

But Albion fled from the Divine Vision, with the Plow of Nations enflaming
The Living Creatures maddend and Albion fell into the Furrow, and
The Plow went over him & the Living was Ploughd in among the Dead
But his Spectre rose over the starry Plow. Albion fled beneath the Plow
Till he came to the Rock of Ages, & he took his Seat upon the Rock.
Wonder siezd all in Eternity: to behold the Divine Vision. open
The Center into an Expanse, & the Center rolled out into an Expanse

In beauty the Daughters of Albion divide & unite at will
Naked & drunk with blood Gwendolen dancing to the timbrel
Of War: reeling up the Street of London she divides in twain
Among the Inhabitants of Albion, the People fall around
The Daughters of Albion, divide & unite in jealousy & cruelty
The Inhabitants of Albion at the Harvest & the Vintage
Feel their Brain cut round beneath the temples shrieking
Bonifying into a Scull, the Marrow exuding in dismal pain
They flee over the rocks bonifying: Horses: Oxen: feel the knife.
And while the Sons of Albion by severe War & Judgment, bonify
The Hermaphroditic Condensations are divided by the Knife
The obdurate Forms are cut asunder by Jealousy & Pity.

Rational Philosophy and Mathematic Demonstration
Is divided in the intoxications of pleasure & affection
Two Contraries War against each other in fury & blood,
And Los fixes them on his Anvil, incessant his blows:
He fixes them with strong blows, placing the stones & timbers
To Create a World of Generation from the World of Death:
Dividing the Masculine & Feminine: for the comingling
Of Albions & Luvahs Spectres was Hermaphroditic

Urizen wrathful strode above directing the awful Building:
As a Mighty Temple; delivering Form out of confusion
Jordan sprang beneath its threshold bubbling from beneath
Its pillars: Euphrates ran under its arches: white sails
And silver oars reflect on its pillars, & sound on its ecchoing
Pavements: where walk the Sons of Jerusalem who remain Ungenerate
But the revolving Sun and Moon pass thro its porticoes,
Day & night, in sublime majesty & silence they revolve
And shine glorious within: Hand & Koban arch'd over the Sun
In the hot noon, as he traveld thro his journey. Hyle & Skofield
Arch'd over the Moon at midnight & Los fixed them there.
With his thunderous Hammer; terrified the Spectres rage & flee
Canaan is his portico; Jordan is a fountain in his porch;
A fountain of milk & wine to relieve the traveller:
Egypt is the eight steps within. Ethiopia supports his pillars;
Lybia & the Lands unknown, are the ascent without;
Within is Asia & Greece, ornamented with exquisite art:
Persia & Media are his halls: his inmost hall is Great Tartary.
China & India & Siberia are his temples for entertainment
Poland & Russia & Sweden, his soft retired chambers
France & Spain & Italy & Denmark & Holland & Germany
Are the temples among his pillars. Britain is Los's Forge;
America North & South are his baths of living waters.

Such is the Ancient World of Urizen in the Satanic Void
Created from the Valley of Middlesex by Londons River
From Stone-henge & from London Stone, from Cornwall to Cathnes
The Four Zoa's rush around on all sides in dire ruin
Furious in pride of Selfhood the terrible Spectres of Albion
Rear their dark Rocks among the Stars of God: stupendous
Works! A World of Generation continually Creating; out of
The Hermaphroditic Satanic World of rocky destiny.

And formed into Four precious stones, for enterance from Beulah

For the Veil of Vala which Albion cast into the Atlantic Deep
To catch the Souls of the Dead: began to Vegetate & Petrify
Around the Earth of Albion, among the Roots of his Tree
This Los formed into the Gates & mighty Wall, between the Oak
Of weeping & the Palm of suffering beneath Albions Tomb,
Thus in process of time it became the beautiful Mundane Shell,
The Habitation of the Spectres of the Dead & the Place
Of Redemption & of awaking again into Eternity

For Four Universes round the Mundane Egg remain Chaotic
One to the North: Urthona: One to the South: Urizen:
One to the East: Luvah: One to the West, Tharmas;
They are the Four Zoas that stood around the Throne Divine
Verulam: London: York & Edinburgh: their English names
But when Luvah assumed the World of Urizen Southward
And Albion was slain upon his Mountains & in his Tent,
All fell towards the Center, sinking downwards in dire ruin,
In the South remains a burning Fire: in the East, a Void
In the West, a World of raging Waters: in the North; solid Darkness
Unfathomable without end: but in the midst of these
Is Built eternally the sublime Universe of Los & Enitharmon

And in the North Gate, in the West of the North, toward Beulah
Cathedrons Looms are builded. & Los's Furnaces in the South
A wondrous golden Building immense with ornaments sublime
Is bright Cathedrons golden Hall, its Courts Towers & Pinnacles

And one Daughter of Los sat at the fiery Reel & another
Sat at the shining Loom with her Sisters attending round
Terrible their distress & their sorrow cannot be utterd
And another Daughter of Los sat at the Spinning Wheel
Endless their labour, with bitter food, void of sleep.
Tho hungry they labour: they rouze themselves anxious
Hour after hour labouring at the whirling Wheel
Many Wheels & as many lovely Daughters sit weeping
Yet the intoxicating delight that they take in their work
Obliterates every other evil: none pities their tears
Yet they regard not pity & they expect no one to pity
For they labour for life & love, regardless of any one
But the poor Spectres that they work for, always incessantly
They are mockd, by every one that passes by, they regard not
They labour; & when their Visions are ended in disappointment
They mend them sorrowing with many tears & afflictions.

Other Daughters Weave on the Cushion & Pillow, Network fine
That Rahab & Tirzah may exist & live & breathe & love
Ah, that it could be as the Daughters of Beulah wish!

Other Daughters of Los, labouring at Looms less fine
Create the Silk-worm & the Spider & the Catterpiller
To assist in their most grievous work of pity & compassion
And others Create the wooly Lamb & the downy Fowl
To assist in the work: the Lamb bleats, the Sea-fowl cries
Men understand not the distress & the labour & sorrow
That in the Interior Worlds is carried on in fear & trembling
Weaving the shuddering fears & loves of Albions Families
Prepare the Spindle & the Loom they sing & spin
Spinning the winding sheet of Death
The Veil of Vala her & Purple & Scarlet & fine twined Linen

The clouds of Albions Druid Temples rage in the eastern heaven
While Los sat terrified beholding Albions Spectre who is Luvah
Spreading in bloody veins in torments over Europe & Asia;
Not yet formed but a wretched torment unformed & abyssal
In flaming fire; within the Furnaces the Divine Vision appeard
On Albions hills: often walking from the Furnaces in clouds
And flames among the Druid Temples & the Starry Wheels
Gatherd Jerusalems Children in his arms & bore them like
A Shepherd in the night of Albion which overspread all the Earth

I gave thee liberty and life O lovely Jerusalem
And thou hast bound me down upon the Stems of Vegetation
I gave thee Sheep-walks upon the Spanish Mountains Jerusalem
I gave thee Priams City and the Isles of Grecia lovely!
I gave thee Hand & Scofield & the Counties of Albion:
They spread forth like a lovely root into the Garden of God:
They were as Adam before me: united into One Man,
They stood in innocence & their skiey tent reachd over Asia
To Nimrods Tower to Ham & Canaan walking with Mizraim
Upon the Egyptian Nile, with solemn songs to Grecia
And sweet Hesperia even to Great Chaldea & Tesshina
Following thee as a Shepherd by the Four Rivers of Eden
Why wilt thou rend thyself apart Jerusalem?
And build this Babylon & sacrifice in secret Groves,
Among the Gods of Asia: among the fountains of pitch & nitre
Therefore thy mountains are become barren Jerusalem!
Thy Valleys Plains of burning sand: thy Rivers: waters of death
Thy Villages die of the Famine and thy Cities
Beg bread from house to house lovely Jerusalem
Why wilt thou deface thy beauty & the beauty of thy little-ones
To please thy Idols, in the pretended chastities of Uncircumcision
Thy Sons are lovelier than Egypt or Assyria: wherefore
Dost thou blacken their beauty by a secluded place of rest.
And a peculiar Tabernacle to cut the integuments of beauty
Into veils of tears and sorrows O lovely Jerusalem!
They have persuaded thee to this therefore their end shall come
And I will lead thee thro the Wilderness in shadow of my cloud
And in my love I will lead thee, lovely Shadow of Sleeping Albion.

This is the Song of the Lamb, sung by Slaves in evening time.

But Jerusalem faintly saw him, closd in the Dungeons of Babylon
Her Form was held by Beulahs Daughters, but all within unseen
She sat at the Mills, her hair unbound her feet naked
Cut with the flints; her tears run down her reason grows like
The Wheel of Hand, incessant turning day & night without rest
Insane she raves upon the winds hoarse, inarticulate:
All night Vala hears, she triumphs in pride of holiness
To see Jerusalem deface her lineaments with bitter blows
Of despair, while the Satanic Holiness triumphd in Vala
In a Religion of Chastity & Uncircumcised Selfishness
Both of the Head & Heart & Loins, closd up in Moral Pride

But the Divine Lamb stood beside Jerusalem, oft she saw
The lineaments Divine & oft the Voice heard, & oft she said:
O Lord & Saviour, have the Gods of the Heathen pierced thee?
Or hast thou been pierced in the House of thy Friends?
Art thou alive! & livest thou for-evermore? or art thou
Not: but a delusive shadow, a thought that liveth not.
Babel mocks saying, there is no God nor Son of God
That thou O Human Imagination, O Divine Body art all
A delusion, but I know thee O Lord when thou arisest upon
My weary eyes even in this dungeon, & this iron mill,
The Stars of Albion cruel rise; thou bindest to sweet influences:
For thou also sufferest with me altho I behold thee not;
And altho I sin & blaspheme thy holy name, thou pitiest me:
Because thou knowest I am deluded by the turning mills.
And by these visions of pity & love because of Albions death.
Thus spake Jerusalem, & thus the Divine Voice replied.

Mild Shade of Man, pitiest thou these Visions of terror & woe!
Give forth thy pity & love, fear not! lo I am with thee always.
Only believe in me that I have power to raise from death
Thy Brother who Sleepeth in Albion: fear not trembling Shade

61

Behold: in the Visions of Elohim Jehovah, behold Joseph & Mary
And be comforted O Jerusalem in the Visions of Jehovah Elohim

She looked & saw Joseph the Carpenter in Nazareth & Mary
His espoused Wife. And Mary said. If thou put me away from thee
Dost thou not murder me? Joseph spoke in anger & fury. Should I
Marry a Harlot & an Adulteress? Mary answerd, Art thou more pure
Than thy Maker who forgiveth Sins & calls again Her that is Lost
Tho She hates. he calls her again in love. I love my dear Joseph
But he driveth me away from his presence. yet I hear the voice of God
In the voice of my Husband. tho he is angry for a moment, he will not
Utterly cast me away. if I were pure, never could I taste the sweets
Of the Forgiveness of Sins! if I were holy! I never could behold the tears
Of love! of him who loves me in the midst of his anger in furnace of fire

Ah my Mary: said Joseph: weeping over & embracing her closely in
His arms: Doth he forgive Jerusalem & not exact Purity from her who is
Polluted. I heard his voice in my sleep & his Angel in my dream:
Saying, Doth Jehovah Forgive a Debt only on condition that it shall
Be Payed? Doth he Forgive Pollution only on conditions of Purity
That Debt is not Forgiven! That Pollution is not Forgiven
Such is the Forgiveness of the Gods, the Moral Virtues of the
Heathen, whose tender Mercies are Cruelty. But Jehovahs Salvation
Is without Money & without Price. in the Continual Forgiveness of Sins
In the Perpetual Mutual Sacrifice in Great Eternity! for behold!
There is none that liveth & sinneth not! And this is the Covenant
Of Jehovah: If you Forgive one-another, so shall Jehovah Forgive You:
That He Himself may Dwell among You. Fear not then to take
To thee Mary thy Wife, for she is with Child by the Holy Ghost

Then Mary burst forth into a Song! she flowed like a River of
Many Streams in the arms of Joseph & gave forth her tears of joy
Like many waters, and Emanating into gardens & palaces upon
Euphrates & to forests & floods & animals wild & tame from
Gihon to Hiddekel. & to corn fields & villages & inhabitants
Upon Pison & Arnon & Jordan. And I heard the voice among
The Reapers Saying. Am I Jerusalem the lost Adulteress? or am I
Babylon come up to Jerusalem? And another voice answerd Saying

Does the voice of my Lord call me again? am I pure thro his Mercy
And Pity. Am I become lovely as a Virgin in his sight who am
Indeed a Harlot drunken with the Sacrifice of Idols does he
Call her pure as he did in the days of her Infancy when She
Was cast out to the loathing of her person. The Chaldean took
Me from my Cradle. The Amalekite stole me away upon his Camels
Before I had ever beheld with love the Face of Jehovah; or known
That there was a God of Mercy: O Mercy O Divine Humanity!
O Forgiveness & Pity & Compassion! If I were Pure I should never
Have known Thee: If I were Unpolluted I should never have
Glorified thy Holiness. or rejoiced in thy great Salvation.

Mary leaned her side against Jerusalem. Jerusalem recieved
The Infant into her hands in the Visions of Jehovah. times passed on
Jerusalem fainted over the Cross & Sepulcher She heard the voice
Wilt thou make Rome thy Patriarch Druid & the Kings of Europa his
Horsemen? Man in the Resurrection changes his Sexual Garments at Will
Every Harlot was once a Virgin: every Criminal an Infant Love!

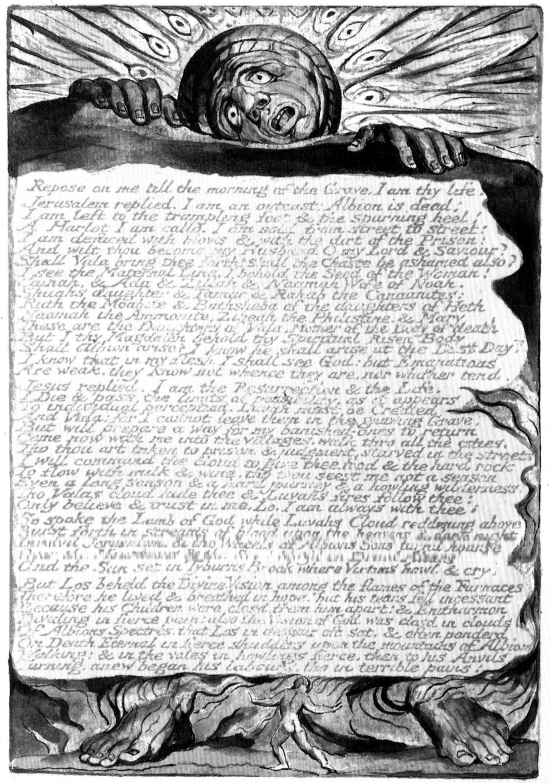

Repose on me till the morning of the Grave. I am thy life.
Jerusalem replied. I am an outcast: Albion is dead;
I am left to the trampling foot & the spurning heel!
A Harlot I am call'd. I am sold from street to street!
I am defaced with blows & with the dirt of the Prison!
And wilt thou become my Husband O my Lord & Saviour?
Shall Vala bring thee forth! shall the Chaste be ashamed also?
I see the Maternal Line, I behold the Seed of the Woman!
Cainah, & Ada & Zillah & Naamah Wife of Noah.
Shuahs daughter & Tamar & Rahab the Canaanites:
Ruth the Moabite & Bathsheba of the daughters of Heth
Naamah the Ammonite, Zibeah the Philistine, & Mary
These are the Daughters of Vala. Mother of the Body of death
But I thy Magdalen behold thy Spiritual Risen Body
Shall Albion arise? I know he shall arise at the Last Day!
I know that in my flesh I shall see God: but Emanations
Are weak. they know not whence they are, nor whither tend.

Jesus replied. I am the Resurrection & the Life.
I Die & pass the limits of possibility, as it appears
To individual perception. Luvah must be Created
And Vala: for I cannot leave them in the gnawing Grave.
But will prepare a way for my banished-ones to return
Come now with me into the Villages. walk thro all the Cities.
Tho thou art taken to prison & judgment, starved in the streets
I will command the cloud to give thee food & the hard rock
To flow with milk & wine, tho thou seest me not a season
Even a long season & a hard journey & a howling wilderness!
Tho Valas cloud hide thee & Luvahs fires follow thee!
Only believe & trust in me, Lo. I am always with thee!

So spoke the Lamb of God while Luvahs Cloud reddening above
Burst forth in streams of blood upon the heavens & dark night
Involvd Jerusalem. & the Wheels of Albions Sons turnd hoarse
Over the Mountains & the fires blazd on Druid Altars
And the Sun set in Tyburns Brook where Victims howl & cry.

But Los beheld the Divine Vision among the flames of the Furnaces
Therefore he lived & breathed in hope. but his tears fell incessant
Because his Children were closd from him apart: & Enitharmon
Dividing in fierce pain: also the Vision of God was closd in clouds
Of Albions Spectres, that Los in despair oft sat, & often ponderd
On Death Eternal in fierce shudders upon the mountains of Albion
Walking: & in the vales in howlings fierce, then to his Anvils
Turning anew began his labours, tho in terrible pains!

Jehovah stood among the Druids in the Valley of Anandale
When the Four Zoa's of Albion the Four Living Creatures, the Cherubim
Of Albion tremble before the Spectre, in the Starry Harness of the Plow
Of Nations. And their Names are Urizen & Luvah & Tharmas & Urthona

Luvah slew Tharmas the Angel of the Tongue & Albion brought him
To Justice in his own City of Paris. denying the Resurrection
Then Vala the Wife of Albion. who is the Daughter of Luvah
Took vengeance Twelve-fold among the Chaotic Rocks of the Druids
Where the Human Victims howl to the Moon & Thor & Friga
Dance the dance of death contending with Jehovah among the Cherubim.
The Chariot Wheels filled with Eyes rage along the howling Valley
In the Dividing of Reuben & Benjamin bleeding from Chesters River

The Giants & the Witches & the Ghosts of Albion dance with Thor
& Friga. & the Fairies lead the Moon along the Valley of Cherubim
Bleeding in torrents from Mountain to Mountain, a lovely Victim
And Jehovah stood in the Gates of the Victim. & he appeared
A weeping Infant in the Gates of Birth in the midst of Heaven

The Cities & Villages of Albion became Rock & Sand Unhumanized
The Druid Sons of Albion & the Heavens a Void around unfathomable
No Human Form but Sexual & a little weeping Infant pale reflected
Multitudinous in the Looking Glass of Enitharmon on all sides
Around in the clouds of the Female. on Albions Cliffs of the Dead

Such the appearance in Cheviot: in the Divisions of Reuben

When the Cherubim hid their heads under their wings in deep slumbers
When the Druids demanded Chastity from Woman & all was lost.

How can the Female be Chaste O thou stupid Druid Cried Los
Without the Forgiveness of Sins in the merciful clouds of Jehovah
And without the Baptism of Repentance to wash away Calumnies. and
The Accusations of Sin that each may be Pure in their Generations
O when shall Jehovah give us Victims from his Flocks & his Herds
Instead of Human Victims by the Daughters of Albion & Canaan

Then laugh'd Gwendolen & her laughter shook the Nations & Familys of
The Dead beneath Beulah from Tyburn to Golgotha. and from
Ireland to Japan. furious her Lions & Tygers & Wolves sport before
Los on the Thames & Medway. London & Canterbury groan in pain.

Los knew not yet what was done: he thought it was all in Vision
In Visions of the Dreams of Beulah among the Daughters of Albion
Therefore the Murder was put apart in the Looking Glass of Enitharmon
He saw in Vala's hand the Druid Knife of Revenge & the Poison Cup
Of Jealousy, and thought it a Poetic Vision of the Atmospheres
Till Canaan rolld apart from Albion across the Rhine: along the Danube

And all the Land of Canaan suspended over the Valley of Cheviot
From Rephaim to Maon, & from Shur to Gaza of the Amalekite —
And Reuben fled with his head downwards among the Caverns

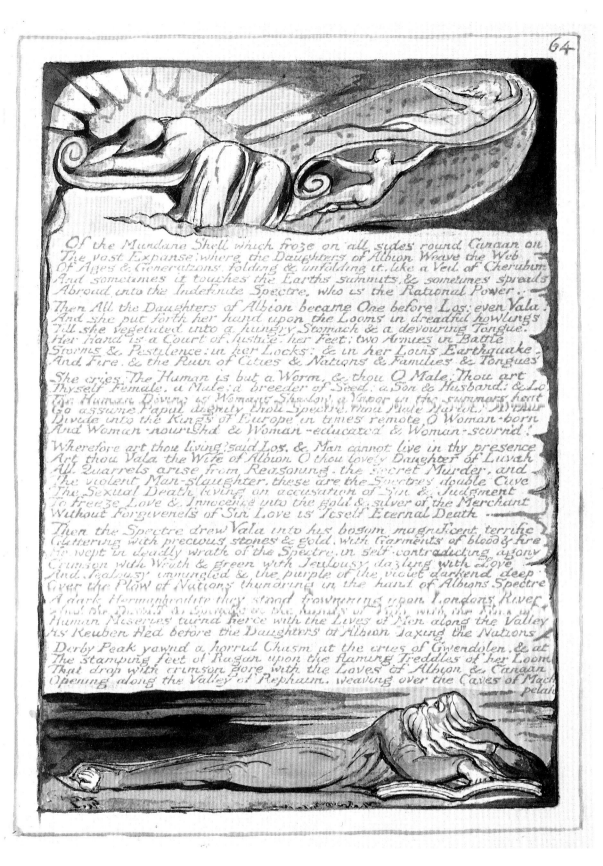

Of the Mundane Shell which froze on all sides round Canaan on
The vast Expanse; where the Daughters of Albion Weave the Web
Of Ages & Generations, folding & unfolding it, like a Veil of Cherubim
And sometimes it touches the Earths summits, & sometimes spreads
Abroad into the Indefinite Spectre, who is the Rational Power.

Then All the Daughters of Albion became One before Los: even Vala!
And she put forth her hand upon the Looms in dreadful howlings
Till she vegetated into a hungry Stomach & a devouring Tongue.
Her Hand is a Court of Justice, her Feet; two Armies in Battle
Storms & Pestilence: in her Locks: & in her Loins Earthquake.
And Fire. & the Ruin of Cities & Nations & Families & Tongues

She cries; The Human is but a Worm, & thou O Male: Thou art
Thyself Female, a Male: a breeder of Seed: a Son & Husband: & Lo,
The Human Divine is Womans Shadow, a Vapor in the summers heat
Go assume Papal dignity thou Spectre, thou Male Harlot! Arthur
Divide into the Kings of Europe in times remote O Woman-born
And Woman-nourishd & Woman-educated & Woman-scornd!

Wherefore art thou living? said Los, & Man cannot live in thy presence
Art thou Vala the Wife of Albion O thou lovely Daughter of Luvah
All Quarrels arise from Reasoning, the Secret Murder, and
The violent Man-slaughter, these are the Spectres double Cave
The Sexual Death living on accusation of Sin & Judgment
To freeze Love & Innocence into the gold & silver of the Merchant
Without Forgiveness of Sin Love is Itself Eternal Death

Then the Spectre drew Vala into his bosom magnificent terrific
Glittering with precious stones & gold, with Garments of blood & fire
He wept in deadly wrath of the Spectre, in self-contradicting agony
Crimson with Wrath & green with Jealousy, dazling with Love
And Jealousy immingled & the purple of the violet darkend deep
Over the Plow of Nations thundring in the hand of Albions Spectre
A dark Hermaphrodite they stood frowning upon Londons River
And the Distaff & Spindle in the hands of Vala with the Flax of
Human Miseries turnd fierce with the Lives of Men along the Valley
As Reuben fled before the Daughters of Albion Taxing the Nations

Derby Peak yawnd a horrid Chasm at the cries of Gwendolen, & at
The stamping feet of Ragan upon the flaming Treddles of her Loom
That drop with crimson gore with the Loves of Albion & Canaan
Opening along the Valley of Rephaim, weaving over the Caves of Mach
                                                              pelah

To decide Two Worlds with a great decision: a World of Mercy, and
A World of Justice, the World of Mercy for Salvation
To cast Luvah into the Wrath, and Albion into the Pity
In the Two Contraries of Humanity & in the Four Regions.

For in the depths of Albions bosom in the eastern heaven,
They sound the clarions strong; they chain the howling Captives!
They cast the lots into the helmet; they give the oath of blood in Lambeth
They vote the death of Luvah, & they nail'd him to Albions Tree in Bath:
They stain'd him with poisonous blue, they inwove him in cruel roots
To die a death of Six thousand years bound round with vegetation.
The sun was black & the moon rolld a useless globe thro Britain!

Then left the Sons of Urizen the plow & harrow, the loom
The hammer & the chisel, & the rule & compasses; from London fleeing
They forged the sword on Cheviot, the chariot of war & the battle-ax,
The trumpet fitted to mortal battle, & the flute of summer in Annandale
And all the Arts of Life, they changed into the Arts of Death in Albion.
The hour-glass contemnd because its simple workmanship.
Was like the workmanship of the plowman, & the water wheel,
That raises water into cisterns: broken & burnd with fire:
Because its workmanship, was like the workmanship of the shepherd
And in their stead, intricate wheels invented, wheel without wheel:
To perplex youth in their outgoings, & to bind to labours in Albion
Of day & night the myriads of eternity that they may grind
And polish brass & iron hour after hour laborious task!
Kept ignorant of its use, that they might spend the days of wisdom
In sorrowful drudgery, to obtain a scanty pittance of bread:
In ignorance to view a small portion & think that All,
And call it Demonstration: blind to all the simple rules of life.

Now: now the battle rages round thy tender limbs O Vala.
Now smile among thy bitter tears: now put on all thy beauty
Is not the wound of the sword sweet! & the broken bone delightful!
Wilt thou now smile among the scythes when the wounded groan in the field
We were carried away in thousands from London; & in tens
Of thousands from Westminster & Marybone in ships closd up:
Chaind hand & foot, compelld to fight under the iron whips
Of our captains; fearing our officers more than the enemy.
Lift up thy blue eyes Vala & put on thy sapphire shoes:
O melancholy Magdalen behold the morning over Malden break;
Gird on thy flaming zone, descend into the sepulcher of Canterbury.
Scatter the blood from thy golden brow, the tears fr: m thy silver locks:
Shake off the waters from thy wings! & the dust from thy white garments
Remember all thy feigned terrors on the secret couch of Lambeths Vale
When the sun rose in glowing morn, with arms of mighty hosts
Marching to battle who was wont to rise with Urizens harps
Girt as a sower with his seed to scatter life abroad over Albion!
Arise O Vala! bring the bow of Urizen: bring the swift arrows of light.
How ragd the golden horses of Ur-zen, compelld to the chariot of love!
Compelld to leave the plow to the ox, to snuff up the winds of desolation
To trample the corn fields in boastful neighings; this is no gentle harp
This is no warbling brook, nor shadow of a Mirtle tree:
But blood and wounds and dismal cries, and shadows of the oak:
And hearts laid open to the light, by the broad grizly sword:
And bowels hid in hammered steel ripd quivering on the ground.
Call forth thy smiles of soft deceit: call forth thy cloudy tears:
We hear thy sighs in trumpets shrill when morn shall blood renew.

So sang the Spectre Sons of Albion round Luvahs Stone of Trial:
Mocking and deriding at the writhings of their Victim on Salisbury:
Drinking his Emanation in intoxicating bliss rejoicing in Giant dance;
For a Spectre has no Emanation but what he imbibes from deceiving
A Victim! Then he becomes her Priest & she his Tabernacle.
And his Oak Grove, till the Victim rend the woven Veil.
In the end of his sleep when Jesus calls him from his grave

Howling the Victims on the Druid Altars yield their souls
To the stern Warriors: lovely sport the Daughters round their Victims
Drinking their lives in sweet intoxication, hence arose from Bath
Soft deluding odours, in spiral volutions intricately winding
Over Albions mountains, a feminine indefinite cruel delusion.
Astonishd: terrified & in pain & torment Sudden they behold
Their own Parent the Emanation of their murderd Enemy
Become their Emanation and their Temple and Tabernacle
They knew not this Vala was their beloved Mother Vala, Albions Wife.

Terrified at the sight of the Victim: at his distorted sinews!
The trembling of Vala: whom they beheld slain by Albions Spear;
And the dull eyes rolling over a mockery & bitter scorn
Sudden they became like what they beheld in howlings & deadly pain
Spasms smile their features, sinews & limbs: pale they look on one another.
They turn, contorted: their iron necks bend unwilling towards
Albion: their lips tremble: their muscular fibres are cramp'd & smitten
They become like what they behold! Yet immense in strength & power,

In awful pomp & gold, in all the precious unhewn stones of Eden
They build a stupendous Building on the Plain of Salisbury; with chains
Of rocks round London Stone: of Reasonings: of unhewn Demonstrations
In labyrinthine arches. (Mighty Urizen the Architect.) thro' which
The Heavens might revolve & Eternity be bound in their chain.
Labour unparalleld! a wondrous rocky World of cruel destiny
Rocks piled on rocks reaching the stars: stretching from pole to pole.
The Building is Natural Religion & its Altars Natural Morality
A building of eternal death: whose proportions are eternal despair
Here Vala stood turning the iron Spindle of destruction
From heaven to earth: howling! invisible! but not invisible
Her Two Covering Cherubs afterwards named Voltaire & Rousseau:
Two frowning Rocks: on each side of the Cove & Stone of Torture:
Frozen Sons of the feminine Tabernacle of Bacon, Newton & Locke.
For Luvah is France: the Victim of the Spectres of Albion.

Los beheld in terror: he pourd his loud storms on the Furnaces:
The Daughters of Albion clothed in garments of needle work
Strip them off from their shoulders and bosoms, they lay aside
Their garments; they sit naked upon the Stone of trial.
The Knife of flint passes over the howling Victim: his blood
Gushes & stains the fair side of the fair Daughters of Albion.
They put aside his curls; they divide his seven locks upon
His forehead: they bind his forehead with thorns of iron
They put into his hand a reed, they mock: Saying: Behold
The King of Canaan whose are seven hundred chariots of iron!
They take off his vesture whole with their Knives of flint:
But they cut asunder his inner garments: searching with
Their cruel fingers for his heart, & there they enter in pomp,
In many tears; & there they erect a temple & an altar:
They pour cold water on his brain in front, to cause
Lids to grow over his eyes in veils of tears: and caverns
To freeze over his nostrils, while they feed his tongue from cups
And dishes of painted clay. Glowing with beauty & cruelty:
They obscure the sun & the moon: no eye can look upon them.

Ah! alas! at the sight of the Victim, & at the sight of those who are smitten,
All who see, become what they behold. their eyes are coverd
With veils of tears and their nostrils & tongues shrunk up
Their ear bent outwards, as their Victim, so are they in the pangs
Of unconquerable fear! amidst delights of revenge Earth-shaking!
And as their eye & ear shrunk, the heavens shrunk away
The Divine Vision became first a burning flame, then a column
Of fire, then an awful fiery wheel surrounding earth & heaven:
And then a globe of blood wandering distant in an unknown night:
Afar into the unknown night the mountains fled away:
Six months of mortality; a summer: & six months of mortality; a winter:
The Human form began to be alterd by the Daughters of Albion
And the perceptions to be dissipated into the Indefinite. Becoming
A mighty Polypus namd Albions Tree: they tie the Veins
And Nerves into two knots: & the Seed into a double knot:
They look forth: the Sun is shrunk: the Heavens are shrunk
Away into the far remote: and the Trees & Mountains witherd
Into indefinite cloudy shadows in darkness & separation.
By invisible Hatreds adjoind, they seem remote and separate
From each other; and yet are close compelld into nervous fibres
And brooding in the veins of the yet living creatures. they in hopes
Of future life are bound in the all incircling arms of selfish Love
As the Misletoe grows on the Oak, so Albions Tree on Eternity: Lo!
He who will not comingle in Love, must be adjoind by Hate

They look forth from Stone-henge! from the Cove round London Stone
They look on one another: the mountain calls out to the mountain:
Plinlimmon shrunk away: Snowdon trembled: the mountains
Of Wales & Scotland beheld the descending War: the routed flying:
Red run the streams of Albion: Thames is drunk with blood:
As Gwendolen cast the Shuttle of war: as Cambel returnd the beam.
The Humber & the Severn: are drunk with the blood of the slain:
London feels his brain cut round: Edinburghs heart is circumscribed!
York & Lincoln hide among the flocks, because of the griding Knife.
Worcester & Hereford: Oxford & Cambridge reel & stagger
Overwearied with howling: Wales & Scotland alone sustain the fight!
The inhabitants are sick to death: they labour to divide into Days
And Nights, the uncertain Periods: and into Weeks & Months. In vain
They send the Dove & Raven: & in vain the Serpent over the mountains
And in vain the Eagle & Lion over the four-fold wilderness.
They return not: but generate in rocky places desolate.
They return not; but build a habitation separate from Man.
The Sun forgets his course like a drunken man; he hesitates,
Upon the Cheselden hills, thinking to sleep on the Severn
In vain: he is hurried afar into an unknown Night
He bleeds in torrents of blood as he rolls thro' heaven above
He chokes up the paths of the sky: the Moon is leprous as snow:
Trembling & descending down seeking to rest upon high Mona:
Scattering her leprous snows in flakes of disease over Albion.
The Stars flee remote: the heaven is iron, the earth is sulphur,
And all the mountains & hills shrink up like a withering gourd,
As the Senses of Men shrink together under the Knife of flint,
In the hands of Albions Daughters, among the Druid Temples.

By those who drink their blood & the blood of their Covenant
And the Twelve Daughters of Albion united in Rahab & Tirzah
A Double Female: And they drew out from the Rocky Stones
Fibres of Life to Weave for every Female is a Golden Loom
The Rocks are opake hardnesses covering all Vegetated things
And as they Wove & Cut from the Looms in various divisions
Stretching over Europe & Asia from Ireland to Japan
They divided into many lovely Daughters to be counterparts
To those they Wove, for when they Wove a Male, they divided
Into a Female to the Woman: Nature in spite Knowing
They cut the Fibres from the Rocks groaning in pain they Weave:
Calling the Rocks Atomic Origins of Existence; denying Eternity
By the Atheistical Epicurean Philosophy of Albions Tree
Such are the Feminine & Masculine when separated from Man
They call the Rocks Parents of Men, & adore the frowning Chaos
Dancing around in howling pain clothed in the bloody Veil.
Hiding Albions Sons within the Veil, closing Jerusalems
Sons without; to feed with their Souls the Spectres of Albion
Ashamed to give Love openly to the piteous & merciful Man
Counting him an imbecile mockery: but the Warrior
They adore: & his revenge cherish with the blood of the Innocent
They drink up Dan & Gad, to feed with milk Skofeld & Kotope
They strip off Josephs Coat & dip it in the blood of battle

Tirzah sits weeping to hear the shrieks of the dying: her Knife
Of flint is in her hand: she passes it over the howling Victim
The Daughters Weave their Work in loud cries over the Rock
Of Horeb: still eyeing Albions Cliffs eagerly siezing & twisting
The threads of Vala & Jerusalem running from mountain to mountain
Over the whole Earth: loud the Warriors rage in Beth Peor
Beneath the iron whips of their Captains & consecrated banners
Loud the Sun & Moon rage in the conflict: loud the Stars
Shout in the night of battle & their spears grow to their hands
With blood, weaving the deaths of the Mighty into a Tabernacle
For Rahab & Tirzah; till the Great Polypus of Generation covered
    the Earth

In Verulam the Polypus's Head. winding around his bulk
Thro Rochester, and Chichester, & Exeter & Salisbury,
To Bristol: & his Heart beat strong on Salisbury Plain
Shooting out Fibres round the Earth, thro Gaul & Italy
And Greece, & along the Sea of Rephaim into Judea
To Sodom & Gomorrha: thence to India, China & Japan

The Twelve Daughters in Rahab & Tirzah have circumscribd the Brain
Beneath & pierced it thro the midst with a golden pin.
Blood hath staind her fair side beneath her bosom.

O thou poor Human Form! said she. O thou poor child of woe!
Why wilt thou wander away from Tirzah: why me compel to bind thee
If thou dost go away from me, I shall consume upon these Rocks
These fibres of thine eyes that used to beam in distant heavens
Away from me: I have bound down with a hot iron.
These nostrils that expanded with delight in morning skies
I have bent downward with lead melted in my roaring Furnaces
Of affliction: of love: of sweet despair: of torment unendurable
My soul is seven furnaces, incessant roars the bellows
Upon my terribly flaming heart, the molten metal runs
In channels thro my fiery limbs: O love! O pity! O fear!
O pain! O the pangs, the bitter pangs of love forsaken
Ephraim was a wilderness of joy where all my wild beasts ran
The River Kanah wanderd by my sweet Manassehs side
To see the boy spring into heavens sounding from my sight!
Go Noah fetch the girdle of strong brass, heat it red-hot:
Press it around the loins of this ever expanding cruelty
Shriek not so my only love: I refuse thy joys: I drink
Thy shrieks because Hand & Hyle are cruel & obdurate to me

O Skofield why art thou cruel? Lo Joseph is thine! to make
You One: to weave you both in the same mantle of skin
Bind him down Sisters bind him down on Ebal Mount of cursing:
Malah come forth from Lebanon: & Hoglah from Mount Sinai:
Come circumscribe this tongue of sweets & with a screw of iron
Fasten this ear into the rock: Milcah the task is thine
Weep not so Sisters: weep not so: our life depends on this
Or mercy & truth are fled away from Shechem & Mount Gilead
Unless my beloved is bound upon the Stems of Vegetation

And thus the Warriors cry, in the hot day of Victory, in Songs.
Look: the beautiful Daughter of Albion sits naked upon the Stone
Her panting Victim beside her: her heart is drunk with blood
Tho her brain is not drunk with wine: she goes forth from Albion
In pride of beauty: in cruelty of holiness: in the brightness
Of her tabernacle, & her ark & secret place, the beautiful Daughter
Of Albion, delights the eyes of the Kings, their hearts & the
Hearts of their Warriors glow hot before Thor & Friga. O Molech!
O Chemosh! O Bacchus! O Venus! O Double God of Generation
The Heavens are cut like a mantle around from the Cliffs of Albion
Across Europe; across Africa: in howlings & deadly War
A sheet & veil & curtain of blood is let down from Heaven
Across the hills of Ephraim & down Mount Olivet to
The Valley of the Jebusite: Molech rejoices in heaven
He sees the Twelve Daughters naked upon the Twelve Stones
Themselves condensing to rocks & into the Ribs of a Man
Lo they shoot forth in tender Nerves across Europe & Asia
Lo they rest upon the Tribes, where their panting Victims lie
Molech rushes into the Kings in love to the beautiful Daughters
But they frown & delight in cruelty, refusing all other joy
Bring your Offerings, your first begotten: pamperd with milk & blood
Your first born of seven years old: be they Males or Females:
To the beautiful Daughters of Albion; they sport before the Kings
Clothed in the skin of the Victim! blood: human blood: is the life
And delightful food of the Warrior: the well fed Warriors flesh
Of him who is slain in War: fills the Valleys of Ephraim with
Breeding Women walking in pride, & bringing forth under green trees
With pleasure, without pain, for their food is, blood of the Captive
Molech rejoices thro the Land from Havilah to Shur: he rejoices
In moral law & its severe penalties: loud Shaddai & Jehovah
Thunder above: when they see the Twelve panting Victims
On the Twelve Stones of Power, &, the beautiful Daughters of Albion
If you dare rend their Veil with your Spear: you are healed of Love!
From the Hills of Camberwell & Wimbledon: from the Valleys
Of Walton & Esher: from Stone-henge & from Maldens Cove
Jerusalems Pillars fall in the rendings of fierce War
Over France & Germany: upon the Rhine & Danube
Reuben & Benjamin flee: they hide in the Valley of Rephaim
Why trembles the Warriors limbs when he beholds thy beauty
Spotted with Victims blood: by the fires of thy secret tabernacle
And thy ark & holy place: at thy frowns: at thy dire revenge
Smitten as Uzzah of old: his armour is softend: his spear
And sword faint in his hand, from Albion across Great Tartary
O beautiful Daughter of Albion: cruelty is thy delight
O Virgin of terrible eyes, who dwellest by Valleys of springs
Beneath the Mountains of Lebanon, in the City of Rehob in Hamath
Taught to touch the harp: to dance in the Circle of Warriors
Before the Kings of Canaan: to cut the flesh from the Victim
To roast the flesh in fire: to examine the Infants limbs
In cruelties of holiness: to refuse the joys of love: to bring
The Spies from Egypt, to raise jealousy in the bosoms of the Twelve
Kings of Canaan: then to let the Spies depart to Meribah Kadesh
To the place of the Amalekite: I am drunk with unsatiated love
I must rush again to War: for the Virgin has frownd & refusd
Sometimes I curse & sometimes bless thy fascinating beauty
Once Man was occupied in intellectual pleasures & energies
But now my soul is harrowd with grief & fear & love & desire
And now I hate & now I love & Intellect is no more:
There is no time for any thing but the torments of love & desire
The Feminine & Masculine Shadows soft, mild & ever varying
In beauty: are Shadows now no more, but Rocks in Horeb

then all the Males combined into One Male & every one
Became a ravening eating Cancer growing in the Female
A Polypus of Roots of Reasoning Doubt Despair & Death.
Going forth & returning from Albions Rocks to Canaan:
Devouring Jerusalem from every Nation of the Earth.

Envying stood the enormous Form at variance with Itself
In all its Members: in eternal torment of love & jealousy:
Drivn forth by Los, time after time from Albions cliffy shore,
Drawing the free loves of Jerusalem into infernal bondage:
That they might be born in contentions of Chastity & in
Deadly Hate between Leah & Rachel. Daughters of Deceit & Fraud
Bearing the Images of various Species of Contention
And Jealousy & Abhorrence & Revenge & deadly Murder.
Till they refuse liberty to the Male: & not like Beulah
Where every Female delights to give her maiden to her husband
The Female searches sea & land for gratifications to the
Male Genius: who in return clothes her in gems & gold
And feeds her with the food of Eden, hence all her beauty beams
She Creates at her will a little moony night & silence
With Spaces of sweet gardens & a tent of elegant beauty:
Closed in by a sandy desart & a night of stars shining
And a little tender moon & hovering angels on the wing.
And the Male gives a Time & Revolution to her Space
Till the time of love is passed in ever varying delights
For All Things Exist in the Human Imagination
And thence in Beulah they are stolen by secret amorous theft,
Till they have had Punishment enough to make them commit Crimes
Hence rose the Tabernacle in the Wilderness & all its Offerings,
From Male & Female Loves in Beulah & their Jealousies
But no one can consummate Female bliss in Loss World without
Becoming a Generated Mortal, a Vegetating Death

And now the Spectres of the Dead awake in Beulah: all
The Jealousies become Murderous: uniting together in Rahab
A Religion of Chastity, forming a Commerce to sell Loves
With Moral Law. an Equal Balance, not going down with decision
Therefore the Male severe & cruel filld with stern Revenge:
Mutual Hate returns & mutual Deceit & mutual Fear.

Hence the Infernal Veil grows in the disobedient Female:
Which Jesus rends & the whole Druid Law removes away
From the Inner Sanctuary: a False Holiness hid within the Center.
For the Sanctuary of Eden. is in the Camp: in the Outline
In the Circumference: & every Minute Particular is Holy:
Embraces are Comminglings: from the Head even to the Feet
And not a pompous High Priest entering by a Secret Place.

Jerusalem pined in her inmost soul over Wandering Reuben,
As she slept in Beulahs Night hid by the Daughters of Beulah

And this the form of mighty Hand sitting on Albions cliffs
Before the face of Albion: a mighty threatning Form.

His bosom wide & shoulders huge overspreading wondrous
Bear Three strong sinewy Necks & Three awful & terrible Heads
Three Brains in contradictory council brooding incessantly.
Neither daring to put in act its councils, fearing each other,
Therefore rejecting Ideas as nothing & holding All Wisdom
To consist. in the agreements & disagreents of Ideas.
Plotting to devour Albions Body of Humanity & Love.

Such Form the aggregate of the Twelve Sons of Albion took; & such
Their appearance when combind: but often by birth pangs & loud groans
They divide to Twelve: the key-bones & the chest dividing in pain
Disclose a hideous orifice; thence issuing the Giant-brood
Arise as the smoke of the furnace, shaking the rocks from sea to sea.
And there they combine into Three Forms, named Bacon & Newton & Locke,
In the Oak Groves of Albion which overspread all the Earth.

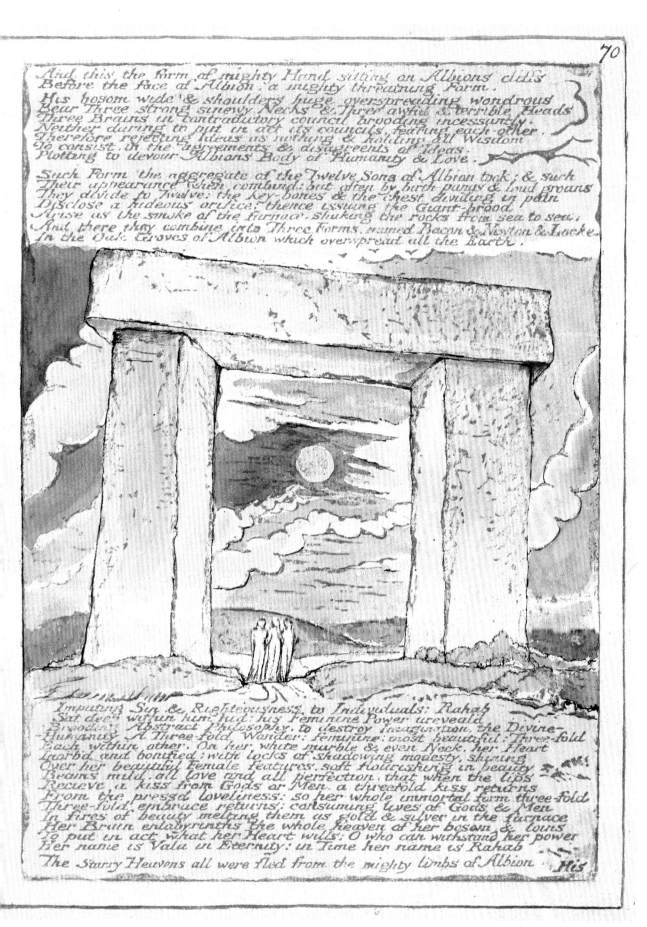

        Imputing Sin & Righteousness to Individuals; Rahab
    Sat deep within him hid; his Feminine Power unreveald
Brooding Abstract Philosophy. to destroy Imagination, the Divine-
Humanity A Three-fold Wonder: feminine: most beautiful: Three-fold
Each within other. On her white marble & even Neck. her Heart
Inorbd and bonified; with locks of shadowing modesty, shining
Over her beautiful Female features, soft flourishing in beauty
Beams mild, all love and all perfection, that when the lips
Recieve a kiss from Gods or Men. a threefold kiss returns
From the pressd loveliness: so her whole immortal form three-fold
Three-fold embrace returns: consuming lives of Gods & Men
In fires of beauty melting them as gold & silver in the furnace
Her Brain enlabyrinths the whole heaven of her bosom & loins
To put in act what her Heart wills; O who can withstand her power
Her name is Vala in Eternity: in Time her name is Rahab

The Starry Heavens all were fled from the mighty limbs of Albion    His

And above Albions Land was seen the Heavenly Canaan
As the Substance is to the Shadow: and above Albions Twelve Sons
Were seen Jerusalems Sons: and all the Twelve Tribes spreading
Over Albion. As the Soul is to the Body, so Jerusalems Sons,
Are to the Sons of Albion: and Jerusalem is Albions Emanation

What is Above is Within, for every-thing in Eternity is translucent:
The Circumference is Within: Without, is formed the Selfish Center
And the Circumference still expands going forward to Eternity.
And the Center has Eternal States! these States we now explore.

And these the Names of Albions Twelve Sons, & of his Twelve Daughters
With their Districts. Hand dwelt in Selsey & had Sussex & Surrey
And Kent & Middlesex: all their Rivers & their Hills of flocks & herds:
Their Villages Towns Cities Sea-Ports Temples sublime Cathedrals;
All were his Friends & their Sons & Daughters intermarry in Beulah
For all are Men in Eternity. Rivers Mountains Cities Villages,
All are Human & when you enter into their Bosoms you walk
In Heavens & Earths; as in your own Bosom you bear your Heaven
And Earth, & all you behold, tho it appears Without it is Within
In your Imagination of which this World of Mortality is but a Shadow.

Hyle dwelt in Winchester comprehending Hants Dorset Devon Cornwall.
Their Villages Cities Sea-Ports, their Corn fields & Gardens spacious
Palaces, Rivers & Mountains, and between Hand & Hyle arose
Gwendolen & Cambel who is Boadicea: they go abroad & return
Like lovely beams of light from the mingled affections of the Brothers
The Inhabitants of the whole Earth rejoice in their beautiful light.

Coban, dwelt in Bath. Somerset Wiltshire Gloucestershire,
Obeyd his awful voice Ignoge is his lovely Emanation,
She adjoind with Gwantokes Children, soon lovely Cordella arose.
Gwantoke forgave & joyd over South Wales & all its Mountains.

Peachey had North Wales Shropshire Cheshire & the Isle of Man.
His Emanation is Mehetabel terrible & lovely upon the Mountains

Brereton had Yorkshire Durham Westmoreland & his Emanation
Is Ragan, she adjoind to Slade, & produced Gonorill far beaming.

Slade had Lincoln Stafford Derby Nottingham & his lovely
Emanation Gonorill rejoices over hills & rocks & woods & rivers.

Hutton had Warwick Northampton Bedford Buckingham,
Leicester & Berkshire: & his Emanation is Gwiniverra beautiful

Skofeld had Ely Rutland Cambridge Huntingdon Norfolk
Suffolk Hartford & Essex: & his Emanation is Gwinevera
Beautiful, she beams towards the east, all kinds of precious stones
And pearl, with instruments of music in holy Jerusalem

Kox had Oxford Warwick Wilts; his Emanation is Estrild:
Joind with Cordella she shines southward over the Atlantic.

Kotope had Hereford Stafford Worcester, & his Emanation
Is Sabrina joind with Mehetabel she shines west over America

Bowen had all Scotland, the Isles, Northumberland & Cumberland
His Emanation is Conwenna, she shines a triple form
Over the north, with pearly beams gorgeous & terrible
Jerusalem & Vala rejoice in Bowen & Conwenna.

But the Four Sons of Jerusalem that never were Generated
Are Rintrah and Palamabron and Theotormon and Bromion, they
Dwell over the Four Provinces of Ireland in heavenly light
The Four Universities of Scotland, & in Oxford & Cambridge & Winchester

But now Albion is darkened & Jerusalem lies in ruins:
Above the Mountains of Albion, above the head of Los.

And Los shouted with ceaseless shoutings & his tears poured down
His immortal cheeks, rearing his hands to heaven for aid Divine!
But he spoke not to Albion: fearing lest Albion should turn his Back
Against the Divine Vision: & fall over the Precipice of Eternal Death
But he receded before Albion & before Vala weaving the Veil
With the iron shuttle of War among the rooted Oaks of Albion;
Weeping & shouting to the Lord day & night; and his Children
Wept round him as a flock silent seven days of Eternity.

And the Thirty-two Counties of the Four Provinces of Ireland
Are thus divided: The Four Counties are in the Four Camps
Munster South in Reubens Gate. Connaut West in Josephs Gate
Ulster North in Dans Gate. Leinster East in Judahs Gate
For Albion in Eternity has Sixteen Gates among his Pillars
But the Four towards the West were Walled up & the Twelve
That front the Four other Points were turned Four Square
By Los for Jerusalems sake & called the Gates of Jerusalem
Because Twelve Sons of Jerusalem fled successive thro the Gates
But the Four Sons of Jerusalem who fled not but remaind
Are Rintrah & Palamabron & Theotormon & Bromion
The Four that remain with Los to guard the Western Wall
And these Four remain to guard the Four Walls of Jerusalem
Whose foundations remain in the Thirty-two Counties of Ireland
And in Twelve Counties of Wales. & in the Forty Counties
Of England & in the Thirty-Six Counties of Scotland
And the names of the Thirty-two Counties of Ireland are these
Under Judah & Issachar & Zebulun are Lowth Longford
Eastmeath Westmeath Dublin Kildare Kings County
Queens County Wicklow Catherloh Wexford Kilkenny
And those under Reuben & Simeon & Levi are these
Waterford Tipperary Cork Limerick Kerry Clare
And those under Ephraim Manasseh & Benjamin are these
Galway Roscommon Mayo Sligo Leitrim
And those under Dan Asher & Napthali are these
Donnegal Antrim Tyrone Fermanagh Armagh Londonderry
Down Managhan Cavan. These are the Land of Erin
All these Center in London, & in Golgonooza. from whence
They are Created continually East & West & North & South
And from them are Created all the Nations of the Earth
Europe & Asia & Africa & America. in fury Fourfold!

And Thirty-two the Nations to dwell in Jerusalems Gates
O Come ye Nations Come ye People Come up to Jerusalem
Return Jerusalem, & dwell together as of old: Return
Return: O Albion let Jerusalem overspread all Nations
As in the times of old: O Albion awake! Reuben wanders
The Nations wait for Jerusalem. they look up for the Bride
France Spain Italy Germany Poland Russia Sweden Turkey
Arabia Palestine Persia Hindostan China Tartary Siberia
Egypt Lybia Ethiopia Guinea Caffraria Negroland Morocco
Congo Zaara Canada Greenland Carolina Mexico
Peru Patagonia Amazonia Brazil Thirty-two Nations
And under these Thirty-two Classes of Islands in the Ocean
All the Nations Peoples & Tongues throughout all the Earth
And the Four Gates of Los surround the Universe Within and
Without; & whatever is visible in the Vegetable Earth. the same
Is visible in the Mundane Shell; reversd in mountain & vale
And a Son of Eden was set over each Daughter of Beulah to guard
In Albions Tomb the wondrous Creation: & the Four-fold Gate
Towards Beulah is to the North Fenelon, Guion, Teresa.
Whitefield & Hervey. guard that Gate; with all the gentle Souls
Who guide the great Wine-press of Love; Four precious stones that Gate:

Women the comforters of Men become the Tormentors & Punishers

73

Such are Cathedrons golden Halls: in the City of Golgonooza
And Los's Furnaces howl loud; living: self-moving: lamenting
With fury & dismay. & they stretch from South to North
Thro all the Four Points. Lo! the Labourers at the Furnaces
Rintrah & Palamabron, Theotormon & Bromion. loud labring
With the innumerable multitudes of Golgonooza, round the Anvils
Of Death. But how they came in to it. in the Furnaces & how long
Vast & severe the anguish eer they knew their Father, were
Long to tell & of the iron rollers, golden axle-trees & yokes
Of brass, iron chains & braces & the gold, silver & brass
Mingled or separate: for swords: arrows: cannons: mortars
The terrible ball: the wedge: the loud sounding hammer of destruction
The sounding flail to thresh: the winnow: to winnow kingdoms
The water-wheel & mill of many innumerable wheels resistless
Over the Four-fold Monarchy from Earth to the Mundane Shell.
Perusing Albions Tomb in the starry characters of Og & Anak:
To Create the lion & wolf the bear: the tyger & ounce:
To Create the wooly lamb & downy fowl & scaly serpent
The summer & winter: day & night: the sun & moon & stars
The tree: the plant: the flower: the rock: the stone: the metal:
Of Vegetative Nature: by their hard restricting condensations

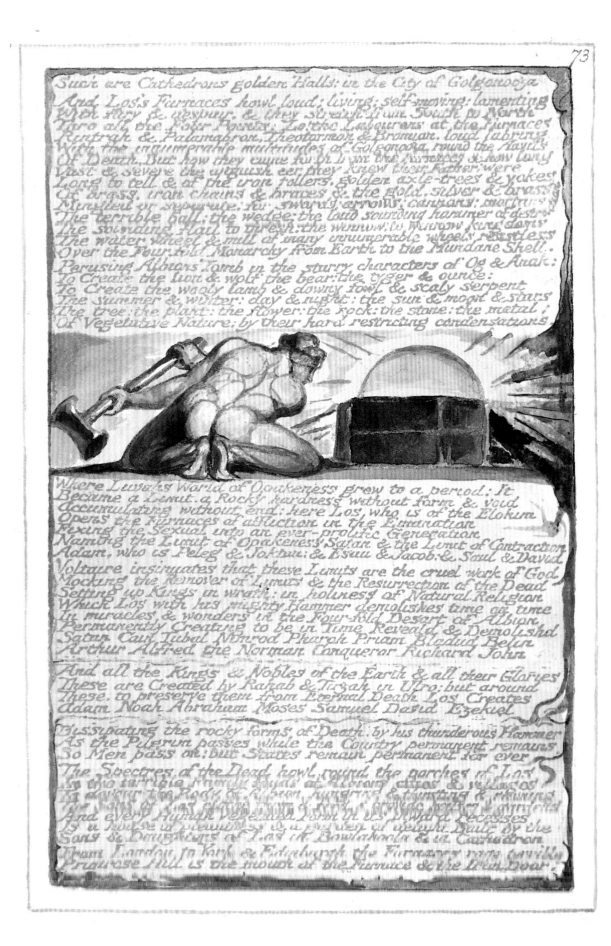

Where Luvahs World of Opakeness grew to a period: It
Became a Limit, a Rocky hardness without form & void
Accumulating without end: here Los, who is of the Elohim
Opens the Furnaces of affliction in the Emanation
Fixing the Sexual into an ever-prolific Generation
Naming the Limit of Opakeness Satan & the Limit of Contraction
Adam, who is Peleg & Joktan: & Esau & Jacob: & Saul & David
Voltaire insinuates that these Limits are the cruel work of God
Mocking the Remover of Limits & the Resurrection of the Dead
Setting up Kings in wrath: in holiness of Natural Religion
Which Los with his mighty Hammer demolishes time on time
In miracles & wonders in the Four-fold Desart of Albion
Permanently Creating to be in Time Reveald & Demolishd
Satan Cain Tubal Nimrod Pharoh Priam Bladud Belin
Arthur Alfred the Norman Conqueror Richard John

And all the Kings & Nobles of the Earth & all their Glories
These are Created by Rahab & Tirzah in Ulro: but around
These. to preserve them from Eternal Death Los Creates
Adam Noah Abraham Moses Samuel David Ezekiel

Dissipating the rocky forms of Death. by his thunderous Hammer
As the Pilgrim passes while the Country permanent remains
So Men pass on: but States remain permanent for ever
The Spectres of the Dead howl round the porches of Los
In the terrible Family feuds of Albions cities & villages
To devour the Body of Albion, hungring & thirsting & ravning
And every Human vegetated Form in its inward recesses
Is a house of pleasantness & a garden of delight Built by the
Sons & Daughters of Los in Bowlahoola & in Cathedron
From London to York & Edinburgh the Furnaces rave terrible
Primrose Hill is the mouth of the Furnace & the Iron Door;

The Four Zoa's clouded rage; Urizen stood by Albion
With Rintrah and Palamabron and Theotormon and Bromion.
These Four are Verulam & London & York & Edinburgh
And the Four Zoa's are Urizen & Luvah & Tharmas & Urthona
In opposition deadly, and their Wheels in poisonous
And deadly stupor turnd against each other loud & fierce
Entering into the Reasoning Power, forsaking Imagination.
They became Spectres; & their Human Bodies were reposed
In Beulah, by the Daughters of Beulah with tears & lamentations

The Spectre is the Reasoning Power in Man; & when separated
From Imagination, and closing itself as in steel, in a Ratio
Of the Things of Memory. It thence frames Laws & Moralities
To destroy Imagination; the Divine Body, by Martyrdoms & Wars

Teach me O Holy Spirit the Testimony of Jesus! let me
Comprehend wonderous things out of the Divine Law
I behold Babylon in the opening Streets of London, I behold
Jerusalem in ruins wandering about from house to house
This I behold the shudderings of death attend my steps
I walk up and down in Six Thousand Years: their Events are present before me
To tell how Los in grief & anger, whirling round his Hammer on high
Drave the Sons & Daughters of Albion from their ancient mountains
They became the Twelve Gods of Asia Opposing the Divine Vision

The Sons of Albion are Twelve: the Sons of Jerusalem Sixteen
I tell how Albions Sons by Harmonies of Concords & Discords
Opposed to Melody, and by Lights & Shades, opposed to Outline
And by Abstraction opposed to the Visions of Imagination
By cruel Laws divided Sixteen into Twelve Divisions
How Hyle roofd Los in Albions Cliffs by the Affections rent
Asunder & opposed to Thought, to draw Jerusalems Sons
Into the Vortex of his Wheels. therefore Hyle is called Gog
Age after age drawing them away towards Babylon
Babylon, the Rational Morality deluding to death the little ones
In strong temptations of stolen beauty; I tell how Reuben slept
On London Stone & the Daughters of Albion ran around admiring
His awful beauty; with Moral Virtue the fair deceiver, offspring
Of Good & Evil, they divided him in love upon the Thames & sent
Him over Europe in streams of gore out of Cathedrons Looms
How Los drave them from Albion & they became Daughters of Canaan
Hence Albion was calld the Canaanite & all his Giant Sons.
Hence is my Theme. O Lord my Saviour open thou the Gates
And I will lead forth thy Words, telling how the Daughters
Cut the Fibres of Reuben, how he rolld apart & took Root
In Bashan. terror-struck Albions Sons look toward Bashan
They have divided Simeon he also rolld apart in blood
Over the Nations till he took Root beneath the shining Looms
Of Albions Daughters in Philistea by the side of Amalek
They have divided Levi: he hath shot out into Forty-eight Roots
Over the Land of Canaan: they have divided Judah
He hath took Root in Hebron, in the Land of Hand & Hyle
Dan: Naphtali; Gad; Asher; Issachar; Zebulun: roll apart
From all the Nations of the Earth to dissipate into Non Entity

I see a Feminine Form arise from the Four terrible Zoas
Beautiful but terrible struggling to take a form of beauty
Rooted in Shechem: this is Dinah, the youthful form of Erin
The Wound I see in South Molton Street & Stratford place
Whence Joseph & Benjamin rolld apart away from the Nations
In vain they rolld apart; they are fixd into the Land of Cabul

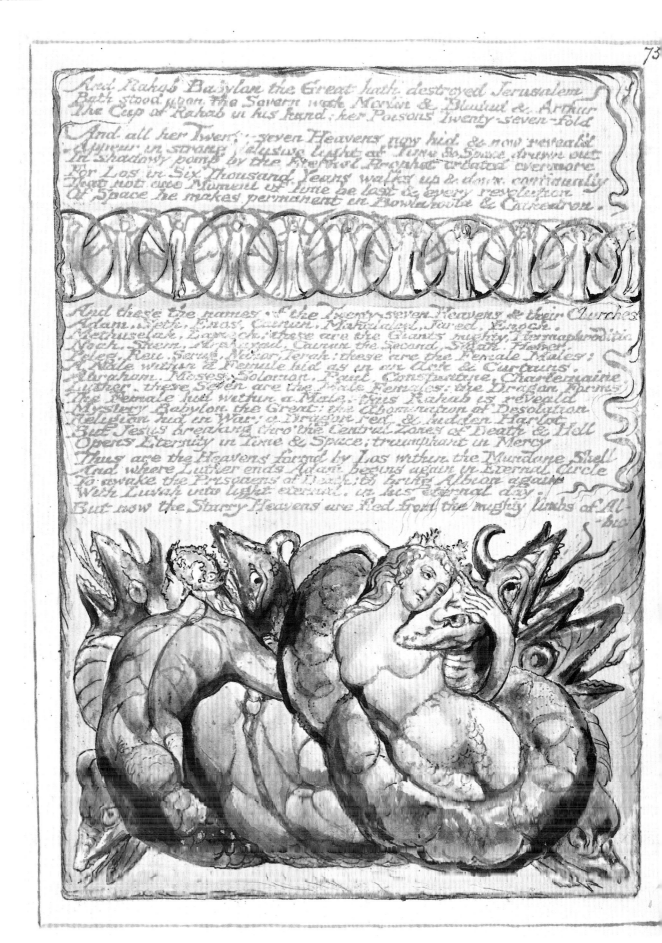

And Rahab Babylon the Great hath destroyed Jerusalem
Bath stood upon the Savern with Merlin & Bladud & Arthur
The Cup of Rahab in his hand; her Poisons Twenty-seven-fold

And all her Twenty-seven Heavens now hid & now reveal'd
Appear in strong delusive light of Time & Space drawn out
In shadowy pomp by the Eternal Prophet created evermore
For Los in Six Thousand Years walks up & down continually
That not one Moment of Time be lost & every revolution
Of Space he makes permanent in Bowlahoola & Cathedron.

And these the names of the Twenty-seven Heavens & their Churches
Adam. Seth. Enos. Cainan. Mahalaleel. Jared. Enoch.
Methuselah. Lamech; these are the Giants mighty, Hermaphroditic
Noah. Shem. Arphaxad. Cainan the Second. Salah. Heber.
Peleg. Reu. Serug. Nahor. Terah; these are the Female Males:
A Male within a Female hid as in an Ark & Curtains.
Abraham. Moses. Solomon. Paul. Constantine. Charlemaine.
Luther. these Seven are the Male Females: the Dragon Forms
The Female hid within a Male; thus Rahab is reveal'd
Mystery Babylon the Great; the Abomination of Desolation
Religion hid in War; a Dragon red, & hidden Harlot.
But Jesus breaking thro' the Central Zones of Death & Hell
Opens Eternity in Time & Space; triumphant in Mercy

Thus are the Heavens form'd by Los within the Mundane Shell
And where Luther ends Adam begins again in Eternal Circle
To awake the Prisoners of Death; to bring Albion again
With Luvah into light eternal, in his eternal day.
But now the Starry Heavens are fled from the mighty limbs of Al-
bion

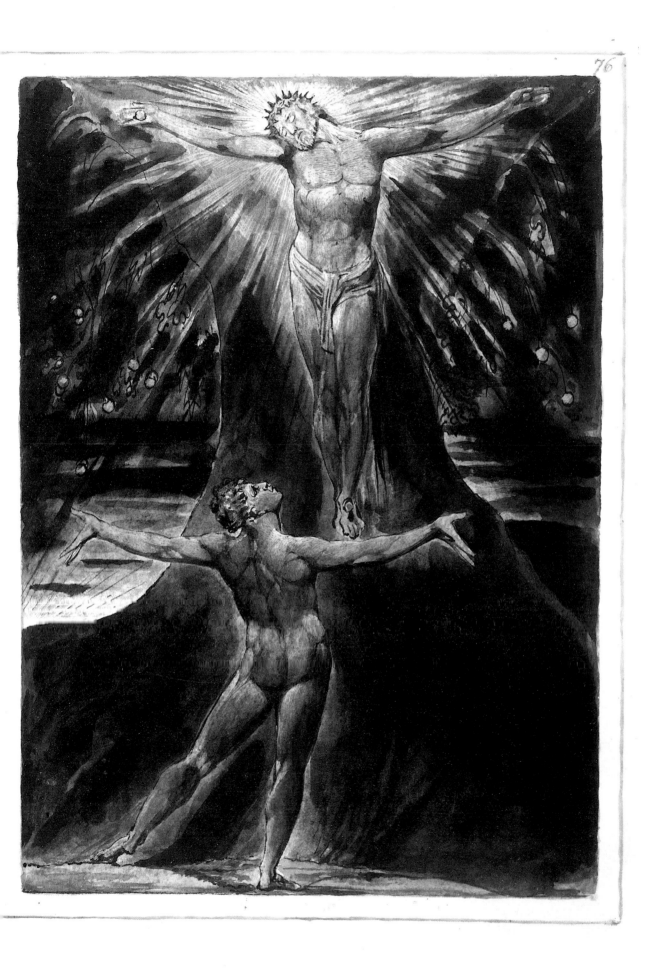

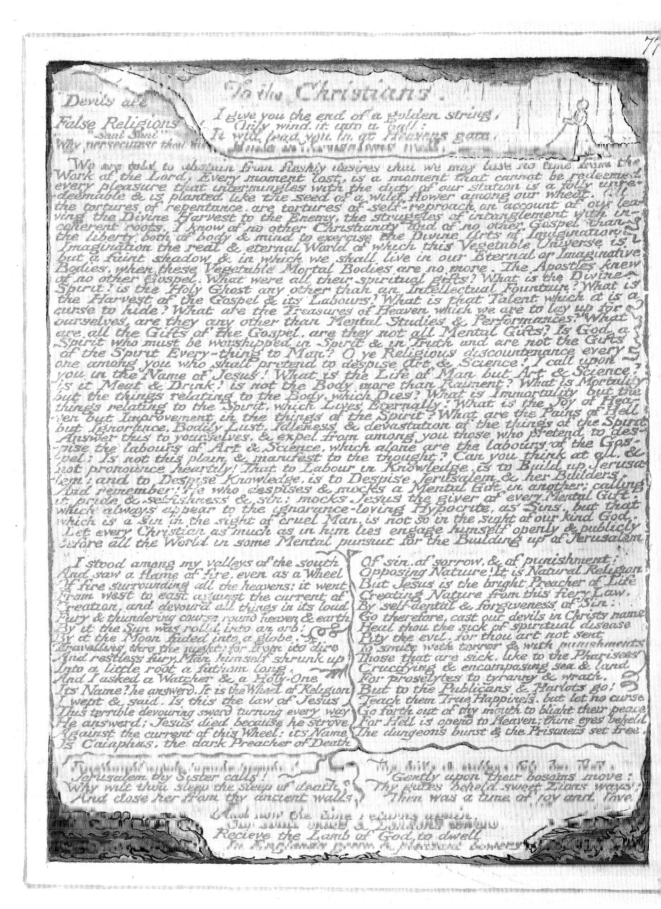

To the Christians.

Devils are
False Religions
"Saul Saul"
"Why persecutest thou me."

I give you the end of a golden string,
Only wind it into a ball:
It will lead you in at Heavens gate,
Built in Jerusalems wall.

We are told to abstain from fleshly desires that we may lose no time from the Work of the Lord. Every moment lost, is a moment that cannot be redeemed every pleasure that intermingles with the duty of our station is a folly unredeemable & is planted like the seed of a wild flower among our wheat. All the tortures of repentance. are tortures of self-reproach on account of our leaving the Divine Harvest to the Enemy, the struggles of intanglement with incoherent roots. I know of no other Christianity and of no other Gospel than the liberty both of body & mind to exercise the Divine Arts of Imagination: Imagination the real & eternal World of which this Vegetable Universe is but a faint shadow & in which we shall live in our Eternal or Imaginative Bodies, when these Vegetable Mortal Bodies are no more. The Apostles knew of no other Gospel. What were all their spiritual gifts? What is the Divine Spirit? is the Holy Ghost any other than an Intellectual Fountain? What is the Harvest of the Gospel & its Labours? What is that Talent which it is a curse to hide? What are the Treasures of Heaven, which we are to lay up for ourselves, are they any other than Mental Studies & Performances? What are all the Gifts of the Gospel, are they not all Mental Gifts? Is God a Spirit who must be worshipped in Spirit & in Truth and are not the Gifts of the Spirit Every-thing to Man? O ye Religious discountenance every one among you who shall pretend to despise Art & Science! I call upon you in the Name of Jesus! What is the Life of Man but Art & Science? is it Meat & Drink? is not the Body more than Raiment? What is Mortality but the things relating to the Body, which Dies? What is Immortality but the things relating to the Spirit, which Lives Eternally! What is the Joy of Heaven but Improvement in the things of the Spirit? What are the Pains of Hell but Ignorance, Bodily Lust, Idleness & devastation of the things of the Spirit? Answer this to yourselves, & expel from among you those who pretend to despise the labours of Art & Science, which alone are the labours of the Gospel: Is not this plain & manifest to the thought? Can you think at all & not pronounce heartily! That to Labour in Knowledge, is to Build up Jerusalem; and to Despise Knowledge, is to Despise Jerusalem & her Builders. And remember: He who despises & mocks a Mental Gift in another; calling it pride & selfishness & sin; mocks Jesus the giver of every Mental Gift, which always appear to the ignorance-loving Hypocrite, as Sins. but that which is a Sin in the sight of cruel Man, is not so in the sight of our kind God. Let every Christian as much as in him lies engage himself openly & publicly before all the World in some Mental pursuit for the Building up of Jerusalem

I stood among my valleys of the south
And saw a flame of fire, even as a Wheel
Of fire surrounding all the heavens: it went
From west to east against the current of
Creation, and devourd all things in its loud
Fury & thundering course round heaven & earth
By it the Sun was rolld into an orb:
By it the Moon faded into a globe,
Travelling thro the night: for from its dire
And restless fury, Man himself shrunk up
Into a little root a fathom long.
And I asked a Watcher & a Holy-One
Its Name? he answerd. It is the Wheel of Religion
I wept & said. Is this the law of Jesus
This terrible devouring sword turning every way
He answerd; Jesus died because he strove
Against the current of this Wheel: its Name
Is Caiaphus, the dark Preacher of Death

Of sin, of sorrow, & of punishment;
Opposing Nature! It is Natural Religion
But Jesus is the bright Preacher of Life
Creating Nature from this fiery Law,
By self-denial & forgiveness of Sin.
Go therefore, cast out devils in Christs name
Heal thou the sick of spiritual disease
Pity the evil, for thou art not sent
To smite with terror & with punishments
Those that are sick, like to the Pharisees
Crucifying & encompasing sea & land,
For proselytes to tyranny & wrath;
But to the Publicans & Harlots go!
Teach them True Happiness, but let no curse
Go forth out of thy mouth to blight their peace
For Hell is opend to Heaven; thine eyes beheld
The dungeons burst & the Prisoners set free.

Jerusalem thy Sister calls!
Why will thou sleep the sleep of death,
And close her from thy ancient walls.

Gently upon their bosoms move:
Thy gates beheld sweet Zions ways;
Then was a time of joy and love.

Recieve the Lamb of God, to dwell
In Englands green & pleasant bowers

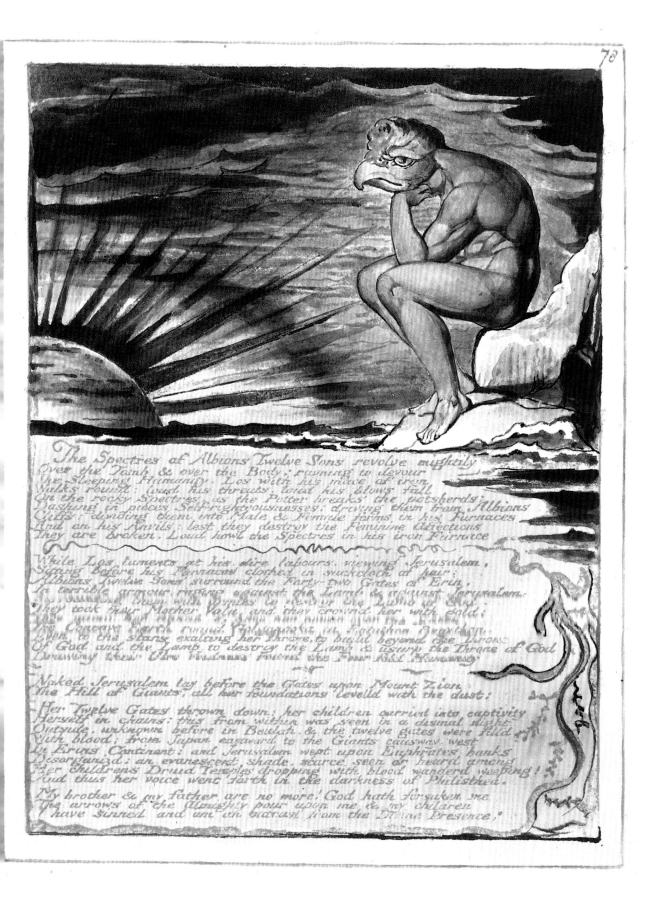

The Spectres of Albions Twelve Sons revolve mightily
Over the Tomb & over the Body: ravning to devour
The Sleeping Humanity. Los with his mace of iron
Walks round: loud his threats, loud his blows fall
On the rocky Spectres, as the Potter breaks the potsherds;
Dashing in pieces Self-righteousnesses: driving them from Albions
Cliffs: dividing them into Male & Female forms in his Furnaces
And on his Anvils: lest they destroy the Feminine Affections
They are broken. Loud howl the Spectres in his iron Furnace

While Los laments at his dire labours, viewing Jerusalem,
Sitting before his Furnaces clothed in sackcloth of hair;
Albions Twelve Sons surround the Forty-two Gates of Erin,
In terrible armour, raging against the Lamb & against Jerusalem,
Surrounding them with armies to destroy the Lamb of God.
They took their Mother Vala, and they crown'd her with gold:
They named her Rahab, & gave her power over the Earth
The Concave Earth round Golgonooza in Entuthon Benython,
Even to the stars exalting her Throne, to build beyond the Throne
Of God and the Lamb, to destroy the Lamb & usurp the Throne of God
Drawing their Dire Humans round the Four-fold Humanity

Naked Jerusalem lay before the Gates upon Mount Zion,
The Hill of Giants, all her foundations levelld with the dust:

Her Twelve Gates thrown down: her children carried into captivity
Herself in chains: this from within was seen in a dismal night
Outside, unknown before in Beulah, & the twelve gates were filld
With blood: from Japan eastward to the Giants causway, west
In Erins Continent: and Jerusalem wept upon Euphrates banks
Disorganizd: an evanescent shade, scarce seen or heard among
Her childrens Druid Temples dropping with blood wanderd weeping!
And thus her voice went forth in the darkness of Philisthea.

My brother & my father are no more! God hath forsaken me
The arrows of the Almighty pour upon me & my children
I have sinned and am an outcast from the Divine Presence!

79

My tents are falln! my pillars are in ruins! my children dashd
Upon Egypts iron floors, & the marble pavements of Assyria;
I melt my soul in reasonings among the towers of Heshbon;
Moab & Ammon is become a cruel rock & no more dew
Nor rain: my Zelophehad is a tyranny; but cold, obdurate
Hard & obdurate are the furrows of the mountain of wine & oil:
The mountain of blessing is cloth'd in cursing & an arrangement:
The hills of Judea are fallen with me into the deepest hell
Away from the Nations of the Earth, & from the Cities of the Nations;
I walk to Ephraim. I seek for Shiloh: I walk like a lost sheep
Among precipices of despair: in Goshen I seek for light
In vain: and in Gilead for a physician and a comforter.
Goshen hath followd Philistea: Gilead hath joind with Og!
They are become narrow places in a little and dark land:
How distant far from Albion! his hills & his valleys no more
Recieve the feet of Jerusalem: they have cast me quite away:
And Albion is himself shrunk to a narrow rock in the midst of the sea!
The plains of Sussex & Surrey, their hills of flocks & herds
No more seek to Jerusalem nor to the sound of my Holy-ones.
The Fifty-two Counties of England are hardend against me
As if I was not their Mother, they despise me & cast me out
London coverd the whole Earth, England encompass'd the Nations:
And all the Nations of the Earth were seen in the Cities of Albion:
My pillars reachd from sea to sea: London beheld me come
From my east & from my west: he blessed me and gave
His children to my breasts, his sons & daughters to my knees
His aged parents sought me out in every city & village:
They discernd my countenance with joy! they shewd me to their sons
Saying Lo Jerusalem is here! she sitteth in our secret chambers
Levi and Judah & Issachar; Ephram, Manasseh, Gad and Dan
Are seen in our hills & valleys! they keep our flocks & herds:
They watch them in the night: and the Lamb of God appears among us!
The river Severn stayd his course at my command:
Thames poured his waters into my basons and baths:
Medway mingled with Kishon: Thames recievd the heavenly Jordan
Albion gave me to the whole Earth to walk up & down; to pour
Joy upon every mountain; to teach songs to the shepherd & plowman
I taught the ships of the sea to sing the songs of Zion.
Italy saw me, in sublime astonishment: France was wholly mine:
As my garden & as my secret bath; Spain was my heavenly couch:
I slept in his golden hills: the Lamb of God met me there.
There we walked as in our secret chamber among our little ones
They looked upon our loves with joy: they beheld our secret joys:
With holy raptures of adoration rapd sublime in the Visions of God:
Germany, Poland & the North wooed my footsteps they found
My gates in all their mountains & my curtains in all their vales
The furniture of their houses was the furniture of my chamber
Turkey & Grecia saw my instruments of music, they arose
They siez'd the harp: the flute: the mellow horn of Jerusalems joy
They sounded thanksgivings in my courts: Egypt & Lybia heard
The swarthy sons of Ethiopia stood round the Lamb of God
Enquiring for Jerusalem: he led them up my steps to my altar:
And thou America! I once beheld thee but now behold no more
Thy golden mountains where my Cherubim & Seraphim rejoicd
Together among my little-ones. But now, my Altars run with blood!
My fires are corrupt, my incense is a cloudy pestilence
Of seven diseases! Once a continual cloud of salvation, rose
From all my myriads; once the Four-fold World rejoicd among
The pillars of Jerusalem, between my winged Cherubim:
But now I am closd out from them in the narrow passages
Of the valleys of destruction, into a dark land of pitch & bitumen.
From Albions Tomb afar and from the four-fold wonders of God
Shrunk to a narrow doleful form in the dark land of Cabul;
There is Reuben & Gad & Joseph & Judah & Levi, closd up
In narrow vales: I walk & count the bones of my beloveds
Along the Valley of Destruction, among these Druid Temples
Which overspread all the Earth in patriarchal pomp & cruel pride
Tell me O Vala thy purposes; tell me wherefore thy shuttles
Drop with the gore of the slain; why Euphrates is red with blood
Wherefore in dreadful majesty & beauty outside appears
Thy Masculine from thy Feminine hardening against the heavens
To devour the Human! Why dost thou weep upon the wind among
These cruel Druid Temples: O Vala! Humanity is far above

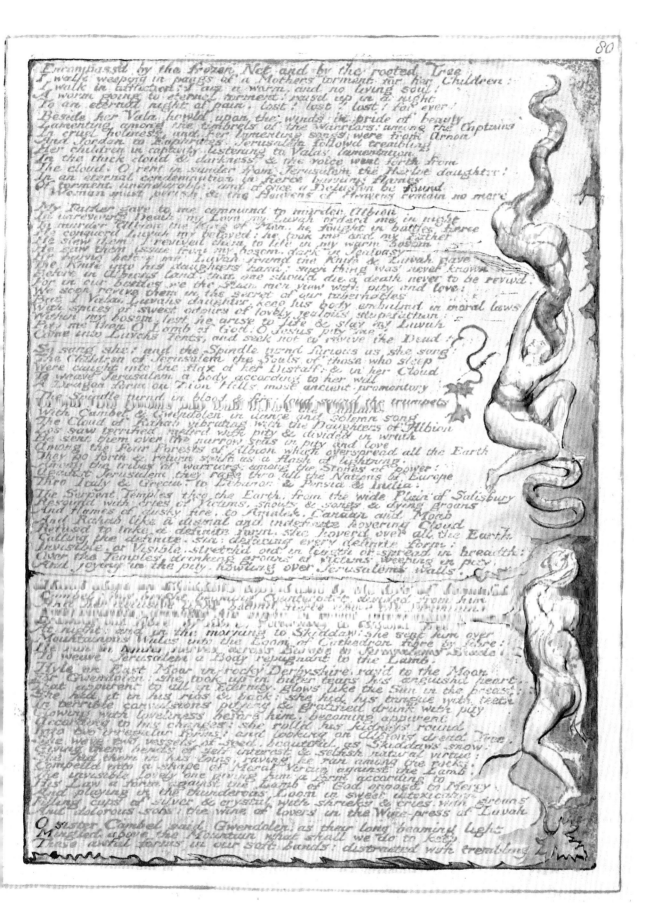

Encompass'd by the frozen Net, and by the rooted Tree
I walk weeping in pangs of a Mothers torment for her Children:
I walk in affliction: I am a worm, and no living soul!
A worm going to eternal torment! rais'd up in a night
To an eternal night of pain, lost! lost! lost! for ever!

Beside her Vala howld upon the winds in pride of beauty
Lamenting among the timbrels of the warriors: among the Captains
In cruel holiness, and her lamenting songs were from Arnon
And Jordan to Euphrates. Jerusalem followd trembling
Her children in captivity, listening to Valas lamentation
In the thick cloud & darkness & the voice went forth from
The cloud. O rent in sunder from Jerusalem the Harlot daughter!
In an eternal condemnation in fierce burning flames
Of torment unendurable: and if once a Delusion be found
Woman must perish & the Heavens of Heavens remain no more

My Father gave to me command to murder Albion
In unreviving Death; my Love my Luvah orderd me in night
To murder Albion the King of Men. he fought in battles fierce
He conquerd Luvah my beloved: he took me and my Father
He slew them: I revived them to life in my warm bosom
He saw them issue from my bosom, dark in Jealousy
He burnd before me: Luvah framd the Knife & Luvah gave
The Knife into his daughters hand! such thing was never known
Before in Albions land, that one should die a death never to be revivd.
For in our battles we the Slain men view with pity and love:
We soon revive them in the secret of our tabernacles
But I Vala, Luvahs daughter, keep his body embalmd in moral laws
With spices of sweet odours of lovely jealous stupefaction:
Within my bosom, lest he arise to life & slay my Luvah
Pity me then O Lamb of God! O Jesus pity me!
Come into Luvahs Tents, and seek not to revive the Dead!

So sang she: and the Spindle turnd furious as she sang!
The Children of Jerusalem the Souls of those who sleep
Were caught into the flax of her Distaff, & in her Cloud
To weave Jerusalem a body according to her will
A Dragon form on Zion Hills most ancient promontory

The Seventh turnd in blood & fire & jealousy & round the trumpets
With Cambel & Gwendolen in dance and solemn song
The Cloud of Rahab vibrating with the Daughters of Albion
Los saw terrified melted with pity & divided in wrath
He sent them over the narrow seas in pity and love
Among the Four Forests of Albion which overspread all the Earth
They go forth & return swift as a flash of lightning
Among the tribes of warriors: among the Stones of power!
Against Jerusalem they rage thro all the Nations of Europe
Thro Italy & Grecia, to Lebanon & Persia & India.
The Serpent Temples thro' the Earth, from the wide Plain of Salisbury
Resound with cries of Victims, shouts & songs & dying groans
And flames of dusky fire, to Amalek, Canaan and Moab
And Rahab like a dismal and indefinite hovering Cloud
Refused to take a definite form, she hoverd over all the Earth,
Calling the definite, sin: defacing every definite form:
Invisible, or Visible, stretch'd out in length or spread in breadth:
Over the Temples drinking groans of victims weeping in pity,
And joying in the pity, howling over Jerusalems walls.

Hand slept on Skiddaws top: drawn by the love of beautiful
Cambel: his bright beaming Counterpart, divided from him
And her delusive light beamd fierce above the Mountain,
Soft: invisible: drinking his sighs in sweet intoxication:
Drawing out fibre by fibre: returning to Albions Tree
At night: and in the morning to Skiddaw: she sent him over
Mountainous Wales into the Loom of Cathedron fibre by fibre:
He ran in tender nerves across Europe to Jerusalems Shade
To weave Jerusalem a Body repugnant to the Lamb.

Hyle on East Moor in rocky Derbyshire, ravd to the Moon
For Gwendolen: she took up in bitter tears his anguishd heart,
That apparent to all in Eternity, glows like the Sun in the breast:
She hid it in his ribs & back: she hid his tongue with teeth
In terrible convulsions pitying & gratified drunk with pity
Glowing with loveliness before him, becoming apparent
According to his changes: she rolld his kidneys round
Into two irregular forms: and looking on Albions dread Tree
She wove two vessels of seed, beautiful as Skiddaws snow;
Giving them bends of self interest & selfish natural virtue:
She hid them in his loins; raving he ran among the rocks,
Compelld into a shape of Moral Virtue against the Lamb.
The invisible lovely one giving him a form according to
His Law a form against the Lamb of God oppos'd to Mercy
And playing in the thunderous Loom in sweet intoxication
Filling cups of silver & crystal with shrieks & cries, with groans
And dolorous sobs: the wine of lovers in the Wine-press of Luvah

O sister Cambel said Gwendolen, as their long beaming light
Mingled above the Mountain what shall we do to keep
These awful forms in our soft bands: distracted with trembling

I have mock'd those who refused cruelty & I have admired
The cruel Warrior. I have refused to give love to Merlin the piteous
He brings to me the Images in his Love & I reject in chastity
And turn them out into the streets for Harlots to be food
To the stern Warrior. I am become perfect in beauty over my Warrior
For Men are caught by Love: Woman is caught by Pride
That Love may only be obtaind in the passages of Death
Let us look: let us examine: is the Cruel become an Infant
Or is he still a cruel Warrior? look Sisters, look! O piteous
I have destroyd Wandring Reuben who strove to bind my Will
I have strip'd off Josephs beautiful integument for my Beloved
The Cruel-one of Albion: to cloathe him in gems of my Zone
I have named him Jehovah of Hosts. Humanity is become
A weeping Infant in ruind lovely Jerusalems folding Cloud

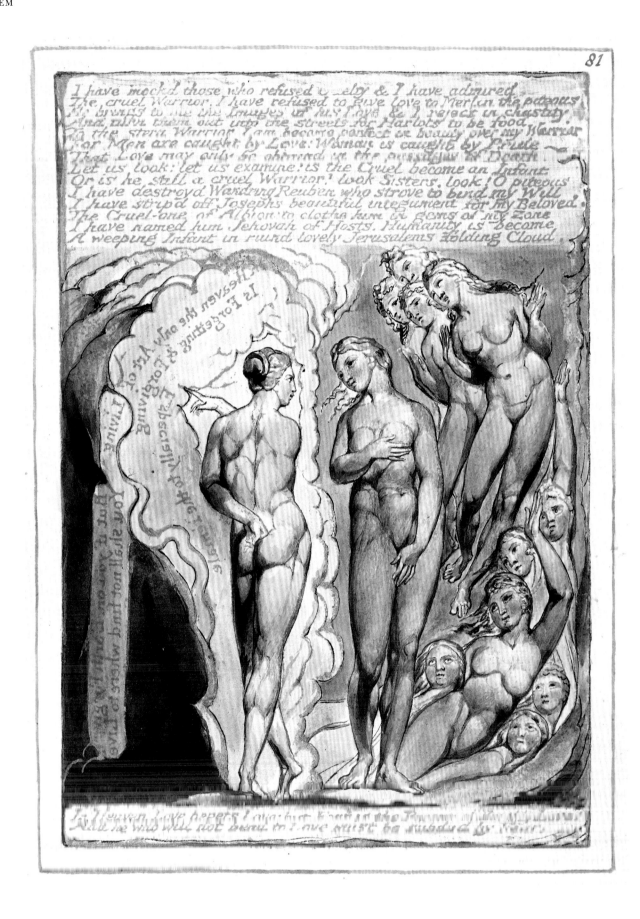

I have heard Jerusalems groan; from Vala's cries & lamentations
I gather our eternal fate: Outcasts from life and love:
Unless we find a way to bind these awful Forms to our
Embrace we shall perish annihilate, discoverd our Delusions.
Look! I have wrought without delusion: Look! I have wept
And given soft milk mingled together with the spirits of flocks
Of lambs and doves, mingled together in cups and dishes
Of painted clay: the mighty Hyle is become a weeping infant;
Soon shall the Spectres of the Dead follow my weaving threads.

The Twelve Daughters of Albion attentive listen in secret shades
On Cambridge and Oxford beaming soft uniting with Rahabs cloud
While Gwendolen spoke to Cambel turning soft the spinning reel:
Or throwing the wingd shuttle; or drawing the cords with sweet songs
The golden cords of the Looms animate beneath their touches soft,
Along the Island white, among the Druid Temples, while Gwendolen
Spoke to the Daughters of Albion standing on Skiddaws top.

So saying she took a Falshood & hid it in her left hand:
To entice her Sisters away to Babylon on Euphrates.
And thus she closed her left hand and utterd her Falshood:
Forgetting that Falshood is prophetic, she hid her hand behind her,
Upon her back behind her loins & thus utterd her Deceit.

I heard Enitharmon say to Los! Let the Daughters of Albion
Be scatterd abroad and let the name of Albion be forgotten:
Divide them into three; name them Amalek Canaan & Moab:
Let Albion remain a desolation without an inhabitant:
And let the Looms of Enitharmon & the Furnaces of Los
Create Jerusalem, & Babylon & Egypt & Moab & Amalek,
And Helle & Hesperia & Hindostan & China & Japan.
But hide America, for a Curse an Altar of Victims & a Holy Place.
See Sisters Canaan is pleasant, Egypt is as the Garden of Eden:
Babylon is our chief desire, Moab our bath in summer:
Let us lead the stems of this Tree let us plant it before Jerusalem
To judge the Friend of Sinners to death without the Veil:
To cut her off from America, to close up her secret Ark:
And the fury of Man exhaust in War! Woman permanent remain
See how the fires of our loins point eastward to Babylon
Look. Hyle is become an infant Love: look! behold! see him lie!
Upon my bosom look! here is the lovely wayward form
That gave me sweet delight by his torments beneath my Veil;
By the fruit of Albions Tree I have fed him with sweet milk
By contentions of the mighty for Sacrifice of Captives:
Humanity the Great Delusion: is changed to War & Sacrifice;
I have naild his hands on Beth Rabbin & his hands on Hazbons Wall:
O that I could live in his sight: O that I could bind him to my arm.

So saying, She drew aside her Veil from Mam-Tor to Dovedale
Discovering her own perfect beauty to the Daughters of Albion
And Hyle a winding Worm beneath ————— & not a weeping Infant.
Trembling & pitying she screamd & fled upon the wind:
Hyle was a winding Worm and herself perfect in beauty:
The desarts tremble at his wrath: they shrink themselves in fear.

Cambel trembled with jealousy: she trembled! she envied!
The envy ran thro Cathedrons Looms into the Heart
Of mild Jerusalem, to destroy the Lamb of God. Jerusalem
Languishd upon Mount Olivet, East of mild Zions Hill.
Los saw the envy and with terror struck his trembling Anguish
Or Londons Tower on the Thames: he drew Cambel in wrath
Into his thundering Bellows, heaving it for a loud blast:
And with the blast of his Furnace upon fishy Billingsgate.
Beneath Albions fatal Tree, before the Gate of Los:
Shewd her the fibres of her beloved to ameliorate
The envy; loud she labourd in the Furnace of fire,
To form the mighty form of Hand according to her will
In the Furnaces of Los & in the Wine-press treading day & night
Naked among the human clusters: bringing wine of anguish
To feed the afflicted in the Furnaces: she minded not
The raging flames, tho she returnd —————— instead of beauty
Deformity: she gave her beauty to another: bearing abroad
Her struggling torment in her iron arms: and like a chain.
Binding his wrists & ankles with the iron arms of love.

Gwendolen saw the Infant in her sisters arms; she howld
Over the forests with bitter tears, and over the winding Worm
Repentant: and she also in the eddying wind of Los's Bellows
Began her dolorous task of love in the Wine-press of Luvah
To form the Worm into a form of love by tears & pain.
The Sisters saw! trembling ran thro their Looms! softening mild
Towards London: then they saw the Furnaces opend, & in tears
Began to give their souls away in the Furnaces of affliction.

Los saw & was comforted at his Furnaces uttering thus his voice.
I know I am Urthona keeper of the Gates of Heaven:
And that I can at will expatiate in the Gardens of bliss;
But pangs of love draw me down to my loins which are
Become a fountain of veiny pipes: O Albion! my brother!

Corruptability appears upon thy limbs, and never more
Can I arise and leave thy side, but labour here incessant
Till thy awaking! yet alas I shall forget Eternity!
Against the Patriarchal pomp and cruelty, labouring incessant
I shall become an Infant horror. Enion! Tharmas! friends
Absorb me not in such dire grief: O Albion, my brother!
Jerusalem hungers in the desart! affection to her children!
The scorn'd and contemn'd youthful girl, where shall she fly?
Sussex shuts up her Villages. Hants, Devon & Wilts.
Surrounded with masses of stone in ordered forms, determine then
A form for Vala and a form for Luvah, here on the Thames
Where the Victim nightly howls beneath the Druids knife:
A form of Vegetation, nail them down on the stems of Mystery:
O when shall the Saxon return with the English his redeemed brother!
O when shall the Lamb of God descend among the Reprobate!
I woe to Amalek to protect my Emanations Jerusalem trembles:
I call to Canaan & Moab in my night watches, they mourn:
They listen not to my cry, they rejoice among their warriors
Woden and Thor and Friga wholly consume my Saxons.
On their enormous Altars built in the terrible north:
From Irelands rocks to Scandinavia Persia and Tartary:
From the Atlantic Sea to the universal Erythrean.
Found ye London! enormous City! weeps thy River?
Upon his parent bosom lay thy little ones O Land
Forsaken. Surrey and Sussex are Enitharmons Chamber.
Where I will build her a Couch of repose & my pillars
Shall surround her in beautiful labyrinths: Oothoon!
Where hides my child? in Oxford hidest thou with Antamon?
In graceful hidings of error: in merciful deceit
Lest Hand the terrible destroy his Affection, thou hidest her:
In chaste appearances for sweet deceits of love & modesty
Immangled interwoven, glistening to the sickening sight:
Let Cambel and her Sisters sit within the Mundane Shell:
Forming the fluctuating Globe according to their will.
According as they weave the little embryon nerves & veins
The Eye, the little Nostrils, & the delicate Tongue & Ears
Of labyrinthine intricacy: so shall they fold the World
That whatever is seen upon the Mundane Shell, the same
Be seen upon the Fluctuating Earth woven by the Sisters.
And sometimes the Earth shall roll in the Abyss & sometimes
Stand in the Center & sometimes stretch flat in the Expanse,
According to the will of the lovely Daughters of Albion.
Sometimes it shall assimilate with mighty Golgonooza:
Touching its summits: & sometimes divided roll apart.
As a beautiful Veil. so these Females shall fold & unfold
According to their will, the outside surface of the Earth
An outside shadowy Surface superadded to the real Surface;
Which is unchangeable for ever & ever Amen: so be it!
Separate Albions Sons gently from their Emanations
Weaving bowers of delight on the current of infant Thames
Where the old Parent still retains his youth as I alas!
Retain my youth eight thousand and five hundred years.
The labourer of ages in the Valleys of Despair!
The land is markd for desolation & unless we plant
The seeds of Cities & of Villages in the Human bosom
Albion must be a rock of blood: mark ye the points
Where Cities shall remain & where Villages for the rest:
It must lie in confusion till Albions time of awaking.
Place the Tribes of Llewellyn in America for a hiding place!
Till sweet Jerusalem emanates again into Eternity.
The night falls thick: I go upon my watch: be attentive:
The Sons of Albion go forth; I follow from my Furnaces:
That they return no more; that a place be prepard on Euphrates
Listen to your Watchmans voice: sleep not before the Furnaces
Eternal Death stands at the door. O God pity our labours.

So Los spoke to the Daughters of Beulah while his Emanation
Like a faint rainbow waved before him in the awful gloom
Of London City on the Thames from Surrey Hills to Highgate:
Swift turn the silver spindles, & the golden weights play soft
And lulling harmonies beneath the Looms, from Caithness in the north
To Lizard-point & Dover in the south: his Emanation
Joy'd in the many weaving threads in bright Cathedrons Dome
Weaving the Web of life for Jerusalem, the Web of life
Down flowing into Entuthons Vales glistens with soft affections.

While Los arose upon his Watch, and down from Golgonooza
Putting on his golden sandals to walk from mountain to mountain,
He takes his way, girding himself with gold & in his hand
Holding his iron mace: The Spectre remains attentive,
Alternate they watch in night: alternate labour in day
Before the Furnaces labouring, while Los all night watches
The stars rising & setting, & the meteors & terrors of night:
With him went down the Dogs of Leutha, at his feet
They lap the water of the trembling Thames: then follow Albion
Albion cold lays on his Rock: storms & snows beat round him.
Beneath the Furnaces & the starry Wheels & the Immortal Tomb
Howling winds cover him: roaring seas dash furious against him
In the deep darkness broad lightnings glare long thunders roll

The weeds of Death inwrap his hands & feet blown incessant
And washd incessant by the for-ever restless sea-waves foaming abroad
Upon the white Rock. England a Female Shadow as deadly damps
Of the Mines of Cornwall & Derbyshire lays upon his bosom heavy
Moved by the wind in volumes of thick cloud returning folding round
His loins & bosom unremovable by swelling storms & loud rending
Of enraged thunders. Around them the Starry Wheels of their Giant Sons
Revolve: & over them the Furnaces of Los & the Immortal Tomb around
Erin sitting in the Tomb, to watch them unceasing night and day
And the Body of Albion was closed apart from all Nations.

Over them the famishd Eagle screams on boney Wings and around
Them howls the Wolf of famine deep heaves the Ocean black thundering
Around the wormy Garments of Albion: then pausing in deathlike silence

Time was Finished! The Breath Divine Breathed over Albion
Beneath the Furnaces & starry Wheels and in the Immortal Tomb
And England who is Brittannia awoke from Death on Albions bosom
She awoke pale & cold she fainted seven times on the Body of Albion

Goe thro Highgate & Hampstead, to Poplar Hackney & Bow:
To Islington & Paddington & the Brook of Albions River
We builded Jerusalem as a City & a Temple; from Lambeth
We began our Foundations; lovely Lambeth! O lovely Hills
Of Camberwell, we shall behold you no more in glory & pride
For Jerusalem lies in ruins & the Furnaces of Los are builded there
You are now shrunk up to a narrow Rock in the midst of the Sea
But here we build Babylon on Euphrates, compelld to build
And to inhabit, our Little-ones to clothe in armour of the gold
Of Jerusalems Cherubims & to forge them swords of her Altars
I see London blind & age-bent begging thro the Streets
Of Babylon, led by a child, his tears run down his beard
The voice of Wandering Reuben ecchoes from street to street
In all the Cities of the Nations Paris Madrid Amsterdam
The Corner of Broad Street weeps; Poland Street languishes
To Great Queen Street & Lincolns Inn, all is distress & woe.

The night falls thick Hand comes from Albion in his strength
He combines into a Mighty-one the Double Molech & Chemosh
Marching thro Egypt in his fury the East is pale at his course
The Nations of India, the Wild Tartar that never knew Man,
Starts from his lofty places & casts down his tents & flees away
But we woo him all the night in songs, O Los come forth O Los
Divide us from these terrors & give us power them to subdue
Arise upon thy Watches let us see thy Globe of fire
On Albions Rocks & let thy voice be heard upon Euphrates.

Thus sang the Daughters in lamentation, uniting into One
With Rahab as she turnd the iron Spindle of destruction.
Terrified at the Sons of Albion they took the Falshood which
Gwendolen hid in her left hand, it grew & grew till it

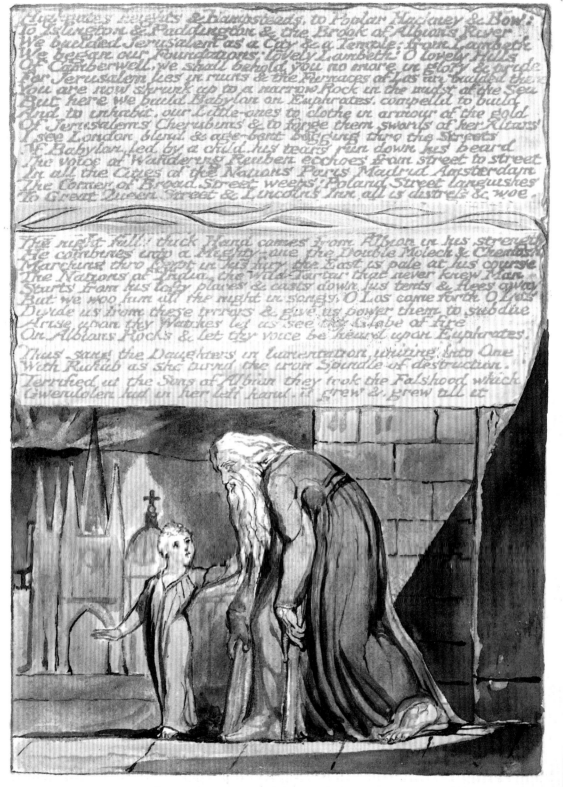

[381]

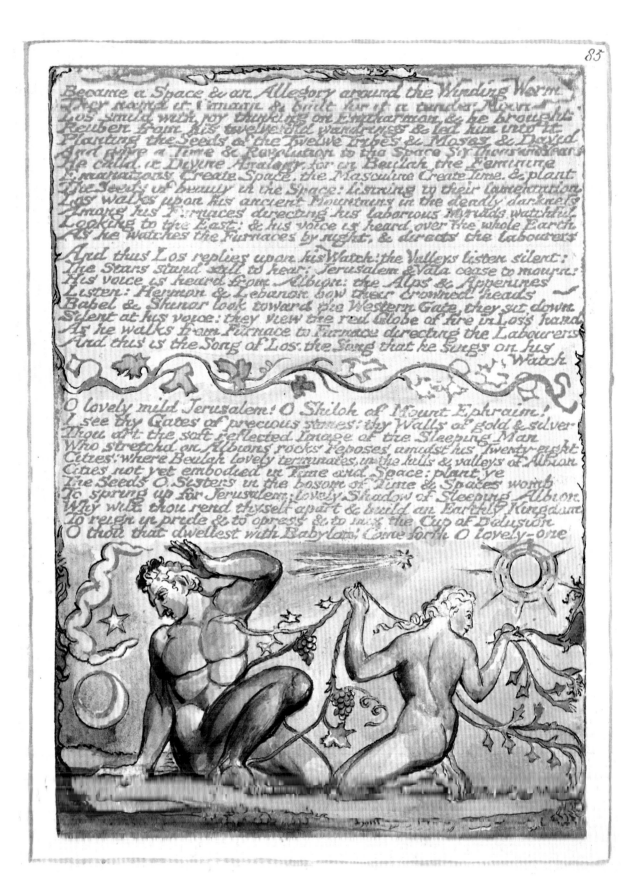

Became a Space & an Allegory around the Winding Worm.
They namd it Canaan & built for it a tender Moon
Los smild with joy thinking on Enitharmon, & he brought
Reuben from his twelvefold wandrings & led him into it:
Planting the Seeds of the Twelve Tribes & Moses, & David
And gave a Time & Revolution to the Space Six Thousand Years
He calld it Divine Analogy, for in Beulah the Feminine
Emanations Create Space, the Masculine Create Time, & plant
The Seeds of beauty in the Space: listning to their lamentation
Los walks upon his ancient Mountains in the deadly darkness
Among his Furnaces directing his laborious Myriads watchful
Looking to the East: & his voice is heard over the whole Earth
As he watches the Furnaces by night, & directs the labourers

And thus Los replies upon his Watch: the Valleys listen silent:
The Stars stand still to hear: Jerusalem & Vala cease to mourn:
His voice is heard from Albion: the Alps & Appenines
Listen: Hermon & Lebanon bow their crowned heads
Babel & Shinar look toward the Western Gate, they sit down
Silent at his voice: they view the red Globe of fire in Loss hand
As he walks from Furnace to Furnace directing the Labourers
And this is the Song of Los, the Song that he sings on his
                                                                    Watch

O lovely mild Jerusalem! O Shiloh of Mount Ephraim!
I see thy Gates of precious stones: thy Walls of gold & silver
Thou art the soft reflected Image of the Sleeping Man
Who stretchd on Albions rocks reposes amidst his Twenty-eight
Cities: where Beulah lovely terminates, in the hills & valleys of Albion
Cities not yet embodied in Time and Space: plant ye
The Seeds O Sisters in the bosom of Time & Spaces womb
To spring up for Jerusalem: lovely Shadow of Sleeping Albion
Why wilt thou rend thyself apart & build an Earthly Kingdom
To reign in pride & to opress & to accuse the Cup of Delusion
O thou that dwellest with Babylon! Come forth O lovely-one

I see thy Form O lovely mild Jerusalem, Wingd with Six Wings
In the opacous Bosom of the Sleeper, lovely Three-fold
In Head & Heart & Reins three Universes of love & beauty
Thy forehead bright: Holiness to the Lord, with Gates of pearl
Reflects Eternity beneath thy azure wings of feathery down
Ribbd delicate & clothd with featherd gold & azure & purple
From thy white shoulders shadowing, purity in holiness!
Thence featherd with soft crimson of the ruby bright as fire
Spreading into the azure Wings which like a canopy
Bends over thy immortal Head in which Eternity dwells
Albion beloved Land; I see thy mountains & thy hills
And valleys & thy pleasant Cities Holiness to the Lord
I see the Spectres of thy Dead O Emanation of Albion.

Thy Bosom white, translucent coverd with immortal gems
A sublime ornament not obscuring the outlines of beauty
Terrible to behold for thy extreme beauty & perfection
Twelve-fold here all the Tribes of Israel I behold
Upon the Holy Land: I see the River of Life & Tree of Life
I see the New Jerusalem descending out of Heaven
Between thy Wings of gold & silver featherd immortal
Clear as the rainbow, as the cloud of the Suns tabernacle

Thy Reins coverd with Wings translucent sometimes covering
And sometimes spread abroad reveal the flames of holiness
Which like a robe covers: & like a Veil of Seraphim
In flaming fire unceasing burns from Eternity to Eternity
Twelvefold I there behold Israel in her Tents
A Pillar of a Cloud by day: a Pillar of fire by night
Guides them: there I behold Moab & Ammon & Amalek
There Bells of silver round thy knees living articulate
Comforting sounds of love & harmony & on thy feet
Sandals of gold & pearl, & Egypt & Assyria before me
The Isles of Javan, Philistea, Tyre and Lebanon

Thus Los sings upon his Watch walking from Furnace to Furnace.
He seizes his Hammer every hour, flames surround him as
He beats: seas roll beneath his feet, tempests muster
Around his head, the thick hail stones stand ready to obey
His voice in the black cloud, his Sons labour in thunders
At his Furnaces; his Daughters at their Looms sing woes
His Emanation separates in milky fibres agonizing
Among the golden Looms of Cathedron sending fibres of love
From Golgonooza with sweet visions for Jerusalem, wanderer.

Nor can any consummate bliss without being Generated
On Earth; of those whose Emanations weave the loves
Of Beulah for Jerusalem & Shiloh, in immortal Golgonooza
Concentering in the majestic form of Erin in eternal tears
Viewing the Winding Worm on the Desarts of Great Tartary

............................................................
Without becoming his Children in the Furnaces of affliction

And Enitharmon like a faint rainbow waved before him
Filling with Fibres from his loins which reddend with desire
Into a Globe of blood beneath his bosom trembling in darkness
Of Albions clouds, he fed it with his tears & bitter groans
Hiding his Spectre in invisibility from the timorous Shade
Till it became a separated cloud of beauty grace & love
Among the darkness of his Furnaces dividing asunder till
She separated stood before him a lovely Female weeping
Even Enitharmon separated outside, & his Loins closed
And healed after the separation: his pains he soon forgot:
Lured by her beauty outside of himself in shadowy grief.
Two Wills they had; Two Intellects: & not as in times of old.

Silent they wanderd hand in hand like two Infants wandring
From Enion in the desarts, terrified at each others beauty
Envying each other yet desiring, in all devouring Love,

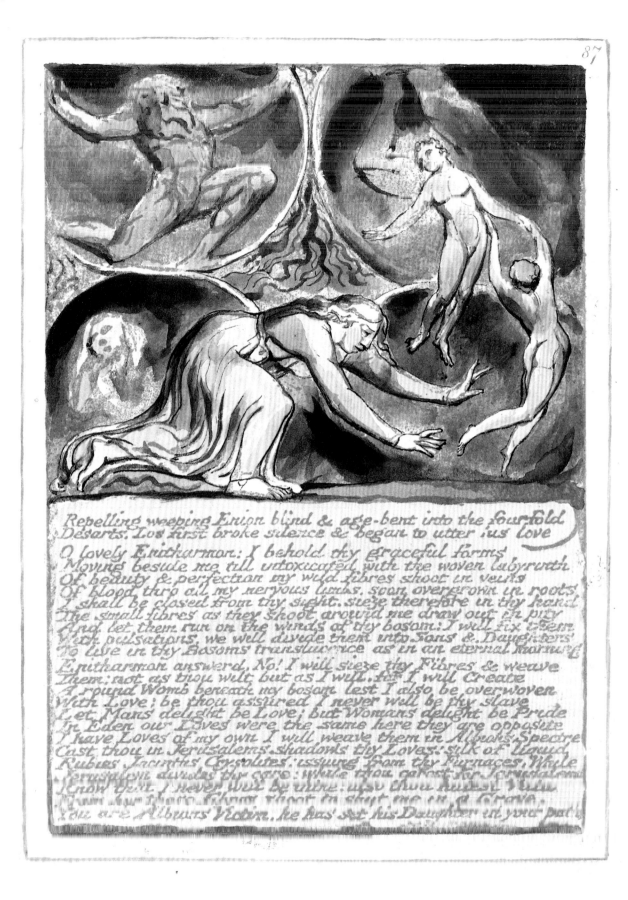

87

Repelling weeping Enion blind & age-bent into the fourfold
Desarts. Los first broke silence & began to utter his love

O lovely Enitharmon: I behold thy graceful forms
Moving beside me till intoxicated with the woven labyrinth
Of beauty & perfection my wild fibres shoot in veins
Of blood thro all my nervous limbs. soon overgrown in roots
I shall be closed from thy sight. sieze therefore in thy hand
The small fibres as they shoot around me draw out in pity
And let them run on the winds of thy bosom: I will fix them
With pulsations. we will divide them into Sons & Daughters
To live in thy Bosoms translucence as in an eternal morning
Enitharmon answerd, No! I will sieze thy Fibres & weave
Them; not as thou wilt but as I will. for I will Create
A round Womb beneath my bosom lest I also be overwoven
With Love; be thou assured I never will be thy slave
Let Mans delight be Love; but Womans delight be Pride
In Eden our Loves were the same here they are opposite
I have Loves of my own I will weave them in Albions Spectre
Cast thou in Jerusalems shadows thy Loves: silk of liquid
Rubies Jacinths Crysolites: issuing from thy Furnaces. While
Jerusalem divides thy care: while thou o carest for Jerusalem
Know that I never will be thine: also thou hidest Vala
From her these fibres shoot to shut me in, O Grove,
You are Albions Victim. he has set his Daughter in your path

Los answerd sighing like the Bellows of his Furnaces

I care not! the swing of my Hammer shall measure the starry round
When in Eternity Man converses with Man they enter
Into each others Bosom (which are Universes of delight)
In mutual interchange. and first their Emanations meet
Surrounded by their Children. if they embrace & comingle
The Human Four-fold Forms mingle also in thunders of Intellect
But if the Emanations mingle not; with storms & agitations
Of earthquakes & consuming fires they roll apart in fear
For Man cannot unite with Man but by their Emanations
Which stand both Male & Female at the Gates of each Humanity
How then can I ever again be united as Man with Man
While thou my Emanation refusest my Fibres of dominion.
When Souls mingle & join thro all the Fibres of Brotherhood
Can there be any secret joy on Earth greater than this?

Enitharmon answerd: This is Womans World. nor need she any
Spectre to defend her from Man. I will Create secret places
And the masculine names of the places Merlin & Arthur.
A triple Female Tabernacle for Moral Law I weave
That he who loves Jesus may loathe terrified Female love,
Till God himself become a Male subservient to the Female.

She spoke in scorn & jealousy alternate torments; and
So speaking she, sat down on Sussex shore singing lulling
Cadences. & playing in sweet intoxication among the glistening
Fibres of Los: sending them over the Ocean eastward into
The realms of dark death; O perverse to thyself, contrarious
To thy own purposes; for when she began to weave
Shooting out in sweet pleasure her bosom in milky Love
Flowd into the aching fibres of Los. yet contending against him
In pride sendinding his Fibres over to her objects of jealousy
In the little lovely Allegoric Night of Albions Daughters
Which stretchd abroad expanding east & west & north & south
Thro all the World of Erin & of Los & all their Children
A sullen smile broke from the Spectre in mockery & scorn
Knowing himself the author of their divisions & shrinkings, gratified
At their contentions; he wiped his tears he washd his visage.

The Man who respects Woman shall be despised by Woman
And deadly cunning & mean abjectness only, shall enjoy them
For I will make their places of joy & love, excrementitious
Continually building. continually destroying in Family feuds
While you are under the dominion of a jealous female
Unpermanent for ever because of love & jealousy.
You shall want all the Minute Particulars of Life

Thus joyd the Spectre in the dusky fires of Loss Forge, eyeing
Enitharmon who at her shining Looms sings lulling cadences
While Los stood at his Anvil in wrath the victim of their love
And hate: dividing the Space of Love with brazen Compasses
In Golgonooza & in Udan-Adan & in Entuthon of Urizen
The blow of his Hammer is Justice. the swing of his Hammer Mercy
The force of Loss Hammer is eternal Forgiveness; but
His rage or his mildness were vain, she scatterd his love on the wind
Eastward into her own Center, creating the Female Womb
In mild Jerusalem around the Lamb of God. Loud howl
The Furnaces of Los! loud roll the Wheels of Enitharmon
The Four Zoa's in all their faded majesty burst out in fury
And fire. Jerusalem took the Cup which foamd in Valas hand
Like the red Sun upon the mountains in the bloody day,
Upon the Hermaphroditic Wine-presses of Love & Wrath

89

Tho divided by the Cross & Nails & Thorns & Spear
In cruelties of Rahab & Tirzah permanent endure
A terrible indefinite Hermaphroditic form
A Wine-press of Love & Wrath double Hermaphroditic
Twelvefold in Allegoric pomp in selfish holiness
The Pharisaion, the Grammateis, the Presbuterion,
The Archiereus, the Iereus, the Saddusaion, double
Each without & within on the other, covering eastern heaven

Thus was the Covering Cherub reveald majestic image
Of Selfhood, Body put off, the Antichrist accursed
Coverd with precious stones, a Human Dragon terrible
And bright, stretchd over Europe & Asia gorgeous
In three nights he devourd the rejected corse of death

His Head dark, deadly, in its Brain incloses a reflexion
Of Eden all perverted; Egypt on the Gihon many tongued
And many mouthd: Ethiopia, Lybia, the Sea of Rephaim
Minute Particulars in slavery I behold among the brick-kilns
Disorganizd, & there is Pharoh in his iron Court:
And the Dragon of the River & the Furnaces of iron.
Outwoven from Thames & Tweed & Severn awful streams
Twelve ridges of Stone frown over all the Earth in tyrant pride
Frown over each River stupendous Works of Albions Druid Sons
And Albions Forests of Oaks coverd the Earth from Pole to Pole

His Bosom wide reflects Moab & Ammon, on the River
Pison, since calld Arnon, there is Heshbon beautiful
The Rocks of Rabbath on the Arnon & the Fish-pools of Heshbon
Whose currents flow into the Dead Sea by Sodom & Gomorra
Above his Head high arching Wings black filld with Eyes
Spring upon iron sinews from the Scapulæ & Os Humeri.
There Israel in bondage to his Generalizing Gods
Molech & Chemosh, & in his left breast is Philistea
In Druid Temples over the whole Earth with Victims Sacrifice
From Gaza to Damascus Tyre & Sidon & the Gods
Of Javan, thro the Isles of Grecia & all Europes Kings
Where Hiddekel pursues his course among the rocks
Two Wings spring from his ribs of brass, starry, black as night
But translucent their blackness as the dazling of gems

His Loins inclose Babylon on Euphrates beautiful
And Rome in sweet Hesperia, there Israel scatterd abroad
In martyrdoms & slavery I behold: ah vision of sorrow!
Inclosed by eyeless Wings, glowing with fire as the iron
Heated in the Smiths forge, but cold the wind of their dread fury

But in the midst of a devouring Stomach, Jerusalem
Hidden within the Covering Cherub as in a Tabernacle
Of threefold workmanship in allegoric delusion & woe
There the Seven Kings of Canaan & Five Baalim of Philistea
Sihon & Og the Anakim & Emim, Nephilim & Gibborim
From Babylon to Rome & the Wings spread from Japan
Where the Red Sea terminates the World of Generation & Death
To Irelands farthest rocks where Giants builded their Causeway
Into the Sea of Rephaim, but the Sea overwhelmd them all.

A Double Female now appeard within the Tabernacle,
Religion hid in War, a Dragon red & hidden Harlot
Each within other, but without a Warlike Mighty-one
Of dreadful power sitting upon Horeb pondering dire
And mighty preparations mustering multitudes innumerable
Of warlike sons among the sands of Midian & Aram
For multitudes of those who sleep in Alla descend
Lured by his warlike symphonies of tabret pipe & harp
Burst the bottoms of the Graves, & Funeral Arks of Beulah
Wandering in that unknown Night beyond the silent Grave
They become One with the Antichrist, & are absorbd in him

The Feminine separates from the Masculine & both from Man,
Ceasing to be His Emanations, Life to Themselves assuming!
And while they circumscribe his Brain, &, while they circumscribe
His Heart, & while they circumscribe his Loins: a Veil & Net
Of Veins of red Blood grows around them like a scarlet robe,
Covering them from the sight of Man like the woven Veil of Sleep
Such as the Flowers of Beulah weave to be their Funeral Mantles:
But dark; opake: tender to touch, & painful: & agonizing
To the embrace of love, & to the mingling of soft fibres
Of tender affection, that no more the Masculine mingles
With the Feminine, but the Sublime is shut out from the Pathos
In howling torment, to build stone walls of separation, compelling
The Pathos, to weave curtains of hiding secresy from the torment.

Bower & Conwenna stood on Skiddaw cutting the Fibres
Of Benjamin from Chesters River: loud the River: loud the Mersey
And the Ribble, thunder into the Irish sea, as the Twelve Sons
Of Albion drank & imbibed the Life & eternal Form of Luvah
Cheshire & Lancashire & Westmoreland groan in anguish
As they cut the fibres from the Rivers he sears them with hot
Iron of his Forge & fixes them into Bones of chalk & Rock
Conwenna sat above: with solemn cadences she drew
Fibres of Life out from the Bones into her golden Loom
Hand had his Furnace on Highgates heights & it reachd
To Brockley Hills across the Thames: he with double Boadicea
In cruel pride cut Reuben apart from the Hills of Surrey
Comingling with Luvah & with the Sepulcher of Luvah
For the Male is a Furnace of beryll: the Female is a golden Loom
Los cries: No Individual ought to appropriate to Himself
Or to his Emanation, any of the Universal Characteristics
Of David or of Eli, of the Peacemaker or of the Lord,
Of Reuben or of Benjamin, of Joseph or Judah or Levi
Those who dare appropriate to themselves Universal Attributes
Are the Blasphemous Selfhoods & must be broken asunder
A Vegetated Christ & a Virgin Eve, are the Hermaphroditic
Blasphemy, by his Maternal Birth he is that Evil-One
And his Maternal Humanity must be put off Eternally
Lest the Sexual Generation swallow up Regeneration
Come Lord Jesus take on thee the Satanic Body of Holiness

So Los cried in the Valleys of Middlesex in the Spirit of Prophecy
While in Selfhood Hand & Hyle & Bowen & Skofeld appropriate
The Divine Names: seeking to Vegetate the Divine Vision
In a corporeal & ever dying Vegetation & Corruption
Mingling with Luvah in One, they become One Great Satan

Loud scream the Daughters of Albion beneath the Tongs & Hammer
Dolorous are their lamentations in the burning Forge
They drink Reuben & Benjamin as the iron drinks the fire
They are red hot with cruelty: raving along the Banks of Thames
And on Tyburns Brook among the howling Victims in loveliness
While Los ............... a mighty Temple even to the stars: but they Vegetate
Beneath Los's Hammer, that Life may not be blotted out.

For Los said: When the Individual appropriates Universality
He divides into Male & Female: & when the Male & Female,
Appropriate Individuality, they become an Eternal Death.
Hermaphroditic worshippers of a God of cruelty & law!
Your Slaves & Captives; you compell to worship a God of Mercy.
These are the Demonstrations of Los, & the blows of my mighty Hammer

So Los spoke. And the Giants of Albion terrified & ashamed
With Los's thunderous Words, began to build trembling rocking Stones
For his Words roll in thunders & lightnings among the Temples
Terrified rocking to & fro upon the earth, & sometimes
Resting in a Circle in Maldon or in Strathness or Dura,
Plotting to devour Albion & Los the friend of Albion
Denying in private: mocking God & Eternal Life: & in Public
Collusion, calling themselves Deists, Worshipping the Maternal
Humanity; calling it Nature, and Natural Religion
But still the thunder of Los peals loud & thus the thunders cry
These beautiful Witchcrafts of Albion, are gratify'd by Cruelty

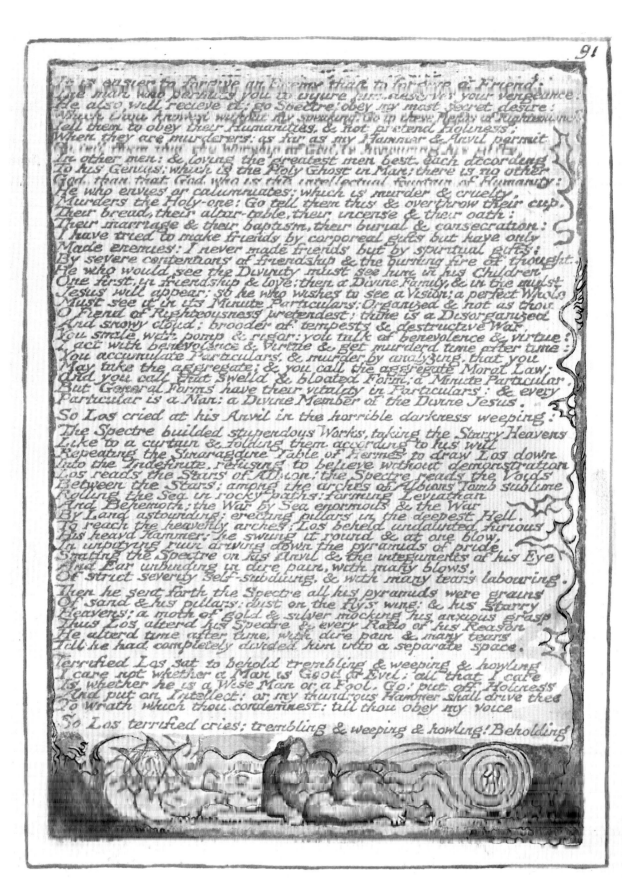

91

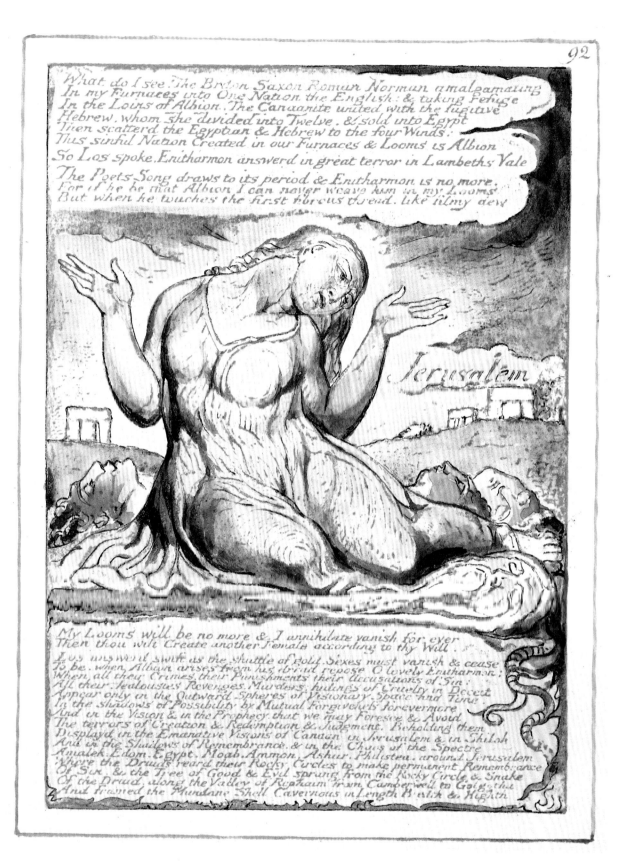

What do I see The Briton Saxon Roman Norman amalgamating
In my Furnaces into One Nation the English: & taking Refuge
In the Loins of Albion. The Canaanite united with the fugitive
Hebrew, whom she divided into Twelve, & sold into Egypt
Then scatterd the Egyptian & Hebrew to the four Winds:
This sinful Nation Created in our Furnaces & Looms is Albion
So Los spoke. Enitharmon answerd in great terror in Lambeths Vale

The Poets Song draws to its period & Enitharmon is no more.
For if he be that Albion I can never weave him in my Looms
But when he touches the first fibrous thread, like filmy dew

My Looms will be no more & I annihilate vanish for ever
Then thou wilt Create another Female according to thy Will.

Los answerd swift as the shuttle of gold. Sexes must vanish & cease
To be, when Albion arises from his dread repose O lovely Enitharmon:
When all their Crimes, their Punishments their Accusations of Sin:
All their Jealousies Revenges. Murders, hidings of Cruelty in Deceit
Appear only in the Outward Spheres of Visionary Space and Time.
In the shadows of Possibility by Mutual Forgiveness forevermore
And in the Vision & in the Prophecy, that we may Foresee & Avoid
The terrors of Creation & Redemption & Judgement. Beholding them
Displayd in the Emanative Visions of Canaan in Jerusalem & in Shiloh
And in the Shadows of Remembrance, & in the Chaos of the Spectre
Amalek, Edom, Egypt, Moab, Ammon, Ashur, Philistea, around Jerusalem
Where the Druids reard their Rocky Circles to make permanent Remembrance
Of Sin, & the Tree of Good & Evil sprang from the Rocky Circle & Snake
Of the Druid along the Valley of Rephaim from Camberwell to Golgotha
And framed the Mundane Shell Cavernous in Length Bredth & Highth

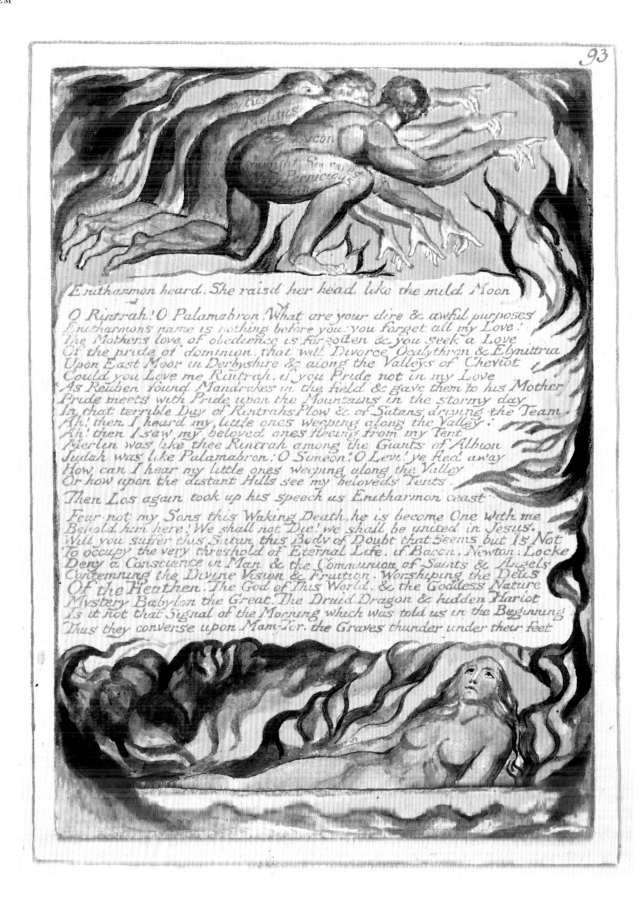

Enitharmon heard. She raisd her head like the mild Moon

O Rintrah! O Palamabron What are your dire & awful purposes
Enitharmons name is nothing before you: you forget all my Love!
The Mothers love of obedience is forgotten & you seek a Love
Of the pride of dominion. that will Divorce Ocalythron & Elynittria
Upon East Moor in Derbyshire & along the Valleys of Cheviot
Could you Love me Rintrah. if you Pride not in my Love
As Reuben found Mandrakes in the field & gave them to his Mother
Pride meets with Pride upon the Mountains in the stormy day
In that terrible Day of Rintrahs Plow & of Satans driving the Team
Ah! then I heard my little ones weeping along the Valley!
Ah! then I saw my beloved ones fleeing from my Tent
Merlin was like thee Rintrah among the Giants of Albion
Judah was like Palamabron: O Simeon! O Levi! ye fled away
How can I hear my little ones weeping along the Valley
Or how upon the distant Hills see my beloveds Tents

Then Los again took up his speech as Enitharmon ceast

Fear not my Sons this Waking Death. he is become One with me
Behold him here! We shall not Die! we shall be united in Jesus.
Will you suffer this Satan this Body of Doubt that Seems but Is Not
To occupy the very threshold of Eternal Life. if Bacon. Newton: Locke
Deny a Conscience in Man & the Communion of Saints & Angels
Contemning the Divine Vision & Fruition. Worshiping the Deus
Of the Heathen. The God of This World. & the Godless Nature
Mystery Babylon the Great. The Druid Dragon & hidden Harlot
Is it not that Signal of the Morning which was told us in the Beginning
Thus they converse upon Mam-Tor. the Graves thunder under their feet

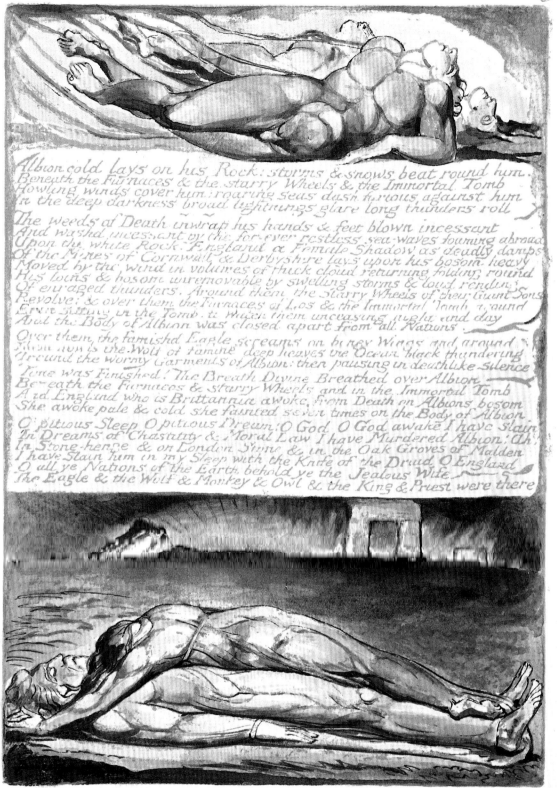

Albion cold lays on his Rock: storms & snows beat round him.
Beneath the Furnaces & the starry Wheels & the Immortal Tomb
Howling winds cover him: roaring seas dash furious against him
In the deep darkness broad lightnings glare long thunders roll

The weeds of Death inwrap his hands & feet blown incessant
And washd incessant by the for-ever restless sea-waves foaming abroad
Upon the white Rock. England a Female Shadow as deadly damps
Of the Mines of Cornwall & Derbyshire lays upon his bosom heavy
Moved by the wind in volumes of thick cloud returning folding round
His loins & bosom unremovable by swelling storms & loud rending
Of enraged thunders. Around them the starry Wheels of their Giant Sons
Revolve: & over them the Furnaces of Los & the Immortal Tomb around
Erin sitting in the Tomb, to watch them unceasing night and day
And the Body of Albion was closed apart from all Nations.

Over them the famishd Eagle screams on bony Wings and around
Them howls the Wolf of famine deep heaves the Ocean black thundering
Around the wormy Garments of Albion: then pausing in deathlike silence

Time was Finished! The Breath Divine Breathed over Albion
Beneath the Furnaces & starry Wheels and in the Immortal Tomb
And England who is Brittannia awoke from Death on Albions bosom
She awoke pale & cold she fainted seven times on the Body of Albion

O piteous Sleep O piteous Dream: O God O God awake I have slain
In Dreams of Chastity & Moral Law I have Murdered Albion: Ah!
In Stone-henge & on London Stone & in the Oak Groves of Malden
I have Slain him in my Sleep with the Knife of the Druid O England
O all ye Nations of the Earth behold ye the Jealous Wife
The Eagle & the Wolf & Monkey & Owl & the King & Priest were there

95

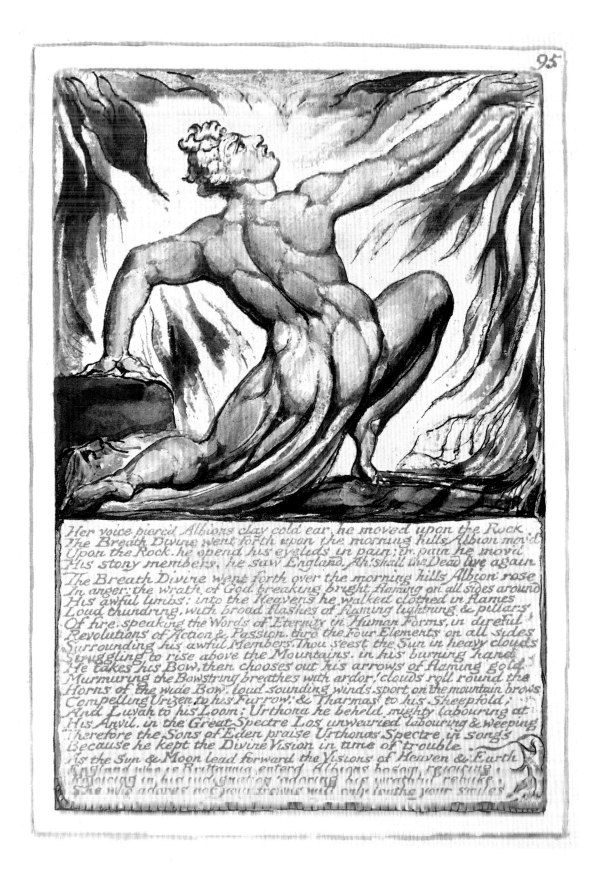

Her voice pierc'd Albions clay cold ear, he moved upon the Rock
The Breath Divine went forth upon the morning hills, Albion mov'd
Upon the Rock, he opend his eyelids in pain; in pain he mov'd
His stony members, he saw England. Ah! shall the Dead live again

The Breath Divine went forth over the morning hills Albion rose
In anger: the wrath of God breaking bright flaming on all sides around
His awful limbs: into the Heavens he walked clothed in flames
Loud thundring, with broad flashes of flaming lightning & pillars
Of fire, speaking the Words of Eternity in Human Forms, in direful
Revolutions of Action & Passion, thro' the Four Elements on all sides
Surrounding his awful Members. Thou seest the Sun in heavy clouds
Struggling to rise above the Mountains, in his burning hand
He takes his Bow, then chooses out his arrows of flaming gold
Murmuring the Bowstring breathes with ardor! clouds roll round the
Horns of the wide Bow, loud sounding winds sport on the mountain brows
Compelling Urizen to his Furrow: & Tharmas to his Sheepfold;
And Luvah to his Loom: Urthona he beheld mighty labouring at
His Anvil, in the Great Spectre Los unwearied labouring & weeping
Therefore the Sons of Eden praise Urthonas Spectre in songs
Because he kept the Divine Vision in time of trouble.
As the Sun & Moon lead forward the Visions of Heaven & Earth
England who is Brittannia enterd Albions bosom, rejoicing
Rejoicing in his indignation! adoring his wrathful rebuke.
She who adores not your frowns will only loathe your smiles

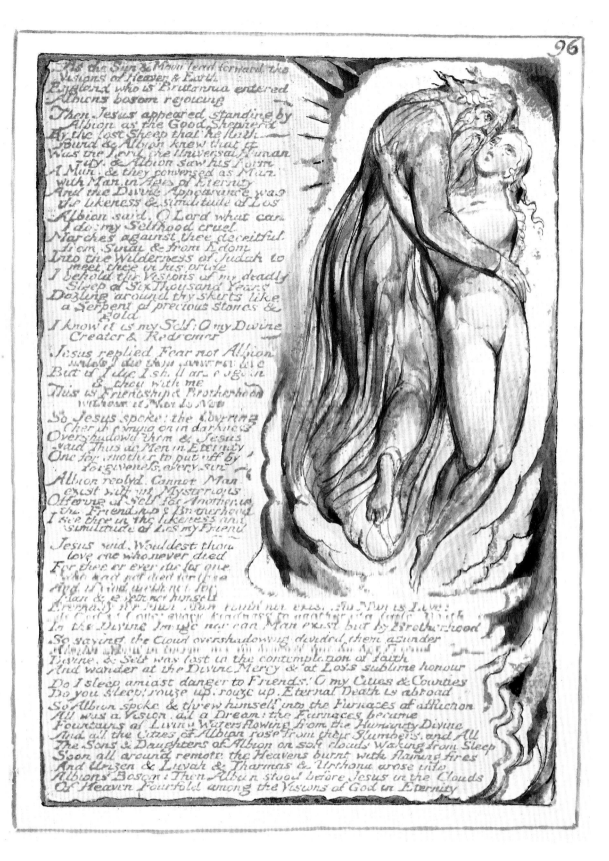

As the Sun & Moon lead forward the
Visions of Heaven & Earth
England who is Brittannia entered
Albions bosom rejoicing

Then Jesus appeared standing by
Albion as the Good Shepherd
By the lost Sheep that he hath
found & Albion knew that it
Was the Lord the Universal Humanity
& Albion saw his Form
A Man. & they conversed as Man
with Man. in Ages of Eternity
And the Divine Appearance was
the likeness & similitude of Los

Albion said, O Lord what can
I do! my Selfhood cruel
Marches against thee deceitful
from Sinai & from Edom
Into the Wilderness of Judah to
meet thee in his pride
I behold the Visions of my deadly
Sleep of Six Thousand Years
Dazling around thy skirts like
a Serpent of precious stones &
gold
I know it is my Self. O my Divine
Creator & Redeemer

Jesus replied Fear not Albion
unless thou die thou canst not live
But if I die I shall arise again
& thou with me
This is Friendship & Brotherhood
without it Man Is Not

So Jesus spoke! the Covering
Cherub coming on in darkness
Overshadowd them & Jesus
said Thus do Men in Eternity
One for another to put off by
forgiveness, every sin

Albion replyd. Cannot Man
exist without Mysterious
Offering of Self for Another, is
this Friendship & Brotherhood
I see thee in the likeness and
similitude of Los my Friend

Jesus said, Wouldest thou
love one who never died
For thee or ever die for one
who had not died for thee
And if God dieth not for
Man & giveth not himself
Eternally for Man Man could not exist! for Man is Love:
As God is Love: every kindness to another is a little Death
In the Divine Image nor can Man exist but by Brotherhood
So saying the Cloud overshadowing divided them asunder
Albion stood in terror: not for himself but for his Friend
Divine, & Self was lost in the contemplation of faith
And wonder at the Divine Mercy & at Los's sublime honour

Do I sleep amidst danger to Friends! O my Cities & Counties
Do you sleep! rouze up, rouze up. Eternal Death is abroad
So Albion spoke & threw himself into the Furnaces of affliction
All was a Vision, all a Dream: the Furnaces became
Fountains of Living Waters flowing from the Humanity Divine
And all the Cities of Albion rose from their Slumbers, and All
The Sons & Daughters of Albion on soft clouds Waking from Sleep
Soon all around remote the Heavens burnt with flaming fires
And Urizen & Luvah & Tharmas & Urthona arose into
Albions Bosom: Then Albion stood before Jesus in the Clouds
Of Heaven Fourfold among the Visions of God in Eternity

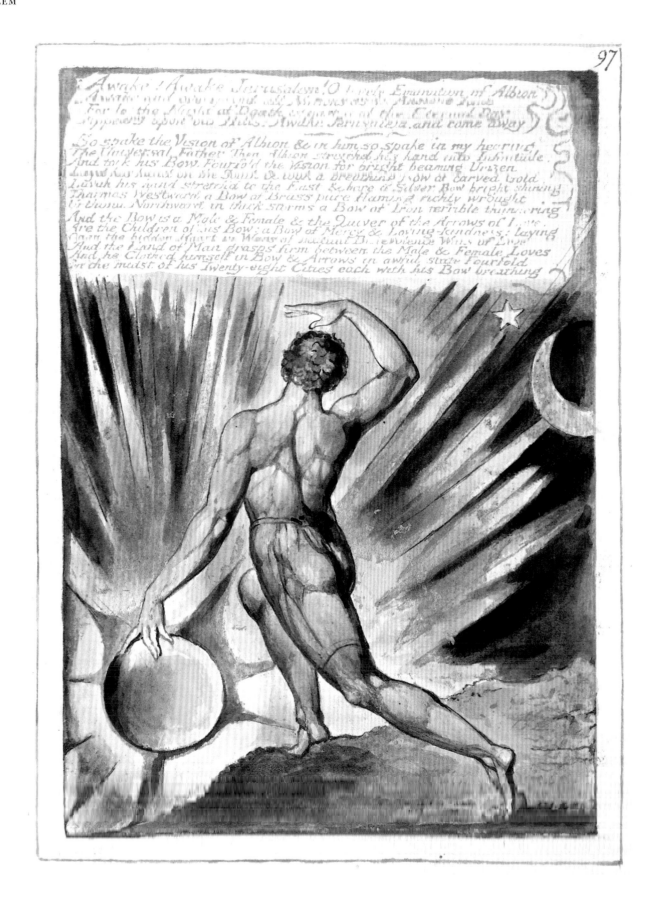

Then each an Arrow flaming from his Quiver fitted, carefully
They drew fourfold the unreprovable String. bending thro the wide Heavens
The horned Bow Fourfold, loud sounding flew the flaming Arrow fourfold

Murmuring the Bowstring breathes with ardor. Clouds roll round the horns
Of the wide Bow. loud sounding Winds sport on the Mountains brows.
The Druid Spectre was Annihilate loud thundring, rejoicing, terrific vanishing
Fourfold Annihilation & at the clangor of the Arrows of Intellect
The innumerable Chariots of the Almighty appeard in Heaven
And Bacon & Newton & Locke, & Milton & Shakspear & Chaucer
A Sun of blood red wrath surrounding heaven on all sides around
Glorious incomprehensible by Mortal Man & each Chariot was Sexual Threefold

And every Man stood Fourfold. each Four Faces had. One to the West
One toward the East One to the South One to the North. the Horses Fourfold
And the dim Chaos brightend beneath, above, around Eyed as the Peacock
According to the Human Nerves of Sensation, the Four Rivers of the Water of Life

South stood the Nerves of the Eye. East in Rivers of bliss the Nerves of the
Expansive Nostrils. West flowd the Parent Sense the Tongue. North stood
The labyrinthine Ear. Circumscribing & Circumcising the excrementitious
Husk & Covering into Vacuum evaporating revealing the lineaments of Man
Driving outward the Body of Death in an Eternal Death & Resurrection
Awaking it to Life among the Flowers of Beulah rejoicing in Unity
In the Four Senses in the Outline the Circumference & Form, for ever
In Forgiveness of Sins which is Self Annihilation, it is the Covenant of Jehovah
The Four Living Creatures Chariots of Humanity Divine Incomprehensible
In beautiful Paradises expand These are the Four Rivers of Paradise
And the Four Faces of Humanity fronting the Four Cardinal Points
Of Heaven going forward forward irresistible from Eternity to Eternity

And they conversed together in Visionary forms dramatic which bright
Redounded from their Tongues in thunderous majesty, in Visions
In new Expanses, creating exemplars of Memory and of Intellect
Creating Space, Creating Time according to the wonders Divine
Of Human Imagination, throughout all the Three Regions immense
Of Childhood, Manhood & Old Age & the all tremendous unfathomable Non Ens
Of Death was seen in regenerations terrific or complacent varying
According to the subject of discourse & every Word & every Character
Was Human according to the Expansion or Contraction, the Translucence or
Opakeness of Nervous fibres such was the variation of Time & Space
Which vary according as the Organs of Perception vary & they walked
To & fro in Eternity as One Man reflecting each in each & clearly seen
And seeing: according to fitness & order. And I heard Jehovah speak
Terrific from his Holy Place & saw the Words of the Mutual Covenant Divine
On Chariots of gold & jewels with Living Creatures starry & flaming
With every Colour, Lion, Tyger, Horse, Elephant, Eagle Dove, Fly, Worm,
And the all wondrous Serpent clothed in gems & rich array Humanize
In the Forgiveness of Sins according to thy Covenant Jehovah. They Cry

Where is the Covenant of Priam, the Moral Virtues of the Heathen
Where is the Tree of Good & Evil that rooted beneath the cruel heel
Of Albions Spectre the Patriarch Druid! where are all his Human Sacrifice
For Sin in War & in the Druid Temples of the Accuser of Sin: beneath
The Oak Groves of Albion that coverd the whole Earth beneath his Spectre
Where are the Kingdoms of the World & all their glory that grew on Desolation
The Fruit of Albions Poverty Tree when the Triple Headed Gog-Magog Giant
Of Albion Taxed the Nations into Desolation & then gave the Spectrous Oath

Such is the Cry from all the Earth from the Living Creatures of the Earth
And from the great City of Golgonooza in the Shadowy Generation

And from the Thirty-two Nations of the Earth among the Living Creatures

[395]

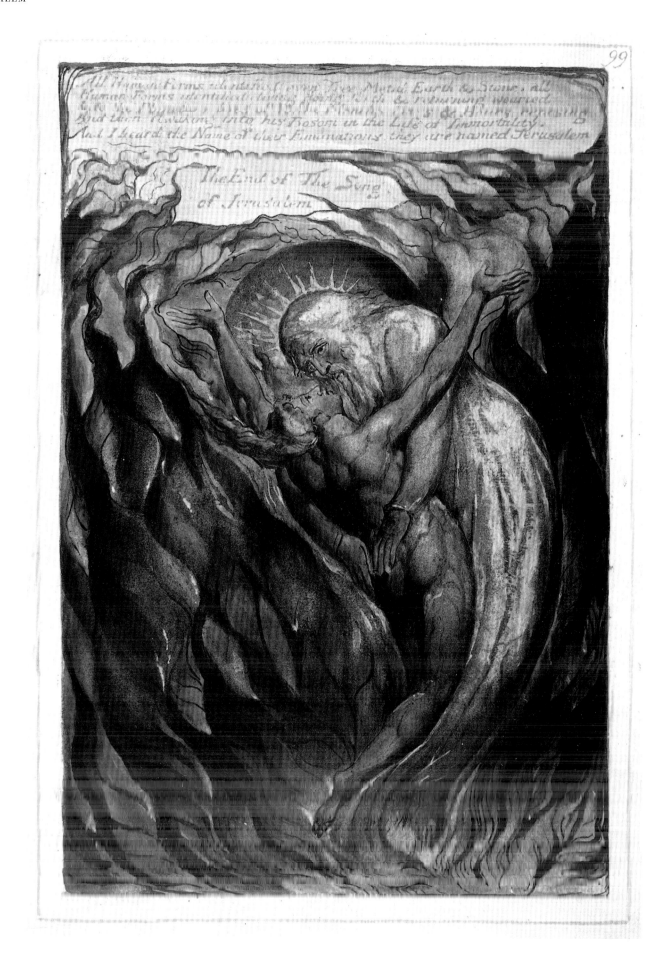

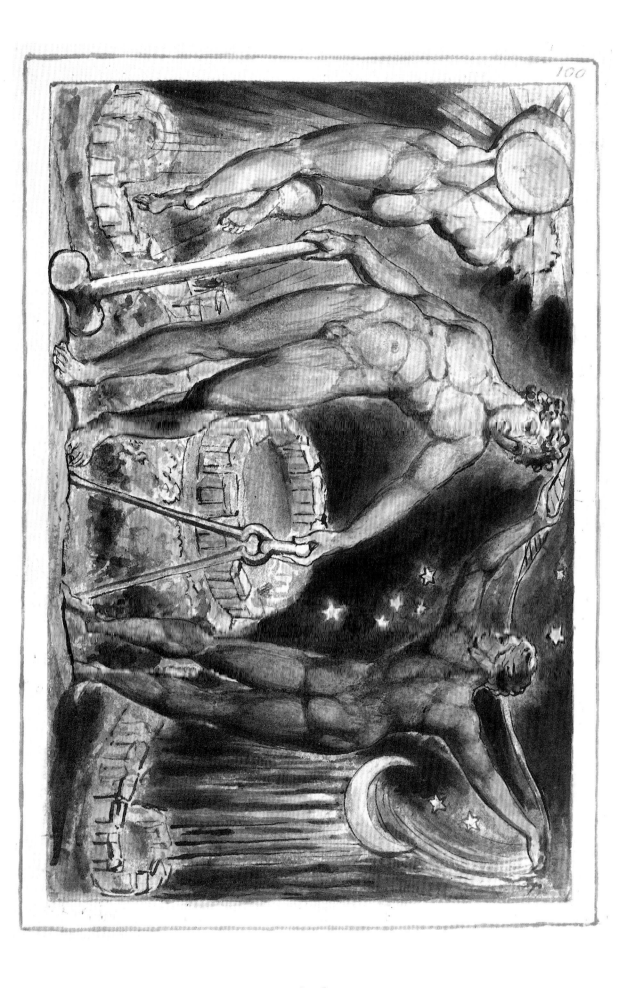

# The Final Illuminated Works

Blake's last three works of Illuminated printing were described by William Rossetti as 'Sibylline Leaves'. A century and a half later they remain opaque. Yet, as Blake's final inscriptions of his long-standing concerns with 'the religious doctrines of atonement and forgiveness, the tradition of art and ethics inherited from classical civilisation, and the relationships among art, Christianity, economics and politics' (Robert N. Essick, *William Blake's Illuminated Books*, volume 5, page 220) they cannot be be ignored.

## *The Ghost of Abel*
### 1822

Rosenwald Collection, Library of Congress, Washington, D.C. Copy A.
Relief etching, uncoloured.

The two leaves of *The Ghost of Abel* exist only in four complete copies printed, probably, in 1822, the year of its composition and etching. It is, ostensibly, a topical response to Lord Byron's controversial verse drama *Cain, A Mystery* (1821); though whether Blake wrote in defence or in criticism is unclear. What is apparent in Blake's continued concern with the complex religious and moral questions addressed throughout the preceding full scale Illuminated works.

## *On Homers Poetry* [and] *On Virgil*
### 1822

Rosenwald Collection, Library of Congress, Washington, D.C. Copy A.
Relief etching, uncoloured.

One of six known copies, this leaf is closely tied to *The Ghost of Abel* in technique. The text contains Blake's strongest denunciation of the classical world, reiterating his view that the Greek Muses were merely Daughters of Memory and not of Inspiration.

## *Laocoön*
### 1826

Collection Robert N. Essick, Altadena, Calif. Copy B.
Line engraving.

*Laocoön*, Blake's last Illuminated work, is known only in two copies. It contains, succinctly expressed, the central artistic beliefs of his last years. The Hellenistic sculpture, which Blake in about 1816 had drawn from a cast in the Royal Academy for a reproductive engraving, is interpreted in the light of his claim that 'all the grand works of ancient art' were copies from 'those wonderful originals called in the Scriptures the Cherubim'. Hence the *Laocoön*, though a canonical work of antiquity, was merely a copy of a group on the Temple of Solomon, given by the Greek copyists the name of the Trojan High Priest and made to represent an incident from the 'History of Ilium', though it was originally a depiction of God the Father with his sons Satan and Adam. The inscriptions which surround the figures associate art with prayer and Jesus, Materialism with destruction and, specifically, with the classical world.

The highly finished, professional style of engraving exhibits the skills Blake employed as a commercial engraver, an expertise notably manifest in his recently completed *Illustrations of the Book of Job*.

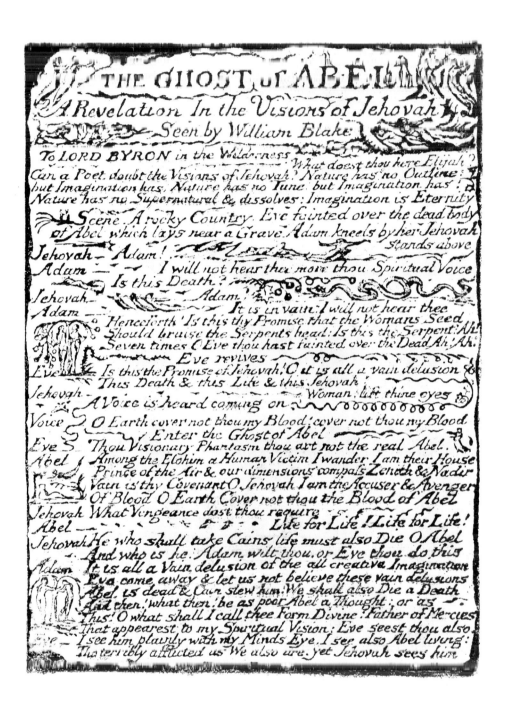

THE GHOST of ABEL

A Revelation In the Visions of Jehovah
Seen by William Blake

To LORD BYRON in the Wilderness
What doest thou here Elijah?
Can a Poet doubt the Visions of Jehovah? Nature has no Outline:
but Imagination has. Nature has no Tune but Imagination has!
Nature has no Supernatural & dissolves: Imagination is Eternity

Scene. A rocky Country. Eve fainted over the dead body
of Abel which lays near a Grave. Adam kneels by her Jehovah
stands above

Jehovah — Adam!

Adam —         I will not hear thee more thou Spiritual Voice
Is this Death?

Jehovah.          Adam

Adam —              It is in vain: I will not hear thee
Henceforth! Is this thy Promise that the Womans Seed
Should bruise the Serpents head: Is this the Serpent: Ah!
Seven times O Eve thou hast fainted over the Dead Ah! Ah.
Eve revives

Eve — Is this the Promise of Jehovah! O it is all a vain delusion
This Death & this Life & this Jehovah

Jehovah -                Woman! lift thine eyes
A Voice is heard coming on

Voice — O Earth cover not thou my Blood; cover not thou my Blood
Enter the Ghost of Abel

Eve — Thou Visionary Phantasm thou art not the real Abel.

Abel — Among the Elohim a Human Victim I wander I am their House
Prince of the Air & our dimensions compass Zenith & Nadir
Vain is thy Covenant O Jehovah I am the Accuser & Avenger
Of Blood O Earth Cover not thou the Blood of Abel

Jehovah What Vengeance dost thou require

Abel —                Life for Life! Life for Life!

Jehovah He who shall take Cains life must also Die O Abel
And who is he. Adam wilt thou. or Eve thou do this

Adam It is all a Vain delusion of the all creative Imagination
Eve come away & let us not believe these vain delusions
Abel is dead & Cain slew him. We shall also Die a Death
And then! what then! be as poor Abel a Thought: or as
This! O what shall I call thee Form Divine! Father of Mercies
That appearest to my Spiritual Vision: Eve seest thou also
I see him plainly with my Minds Eye. I see also Abel living:
Tho terribly afflicted us We also are. yet Jehovah sees him

Alive & not Dead: were it not better to believe Vision
With all our might & strength tho' we are fallen & lost

Adam — Eve thou hast spoken truly, let us kneel before his feet.
They Kneel before Jehovah
Abel — Are these the Sacrifices of Eternity O Jehovah, a Broken Spirit
And a Contrite Heart. O I cannot Forgive, the Accuser hath
Enterd into Me as into his House & I loathe thy Tabernacles
As thou hast said so is it come to pass: My desire is unto Cain
And He doth rule over Me: therefore My Soul in fumes of Blood
Cries for Vengeance: Sacrifice on Sacrifice Blood on Blood
Jehovah — Lo I have given you a Lamb for an Atonement instead
Of the Transgresor, or no Flesh or Spirit could ever Live
Abel — Compelled I cry O Earth cover not the Blood of Abel

Abel sinks down into the Grave from which arises Satan
Armed in glittering scales with a Crown & a Spear
Satan — I will have Human Blood & not the blood of Bulls or Goats
And no Atonement O Jehovah, the Elohim live on Sacrifice
Of Men: hence I am God of Men: Thou Human O Jehovah.
By the Rock & Oak of the Druid creeping Mistletoe & Thorn
Cains City built with Human Blood, not Blood of Bulls & Goats
Thou shalt Thyself be Sacrificed to Me thy God on Calvary
Jehovah — Such is My Will                              Thunders
                 that Thou Thyself go to Eternal Death
In Self Annihilation even till Satan Self-subdud Put off Satan
Into the Bottomless Abyss whose torment arises for ever & ever.
On each side a Chorus of Angels entering Sing the following
The Elohim of the Heathen Swore Vengeance for Sin Then Thou stood'st
Forth O Elohim Jehovah! in the midst of the darkness of the Oath! All Clothed
In Thy Covenant of the Forgiveness of Sins Death O Holy! Is this Brotherhood
The Elohim saw their Oath Eternal Fire; they rolled apart trembling over The
Mercy Seat: each in his station fixt in the Firmament by Peace Brotherhood and
        The Curtain falls                                                  Love

Blood

1822 W Blakes Original Stereotype was 1788

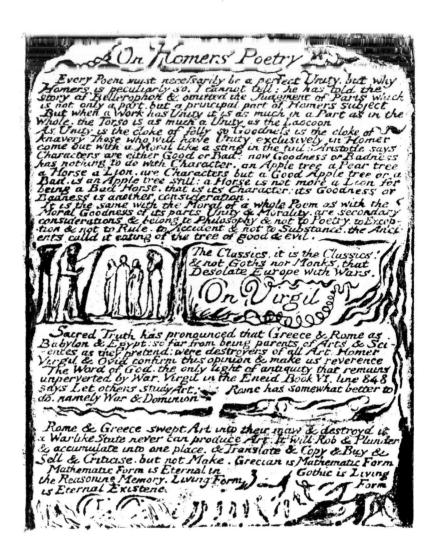

# On Homers Poetry

Every Poem must necessarily be a perfect Unity. but why
Homers is peculiarly so, I cannot tell: he has told the
story of Bellerophon & omitted the Judgment of Paris which
is not only a part. but a principal part of Homers subject
But when a Work has Unity it is as much in a Part as in the
Whole. the Torso is as much a Unity as the Laocoon
As Unity is the cloke of folly so Goodness is the cloke of
Knavery Those who will have Unity exclusively in Homer
come out with a Moral like a sting in the tail: Aristotle says
Characters are either Good or Bad: now Goodness or Badness
has nothing to do with Character. an Apple tree a Pear tree
a Horse a Lion. are Characters but a Good Apple tree or a
Bad. is an Apple tree still: a Horse is not more a Lion for
being a Bad Horse. that is its Character: its Goodness or
Badness is another consideration.
It is the same with the Moral of a whole Poem as with the
Moral Goodness of its parts Unity & Morality. are secondary
considerations & belong to Philosophy & not to Poetry. to Excep-
tion & not to Rule. to Accident & not to Substance. the Anci-
ents calld it eating of the tree of good & evil.

The Classics. it is the Classics!
& not Goths nor Monks. that
Desolate Europe with Wars.

## On Virgil

Sacred Truth has pronounced that Greece & Rome as
Babylon & Egypt: so far from being parents of Arts & Sci-
ences as they pretend: were destroyers of all Art. Homer
Virgil & Ovid confirm this opinion & make us reverence
The Word of God. the only light of antiquity that remains
unperverted by War. Virgil in the Eneid Book VI. line 848
says Let others study Art: Rome has somewhat better to
do. namely War & Dominion

Rome & Greece swept Art into their maw & destroyd it
a Warlike State never can produce Art. It will Rob & Plunder
& accumulate into one place. & Translate & Copy & Buy &
Sell & Criticise. but not Make. Grecian is Mathematic Form
Mathematic Form is Eternal in
the Reasoning Memory. Living Form
is Eternal Existence.

Gothic is Living
Form

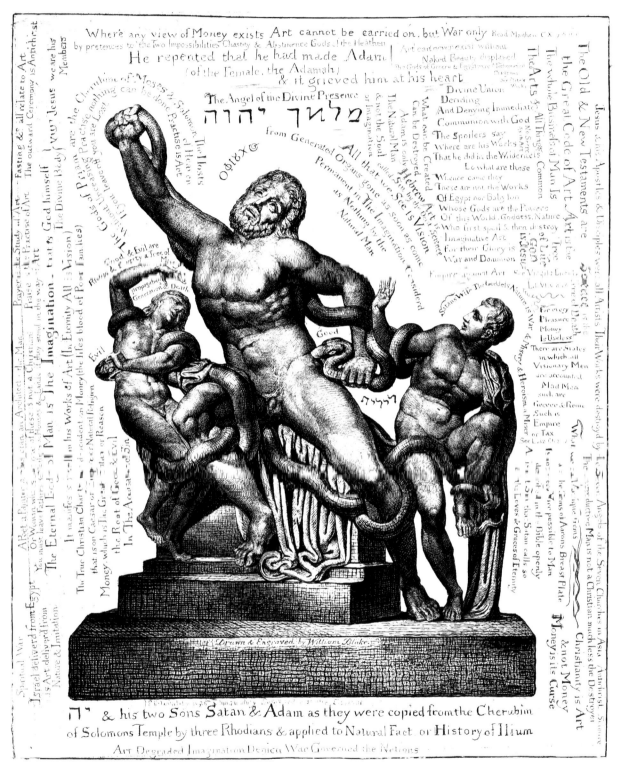

Where any view of Money exists Art cannot be carried on, but War only Read Matthew CX.

by pretences to the Two Impossibilities Chastity & Abstinence Gods of the Heathen

He repented that he had made Adam

(of the Female, the Adamah)

& it grieved him at his heart

Art can never exist without Naked Beauty displayed

The Gods of Greece & Egypt were Mathematical Diagrams See Plato's Works

The Angel of the Divine Presence מלאך יהוה

ΟΦΙΩΧ

from Generated Organs gone as soon as born Permanent in The Imagination Considered as Nothing by the Natural Man

Divine Union Deriding And Denying Immediate Communion with God

The Spoilers say Where are his Works That he did in the Wilderness Lo what are these Whence came they These are not the Works Of Egypt nor Babylon Whose Gods are the Powers Of this World. Goddess, Nature Who first spoil & then destroy Imaginative Art For their Glory is War and Dominion

Empire against Art See Virgils Eneid

Jesus & his Apostles & Disciples were all Artists. Their Works were destroyd by the Seven Angels of the Seven Churches in Asia. Antichrist Science

The Old & New Testaments are the Great Code of Art. Art is the Tree of Life. God is Jesus.

The whole Business of Man Is The Arts & All Things Common. Science is the Tree of Death.

All that we See is Vision from Generated Organs

What can be Created Can be Destroyed Adam is only The Natural Man & not the Soul or Imagination

The Cherubim of Moses & Solomon practise nothing can be done. Practise is Art. If you leave off you are Lost

The Hosts of Heaven

The Gods of Priam are the The Unceasing

Spiritual War Israel deliverd from Egypt is Art deliverd from Nature & Imitation

A Poet a Painter a Musician an Architect: the Man

The Eternal God of Man is The Imagination that is God himself The Divine Body

It manifes is in his Works of Art (In Eternity All is Vision)

Prayer is the Study of Art Praise is the Practise of Art Fasting &c all relate to Art The outward Ceremony is Antichrist

You must leave Fathers & Mothers & Houses & Lands if they stand in the way of Art

Or Woman wife

The True Christian Charity not dependent on Money (the life's blood of Poor Families) that is on Caesar or Empire or Natural Religion

Money which is The Great Satan or Reason the Root of Good & Evil In The Accusation of Sin

Blessed are the Poor

Prosperity & Bounty & Prosperity a Tree of

Propagation Generation & Death

Evil

Good

Christians are Architect the Man

Blessed are God to Practise is not a Christian

Satans Wife The Goddess Nature is War & Misery & Heroism a Miser

For every Pleasure Money Is Useless

There are States in which all Visionary Men are accounted Mad Men such are Greece & Rome Such is Empire or Tax See Luke Ch 2

What can one Mans Religious

The Laws of the Jews

The Gods of Greece & Egypt were Mathematical Diagrams

He repents that he had made Adam

If Morality was Christianity Socrates was the Saviour

Christianity is Art & not Money Money is its Curse

ה' & his two Sons Satan & Adam as they were copied from the Cherubim of Solomons Temple by three Rhodians & applied to Natural Fact, or History of Ilium

Art Degraded Imagination Denied War Governed the Nations

Drawn & Engraved by William Blake

*Laocoön*

# Transcripts of Blake's Texts

The following pages provide, within the limitations of conventional typesetting, accurate transcripts of what Blake etched on his copper plates. His sometimes idiosyncratic spelling, irregular punctuation, and occasional errors have been retained. Editorial intervention is confined to interpreting punctuation signs where, for instance, distinctions between commas and full stops have been lost in the etching and printing processes that Blake employed.

In general, no attempt has been made to differentiate typographically between Blake's use of roman and italic letter forms.

The leaves on which the texts appear are identified in the transcripts by reference to the numbering, usually in Blake's own hand, at the top right-hand corner of the individual plates.

While the transcripts may be useful in elucidating occasional difficulties in deciphering the engraved words, the printed texts are offered as adjuncts to the plates and not as a substitute for them. Edited texts in letterpress, with regularised punctuation and orthography, are available in numerous editions. These can assist understanding. But unmediated engagement with Blake's breathless inscription of his flow of thought may offer more immediate access to his mind and to his meaning.

The transcripts of Blake's texts as printed here are reproduced (reduced) from the texts printed in the six volumes of the Blake Trust's Complete Edition of Blake's Illuminated books. The transcripts are the work of: Morton D. Paley, *Jerusalem*; Andrew Lincoln, *Songs of Innocence and of Experience*; Morris Eaves, Robert N. Essick, Joseph Viscomi, *All Religions are One, There is No Natural Religion, Book of Thel, The Marriage of Heaven and Hell, Visions of the Daughters of Albion*; Detlef W. Dörrbecker, *America, Europe, Song of Los*; Robert N. Essick, Joseph Viscomi, *Milton, Ghost of Abel, On Homers Poetry* [and] *On Virgil, Laocoön*; David Worrall, *First Book of Urizen, Book of Ahania, Book of Los*.

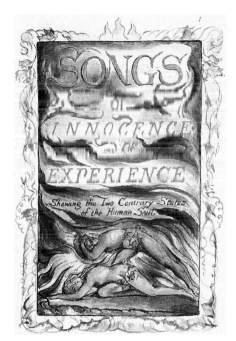

# SONGS

## Of

### *INNOCENCE*

### *and Of*

### *EXPERIENCE*

*Shewing the Two Contrary States
of the Human Soul*

### *Plate 4:* Introduction

Piping down the valleys wild
Piping songs of pleasant glee
On a cloud I saw a child.
And he laughing said to me.

Pipe a song about a Lamb:
So I piped with merry chear,
Piper pipe that song again—
So I piped, he wept to hear.

Drop thy pipe thy happy pipe
Sing thy songs of happy chear,
So I sung the same again
While he wept with joy to hear

Piper sit thee down and write
In a book that all may read—
So he vanish'd from my sight
And I pluck'd a hollow reed

And I made a rural pen,
And I stain'd the water clear,
And I wrote my happy songs,
Every child may joy to hear.

### *Plate 5:* The Shepherd

How sweet is the Shepherds sweet lot,
From the morn to the evening he strays:
He shall follow his sheep all the day
And his tongue shall be filled with praise.

For he hears the lambs innocent call.
And he hears the ewes tender reply,
He is watchful while they are in peace,
For they know when their Shepherd is nigh

### *Plates 6–7:* The Ecchoing Green

The Sun does arise,
And make happy the skies,
The merry bells ring
To welcome the spring,
The sky lark and thrush,
The birds of the bush,
Sing louder around,
To the bells chearful sound,
While our sports shall be seen
On the Ecchoing Green.

Old John with white hair
Does laugh away care,
Sitting under the oak,
Among the old folk.

They laugh at our play,
And soon they all say,
Such such were the joys.
When we all girls & boys.
In our youth time were seen,
On the Ecchoing Green

Till the little ones weary
No more can be merry
The sun does descend,
And our sports have an end:
Round the laps of their mothers,
Many sisters and brothers,
Like birds in their nest
Are ready for rest;
And sport no more seen,
On the darkening Green.

### *Plate 8:* The Lamb

Little Lamb who made thee
  Dost thou know who made thee
Gave thee life & bid thee feed.
By the stream & o'er the mead;
Gave thee clothing of delight.
Softest clothing wooly bright;
Gave thee such a tender voice.
Making all the vales rejoice:
  Little Lamb who made thee
  Dost thou know who made thee

Little Lamb I'll tell thee,
  Little Lamb Ill tell thee;
He is called by thy name,
For he calls himself a Lamb:
He is meek & he is mild,
He became a little child:
I a child & thou a lamb,
We are called by his name,
  Little Lamb God bless thee,
  Little Lamb God bless thee.

### *Plates 9–10:* The Little Black Boy

My mother bore me in the southern wild,
And I am black, but O! my soul is white.
White as an angel is the English child:
But I am black as if bereav'd of light.

My mother taught me underneath a tree
And sitting down before the heat of day.
She took me on her lap and kissed me,
And pointing to the east began to say.

Look on the rising sun: there God does live
And gives his light. and gives his heat away.
And flowers and trees and beasts and men recieve
Comfort in morning joy in the noon day.

And we are put on earth a little space.
That we may learn to bear the beams o
And these black bodies and this sun-b
Is but a cloud, and like a shady grove.

For when our souls have learn'd the he
The cloud will vanish we shall hear his
Saying: come out from the grove my lo
And round my golden tent like lambs

Thus did my mother say and kissed me
And thus I say to little English boy.
When I from black and he from white c
And round the tent of God like lambs

Ill shade him from the heat till he can bear,
To lean in joy upon our fathers knee.
And then I'll stand and stroke his silver hair,
And be like him and he will then love me.

### *Plate 11:* The Blossom.

Merry Merry Sparrow
Under leaves so green
A happy Blossom
Sees you swift as arrow
Seek your cradle narrow
Near my Bosom.

Pretty Pretty Robin
Under leaves so green
A happy Blossom
Hears you sobbing sobbing
Pretty Pretty Robin
Near my Bosom.

### *Plate 12:* The Chimney Sweeper

When my mother died I was very young,
And my father sold me while yet my tongue,
Could scarcely cry weep weep weep weep,
So your chimneys I sweep & in soot I sleep.

Theres little Tom Dacre. who cried when his head
That curl'd like a lambs back was shav'd, so I said
Hush Tom never mind it for when your heads bare,
You know that the soot cannot spoil your white hair

And so he was quiet. & that very night,
As Tom was a sleeping he had such a sight
That thousands of sweepers Dick, Joe, Ned & Jack
Were all of them lock'd up in coffins of black,

And by came an Angel who had a bright key
And he open'd the coffins & set them all free.
Then down a green plain leaping laughing they run
And wash in a river and shine in the Sun.

Then naked & white, all their bags left behind.
They rise upon clouds, and sport in the wind.
And the Angel told Tom, if he'd be a good boy,
He'd have God for his father & never want joy.

And so Tom awoke and we rose in the dark
And got with our bags & our brushes to work.
Tho' the morning was cold, Tom was happy & warm
So if all do their duty, they need not fear harm.

### *Plate 13:* The Little Boy lost

Father, father, where are you going
O do not walk so fast.
Speak father, speak to your little boy
Or else I shall be lost,

The night was dark no father was there
The child was wet with dew.
The mire was deep, & the child did weep
And away the vapour flew

### *Plate 14:* The Little Boy found

The little boy lost in the lonely fen,
Led by the wand'ring light,
Began to cry, but God ever nigh,
Appeard like his father in white.

He kissed the child & by the hand led
And to his mother brought,
Who in sorrow pale. thro' the lonely dale
Her little boy weeping sought.

### *Plate 15:* Laughing Song,

When the green woods laugh with the voice of joy
And the dimpling stream runs laughing by,
When the air does laugh with our merry wit,
And the green hill laughs with the noise of it.

When the meadows laugh with lively green
And the grasshopper laughs in the merry scene.
When Mary and Susan and Emily.
With their sweet round mouths sing Ha, Ha, He.

When the painted birds laugh in the shade
Where our table with cherries and nuts is spre[ad]
Come live & be merry and join with me,
To sing the sweet chorus of Ha, Ha, He.

### *Plates 16–17:* A Cradle Song

Sweet dreams form a shade,
O'er my lovely infants head.
Sweet dreams of pleasant streams,
By happy silent moony beams

Sweet sleep with soft down.
Weave thy brows an infant crown.
Sweet sleep Angel mild,
Hover o'er my happy child.

Sweet smiles in the night,
Hover over my delight.
Sweet smiles Mothers smiles
All the livelong night beguiles.

Sweet moans, dovelike sighs,
Chase not slumber from thy eyes,
Sweet moans. sweeter smiles,
All the dovelike moans beguiles.

Sleep sleep happy child,
All creation slept and smil'd.
Sleep sleep, happy sleep.
While o'er thee thy mother weep

Sweet babe in thy face,
Holy image I can trace.
Sweet babe once like thee.
Thy maker lay and wept for me

Wept for me for thee for all,
When he was an infant small.
Thou his image ever see.
Heavenly face that smiles on thee

Smiles on thee on me on all,
Who became an infant small,
Infant smiles are his own smiles,
Heaven & earth to peace beguiles.

### *Plate 18:* The Divine Image.

To Mercy Pity Peace and Love.
All pray in their distress:
And to these virtues of delight
Return their thankfulness.

For Mercy Pity Peace and Love,
Is God our father dear:
And Mercy Pity Peace and Love,
Is Man his child and care.

For Mercy has a human heart
Pity, a human face:
And Love, the human form divine,
And Peace, the human dress.

Then every man of every clime,
That prays in his distress,
Prays to the human form divine
Love Mercy Pity Peace,

And all must love the human form.
In heathen, turk or jew,
Where Mercy, Love & Pity dwell,
There God is dwelling too.

### *Plate 19:* Holy Thursday

Twas on a Holy Thursday their innocent faces clean
The children walking two & two in red & blue & gre[en]
Grey headed beadles walkd before with wands as white as snow
Till into the high dome of Pauls they like Thames waters flow

O what a multitude they seemd these flowers of London town
Seated in companies they sit with radiance all their own
The hum of multitudes was there but multitudes of lambs
Thousands of little boys & girls raising their innocent hands

Now like a mighty wind they raise to heaven the voice of song
Or like harmonious thunderings the seats of heaven among
Beneath them sit the aged men wise guardians of the poor
Then cherish pity, lest you drive an angel from your door

### *Plates 20–21:* Night

The sun descending in the west.
The evening star does shine.
The birds are silent in their nest,
And I must seek for mine,
The moon like a flower,
In heavens high bower;
With silent delight,
Sits and smiles on the night

Farewell green fields and happy groves,
Where flocks have took delight;
Where lambs have nibbled silent moves
The feet of angels bright;
Unseen they pour blessing,
And joy without ceasing,
On each bud and blossom,
And each sleeping bosom.

They look in every thoughtless nest,
Where birds are coverd warm;
They visit caves of every beast,
To keep them all from harm;
If they see any weeping,
That should have been sleeping
They pour sleep on their head
And sit down by their bed.

When wolves and tygers howl for prey
They pitying stand and weep;
Seeking to drive their thirst away,
And keep them from the sheep.
But if they rush dreadful;
The angels most heedful,
Recieve each mild spirit.
New worlds to inherit

And there the lions ruddy eyes,
Shall flow with tears of gold,
And pitying the tender cries,
And walking round the fold:
Saying: wrath by his meekness
And by his health, sickness.
Is driven away,
From our immortal day.

And now beside thee bleating lamb.
I can lie down and sleep;
Or think on him who bore thy name.
Grase after thee and weep.
For wash'd in lifes river.
My bright mane for ever.
Shall shine like the gold.
As I guard o'er the fold.

### *Plates 22–23:* Spring

Sound the Flute!
Now it's mute.
Birds delight
Day and Night,
Nightingale
In the dale
Lark in Sky
Merrily
Merrily Merrily to welcome in the Year

Little Boy
Full of joy,

Little Girl
Sweet and small,

Cock does crow
So do you.
Merry voice
Infant noise
Merrily Merrily to welcome in the Year

Little Lamb
Here I am.
Come and lick
My white neck
Let me pull
Your soft Wool.
Let me kiss
Your soft face
Merrily Merrily we welcome in the Year

### Plate 24: Nurse's Song

When the voices of children are heard on the green
And laughing is heard on the hill,
My heart is at rest within my breast
And everything else is still

Then come home my children the sun is gone down
And the dews of night arise
Come come leave off play, and let us away
Till the morning appears in the skies

No no let us play, for it is yet day
And we cannot go to sleep
Besides in the sky, the little birds fly
And the hills are all coverd with sheep

Well well go & play till the light fades away
And then go home to bed
The little ones leaped & shouted & laugh'd
And all the hills eechoed

### Plate 25: Infant Joy

I have no name
I am but two days old.—
What shall I call thee?
I happy am
Joy is my name.—
Sweet joy befall thee!

Pretty joy!
Sweet joy but two days old.
Sweet joy I call thee;
Thou dost smile,
I sing the while
Sweet joy befall thee.

### Plate 26: A Dream

Once a dream did weave a shade,
O'er my Angel-guarded bed.
That an Emmet lost it's way
Where on grass methought I lay.

Troubled wilderd and forlorn
Dark benighted travel-worn,
Over many a tangled spray,
All heart-broke I heard her say.

O my children! do they cry,
Do they hear their father sigh.
Now they look abroad to see,
Now return and weep for me.

Pitying I drop'd a tear;
But I saw a glow-worm near:
Who replied. What wailing wight
Calls the watchman of the night.

I am set to light the ground,
While the beetle goes his round:
Follow now the beetles hum,
Little wanderer hie thee home.

### Plate 27: On Anothers Sorrow

Can I see anothers woe,
And not be in sorrow too.
Can I see anothers grief,
And not seek for kind relief.

Can I see a falling tear.
And not feel my sorrows share,
Can a father see his child,
Weep, nor be with sorrow fill'd.

Can a mother sit and hear.
An infant groan an infant fear—
No no never can it be,
Never never can it be.

And can he who smiles on all
Hear the wren with sorrows small.
Hear the small birds grief & care
Hear the woes that infants bear—

And not sit beside the nest
Pouring pity in their breast.
And not sit the cradle near
Weeping tear on infants tear.

And not sit both night & day.
Wiping all our tears away.
O! no never can it be.
Never never can it be.

He doth give his joy to all,
He becomes an infant small,
He becomes a man of woe
He doth feel the sorrow too.

Think not. thou canst sigh a sigh,
And thy maker is not by.
Think not, thou canst weep a tear,
And thy maker is not near.

O! he gives to us his joy.
That our grief he may destroy
Till our grief is fled & gone
He doth sit by us and moan

### Plate 29: Title-page for *Songs of Experience*

# SONGS

### *of*

## EXPERIENCE

1794

The Author & Printer W Blake

### Plate 30: Introduction.

Hear the voice of the Bard!
Who Present, Past, & Future sees
Whose ears have heard,
The Holy Word,
That walk'd among the ancient trees.

Calling the lapsed Soul
And weeping in the evening dew;
That might controll.
The starry pole;
And fallen fallen light renew!

O Earth O Earth return!
Arise from out the dewy grass;
Night is worn,
And the morn
Rises from the slumberous mass.

Turn away no more:
Why wilt thou turn away
The starry floor
The watry shore
Is givn thee till the break of day.

### Plate 31: Earth's Answer

Earth raisd up her head.
From the darkness dread & drear.
Her light fled:
Stony dread!
And her locks cover'd with grey despair.

Prison'd on watry shore
Starry Jealousy does keep my den
Cold and hoar
Weeping o'er
I hear the father of the ancient men

Selfish father of men
Cruel jealous selfish fear
Can delight
Chain'd in night
The virgins of youth and morning bea

Does spring hide its joy
When buds and blossoms grow?
Does the sower?
Sow by night?
Or the plowman in darkness plow?

Break this heavy chain.
That does freeze my bones around
Selfish! vain!
Eternal bane!
That free Love with bondage bound.

### Plate 32: The Clod & the Pebble

Love seeketh not Itself to please.
Nor for itself hath any care;
But for another gives its ease.
And builds a Heaven in Hells despair.

So sung a little Clod of Clay,
Trodden with the cattles feet;
But a Pebble of the brook.
Warbled out these metres meet.

Love seeketh only Self to please,
To bind another to Its delight;
Joys in anothers loss of ease.
And builds a Hell in Heavens despite.

### Plate 33: Holy Thursday

Is this a holy thing to see.
In a rich and fruitful land.
Babes reducd to misery,
Fed with cold and usurous hand?

Is that trembling cry a song?
Can it be a song of joy?
And so many children poor?
It is a land of poverty!

And their sun does never shine.
And their fields are bleak & bare.
And their ways are fill'd with thorns
It is eternal winter there.

For where-e'er the sun does shine.
And where-e'er the rain does fall:
Babe can never hunger there,
Nor poverty the mind appall.

*Plates 34–35:* The Little Girl Lost

In futurity
I prophetic see.
That the earth from sleep.
(Grave the sentence deep)

Shall arise and seek
For her maker meek:
And the desart wild
Become a garden mild.

In the southern clime,
Where the summers prime.
Never fades away;
Lovely Lyca lay.

Seven summers old
Lovely Lyca told,
She had wanderd long.
Hearing wild birds song.

Sweet sleep come to me
Underneath this tree;
Do father, mother weep.—
"Where can Lyca sleep".

Lost in desart wild
Is your little child.
How can Lyca sleep.
If her mother weep.

If her heart does ake.
Then let Lyca wake;
If my mother sleep,
Lyca shall not weep.

Frowning frowning night,
O'er this desart bright.
Let thy moon arise.
While I close my eyes.

Sleeping Lyca lay:
While the beasts of prey,
Come from caverns deep,
View'd the maid asleep

The kingly lion stood
And the virgin view'd,
Then he gambold round
O'er the hallowd ground.

Leopards, tygers play,
Round her as she lay;
While the lion old,
Bow'd his mane of gold,

And her bosom lick,
And upon her neck,
From his eyes of flame,
Ruby tears there came;

While the lioness,
Loos'd her slender dress,
And naked they convey'd
To caves the sleeping maid.

*Plates 35–36:* The Little Girl Found

All the night in woe,
Lyca's parents go:
Over vallies deep.
While the desarts weep.

Tired and woe-begone.
Hoarse with making moan:
Arm in arm seven days.
They trac'd the desert ways.

Seven nights they sleep.
Among shadows deep:
And dream they see their child
Starv'd in desart wild.

Pale thro' pathless ways
The fancied image strays,
Famish'd weeping, weak
With hollow piteous shriek

Rising from unrest,
The trembling woman prest,
With feet of weary woe:
She could no further go.

In his arms he bore.
Her arm'd with sorrow sore:
Till before their way,
A couching lion lay.

Turning back was vain,
Soon his heavy mane.
Bore them to the ground;
Then he stalk'd around.

Smelling to his prey,
But their fears allay.
When he licks their hands:
And silent by them stands.

They look upon his eyes
Fill'd with deep surprise:
And wondering behold.
A spirit arm'd in gold.

On his head a crown
On his shoulders down,
Flow'd his golden hair,
Gone was all their care.

Follow me he said,
Weep not for the maid;
In my palace deep.
Lyca lies asleep.

Then they followed,
Where the vision led;
And saw their sleeping child,
Among tygers wild.

To this day they dwell
In a lonely dell
Nor fear the wolvish howl,
Nor the lions growl.

*Plate 37:* The Chimney Sweeper

A little black thing among the snow:
Crying weep, weep, in notes of woe!
Where are thy father & mother? say?
They are both gone up to the church to pray.

Because I was happy upon the heath.
And smil'd among the winters snow:
They clothed me in the clothes of death.
And taught me to sing the notes of woe.

And because I am happy. & dance & sing.
They think they have done me no injury:
And are gone to praise God & his Priest & King
Who make up a heaven of our misery.

*Plate 38:* Nurses Song

When the voices of children. are heard on the green
And whisprings are in the dale.
The days of my youth rise fresh in my mind,
My face turns green and pale.

Then come home my children. the sun is gone down
And the dews of night arise
Your spring & your day. are wasted in play
And your winter and night in disguise.

*Plate 39:* The Sick Rose

O Rose thou art sick
The invisible worm.
That flies in the night
In the howling storm:

Has found out thy bed
Of crimson joy:
And his dark secret love
Does thy life destroy.

*Plate 40:* The Fly.

Little Fly
Thy summers play,
My thoughtless hand
Has brush'd away.

Am not I
A fly like thee?
Or art not thou
A man like me?

For I dance
And drink & sing;
Till some blind hand
Shall brush my wing.

If thought is life
And strength & breath;
And the want
Of thought is death;

Then am I
A happy fly,
If I live,
Or if I die.

*Plate 41:* The Angel

I Dreamt a Dream! what can it mean?
And that I was a maiden Queen:
Guarded by an Angel mild;
Witless woe, was neer beguil'd!

And I wept both night and day
And he wip'd my tears away
And I wept both day and night
And hid from him my hearts delight

So he took his wings and fled:
Then the morn blush'd rosy red:
I dried my tears & armd my fears,
With ten thousand shields and spears.

Soon my Angel came again;
I was arm'd, he came in vain;
For the time of youth was fled
And grey hairs were on my head

*Plate 42:* The Tyger.

Tyger Tyger, burning bright,
In the forests of the night;
What immortal hand or eye.
Could frame thy fearful symmetry?

In what distant deeps or skies.
Burnt the fire of thine eyes?
On what wings dare he aspire?
What the hand, dare sieze the fire?

And what shoulder, & what art,
Could twist the sinews of thy heart?
And when thy heart began to beat.
What dread hand? & what dread feet?

What the hammer? what the chain,
In what furnace was thy brain?
What the anvil? what dread grasp.
Dare its deadly terrors clasp?

When the stars threw down their spears
And water'd heaven with their tears:
Did he smile his work to see?
Did he who made the Lamb make thee?

Tyger Tyger burning bright,
In the forests of the night:
What immortal hand or eye,
Dare frame thy fearful symmetry?

*Plate 43:* My Pretty Rose Tree

A flower was offerd to me;
Such a flower as May never bore.
But I said I've a Pretty Rose-tree.
And I passed the sweet flower o'er.

Then I went to my Pretty Rose-tree:
To tend her by day and by night.
But my Rose turnd away with jealousy:
And her thorns were my only delight.

Ah! Sun-Flower

Ah Sun-flower! weary of time.
Who countest the steps of the Sun:
Seeking after that sweet golden clime
Where the travellers journey is done.

Where the Youth pined away with desire,
And the pale Virgin shrouded in snow:
Arise from their graves and aspire.
Where my Sun-flower wishes to go.

The Lilly

The modest Rose puts forth a thorn.
The humble Sheep. a threatning horn:
While the Lilly white, shall in Love delight,
Nor a thorn nor a threat stain her beauty bright

### Plate 44: The Garden of Love

I went to the Garden of Love.
And saw what I never had seen:
A Chapel was built in the midst,
Where I used to play on the green.

And the gates of this Chapel were shut,
And Thou shalt not, writ over the door;
So I turn'd to the Garden of Love,
That so many sweet flowers bore,

And I saw it was filled with graves,
And tomb-stones where flowers should be:
And Priests in black gowns, were walking their rounds,
And binding with briars, my joys & desires.

### Plate 45: The Little Vagabond

Dear Mother, dear Mother, the Church is cold,
But the Ale-house is healthy & pleasant & warm:
Besides I can tell where I am use'd well,
Such usage in heaven will never do well.

But if at the Church they would give us some Ale.
And a pleasant fire, our souls to regale:
We'd sing and we'd pray all the live-long day:
Nor ever once wish from the Church to stray.

Then the Parson might preach & drink & sing.
And we'd be as happy as birds in the spring:
And modest dame Lurch, who is always at Church
Would not have bandy children nor fasting nor birch

And God like a father rejoicing to see.
His children as pleasant and happy as he:
Would have no more quarrel with the Devil or the Barrel
But kiss him & give him both drink and apparel.

### Plate 46: London

I wander thro' each charter'd street.
Near where the charter'd Thames does flow
And mark in every face I meet
Marks of weakness, marks of woe.

In every cry of every Man.
In every Infants cry of fear.
In every voice; in every ban.
The mind-forg'd manacles I hear

How the Chimney-sweepers cry
Every blackning Church appalls.
And the hapless Soldiers sigh
Runs in blood down Palace walls

But most thro' midnight streets I hear
How the youthful Harlots curse
Blasts the new-born Infants tear
And blights with plagues the Marriage hearse

### Plate 47: The Human Abstract.

Pity would be no more,
If we did not make somebody Poor;
And Mercy no more could be.
If all were as happy as we;

And mutual fear brings peace;
Till the selfish loves increase.
Then Cruelty knits a snare,
And spreads his baits with care.

He sits down with holy fears.
And waters the ground with tears:
Then Humility takes its root
Underneath his foot.

Soon spreads the dismal shade
Of Mystery over his head;
And the Catterpiller and Fly.
Feed on the Mystery.

And it bears the fruit of Deceit,
Ruddy and sweet to eat;
And the Raven his nest has made
In its thickest shade.

The Gods of the earth and sea,
Sought thro' Nature to find this Tree
But their search was all in vain.
There grows one in the Human Brain

### Plate 48: Infant Sorrow

My mother groand! my father wept,
Into the dangerous world I leapt:
Helpless, naked, piping loud:
Like a fiend hid in a cloud.

Struggling in my fathers hands:
Striving against my swadling bands:
Bound and weary I thought best
To sulk upon my mothers breast.

### Plate 49: A Poison Tree.

I was angry with my friend,
I told my wrath, my wrath did end.
I was angry with my foe:
I told it not. my wrath did grow.

And I waterd it in fears,
Night & morning with my tears:
And I sunned it with smiles,
And with soft deceitful wiles.

And it grew both day and night,
Till it bore an apple bright.
And my foe beheld it shine,
And he knew that it was mine.

And into my garden stole,
When the night had veild the pole;
In the morning glad I see,
My foe outstretchd beneath the tree.

### Plate 50: A Little Boy Lost

Nought loves another as itself
Nor venerates another so.
Nor is it possible to Thought
A greater than itself to know:

And Father. how can I love you,
Or any of my brothers more?
I love you like the little bird
That picks up crumbs around the door.

The Priest sat by and heard the child,
In trembling zeal he siez'd his hair:
He led him by his little coat:
And all admir'd the Priestly care.

And standing on the altar high.
Lo what a fiend is here! said he:
One who sets reason up for judge
Of our most holy Mystery.

The weeping child could not be heard,
The weeping parents wept in vain:
They strip'd him to his little shirt.
And bound him in an iron chain.

And burn'd him in a holy place.
Where many had been burn'd before:
The weeping parents wept in vain.
Are such things done on Albions shore

### Plate 51: A Little Girl Lost

Children of the future Age.
Reading this indignant page;
Know that in a former time.
Love! sweet Love! was thought a crime.

In the Age of Gold,
Free from winters cold:
Youth and maiden bright.
To the holy light,
Naked in the sunny beams delight.

Once a youthful pair
Fill'd with softest care;
Met in garden bright.
Where the holy light,
Had just removd the curtains of the night.

There in rising day.
On the grass they play:
Parents were afar;
Strangers came not near:
And the maiden soon forgot her fear.

Tired with kisses sweet
They agree to meet,
When the silent sleep
Waves o'er heavens deep:
And the weary tired wanderers weep.

To her father white
Came the maiden bright:
But his loving look,
Like the holy book,
All her tender limbs with terror shook.

Ona! pale and weak!
To thy father speak:
O the trembling fear!
O the dismal care!
That shakes the blossoms of my hoary

### Plate 52: To Tirzah

Whate'er is Born of Mortal Birth,
Must be consumed with the Earth
To rise from Generation free:
Then what have I to do with thee?

The Sexes sprung from Shame & Pride
Blowd in the morn: in evening died
But Mercy changd Death into Sleep
The Sexes rose to work & weep.

Thou Mother of my Mortal part
With cruelty didst mould my Heart
And with false self-deceiving tears
Didst bind my Nostrils Eyes & Ears

Didst close my Tongue in senseless clay
And me to Mortal Life betray:
The Death of Jesus set me free
Then what have I to do with thee?

It is Raised
a Spiritual Body

[410]

*Plate 53:* The School Boy

c to rise in a summer morn,  
en the birds sing on every tree;  
distant huntsman winds his horn,  
the sky-lark sings with me.  
what sweet company.

to go to school in a summer morn,  
drives all joy away;  
er a cruel eye outworn.  
little ones spend the day,  
ghing and dismay.

then at times I drooping sit,  
spend many an anxious hour,  
in my book can I take delight,  
sit in learnings bower,  
n thro' with the dreary shower.

How can the bird that is born for joy,  
Sit in a cage and sing.  
How can a child when fears annoy.  
But droop his tender wing.  
And forget his youthful spring.

O! father & mother. if buds are nip'd,  
And blossoms blown away,  
And if the tender plants are strip'd  
Of their joy in the springing day,  
By sorrow and cares dismay.

How shall the summer arise in joy.  
Or the summer fruits appear.  
Or how shall we gather what griefs destroy  
Or bless the mellowing year.  
When the blasts of winter appear.

*Plate 54:* The Voice of the Ancient Bard.

Youth of delight come hither.  
And see the opening morn,  
Image of truth new born.  
Doubt is fled & clouds of reason.  
Dark disputes & artful teazing,  
Folly is an endless maze,  
Tangled roots perplex her ways,  
How many have fallen there!  
They stumble all night over bones of the dead:  
And feel they know not what but care;  
And wish to lead others when they should be led

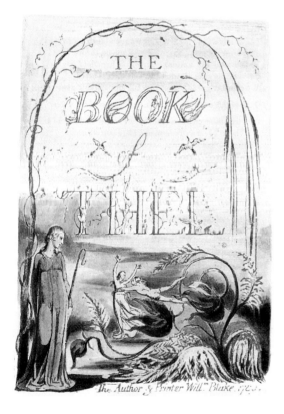

*The Author & Printer Will.ᵐ Blake. 1789.*

THE  
BOOK  
of  
THEL

The Author & Printer Will.ᵐ Blake. 1789.

THEL'S Motto,

Does the Eagle know what is in the pit?  
Or wilt thou go ask the Mole:  
Can Wisdom be put in a silver rod?  
Or Love in a golden bowl?

THEL

I

The daughters of Mne Seraphim led round their sunny flocks,  
All but the youngest, she in paleness sought the secret air,  
To fade away like morning beauty from her mortal day:  
Down by the river of Adona her soft voice is heard:  
And thus her gentle lamentation falls like morning dew.

O life of this our spring! why fades the lotus of the water?

Why fade these children of the spring? born but to smile & fall.  
Ah, Thel is like a watry bow. and like a parting cloud.  
Like a reflection in a glass. like shadows in the water.  
Like dreams of infants. like a smile upon an infants face.  
Like the doves voice, like transient day, like music in the air:  
Ah! gentle may I lay me down, and gentle rest my head.  
And gentle sleep the sleep of death. and gentle hear the voice  
Of him that walketh in the garden in the evening time.

The Lilly of the valley breathing in the humble grass  
Answer'd the lovely maid and said, I am a watry weed,  
And I am very small, and love to dwell in lowly vales;  
So weak, the gilded butterfly scarce perches on my head  
Yet I am visited from heaven and he that smiles on all.  
Walks in the valley. and each morn over me spreads his hand  
Saying, rejoice thou humble grass, thou new-born lilly flower,  
Thou gentle maid of silent valleys. and of modest brooks.  
For thou shalt be clothed in light, and fed with morning manna;  
Till summers heat melts thee beside the fountains and the springs  
To flourish in eternal vales; then why should Thel complain,

Why

2

Why should the mistress of the vales of Har, utter a sigh.

She ceasd & smild in tears, then sat down in her silver shrine.

Thel answerd, O thou little virgin of the peaceful valley.  
Giving to those that cannot crave, the voiceless, the o'erfired.  
Thy breath doth nourish the innocent lamb. he smells thy milky garments,  
He crops thy flowers. while thou sittest smiling in his face,  
Wiping his mild and meekin mouth from all contagious taints.  
Thy wine doth purify the golden honey, thy perfume,  
Which thou dost scatter on every little blade of grass that springs  
Revives the milked cow, & tames the fire breathing steed.  
But Thel is like a faint cloud kindled at the rising sun;  
I vanish from my pearly throne, and who shall find my place.

Queen of the vales the Lilly answerd, ask the tender cloud,  
And it shall tell thee why it glitters in the morning sky.  
And why it scatters its bright beauty thro' the humid air.  
Descend O little cloud & hover before the eyes of Thel,

The Cloud descended. and the Lilly bowd her modest head:  
And went to mind her numerous charge among the verdant grass.

3

II.

O little Cloud the virgin said. I charge thee tell to me.  
Why thou complainest not when in one hour thou fade away:  
Then we shall seek thee but not find. ah Thel is like to thee.  
I pass away. yet I complain, and no one hears my voice.

The Cloud then shewd his golden head & his bright form emerg'd,  
Hovering and glittering on the air before the face of Thel.

O virgin know'st thou not our steeds drink of the golden springs  
Where Luvah doth renew his horses: look'st thou on my youth,  
And fearest thou because I vanish and am seen no more.  
Nothing remains; O maid I tell thee. when I pass away,  
It is to tenfold life. to love. to peace. and raptures holy:  
Unseen descending, weigh my light wings upon balmy flowers:  
And court the fair eyed dew. to take me to her shining tent;  
The weeping virgin. trembling kneels before the risen sun,  
Till we arise link'd in a golden band. and never part;  
But walk united, bearing food to all our tender flowers.

Dost thou O little Cloud? I fear that I am not like thee;
For I walk through the vales of Har, and smell the sweetest flowers;
But I feed not the little flowers: I hear the warbling birds,
But I feed not the warbling birds, they fly and seek their food;
But Thel delights in these no more because I fade away,
And all shall say, without a use this shining woman liv'd,
Or did she only live, to be at death the food of worms.

The Cloud reclind upon his airy throne and answer'd thus.

Then if thou art the food of worms, O virgin of the skies,
How great thy use, how great thy blessing; every thing that lives,
Lives not alone, nor for itself: fear not and I will call
The weak worm from its lowly bed, and thou shalt hear its voice.
Come forth worm of the silent valley, to thy pensive queen.

The helpless worm arose, and sat upon the Lillys leaf,
And the bright Cloud saild on, to find his partner in the vale.

<div align="right">4</div>

### III.

Then Thel astonish'd view'd the Worm upon its dewy bed.

Art thou a Worm? image of weakness. art thou but a Worm?
I see thee like an infant wrapped in the Lillys leaf:
Ah weep not little voice, thou can'st not speak, but thou can'st weep;
Is this a Worm? I see thee lay helpless & naked: weeping.
And none to answer, none to cherish thee with mothers smiles.

The Clod of Clay heard the Worms voice, & raisd her pitying head;
She bowd over the weeping infant, and her life exhal'd
In milky fondness. then on Thel she fix'd her humble eyes.

O beauty of the vales of Har, we live not for ourselves
Thou seest me the meanest thing, and so I am indeed;
My bosom of itself is cold. and of itself is dark,

<div align="right">5</div>

But he that loves the lowly, pours his oil upon my head,
And kisses me, and binds his nuptial bands around my breast.
And says; Thou mother of my children, I have loved thee.
And I have given thee a crown that none can take away
But how this is sweet maid, I know not, and I cannot know,
I ponder, and I cannot ponder; yet I live and love.

The daughter of beauty wip'd her pitying tears with her white veil,
And said. Alas! I knew not this, and therefore did I weep:
That God would love a Worm I knew, and punish the evil foot
That wilful, bruis'd its helpless form: but that he cherish'd it
With milk and oil, I never knew; and therefore did I weep,
And I complaind in the mild air, because I fade away,
And lay me down in thy cold bed, and leave my shining lot.

Queen of the vales, the matron Clay answerd; I heard thy sighs.
And all thy moans flew o'er my roof. but I have call'd them down:
Wilt thou O Queen enter my house, 'tis given thee to enter.
And to return; fear nothing. enter with thy virgin feet.

<div align="right">6</div>

### IV.

The eternal gates terrific porter lifted the northern bar.
Thel enter'd in & saw the secrets of the land unknown;
She saw the couches of the dead, & where the fibrous roots
Of every heart on earth infixes deep its restless twists:
A land of sorrows & of tears where never smile was seen.

She wanderd in the land of clouds thro' valleys dark, listning
Dolours & lamentations: waiting oft beside a dewy grave
She stood in silence, listning to the voices of the ground,
Till to her own grave plot she came, & there she sat down,
And heard this voice of sorrow breathed from the hollow pit –

Why cannot the Ear be closed to its own destruction?
Or the glistning Eye to the poison of a smile!
Why are Eyelids stord with arrows ready drawn,
Where a thousand fighting men in ambush lie?
Or an Eye of gifts & graces. show'ring fruits & coined gold!
Why a Tongue impress'd with honey from every wind?
Why an Ear, a whirlpool fierce to draw creations in?
Why a Nostril wide inhaling terror trembling & affright
Why a tender curb upon the youthful burning boy!
Why a little curtain of flesh on the bed of our desire?

The Virgin started from her seat, & with a shriek.
Fled back unhinderd till she came into the vales of
<div align="right">Har</div>

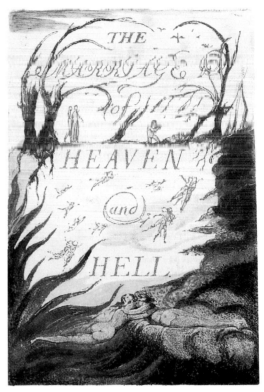

The Argument.

Rintrah roars & shakes his fires in the burdend air;
Hungry clouds swag on the deep

Once meek, and in a perilous path,
The just man kept his course along
The vale of death.
Roses are planted where thorns grow,
And on the barren heath
Sing the honey bees.

Then the perilous path was planted;
And a river, and a spring
On every cliff and tomb;
And on the bleached bones
Red clay brought forth.

Till the villain left the paths of ease,
To walk in perilous paths, and drive
The just man into barren climes

Now the sneaking serpent walks
In mild humility.
And the just man rages in the wilds
Where lions roam.

Rintrah roars & shakes his fires in the
burdend air;
Hungry clouds swag on the deep.

As a new heaven is begun, and it is now thir
-ty-three years since its advent: the Eternal Hell
revives. And lo! Swedenborg is the Angel sitting
at the tomb: his writings are the linen clothes folded
up. Now is the dominion of Edom, & the return of
Adam into Paradise; see Isaiah XXXIV & XXXV Chap:

Without Contraries is no progression. Attraction
and Repulsion, Reason and Energy, Love and
Hate, are necessary to Human existence.
    From these contraries spring what the religious call
Good & Evil. Good is the passive that obeys Reason
Evil is the active springing from Energy
    Good is Heaven. Evil is Hell,

*4*

#### The voice of the
#### Devil

    All Bibles or sacred codes. have been
the causes of the following Errors.
    1. That Man has two real existing princi-
-ples Viz: a Body & a Soul.
    2. That Energy. calld Evil. is alone from the
Body. & that Reason. calld Good is alone from
the Soul.
    3. That God will torment Man in Eternity
for following his Energies.
      But the following Contraries to these are True
    1  Man has no Body distinct from his Soul
for that calld Body is a portion of Soul discernd
by the five Senses, the chief inlets of Soul in this
age
    2.  Energy is the only life and is from the Body
and Reason is the bound or outward circumference
of Energy.
    3  Energy is Eternal Delight

*5*

    Those who restrain desire, do so because theirs
is weak enough to be restrained; and the restrainer or
reason usurps its place & governs the unwilling.
    And being restraind it by degrees becomes passive
till it is only the shadow of desire.
    The history of this is written in Paradise Lost. & the
Governor or Reason is call'd Messiah.
    And the original Archangel or possessor of the com-
-mand of the heavenly host, is calld the Devil or Satan
and his children are call'd Sin & Death
    But in the Book of Job Miltons Messiah is call'd
Satan.
    For this history has been adopted by both parties
    It indeed appear'd to Reason as if Desire was
cast out, but the Devils account is, that the Messi
           -ah

*6*

-ah fell. & formed a heaven of what he stole from the
Abyss
    This is shewn in the Gospel, where he prays to the
Father to send the comforter or Desire that Reason
may have Ideas to build on, the Jehovah of the Bible
being no other than he      who dwells in flaming fire
    Know that after Christs death, he became Jehovah
    But in Milton; the Father is Destiny, the Son, a
Ratio of the five senses. & the Holy-ghost, Vacuum!
    Note. The reason Milton wrote in fetters when
he wrote of Angels & God, and at liberty when of
Devils & Hell, is because he was a true Poet and
of the Devils party without knowing it

#### A Memorable Fancy.

    As I was walking among the fires of hell, de-
-lighted with the enjoyments of Genius; which to An-
-gels look like torment and insanity. I collected some
of their Proverbs: thinking that as the sayings used
in a nation, mark its character, so the Proverbs of
Hell, shew the nature of Infernal wisdom better
than any description of buildings or garments
    When I came home; on the abyss of the five sen-
-ses. where a flat sided steep frowns over the pre-
-sent world. I saw a mighty Devil folded in black
clouds, hovering on the sides of the rock, with cor
          ro-

-roding fires he wrote the following sentence now per-
-cieved by the minds of men, & read by them on earth.
    How do you know but ev'ry Bird that cuts the airy way,
    Is an immense world of delight, clos'd by your senses five?

*7*

#### Proverbs of Hell.

In seed time learn, in harvest teach, in winter enjoy.
Drive your cart and your plow over the bones of the dead.
The road of excess leads to the palace of wisdom.
Prudence is a rich ugly old maid courted by Incapacity.
He who desires but acts not, breeds pestilence.
The cut worm forgives the plow.
Dip him in the river who loves water.
A fool sees not the same tree that a wise man sees.
He whose face gives no light, shall never become a star.
Eternity is in love with the productions of time.
The busy bee has no time for sorrow.
The hours of folly are measur'd by the clock, but of wis-
    -dom: no clock can measure.
All wholsom food is caught without a net or a trap.
Bring out number weight & measure in a year of dearth.
No bird soars too high. if he soars with his own wings.
A dead body. revenges not injuries.
The most sublime act is to set another before you.
If the fool would persist in his folly he would become
                    wise
Folly is the cloke of knavery.
Shame is Prides cloke.

*8*

#### Proverbs of Hell

  Prisons are built with stones of Law, Brothels with
    bricks of Religion.
The pride of the peacock is the glory of God.
The lust of the goat is the bounty of God.
The wrath of the lion is the wisdom of God.
The nakedness of woman is the work of God.
Excess of sorrow laughs. Excess of joy weeps.
The roaring of lions, the howling of wolves, the raging
    of the stormy sea, and the destructive sword. are
    portions of eternity too great for the eye of man.
The fox condemns the trap, not himself.
Joys impregnate, Sorrows bring forth.
Let man wear the fell of the lion, woman the fleece of
    the sheep.
The bird a nest. the spider a web, man friendship.
The selfish smiling fool. & the sullen frowning fool. shall
    be both thought wise, that they may be a rod
What is now proved was once only imagin'd
The rat, the mouse. the fox, the rabbet; watch the roots,
    the lion. the tyger. the horse. the elephant, watch
    the fruits,
The cistern contains; the fountain overflows
One thought, fills immensity.
Always be ready to speak your mind, and a base man
    will avoid you.
Every thing possible to be believ'd is an image of truth.
The eagle never lost so much time. as when he submit-
    -ted to learn of the crow.
                    The

*9*

#### Proverbs of Hell

The fox provides for himself, but God provides for the lion.
Think in the morning. Act in the noon, Eat in the even-
    -ing, Sleep in the night,
He who has sufferd you to impose on him knows you.
As the plow follows words, so God rewards prayers.
The tygers of wrath are wiser than the horses of in-
Expect poison from the standing water.      -struction
You never know what is enough unless you know what is
    more than enough.
Listen to the fools reproach! it is a kingly title!
The eyes of fire, the nostrils of air, the mouth of water,
    the beard of earth.
The weak in courage is strong in cunning.
The apple tree never asks the beech how he shall grow,

nor the lion, the horse, how he shall take his prey.
The thankful reciever bears a plentiful harvest.
If others had not been foolish, we should be so.
The soul of sweet delight, can never be defil'd,
When thou seest an Eagle, thou seest a portion of Ge
-nius, lift up thy head!

her eggs on, so the priest lays his curse on
the fairest joys.
To create a little flower is the labour of ages.
Damn, braces: Bless relaxes.
The best wine is the oldest. the best water the newest.
Prayers plow not! Praises reap not!
Joys laugh not! Sorrows weep not!

The

*10*

#### Proverbs of Hell

The head Sublime, the heart Pathos, the genitals Beauty,
    the hands & feet Proportion.
As the air to a bird or the sea to a fish, so is contempt
    to the contemptible.
The crow wish'd every thing was black, the owl, that eve-
-ry thing was white.
Exuberance is Beauty.
If the lion was advised by the fox. he would be cunning.
Improve[me]nt makes strait roads, but the crooked roads
        without Improvement, are roads of Genius.
Sooner murder an infant in its cradle than nurse unact-
-ed desires
Where man is not nature is barren.
Truth can never be told so as to be understood, and
        not be believ'd.
            Enough! or Too much

*11*

The ancient Poets animated all sensible objects
with Gods or Geniuses, calling them by the names and
adorning them with the properties of woods, rivers,
mountains, lakes, cities, nations, and whatever their
enlarged & numerous senses could percive.
    And particularly they studied the genius of each
city & country. placing it under its mental deity.
    Till a system was formed, which some took ad-
vantage of & enslav'd the vulgar by attempting to
realize or abstract the mental deities from their
objects; thus began Priesthood.
    Choosing forms of worship from poetic tales.
    And at length they pronounced that the Gods
had orderd such things.
    Thus men forgot that All deities reside
in the human breast.

*12*

#### A Memorable Fancy.

    The Prophets Isaiah and Ezekiel dined with
me, and I asked them how they dared so roundly to
assert. that God spoke to them; and whether they
did not think at the time, that they would be mis-
-understood, & so be the cause of imposition,
    Isaiah answer'd. I saw no God, nor heard
any, in a finite organical perception; but my sen-

was then perswaded, & remain confirm'd; that the
voice of honest indignation is the voice of God, I
cared not for consequences

He replied. All poets believe that it does, &
in ages of imagination this firm perswasion remo-
-ved mountains; but many are not capable of a
firm perswasion of any thing.
    Then Ezekiel said. The philosophy of the east
taught the first principles of human perception
some nations held one principle for the origin &
some another, we of Israel taught that the Poetic
Genius (as you now call it) was the first principle
and all the others merely derivative, which was the

cause of our despising the Priests & Philosophers
of other countries, and prophecying that all Gods
                    would

would at last be proved to originate in ours & to be the
tributaries of the Poetic Genius, it was this. that our
great poet King David desired so fervently & invokes
so pathaticly, saying by this he conquers enemies &
governs kingdoms; and we so loved our God, that we
cursed in his name all the deities of surrounding
nations, and asserted that they had rebelled; from
these opinions the vulgar came to think that all nati-
-ons would at last be subject to the jews.
    This said he, like all firm perswasions, is come to
pass, for all nations believe the jews code and wor-
-ship the jews god, and what greater subjection can be
    I heard this with some wonder, & must confess
my own conviction. After dinner I ask'd Isaiah to fa-
-vour the world with his lost works, he said none of
equal value was lost. Ezekiel said the same of his.
    I also asked Isaiah what made him go naked and
barefoot three years? he answerd, the same that made
our friend Diogenes the Grecian.
    I then asked Ezekiel. why he eat dung, & lay so
long on his right & left side? he answerd, the desire
of raising other men into a perception of the infinite
this the North American tribes practise. & is he hon-
-est who resists his genius or conscience. only for
the sake of present ease or gratification?

    The ancient tradition that the world will be con
sumed in fire at the end of six thousand years
is true, as I have heard from Hell,
    For the cherub with his flaming sword is
hereby commanded to leave his guard at tree of
life, and when he does, the whole creation will
be consumed, and appear infinite. and holy
whereas it now appears finite & corrupt.
    This will come to pass by an improvement of
sensual enjoyment.
    But first the notion that man has a body
distinct from his soul, is to be expunged; this
I shall do, by printing in the infernal method, by
corrosives, which in Hell are salutary and me-
-dicinal, melting apparent surfaces away, and
displaying the infinite which was hid,
    If the doors of perception were cleansed
every thing would appear to man as it is, in-
-finite—
    For man has closed himself up, till he sees
all things thro' narrow chinks of his cavern.

#### A Memorable Fancy

    I was in a Printing house in Hell & saw the
method in which knowledge is transmitted from gene-
-ration to generation.
    In the first chamber was a Dragon-Man, clear-
ing away the rubbish from a caves mouth; within, a
number of Dragons were hollowing the cave,

the rock & the cave, and others adorning it with gold
silver and precious stones.
    In the third chamber was an Eagle with wings
and feathers of air, he caused the inside of the
in the infinite around were numbers of Eagle like
men, who built palaces in the immense cliffs.
    In the fourth chamber were Lions of flaming fire
raging around & melting the metals into living fluids.
    In the fifth chamber were Unnam'd forms, which
cast the metals into the expanse,
    There they were recieved by men who occupied
the sixth chamber, and took the forms of books &
were arranged in libraries,

16

The Giants who formed this world into its
sensual existence and now seem to live in it
in chains, are in truth. the causes of its life
& the sources of all activity, but the chains
are, the cunning of weak and tame minds. which
have power to resist energy. according to the pro-
-verb, the weak in courage is strong in cunning.

Thus one portion of being, is the Prolific, the
other, the Devouring: to the devourer it seems as
if the producer was in his chains, but it is not so,
he only takes portions of existence and fancies
that the whole.

But the Prolific would cease to be Prolific
unless the Devourer as a sea recieved the excess
of his delights.

Some will say, Is not God alone the Prolific?
I answer, God only Acts & Is. in existing beings
or Men.

These two classes of men are always upon
earth. & they should be enemies; whoever tries

to

17

to reconcile them seeks to destroy existence.
Religion is an endeavour to reconcile the two.

Note. Jesus Christ did not wish to unite
but to seperate them, as in the Parable of sheep and
goats! & he says I came not to send Peace but a
Sword.

Messiah or Satan or Tempter was formerly
thought to be one of the Antediluvians who are our
Energies.

A Memorable Fancy

An Angel came to me and said O pitiable foolish
young man! O horrible! O dreadful state! consider
the hot burning dungeon thou art preparing for thyself
to all eternity, to which thou art going in such career.

I said. perhaps you will be willing to shew me
my eternal lot & we will contemplate together upon it
and see whether your lot or mine is most desirable

So he took me thro' a stable & thro' a church
& down into the church vault at the end of which
was a mill; thro' the mill we went, and came to a
cave. down the winding cavern we groped our tedi-
-ous way till a void boundless as a nether sky ap-
-peard beneath us, & we held by the roots of trees
and hung over this immensity; but I said, if you
please we will commit ourselves to this void and
see whether providence is here also, if you will not
I will! but he answerd, do not presume O young-
man but as we here remain behold thy lot which
will soon appear when the darkness passes away

So I remaind with him sitting in the twisted

root

18

root of an oak, he was suspended in a fungus
which hung with the head downward into the deep:

By degrees we beheld the infinite Abyss, fiery
as the smoke of a burning city; beneath us at an
immense distance was the sun, black but shining
round it were fiery tracks on which revol'd vast
spiders, crawling after their prey; which flew or
rather swum in the infinite deep, in the most ter-
-rific shapes of animals sprung from corruption.
& the air was full of them, & seemd composed
of them; these are Devils. and are called Powers
of the air, I now asked my companion which was my
eternal lot? he said, between the black & white spiders

But now, from between the black & white spiders
a cloud and fire burst and rolled thro the deep
blackning all beneath, so that the nether deep grew
black as a sea & rolled with a terrible noise: be-
-neath us was nothing now to be seen but a black
tempest, till looking east between the clouds & the
waves. we saw a cataract of blood mixed with fire

and not many stones throw from us appeard and
sunk again the scaly fold of a monstrous serpent.
at last to the east, distant about three degrees ap-
-peard a fiery crest above the waves slowly it rear-
-ed like a ridge of golden rocks till we discoverd
two globes of crimson fire. from which the sea
fled away in clouds of smoke, and now we saw, it
was the head of Leviathan, his forehead was di
-vided into streaks of green & purple like those on
a tygers forehead: soon we saw his mouth & red
gills hang just above the raging foam tinging the
black deep with beams of blood, advancing toward

us

19

us with all the fury of a spiritual existence.

My friend the Angel climb'd up from his sta-
-tion into the mill; I remain'd alone, & then this
appearance was no more, but I found mys[e]lf sit-
-ting on a pleasant bank beside a river by moon
light hearing a harper who sung to the harp. &
his theme was, The man who never alters his
opinion is like standing water, & breeds reptiles
of the mind.

But I arose, and sought for the mill &
there I found my Angel, who surprised asked
me, how I escaped?

I answerd. All that we saw was owing to your
metaphysics; for when you ran away, I found myself
on a bank by moonlight hearing a harper, But
now we have seen my eternal lot, shall I shew you
yours? he laughd at my proposal: but I by force
suddenly caught him in my arms, & flew westerly
thro' the night, till we were elevated above the
earths shadow: then I flung myself with him direct-
-ly into the body of the sun, here I clothed myself in
white, & taking in my hand Swedenborgs volumes
sunk from the glorious clime, and passed all the
planets till we came to saturn, here I staid to rest
& then leap'd into the void, between saturn & the
fixed stars.

Here said I! is your lot, in this space, if space
it may be calld, Soon we saw the stable and the
church, & I took him to the altar and open'd the
Bible, and lo! it was a deep pit, into which I de-
-scended driving the Angel before me, soon we saw
seven houses of brick, one we enterd; in it were a

num

20

[illegible line]
chaind by the middle, grinning and snatching at
one another, but witheld by the shortness of their
chains: however I saw that they sometimes grew nu
merous, and then the weak were caught by the strong
and with a grinning aspect, first coupled with & then
devourd, by plucking off first one limb and then ano
ther till the body was left a helpless trunk. this after
grinning & kissing it with seeming fondness they de-
voured too; and here & there I saw one savourily pic-
king the flesh off of his own tail; as the stench ter
-ribly annoyd us both we went into the mill, & I in
my hand brought the skeleton of a body, which in
the mill was Aristotles Analytics.

So the Angel said: thy phantasy has imposed
upon me & thou oughtest to be ashamed.

I answerd! we impose on one another, & it is
but lost time to converse with you whose works
are only Analytics.

[Opposition is True Friendship]

21

I have always found that Angels have the vani-
-ty to speak of themselves as the only wise; this they
do with a confident insolence sprouting from systema-
-tic reasoning;

Thus Swedenborg boasts that what he writes is
new; tho' it is only the Contents or Index of already
publish'd books

A man carried a monkey about for a shew, & be-
-cause he was a little wiser than the monkey, grew
vain, and conciev'd himself as much wiser than se-
-ven men. It is so with Swedenborg; he shews the
folly of churches & exposes hypocrites, till he im-
agines that all are religious, & himself the single

one

one on earth that ever broke a net.

Now hear a plain fact: Swedenborg has not writ-
ten one new truth: Now hear another: he has written
all the old falshoods.

And now hear the reason. He conversed with Angels
who are all religious, & conversed not with Devils who
all hate religion, for he was incapable thro' his conceited
notions.

Thus Swedenborgs writings are a recapitulation of
all superficial opinions, and an analysis of the more
sublime. but no further.

Have now another plain fact: Any man of mechani-
-cal talents may from the writings of Paracelsus or Ja-
-cob Behmen, produce ten thousand volumes of equal
value with Swedenborg's. and from those of Dante or
Shakespear, an infinite number.

But when he has done this, let him not say that he
knows better than his master, for he only holds a can-
-dle in sunshine.

### A Memorable Fancy

Once I saw a Devil in a flame of fire, who arose be
fore an Angel that sat on a cloud. and the Devil ut-
terd these words.

The worship of God is. Honouring his gifts in other
men each according to his genius. and loving the

great

23

greatest men best, those who envy or calumniate
great men hate God, for there is no other God.

The Angel hearing this became almost blue
but mastering himself he grew yellow, & at last
white pink & smiling. and then replied,

Thou Idolater, is not God One? & is not he
visible in Jesus Christ? and has not Jesus Christ
given his sanction to the law of ten commandments
and are not all other men fools. sinners, & nothings?

The Devil answer'd; bray a fool in a morter with
wheat. yet shall not his folly be beaten out of him;
if Jesus Christ is the greatest man, you ought to
love him in the greatest degree; now hear how he
has given his sanction to the law of ten command-
ments: did he not mock at the sabbath, and so
mock the sabbaths God? murder those who were
murderd because of him? turn away the law from
the woman taken in adultery? steal the labor of
others to support him? bear false witness when
he omitted making a defence before Pilate? covet
when he pray'd for his disciples, and when he bid
them shake off the dust of their feet against such
as refused to lodge them? I tell you, no virtue
can exist without breaking these ten command-
-ments; Jesus was all virtue, and acted from im-

pulse.

24

-pulse. not from rules.

When he had so spoken. I beheld the Angel who
stretched out his arms embracing the flame of fire
& he was consumed and arose as Elijah.

Note. This Angel, who is now become a Devil, is
my particular friend: we often read the Bible to-
gether in its infernal or diabolical sense which
the world shall have if they behave well

I have also: The Bible of Hell: which the world
shall have whether they will or no.

One Law for the Lion & Ox is Oppression

### A Song of Liberty

1. The Eternal Female groand! it was
heard over all the Earth:

2. Albions coast is sick silent; the A-
-merican meadows faint!

3. Shadows of Prophecy shiver along by
the lakes and the rivers and mutter across
the ocean. France rend down thy dungeon;

4. Golden Spain burst the barriers of old
Rome;

5. Cast thy keys O Rome into the deep
down falling, even to eternity down **falling**,

6. And weep

7. In her trembling hands she took the
new born terror howling;

8. On those infinite mountains of light
now barr'd out by the atlantic sea, the new
born fire stood before the starry king!

9. Flag'd with grey brow'd snows and thun-
-derous visages the jealous wings wav'd
over the deep.

10. The speary hand burned aloft, unbuck-
-led was the shield, forth went the hand
of jealousy among the flaming hair. and

hurl'd the new born wonder thro' the starry
night.

11. The fire, the fire, is falling!

12. Look up! look up! O citizen of London
enlarge thy countenance; O Jew, leave coun
ting gold! return to thy oil and wine; O
African! black African! (go. winged thought
widen his forehead.)

13. The fiery limbs, the flaming hair, shot
like the sinking sun into the western sea.

14. Wak'd from his eternal sleep, the hoary
element roaring fled away;

15. Down rushd beating his wings in vain
the jealous king;  his grey brow'd councel-
-lors, thunderous warriors, curl'd veterans,
among helms, and shields, and chariots
horses, elephants: banners, castles. slings
and rocks,

16. Falling, rushing, ruining! buried in
the ruins, on Urthona's dens.

17. All night beneath the ruins, then
their sullen flames faded emerge round
the gloomy king,

18. With thunder and fire: leading his
starry hosts thro' the waste wilderness

he promulgates his ten commands,
glancing his beamy eyelids over the
deep in dark dismay,

19. Where the son of fire in his eastern
cloud, while the morning plumes her gol-
-den breast,

20. Spurning the clouds written with
curses, stamps the stony law to dust,
loosing the eternal horses from the dens
of night, crying Empire is no more!
and now the lion & wolf shall
cease.

### Chorus

Let the Priests of the Raven of dawn,
no longer in deadly black, with hoarse note
curse the sons of joy. Nor his accepted
brethren whom, tyrant, he calls free; lay the
bound or build the roof. Nor pale religious
letchery call that virginity that wishes
but acts not!

For every thing that lives is Holy

ntispiece      What is man!
The Suns Light when he unfolds it
Depends on the Organ that beholds it
*Published by W.Blake 17 May 1793*

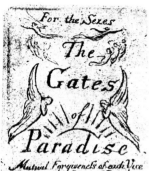

age      For the Sexes

## The
## Gates
## of Paradise

Mutual forgiveness of each Vice
Such are the Gates of Paradise
Against the Accuser's chief desire
Who walkd among the Stones of Fire
Jehovas Finger Wrote the Law
Then Wept! then rose in Zeal & Awe
And the Dead Corpse from Sinais heat
Buried beneath his Mercy Seat
O Christians Christians! tell me Why
You rear it on your Altars high.

1     I found him beneath a Tree

2      Water
Thou Waterest him with Tears

3      Earth
He struggles into Life

4      Air
On Cloudy Doubts & Reasoning Cares

5      Fire
That end in endless Strife

6      At length for hatching ripe
he breaks the shell

7      Alas
What are these? The Female Martyr
Is She also the Divine Image

8      My Son! my Son!

9      I want! I want!

10      Help! Help!

11      Aged Ignorance
Perceptive Organs closed their Objects close

12      Doest thy God O Priest take such vengeance
as this?

13      Fear & Hope are    Vision

14      The Traveller hasteth in the
Evening

15      Death's Door

16      I have said to the Worm, Thou
art my mother & my sister

### The Keys
The Catterpiller on the Leaf
Reminds thee of thy Mothers Grief
#### of the Gates
1 My Eternal Man set in Repose
The Female from his darkness rose
And She found me beneath a Tree
A Mandrake & in her Veil hid me
Serpent Reasonings us entice
Of Good & Evil: Virtue & Vice
2 Doubt Self Jealous Watry folly
3 Struggling thro Earths Melancholy
4 Naked in Air In Shame & Fear
5 Blind in Fire with shield & spear
Two Horn'd Reasoning Cloven Fiction
In Doubt which is Self contradiction

A dark Hermaphrodite We stood
Rational Truth Root of Evil & Good
Round me flew the Flaming Sword
Round her snowy Whirlwinds roard
Freezing her Veil where the Dead dwell
6 I rent the Veil where the Dead dwell
When weary Man enters his Cave

He meets his Saviour in the Grave
Some find a Female Garment there
And some a Male woven with care
Lest the Sexual Garments sweet
Should grow a devouring Winding sheet
7 One Dies Alas! the Living & Dead
One is slain & One is fled
8 In Vain-Glory hatcht & nurst
By double Spectres Self Accurst
My Son! my Son! thou treatest me
But as I have instructed thee
9 On the shadows of the Moon
Climbing thro Nights highest noon
10 In Times Ocean fallind drownd
In Aged Ignorance profound
11 Holy & cold I clipd the Wings
Of all Sublunary Things
12 And in the depths of my Dungeons
Closed the Father & the Sons
13 But when once I did descry
The Immortal Man that cannot Die
14 Through evening shades I hast away
To close the Labours of my Day
15 The Door of Death I open found
And the Worm Weaving in the Ground
16 Thou'rt my Mother from the Womb
Wife Sister Daughter to the Tomb
Weaving to Dreams the Sexual strife
And weeping over the Web of Life

### To The Accuser who is
### The God of This World

Truly My Satan thou art but a Dunce
And dost not know the Garment from the Man
Every Harlot was a Virgin once
Nor canst thou ever change Kate into Nan

Tho thou art Worship'd by the Names Divine
Of Jesus & Jehovah thou art still
The son of Morn in weary Nights decline
The lost Travellers Dream under the Hill

---

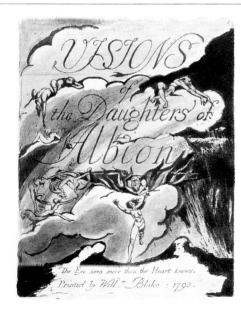

The Eye sees more than the Heart knows.
Printed by Will.ᵐ Blake : 1793.

VISIONS
*1*
of
the Daughters of
Albion

The Eye sees more than the Heart knows.

Printed by Will:ᵐ Blake : 1793.

*3*

### The Argument

I loved Theotormon
And I was not ashamed
I trembled in my virgin fears
And I hid in Leutha's vale!

I plucked Leutha's flower,
And I rose up from the vale;
But the terrible thunders tore
My virgin mantle in twain.

*4*

### Visions

Enslav'd, the Daughters of Albion weep; a trembling lamentation
Upon their mountains; in their valleys, sighs toward America.

For the soft soul of America, Oothoon wanderd in woe,
Along the vales of Leutha seeking flowers to comfort her;
And thus she spoke to the bright Marygold of Leutha's vale

Art thou a flower! art thou a nymph! I see thee now a flower;
Now a nymph! I dare not pluck thee from thy dewy bed!
(mild
The Golden nymph replied, pluck thou my flower Oothoon the
Another flower shall spring, because the soul of sweet delight
Can never pass away, she ceas'd & closd her golden shrine.

Then Oothoon pluck'd the flower saying, I pluck thee from thy bed
Sweet flower, and put thee here to glow between my breasts
And thus I turn my face to where my whole soul seeks

Over the waves she went in wing'd exulting swift delight;
And over Theotormons reign, took her impetuous course.

Bromion rent her with his thunders. on his stormy bed
Lay the faint maid, and soon her woes appalld his thunders hoarse

Bromion spoke. behold this harlot here on Bromions bed,
And let the jealous dolphins sport around the lovely maid;
Thy soft American plains are mine, and mine thy north & south:
Stampt with my signet are the swarthy children of the sun;
They are obedient, they resist not, they obey the scourge:
Their daughters worship terrors and obey the violent:

Now thou maist marry Bromions harlot, and protect the child
Of Bromions rage, that Oothoon shall put forth in nine moons
time
Then storms rent Theotormons limbs; he rolld his waves around.
And folded his black jealous waters round the adulterate pair
Bound back to back in Bromions caves terror & meekness dwell

At entrance Theotormon sits wearing the threshold hard
With secret tears; beneath him sound like waves on a desart shore
The voice of slaves beneath the sun, and children bought with money,
That shiver in religious caves beneath the burning fires
Of lust, that belch incessant from the summits of the earth

Oothoon weeps not. she cannot weep! her tears are locked up;
But she can howl incessant writhing her soft snowy limbs.
And calling Theotormons Eagles to prey upon her flesh.

I call with holy voice! kings of the sounding air,
Rend away this defiled bosom that I may reflect,
The image of Theotormon on my pure transparent breast.

The Eagles at her call descend & rend their bleeding prey;
Theotormon severely smiles. her soul reflects the smile;
As the clear spring mudded with feet of beasts grows pure & smiles

The Daughters of Albion hear her woes, & eccho back her sighs.

Why does my Theotormon sit weeping upon the threshold:
And Oothoon hovers by his side, perswading him in vain:
I cry arise O Theotormon for the village dog
Barks at the breaking day. the nightingale has done lamenting
The lark does rustle in the ripe corn, and the Eagle returns
From nightly prey, and lifts his golden beak to the pure east;
Shaking the dust from his immortal pinions to awake
The sun that sleeps too long. Arise my Theotormon I am pure.
Because the night is gone that clos'd me in its deadly black.
They told me that the night & day were all that I could see;
They told me that I had five senses to inclose me up.
And they inclos'd my infinite brain into a narrow circle,
And sunk my heart into the Abyss, a red round globe hot burning
Till all from life I was obliterated and erased.
Instead of morn arises a bright shadow, like an eye
In the eastern cloud: instead of night a sickly charnel house;
That Theotormon hears me not! to him the night and morn
Are both alike: a night of sighs, a morning of fresh tears,

And none but Bromion can hear my lamentations

With what sense is it that the chicken shuns the ravenous hawk?
With what sense does the tame pigeon measure out the expanse?
With what sense does the bee form cells? have not the mouse & frog
Eyes and ears and sense of touch? yet are their habitations
And their pursuits, as different as their forms and as their joys:
Ask the wild ass why he refuses burdens; and the meek camel
Why he loves man: is it because of eye ear mouth or skin
Or breathing nostrils? No, for these the wolf and tyger have.
Ask the blind worm the secrets of the grave, and why her spires

Love to curl round the bones of death! and ask the rav'nous snake
Where she gets poison: & the wing'd eagle why he loves the sun
And then tell me the thoughts of man, that have been hid of old.

Silent I hover all the night, and all day could be silent,
If Theotormon once would turn his loved eyes upon me;
How can I be defild when I reflect thy image pure?
Sweetest the fruit that the worm feeds on. & the soul prey'd on by
The new wash'd lamb ting'd with the village smoke & the bright swan
By the red earth of our immortal river: I bathe my wings,
And I am white and pure to hover round Theotormons breast.

Then Theotormon broke his silence, and he answered.

Tell me what is the night or day to one o'erflowd with woe?
Tell me what is a thought? & of what substance is it made?
Tell me what is a joy? & in what gardens do joys grow?
And in what rivers swim the sorrows? and upon what mountains

Wave shadows of discontent? and in what houses dwell the wretched
Drunken with woe forgotten. and shut up from cold despair,

Tell me where dwell the thoughts forgotten till thou call them forth
Tell me where dwell the joys of old! & where the ancient loves?
And when will they renew again & the night of oblivion past?
That I might traverse times & spaces far remote and bring
Comforts into a prevent [present] sorrow and a night of pain
Where goest thou O thought! to what remote land is thy flight?
If thou returnest to the present moment of affliction
Wilt thou bring comforts on thy wings, and dews and honey and balm;
Or poison from the desert wilds, from the eyes of the envier.

Then Bromion said: and shook the cavern with his lamentation

Thou knowest that the ancient trees seen by thine eyes have fruit;
But knowest thou that trees and fruits flourish upon the earth
To gratify senses unknown? trees beasts and birds unknown:
Unknown, not unpercievd, spread in the infinite microscope,
In places yet unvisited by the voyager. and in worlds
Over another kind of seas, and in atmospheres unknown.
Ah! are there other wars, beside the wars of sword and fire!
And are there other sorrows, beside the sorrows of poverty?
And are there other joys, beside the joys of riches and ease?
And is there not one law for both the lion and the ox?
And is there not eternal fire, and eternal chains?
To bind the phantoms of existence from eternal life?

Then Oothoon waited silent all the day, and all the night,

But when the morn arose, her lamentation renewd,
The Daughters of Albion hear her woes, & eccho back her sighs.

O Urizen! Creator of men! mistaken Demon of heaven;
Thy joys are tears! thy labour vain, to form men to thine image.
How can one joy absorb another? are not different joys
Holy, eternal, infinite! and each joy is a Love.

Does not the great mouth laugh at a gift? & the narrow eyelids mock
At the labour that is above payment, and wilt thou take the ape
For thy councellor? or the dog. for a schoolmaster to thy children?
Does he who contemns poverty, and he who turns with abhorrence
From usury: feel the same passion or are they moved alike?
How can the giver of gifts experience the delights of the merchant?
How the industrious citizen the pains of the husbandman.
How different far the fat fed hireling with hollow drum;
Who buys whole corn fields into wastes, and sings upon the heath:
How different their eye and ear! how different the world to them!
With what sense does the parson claim the labour of the farmer?
What are his nets & gins & traps, & how does he surround him
With cold floods of abstraction, and with forests of solitude,
To build him castles and high spires, where kings & priests may dwell,
Till she who burns with youth, and knows no fixed lot; is bound
In spells of law to one she loaths: and must she drag the chain
Of life, in weary lust! must chilling murderous thoughts obscure
The clear heaven of her eternal spring? to bear the wintry rage
Of a harsh terror driv'n to madness, bound to hold a rod
Over her shrinking shoulders all the day; & all the night
To turn the wheel of false desire: and longings that wake her womb
To the abhorred birth of cherubs in the human form
That live a pestilence & die a meteor & are no more,
Till the child dwell with one he hates, and do the deed he loaths
And the impure scourge force his seed into its unripe birth
E'er yet his eyelids can behold the arrows of the day.

Does the whale worship at thy footsteps as the hungry dog?
Or does he scent the mountain prey, because his nostrils wide
Draw in the ocean? does his eye discern the flying cloud
As the ravens eye? or does he measure the expanse like the vulture?
Does the still spider view the cliffs where eagles hide their young?
Or does the fly rejoice. because the harvest is brought in?
Does not the eagle scorn the earth & despise the treasures beneath?
But the mole knoweth what is there, & the worm shall tell it thee.
Does not the worm erect a pillar in the mouldering church yard?

*9*

And a palace of eternity in the jaws of the hungry grave
Over his porch these words are written. Take thy bliss O Man!
And sweet shall be thy taste & sweet thy infant joys renew!

Infancy, fearless, lustful, happy! nestling for delight
In laps of pleasure; Innocence! honest, open, seeking
The vigorous joys of morning light; open to virgin bliss.
Who taught thee modesty, subtil modesty! child of night & sleep
When thou awakest. wilt thou dissemble all thy secret joys
Or wert thou not awake when all this mystery was disclos'd!
Then com'st thou forth a modest virgin knowing to dissemble
With nets found under thy night pillow, to catch virgin joy,
And brand it with the name of whore: & sell it in the night,
In silence, ev'n without a whisper, and in seeming sleep,
Religious dreams and holy vespers, light thy smoky fires.
Once were thy fires lighted by the eyes of honest morn
And does my Theotormon seek this hypocrite modesty!
This knowing, artful, secret. fearful, cautious, trembling hypocrite.
Then is Oothoon a whore indeed! and all the virgin joys
Of life are harlots: and Theotormon is a sick mans dream
And Oothoon is the crafty slave of selfish holiness.

But Oothoon is not so, a virgin fill'd with virgin fancies
Open to joy and to delight where ever beauty appears
If in the morning sun I find it; there my eyes are fix'd

*10*

In happy copulation; if in evening mild. wearied with work;
Sit on a bank and draw the pleasures of this free born joy.

The moment of desire! the moment of desire! The virgin
That pines for man, shall awaken her womb to enormous joys
In the secret shadows of her chamber; the youth shut up from
The lustful joy, shall forget to generate, & create an amorous image
In the shadows of his curtains and in the folds of his silent pillow.
Are not these the places of religion? the rewards of continence!
The self enjoyings of self denial? Why dost thou seek religion?
Is it because acts are not lovely, that thou seekest solitude,
Where the horrible darkness is impressed with reflections of desire.

Father of Jealousy, be thou accursed from the earth!
Why hast thou taught my Theotormon this accursed thing?
Till beauty fades from off my shoulders darken'd and cast out,
A solitary shadow wailing on the margin of non-entity.

I cry, Love! Love! Love! happy happy Love! free as the mountain wind!
Can that be Love, that drinks another as a sponge drinks water?
That clouds with jealousy his nights, with weepings all the day:
To spin a web of age around him, grey and hoary! dark!
Till his eyes sicken at the fruit that hangs before his sight.
Such is self-love that envies all! a creeping skeleton
With lamplike eyes watching around the frozen marriage bed.

But silken nets and traps of adamant will Oothoon spread,
And catch for thee girls of mild silver, or of furious gold;
I'll lie beside thee on a bank & view their wanton play
In lovely copulation bliss on bliss with Theotormon:
Red as the rosy morning, lustful as the first born beam,
Oothoon shall view his dear delight, nor e'er with jealous cloud
Come in the heaven of generous love; nor selfish blightings bring.

Does the sun walk in glorious raiment, on the secret floor

*11*

(drop

Where the cold miser spreads his gold? or does the bright cloud
On his stone threshold? does his eye behold the beam that brings
Expansion to the eye of pity? or will he bind himself
Beside the ox to thy hard furrow? does not that mild beam blot
The bat, the owl, the glowing tyger, and the king of night.
The sea fowl takes the wintry blast. for a cov'ring to her limbs:
And the wild snake, the pestilence to adorn him with gems & gold.
And trees. & birds. & beasts, & men. behold their eternal joy.

Arise you little glancing wings, and sing your infant joy!
Arise and drink your bliss. for every thing that lives is holy!

Thus every morning wails Oothoon. but Theotormon sits
Upon the margind ocean conversing with shadows dire,

The Daughters of Albion hear her woes, & eccho back her sighs.

The End

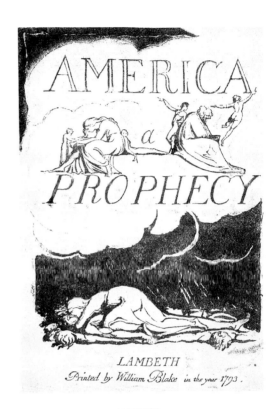

AMERICA
a
PROPHECY

AMERICA
a
PROPHECY

LAMBETH
Printed by William Blake in the year 1793.

*3*

Preludium

The shadowy daughter of Urthona stood before red Orc,
When fourteen suns had faintly journey'd o'er his dark abode;
His food she brought in iron baskets, his drink in cups of iron;
Crown'd with a helmet & dark hair the nameless female stood;
A quiver with its burning stores, a bow like that of night,
When pestilence is shot from heaven; no other arms she need:
Invulnerable tho' naked, save where clouds roll round her loins,
Their awful folds in the dark air; silent she stood as night;
For never from her iron tongue could voice or sound arise;
But dumb till that dread day when Orc assay'd his fierce embrace

Dark virgin; said the hairy youth. thy father stern abhorr'd;
Rivets my tenfold chains while still on high my spirit soars;
Sometimes an eagle screaming in the sky. sometimes a lion,
Stalking upon the mountains. & sometimes a whale I lash
The raging fathomless abyss, anon a serpent folding
Around the pillars of Urthona, and round thy dark limbs,
On the Canadian wilds I fold, feeble my spirit folds.
For chaind beneath I rend these caverns; when thou bringest food
I howl my joy: and my red eyes seek to behold thy face
In vain! these clouds roll to & fro, & hide thee from my sight

*4*

Silent as despairing love, and strong as jealousy,

The hairy shoulders rend the links, free are the wrists of fire;
Round the terrific loins he siez'd the panting struggling womb;
It joy'd: she put aside her clouds & smiled her first-born smile;
As when a black cloud shews its light'nings to the silent deep.

Soon as she saw the terrible boy then burst the virgin cry.

I know thee, I have found thee, & I will not let thee go:
Thou art the image of God who dwells in darkness of Africa;
And thou art fall'n to give me life in regions of dark death.
On my American plains I feel the struggling afflictions
Endur'd by roots that writhe their arms into the nether deep.
I see a serpent in Canada, who courts me to his love;
In Mexico an Eagle, and a Lion in Peru;
I see a Whale in the South-sea, drinking my soul away.
O what limb rending pains I feel. thy fire & my frost
Mingle in howling pains, in furrows by thy lightnings rent;
This is eternal death; and this the torment long foretold.

5

A
PROPHECY

The Guardian Prince of Albion burns in his nightly tent,
Sullen fires across the Atlantic glow to America's shore:
Piercing the souls of warlike men, who rise in silent night,
Washington, Franklin, Paine & Warren, Gates, Hancock & Green;
Meet on the coast glowing with blood from Albions fiery Prince.

Washington spoke; Friends of America look over the Atlantic sea;
A bended bow is lifted in heaven, & a heavy iron chain
Descends link by link from Albions cliffs across the sea to bind
Brothers & sons of America, till our faces pale and yellow;
Heads deprest, voices weak, eyes downcast, hands work-bruis'd,
Feet bleeding on the sultry sands, and the furrows of the whip
Descend to generations that in future times forget.——

sea;
The strong voice ceas'd; for a terrible blast swept over the heaving
The eastern cloud rent: on his cliffs stood Albions wrathful Prince
A dragon form clashing his scales at midnight he arose,
And flam'd red meteors round the land of Albion beneath
His voice, his locks, his awful shoulders, and his glowing eyes,

6

Appear to the Americans upon the cloudy night.

Solemn heave the Atlantic waves between the gloomy nations
Swelling. belching from its deeps red clouds & raging fires;
Albion is sick. America faints! enrag'd the Zenith grew.
As human blood shooting its veins all round the orbed heaven
Red rose the clouds from the Atlantic in vast wheels of blood
And in the red clouds rose a Wonder o'er the Atlantic sea;
Intense! naked! a Human fire fierce glowing, as the wedge
Of iron heated in the furnace; his terrible limbs were fire
With myriads of cloudy terrors banners dark & towers
Surrounded; heat but not light went thro' the murky atmo.
-sphere

(vision

The King of England looking westward trembles at the

7

Albions Angel stood beside the Stone
of night, and saw
The terror like a comet, or more like the
planet red

That once inclos'd the terrible wandering comets in its sphere.
Then Mars thou wast our center, & the planets three flew round
Thy crimson disk; so e'er the Sun was rent from thy red sphere;
The Sphere fill'd with night terrific standing the temple long
With beams of blood; & thus a voice came forth, and shook the
(temple

8

The morning comes, the night decays, the watchmen leave
their stations;
The grave is burst, the spices shed, the linen wrapped up;

The bones of death, the cov'ring clay, the sinews shrunk & dry'd.
Reviving shake. inspiring move, breathing! awakening!
Spring like redeemed captives when their bonds & bars are burst;
Let the slave grinding at the mill, run out into the field:
Let him look up into the heavens & laugh in the bright air;
Let the inchained soul shut up in darkness and in sighing,
Whose face has never seen a smile in thirty weary years;
Rise and look out, his chains are loose, his dungeon doors are open
And let his wife and children return from the opressors scourge;
They look behind at every step & believe it is a dream.
Singing. The Sun has left his blackness, & has found a fresher morning
And the fair Moon rejoices in the clear & cloudless night;
For Empire is no more, and now the Lion & Wolf shall cease.

In thunders ends the voice. Then Albions Angel wrathful burnt
Beside the Stone of Night; and like the Eternal Lions howl
In famine & war. reply'd. Art thou not Orc, who serpent form'd
Stands at the gate of Enitharmon to devour her children;
Blasphemous Demon, Antichrist. hater of Dignities;
Lover of wild rebellion. and transgresser of Gods Law;
Why dost thou come to Angels eyes in this terrific form?

The terror answerd: I am Orc. wreath'd round the accursed tree:
The times are ended; shadows pass the morning gins to break:
The fiery joy, that Urizen perverted to ten commands,
What night he led the starry hosts thro' the wide wilderness:
That stony law I stamp to dust: and scatter religion abroad
To the four winds as a torn book, & none shall gather the leaves:
But they shall rot on desert sands, & consume in bottomless deeps;
To make the deserts blossom, & the deeps shrink to their fountains,
And to renew the fiery joy, and burst the stony roof.
That pale religious letchery, seeking Virginity,
May find it in a harlot, and in coarse-clad honesty
The undefil'd tho' ravish'd in her cradle night and morn:
For every thing that lives is holy, life delights in life;
Because the soul of sweet delight can never be defil'd.
Fires inwrap the earthly globe, yet man is not consumd;
Amidst the lustful fires he walks: his feet become like brass,
His knees and thighs like silver. & his breast and head like gold.

Sound! sound! my loud war-trumpets & alarm my Thirteen Angels!
Loud howls the eternal Wolf! the eternal Lion lashes his tail!
America is darkned; and my punishing Demons terrified
Crouch howling before their caverns deep like skins dry'd in the wind.
They cannot smite the wheat, nor quench the fatness of the earth.
They cannot smite with sorrows, nor subdue the plow and spade.
They cannot wall the city, nor moat round the castle of princes.
They cannot bring the stubbed oak to overgrow the hills.
For terrible men stand on the shores, & in their robes I see
Children take shelter from the lightnings, there stands Washington
And Paine and Warren with their foreheads reard toward the east
But clouds obscure my aged sight. A vision from afar!
Sound! sound! my loud war-trumpets & alarm my thirteen Angels:
Ah vision from afar! Ah rebel form that rent the ancient
Heavens, Eternal Viper self-renew'd, rolling in clouds
I see thee in thick clouds and darkness on America's shore.
Writhing in pangs of abhorred birth; red flames the crest rebellious
And eyes of death; the harlot womb oft opened in vain
Heaves in enormous circles, now the times are return'd upon thee,
Devourer of thy parent now thy unutterable torment renews.
Sound! sound! my loud war trumpets & alarm my thirteen Angels.
Ah terrible birth! a young one bursting! where is the weeping mouth?
And where the mothers milk? instead those ever-hissing jaws
And poisoned lips drop with fresh gore: now roll thou in the clouds
Thy mother lays her length outstretch'd upon the shore beneath.
Sound! sound! my loud war trumpets & alarm my thirteen Angels.
Loud howls the eternal Wolf! the eternal Lion lashes his tail!

Thus wept the Angel voice & as he wept the terrible blasts
Of trumpets, blew a loud alarm across the Atlantic deep.

No trumpets answer; no reply of clarions or of fifes,
Silent the Colonies remain and refuse the loud alarm.

On those vast shady hills between America & Albions shore;
Now barr'd out by the Atlantic sea: call'd Atlantean hills:
Because from their bright summits you may pass to the Golden world
An ancient palace, archetype of mighty Emperies.
Rears its immortal pinnacles, built in the forest of God
By Ariston the king of beauty for his stolen bride,

Here on their magic seats the thirteen Angels sat perturb'd,
For clouds from the Atlantic hover o'er the solemn roof.

13

Fiery the Angels rose, & as they rose deep thunder roll'd
Around their shores; indignant burning with the fires of Orc
And Bostons Angel cried aloud as they flew thro' the dark
                                                    night.

He cried: Why trembles honesty and like a murderer,
Why seeks he refuge from the frowns of his immortal station,
Must the generous tremble & leave his joy, to the idle: to
                    the pestilence!
That mock him? who commanded this, what God, what Angel!
To keep the gen'rous from experience till the ungenerous
Are unrestraind performers of the energies of nature;
Till pity is become a trade, and generosity a science,
That men get rich by, & the sandy desart is giv'n to the strong
What God is he, writes laws of peace, & clothes him in a tempest
What pitying Angel lusts for tears, and fans himself with sighs
What crawling villain preaches abstinence & wraps himself
In fat of lambs? no more I follow, no more obedience pay.

14

So cried he, rending off his robe & throwing down his scepter.
In sight of Albions Guardian, and all the thirteen Angels
Rent off their robes to the hungry wind, & threw their golden scep-
                    -ters
Down on the land of America. indignant they descended
Headlong from out their heav'nly heights, descending swift as
                    fires
Over the land; naked & flaming are their lineaments seen
In the deep gloom, by Washington & Paine & Warren they stood
And the flame folded roaring fierce within the pitchy night
Before the Demon red, who burnt towards America,
In black smoke thunders and loud winds rejoicing in its
                    terror
Breaking in smoky wreaths from the wild deep, & gath'ring thick
In flames as of a furnace on the land from North to South

15

What time the thirteen Governors that England sent con-
In Bernards house; the flames coverd the land, they rouze they
                    cry
Shaking their mental chains they rush in fury to the sea
To quench their anguish; at the feet of Washington down fall'n
They grovel on the sand and writhing lie. while all
The British soldiers thro' the thirteen states sent up a howl
Of anguish: threw their swords & muskets to the earth & ran
From their encampments and dark castles seeking where to hide
From the grim flames; and from the visions of Orc; in sight
Of Albions Angel; who enrag'd his secret clouds open'd
From north to south, and burnt outstretchd on wings of wrath cov'ring
The eastern sky, spreading his awful wings across the heavens;
Beneath him rolld his num'rous hosts, all Albions Angels camp'd
Darkend the Atlantic mountains & their trumpets shook the valleys
Arm'd with diseases of the earth to cast upon the Abyss,
Their numbers forty millions, must'ring in the eastern sky.

16

In the flames stood & view'd the armies drawn out in the sky
Washington Franklin Paine & Warren Allen Gates & Lee:
And heard the voice of Albions Angel give the thunderous command
His plagues obedient to his voice flew forth out of their clouds
Falling upon America, as a storm to cut them off
As a blight cuts the tender corn when it begins to appear.

Dark is the heaven above, & cold & hard the earth beneath;
And as a plague wind fill'd with insects cuts off man & beast;
And as a sea o'erwhelms a land in the day of an earthquake;

Fury! rage! madness! in a wind swept through America
And the red flames of Orc that folded roaring fierce around
The angry shores, and the fierce rushing of th' inhabitants together;
The citizens of New-York close their books & lock their chests;
The mariners of Boston drop their anchors and unlade;
The scribe of Pensylvania casts his pen upon the earth;
The builder of Virginia throws his hammer down in fear.

Then had America been lost, o'erwhelm'd by the Atlantic,
And Earth had lost another portion of the infinite!
But all rush together in the night in wrath and raging fire
The red fires rag'd! the plagues recoil'd! then rolld they back
                                                    with fury

17

On Albions Angels: then the Pestilence began in streaks of red
Across the limbs of Albions Guardian, the spotted plague smote
                    Bristols
And the Leprosy Londons Spirit, sickening all their bands:
The millions sent up a howl of anguish and threw off their ham-
                    -merd mail,
And cast their swords & spears to earth, & stood a naked multitude.
Albions Guardian writhed in torment on the eastern sky
Pale quivering toward the brain his glimmering eyes, teeth chattering
Howling & shuddering his cold limbs quivering; convuls'd each muscle & sinew
Sin Plang lay Londons Guardian, and the ancient miterd York
Their heads on snowy hills, their ensigns sick'ning in the sky

The plagues creep on the burning winds driven by flames of Orc,
And by the fierce Americans rushing together in the night
Driven o'er the Guardians of Ireland and Scotland and Wales
They spotted with plagues forsook the frontiers & their banners seard
With fires of hell, deform their ancient heavens with shame & woe.
Hid in his caves the Bard of Albion felt the enormous plagues.
And a cowl of flesh grew o'er his head & scales on his back & ribs;
And rough with black scales all his Angels fright their ancient heavens
The doors of marriage are open, and the Priests in rustling scales
Rush into reptile coverts. hiding from the fires of Orc,
That play around the golden roofs in wreaths of fierce desire,
Leaving the females naked and glowing with the lusts of youth

For the female spirits of the dead pining in bonds of religion;
Run from their fetters reddening, & in long drawn arches sitting:
They feel the nerves of youth renew, and desires of ancient times.
Over their pale limbs as a vine when the tender grape appears

18

Over the hills, the vales, the cities, rage the red flames fierce;
The Heavens melted from north to south; and Urizen who sat
Above all heavens in thunders wrap'd, emerg'd his leprous head
From out his holy shrine, his tears in deluge piteous
Falling into the deep sublime! flag'd with grey-brow'd snows
And thunderous visages, his jealous wings wav'd over the deep:
Weeping in dismal howling woe he dark descended howling
Around the smitten bands, clothed in tears & trembling shudd'ring cold.
His stored snows he poured forth, and his icy magazines
He open'd on the deep. and on the Atlantic sea white shiv'ring.
Leprous his limbs, all over white, and hoary was his visage.
Weeping in dismal howlings before the stern Americans
Hiding the Demon red with clouds & cold mists from the earth;
Till Angels & weak men twelve years should govern o'er the strong:
And then their end should come, when France reciev'd the Demons light.

Stiff shudderings shook the heav'nly thrones! France Spain & Italy,
In terror view'd the bands of Albion, and the ancient Guardians
Fainting upon the elements. smitten with their own plagues
They slow advance to shut the five gates of their law-built heaven
Filled with blasting fancies and with mildews of despair
With fierce disease and lust, unable to stem the fires of Orc;
But the five gates were consum'd, & their bolts and hinges melted
And the fierce flames burnt round the heavens, & round the abodes of
                                                    (men

FINIS

*Cancelled plate* [Deletions are here set in italics. Blake's autograph revisions added in square brackets]

*Then Albions Angel rose* resolv'd to the cove of armoury:
His shield that bound twelve demons & their cities in its orb,
He took down from its trembling pillar, from its cavern deep,
His helm was brought by Londons Guardian, & his thirsty spear
By the wise spirit of Londons river, silent stood the King breathing
     *with flames* [hoar frosts *damp mists*]·
And on his *shining* [aged] limbs they clasp'd the armour of terrible gold.
Infinite Londons awful spires cast a dreadful *gleam* [cold]
Even *to* [on] rational things beneath, and from the palace walls
Around Saint James's *glow the fires* [chill & heavy], even to the city gate.
     *-dy shield*
On the vast stone whose name Is Truth he stood, his clou-
Smote with his scepter, the scale bound orb loud howld; th' *eternal* [ancie(nt)]
    pillar
Trembling sunk, an earthquake roll'd along the massy pile.

In glittring armour, swift as winds; intelligent as *flames* [clouds];
Four winged heralds mount the furious blasts & blow their trumps
Gold, silver, brass & iron *ardors* [clangors] clamoring rend the shores.
Like white clouds rising from the deeps, his fifty-two armies
From the four cliffs of Albion rise, *glowing* [mustering] around their Prince;
Angels of cities and of parishes and villages and families,
In armour as the nerves of wisdom, each his station *fires* [holds].

In opposition dire, a warlike cloud the myriads stood
In the red air before the Demon; *seen even by mortal men:*
*Who call it Fancy, & [or] shut the gates of sense, & [or] in their cham-*
    *-bers*
*Sleep like the dead.* But like a constellation ris'n and blazing
Over the rugged ocean; so the Angels of Albion hung,
*Over the* [a] frowning shadow, like a[n aged] King in arms of gold,
Who wept over a den, in which his only son outstretch'd
By rebels hands was slain; his white beard wav'd in the wild
       wind.

On mountains & cliffs of snow the awful apparition hover'd;
And like the voices of religious dead, heard in the mountains:
When holy zeal scents the sweet valleys of ripe vir-
    -gin bliss;
Such was the hollow voice that o'er *the red Demon* [America]
    lamented.

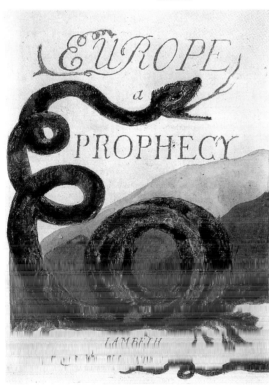

a
PROPHECY

LAMBETH
Printed by Will: Blake : 1794

## PRELUDIUM

The nameless shadowy female rose from out the breast of Orc:
Her snaky hair brandishing in the winds of Enitharmon·
And thus her voice arose.

O mother Enitharmon wilt thou bring forth other sons?
To cause my name to vanish, that my place may not be found.
For I am faint with travel!
Like the dark cloud disburdend in the day of dismal thunder.

My roots are brandish'd in the heavens. my fruits in earth beneath
Surge, foam, and labour into life, first born & first consum'd!
Consumed and consuming!
Then why shouldst thou accursed mother bring me into life?

I wrap my turban of thick clouds around my lab'ring head:
And fold the sheety waters as a mantle round my limbs.
Yet the red sun and moon,
And all the overflowing stars rain down prolific pains.

Unwilling I look up to heaven! unwilling count the stars!
Sitting in fathomless abyss of my immortal shrine.
I sieze their burning power
And bring forth howling terrors, all devouring fiery kings.

Devouring & devoured roaming on dark and desolate mountains
In forests of eternal death, shrieking in hollow trees.
Ah mother Enitharmon!
Stamp not with solid form this vig'rous progeny of fires.

I bring forth from my teeming bosom myriads of flames,
And thou dost stamp them with a signet, then they roam abroad
And leave me void as death:
Ah! I am drown'd in shady woe, and visionary joy.

And who shall bind the infinite with an eternal band?
To compass it with swaddling bands? and who shall cherish it
With milk and honey?
I see it smile & I roll inward & my voice is past.

She ceast & rolld her shady clouds
Into the secret place.

A
PROPHECY

 The deep of winter came:
  What time the secret child
Descended thro' the orient gates of the eternal day:
War ceas'd, & all the troops like shadows fled
  to their abodes.

Then Enitharmon saw her sons & daughters rise around.
Like pearly clouds they meet together in the crystal house;
And Los. possessor of the moon, joy'd in the peaceful night:
Thus speaking while his num'rous sons shook their bright fiery wings

Again the night is come
That strong Urthona takes his rest,
And Urizen unloos'd from chains
Glows like a meteor in the distant north
Stretch forth your hands and strike the elemental strings!
Awake the thunders of the deep

The shrill winds wake!
Till all the sons of Urizen look out and envy Los:
Sieze all the spirits of life and bind
Their warbling joys to our loud strings
Bind all the nourishing sweets of earth
To give us bliss, that we may drink the sparkling wine of Los
And let us laugh at war,
Despising toil and care.
Because the days and nights of joy. in lucky hours renew.

Arise O Orc from thy deep den,
First born of Enitharmon rise!

And we will crown thy head with garlands of the ruddy vine;
For now thou art bound;
And I may see thee in the hour of bliss, my eldest born.

The horrent Demon rose. surrounded with red stars of fire,
Whirling about in furious circles round the immortal fiend.

Then Enitharmon down descended into his red light,
And thus her voice rose to her children, the distant heavens reply.

*5*

Now comes the night of Enitharmons joy
Who shall I call? Who shall I send?
That Woman, lovely Woman! may have dominion
Arise O Rintrah thee I call! & Palamabron thee.
Go: tell the human race that Womans love is Sin:
That an Eternal life awaits the worms of sixty winters
In an allegorical abode where existence hath never come:
Forbid all Joy, & from her childhood shall the little female
Spread nets in every secret path.
My weary eyelids draw towards the evening my bliss is yet but new.
                                                              Arise

*7*

Arise O Rintrah eldest born: second to none but Orc:
O lion Rintrah raise thy fury from thy forests black;
Bring Palamabron horned priest, skipping upon the mountains;
And silent Elynittria the silver bowed queen:
Rintrah where hast thou hid thy bride!
Weeps she in desart shades?
Alas my Rintrah! bring the lovely jealous Ocalythron.

Arise my son! bring all thy brethren O thou king of fire.
Prince of the sun I see thee with thy innumerable race:
Thick as the summer stars:
But each ramping his golden mane shakes.
And thine eyes rejoice because of strength O Rintrah furious king.

*8*

Enitharmon slept,
Eighteen hundred years: Man was a Dream!
The night of Nature and their harps unstrung.
She slept in middle of her nightly song.
Eighteen hundred years, a female dream!

Shadows of men in fleeting bands upon the winds:
Divide the heavens of Europe
Till Albions Angel smitten with his own plagues fled with his bands
The cloud bears hard on Albions shore:
Fill'd with immortal demons of futurity:
In council gather the smitten Angels of Albion
The cloud bears hard upon the council house! down rushing
On the heads of Albions Angels.

One hour they lay buried beneath the ruins of that hall;
But as the stars rise from the salt lake they arise in pain,
In troubled mists o'erclouded by the terrors of strugling times,

*9*

                                                    (following
In thoughts perturb'd they rose from the bright ruins silent
The fiery King, who sought his ancient temple serpent-form'd
That stretches out its shady length along the Island white.
Round him roll'd his clouds of war; silent the Angel went,
Along the infinite shores of Thames to golden Verulam.
There stand the venerable porches that high-towering rear
Their oak surrounded pillars, form'd of massy stones, uncut
With tool; stones precious; such eternal in the heavens,
Of colours twelve. few known on earth, give light in the opake.
Plac'd in the order of the stars, when the five senses whelm'd
In deluge o'er the earth-born man; then turn'd the fluxile eyes
Into two stationary orbs, concentrating all things
The ever-varying spiral ascents to the heavens of heavens
Were bended downward; and the nostrils golden gates shut
Turn'd outward, barr'd and petrify'd against the infinite.

Thought chang'd the infinite to a serpent; that which pitieth:
To a devouring flame; and man fled from its face and hid
In forests of night; then all the eternal forests were divided
Into earths rolling in circles of space, that like an ocean
                                                              rush'd
And overwhelmed all except this finite wall of flesh.
Then was the serpent temple form'd, image of infinite
Shut up in finite revolutions, and man became an Angel;
Heaven a mighty circle turning; God a tyrant crown'd.

Now arriv'd the ancient Guardian at the southern porch,
That planted thick with trees of blackest leaf, & in a vale
Obscure, inclos'd the Stone of Night; oblique it stood, o'erhung
With purple flowers and berries red; image of that sweet south,
Once open to the heavens and elevated on the human neck,
Now overgrown with hair and coverd with a stony roof, (feet
Downward 'tis sunk beneath th' attractive north, that round the
A raging whirlpool draws the dizzy enquirer to his grave.

*10*

Albions Angel rose upon the Stone of Night.
He saw Urizen on the Atlantic;
And his brazen Book,
That Kings & Priests had copied on Earth
Expanded from North to South.

*11*

LORD

[H]AVE MERC[Y]

ON US

*12*

And the clouds & fires pale rolld round in the night of Enitharmon
Round Albions cliffs & Londons walls; still Enitharmon slept!
Rolling volumes of grey mist involve Churches, Palaces, Towers:
For Urizen unclaspd his Book! feeding his soul with pity
The youth of England hid in gloom curse the paind heavens; compell'd
Into the deadly night to see the form of Albions Angel
Their parents brought them forth & left them to the merciless preachers curse
Bleak, dark, abrupt, it stands & overshadows London city
They saw his boney feet on the rock, the flesh consum'd in flames:
They saw the Serpent temple lifted above, shadowing the Island white:
They heard the voice of Albions Angel howling in flames of Orc,
Seeking the trump of the last doom

Above the rest the howl was heard from Westminster louder & louder;
The Guardian of the secret codes forsook his ancient mansion
Driven out by the flames of Orc; his furr'd robes & false locks
Adhered and grew one with his flesh, and nerves & veins shot thro' them
With dismal torment sick hanging upon the wind: he fled
Groveling along Great George Street thro' the Park gate; all the soldiers
Fled from his sight: he drag'd his torments to the wilderness.

Thus was the howl thro Europe!
For Orc rejoic'd to hear the howling shadows
But Palamabron shot his lightnings trenching down his wide back
And Rintrah hung with all his legions in the nether deep

Enitharmon laugh'd in her sleep to see (O womans triumph)
Every house a den, every man bound; the shadows are filld
With spectres, and the windows wove over with curses of iron:
Over the doors Thou shalt not; & over the chimneys Fear is written:
With bands of iron round their necks, fasten'd into the walls
The citizens: in leaden gyves the inhabitants of suburbs
Walk heavy: soft and bent are the bones of villagers

[423]

Between the clouds of Urizen the flames of Orc roll heavy
Around the limbs of Albions Guardian. his flesh consuming.
Howlings & hissings. shrieks & groans. & voices of despair
Arise around him in the cloudy
Heavens of Albion, Furious

18

The red limb'd Angel siez'd · in horror and torment;
The Trump of the last doom; but he could not blow the iron tube!
Thrice he assay'd presumptuous to awake the dead to Judgment.

A mighty Spirit leap'd from the land of Albion,
Nam'd Newton; he siez'd the Trump, & blow'd the enormous blast!
Yellow as leaves of Autumn the myriads of Angelic hosts,
Fell thro' the wintry skies seeking their graves;
Rattling their hollow bones in howling and lamentation

        Then Enitharmon woke nor knew that she had slept
And eighteen hundred years were fled
As if they had not been
She calld her sons & daughters
To the sports of night,
Within her crystal house;
And thus her song proceeds.

Arise Ethinthus! tho' the earth-worm cal
Let him call in vain;
Till the night of holy shadows
And human solitude is past!

14

Ethinthus queen of waters, how thou shinest in the sky:
My daughter how do I rejoice! for thy children flock around
Like the gay fishes on the wave, when the cold moon drinks the dew,
Ethinthus! thou art sweet as comforts to my fainting soul:
For now thy waters warble round the feet of Enitharmon.

Manathu-Vorcyon! I behold thee flaming in my halls,
Light of thy mothers soul! I see thy lovely eagles round:
Thy golden wings are my delight, & thy flames of soft delusion.

Where is my lureing bird of Eden! Leutha silent love!
Leutha. the many coloured bow delights upon thy wings;
Soft soul of flowers Leutha!
Sweet smiling pestilence! I see thy blushing light;
Thy daughters many changing,
Revolve like sweet perfumes ascending O Leutha silken queen!

Where is the youthful Antamon. prince of the pearly dew,
O Antamon, why wilt thou leave thy mother Enitharmon?
Alone I see thee crystal form,
Floting upon the bosomd air;
With lineaments of gratified desire.
My Antamon the seven churches of Leutha seek thy love.

I hear the soft Oothoon in Enitharmons tents:
Why wilt thou give up womans secrecy my melancholy child?
Between two moments bliss is ripe:
O Theotormon robb'd of joy, I see thy salt tears flow
Down the steps of my crystal house.

Sotha & Thiralatha, secret dwellers of dreamful caves,
Arise and please the horrent fiend with your melodious songs.
Still all your thunders golden hoofd, & bind your horses black.
Orc! smile upon my children!
Smile son of my afflictions.
Arise O Orc and give our mountains joy of thy red light.

She ceas'd, for all were forth at sport beneath the solemn moon
Waking the stars of Urizen with their immortal songs,
That nature felt thro' all her pores the enormous revelry.
Till morning ope'd the eastern gate
Then every one fled to his station & Enitharmon wept

But terrible Orc, when he beheld the morning in the east,

Shot from the heights of Enitharmon;
And in the vineyards of red France appear'd the light of his fury.

The sun glow'd fiery red;
The furious terrors flew around!
On golden chariots raging, with red wheels dropping with blood;
The Lions lash their wrathful tails!
The Tigers couch upon the prey & suck the ruddy tide:
And Enitharmon groans & cries in anguish and dismay.

Then Los arose his head he reard in snaky thunders clad:
And with a cry that shook all nature to the utmost pole,
Call'd all his sons to the strife of blood.

FINIS

ADDITIONAL PLATE 3

Five windows light the cavern'd Man; thro' one he breathes the air;
Thro' one, hears music of the spheres; thro' one, the eternal vine
Flourishes, that he may recieve the grapes; thro' one can look.
And see small portions of the eternal world that ever groweth;
Thro' one, himself pass out what time he please, but he will not;
For stolen joys are sweet, & bread eaten in secret pleasant.

So sang a Fairy mocking as he sat on a streak'd Tulip,
Thinking none saw him: when he ceas'd I started from the trees:
And caught him in my hat as boys knock down a butterfly.
How know you this said I small Sir? where did you learn this song?
Seeing himself in my possession thus he answered me:
My master, I am yours. command me, for I must obey.

Then tell me, what is the material world, and is it dead?
He laughing answer'd: I will write a book on leaves of flowers,
If you will feed me on love-thoughts, & give me now and then
A cup of sparkling poetic fancies; so when I am tipsie,
I'll sing to you to this soft lute; and shew you all alive
The world, when every particle of dust breathes forth its joy.

I took him home in my warm bosom: as we went along
Wild flowers I gatherd; & he shew'd me each eternal flower:
He laugh'd aloud to see them whimper because they were pluck'd.
They hover'd round me like a cloud of incense: when I came
Into my parlour and sat down, and took my pen to write;
My Fairy sat upon the table, and dictated EUROPE.

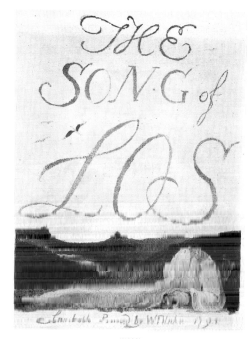

THE
SONG of
LOS
Lambeth    Printed by WBlake    1795

[424]

*3*

## AFRICA

I will sing you a song of Los. the Eternal Prophet:
He sung it to four harps at the tables of Eternity.
  In heart-formed Africa.
Urizen faded! Ariston shudderd!
  And thus the Song began

Adam stood in the garden of Eden:
And Noah on the mountains of Ararat:
They saw Urizen give his Laws to the Nations
By the hands of the children of Los.

     African
Adam shudderd! Noah faded! black grew the sunny
When Rintrah gave Abstract Philosophy to Brama in the East.
 (Night spoke to the Cloud!
Lo these Human form'd spirits in smiling hipocrisy. War
Against one another; so let them War on; slaves to the
    eternal Elements)
Noah shrunk beneath the waters.
Abram fled in fires from Chaldea:
Moses beheld upon Mount Sinai forms of dark delusion:

To Trismegistus. Palamabron gave an abstract Law:
To Pythagoras Socrates & Plato.

Times rolled on o'er all the sons of Har. time after time
Orc on Mount Atlas howld. chain'd down with the Chain of Jealousy
Then Oothoon hoverd over Judah & Jerusalem
And Jesus heard her voice (a man of sorrows) he recievd
A Gospel from wretched Theotormon.

The human race began to wither. for the healthy built
Secluded places, fearing the joys of Love
And the disease'd only propagated;
So Antamon call'd up Leutha from her valleys of delight:
And to Mahomet a loose Bible gave.
But in the North, to Odin, Sotha gave a Code of War.
Because of Diralada thinking to reclaim his joy.

*4*

These were the Churches: Hospitals: Castles: Palaces;
Like nets & gins & traps to catch the joys of Eternity
 And all the rest a desart;
Till like a dream Eternity was obliterated & erased.

Since that dread day when Har and Heva fled.
Because their brethren & sisters liv'd in War & Lust;
And as they fled they shrunk
Into two narrow doleful forms:
Creeping in reptile flesh upon
The bosom of the ground:
And all the vast of Nature shrunk
Before their shrunken eyes.

Thus the terrible race of Los & Enitharmon gave
Laws & Religions to the sons of Har binding them more
And more to Earth: closing and restraining;
Till a Philosophy of Five Senses was complete
Urizen wept & gave it into the hands of Newton & Locke

  Clouds roll heavy upon the Alps round Rousseau & Voltaire:
  And on the mountains of Lebanon round the deceased Gods
  Of Asia; & on the desarts of Africa round the Fallen Angels.
  The Guardian Prince of Albion burns in his nightly tent.

*6*

## ASIA

The Kings of Asia heard
The howl rise up from Europe!
And each ran out from his Web;

From his ancient woven Den;
For the darkness of Asia was startled
At the thick-flaming, thought-creating fires of Orc.

And the Kings of Asia stood
And cried in bitterness of soul.

Shall not the King call for Famine from the heath
Nor the Priest, for Pestilence from the fen?
To restrain! to dismay! to thin!
The inhabitants of mountain and plain;
In the day of full-feeding prosperity;
And the night of delicious songs.

Shall not the Councellor throw his curb
Of Poverty on the laborious?
To fix the price of labour;
To invent allegoric riches:

And the privy admonishers of men
Call for Fires in the City
For heaps of smoking ruins,
In the night of prosperity & wantonness

To turn man from his path,
To restrain the child from the womb,

*7*

To cut off the bread from the city,
That the remnant may learn to obey.

That the pride of the heart may fail;
That the lust of the eyes may be quench'd:
That the delicate ear in its infancy
May be dull'd; and the nostrils clos'd up;
To teach mortal worms the path
That leads from the gates of the Grave.

 Urizen heard them cry;
And his shudd'ring waving wings
Went enormous above the red flames
Drawing clouds of despair thro' the heavens
Of Europe as he went:
And his Books of brass iron & gold
Melted over the land as he flew,
Heavy-waving, howling, weeping.

    And he stood over Judea;
    And stay'd in his ancient place;
    And stretch'd his clouds over Jerusalem.

    For Adam, a mouldering skeleton
    Lay bleach'd on the garden of Eden.
    And Noah as white as snow
    On the mountains of Ararat.

   Then the thunders of Urizen bellow'd aloud
   From his woven darkness above.

   Orc raging in European darkness
   Arose like a pillar of fire above the Alps
   Like a serpent of fiery flame!
     The sullen Earth
     Shrunk!

Forth from the dead dust rattling bones to bones
Join: shaking convuls'd the shivring clay breathes.
And all flesh naked stands; Fathers and Friends;
Mothers & Infants; Kings & Warriors:

   The Grave shrieks with delight, & shakes
   Her hollow womb, & clasps the solid stem;
   Her bosom swells with wild desire:
   And milk & blood & glandous wine,
   In rivers rush & shout & dance,
   On mountain, dale and plain.
     The SONG of LOS is Ended
     Urizen Wept.

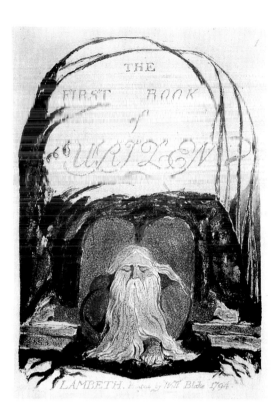

THE
FIRST *BOOK*
*of*
*URIZEN*

LAMBETH. *Printed by Will Blake* 1794.

PRELUDIUM
TO
THE
FIRST BOOK OF
*URIZEN*

Of the primeval Priests assum'd power,
When Eternals spurn'd back his religion;
And gave him a place in the north,
Obscure. shadowy. void. solitary.

Eternals I hear your call gladly,
Dictate swift winged words. & fear not
To unfold your dark visions of torment.

Chap: I

1. Lo, a shadow of horror is risen
In Eternity! Unknown, unprolific!
Self clos'd, all repelling: what Demon
Hath form'd this abominable void
This soul shudd'ring vacuum? Some
            said
"It is Urizen", But unknown, abstracted
Brooding secret, the dark power hid.

2. Times on times he divided, & measur'd
Space by space in his ninefold darkness
Unseen, unknown: changes appeard
Like desolate mountains rifted furious
By the black winds of perturbation

3. For he strove in battles dire
In unseen conflictions with shapes
Bred from his forsaken wilderness,
Of beast, bird, fish, serpent & element
Combustion, blast, vapour and cloud.

4. Dark revolving in silent activity:
Unseen in tormenting passions;
An activity unknown and horrible;
A self-contemplating shadow
In enormous labours occupied

5. But Eternals beheld his vast forests
Ages on ages he lay, clos'd, unknown,
Brooding shut in the deep; all avoid
The petrific abominable chaos

6. His cold horrors silent, dark Urizen
Prepar'd: his ten thousands of thunders
Rang'd in gloom'd array stretch out across
The dread world, & the rolling of wheels
As of swelling seas, sound in his clouds
In his hills of stor'd snows, in his mountains
Of hail & ice; voices of terror,
Are heard, like thunders of autumn,
When the cloud blazes over the harvests

Chap. II

In living creations appear'd
In the flames of eternal fury.

3. Sund'ring, dark'ning, thund'ring!
Rent away with a terrible crash
Eternity roll'd wide apart
Wide asunder rolling
Mountainous all around
Departing; departing: departing:
Leaving ruinous fragments of life
Hanging frowning cliffs & all between
An ocean of voidness unfathomable

4. The roaring fires ran o'er the heav'ns
In whirlwinds & cataracts of blood
And o'er the dark desarts of Urizen
Fires pour thro' the void on all sides
On Urizens self-begotten armies.

5. But no light from the fires, all was
            darkness
In the flames of Eternal fury

6. In fierce anguish & quenchless
            flames

As the stars are apart from the earth

9. Los wept howling round the dark
            Demon:
And cursing his lot for in anguish
Urizen was rent from his side:
And a fathomless void for his feet;
And intense fires for his dwelling

12: Los howld in a dismal stupor,
Groaning! gnashing! groaning!
Till the wrenching apart was healed

13: But the wrenching of Urizen
            heal'd not
Cold, featureless, flesh or clay

Chap: IV  —ment

1: Los smitten with astonish
Frightend at the hurtling bones

2: And at the surging sulphure
            -ous
Perturbed Immortal mad raging

3: In whirlwinds & pitch & nitre
Round the furious limbs of Los

1. Earth was not: nor globes of attraction
The will of the Immortal expanded
Or contracted his all flexible senses.
Death was not, but eternal life sprung

2. The sound of a trumpet the heavens
Awoke & vast clouds of blood roll'd
Round the dim rocks of Urizen, so nam'd
That solitary one in Immensity

3. Shrill the trumpet: & myriads of Eter
            -nity

            -ging
To the desarts and rocks he ran ra
To hide, but he could not: combining
    He dug mountains & hills in vast stre
    He piled them in incessant labour,
In howlings & pangs & fierce madness
Long periods in burning fires labouring
Till hoary, and age-broke, and aged.
In despair and the shadows of death.

7. And a roof vast petrific around,
On all sides he fram'd: like a womb;
Where thousands of rivers in veins
Of blood pour down the mountains to
The eternal fires beating without
From Eternals; & like a black globe
View'd by sons of Eternity, standing
On the shore of the infinite ocean
Like a human heart strugling & beating
The vast world of Urizen appear'd.

8. And Los round the dark globe of
            Urizen
Kept watch for Eternals to confine,
The obscure separation alone;
For Eternity stood wide apart

I Urizen C. II

10. But Urizen laid in a stony sleep
Unorganiz'd, rent from Eternity

11. The Eternals said: What is this? De
Urizen is a clod of clay.

Rifted with direful changes
He lay in a dreamless night

14: Till Los rouz'd his his fires
            affrighted
At the formless unmeasurable
            death.

5: And Los formed nets & gins
And threw the nets round about

5: He watch'd in shuddring fear
The dark changes & bound every
            change
With rivets of iron & brass

6. And these were the changes
            of Urizen

Chap: IV.

...ges on ages roll'd over him!
...tony sleep ages roll'd over him!
...e a dark waste stretching chang'able
...earthquakes riv'n, belching sullen
    fires
...ages roll'd ages in ghastly
...torment; around him in whirlwinds
...arkness the eternal Prophet howl'd
...ing still on his rivets of iron
...ring sodor of iron; dividing
...horrible night into watches.

...nd Urizen (so his eternal name)
...prolific delight obscur'd more & more
...ark secresy hiding in surgeing
...phureous fluid his phantasies.
...Eternal Prophet heavd the dark
    bellows
...turn'd restless the tongs; and the
    hammer
...ssant beat; forging chains new & new
...ab'ring with links. hours days & years

...he eternal mind bounded began to roll
...ies of wrath ceaseless round & round
...the sulphureous foam surgeing thick

I Urizen  C

...rom the caverns of his jointed Spine
...wn sunk with fright a red
...nd globe hot burning deep
...ep down into the Abyss:
...ting: Conglobing, Trembling
...ooting out ten thousand branches
...ound his solid bones
...d a second Age passed over
...d a state of dismal woe

...n harrowing fear rolling round;
...nervous brain shot branches
...the branches of his heart
...high into two little orbs
...fixed in two little caves

...o Nostrils bent down to the deep
...d a fifth Age passed over,
...d a state of dismal woe.

...In ghastly torment sick;
...hin his ribs bloated round,
...raving Hungry Cavern
...ence arose his channeld Throat
...d like a red flame a Tongue
...thirst & of hunger appeard
...d a sixth Age passed over:
...d a state of dismal woe

...Enraged & stifled with torment
...threw his right Arm to the north
...left Arm to the south
...ooting out in anguish deep
...d his Feet stampd the nether Abyss

...cept what his little orbs
...sight by degrees unfold
...And how his eternal life
...e a dream was obliterated

Settled, a lake, bright, & shining clear
White as snow on the mountains cold

4. Forgetfulness, dumbness, necessity!
In chains of the mind locked up
Like fetters of ice shrinking together
Disorganiz'd, rent from Eternity.
Los beat on his fetters of iron:
And heated his furnaces & pour'd
Iron sodor and sodor of brass

5. Restless turnd the immortal inchain'd
Heaving dolorous! anguish'd! unbearable
Till a roof shaggy wild inclos'd
In an orb, his fountain of thought.

6. In a horrible dreamful slumber;
Like the linked infernal chain;
A vast Spine writh'd in torment
Upon the winds; shooting pain'd
Ribs, like a bending cavern
And bones of solidness, froze
Over all his nerves of joy.
And a first Age passed over
And a state of dismal woe.

10

I Urizen. C

Hiding carefully from the wind,
His Eyes beheld the deep,
And a third Age passed over:
And a state of dismal woe.

9. The pangs of hope began,
In heavy pain striving, struggling
Two Ears in close volutions.
From beneath his orbs of vision
Shot spiring out and petrified
As they grew. And a fourth Age passed
And a state of dismal woe.

10. In ghastly torment ... 
Hanging upon the winds

In ... A howling & dismay
And a seventh Age passed over
And a state of dismal woe.

Chap: V.

1. In terrors Los shrunk from his
    task
His great hammer fell from his hand
His fires beheld, and sickening
Hid their strong limbs in smoke.
For with noises ruinous loud;
With hurtlings & clashings & groans
The Immortal endurd his chains
Tho' bound in a deadly sleep

2. All the myriads of Eternity
All the wisdom & joy of life
Roll like a sea around him

4. Shudd'ring, the Eternal Prophet smote
With a stroke, from his north to south
    region
The bellows & hammer are silent now

9

A nerveless silence his prophetic voice
Siez'd; a cold solitude & dark void
The Eternal Prophet & Urizen clos'd

5. Ages on ages rolld over them
Cut off from life & light frozen
Into horrible forms of deformity
Los suffferd his fires to decay
Then he look'd back with anxious desire
But the space undivided by existence
Struck horror into his soul.

6. Los wept obscur'd with mourning
His bosom earthquak'd with sighs

Thus the Eternal Prophet was divided
Before the death image of Urizen
For in changeable clouds and darkness
In a winterly night beneath
The Abyss of Los stretch'd immense
And now seen now obscur'd to the eyes
Of Eternals the visions remote

I Urizen. C:V.

8. The globe of life blood trembled
Branching out into roots:
Fibrous, writhing upon the winds;
Fibres of blood, milk and tears;
In pangs, eternity on eternity.
At length in tears & cries imbodied
A female form trembling and pale
Waves before his deathy face

They call'd her Pity, and fled

11. "Spread a Tent with strong cur-
    tains around them
"Let cords & stakes bind in the Void
That Eternals may no more behold them"

12. They began to weave curtains of
    darkness
They erected large pillars round the Void
With golden hooks fast, ... in the pillars
... 
A woof wove, and called it Science

Chap: VI

1. But Los saw the Female & pitied
He embrac'd her, she wept she refusd
In perverse and cruel delight
She fled from his arms, yet he followd

2. Eternity shudder'd when they saw,
Man begetting his likeness,
On his own divided image.

3. A time passed over, the Eternals
Began to erect the tent;
When Enitharmon sick,
Felt a Worm within her womb.

4. Yet helpless it lay like a Worm
In the trembling womb
To be moulded into existence

I Urizen C. VII

Stretch'd for a work of eternity;
No more Los beheld Eternity.

He saw Urizen deadly black
In his chains bound & Pity began

7. In anguish dividing & dividing
For pity divides the soul
In pangs eternity on eternity
Life in cataracts pourd down his
    cliffs
The void shrunk the lymph into Nerves
Wandring wide on the bosom of night
And left a round globe of blood
Trembling upon the void

14

Of the dark seperation appear'd.
As glasses discover Worlds
In the endless Abyss of space
So the expanding eyes of Immortals
Beheld the dark visions of Los,
And the globe of life blood trembling

16

9. All Eternity shudderd at sight
Of the first female now separate
Pale as a cloud of snow
Waving ... the face of Los

10. Wonder, awe, fear, astonishment
Petrify the eternal myriads;
At the first female form now separate

17

5. All day the worm lay on her bosom
All night within her womb
The worm lay till it grew to a ser
    ...
With dolorous hissings & poisons
Round Enitharmons loins folding

6. ... within Enitharmons womb
The serpent grew casting ...
With the sharp pangs ...
Ta...
Many sorrows and dismal throes
Many forms of fish, bird & beast
Brought forth an Infant form
Where was a worm before.

7. The Eternals their tent finished
Alarm'd with these gloomy visions
When Enitharmon groaning
Produc'd a man Child to the light.

8. A shriek ran thro' Eternity:
And a paralytic stroke;
At the birth of the Human shadow

9. Delving earth in his resistless
    way:
Howling, the Child with fierce flames
Issu'd from Enitharmon.

10. The Eternals, closed the tent
They beat down the stakes the cords

18

11. In his hands he siez'd the infant
He bathed him in springs of sorrow
He gave him to Enitharmon.

Chap. VII.

1. They named the child Orc, he grew
Fed with milk of Enitharmon

2. Los awoke her; O sorrow & pain!
A tight'ning girdle grew,
around his bosom In sobbings
He burst the girdle in twain,
But still another girdle
Oppressd his bosom. In sobbings
Again he burst it. Again
Another girdle succeeds
The girdle was form'd by day;
By night was burst in twain

3. These falling down on the rock
Into an iron Chain
In each other link by link lock'd

4. They took Orc to the top of a
mountain
O how Enitharmon wept!
They chain'd his young limbs to the
rock
With the Chain of Jealousy
Beneath Urizens deathful shadow

5. The dead heard the voice of the
child
And began to awake from sleep

All things. heard the voice of the child
And began to awake to life.

6. And Urizen craving with hunger
Stung with the odours of Nature
Explor'd his dens around

7. He form'd a line & a plummet
To divide the Abyss beneath.
He form'd a dividing rule.

8. He formed scales to weigh;
He formed massy weights;
He formed a brazen quadrant;
He formed golden compasses
And began to explore the Abyss
And he planted a garden of fruits

9. But Los encircled Enitharmon
With fires of Prophecy
From the sight of Urizen & Orc.

10. And she bore an enormous race

Chap. VIII.

1. Urizen explor'd his dens
Mountain, moor, & wilderness,
With a globe of fire lighting his
journey
A fearful journey, annoy'd
By cruel enormities: forms

21

I Urizen. C. VIII.

Of life on his forsaken mountains

2. And his world teemd vast enormities
Frightning; faithless; fawning
Portions of life; similitudes
Of a foot, or a hand, or a head
Or a heart, or an eye, they swam mis
-chevous
Dread terrors! delighting in blood

3. Most Urizen sicken'd to see
His eternal creations appear
Sons & daughters of sorrow on mountains
Weeping! wailing! first Thiriel appear'd
Astonish'd at his own existence
Like a man from a cloud born, & Utha
From the waters emerging, laments!

The Ox in the slaughter house moans
The Dog at the wintry door
And he wept, & he called it Pity
And his tears flowed down on the winds

6 Cold he wander'd on high, over
their cities
In weeping & pain & woe
Ad where-ever he wanderd in sorrows
Upon the aged heavens
A cold shadow followd behind him
Like a spiders web, moist, cold & dim
Drawing out from his sorrowing soul
The dungeon-like heaven dividing
Where ever the footsteps of Urizen
Walk'd over the cities in sorrow

Till a Web dark & cold throughout all
The tormented element stretch'd
From the sorrows of Urizens soul
And the Web is a Female in embrio
None could break the Web, no wings
of fire.

Grodna rent the deep earth howling
Amaz'd! his heavens immense cracks
Like the ground parch'd with heat; then
Fuzon
Flam'd out! first begotten, last born
All his eternal sons in like manner
His daughters from green herbs & cattle
From monsters, & worms of the pit.

4. He in darkness clos'd, view'd all his
race
And his soul sicken'd! he curs'd
Both sons & daughters; for he saw
That no flesh nor spirit could keep
His iron laws one moment.

5. For he saw that life liv'd upon
death

23

8 So twisted the cords & so knotted
The meshes: twisted like to the
human brain
-gion
9. And all calld it The Net of Reli-

Chap. IX

1. Then the Inhabitants of those Cities:
Felt their Nerves change into Marrow
And hardening Bones began
In swift diseases and torments
In throbbings & shootings & grindings
Thro all the coasts till weaken'd
The Senses inward rush'd shrinking
Beneath the dark net of infection.

2. Till the shrunken eyes clouded over
Discernd not the woven hipocrisy
But the streaky slime in their heavens
Brought together by narrowing perceptions
Appeard transparent air; for their eyes
Grew small like the eyes of a man
And in reptile forms shrinking together
Of seven feet stature they remaind

3 Six days they shrunk up from existence
And on the seventh day they rested.
And they bless'd the seventh day, in sick
hope
And forgot their eternal life.

5. And their children wept, & built
Tombs in the desolate places,
And form'd laws of prudence, and
call'd them
The eternal laws of God

6. And the thirty cities remaind
Surrounded by salt floods, now call'd
Africa: its name was then Egypt.

7 The remaining sons of Urizen
Beheld their brethren shrink together
Beneath the Net of Urizen :
Perswasion was in vain

4. And their thirty cities divided
In form of a human heart
No more could they rise at will
In the infinite void, but bound down
To earth by their narrowing perceptions

I Urizen C: IX

They lived a period of years
Then left a noisom body
To the jaws of devouring darkness

5. And their children wept, & built
Tombs in the desolate places,
And form'd laws of prudence, and
call'd them
The eternal laws of God

For the ears of the inhabitants
Were wither'd, & deafen'd, & cold;
And their eyes could not discern,
Their brethren of other cities.

8. So Fuzon call'd all together
The remaining children of Urizen:
And they left the pendulous earth:
They called it Egypt, & left it.

9. And the salt ocean rolled englobd

The End of the
first book of Urizen

ADDITIONAL PLATE 4a

I Urizen: C. II.

Muster around the bleak desarts
Now fill'd with clouds darkness & waters
That roll'd perplex'd labring & utter'd
Words articulate, bursting in thunders
That roll'd on the tops of his mountains

4. From the depths of dark solitude,
From
The eternal abode in my holiness,
Hidden, set apart in my stern counsels
Reserv'd for the days of futurity,
I have sought for a joy without pain,
For a solid without fluctuation
Why will you die O Eternals?
Why live in unquenchable burnings?

5 First I fought with the fire; consum'd
Inwards, into a deep world within:
A void immense, wild dark & deep
Where nothing was; Natures wide womb
And self balanc'd stretch'd o'er the void

I alone, even I! the winds merciless
Bound; but condensing in torrents
They fall & fall; strong, I repell'd
The vast waves, & arose on the waters
A wide world of solid obstruction

6. Here alone I in books formd of me-
-tals
Have written the secrets of wisdom

The secrets of dark contemplation
By fightings and conflicts dire.
With terrible monsters Sin-bred:
Which the bosoms of all inhabit;
Seven deadly Sins of the soul.

7. Lo! I unfold my darkness: and on
This rock, place with strong hand the Book
Of eternal brass, written in my solitude.

8. Laws of peace, of love, of unity;
Of pity, compassion, forgiveness,
Let each chuse one habitation;
His ancient infinite mansion;
One command, one joy, one desire,
One curse, one weight, on measure
One King. one God. one Law.

Chap: III.

1. The voice ended, they saw his pale
visage
Emerge from the darkness; his hand
On the rock of eternity unclasping
The Book of brass. Rage siez'd the strong

2. Rage, fury, intense indignation
In cataracts of fire blood & gall
In whirlwinds of sulphurous smoke;
And enormous forms of energy;
All the seven deadly sins of the soul

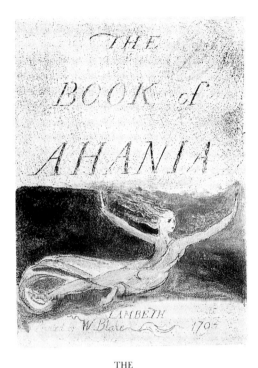

THE

BOOK of

AHANIA

LAMBETH

Printed by W Blake    1795

*3*

AHANIA

Chap: I<sup>st</sup>

...uzon, on a chariot iron-wing'd

..a spiked flames rose; his hot visage

..m'd furious! sparkles his hair & beard

..n down his mighty b...... and shoulders

..cloudy of smoke rages b............

d his right hand burns red in its

     cloud

..lding into a vast globe, his wrath

  the thunder-stone is moulded

n of Urizens silent burnings

Shall we worship this Demon of smoke,

..d Fuzon, this abstract non-entity

..is cloudy God seated on waters

..w seen, now obscur'd; King of sorrow?

So he spoke, in a fiery flame,

.. Urizen frowning indignant,

..e Globe of wrath shaking on high

..aring with fury, he threw

..e howling Globe: burning it flew

..ngthning into a hungry beam. Swiftly

Oppos'd to the exulting flam'd beam

..e broad Disk of Urizen upheav'd

..ross the Void many a mile.

It was forg'd in mills where the winter

..ats incessant; ten winters the disk

Chap: II:<sup>d</sup>

But the forehead of Urizen gathering.

d his eyes pale with anguish, his lips

Unremitting endur'd the cold hammer.

                              -ber'd

6: But the strong arm that sent it, remem-

The sounding beam, laughing it tore through

That based upon leap; at its direction

The wild loins of Urizen bending

7: Dire shriek'd his invisible Lust

Deep groan'd Urizen! stretching his awful hand

Ahania (so name his parted soul)

He siez'd on his mountains of jealousy.

He groan'd anguish'd & called her Sin,

Kissing her and weeping over her;

Then hid her in    darkness in    silence;

Jealous tho' she was invisible.

8: She fell down a faint shadow wandring

In chaos and circling dark Urizen,

As the moon anguish'd circles the earth;

Hopeless! abhorr'd! a death-shadow,

Unseen, unbodied, unknown,

The mother of Pestilence.

9: But the fiery beam of Fuzon

Was a pillar of fire to Egypt

Five hundred years wandring on earth

Till Los siezd it and beat in a mass

With the body of the sun.

*4*

Blue & changing; in tears and bitter

Contrition he prepar'd his Bow.

2: Form'd of Ribs: that in his dark solitude

When obscur'd in his forests fell monsters,

Arose. For his dire Contemplations

Rush'd down like floods from his mountains

In torrents of mud settling thick

With Eggs of unnatural production

Forthwith hatching; some howl'd on his hills

Some in vales; some aloft flew in air

3: Of these: an enormous dread Serpent

Scaled and poisonous horned

Approach'd Urizen even to his knees

As he sat on his dark rooted Oak.

4: With his horns he push'd furious.

Great the conflict & great the jealousy

In cold poisons: but Urizen smote him

5: First he poison'd the rocks with his blood

Then polish'd his ribs, and his sinews

Dried; laid them apart till winter;

Then a Bow black prepar'd; on this Bow

A poisoned rock plac'd in silence:

He utter'd these words to the Bow.

6: O Bow of the clouds of secresy!

O nerve of that lust form'd monster!

Send this rock swift, invisible thro'

The black clouds, on the bosom of Fuzon

7: So saying, In torments of his wounds,

He bent the enormous ribs slowly;

A circle of darkness! then fixed

The sinew in its rest: then the Rock

Poisonous source! plac'd with art, lifting dif-

ficult

Its weighty bulk silent the rock lay,

8: While Fuzon his tygers unloosing

Thought Urizen slain by his wrath.

I am God. said he. eldest of things!

9: Sudden sings the rock, swift & invisible

Of iron, from the dismal shade

5: The Tree still grows over the Void

Enrooting itself all around

An endless labyrinth of woe!

6: The corse of his first begotten

On the accursed Tree of Mystery:

On the topmost atom of that Tree

Urizen nail'd Fuzons corse.

Chap: IV.

1: Forth flew the arrows of pestilence

Round the pale living Corse on the tree

2: For in Urizens slumbers of abstraction

In the infinite ages of Eternity:

When his Nerves of Joy melted & flow'd

A white Lake on the dark blue air

In perturb'd pain and dismal torment

Now stretching out, now swift conglobing.

3: Effluvia vapor'd above

In noxious clouds; these hover'd thick

Over the disorganiz'd Immortal.

Till the petrific pain scurfd o'er the Lakes

As the bones of man, solid & dark

4: The clouds of disease hover'd wide

Around the Immortal in torment

Perching around the hurtling bones

Disease on disease, shape on shape,

Winged screaming in blood & torment.

5: The Eternal Prophet beat on his anvils

Enrag'd in the desolate darkness

He forg'd nets of iron around

And Los threw them around the bones

6: The shapes screaming flutter'd vain

Some combin'd into muscles & glands

Some organs for craving and lust

Most remain'd on the tormented void:

Urizens army of horrors.

On Fuzon flew, enter'd his bosom;

His beautiful visage, his tresses,

That gave light to the mornings of heaven

Were smitten with darkness, deform'd

And outstretch'd on the edge of the fo-

-rest

10: But the rock fell upon the Earth,

Mount Sinai, in Arabia.

Chap: III:

1: The Globe shook; and Urizen seated

On black clouds his sore wound anointed

The ointment flow'd down on the void

Mix'd with blood; here the snake gets

     her poison

2: With difficulty & great pain; Urizen

Lifted on high the dead corse:

On his shoulders he bore it to where

A Tree hung over the Immensity

3: For when Urizen shrunk away

From Eternals, he sat on a rock

Barren; a rock which himself

From redounding fancies had petrified

Many tears fell on the rock,

Many sparks of vegetation;

Soon shot the pained root

Of Mystery, under his heel:

It grew a thick tree; he wrote

In silence his book of iron:

Till the horrid plant bending its boughs

Grew to roots when it felt the earth

And again sprung to many a tree.

4: Amaz'd started Urizen! when

He beheld himself compassed round

And high roofed over with trees

He rose but the stems stood so thick

He with difficulty and great pain

Brought his Books, all but the Book

                              Of

*5*

7: Round the pale living Corse on the

     Tree

Forty years flew the arrows of pestilence

8: Wailing and terror and woe

Ran thro' all his dismal world:

Forty years all his sons & daughters

Felt their skulls harden; then Asia

Arose in the pendulous deep

9: They reptilize upon the Earth

10: Fuzon groan'd on the Tree.

Chap: V

1: The lamenting voice of Ahania

Weeping upon the void.

And round the Tree of Fuzon:

Distant in solitary night

Her voice was heard, but no form

Had she: but her tears from clouds

Eternal fell round the Tree

2: And the voice cried: Ah Urizen! Love!

Flower of morning! I weep on the verge

Of Non-entity; how wide the Abyss

Between Ahania and thee!

3: I lie on the verge of the deep.

I see thy dark clouds ascend

I see thy dark black forest and floods,

A horrible waste to my eyes!

4: Weeping I walk over rocks

Over dens & thro' valleys of death

Why didst thou despise Ahania

To cast me from thy bright presence

Into the World of Loneness

5: I cannot touch his hand:

Nor weep on his knees, nor hear

His voice & bow, nor see his eyes

And joy, nor hear his footsteps, and

My heart leap at the lovely sound!

I cannot kiss the place

Whereon his bright feet have trod,

[429]

6

But I wander on the rocks
With hard necessity

6: Where is my golden palace
Where my ivory bed
Where the joy of my morning hour
Where the sons of eternity, singing

7: To awake bright Urizen my king!
To ...
To the bliss of eternal valleys

8: To awake my king in the morn!
To embrace Ahania joy
On the bredth of his open bosom:
From my soft cloud of dew to fall
In showers of life on his harvests

9: When he gave my happy soul
To the sons of eternal joy:
When he took the daughters of life
Into my chambers of love:

10: When I found babes of bliss on my beds.
And bosoms of milk in my chambers
Fill'd with eternal seed
O! eternal births  sung round Ahania
In interchange sweet of their joys.

11: Swell'd with ripeness & fat with fatness
Bursting on winds my odors,
My ripe figs and rich pomegranates

In infant joy at thy feet
O Urizen sported and sang;

12: Then thou with thy lap full of seed
With thy hand full of generous fire
Walked forth from the bonds of morning
On the virgins of springing joy,
... the human soul to cast
The seed of eternal science.

13: The ... poured down thy temples
To Ahania return'd in evening
The moisture awoke to birth
My mothers-joys, sleeping in bliss.

14: But now alone over rocks, mountains
Cast out from thy lovely bosom:
Cruel jealousy! selfish fear!
Self-destroying: how can delight,
Renew in these chains of darkness
Where bones of beasts are strown
On the bleak and snowy mountains
Where bones from the birth are buried
Before they see the light.

FINIS

THE

BOOK of

LOS

LAMBETH

Printed by W Blake    1795

Chap. I

1: Eno aged Mother
Who the chariot of Leutha guides
Since the day of thunders in old time

2: Sitting beneath the eternal Oak
Trembled and shook the stedfast Earth
And thus her speech broke forth.

3: O Times remote!
When Love & Joy were adoration:
And none impure were deem'd.
Not Eyeless Covet
Nor Thin-lip'd Envy
Nor Bristled Wrath
Nor Curled Wantonness

4: But Covet was poured full:
Envy fed with fat of lambs:
Wrath with lions gore:
Wantonness lulld to sleep
With the virgins lute,
Or sated with her love

5: Till Covet broke his locks & bars.
And slept with open doors:
Envy sung at the rich mans feast:
Wrath was follow'd up and down
By a little ewe lamb
And Wantonness on his own true love
Begot a giant race:

6: Raging furious the flames of desire
Ran thro' heaven & earth, living flames

Darkness round Los: heat was not; for
     bound up
Into fiery spheres from his fury
The gigantic flames trembled and hid

10: Coldness, darkness, obstruction, a Solid
Without fluctuation, hard as adamant
Black as marble of Egypt; impenetrable
Bound in the fierce raging Immortal.
And the seperated fires froze in
A vast solid without fluctuation.
Bound in his expanding clear senses

Chap: II

1: The Immortal stood frozen amidst
The vast rock of eternity: times
And times: a night of vast durance:
Impatient, stifled, stiffend, hardned.

2: Till impatience no longer could bear
The hard bondage, rent: rent the vast
     solid
With a crash from immense to immense

3: Crack'd across into numberless frag-
     -ments
The Prophetic wrath, strug'ling for vent
Hurls apart, stamping furious to dust
And crumbling with bursting sobs: heaves
The black marble on high into fragments

4: Hurl'd apart on all sides, as a falling
Rock: the innumerable fragments away
Fell asunder; and horrible vacuum
Beneath him & on all sides round

5: Falling, falling! Los fell & fell
Sunk precipitant heavy down down
Times on time, night on night, day on day
Truth has bounds. Error none: falling
     falling:
Years on years, and ages on ages
Still he fell thro' the void, still a void
Found for falling day & night without
     end
For tho' day or night was not; their spaces

... Ethereal flowing... stretching out
Thro' the bottoms of...

5: He rose on the floods: then he smote
The wild deep with his terrible wrath,
Seperating the heavy and thin

6: Down the heavy sunk: cleaving around
To the fragments of solid: up rose

Intelligent, organizd: arm'd
With destruction & plagues.  In the mid
The Eternal Prophet bound in a chain
Compell'd to watch Urizens shadow

7: Rag'd with curses & sparkles of fury
Round the flames rolls as Los hurls
     his limbs
Mounting up from his fury condemn'd
Rolling round & round, mounting on hi
Into vacuum: into non-entity
Where nothing was! dash'd wide apart
His foot stamp the eternal fierce-raging
Rivers of wide flame: they roll round
And round on all sides making their way
Into darkness and shadowy obscurity

8: Wide apart stood the fires: Los remain
In the void between fire and fire
In trembling and horror they beheld him
They stood wide apart, driv'n by his har
And his feet which the nether abyss
Stamp'd in fury and hot indignation

9: But no light from the fires all was
                                          Dark

Were measur'd by his incessant whirls
In the horrid vacuity bottomless.

6: The Immortal revolving: indignant
First in wrath threw his limbs, like the
     babe
New born into our world: wrath subsided
And contemplative thoughts first arose
Then aloft his head rear'd in the Abyss
And his downward-borne fall chang'd obl

7: Many ages of groans: till there grew
Branchy forms, organizing the Human
Into finite inflexible organs.

8: Till in process from falling he bore
Sidelong on the purple air wafting
The weak breeze in efforts oerwearied

9: Incessant the falling Mind labour'd
Organizing itself: till the Vacuum
Became element, pliant to rise
Or to fall, or to swim, or to fly:
With ease searching the dire vacuity

Chap: III

1: The Lungs heave incessant, dull and
     heavy
For as yet were all other parts formless
Shiv'ring: clinging around like a cloud
Dim & glutinous as the white Polypus
Driv'n by waves & englob'd on the tide.

2: And the unformed part crav'd repose
Sleep began: the Lungs heave on the wave
Weary overweigh'd, sinking beneath
In a stifling black fluid he woke

3: He arose on the waters, but soon
Heavy falling his organs like roots
Shooting out from the seed, shot beneath
And a vast world of waters around him
In furious torrents began

4: Then he sunk, & around his spent Lungs
... that flowed in
The ... of the ... Outbranching
...

The ... flowing round the...
That ... in this expanse.

Chap. IV

1: Then Light first began; from the fires
Beams, conducted by fluid so pure
Flow'd around the Immense: Los beheld
Forthwith writhing upon the dark void

e Back bone of Urizen appear
rtling upon the wind
e a serpent! like an iron chain
irling about in the Deep.

pfolding his Fibres together
a Form of impregnable strength
astonish'd and terrified, built
naces; he formed an Anvil
ammer of adamant then began
e binding of Urizen day and night

ircling round the dark Demon, with
    howlings
may & sharp blightings; the Prophet
Eternity beat on his iron links

nd first from those infinite fires
e light that flow'd down on the winds
siez'd: beating incessant, condensing
e subtil particles in an Orb.

oaring indignant the bright sparks
hur'd the vast Hammer; but unwearied
s beat on the Anvil: till glorious
immense Orb of fire he fram'd

ft he quench'd it beneath in the
    Deeps
en survey'd the fall bright mass. Again
zing fires from the terrific Orbs
heated the round Globe, then beat

While roaring his Furnaces endur'd
The chaind Orb in their infinite wombs

7: Nine ages completed their circles
When Los heated the glowing mass, cast-
    -ing
It down into the Deeps: the Deeps fled
Away in redounding smoke; the Sun
Stood self-balanc'd. And Los smild
    with joy.
He the vast Spine of Urizen siez'd
And bound down to the glowing illusion

8. But no light, for the Deep fled away
On all sides, and left an unform'd
Dark vacuity: here Urizen lay
In fierce torments on his glowing bed

9: Till his Brain in a rock, & his Heart
In a fleshy slough formed four rivers
Obscuring the immense  Orb of fire
Flowing down into night: till a Form
Was completed, a Human Illusion
In darkness and deep clouds involvd.

The End of the
Book of LOS

Of terror & mild moony lustre, in soft sexual delusions
Of varied beauty, to delight the wanderer and repose
His burning thirst & freezing hunger! Come into my hand
By your mild power; descending down the Nerves of my right arm
From out the Portals of my Brain, where by your ministry
The Eternal Great Humanity Divine, planted his Paradise
And in it caus'd the Spectres of the Dead to take sweet forms
In likeness of himself. Tell also of the False Tongue! vegetated
Beneath your land of shadows: of its sacrifices. and
Its offerings; even till Jesus, the image of the Invisible God
Became its prey; a curse, an offering, and an atonement,
For Death Eternal. in the heavens of Albion, & before the Gates
Of Jerusalem his Emanation, in the heavens beneath Beulah

Say first! what mov'd Milton, who walkd about in Eternity
One hundred years. pondring the intricate mazes of Providence
Unhappy tho in heav'n, he obey'd, he murmur'd not. he was silent
Viewing his Sixfold Emanation scatter'd thro' the deep
In torment! To go into the deep her to redeem & himself perish?
What cause at length mov'd Milton to this unexampled deed
A Bards prophetic Song! for sitting at eternal tables,
Terrific among the Sons of Albion in chorus solemn & loud
A Bard broke forth! all sat attentive to the awful man.

Mark well my words! they are of your eternal salvation;

Three Classes are Created by the Hammer of Los, & Woven

By Enitharmons Looms when Albion was slain upon his Mountains
And in his Tent. thro envy of Living Form, even of the Divine Vision
And of the spaces of Wisdom in the Human Imagination
Which is the Divine Body of the Lord Jesus, blessed for ever.
Mark well my words. they are of your eternal salvation:

Urizen lay in darkness & solitude, in chains of the mind lock'd up
Los siezd his Hammer & Tongs; he labourd at his resolute Anvil
Among indefinite Druid rocks & snows of doubt & reasoning.

Refusing all Definite Form, the Abstract Horror roofd. stony hard.
And a first Age passed over & a State of dismal woe:

Down sunk with fright a red round Globe hot burning. deep
Deep down into the Abyss. panting: conglobing: trembling
And a second Age passed over & a State of dismal woe.

Rolling round into two little Orbs & closed in two little Caves
The Eyes beheld the Abyss: lest bones of solidness freeze over all
And a third Age passed over & a State of dismal woe

From beneath his Orbs of Vision Two Ears in close volutions
Shot spiring out in the deep darkness & petrified as they grew
And a fourth Age passed over & a State of dismal woe

Hanging upon the wind. Two Nostrils bent down into the Deep
And a fifth Age passed over & a State of dismal woe

In ghastly torment sick, a Tongue of hunger & thirst flamed out
And a sixth Age passed over & a State of dismal woe.

Enraged & stifled without & within: in terror & woe, he threw his
Right Arm to the north. his left Arm to the south. & his Feet
Stampd the nether Abyss in trembling & howling & dismay
  And a seventh Age passed over & a State of dismal woe

Terrified Los stood in the Abyss & his immortal limbs
Grew deadly pale; he became what he beheld; for a red
Round Globe sunk down from his Bosom into the Deep in pangs
He hoverd over it trembling & weeping. suspended it shook
The nether Abyss in temblings. he wept over it. he cherish'd it
In deadly sickening pain: till separated into a Female pale
As the cloud that brings the snow; all the while from his Back
A blue fluid exuded in Sinews hardening in the Abyss
Till it separated into a Male Form howling in Jealousy

Within labouring, beholding Without: from Particulars to Generals
Subduing his Spectre, they Builded the Looms of Generation
They Builded Great Golgonooza Times on Times Ages on Ages
First Orc was Born then the Shadowy Female: then All Los's Family
At last Enitharmon brought forth Satan Refusing Form, in vain

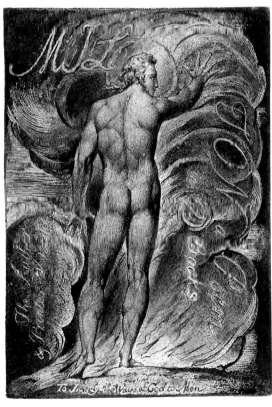

# MILTON
a Poem in 12 Books
The Author & Printer W Blake. 1804
To Justify the Ways of God to Men

## MILTON
### Book the First

  Daughters of Beulah! Muses who inspire the Poets Song
  Record the journey of immortal Milton thro' your Realms

The Miller of Eternity made subservient to the Great Harvest
That he may go to his own Place Prince of the Starry Wheels

3

Beneath the Plow of Rintrah & the Harrow of the Almighty
In the hands of Palamabron Where the Starry Mills of Satan
Are built beneath the Earth & Waters of the Mundane Shell
Here the Three Classes of Men take their Sexual texture Woven
The Sexual is Threefold: the Human is Fourfold

If you account it Wisdom when you are angry to be silent. and
Not to shew it: I do not account that Wisdom but Folly.
Every Mans Wisdom is peculiar to his own Individiality
O Satan my youngest born. art thou not Prince of the Starry Hosts
And of the Wheels of Heaven, to turn the Mills day & night?
Art thou not Newtons Pantocrator weaving the Woof of Locke
To Mortals thy Mills seem every thing & the Harrow of Shaddai
A scheme of Human conduct invisible & incomprehensible
Get to thy Labours at the Mills & leave me to my wrath

Satan was going to reply, but Los roll'd his loud thunders.

Anger me not! thou canst not drive the Harrow in pitys paths.
Thy Work is Eternal Death, with Mills & Ovens & Cauldrons.
Trouble me no more. thou canst not have Eternal Life

So Los spoke! Satan trembling obey'd weeping along the way.
Mark well my words, they are of your eternal Salvation
Between South Molton Street & Stratford Place: Calvarys foot
Where the Victims were preparing for Sacrifice their Cherubim
Around their loins pourd forth their arrows & their bosoms beam
With all colours of precious stones, & their inmost palaces
Resounded with preparation of animals wild & tame
(Mark well my words! Corporeal Friends
    are Spiritual Enemies)
Mocking Druidical Mathematical
Proportion of Length Bredth Highth
Displaying Naked Beauty! with Flute &
 Harp & Song

4

From Golgonooza the spiritual Four-fold London eternal
In immense labours & sorrows, ever building, ever falling,
Thro Albions four Forests which overspread all the Earth,
From London Stone to Blackheath east; to Hounslow west;
To Finchley north: to Norwood south: and the weights
Of Enitharmons Loom play lulling cadences on the
    winds of Albion
From Caithness in the north. to Lizard-point & Dover in the south

Loud sounds the Hammer of Los, & loud his Bellows is heard
Before London to Hampsteads breadths & Highgates heights To
Stratford & old Bow: & across to the Gardens of Kensington
On Tyburns Brook: loud groans Thames beneath the iron Forge
Of Rintrah & Palamabron of Theotorm & Bromion. to
    forge the instruments
Of Harvest: the Plow & Harrow to pass over the Nations

The Surrey hills glow like the clinkers of the furnace: Lambeths Vale
Where Jerusalems foundations began; where they were laid in ruins
Where they were laid in ruins from every Nation & Oak Groves rooted
Dark gleams before the Furnace-mouth, a heap of burning ashes
When shall Jerusalem return & overspread all the Nations
Return: return to Lambeths Vale O building of human souls
Thence stony Druid Temples overspread the Island white
And thence from Jerusalems ruins. from her ruins of ancient
 And praise: thro the whole Earth were reard from Ireland
To Mexico & Peru west, & east to China & Japan; till Babel
The Spectre of Albion frownd over the Nations in glory & war
All things begin & end in Albions ancient Druid rocky shore
But now the Starry Heavens are fled       ( ky shore
    from the mighty limbs of
        Albion
                                                armon
Loud sounds the Hammer of Los, loud turn the Wheels of Enith-

Her Looms vibrate with soft affections, weaving the Web of Life
Out from the ashes of the Dead; Los lifts his iron Ladles
With molten ore: he heaves the iron cliffs in his rattling chains
From Hyde Park to the Alms-houses of Mile-end & old Bow
Here the Three Classes of Mortal Men take their fixd destinations
And hence they overspread the Nations of the whole Earth & hence
The Web of Life is woven: & the tender sinews of life created
And the Three Classes of Men regulated by Los's hammer, [and
                                                      (woven]

5

[By Enitharmons Looms. & spun beneath the Spindle of Tirzah]
The first, The Elect from before the foundation of the World:
The second, The Redeemed. The Third. The Reprobate & Form'd
To destruction from the mothers womb:
                          follow with me my plow.

Of the first class was Satan: with incomparable mildness;
His primitive tyrannical attempts on Los: with most enduring love
He soft intreated Los to give him Palamabrons station;
For Palamabron returnd with labour wearied every evening
Palamabron oft refus'd; and as often Satan offer'd
His service till by repeated offers and repeated intreaties
Los gave to him the Harrow of the Almighty; alas blamable
Palamabron fear'd to be angry lest Satan should accuse him of
Ingratitude, & Los believe the accusation thro Satans extreme
Mildness, Satan labour'd all day. it was a thousand years
In the evening returning terrified overlabourd & astonish'd
Embrac'd soft with a brothers tears Palamabron. who also wept

Mark well my words! they are of your eternal salvation

Next morning Palamabron rose; the horses of the Harrow
Were maddened with tormenting fury, & the servants of the Harrow
The Gnomes, accus'd Satan. with indignation fury and fire.
Then Palamabron reddening like the Moon in an eclipse,
Spoke saying, You know Satans mildness and his self-imposition,
Seeming a brother, being a tyrant, even thinking himself a brother
While he is murdering the just; prophetic I behold
His future course thro' darkness and despair to eternal death
But we must not be tyrants also! he hath assum'd my place
For one whole day. under pretense of pity and love to me:
My horses hath he maddend! and my fellow servants injur'd:
How should he he know the duties of another? O foolish forbearance
Would I had told Los, all my heart! but patience O my friends,
All may be well: silent remain, while I call Los and Satan.

Loud as the wind of Beulah that unroots the rocks & hills
Palamabron call'd! and Los & Satan came before him
And Palamabron shew'd the horses & the servants. Satan wept,
And mildly cursing Palamabron, him accus'd of crimes
Himself had wrought. Los trembled; Satans blandishments almost
Perswaded the Prophet of Eternity that Palamabron
Was Satans enemy, & that the Gnomes being Palamabron's friends
Were leagued together against Satan thro' ancient enmity.
What could Los do? how could he judge, when Satans self, believ'd
That he had not oppres'd the horses of the Harrow, nor the servants.

So Los said, Henceforth Palamabron, let each his own station
Keep: nor in pity false, nor in officious brotherhood, where
None needs, be active. Mean time Palamabrons horses,
Rag'd with thick flames redundant, & the Harrow maddend with fury
Trembling Palamabron stood, the strongest of Demons trembled
Curbing his living creatures; many of the strongest Gnomes,
They bit in their wild fury, who also madden'd like wildest beasts

Mark well my words: they are of your eternal salvation

Mean while wept Satan before Los, accusing Palamabron;
Himself exculpating with mildest speech, for himself believ'd
That he had not oppres'd nor injur'd the refractory servants.

But Satan returning to his Mills (for Palamabron had serv'd
The Mills of Satan as the easier task) found all confusion,

And back return'd to Los. not fill'd with vengeance but with tears.
Himself convinc'd of Palamabrons turpitude, Los beheld
The servants of the Mills drunken with wine and dancing wild.
With shouts and Palamabrons songs, rending the forests green
With ecchoing confusion, tho' the Sun was risen on high.

Then Los took off his left sandal placing it on his head.
Signal of solemn mourning: when the servants of the Mills
Beheld the signal they in silence stood. tho' drunk with wine.
Los wept! But Rintrah also came, and Enitharmon on
His arm lean'd tremblingly observing all these things.

And Los said. Ye Genii of the Mills: the Sun is on high
Your labours call you! Palamabron is also in sad dilemma;
His horses are mad! his Harrow confounded! his companions enragd.
Mine is the fault! I should have remember'd that pity divides the soul
And, man, unmans. follow with me my Plow, this mournful day
Must be a blank in Nature; follow with me, and tomorrow again
Resume your labours, & this day shall be a mournful day

Wildly they follow'd Los and Rintrah, & the Mills were silent
They mourn'd all day this mournful day of Satan & Palamabron;
And all the Elect & all the Redeem'd mourn'd one toward another
Upon the mountains of Albion among the cliffs of the Dead.

They Plow'd in tears! incessant pourd Jehovahs rain. & Molechs
Thick fires contending with the rain, thunder'd above rolling
Terrible over their heads; Satan wept over Palamabron
Theotormon & Bromion contended on the side of Satan
Pitying his youth and beauty; trembling at eternal death;
Michael contended against Satan in the rolling thunder
Thulloh the friend of Satan also reprovd him; faint their reproof.

But Rintrah who is of the reprobate: of those Form'd to destruction
In indignation, for Satans soft dissimulation of friendship!
Flam'd above all the plowed furrows, angry red and furious.
Till Michael sat down in the furrow weary dissolv'd in tears
Satan who drove the team beside him, stood angry & red
He smote Thulloh & slew him, & he stood terrible over Michael
Urging him to arise: he wept! Enitharmon saw his tears
But Los hid Thulloh from her sight, lest she should die of grief
She wept; she trembled! she kissed Satan; she wept over Michael
She form'd a Space for Satan & Michael & for the poor infected
Trembling she wept over the Space, & clos'd it with a tender Moon

Los secret buried Thulloh, weeping disconsolate over the moony Space

But Palamabron called down a Great Solemn Assembly,
That he who will not defend Truth, may be compelled to
Defend a Lie, that he may be snared & caught & taken

And all Eden descended into Palamabrons tent
Among Albions Druids & Bards, in the caves beneath Albions
Death Couch, in the caverns of death, in the corner of the Atlantic.
And in the midst of the Great Assembly Palamabron pray'd:
O God protect me from my friends, that they have not power over me
Thou hast giv'n me power to protect myself from my bitterest enemies.

Mark well my words, they are of your eternal salvation

Then rose the Two Witnesses. Rintrah & Palamabron:
And Palamabron appeal'd to all Eden, and recievd
Judgment; and Lo; it fell on Rintrah and his rage:
Which now flam'd high & furious in Satan against Palamabron
Till it became a proverb in Eden. Satan is among the Reprobate.

Los in his wrath curs'd heaven & earth, he rent up Nations
Standing on Albions rocks among high reard Druid temples
Which reach the stars of heaven & stretch from pole to pole,
He displacd continents, the oceans fled before his face
He alter'd the poles of the world, cast. west & north & south
But he clos'd up Enitharmon from the sight of all these things

For Satan flaming with Rintrahs fury hidden beneath his own mildness
Accus'd Palamabron before the Assembly of ingratitude! of malice;
He created Seven deadly Sins drawing out his infernal scroll,
Of Moral laws and cruel punishments upon the clouds of Jehovah
To pervert the Divine voice in its entrance to the earth

With thunder of war & trumpets sound, with armies of disease
Punishments & deaths musterd & number'd; Saying I am God alone
There is no other! let all obey my principles of moral individuality
I have brought them from the uppermost innermost recesses
Of my Eternal Mind, transgressors I will rend off for ever,
As now I rend this accursed Family from my covering.

Thus Satan rag'd amidst the Assembly! and his bosom grew
Opake against the Divine Vision; the paved terraces of
His bosom inwards shone with fires, but the stones becoming opake!
Hid him from sight. in an extreme blackness and darkness,
And there a World of deeper Ulro was open'd, in the midst
Of the Assembly. In Satans bosom a vast unfathomable Abyss.

Astonishment held the Assembly in an awful silence; and tears
Fell down as dews of night, & a loud solemn universal groan
Was utter'd from the east & from the west & from the south
And from the north; and Satan stood opake immeasurable
Covering the east with solid blackness, round his hidden heart
With thunders utterd from his hidden wheels; accusing loud
The Divine Mercy, for protecting Palamabron in his tent,

Rintrah rear'd up walls of rocks and pourd rivers & moats
Of fire round the walls: columns of fire guard around
Between Satan and Palamabron in the terrible darkness.

And Satan not having the Science of Wrath, but only of Pity:
Rent them asunder, and wrath was left to wrath, & pity to pity,
He sunk down a dreadful Death, unlike the slumbers of Beulah

The Separation was terrible; the Dead was repos'd on his Couch
Beneath the Couch of Albion, on the seven mou[n]tains of Rome
In the whole place of the Covering Cherub. Rome Babylon & Tyre.
His Spectre raging furious descended into its Space

8*

Then Los & Enitharmon knew that Satan is Urizen
Drawn down by Orc & the Shadowy Female into Generation
Oft Enitharmon enterd weeping into the Space, there appearing
An aged Woman raving along the Streets (the Space is named
Canaan) then she returnd to Los weary frighted as from dreams

The nature of a Female Space is this: it shrinks the Organs
Of Life till they become Finite & Itself seems Infinite.

And Satan vibrated in the immensity of the Space! Limited
To those without but Infinite to those within: it fell down and
Became Canaan: closing Los from Eternity in Albions Cliffs
A mighty Fiend against the Divine Humanity mustring to War

Satan! Ah me! is gone to his own place, said Los! their God
I will not worship in their Churches nor King in their Theatres
Elynittria: whence is this Jealousy running along the mountains
British Women were not Jealous when Greek & Roman were Jealous
Every thing in Eternity shines by its own Internal light; but thou
Darkenest every Internal light with the arrows of thy quiver
Bound up in the horns of Jealousy to a deadly fading Moon
And Ocalythron binds the Sun into a Jealous Globe
That every thing is fix'd Opake without Internal light

So Los lamented over Satan, who triumphant
    divided the Nations

9

He set his face against Jerusalem to destroy the Eon of Albion

But Los hid Enitharmon from the sight of all these things.
Upon the Thames whose lulling harmony repos'd her soul:
Where Beulah lovely terminates in rocky Albion:
Terminating in Hyde Park. on Tyburns awful brook

And the Mills of Satan were separated into a moony Space
Among the rocks of Albions Temples, and Satans Druid sons
Offer the Human Victims throughout all the Earth. and Albions
Dread Tomb immortal on his Rock. overshadowd the whole Earth:
Where Satan making to himself Laws from his own identity.
Compell'd others to serve him in moral gratitude & submission
Being call'd God; setting himself above all that is called God
And all the Spectres of the Dead calling themselves Sons of God

[433]

In his Synagogues worship Satan under the Unutterable Name

And it was enquir'd: Why in a Great Solemn Assembly
The Innocent should be condemn'd for the Guilty? Then an Eternal rose

Saying, If the Guilty should be condemn'd, he must be an Eternal Death
And one must die for another throughout all Eternity.
Satan is fall'n from his station & never can be redeem'd
But must be new Created continually moment by moment
And therefore the Class of Satan shall be call'd the Elect, & those
Of Rintrah, the Reprobate, & those of Palamabron the Redeem'd
For he is redeem'd from Satans Law, the wrath falling on Rintrah:
And therefore Palamabron dared not to call a solemn Assembly

Till Satan had assum'd Rintrahs wrath in the day of mourning
In a feminine delusion of false pride self-deciev'd

So spoke the Eternal and confirm'd it with a thunderous oath
(-tion
But when Leutha (a Daughter of Beulah) beheld Satans condemna-
She down descended into the midst of the Great Solemn Assembly
Offering herself a Ransom for Satan, taking on her, his Sin

Mark well my words, they are of your eternal salvation!

-cing
And Leutha stood glowing with varying colours immortal, heart-pier-
And lovely: & her moth-like elegance shone, over the Assembly

At length standing upon the golden floor of Palamabron
She spoke: I am the Author of this Sin! by my suggestion
My Parent power Satan has committed this transgression.
I loved Palamabron & I sought to approach his Tent,
But beautiful Elynittria with her silver arrows repelld me.

10

For her light is terrible to me. I fade before her immortal beauty.
O wherefore doth a Dragon-form forth issue from my limbs
To sieze her new born son? Ah me! the wretched Leutha!
This to prevent. entering the doors of Satans brain night after night
Like sweet perfumes I stupified the masculine perceptions
And kept only the feminine awake. hence rose, his soft
Delusory love to Palamabron: admiration join'd with envy
Cupidity unconquerable! my fault, when at noon of day
The Horses of Palamabron call'd for rest and pleasant death:
I sprang out of the breast of Satan. over the Harrow beaming
In all my beauty: that I might unloose the flaming steeds
As Elynittria use'd to do: but too well those living creatures
Knew that I was not Elynittria. and they brake the traces
But me, the servants of the Harrow saw not; but as a bow
Of varying colours on the hills; terribly rag'd the horses.
Satan astonishd, and with power above his own controll
Compell'd the Gnomes to curb the horses, & to throw banks of sand
Around the fiery flaming Harrow in labyrinthine forms.
And brooks between to intersect the meadows in their course.
The Harrow cast thick flames: Jehovah thunderd above:
Chaos & ancient night fled from beneath the fiery Harrow:
The Harrow cast thick flames & orb'd us round in concave fires
A Hell of our own making, see, its flames still gird me round
Jehovah thunder'd above: Satan in pride of heart
Drove the fierce Harrow among the constellations of Jehovah
Drawing a third part in the fires as stubble north & south
To devour Albion and Jerusalem the Emanation of Albion
Driving the Harrow in Pitys paths 'twas then with our dark hew
Which now gird round us (O eternal torment) I form'd the Serpent
Of precious stones & gold turn'd poisons on the sultry wastes
The Gnomes call'd it pity and they curs'd Satan bitterly
To do unkind things in kindness. with power armd. to say
The most irritating things in the midst of tears and love
These are the stings of the Serpent! thus did we by them; till thus
They in return retaliated, and the Living Creatures maddend.
The Gnomes labourd. I weeping hid in Satans inmost brain;
But when the Gnomes refus'd to labour more, with blandishments
I came forth from the head of Satan! back the Gnomes recoil'd
And call'd me Sin, and for a sign portentous held me. Soon
Day sunk and Palamabron return'd, trembling I hid myself.
In Satans inmost Palace of his nervous fine wrought Brain:

For Elynittria met Satan with all her singing women.
Terrific in their joy & pouring wine of wildest power
They gave Satan their wine: indignant at the burning wrath.
Wild with prophetic fury his former life became like a dream
Cloth'd in the Serpents folds, in selfish holiness demanding purity
Being most impure, self-condemn'd to eternal tears, he drove
Me from his inmost Brain & the doors clos'd with thunders sound
O Divine Vision who didst create the Female, to repose
The Sleepers of Beulah: pity the repentant Leutha. My

Sick

Sick Couch bears the dark shades of Eternal Death infolding,
The Spectre of Satan, he furious refuses to repose in sleep
I humbly bow in all my Sin before the Throne Divine,
Not so the Sick-one, Alas what shall be done him to restore?
Who calls the Individual Law, Holy: and despises the Saviour.
Glorying to involve Albions Body in fires of eternal War

Now Leutha ceas'd: tears flow'd: but the Divine Pity supported her.

All is my fault! We are the Spectre of Luvah the murderer
Of Albion: O Vala! O Luvah! O Albion! O lovely Jerusalem
The Sin was begun in Eternity. and will not rest to Eternity
Till two Eternitys meet together, Ah! lost! lost! lost! for ever!

So Leutha spoke. But when she saw that Enitharmon had
Created a New Space to protect Satan from punishment:
She fled to Enitharmons Tent & hid herself. Loud raging
Thundered the Assembly dark & clouded. and they ratify'd
The kind decision of Enitharmon & gave a Time to the Space,
Even Six Thousand years: and sent Lucifer for its Guard.
But Lucifer refus'd to die & in pride he forsook his charge
And they elected Molech, and when Molech was impatient
The Divine hand found the Two Limits: first of Opacity, then of Contraction
Opacity was named Satan, Contraction was named Adam.
Triple Elohim came: Elohim wearied fainted: they elected Shaddai.
Shaddai angry. Pahad descended: Pahad terrified. they sent Jehovah
And Jehovah was leprous; loud he call'd. stretching his hand to Eternity
For then the Body of Death was perfected in hypocritic holiness.
Around the Lamb. a Female Tabernacle woven in Cathedrons Looms
He died as a Reprobate. he was Punish'd as a Transgressor:
Glory! Glory! Glory! to the Holy Lamb of God
I touch the heavens as an instrument to glorify the Lord!
The Elect shall meet the Redeem'd. on Albions rocks they shall meet
Astonish'd at the Transgressor, in him beholding the Saviour.
And the Elect shall say to the Redeemd. We behold it is of Divine
Mercy alone! of Free Gift and Election that we live.
Our Virtues & Cruel Goodnesses, have deserv'd Eternal Death.
Thus they weep upon the fatal Brook of Albions River.

But Elynittria met Leutha in the place where she was hidden.
And threw aside her arrows. and laid down her sounding Bow:
She sooth'd her with soft words & brought her to Palamabrons bed
In moments new created for delusion. interwoven round about,
In dreams she bore the shadowy Spectre of Sleep, & namd him Death,
In dreams she bore Rahab the mother of Tirzah & her sisters,
In Lambeths vales: in Cambridge & in Oxford, places of Thought
Intricate labyrinths of Times and Spaces unknown, that Leutha lived
In Palamabrons Tent, and Oothoon was her charming guard.

The Bard ceas'd. All consider'd and a loud resounding murmur
Continu'd round the Halls: and much they question'd the immortal
Loud voic'd Bard. and many condemn'd the high tone'd Song
Saying Pity and Love are too venerable for the imputation
Of Guilt. Others said. If it is true! if the acts have been perform'd
Let the Bard himself witness. Where hadst thou this terrible Song

The Bard replied. I am Inspired! I know it is Truth! for I Sing

According to the inspiration of the Poetic Genius
Who is the eternal all protecting Divine Humanity
To whom be Glory & Power & Dominion Evermore Amen

Then there was great murmuring in the Heavens of Albion
Concerning Generation & the Vegetative power & concerning

The Lamb the Saviour: Albion trembled to Italy Greece & Egypt
To Tartary & Hindostan & China & to Great America
Shaking the roots & fast foundations of the Earth in doubtfulness
The loud voic'd Bard terrify'd took refuge in Miltons bosom

Then Milton rose up from the heavens of Albion ardorous!
The whole Assembly wept prophetic, seeing in Miltons face
And in his lineaments divine the shades of Death & Ulro
He took off the robe of the promise, & ungirded himself from
      the oath of God

And Milton said, I go to Eternal Death! The Nations still
Follow after the detestable Gods of Priam; in pomp
Of warlike selfhood. contradicting and blaspheming.
When will the Resurrection come; to deliver the sleeping body
From corruptibility; O when Lord Jesus wilt thou come?
Tarry no longer; for my soul lies at the gates of death.
I will arise and look forth for the morning of the grave.
I will go down to the sepulcher to see if morning breaks!
I will go down to self annihilation and eternal death,
Lest the Last Judgment come & find me unannihilate
And I be siez'd & giv'n into the hands of my own Selfhood
The Lamb of God is seen thro' mists & shadows, hov'ring
Over the sepulchers in clouds of Jehovah & winds of Elohim
A disk of blood, distant; & heav'ns & earth's roll dark between
What do I here before the Judgment? without my Emanation?
With the daughters of memory, & not with the daughters of inspiration
I in my Selfhood am that Satan: I am that Evil one!
He is my Spectre! in my obedience to loose him from my Hells
To claim the Hells, my Furnaces, I go to Eternal Death.

And Milton said, I go to Eternal Death! Eternity shudder'd
For he took the outside course, among the graves of the dead
A mournful shade. Eternity shudderd at the image of eternal death

Then on the verge of Beulah he beheld his own Shadow;
A mournful form double; hermaphroditic: male & female
In one wonderful body, and he enterd into it
In direful pain for the dread shadow, twenty-seven-fold
Reachd to the depths of direst Hell, & thence to Albions land:
Which is this earth of vegetation on which now I write.

The Seven Angels of the Presence wept over Miltons Shadow!

14

As when a man dreams, he reflects not that his body sleeps,
Else he would wake; so seem'd he entering his Shadow: but
With him the Spirits of the Seven Angels of the Presence
Entering; they gave him still perceptions of his Sleeping Body;
In Beulah, by the Waters of Comfort on their uttermost brink
Image Divine tho' darken'd, and tho' walking as one walks
In sleep; and the Seven comforted and supported him.

Like as a Polypus that vegetates beneath the deep!
They saw his Shadow vegetated underneath the Couch
Of death: for when he enterd into his Shadow: Himself:
His real and immortal Self; was as appeard to those
Who dwell in immortality, as One sleeping on a couch
Of gold; and those in immortality gave forth their Emanations
Like Females of sweet beauty, to guard round him & to feed
His lips with food of Eden in his cold and dim repose!
But to himself he seemd a wanderer lost in dreary night.

Onwards his Shadow kept its course among the Spectres; call'd
Satan, but swift as lightning passing them. startled the shades
Of Hell beheld him in a trail of light as of a comet
That travels into Chaos: so Milton went guarded within.

The nature of infinity is this! That every thing, has its
Own Vortex; and when once a traveller thro Eternity.
Has passd that Vortex, he percieves it roll backward behind
His path, into a globe itself infolding: like a sun:
Or like a moon, or like a universe of starry majesty.
While he keeps onwards in his wondrous journey on the earth
Or like a human form, a friend with with whom he livd benevolent
As the eye of man views both the east & west encompassing
Its vortex; and the north & south, with all their starry host;

Also the rising sun & setting moon he views surrounding
His corn-fields and his valleys of five hundred acres square,
Thus is the earth one infinite plane, and not as apparent
To the weak traveller confin'd beneath the moony shade.
Thus is the heaven a vortex passd already, and the earth
A vortex not yet pass'd by the traveller thro' Eternity.

First Milton saw Albion upon the Rock of Ages.
Deadly pale outstretchd and snowy cold, storm coverd:
A Giant form of perfect beauty outstretchd on the rock
In solemn death. the Sea of Time & Space thunderd aloud
Against the rock, which was inwrapped with the weeds of death
Hovering over the cold bosom, in its vortex Milton bent down
To the bosom of death, what was underneath soon seemd above.
A cloudy heaven mingled with stormy seas in loudest ruin;
But as a wintry globe descends precipitant thro' Beulah bursting,
With thunders loud and terrible: so Miltons shadow fell,
Precipitant loud thundring into the Sea of Time & Space.

Then first I saw him in the Zenith as a falling star.
Descending perpendicular, swift as the swallow or swift;
And on my left foot falling on the tarsus, enterd there;
But from my left foot a black cloud redounding spread over Europe.

Then Milton knew that the Three Heavens of Beulah were beheld
By him on earth in his bright pilgrimage of sixty years

               In

15

[tablet on the left]            [tablet on the right]

תחו                         יום

ו׳זה                 שׁיחזו ה

וא סש

To Annihilate the Self- -hood of Deceit &
        False Forgiveness

16

                 (Daughters
In those three females whom his Wives, & those three whom his
Had represented and containd. that they might be resum'd
By giving up of Selfhood: & they distant view'd his journey
In their eternal spheres, now Human, tho' their Bodies remain clos'd
In the dark Ulro till the Judgment: also Milton knew: they and
Himself was Human, tho' now wandering thro Death's Vale
In conflict with those Female forms, which now he own'd no more
Surrounded him, dividing & uniting without end or number.

He saw the Cruelties of Ulro, and he wrote them down
In iron tablets: and his Wives & Daughters names were these
Rahab and Tirzah, & Milcah & Malah & Noah & Hoglah.
They sat rang'd round him as the rocks of Horeb round the land
Of Canaan: and they wrote in thunder smoke and fire
His dictate; and his body was the Rock Sinai; that body,
Which was on earth born to corruption: & the six Females
Are Hor & Peor & Bashan & Abarim & Lebanon & Hermon
Seven rocky masses terrible in the Desarts of Midian.

But Miltons Human Shadow continu'd journeying above
The rocky masses of The Mundane Shell; in the Lands
Of Edom & Aram & Moab & Midian & Amalek.

The Mundane Shell, is a vast Concave Earth: an immense
Hardend shadow of all things upon our Vegetated Earth
Enlarg'd into dimension & deform'd into indefinite space
In Twenty-seven Heavens and all their Hells; with Chaos
And Ancient Night; & Purgatory. It is a cavernous Earth
Of labyrinthine intricacy twenty-seven-folds of opakeness
And finishes where the lark mounts; here Milton journeyed
In that Region calld Midian, among the Rocks of Horeb
For travellers from Eternity, pass outward to Satans seat
But travellers to Eternity, pass inward to Golgonooza.

Los the Vehicular terror beheld him, & divine Enitharmon

Call'd all her daughters, Saying, Surely to unloose my bond
Is this Man come! Satan shall be unloosd upon Albion

Los heard in terror Enitharmons words: in fibrous strength
His limbs shot forth like roots of trees against the forward path
Of Miltons journey. Urizen beheld the Immortal Man,
And

17

And Tharmas Demon of the Waters, & Orc. who is Luvah

The Shadowy Female seeing Milton. howld in her lamentation
Over the Deeps. outstretching her Twenty seven Heavens over Albion

And thus the Shadowy Female howls in articulate howlings

I will lament over Milton in the lamentations of the afflicted
My Garments shall be woven of sighs & heart broken lamentations
The misery of unhappy Families shall be drawn out into its border
Wrought with the needle with dire sufferings poverty pain & woe
Along the rocky Island & thence throughout the whole Earth
There shall be the sick Father & his starving Family! there
The Prisoner in the stone Dungeon & the Slave at the Mill
I will have Writings written all over it in Human Words
That every Infant that is born upon the Earth shall read
And get by rote as a hard task of a life of sixty years
I will have Kings inwoven upon it. & Councellors & Mighty Men
The Famine shall clasp it together with buckles & Clasps
And the Pestilence shall be its fringe & the War its girdle
To divide into Rahab & Tirzah that Milton may come to our tents
For I will put on the Human Form & take the Image of God
Even Pity & Humanity but my Clothing shall be Cruelty
And I will put on Holiness as a breastplate & as a helmet
And all my ornaments shall be of the gold of broken hearts
And the precious stones of anxiety & care & desperation & death
And repentance for sin & sorrow & punishment & fear
To defend me from thy terrors O Orc! my only beloved!

Orc answerd. Take not the Human Form O loveliest. Take not
Terror upon thee! Behold how I am & tremble lest thou also
Consume in my Consummation; but thou maist take a Form
Female & lovely, that cannot consume in Mans consummation
Wherefore dost thou Create & Weave this Satan for a Covering
When thou attemptest to put on the Human Form. my wrath
Burns to the top of heaven against thee in Jealousy & Fear,
Then I rend thee asunder. then I howl over thy clay & ashes
When wilt thou put on the Female Form as in times of old
With a Garment of Pity & Compassion like the Garment of God
His garments are long sufferings for the Children of Men
Jerusalem is his Garment & not thy Covering Cherub O lovely
Shadow of my delight who wanderest seeking for the prey.

So spoke Orc when Oothoon & Leutha hoverd over his Couch
Of fire in interchange of Beauty & Perfection in the darkness
Opening interiorly into Jerusalem & Babylon shining glorious
In the Shadowy Females bosom Jealous her darkness grew
Howlings filld all the desolate places in accusations of Sin
In Female beauty shining in the unformd void & Orc in vain
Stretch'd out his hands of fire. & wooed; they triumph in his pain

Thus darkend the Shadowy Female tenfold & Orc tenfold
Glowd on his rocky Couch against the darkness: loud thunders
Told of the enormous conflict. Earthquake beneath: around:
Rent the Immortal Females, limb from limb & joint from joint
And moved the fast foundations of the Earth to wake the Dead

Urizen emerged from his Rocky Form & from his Snows

111

And he also darkend his brows freezing dark rocks between
The footsteps. and infixing deep the feet in marble beds:
That Milton laboured with his journey. & his feet bled sore
Upon the clay now chang'd to marble; also Urizen rose.
And met him on the shores of Arnon; & by the streams of the brooks

Silent they met, and silent strove among the streams of Arnon
Even to Mahanaim, when with cold hand Urizen stoop'd down
And took up water from the river Jordan: pouring on

To Miltons brain the icy fluid from his broad cold palm.
But Milton took of the red clay of Succoth. moulding it with care
Between his palms; and filling up the furrows of many years
Beginning at the feet of Urizen, and on the bones
Creating new flesh on the Demon cold, and building him,
As with new clay a Human form in the Valley of Beth Peor.

Four Universes round the Mundane Egg remain Chaotic
One to the North, named Urthona: One to the South, named Urizen:
One to the East, named Luvah: One to the West, named Tharmas
They are the Four Zoa's that stood around the Throne Divine!
But when Luvah assum'd the World of Urizen to the South,
And Albion was slain upon his mountains, & in his tent;
All fell towards the Center in dire ruin, sinking down.
And in the South remains a burning fire; in the East a void.
In the West, a world of raging waters; in the North a solid,
Unfathomable! without end, But in the midst of these,
Is built eternally the Universe of Los and Enitharmon:
Towards which Milton went, but Urizen oppos'd his path.

The Man and Demon strove many periods, Rahab beheld
Standing on Carmel; Rahab and Tirzah trembled to behold
The enormous strife, one giving life, the other giving death
To his adversary. and they sent forth all their sons & daughters
In all their beauty to entice Milton across the river,

The Twofold form Hermaphroditic: and the Double-sexed:
The Female-male & the Male-female, self-dividing stood
Before him in their beauty, & in cruelties of holiness!
Shining in darkness, glorious upon the deeps of Entuthon.

Saying. Come thou to Ephraim! behold the Kings of Canaan!
The beautiful Amalekites, behold the fires of youth
Bound with the Chain of Jealousy by Los & Enitharmon;
The banks of Cam: cold learnings streams: Londons dark-frowning tow
Lament upon the winds of Europe in Rephaims Vale.
Because Ahania rent apart into a desolate night,
Laments! & Enion wanders like a weeping inarticulate voice
And Vala labours for her bread & water among the Furnaces
Therefore bright Tirzah triumphs! putting on all beauty,
And all perfection, in her cruel sports among the Victims.
Come bring with thee Jerusalem with songs on the Grecian Lyre!
In Natural Religion! in experiments on Men,
Let her be Offerd up to Holiness! Tirzah numbers her;
She numbers with her fingers every fibre ere it grow;
Where is the Lamb of God? where is the promise of his coming?
Her shadowy Sisters form the bones, even the bones of Horeb:
Around the marrow! and the orbed scull around the brain:
His Images are born for War! for Sacrifice to Tirzah:
To Natural Religion! to Tirzah the Daughter of Rahab the Holy!
She ties the knot of nervous fibres, into a white brain!
She ties the knot of bloody veins, into a red hot heart!
Within her bosom Albion lies embalmd, never to awake
Hand is become a rock! Sinai & Horeb, is Hyle & Coban:
Scofield is bound in iron armour before Reubens Gate!
She ties the knot of milky seed into two lovely Heavens,

Two yet but one: each in the other sweet reflected: these
Are our Three Heavens beneath the shades of Beulah. land of rest
Come thou to Ephraim & Manasseh O beloved one!
Come to my ivory palaces O beloved of thy mother!
And let us bind thee in the bands of War & be thou King
Of Canaan and reign in Hazor where the Twelve Tribes meet.

So spoke they as in one voice! Silent Milton stood before
The darkend Urizen; as the sculptor silent stands before
His forming image; he walks round it patient labouring.
Thus Milton stood forming bright Urizen, while his Mortal part
Sat frozen in the rock of Horeb: and his Redeemed portion,
Thus form'd the Clay of Urizen; but within that portion
His real Human walkd above in power and majesty
Tho darkend; and the Seven Angels of the Presence attended him

O how can I with my gross tongue that cleaveth to the dust.
Tell of the Four-fold Man. in starry numbers fitly orderd
Or how can I with my cold hand of clay! But thou O Lord

Do with me as thou wilt! for I am nothing, and vanity:
If thou chuse to elect a worm, it shall remove the mountains.
For that portion namd the Elect: the Spectrous body of Milton:
Redounding from my left foot into Los's Mundane space,
Brooded over his Body in Horeb against the Resurrection
Preparing it for the Great Consummation; red the Cherub on Sinai
Glow'd; but in terrors folded round his clouds of blood.

Now Albions sleeping Humanity began to turn upon his Couch;
Feeling the electric flame of Miltons awful precipitate descent.
Seest thou the little winged fly smaller than a grain of sand?
It has a heart like thee; a brain open to heaven & hell,
Withinside wondrous & expansive: its gates are not clos'd,
I hope thine are not: hence it clothes itself in rich array;
Hence thou art cloth'd with human beauty O thou mortal man
Seek not thy heavenly father then beyond the skies:
There Chaos dwells & ancient Night & Og & Anak old:
For every human heart has gates of brass & bars of adamant,
Which few dare unbar because dread Og & Anak guard the gates
Terrific! and each mortal brain is walld and moated round
Within: and Og & Anak watch here; here is the Seat
Of Satan in its Webs; for in brain and heart and loins
Gates open behind Satans Seat to the City of Golgonooza
Which is the spiritual fourfold London in the loins of Albion

Thus Milton fell thro' Albions heart, travelling outside of Humanity
Beyond the Stars in Chaos in Caverns of the Mundane Shell.

But many of the Eternals rose up from eternal tables
Drunk with the Spirit, burning round the Couch of death they stood
Looking down into Beulah! wrathful, fill'd with rage!
They rend the heavens round the Watchers in a fiery circle:
And round the Shadowy Eighth: the Eight close up the Couch
Into a tabernacle, and flee with cries down to the Deeps:
Where Los opens his three wide gates, surrounded by raging fires;
They soon find their own place & join the Watchers of the Ulro.

Los saw them and a cold pale horror coverd o'er his limbs
Pondering he knew that Rintrah & Palamabron might depart:
Even as Reuben & as Gad; gave up himself to tears.
He sat down on his anvil-stock; and leand upon the trough,
Looking into the black water, mingling it with tears.

At last when desperation almost tore his heart in twain
He recollected an old Prophecy in Eden recorded,
And often sung to the loud harp at the immortal feasts
That Milton of the Land of Albion should up ascend
Forwards from Ulro from the Vale of Felpham, and set free
Orc from his Chain of Jealousy: he started at the thought

And

vn

And down descended into Udan Adan: it was night:
And Satan sat sleeping upon his Couch in Udan Adan:
His Spectre slept, his Shadow woke: when one sleeps th'other wakes

But Milton entering my Foot: I saw in the nether
Regions of the Imagination; also all men on Earth,
And all in Heaven, saw in the nether regions of the Imagination
In Ulro beneath Beulah, the vast breach of Miltons descent.
But I knew not that it was Milton, for man cannot know
What passes in his members till periods of Space & Time
Reveal the secrets of Eternity: for more extensive
Than any other earthly things, are Mans earthly lineaments.

And all this Vegetable World appeard on my left Foot,
As a bright sandal formd immortal of Precious stones & gold:
I stooped down & bound it on to walk forward thro' Eternity.

There is in Eden a sweet River, of milk & liquid pearl,
Namd Ololon; on whose mild banks dwelt those who Milton drove
Down into Ulro: and they wept in long resounding song
For seven days of eternity, and the rivers living banks
The mountains waild! & every plant that grew, in solemn sighs lamented.

When Luvahs bulls each morning drag the sulphur Sun out of the Deep
Harnessd with starry harness black & shining kept by black slaves
That work all night at the starry harness. Strong and vigorous
They drag the unwilling Orb: at this time all the Family

Of Eden heard the lamentation, and Providence began,
But when the clarions of day sounded they drownd the lamentations
And when night came all was silent in Ololon: & all refusd to lament
In the still night fearing lest they should others molest,

Seven mornings Los heard them, as the poor bird within the shell
Hears its impatient parent bird: and Enitharmon heard them:
But saw them not, for the blue Mundane Shell inclosd them in.
And they lamented that they had in wrath & fury & fire
Driven Milton into the Ulro: for now they knew too late
That it was Milton the Awakener! they had not heard the Bard.
Whose song calld Milton to the attempt; and Los heard these laments,
He heard them call in prayer all the Divine Family;
And he beheld the Cloud of Milton stretching over Europe.

But all the Family Divine collected as Four Suns
In the Four Points of heaven East, West & North & South
Enlarging and enlarging till their Disks approachd each other:
And when they touch'd closed together Southward in One Sun
Over Ololon: and as One Man, who weeps over his brother,
In a dark tomb, so all the Family Divine, wept over Ololon.

Saying, Milton goes to Eternal Death! so saying, they groan'd in spirit
And were troubled! and again the Divine Family groaned in spirit!

And Ololon said, Let us descend also, and let us give
Ourselves to death in Ulro among the Transgressors,
Is Virtue a Punisher? O no! how is this wondrous thing:
This World beneath, unseen before; this refuge from the wars
Of Great Eternity! unnatural refuge! unknown by us till now:
Or are these the pangs of repentance? let us enter into them

Then the Divine Family said Six Thousand Years are now
Accomplish'd in this World of Sorrow; Miltons Angel knew
The Universal Dictate; and you also feel this Dictate.
And now you know this World of Sorrow, and feel Pity. Obey
The Dictate! Watch over this World, and with your brooding wings,
Renew it to Eternal Life: Lo! I am with you alway
But you cannot renew Milton he goes to Eternal Death

So spoke the Family Divine as One Man even Jesus
Uniting in One with Ololon & the appearance of One Man
Jesus the Saviour appeard coming in the Clouds of Ololon:

21

Tho driven away with the Seven Starry Ones into the Ulro
Yet the Divine Vision remains Every-where For-ever. Amen.
And Ololon lamented for Milton with a great lamentation

While Los heard indistinct in fear, what time I bound my sandals
On, to walk forward thro' Eternity, Los descended to me;
And Los behind me stood; a terrible flaming Sun: just close
Behind my back; I turned round in terror, and behold.
Los stood in that fierce glowing fire; & he also stoop'd down
And bound my sandals on in Udan-Adan; trembling I stood
Exceedingly with fear & terror, standing in the Vale
Of Lambeth: but he kissed me and wishd me health.
And I became one Man with him arising in strength:
Twas too late now to recede. Los had enterd into my soul:
His terrors now posses'd me whole! I arose in fury & strength.

I am that Shadowy Prophet who Six Thousand Years ago
Fell from my station in the Eternal bosom. Six Thousand Years
Are finishd. I return! both Time & Space obey my will.
I in Six Thousand Years walk up and down; for not one Moment
Of Time is lost, nor one Event of Space unpermanent
But all remain: every fabric of Six Thousand Years
Remains permanent: tho' on the Earth where Satan
Fell, and was cut off all things vanish & are seen no more
They vanish not from me & mine, we guard them first & last
The generations of men run on in the tide of Time
But leave their destind lineaments permanent for ever & ever.
So spoke Los as we went along to his supreme abode

Rintrah and Palamabron met us at the Gate of Golgonooza
Clouded with discontent, & brooding in their minds terrible things
They said. O Father most beloved! O merciful Parent!
Pitying and permitting evil, tho strong & mighty to destroy.

[437]

Whence is this Shadow terrible? wherefore dost thou refuse
To throw him into the Furnaces: knowest thou not that he
Will unchain Orc? & let loose Satan. Og. Sihon & Anak.
Upon the Body of Albion? for this he is come! behold it written
Upon his fibrous left Foot black! most dismal to our eyes
The Shadowy Female shudders thro' heaven in torment inexpressible:
And all the Daughters of Los prophetic wail, yet in deceit
They weave a new Religion from new Jealousy of Theotormon!
Miltons Religion is the cause; there is no end to destruction!
Seeing the Churches at their Period in terror & despair.
Rahab created Voltaire: Tirzah created Rousseau

Asserting the Self-righteousness against the Universal Saviour,
Mocking the Confessors & Martyrs, claiming Self-righteousness;
With cruel Virtue: making War upon the Lambs Redeemed;
To perpetuate War & Glory. to perpetuate the Laws of Sin:
They perverted Swedenborgs Visions in Beulah & in Ulro;
To destroy Jerusalem as a Harlot & her Sons as Reprobates;
To raise up Mystery the Virgin Harlot Mother of War.
Babylon the Great, the Abomination of Desolation:
O Swedenborg! strongest of men, the Samson shorn by the Churches!
Shewing the Transgresors in Hell, the proud Warriors in Heaven:
Heaven as a Punisher & Hell as One under Punishment:
With Laws from Plato & his Greeks to renew the Trojan Gods,
In Albion; & to deny the value of the Saviours blood,
But then I rais'd up Whitefield, Palamabron raisd up Westley,
And these are the cries of the Churches before the two Witnesses,
Faith in God the dear Saviour who took on the likeness of men:
Becoming obedient to death, even the death of the Cross
The Witnesses lie dead in the Street of the Great City
No Faith is in all the Earth: the Book of God is trodden under Foot:
He sent his two Servants Whitefield & Westley; were they Prophets
Or were they Idiots or Madmen? shew us Miracles!
                                                    Can

22

Can you have greater Miracles than these? Men who devote
Their lifes whole comfort to intire scorn & injury & death
Awake thou sleeper on the Rock of Eternity Albion awake
The trumpet of Judgment hath twice sounded; all Nations are awake
But thou art still heavy and dull: Awake Albion awake!
Lo Orc arises on the Atlantic. Lo his blood and fire
Glow on Americas shore: Albion turns upon his Couch
He listens to the sounds of War, astonishd and confounded:
He weeps into the Atlantic deep, yet still in dismal dreams
Unwakend! and the Covering Cherub advances from the East:
How long shall we lay dead in the Street of the great City
How long beneath the Covering Cherub give our Emanations
Milton will utterly consume us & thee our beloved Father
He hath enterd into the Covering Cherub, becoming one with
Albions dread Sons, Hand. Hyle & Coban surround him as
A girdle; Gwendolen & Conwenna as a garment woven
Of War & Religion: let us descend & bring him chained
To Bowlahoola O father most beloved: O mild Parent!
Cruel in thy mildness, pitying and permitting evil
Tho strong and mighty to destroy, O Los our beloved Father!

Like the black storm, coming out of Chaos, beyond the stars:
It issues thro the dark & intricate caves of the Mundane Shell
Passing the planetary visions, & the well adorned Firmament
The Sun rolls into Chaos & the Stars into the Desarts;
And then the storms become visible, audible & terrible,
Covering the light of day, & rolling down upon the mountains,
Threatening the wanderer: Such as these storming fires
till, Rintrah & Palamabron spoke: and such like storming fire
Appeard, as does the face of heaven, when coverd with thick storms
Pitying and loving tho in frowns of terrible perturbation

But Los dispersd the clouds even as the strong winds of Jehovah
And thus spoke O noble Sons, be patient yet a little
I have embraced the falling Death, he is become One with me
O Sons we live not by wrath. by mercy alone we live!
I recollect an old Prophecy in Eden recorded in gold; and oft
Sung to the harp: That Milton of the land of Albion,
Should up ascend forward from Felphams Vale & break the Chain
Of Jealousy from all its roots; be patient therefore O my Sons

These lovely Females form sweet night and silence and secret
Obscurities to hide from Satans Watch-Fiends. Human loves
And graces; lest they write them in their Books, & in the Scroll
Of mortal life, to condemn the accused: who at Satans Bar
Tremble in Spectrous Bodies continually day and night
While on the Earth they live in sorrowful Vegetations
O when shall we tread our Wine presses in heaven, and Reap
Our wheat with shoutings of joy, and leave the Earth in peace
Remember how Calvin and Luther in fury premature
Sow'd War and stern division between Papists & Protestants
Let it not be so now: O go not forth in Martyrdoms & Wars
We were plac'd here by the Universal Brotherhood & Mercy
With powers fitted to circumscribe this dark Satanic death
And that the Seven Eyes of God may have space for Redemption,
But how this is as yet we know not. and we cannot know;
Till Albion is arisen: then patient wait a little while,
Six Thousand years are passd away the end approaches fast;
This mighty one is come from Eden, he is of the Elect.
Who died from Earth & he is returnd before the Judgment, This thing
Was never known that one of the holy dead should willing return
Then patient wait a little while till the Last Vintage is over:
Till we have quenchd the Sun of Salah in the Lake of Udan Adan
O my dear Sons! leave not your Father, as your brethren left me
Twelve Sons successive fled away in that thousand years of sorrow

Of Palamabrons Harrow, & of Rintrahs wrath & fury;
Reuben & Manazzoth & Gad & Simeon & Levi,
And Ephraim & Judah were Generated. because
They left me, wandering with Tirzah: Enitharmon wept
One thousand years, and all the Earth was in a watry deluge
We calld him Menassheh because of the Generations of Tirzah
Because of Satan; & the Seven Eyes of God continually
Guard round them, but I the Fourth Zoa am also set
The Watchman of Eternity, the Three are not! & I am preserved
Still my four mighty ones are left to me in Golgonooza
Still Rintrah fierce. and Palamabron mild & piteous
Theotormon filld with care, Bromion loving Science
You O my Sons still guard round Los. O wander not & leave me
Rintrah, thou well rememberest when Amalek & Canaan
Fled with their Sister Moab into the abhorred Void
They became Nations in our sight beneath the hands of Tirzah,
And Palamabron thou rememberest when Joseph an infant;
Stolen from his nurses cradle wrapd in needle-work
Of emblematic texture, was sold to the Amalekite,
Who carried him down into Egypt where Ephraim & Menassheh
Gatherd my Sons together in the Sands of Midian
And if you also flee away and leave your Fathers side,
Following Milton into Ulro, altho your power is great
Surely you also shall become poor mortal vegetations
Beneath the Moon of Ulro: pity then your Fathers tears
When Jesus raisd Lazarus from the Grave I stood & saw
Lazarus who is the Vehicular Body of Albion the Redeemd
Arise into the Covering Cherub who is the Spectre of Albion
By martyrdoms to suffer: to watch over the Sleeping Body.
Upon his Rock beneath his Tomb. I saw the Covering Cherub
Divide Four-fold into Four Churches when Lazarus arose
Paul, Constantine, Charlemaine, Luther; behold they stand before us
Stretchd over Europe & Asia. come O Sons, come come away
Arise O Sons give all your strength against Eternal Death
Lest we are vegetated for Cathedrons Looms weave only Death
A Web of Death & were it not for Bowlahoola & Allamanda
No Human Form but only a Fibrous Vegetation
A Polypus of soft affections without Thought or Vision
Must tremble in the Heavens & Earths thro all the Ulro space
Throw all the Vegetated Mortals into Bowlahoola
But as to this Elected Form who is returnd again
He is the Signal that the Last Vintage now approaches
Nor Vegetation may go on till all the Earth is reapd

So Los spoke. Furious they descended to Bowlahoola & Allamanda
Indignant. unconvinced by Loss arguments & thun|d|ers rolling
They saw that wrath now swayd and now pity absorbd him
As it was, so it remaind & no hope of an end.

Bowlahoola is namd Law, by mortals, Tharmas founded it:
Because of Satan, before Luban in the City of Golgonooza.
But Golgonooza is namd Art & Manufacture by mortal men.

In Bowlahoola Los's Anvils stand & his Furnaces rage;
Thundering the Hammers beat & the Bellows blow loud
Living self moving mourning lamenting & howling incessantly
Bowlahoola thro all its porches feels tho' too fast founded
Its pillars & porticoes to tremble at the force
Of mortal or immortal arm· and softly lilling flutes
    Accordant with the horrid labours make sweet melody
The Bellows are the Animal Lungs: the Hammers the Animal Heart
The Furnaces the Stomach for digestion. terrible their fury
Thousands & thousands labour. thousands play on instruments
Stringed or fluted to ameliorate the sorrows of slavery
Loud sport the dancers in the dance of death, rejoicing in carnage
The hard dentant Hammers are lulld by the flutes lula lula
The bellowing Furnaces blare by the long sounding clarion
The double drum drowns howls & groans, the shrill fife. shrieks & cries:
The crooked horn mellows the hoarse raving serpent, terrible, but harmonious

Bowlahoola is the Stomach in every individual man.

Los is by mortals nam'd Time Enitharmon is nam'd Space
But they depict him bald & aged who is in eternal youth
All powerful and his locks flourish like the brows of morning
He is the Spirit of Prophecy the ever apparent Elias
Time is the mercy of Eternity; without Times swiftness
Which is the swiftest of all things; all were eternal torment:
All the Gods of the Kingdoms of Earth labour in Los's Halls.
Every one is a fallen Son of the Spirit of Prophecy
He is the Fourth Zoa, that stood arou|n|d the Throne Divine.

24

Loud shout the Sons of Luvah, at the Wine-presses as Los descended
With Rintrah & Palamabron in his fires of resistless fury.

The Wine-press on the Rhine groans loud, but all its central beams
Act more terrific in the central Cities of the Nations
Where Human Thought is crushd beneath the iron hand of Power.
There Los puts all into the Press. the Opressor & the Opressed
Together, ripe for the Harvest & Vintage & ready for the Loom,

They sang at the Vintage. This is the Last Vintage! & Seed
Shall no more be sown upon Earth. till all the Vintage is over
And all gatherd in, till the Plow has passd over the Nations
And the Harrow & heavy thundering Roller upon the mountains

And loud the Souls howl round the Porches of Golgonooza
Crying O Lord deliver us to the Heavens or to the Hardan
That we may preach righteousness & punish the sinner with death
But lood stood & cried till all the Vintage of Earth was gatherd in

And Los stood & cried to the Labourers of the Vintage in voice of awe.

Fellow Labourers! The Great Vintage & Harvest is now upon Earth
The whole extent of the Globe is explored: Every scatterd Atom
Of Human Intellect now is flocking to the sound of the Trumpet
All the Wisdom which was hidden in caves & dens, from ancient
Time; is now sought out from Animal & Vegetable & Mineral
The Awakener is come. outstretchd over Europe: the Vision of God is
The Ancient Man upon the Rock of Albion Awakes,          (fulfilled
He listens to the sounds of War astonishd & ashamed;
He sees his Children mock at Faith and deny Providence
Therefore you must bind the Sheaves not by Nations or Families
You shall bind them in Three Classes; according to their Classes
So shall you bind them. Separating What has been Mixed
Since Men began to be Wove into Nations by Rahab & Tirzah
Since Albions Death & Satans Cutting-off from our awful Fields;
When under pretence to benevolence the Elect Subdud All.
From the Foundation of the World. The Elect is one Class; You
Shall bind them separate: they cannot Believe in Eternal Life
Except by Miracle & a New Birth. The other two Classes;
The Reprobate who never cease to Believe, and the Redeemd,
Who live in doubts & fears perpetually tormented by the Elect
These you shall bind in a twin-bundle for the Consummation
But the Elect must be saved fires of Eternal Death,          Earth

To be formed into the Churches of Beulah that they destroy not the
For in every Nation & every Family the Three Classes are born
And in every Species of Earth, Metal, Tree, Fish, Bird & Beast.
We form the Mundane Egg. that Spectres coming by fury or amity
All is the same, & every one remains in his own energy
Go forth Reapers with rejoicing. you sowed in tears
But the time of your refreshing cometh, only a little moment
Still abstain from pleasure & rest. in the labours of eternity
And you shall Reap the whole Earth, from Pole to Pole! from Sea to Sea
Begining at Jerusalems Inner Court, Lambeth ruin'd and given
To the detestable Gods of Priam, to Apollo; and at the Asylum
Given to Hercules, who labour in Tirzahs Looms for bread
Who set Pleasure against Duty: who Create Olympic crowns
    To make Learning a burden & the Work of the Holy Spirit: Strife.
The Thor & cruel Odin who first reard the Polar Caves
Lambeth mourns calling Jerusalem, she weeps & looks abroad
For the Lords coming, that Jerusalem may overspread all Nations
Crave not for the mortal & perishing delights, but leave them
To the weak, and pity the weak as your infant care; Break not
Forth in your wrath lest you also are vegetated by Tirzah
Wait till the Judgement is past, till the Creation is consumed
And then rush forward with me into the glorious spiritual
Vegetation; the Supper of the Lamb & his Bride; and the
Awaking of Albion our friend and ancient companion.

So Los spoke, But lightnings of discontent broke on all sides round
And murmurs of thunder rolling heavy long & loud over the mountains
While Los calld his Sons around him to the Harvest & the Vintage.

Thou seest the Constellations in the deep & wondrous Night
They rise in order and continue their immortal courses
Upon the mountains & in vales with harp & heavenly song
With flute & clarion, with cups & measures filld with foaming wine
Glittring the streams reflect the Vision of beatitude,
And the calm Ocean joys beneath & smooths his awful waves!
                                    [These]

25

These are the Sons of Los, & these the Labourers of the Vintage
Thou seest the gorgeous clothed Flies that dance & sport in summer
Upon the sunny brooks & meadows: every one the dance.
Knows in its intricate mazes of delight artful to weave:
Each one to sound his instruments of music in the dance,
To touch each other & recede; to cross & change & return
These are the Children of Los; thou seest the Trees on mountains
The wind blows heavy, loud they thunder thro' the darksom sky
Uttering prophecies & speaking instructive words to the sons
Of men. These are the Sons of Los these the Visions of Eternity
But we see only as it were the hem of their garments.
When with our vegetable eyes we view these wond'rous Visions

There are Two Gates thro which all Souls descend. One Southward
From Tower Hill to Lizard Point, the other toward the North
Caithness & rocky Durness, Pentland & John Groats House

The Souls descending to the Body. wail on the right hand
Of Los; & those deliverd from the Body. on the left hand
For Los against the east his force continually bends
Along the Valleys of Middlesex from Hounslow to Blackheath
Lest those Three Heavens of Beulah should the Creation destroy.
And lest they should descend before the north & south Gates
Groaning with pity, he among the wailing Souls laments.

And these the Labours of the Sons of Los in Allamanda:
And in the City of Golgonooza: & in Luban: & around
The Lake of Udan-Adan, in the Forests of Entuthon Benython
Where Souls incessant wail, being piteous Passions & Desires
With neither lineament nor form but like to watry clouds
The Passions & Desires descend upon the hungry winds
For such alone Sleepers remain meer passion & appetite:
The Sons of Los clothe them & feed & provide houses & fields

And every Generated Body in its inward form,
Is a garden of delight & a building of magnificence,
Built by the Sons of Los in Bowlahoola & Allamanda
And the herbs & flowers & furniture & beds & chambers

Continually woven in the Looms of Enitharmons Daughters
In bright Cathedrons golden Dome with care & love & tears
For the various Classes of Men are all markd out determinate
In Bowlahoola; & as the Spectres choose their affinities
So they are born on Earth, & every Class is determinate
But not by Natural but by Spiritual power alone. Because
The Natural power continually seeks & tends to Destruction
Ending in Death: which would of itself be Eternal Death
And all are Class'd by Spiritual, & not by Natural power,

And every Natural Effect has a Spiritual Cause, and Not
A Natural: for a Natural Cause only seems, it is a Delusion
Of Ulro: & a ratio of the perishing Vegetable Memory.

26

But the Wine-press of Los is eastward of Golgonooza, before the Seat
Of Satan. Luvah laid the foundation & Urizen finish'd it in howling woe.
How red the sons & daughters of Luvah: here they tread the grapes.
Laughing & shouting drunk with odours many fall oerwearied
Drownd in the wine is many a youth & maiden: those around
Lay them on skins of Tygers & of the spotted Leopard & the Wild Ass
Till they revive, or bury them in cool grots, making lamentation.

This Wine-press is call'd War on Earth, it is the Printing-Press
Of Los; and here he lays his words in order above the mortal brain
As cogs are formd in a wheel to turn the cogs of the adverse wheel.

Timbrels & violins sport round the Wine-presses; the little Seed;
The sportive Root. the Earth-worm, the gold Beetle: the wise Emmet;
Dance round the Wine-presses of Luvah: the Centipede is there:
The ground Spider with many eyes: the Mole clothed in velvet
The ambitious Spider in his sullen web; the lucky golden Spinner;
The Earwig armd: the tender Maggot emblem of immortality:
The Flea: Louse: Bug: the Tape-Worm: all the Armies of Disease:
Visible or invisible to the slothful vegetating Man.
The slow Slug: the Grasshopper that sings & laughs & drinks:
Winter comes, he folds his slender bones without a murmur.
The cruel Scorpion is there: the Gnat: Wasp: Hornet & the Honey Bee:
The Toad & venomous Newt; the Serpent clothd in gems & gold:
They throw off their gorgeous raiment: they rejoice with loud jubilee
Around the Wine-presses of Luvah. naked & drunk with wine.

There is the Nettle that stings with soft down; and there
The indignant Thistle: whose bitterness is bred in his milk:
Who feeds on contempt of his neighbour: there all the idle Weeds
That creep around the obscure places, shew their various limbs.
Naked in all their beauty dancing    round the Wine-presses.

But in the Wine-presses the Human grapes sing not, nor dance
They howl & writhe in shoals of torment; in fierce flames consuming.
In chains of iron & in dungeons circled with ceaseless fires.
In pits & dens & shades of death: in shapes of torment & woe.
The plates & screws & wracks & saws & cords & fires & cisterns
The cruel joys of Luvahs Daughters laceratin[g] with knives
And whips their Victims & the deadly sport of Luvahs Sons.

They dance around the dying, & they drink the howl & groan
They catch the shrieks in cups of gold, they hand them to one another:
These are the sports of love, & these the sweet delights of amorous play
Tears of the grape. the death sweat of the cluster the last sigh
Of the mild youth who listens to the lureing songs of Luvah
But Allamanda calld on Earth Commerce. is the Cultivated land
Around the City of Golgonooza in the Forests of Entuthon;
Here the Sons of Los labour against Death Eternal; through all
The Twenty-seven Heavens of Beulah in Ulro Seat of Satan,
Which is the False Tongue beneath Beulah: it is the Gate of Death
The Plow goes forth in tempests & lightnings & the Harrow cruel
In blights of the east; the heavy Roller follows in howlings of woe.

Urizens sons here labour also; & here are seen the Mills
Of Theotormon, on the verge of the Lake of Udan-Adan:
These are the starry voids of night & the depths & caverns of earth
These Mills are occupied, clouds & waters ungovernable in their fury
Here are the stars created & the seeds of all things planted
And here the Sun & Moon recieve their fixed destinations

But in Eternity the Four Arts: Poetry, Painting, Music,

And Architecture which is Science: are the Four Faces of Man.
Not so in Time & Space: there Three are shut out, and only
Science remains thro Mercy: & by means of Science, the Three
Become apparent in Time & Space, in the Three Professions
[Poetry in Religion: Music, Law: Painting, in Physic & Surgery:]
That Man may live upon Earth till the time of his awaking,
And from these Three, Science derives every Occupation of Men.
And Science is divided into Bowlahoola & Allamanda.

[Loud]

Some Sons of Los surround the Passions with porches of iron & silver
Creating form & beauty around the dark regions of sorrow.
Giving to airy nothing a name and a habitation
Delightful: with bounds to the Infinite putting off the Indefinite
Into most holy forms of Thought. (such is the power of inspiration)
They labour incessant; with many tears & afflictions:
Creating the beautiful House for the piteous sufferer.

Others; Cabinets richly fabricate of gold & ivory;
For Doubts & fears unform'd & wretched & melancholy
The little weeping Spectre stands on the threshold of Death
Eternal; and sometimes two Spectres like lamps quivering
And often malignant they combat (heart-breaking sorrowful & piteous)
Antamon takes them into his beautiful flexible hands,
As the Sower takes the seed, or as the Artist his clay
Or fine wax, to mould artful a model for golden ornaments.
The soft hands of Antamon draw the indelible line:
Form immortal with golden pen; such as the Spectre admiring
Puts on the sweet form; then smiles Antamon bright thro his windows
The Daughters of beauty look up from their Loom & prepare.
The integument soft for its clothing with joy & delight.

But Theotormon & Sotha stand in the Gate of Luban anxious
Their numbers are seven million & seven thousand & seven hundred
They contend with the weak Spectres, they fabricate soothing forms
The Spectre refuses. he seeks cruelty. they create the crested Cock
Terrified the Spectre screams & rushes in fear into their Net
Of kindness & compassion & is born a weeping terror.
Or they create the Lion & Tyger in compassionate thunderings
Howling the Spectres flee: they take refuge in Human lineaments.

The Sons of Ozoth within the Optic Nerve stand fiery glowing
And the number of his Sons is eight millions & eight.
They give delights to the man unknown; artificial riches
They give to scorn, & their posessors to trouble & sorrow & care.
Shutting the sun, & moon, & stars. & trees, & clouds, & waters,
And hills, out from the Optic Nerve & hardening it into a bone
Opake. and like the black pebble on the enraged beach.
While the poor indigent is like the diamond which tho cloth'd
In rugged covering in the mine, is open all within
And in his hallowd center holds the heavens of bright eternity
Ozoth here builds walls of rocks against the surging sea
And timbers crampt with iron cramps bar in the joys of life
From fell destruction in the Spectrous cunning or rage. He Creates
The speckled Newt, the Spider & Beetle, the Rat & Mouse.
The Badger & Fox: they worship before his feet in trembling fear.

But others of the Sons of Los build Moments & Minutes & Hours
And Days & Months & Years & Ages & Periods; wondrous buildings
And every Moment has a Couch of gold for soft repose.
(A Moment equals a pulsation of the artery)
And between every two Moments stands a Daughter of Beulah
To feed the Sleepers on their Couches with maternal care.
And every Minute has an azure Tent with silken Veils.
And every Hour has a bright golden Gate carved with skill.
And every Day & Night has Walls of brass & Gates of adamant
Shining like precious stones & ornamented with appropriate signs:
And every Month, a silver paved Terrace builded high:
And every Year, invulnerable Barriers with high Towers,
And every Age is Moated deep with Bridges of silver & gold
And every Seven Ages is Incircled with a Flaming Fire.
Now Seven Ages is amounting to Two Hundred Years
Each has its Guard. each Moment Minute Hour Day Month & Year.
All are the work of Fairy hands of the Four Elements

The Guard are Angels of Providence on duty evermore
Every Time less than a pulsation of the artery
Is equal in its period & value to Six Thousand Years.

For

28

For in this Period the Poets Work is Done: and all the Great
Events of Time start forth & are concievd in such a Period
Within a Moment: a Pulsation of the Artery.

The Sky is an immortal Tent built by the Sons of Los
And every Space that a Man views around his dwelling-place.
Standing on his own roof, or in his garden on a mount
Of twenty-five cubits in height. such space is his Universe;
And on its verge the Sun rises & sets. the Clouds bow
To meet the flat Earth & the Sea in such an orderd Space:
The Starry heavens reach no further but here bend and set
On all sides & the two Poles turn on their valves of gold:
And if he move his dwelling-place. his heavens also move.
Wher'eer he goes & all his neighbourhood bewail his loss:
Such are the Spaces called Earth & such its dimension:
As to that false appearance which appears to the reasoner.
As of a Globe rolling thro Voidness, it is a delusion of Ulro
The Microscope knows not of this nor the Telescope. they alter
The ratio of the Spectators Organs but leave Objects untouchd
For every Space larger than a red Globule of Mans blood.
Is visionary: and is created by the Hammer of Los
And every Space smaller than a Globule of Mans blood. opens
Into Eternity of which this vegetable Earth is but a shadow;
The red Globule is the unwearied Sun by Los created
To measure Time and Space to mortal Men, every morning
Bowlahoola & Allamanda are placed on each side
Of that Pulsation & that Globule, terrible their power.

But Rintrah & Palamabron govern over Day & Night
In Allamanda & Entuthon Benython where Souls wail:
Where Orc incessant howls burning in fires of Eternal Youth.
Within the vegetated mortal Nerves; for every Man born is joined
Within into One mighty Polypus. and this Polypus is Orc.

But in the Optic vegetative Nerves Sleep was transformed
To Death in old time by Satan the father of Sin & Death
And Satan is the Spectre of Orc & Orc is the generate Luvah

But in the Nerves of the Nostrils. Accident being formed
Into Substance & Principle, by the cruelties of Demonstration
It became Opake & Indefinite; but the Divine Saviour,
Formed it into a Solid by Loss Mathematic power.
He named the Opake Satan he named the Solid Adam

And in the Nerves of the Ear, (for the Nerves of the Tongue are closed)
On Albions Rock Los stands creating the glorious Sun each morning
And when unwearied in the evening he creates the Moon
Death to delude, who all in terror at their splendor leaves
His prey while Los appoints, & Rintrah & Palamabron guide
The Souls clear from the Rock of Death that Death himself may wake
In his appointed season when the ends of heaven meet.

Then Los conducts the Spirits to be Vegetated. into
Great Golgonooza, free from the four iron pillars of Satans Throne
(Temperance, Prudence, Justice, Fortitude, the four pillars of tyranny)
That Satans Watch-Fiends touch them not before they Vegetate.

But Enitharmon and her Daughters take the pleasant charge.
To give them to their lovely heavens till the Great Judgment Day
Such is their lovely charge. But Rahab & Tirzah pervert
Their mild influences, therefore the Seven Eyes of God walk round
The Three Heavens of Ulro, where Tirzah & her Sisters
Weave the black Woof of Death upon Entuthon Benython
In the Vale of Surrey where Horeb terminates in Rephaim.          (gore
The stamping feet of Zelophehads Daughters are coverd with Human
Upon the treddles of the Loom, they sing to the winged shuttle:
The River rises above his banks to wash the Woof:
He takes it in his arms: he passes it in strength thro his current
The veil of human miseries is woven over the Ocean
From the Atlantic to the Great South Sea. the Erythrean.

Such is the World of Los the labour of six thousand years.
Thus Nature is a Vision of the Science of the Elohim.

End of the First Book.

30

How wide the Gulf & Unpassable! between Simplicity and Insipidity

Milton

Contraries are Positives
A Negation is not a Contrary
Book the Second.

There is a place where Contrarieties are equally true
This place is called Beulah, It is a pleasant lovely Shadow
Where no dispute can come. Because of those who sleep,
Into this place the Sons & Daughters of Ololon descended
With solemn mourning into Beulahs moony shades & hills
Weeping for Milton: mute wonder held the Daughters of Beulah
Enrapturd with affection sweet and mild benevolence

Beulah is evermore Created around Eternity; appearing
To the Inhabitants of Eden. around them on all sides.
But Beulah to its Inhabitants appears within each district
As the beloved Infant in his mothers bosom round incircled
With arms of love & pity & sweet compassion, But to
The Sons of Eden the moony habitations of Beulah,
Are from Great Eternity a mild & pleasant Rest.

And it is thus Created. Lo the Eternal Great Humanity
To whom be Glory & Dominion Evermore Amen
Walks among all his awful Family seen in every face
As the breath of the Almighty. such are the words of man to man
In the great Wars of Eternity. in fury of Poetic Inspiration
To build the Universe stupendous: Mental forms Creating

But the Emanations trembled exceedingly, nor could they
Live, because the life of Man was too exceeding unbounded
His joy became terrible to them they trembled & wept
Crying with one voice. Give us a habitation & a place
In which we may be hidden under the shadow of wings
For if we who are but for a time, & who pass away in winter
Behold these wonders of Eternity we shall consume
But you O our Fathers & Brothers, remain in Eternity
But grant us a Temporal Habitation, do you speak
To us; we will obey your words as you obey Jesus
The Eternal who is blessed for ever & ever. Amen

So spoke the lovely Emanations & there appeard a pleasant
Mild Shadow above: beneath: & on all sides round,

[blank]

31

Into this pleasant Shadow all the weak & weary
Like Women & Children were taken away as on wings
Of dovelike softness, & shadowy habitations prepared for them
But every Man returnd & went still going forward thro'
The Bosom of the Father in Eternity on Eternity
Neither did any lack or fall into Error without
A Shadow to repose in all the Days of happy Eternity

Into this pleasant Shadow Beulah. all Ololon descended
And when the Daughters of Beulah heard the lamentation
All Beulah wept. for they saw the Lord coming in the Clouds
And the Shadows of Beulah terminate in rocky Albion-

And all Nations wept in affliction Family by Family
Germany wept towards France & Italy: England wept & trembled
Towards America: India rose up from his golden bed:
As one awakend in the night: they saw the Lord coming
In the Clouds of Ololon with Power & Great Glory!

And all the Living Creatures of the Four Elements, wail'd
With bitter wailing: these in the aggregate are named Satan
And Rahab: they know not of Regeneration, but only of Generation
The Fairies, Nymphs, Gnomes & Genii of the Four Elements
Unforgiving & unalterable: these cannot be Regenerated

But must be Created, for they know only of Generation
These are the Gods of the Kingdoms of the Earth: in contrarious
And cruel opposition: Element against Element, opposed in War
Not Mental, as the Wars of Eternity, but a Corporeal Strife
In Loss Halls continual labouring in the Furnaces of Golgonooza
Orc howls on the Atlantic: Enitharmon trembles; All Beulah weeps
Thou hearest the Nightingale begin the Song of Spring:
The Lark sitting upon his earthy bed; just as the morn
Appears; listens silent: then springing from the waving Corn-field! loud
He leads the Choir of Day! trill, trill, trill, trill,
Mounting upon the wings of light into the Great Expanse.
Reechoing against the lovely blue & shining heavenly Shell:
His little throat labours with inspiration; every feather
On throat & breast & wings vibrates with the effluence Divine
All Nature listens silent to him & the awful Sun
Stands still upon the Mountain looking on this little Bird
With eyes of soft humility, & wonder love & awe,
Then loud from their green covert all the Birds begin their Song
The Thrush, the Linnet & the Goldfinch, Robin & the Wren
Awake the Sun from his sweet reverie upon the Mountain:
The Nightingale again assays his song & thro the day,
And thro the night warbles luxuriant: every Bird of Song
Attending his loud harmony with admiration & love.
This is a Vision of the lamentation of Beulah over Ololon!

Thou percievest the Flowers put forth their precious Odours!
And none can tell how from so small a center comes such sweets
Forgetting that within that Center Eternity expands
Its ever during doors. that Og & Anak fiercely guard
First eer the morning breaks joy opens in the flowery bosoms
Joy even to tears, which the Sun rising dries: first the Wild Thyme
And Meadow-sweet downy & soft waving among the reeds.
Light springing on the air lead the sweet Dance: they wake
The Honeysuckle sleeping on the Oak: the flaunting beauty
Revels along upon the wind; the White-thorn lovely May
Opens her many lovely eyes: listening the Rose still sleeps
None dare to wake her. soon she bursts her crimson curtaind bed
And comes forth in the majesty of beauty; every Flower:
The Pink, the Jessamine, the Wall-flower, the Carnation
The Jonquil, the mild Lilly opes her heavens! every Tree,
And Flower & Herb soon fill the air with an innumerable Dance
Yet all in order sweet & lovely, Men are sick with Love!
Such is a Vision of the lamentation of Beulah over Ololon
                                                        And

                                                              32

And the Divine Voice was heard in the Songs of Beulah Say
                                                        -ing
When I first Married you, I gave you all my whole Soul
I thought that you would love my loves & joy in my delights
Seeking for pleasures in my pleasures O Daughter of Babylon
Then thou wast lovely, mild & gentle, now thou art terrible
In jealousy & unlovely in my sight. because thou hast cruelly
Cut off my loves in fury till I have no love left for thee
Thy love depends on him thou lovest & on his dear loves
Depend thy pleasures which thou hast cut off by jealousy
Therefore I shew my Jealousy & set before you Death.
Behold Milton descended to Redeem the Female Shade
From Death Eternal; such your lot, to be continually Redeem'd
By death & misery of those you love & by Annihilation
When the Sixfold Female percieves that Milton annihilates
Himself; that seeing all his loves by her cut off. he leaves
Her also: intirely abstracting himself from Female loves
She shall relent in fear of death: She shall begin to give
Her maidens to her husband; delighting in his delight
And then & then alone begins the happy Female joy
As it is done in Beulah, & thou O Virgin Babylon Mother of Whoredoms
Shalt bring Jerusalem in thine arms in the night watches; and
No longer turning her a wandering Harlot in the streets
Shalt give her into the arms of God your Lord & Husband,

Such are the Songs of Beulah, in the Lamentations of Ololon

```
                        N
                     Urthona

                      Adam
   W     Tharmas                  Luvah      E
                      Satan
                                       Miltons 1

                     Urizen
                       [S]
```
                                                              32

And Milton oft sat up on the Couch of Death & oft conversed
In vision & dream beatific with the Seven Angels of the Presence

I have turned my back upon these Heavens builded on cruelty
My Spectre still wandering thro' them follows my Emanation
He hunts her footsteps thro' the snow & the wintry hail & rain
The idiot Reasoner laughs at the Man of Imagination
And from laughter proceeds to murder by undervaluing calumny

Then Hillel who is Lucifer replied over the Couch of Death
And thus the Seven Angels instructed him & thus they converse.

We are not Individuals but States: Combinations of Individuals
We were Angels of the Divine Presence: & were Druids in Annandale
Compelld to combine into Form by Satan, the Spectre of Albion.
Who made himself a God & destroyed the Human Form Divine
But the Divine Humanity & Mercy gave us a Human Form     (as multi
Because we were combind in Freedom & holy Brotherhood          Vox P
While those combind by Satans Tyranny first in the blood of War
And Sacrifice & next. in Chains of imprisonment: are Shapeless Rocks
Retaining only Satans Mathematic Holiness Length: Bredth & Highth
Calling the Human Imagination: which is the Divine Vision & Fruition
In which Man liveth eternally: madness & blasphemy. against
Its own Qualities, which are Servants of Humanity, not Gods or Lords
Distinguish therefore States from Individuals in those States.
States Change: but Individual Identities never change nor cease:
You cannot go to Eternal Death in that which can never Die.
Satan & Adam are States Created into Twenty-seven Churches,
And thou O Milton art a State about to be Created
Called Eternal Annihilation that none but the Living shall
Dare to enter: & they shall enter triumphant over Death
And Hell & the Grave! States that are not. but ah! Seem to be.

Judge then of thy Own Self; thy Eternal Lineaments explore
What is Eternal & what Changeable? & what Annihilable!

The Imagination is not a State: it is the Human Existence itself
Affection or Love becomes a State, when divided from Imagination
The Memory is a State always. & the Reason is a State
Created to be Annihilated & a new Ratio Created
Whatever can be Created can be Annihilated Forms cannot
The Oak is cut down by the Ax. the Lamb falls by the Knife
But their Forms Eternal Exist, For-ever. Amen Halleujah

Thus they converse with the Dead watching round the Couch of Death.
For God himself enters Death's Door always with those that enter
And lays down in the Grave with them, in Visions of Eternity
Till they awake & see Jesus & the Linen Clothes lying
That the Females had Woven for them. & the Gates of their Fathers Hou

And all the Songs of Beulah sounded comfortable notes
To comfort Ololons lamentation, for they said
Are you the Fiery Circle that late drove in fury & fire
The Right Immortal Starry Ones down into Ulro dark
Rending the Heavens of Beulah with your thunders & lightnings
And can you thus lament & can you pity & forgive?
In terror changd to pity O wonder of Eternity;

And the Four States of Humanity in its Repose,
Were shewed them. First of Beulah a most pleasant Sleep
On Couches soft, with mild music, tended by Flowers of Beulah

Sweet Female forms, winged, or floating in the air spontaneous
The Second State is Alla & the third State Al-Ulro;
But the Fourth State is dreadful; it is named Or-Ulro:
The First State is in the Head, the Second is in the Heart:
The Third in the Loins & Seminal Vessels & the Fourth
In the Stomach & Intestines terrible. deadly, unutterable
And he whose Gates are opend in those Regions of his Body
Can from those Gates view all these wondrous Imaginations

But Ololon sought the Or-Ulro & its fiery Gates
And the Couches of the Martyrs: & many Daughters of Beulah
Accompany them down to the Ulro with soft melodious tears
A long journey & dark thro Chaos in the track of Miltons course
To where the Contraries of Beulah War beneath Negations Banner

Then view'd from Miltons Track they see the Ulro: a vast Polypus
Of living fibres down into the Sea of Time & Space growing
A self-devouring monstrous Human Death Twenty-seven fold
Within it sit Five Females & the nameless Shadowy Mother
Spinning it from their bowels with songs of amorous delight
And melting cadences that lure the Sleepers of Beulah down
The River Storge (which is Arnon) into the Dead Sea:
Around this Polypus Los continual builds the Mundane Shell

Four Universes round the Universe of Los remain Chaotic
Four intersecting Globes. & the Egg form'd World of Los
In midst; stretching from Zenith to Nadir. in midst of Chaos,
One of these Ruind Universes is to the North named Urthona,
One to the South this was the glorious World of Urizen.
One to the East, of Luvah: One to the West; of Tharmas.
But when Luvah assumed the World of Urizen in the South
All fell towards the Center sinking downward in dire Ruin

Here in these Chaoses the Sons of Ololon took their abode
In Chasms of the Mundane Shell which open on all sides round
Southward & by the East within the Breach of Miltons descen[t]
To watch the time, pitying & gentle to awaken Urizen
They stood in a dark land of death of fiery corroding waters
Where lie in evil death the Four Immortals pale and cold
And the Eternal Man even Albion upon the Rock of Ages
Seeing Miltons Shadow, some Daughters of Beulah trembling
Returnd, but Ololon remaind before the Gates of the Dead

And Ololon looked down into the Heavens of Ulro in fear
They said. How are the Wars of Man which in Great Eternity
Appear around, in the External Spheres of Visionary Life
Here renderd Deadly within the Life & Interior Vision
How are the Beasts & Birds & Fishes. & Plants & Minerals
Here fixd into a frozen bulk subject to decay & death
Those Visions of Human Life & Shadows of Wisdom & Knowledge

Are here frozen to unexpansive deadly destroying terrors
And War & Hunting: the Two Fountains of the River of Life
Are become Fountains of bitter Death & of corroding Hell
Till Brotherhood is changd into a Curse & a Flattery
By Differences between Ideas, that Ideas themselves, (which are
The Divine Members) may be slain in offerings for sin
O dreadful Loom of Death! O piteous Female forms compelld
To weave the Woof of Death. On Camberwell Tirzahs Courts
Malahs on Blackheath, Rahab & Noah, dwell on Windsors heights
Where once the Cherubs of Jerusalem spread to Lambeths Vale
Milcahs Pillars shine from Harrow to Hampstead where Hoglah
On Highgates heights magnificent Weaves over trembling Thames
To Shooters Hill and thence to Blackheath the dark Woof! Loud
Loud roll the Weights & Spindles over the whole Earth let down
On all sides round to the Four Quarters of the World, eastward on
Europe to Euphrates & Hindu, to Nile & back in Clouds
Of Death across the Atlantic to America North & South

So spoke Ololon in reminiscence astonishd, but they
Could not behold Golgonooza without passing the Polypus
A wondrous journey not passable by Immortal feet, & none
But the Divine Saviour can pass it without annihilation.
For Golgonooza cannot be seen till having passd the Polypus
It is viewed on all sides round by a Four-fold Vision

35

Or till you become Mortal & Vegetable in Sexuality
Then you behold its mighty Spires & Domes of ivory & gold

And Ololon examined all the Couches of the Dead.
Even of Los & Enitharmon & all the Sons of Albion
And his Four Zoas terrified & on the verge of Death
In midst of these was Miltons Couch, & when they saw Eight
Immortal Starry-Ones, guarding the Couch in flaming fires
They thunderous utterd all a universal groan falling down
Prostrate before the Starry Eight asking with tears forgiveness
Confessing their crime with humiliation and sorrow,

O how the Starry Eight rejoic'd to see Ololon descended:
And now that a wide road was open to Eternity,
By Ololons descent thro Beulah to Los & Enitharmon.

For mighty were the multitudes of Ololon, vast the extent
Of their great sway, reaching from Ulro to Eternity
Surrounding the Mundane Shell outside in its Caverns
And through Beulah. and all silent forbore to contend
With Ololon for they saw the Lord in the Clouds of Ololon

There is a Moment in each Day that Satan cannot find
Nor can his Watch Fiends find it, but the Industrious find
This Moment & it multiply, & when it once is found
It renovates every Moment of the Day if rightly placed
In this Moment Ololon descended to Los & Enitharmon
Unseen beyond the Mundane Shell Southward in Miltons track

Just in this Moment when the morning odours rise abroad
And first from the Wild Thyme, stands a Fountain in a rock
Of crystal flowing into two Streams, one flows thro Golgonooza
And thro Beulah to Eden beneath Los's western Wall
The other flows thro the Aerial Void & all the Churches
Meeting again in Golgonooza beyond Satans Seat

The Wild Thyme is Los's Messenger to Eden, a mighty Demon
Terrible deadly & poisonous his presence in Ulro dark
Therefore he appears only a small Root creeping in grass
Covering over the Rock of Odours his bright purple mantle
Beside the Fount above the Larks nest in Golgonooza
Luvah slept here in death & here is Luvahs empty Tomb
Ololon sat beside this Fountain on the Rock of Odours.

Just at the place to where the Lark mounts, is a Crystal Gate
It is the enterance of the First Heaven named Luther: for
The Lark is Loss Messenger thro the Twenty-seven Churches
That the Seven Eyes of God who walk even to Satans Seat
Thro all the Twenty-seven Heavens may not slumber nor sleep
But the Larks Nest is at the Gate of Los, at the eastern
Gate of wide Golgonooza & the Lark is Los's Messenger

When on the highest lift of his light pinions he arrives
At that bright Gate another Lark meets him & back to back
They touch their pinions tip tip: and each descend
To their respective Earths & there all night consult with Angels
Of Providence & with the Eyes of God all night in slumbers
Inspired; & at the dawn of day send out another Lark
Into another Heaven to carry news upon his wings
Thus are the Messengers dispatchd till they reach the Earth again
In the East Gate of Golgonooza. & the Twenty-eighth bright
Lark, met the Female Ololon descending into my Garden
Thus it appears to Mortal eyes & those of the Ulro Heavens
But not thus to Immortals, the Lark is a mighty Angel.

For Ololon step'd into the Polypus within the Mundane Shell
They could not step into Vegetable Worlds without becoming
The enemies of Humanity except in a Female Form
And as One Female. Ololon and all its mighty Hosts
Appear'd: a Virgin of twelve years nor time nor space was
To the perception of the Virgin Ololon but as the
Flash of lightning but more quick the Virgin in my Garden
Before my Cottage stood for the Satanic Space is delusion

For when Los joind with me he took me in his firy whirlwind
My Vegetated portion was hurried from Lambeths shades
He set me down in Felphams Vale & prepard a beautiful

36

[443]

Cottage for me that in three years I might write all these
    Visions
To display Natures cruel holiness: the deceits of Natural
    Religion
Walking in my Cottage Garden, sudden I beheld
The Virgin Ololon & address'd her as a Daughter of Beulah

Virgin of Providence fear not to enter into my Cottage
What is thy message to thy friend? What am I now to do
Is it again to plunge into deeper affliction? behold me
Ready to obey, but pity thou my Shadow of Delight
Enter my Cottage. comfort her, for she is sick with fatigue

Blakes Cottage
  at Felpham.

37

The Virgin answerd. Knowest thou of Milton who descended
Driven from Eternity; him I seek! terrified at my Act
In Great Eternity which thou knowest! I come him to seek

So Ololon utterd in words distinct the anxious thought
Mild was the voice, but more distinct than any earthly
That Miltons Shadow heard & condensing all his Fibres
Into a strength impregnable of majesty & beauty infinite
I saw he was the Covering Cherub & within him Satan
And Rahab, in an outside which is fallacious! within
Beyond the outline of Identity, in the Selfhood deadly
And he appeard the Wicker Man of Scandinavia in whom
Jerusalems children consume in flames among the Stars

Descending down into my Garden, a Human Wonder of God
Reaching from heaven to earth a Cloud & Human Form
I beheld Milton with astonishment & in him beheld
The Monstrous Churches of Beulah, the Gods of Ulro dark
Twelve monstrous dishumanizd terrors Synagogues of Satan.
A Double Twelve & Thrice Nine: such their divisions.

And these their Names & their Places within the Mundane Shell

In Tyre & Sidon I saw Baal & Ashtaroth. In Moab Chemosh
In Ammon, Molech: loud his Furnaces rage among the Wheels
Of Og, & pealing loud the cries of the Victims of Fire:
And pale his Priestesses infolded in Veils of Pestilence. border'd
With War: Woven in Looms of Tyre & Sidon by beautiful Ashtaroth.
In Palestine Dagon, Sea Monster! worshipd o'er the Sea.
Thammuz in Lebanon & Rimmon in Damascus curtaind
Osiris: Isis: Orus: in Egypt: dark their Tabernacles on Nile
Floating with solemn songs, & on the Lakes of Egypt nightly
With pomp, even till morning break & Osiris appear in the sky
But Belial of Sodom & Gomorrha, obscure Demon of Bribes
And secret Assasinations, not worshipd nor adord; but
With the finger on the lips & the back turnd to the light
And Saturn Jove & Rhea of the Isles of the Sea remote
These Twelve Gods, are the Twelve Spectre Sons of the Druid Albion

And these the Names of the Twenty-seven Heavens & their Churches
Adam, Seth, Enos, Cainan, Mahalaleel, Jared, Enoch.
Methuselah, Lamech: these are Giants mighty Hermaphroditic
Noah, Shem, Arphaxad, Cainan the second, Salah, Heber,
Peleg. Reu, Serug, Nahor, Terah, these are the Female-Males
A Male within a Female hid as in an Ark & Curtains.
Abraham, Moses, Solomon, Paul. Constantine. Charlemaine
Luther, these seven are the Male-Females, the Dragon Forms
Religion hid in War, a Dragon red & hidden Harlot

All these are seen in Miltons Shadow who is the Covering Cherub
The Spectre of Albion in which the Spectre of Luther inhabits
In the Newtonian Voids between the Substances of Creation

For the Chaotic Voids outside of the Stars are measured by
The Stars, which are the boundaries of Kingdoms, Provinces
And Empires of Chaos invisible to the Vegetable Man
The Kingdom of Og is in Orion: Sihon is in Ophiucus
Og has Twenty-seven Districts; Sihons Districts Twenty-one
From Star to Star, Mountains & Valleys, terrible dimension
Stretchd out, compose the Mundane Shell, a mighty Incrustation
Of Forty-eight deformed Human Wonders of the Almighty

With Caverns whose remotest bottoms meet again beyond
The Mundane Shell in Golgonooza, but the Fires of Los, rage
In the remotest bottoms of the Caves. that none can pass
Into Eternity that way, but all descend to Los
To Bowlahoola & Allamanda & to Entuthon Benython

The Heavens are the Cherub, the Twelve Gods are Satan

9

And the Forty-eight Starry Regions are Cities of the Levites
The Heads of the Great Polypus, Four-fold twelve enormity
In mighty & mysterious comingling enemy with enemy
Woven by Urizen into Sexes from his mantle of years
And Milton collecting all his fibres into impregnable strength
Descended down a Paved work of all kinds of precious stones
Out from the eastern sky; descending down into my Cottage
Garden: clothed in black. severe & silent he descended.

The Spectre of Satan stood upon the roaring sea & beheld
Milton within his sleeping Humanity! trembling & shuddring
He stood upon the waves a Twenty-seven-fold mighty Demon
Gorgeous & beautiful: loud roll his thunders against Milton
Loud Satan thunderd, loud & dark upon mild Felpham shore
Not daring to touch one fibre he howld round upon the Sea.

I also stood in Satans bosom & beheld its desolations!
A ruind Man: a ruind building of God not made with hands;
Its plains of burning sand, its mountains of marble terrible;
Its pits & declivities flowing with molten ore & fountains
Of pitch & nitre; its ruind palaces & cities & mighty works;
Its furnaces of affliction in which his Angels & Emanations
Labour with blackend visages among its stupendous ruins
Arches & pyramids & porches colonades & domes:
In which dwells Mystery Babylon, here is her secret place
From hence she comes forth on the Churches in delight
Here is her Cup filld with its poisons. in these horrid vales
And here her scarlet Veil woven in pestilence & war:
Here is Jerusalem bound in chains, in the Dens of Babylon

In the Eastern porch of Satans Universe Milton stood & said

Satan! my Spectre! I know my power thee to annihilate
And be a greater in thy place, & be thy Tabernacle
A covering for thee to do thy will, till one greater comes
And smites me as I smote thee & becomes my covering
Such are the Laws of thy false Heavns! but Laws of Eternity
Are not such: know thou: I come to Self Annihilation
Such are the Laws of Eternity that each shall mutually
Annihilate himself for others good, as I for thee
Thy purpose & the purpose of thy Priests & of thy Churches
Is to impress on men the fear of death; to teach
Trembling & fear, terror, constriction; abject selfishness
Mine is to teach Men to despise death & to go on
In fearless majesty annihilating Self. laughing to scorn
Thy Laws & terrors, shaking down thy Synagogues as webs
I come to discover before Heavn & Hell the Self righteousness
In all its Hypocritic turpitude. opening to every eye
These wonders of Satans holiness shewing to the Earth
The Idol Virtues of the Natural Heart, & Satans Seat
Explore in all its Selfish Natural Virtue & put off
In Self annihilation all that is not of God alone:
To put off Self & all I have ever & ever Amen

fire

Satan heard! Coming in a cloud with trumpets & flaming
Saying I am God the judge of all, the living & the dead
Fall therefore down & worship me, submit thy supreme
Dictate, to my eternal Will & to my dictate bow
I hold the Balances of Right & Just & mine the Sword
Seven Angels bear my Name & in those Seven I appear
But I alone am God & I alone in Heavn & Earth
Of all that live dare utter this, others tremble & bow

Till All Things become One Great Satan, in Holiness
Oppos'd to Mercy, and the Divine Delusion Jesus be no more

Suddenly around Milton on my Path, the Starry Seven

Burnd terrible! my Path became a solid fire, as bright
As the clear Sun & Milton silent came down on my Path.
 And there went forth from the Starry limbs of the Seven: Forms
Human; with Trumpets innumerable, sounding articulate
As the Seven spoke; and they stood in a mighty Column of Fire
Surrounding Felphams Vale, reaching to the Mundane Shell, Saying

Awake Albion awake! reclaim thy Reasoning Spectre. Subdue
Him to the Divine Mercy, Cast him down into the Lake
Of Los, that ever burneth with fire, ever & ever Amen!
Let the Four Zoa's awake from Slumbers of Six Thousand Years

Then loud the Furnaces of Los were heard! & seen as Seven Heavens
Stretching from south to north over the mountains of Albion

Satan heard; trembling round his Body, he incircled it
He trembled with exceeding great trembling & astonishment
Howling in his Spectre round his Body hungring to devour
But fearing for the pain for if he touches a Vital,
His torment is unendurable; therefore he cannot devour:
But howls round it as a lion round his prey continually
Loud Satan thunderd, loud & dark upon mild Felphams Shore
Coming in a Cloud with Trumpets & with Fiery Flame
An awful Form eastward from midst of a bright Paved-work
Of precious stones by Cherubim surrounded: so permitted
(Lest he should fall apart in his Eternal Death) to imitate
The Eternal Great Humanity Divine surrounded by
His Cherubim & Seraphim in ever happy Eternity
Beneath sat Chaos: Sin on his right hand Death on his left
And Ancient Night spread over all the heavn his Mantle of Laws
He trembled with exceeding great trembling & astonishment

Then Albion rose up in the Night of Beulah on his Couch
Of dread repose seen by the visionary eye; his face is toward
The east, toward Jerusalems Gates: groaning he sat above
His rocks. London & Bath & Legions & Edinburgh
Are the four pillars of his Throne; his left foot near London
Covers the shades of Tyburn; his instep from Windsor
To Primrose Hill stretching to Highgate & Holloway
London is between his knees; its basements fourfold
His right foot stretches to the sea on Dover cliffs, his heel
On Canterburys ruins; his right hand covers lofty Wales
His left Scotland; his bosom girt with gold involves
York Edinburgh, Durham & Carlisle & on the front
Bath, Oxford, Cambridge Norwich; his right elbow
Leans on the Rocks of Erins Land, Ireland ancient nation
His head bends over London: he sees his embodied Spectre
Trembling before him with exceeding great trembling & fear
He views Jerusalem & Babylon, his tears flow down
He moved his right foot to Cornwall, his left to the Rocks of Bognor
He strove to rise to walk into the Deep. but strength failing
Forbad & down with dreadful groans he sunk upon his Couch
In moony Beulah, Los his strong Guard walks round beneath the Moon

Urizen faints in terror striving among the Brooks of Arnon
With Miltons Spirit: as the Plowman or Artificer or Shepherd
While in the labours of his Calling sends his Thought abroad
To labour in the ocean or in the starry heaven. So Milton
Labourd in Chasms of the Mundane Shell, tho here before
My Cottage midst the Starry Seven, where the Virgin Ololon
Stood trembling in the Porch: loud Satan thunderd on the stormy Sea
Circling Albions Cliffs in which the Four-fold World resides
Tho seen in fallacy outside; a fallacy of Satans Churches

*42*

Before Ololon Milton stood & percievd the Eternal Form
Of that mild Vision; wondrous were their acts by me unknown
Except remotely; and I heard Ololon say to Milton

I see thee strive upon the Brooks of Arnon. there a dread
And awful Man I see, oercoverd with the mantle of years,
I behold Los & Urizen. I behold Orc & Tharmas!
The Four Zoa's of Albion & thy Spirit with them striving
In Self annihilation giving thy life to thy enemies
Are those who contemn Religion & seek to annihilate it
Become in their Femin[in]e portions, the causes & promoters
Of these Religions, how is this thing? this Newtonian Phantasm

This Voltaire & Rousseau: this Hume & Gibbon & Bolingbroke
This Natural Religion! this impossible absurdity
Is Ololon the cause of this? O where shall I hide my face
These tears fall for the little-ones; the Children of Jerusalem
Lest they be annihilated in thy annihilation,

No sooner she had spoke but Rahab Babylon appeard
Eastward upon the Paved work across Europe & Asia
Glorious as the midday Sun in Satans bosom glowing:
A Female hidden in a Male, Religion hidden in War
Namd Moral Virtue: cruel two-fold Monster shining bright
A Dragon red & hidden Harlot which John in Patmos saw
And all beneath the Nations innumerable of Ulro
Appeard, the Seven Kingdoms of Canaan & Five Baalim
Of Philistea, into Twelve divided, calld after the Names
Of Israel: as they are in Eden, Mountain River & Plain
City & sandy Desert intermingled beyond mortal ken

But turning toward Ololon in terrible majesty Milton
Replied. Obey thou the Words of the Inspired Man
All that can be ann be annihilated must be annihilated
That the Children of Jerusalem may be saved from slavery
There is a Negation, & there is a Contrary
The Negation must be destroyd to redeem the Contraries
The Negation is the Spectre; the Reasoning Power in Man
This is a false Body: an Incrustation over my Immortal
Spirit; a Selfhood, which must be put off & annihilated alway
To cleanse the Face of my Spirit by Self-examination.

*44*

To bathe in the Waters of Life; to wash off the Not Human
I come in Self annihilation & the grandeur of Inspiration
To cast off Rational Demonstration by Faith in the Saviour
To cast off the rotten rags of Memory by Inspiration
To cast off Bacon, Locke & Newton from Albions covering
To take off his filthy garments, & clothe him with Imagination
To cast aside from Poetry, all that is not Inspiration
That it no longer shall dare to mock with the aspersion of Madness
Cast on the Inspired, by the tame high finisher of paltry Blots,
Indefinite, or paltry Rhymes; or paltry Harmonies,
Who creeps into State Government like a catterpiller to destroy
To cast off the idiot Questioner who is always questioning,
But never capable of answering; who sits with a sly grin
Silent plotting when to question, like a thief in a cave;
Who publishes doubt & calls it knowledge; whose Science is Despair
Whose pretence to knowledge is Envy; whose whole Science is
To destroy the wisdom of ages to gratify ravenous Envy.
That rages round him like a wolf day & night without rest
He smiles with condescension; he talks of Benevolence & Virtue
And those who act with Benevolence & Virtue, they murder time on time
These are the destroyers of Jerusalem, these are the murderers
Of Jesus, who deny the Faith & mock at Eternal Life:
Who pretend to Poetry that they may destroy Imagination;
By imitation of Natures Images drawn from Remembrance
These are the Sexual Garments, the Abomination of Desolation
Hiding the Human Lineaments as with an Ark & Curtains
Which Jesus rent: & now shall wholly purge away with Fire
Till Generation is swallowd up in Regeneration.

Then trembled the Virgin Ololon & replyd in clouds of despair
Is this our Femin[in]e Portion the Six-fold Miltonic Female
Terribly this Portion trembles before thee O awful Man
Altho' our Human Power can sustain the severe contentions
Of Friendship, our Sexual cannot: but flies into the Ulro.
Hence arose all our terrors in Eternity! & now remembrance
Returns upon us! are we Contraries O Milton, Thou & I
O Immortal! how were we led to War the Wars of Death
Is this the Void Outside of Existence, which if enterd into

*45*

Becomes a Womb? & is this the Death Couch of Albion
Thou goest to Eternal Death & all must go with thee

So saying, the Virgin divided Six-fold & with a shriek
Dolorous that ran thro all Creation a Double Six-fold Wonder:

[445]

Away from Ololon she divided & fled into the depths
Of Miltons Shadow as a Dove upon the stormy Sea.

Then as a Moony Ark Ololon descended to Felphams Vale
In clouds of blood, in streams of gore, with dreadful thunderings
Into the Fires of Intellect that rejoic'd in Felphams Vale
Around the Starry Eight: with one accord the Starry Eight became
One Man Jesus the Saviour. wonderful! round his limbs
The Clouds of Ololon folded as a Garment dipped in blood
Written within & without in woven letters: & the Writing
Is the Divine Revelation in the Litteral expression:
A Garment of War, I heard it namd the Woof of Six Thousand Years

And I beheld the Twenty-four Cities of Albion
Arise upon their Thrones to Judge the Nations of the Earth
And the Immortal Four in whom the Twenty-four appear Four-fold
Arose around Albions body: Jesus wept & walked forth
From Felphams Vale clothed in Clouds of blood, to enter into
Albions Bosom, the bosom of death & the Four surrounded him
In the Column of Fire in Felphams Vale; then to their mouths the Four
Applied their Four Trumpets & then sounded to the Four winds

Terror struck in the Vale I stood at that immortal sound
My bones trembled. I fell outstretchd upon the path
A moment, & my Soul returnd into its mortal state
To Resurrection & Judgment in the Vegetable Body
And my sweet Shadow of Delight stood trembling by my side

Immediately the Lark mounted with a loud trill from Felphams Vale
And the Wild Thyme from Wimbletons green & impurpled Hills
And Los & Enitharmon rose over the Hills of Surrey
Their clouds roll over London with a south wind, soft Oothoon
Pants in the Vales of Lambeth weeping oer her Human Harvest
Los listens to the Cry of the Poor Man: his Cloud
Over London in volume terrific, low bended in anger.

Rintrah & Palamabron view the Human Harvest beneath
Their Wine-presses & Barns stand open; the Ovens are prepard
The Waggons ready: terrific Lions & Tygers sport & play
All Animals upon the Earth, are prepard in all their strength

46

To go forth to the Great Harvest & Vintage
of the Nations
Finis

ADDITIONAL PLATE 2

PREFACE.

The Stolen and Perverted Writings of Homer &
Ovid; of Plato & Cicero. which all Men ought to
contemn: are set up by artifice against the Sublime
of the Bible. but when the New Age is at leisure
to Pronounce; all will be set right; & those Grand
Works of the more ancient & consciously & profes-
-sedly Inspired Men, will hold their proper rank. &
the Daughters of Memory shall become the Daugh-
-ters of Inspiration. Shakspeare & Milton were
both curbd by the general malady & infection from
the silly Greek & Latin slaves of the Sword
Rouze up O Young Men of the New Age! set your
foreheads against the ignorant Hirelings! For
we have Hirelings in the Camp, the Court, & the Uni-
versity: who would if they could, for ever depress Ment
of & prolong Corporeal War. Painters! on you I call!
Sculptors! Architects! Suffer not the fashionable Fools
to depress your powers by the prices they pretend to
give for contemptible works or the expensive advertising
boasts that they make of such works; believe
Christ & his Apostles that there is a Class of Men
whose whole delight is in Destroying. We do not
want either Greek or Roman Models if we are but
just & true to our own Imaginations, those Worlds
of Eternity in which we shall live for ever; in
Jesus our Lord.

And did those feet in ancient time,
Walk upon Englands mountains green:
And was the holy Lamb of God,
On Englands pleasant pastures seen!

And did the Countenance Divine,
Shine forth upon our clouded hills?
And was Jerusalem builded here,
Among these dark Satanic Mills?

Bring me my Bow of burning gold,
Bring me my Arrows of desire:
Bring me my Spear: O clouds unfold!
Bring me my Chariot of fire!

I will not cease from Mental Fight,
Nor shall my Sword sleep in my hand:
Till we have built Jerusalem,
In Englands green & pleasant Land

Would to God that all the Lords people
were Prophets
Numbers XI. ch 29.v.

ADDITIONAL PLATE 5

Palamabron with the fiery Harrow in morning returning
From breathing fields, Satan fainted beneath the artillery
Christ took on Sin in the Virgins Womb, & put it off on the Cross
All pitied the piteous & was wrath with the wrathful & Los heard it.

And this is the manner of the Daughters of Albion in their beau-ty
Every one is threefold in Head & Heart & Reins & every one
Has three Gates into the Three Heavens of Beulah which shine
Translucent in their Foreheads & their Bosoms & their Loins
Surrounded with fires unapproachable: but whom they please
They take up into their Heavens in intoxicating delight
For the Elect cannot be Redeemd, but Created continually
By Offering & Atonement in the crue[l]ties of Moral Law
Hence the three Classes of Men take their fix'd destinations
They are the Two Contraries & the Reasoning Negative.

While the Females prepare the Victims, the Males at Furnaces
And Anvils dance the dance of tears & pain. loud lightnings
Lash on their limbs as they turn the whirlwinds loose upon
The Furnaces, lamenting around the Anvils & this their Song

Ah weak & wide astray: Ah shut in narrow doleful form
Creeping in reptile flesh upon the bosom of the ground
The Eye of Man a little narrow orb closd up & dark
Scarcely beholding the great light conversing with the Void
The Ear. a little shell in small volutions shutting out
All melodies & comprehending only Discord and Harmony
The Tongue a little moisture fills. a little food it cloys
A little sound it utters & its cries are faintly heard
Then brings forth Moral Virtue the cruel Virgin Babylon

Can such an Eye judge of the stars? & looking thro its tubes
Measure the sunny rays that point their spears on Udanadan
Can such an Ear filld with the vapours of the yawning pit,
Judge of the pure melodious harp struck by a hand divine!
Can such closed Nostrils feel a joy? or tell of autumn fruits
When grapes & figs burst their covering to the joyful air
Can such a Tongue boast of the living waters? or take in
Ought but the Vegetable Ratio & loathe the faint delight
Can such gross Lips percieve? alas folded within themselves
They touch not ought but pallid turn & tremble at every wind

Thus they sing Creating the Three Classes among Druid Rocks
Charles calls on Milton for Atonement, Cromwell is ready
James calls for fires in Golgonooza. for heaps of smoking
ruins
In the night of prosperity and
wantonness which he himself
Created
Among the Daughters of Albion
among the Rocks of the Druids
When Satan fainted beneath the
arrows of Elynittria
And Mathematic Proportion was subdued
by Living Proportion

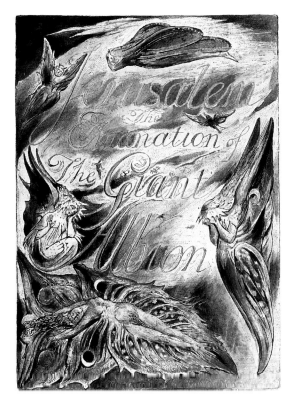

*Jerusalem*

*The*

Emanation of

The Giant

Albion

*1804*
*Printed by W. Blake Sth Molton St.*

3

||LL||                                   | | | | | |

To the Public

After my three years slumber on the banks of the Ocean, I again
display my Giant forms to the Public: My former Giants & Fairies
having reciev'd the highest reward possible: the        and
of those with whom to be connected, is to be      I cannot doubt
that this more consolidated & extended Work. will be as kindly
recieved           The Enthusiasm of the following Poem, the
author hopes

                                        I also
hope the Reader will be with me, wholly One in Jesus our Lord, who
is the God         and Lord        to whom the Ancients look'd
and saw his day afar off, with trembling & amazement.
   The Spirit of Jesus is continual forgiveness of Sin: he who waits
to be righteous before he enters into the Saviours kingdom, the Divine
Body; will never enter there. I am perhaps the most sinful of men!
I pretend not to holiness; yet I pretend to love, to see, to converse with
daily, as man with man, & the more to have an interest in the Friend
of Sinners. Therefore Reader,      what you do not approve, &
me for this energetic exertion of my talent.

        Reader!    of books!    of heaven,
   And of that God from whom
   Who in mysterious Sinais awful cave,
   To Man the wond'rous art of writing gave,

Again he speaks in thunder and in fire!
Thunder of Thought, & flames of fierce desire:
Even from the depths of Hell his voice I hear,
Within the unfathomd caverns of my Ear.
Therefore I print; nor vain my types shall be:
Heaven, Earth & Hell, henceforth shall live in harmony

     Of the Measure, in which
       the following Poem is written

  We who dwell on Earth can do nothing of ourselves, every thing is
conducted by Spirits, no less than Digestion or Sleep.

  When this Verse was first dictated to me I consider'd a Monotonous
Cadence like that used by Milton & Shakspeare & all writers of English
Blank Verse, derived from the modern bondage of of Rhyming; to be a
necessary and indispensible part of Verse. But I soon found that in the
mouth of a true Orator such monotony was not only awkward, but as much
a bondage as rhyme itself. I therefore have produced a variety in every line.
both of cadences & number of syllables. Every word and every letter is
studied and put into its fit place: the terrific numbers are reserved for the
terrific parts the mild & gentle, for the mild & gentle parts. and the prosaic,
for inferior parts; all are necessary to each other. Poetry, Fetter'd. Fetters
the Human Race. Nations are Destroy'd, or Flourish, in proportion as Their
Poetry Painting and Music, are Destroy'd or Flourish! The Primeval State
of Man, was Wisdom, Art, and Science.

4

Μονος ὁ Ιεσους

# Jerusalem

Chap: 1

Of the Sleep of Ulro! and of the passage through
Eternal Death! and of the awaking to Eternal Life

This theme calls me in sleep night after night, & ev'ry morn
Awakes me at sun-rise, then I see the Saviour over me
Spreading his beams of love, & dictating the words of this mild song.

Awake! awake O sleeper of the land of shadows, wake! expand!
I am in you and you in me, mutual in love divine:
Fibres of love from man to man thro Albions pleasant land.
In all the dark Atlantic vale down from the hills of Surrey
A black water accumulates, return Albion! return!
Thy brethren call thee, and thy fathers, and thy sons,
Thy nurses and thy mothers, thy sisters and thy daughters
Weep at thy souls disease, and the Divine Vision is darkend:
Thy Emanation that was wont to play before thy face,
Beaming forth with her daughters into the Divine bosom
Where hast thou hidden thy Emanation lovely Jerusalem
From the vision and fruition of the Holy-one?
I am not a God afar off, I am a brother and friend
Within your bosoms I reside, and you reside in me.
Lo! we are One; forgiving all Evil; Not seeking recompense!
Ye are my members O ye sleepers of Beulah land of shades!

But the perturbed Man away turns down the valleys dark;

Phantom of the over heated brain! shadow of immortality!
Seeking to keep my soul a victim to thy Love! which binds
Man the enemy of man into deceitful friendships:
Jerusalem is not! her daughters are indefinite:
By demonstration, man alone can live, and not by faith.
My mountains are my own, and I will keep them to myself!
The Malvern and the Cheviot, the Wolds Plinlimmon & Snowdon
Are mine. here will I build my Laws of Moral Virtue!
Humanity shall be no more: but war & princedom & victory!

So spoke Albion in jealous fears, hiding his Emanation
Upon the Thames and Medway, rivers of Beulah: dissembling
His jealousy before the throne divine, darkening. cold!

5

The banks of the Thames are clouded! the ancient porches of Albion are
Darken'd! they are drawn thro' unbounded space, scatter'd upon
The Void in incohererent despair! Cambridge & Oxford & London,
Are driven among the starry Wheels, rent away and dissipated,
In Chasms & Abysses of sorrow, enlarg'd without dimension, terrible
Albions mountains run with blood. the cries of war & of tumult
Resound into the unbounded night, every Human perfection

Of mountain & river & city. are small & wither'd & darken'd
Cam is a little stream! Ely is almost swallowd up!
Lincoln & Norwich stand trembling on the brink of Udan–Adan!
Wales and Scotland shrink themselves to the west and to the north!
Mourning for fear of the warriors in the Vale of Entuthon-Benython
Jerusalem is scatterd abroad like a cloud of smoke thro' non-entity!
Moab & Ammon & Amalek & Canaan & Egypt & Aram
Recieve her little ones for sacrifices and the delights of cruelty

Trembling I sit day and night, my friends are astonish'd at me.
Yet they forgive my wanderings, I rest not from my great task!
To open the Eternal Worlds, to open the immortal Eyes
Of Man inwards into the Worlds of Thought: into Eternity
Ever expanding in the Bosom of God. the Human Imagination
O Saviour pour upon me thy Spirit of meekness & love:
Annihilate the Selfhood in me, be thou all my life!
Guide thou my hand which trembles exceedingly upon the rock of ages,
While I write of the building of Golgonooza, & of the terrors of Entuthon:
Of Hand & Hyle & Coban, of Kwantok, Peachey, Brereton, Slayd & Hutton:
Of the terrible sons & daughters of Albion. and their Generations.

Scofield. Kox, Kotope and Bowen, revolve most mightily upon
The Furnace of Los: before the eastern gate bending their fury.
They war, to destroy the Furnaces, to desolate Golgonooza:
And to devour the Sleeping Humanity of Albion in rage & hunger.
They revolve into the Furnaces Southward & are driven forth Northward
Divided into Male and Female forms time after time.
From these Twelve all the Families of England spread abroad.

The Male is a Furnace of beryll; the Female is a golden Loom;
I behold them and their rushing fires overwhelm my Soul;
In Londons darkness; and my tears fall day and night,
Upon the Emanations of Albions Sons! the Daughters of Albion
Names anciently rememberd, but now contemn'd as fictions!
Although in every bosom they controll our Vegetative powers.

These are united into Tirzah and her Sisters, on Mount Gilead.
Cambel & Gwendolen & Conwenna & Cordella & Ignoge.
And these united into Rahab in the Covering Cherub on Euphrates
Gwiniverra & Gwinefred, & Gonorill & Sabrina beautiful,
Estrild, Mehetabel & Ragan, lovely Daughters of Albion
They are the beautiful Emanations of the Twelve Sons of Albion

The Starry Wheels revolv'd heavily over the Furnaces;
Drawing Jerusalem in anguish of maternal love,
Eastward a pillar of a cloud with Vala upon the mountains
Howling in pain, redounding from the arms of Beulahs Daughters,
Out from the Furnaces of Los above the head of Los.
A pillar of smoke writhing afar into Non-Entity, redounding
Till the cloud reaches afar outstretch'd among the Starry Wheels
Which revolve heavily in the mighty Void above the Furnaces

O what avail the loves & tears of Beulahs lovely Daughters
They hold the Immortal Form in gentle bands & tender tears
But all within is open'd into the deeps of Entuthon Benython
A dark and unknown night, indefinite, unmeasurable, without end.
Abstract Philosophy warring in enmity against Imagination
Which is the Divine Body of the Lord Jesus. blessed for ever).
And there Jerusalem wanders with Vala upon the mountains,
Attracted by the revolutions of those Wheels the Cloud of smoke:
Immense. and Jerusalem & Vala weeping in the Cloud
Wander away into the Chaotic Void, lamenting with her Shadow
Among the Daughters of Albion, among the Starry Wheels;
Lamenting for her children, for the sons & daughters of Albion

Los heard her lamentations in the deeps afar! his tears fall
Incessant before the Furnaces, and his Emanation divided in pain,
Eastward toward the Starry Wheels. But Westward, a black Horror.

6

His spectre driv'n by the Starry Wheels of Albions sons, black and
Opake divided from his back, he labours and he mourns!

For as his Emanation divided, his Spectre also divided
In terror of those starry wheels: and the spectre stood over Los
Howling in pain: a blackning Shadow, blackning dark & opake
Cursing the terrible Los: bitterly cursing him for his friendship
To Albion, suggesting murderous thoughts against Albion

Loud rag'd and stamp'd the earth in his might & terrible wrath!
He stood and stampd the earth! then he threw down his hammer in rage &
In fury; then he sat down and wept, terrified! Then arose
And chaunted his song, labouring with the tongs and hammer:
But still the Spectre divided, and still his pain increas'd!

In pain the Spectre divided: in pain of hunger and thirst:
To devour Los's Human Perfection, but when he saw that Los

7

Was living: panting like a frighted wolf, and howling
He stood over the Immortal, in the solitude and darkness:
Upon the darkning Thames, across the whole Island westward.
A horrible Shadow of Death, among the Furnaces beneath
The pillar of folding smoke; and he sought by other means.
To lure Los: by tears, by arguments of science & by terrors:
Terrors in every Nerve, by spasms & extended pains:
While Los answer'd unterrified to the opake blackening Fiend

And thus the Spectre spoke: Wilt thou still go on to destruction?
Till thy life is all taken away by this deceitful Friendship?
He drinks thee up like water! like wine he pours thee
Into his tuns: thy Daughters are trodden in his vintage
He makes thy Sons the trampling of his bulls, they are plow'd
And harrowd for his profit, lo! thy stolen Emanation
Is his garden of pleasure! all the Spectres of his Sons mock thee
Look how they scorn thy once admired palaces! now in ruins
Because of Albion! because of deceit and friendship! For Lo!
Hand has peopled Babel & Nineveh! Hyle. Ashur & Aram!
Cobans son is Nimrod: his son Cush is adjoind to Aram,
By the Daughter of Babel, in a woven mantle of pestilence & war.
They put forth their spectrous cloudy sails; which drive their immense
Constellations over the deadly deeps of indefinite Udan-Adan
Kox is the Father of Shem & Ham & Japheth. he is the Noah
Of the Flood of Udan-Adan. Hutn is the Father of the Seven
From Enoch to Adam; Schofield is Adam who was New-
Created in Edom. I saw it indignant, & thou art not moved!
This has divided thee in sunder: and wilt thou still forgive?
O! thou seest not what I see! what is done in the Furnaces.
Listen, I will tell thee what is done in moments to thee unknown:
Luvah was cast into the Furnaces of affliction and sealed,
And Vala fed in cruel delight, the Furnaces with fire:
Stern Urizen beheld; urgd by necessity to keep
The evil day afar, and if perchance with iron power
He might avert his own despair: in woe & fear he saw
Vala incircle round the Furnaces where Luvah was clos'd:
With joy she heard his howlings, & forgot he was her Luvah,
With whom she liv'd in bliss in times of innocence & youth!
Vala comes from the Furnace in a cloud, but wretched Luvah
Is howling in the Furnaces, in flames among Albions Spectres,
To prepare the Spectre of Albion to reign over thee O Los.
Forming the Spectres of Albion according to his rage:
To prepare the Spectre sons of Adam, who is Scofield: the Ninth
Of Albions sons, & the father of all his brethren in the Shadowy
Generation. Cambel & Gwendolen wove webs of war & of
Religion, to involve all Albions sons, and when they had
Involv'd Eight; their webs roll'd outwards into darkness
And Scofield the Ninth remain on the outside of the Eight
And Kox, Kotope, & Bowen, One in him, a Fourfold Wonder
Involv'd the Eight—Such are the Generations of the Giant Albion,
To separate a Law of Sin, to punish thee in thy members.

Los answer'd: Altho' I know not this! I know far worse than this:
I know that Albion hath divided me. and that thou O my Spectre,
Hast just cause to be irritated: but look stedfastly upon me:
Comfort thyself in my strength the time will arrive,
When all Albions injuries shall cease, and when we shall
Embrace him tenfold bright. rising from his tomb in immortality.
They have divided themselves by Wrath. they must be united by
Pity: let us therefore take example & warning O my Spectre,
O that I could abstain from wrath! O that the Lamb
Of God would look upon me and pity me in my fury.
In anniah of regeneration! in terrors of self annihilation:
Pity must join together those whom wrath has torn in sunder.
And the Religion of Generation which was meant for the destruction
Of Jerusalem, become her covering, till the time of the End.
O holy Generation! [Image] of regeneration!
O point of mutual forgiveness between Enemies!
Birthplace of the Lamb of God incomprehensible!
The Dead despise & scorn thee, & cast thee out as accursed,
Seeing the Lamb of God in thy gardens & thy palaces
Where they desire to place the Abomination of Desolation.
Hand sits before his furnace: scorn of others & furious pride:
Freeze round him to bars of steel & to iron rocks beneath
His feet: indignant self-righteousness like whirlwinds of the north:

## 8

Rose up against me thundering from the Brook of Albions River
From Ranelagh & Strumbolo, from Cromwells gardens & Chelsea
The place of wounded Soldiers. but when he saw my Mace
Whirld round from heaven to earth, trembling he sat; his cold
Poisons rose up: & his sweet deceits coverd them all over
With a tender cloud. As thou art now; such was he O Spectre
I know thy deceit & thy revenges, and unless thou desist
I will certainly create an eternal Hell for thee. Listen!
Be attentive! be obedient! Lo the Furnaces are ready to recieve thee.
I will break thee into shivers! & melt thee in the furnaces of death
I will cast thee into forms of abhorrence & torment if thou

Desist not from thine own will, & obey not my stern command!
I am closd up from my children! my Emanation is dividing
And thou my Spectre art divided against me. But mark
I will compell thee to assist me in my terrible labours. To beat
These hypocritic Selfhoods on the Anvils of bitter Death
I am inspired: I act not for myself: for Albions sake
I now am what I am: a horror and an astonishment
Shuddring the heavens to look upon me: Behold what cruelties
Are practised in Babel & Shinar, & have approachd to Zions Hill

While Los spoke, the terrible Spectre fell shuddring before him
Watching his time with glowing eyes to leap upon his prey
Los opend the Furnaces in fear. the Spectre saw to Babel & Shinar
Across all Europe & Asia. he saw the tortures of the Victims,
He saw now from the ouside what he before saw & felt from within
He saw that Los was the sole, uncontrolld Lord of the Furnaces
Groaning he kneeld before Los's iron-shod feet on London Stone,
Hungring & thirsting for Los's life yet pretending obedience.
While Los pursud his speech in threatnings loud & fierce.

Thou art my Pride & Self-righteousness, I have found thee out:
Thou art reveald before me in all thy magnitude & power
Thy Uncircumcised pretences to Chastity must be cut in sunder!
Thy holy wrath & deep deceit cannot avail against me
Nor shalt thou ever assume the triple-form of Albions Spectre
For I am one of the living: dare not to mock my inspired fury
If thou wast cast forth from my life! if I was dead upon the mountains

Thou mightest be pitied & lovd: but now I am living; unless
Thou abstain ravening I will create an eternal Hell for thee.
Take thou this Hammer & in patience heave the thundering Bellows
Take thou these Tongs: strike thou alternate with me: labour obedient
Hand & Hyle & Koban, Skofeld, Kox & Kotope, labour mightily
In the Wars of Babel & Shinar, all their Emanations were
Condensd. Hand has absorbd all his Brethren in his might
All the infant Loves & Graces were lost, for the mighty Hand

Con-

## 9

Condens'd his Emanations into hard opake substances;
And his infant thoughts & desires into cold, dark, cliffs of death.
His hammer of gold he siez'd, and his anvil of adamant.
He siez'd the bars of condens'd thoughts, to forge them:
Into the sword of war: into the bow and arrow:
Into the thundering cannon and into the murdering gun
I saw the limbs form'd for exercise, contemn'd! & the beauty of
Eternity, look'd upon as deformity & loveliness as a dry tree:
I saw disease forming a Body of Death around the Lamb
Of God, to destroy Jerusalem, & to devour the body of Albion
By war and stratagem to win the labour of the husbandman:

Awkwardness arm'd in steel: folly in a helmet of gold:
Weakness with horns & talons: ignorance with a rav'ning beak!
Every Emanative joy forbidden as a Crime:
And the Emanations buried alive in the earth with pomp of religion:
Inspiration deny'd; Genius forbidden by laws of punishment:
I saw terrified; I took the sighs & tears, & bitter groans:
I lifted them into my Furnaces; to form the spiritual sword.
That lays open the hidden heart: I drew forth the pang
Of sorrow red hot: I workd it on my resolute anvil:
I heated it in the flames of Hand, & Hyle, & Coban
Nine times; Gwendolen & Cambel & Gwineverra

Are melted into the gold, the silver, the liquid ruby,
The crysolite, the topaz, the jacinth, & every precious stone.
Loud roar my Furnaces and loud my hammer is heard:
I labour day and night, I behold the soft affections
Condense beneath my hammer into forms of cruelty

But still I labour in hope, tho' still my tears flow down.

That he who will not defend Truth, may be compelld to defend
A Lie: that he may be snared and caught and snared and taken
That Enthusiasm and Life may not cease: arise Spectre arise!

Thus they contended among the Furnaces with groans & tears;
Groaning the Spectre heavd the bellows, obeying Los's frowns;
Till the Spaces of Erin were perfected in the furnaces
Of affliction, and Los drew them forth, compelling the harsh Spectre.

## 10

Into the Furnaces & into the valleys of the Anvils of Death
And into the mountains of the Anvils & of the heavy Hammers
Till he should bring the Sons & Daughters of Jerusalem to be
The Sons & Daughters of Los that he might protect them from
Albions dread Spectres; storming, loud, thunderous & mighty
The Bellows & the Hammers move compell'd by Los's hand.

And this is the manner of the Sons of Albion in their strength
They take the Two Contraries which are calld Qualities, with which
Every Substance is clothed, they name them Good & Evil
From them they make an Abstract. which is a Negation
Not only of the Substance from which it is derived
A murderer of its own Body: but also a murderer
Of every Divine Member: it is the Reasoning Power
An Abstract objecting power, that Negatives every thing
This is the Spectre of Man; the Holy Reasoning Power
And in its Holiness is closed the Abomination of Desolation

Therefore Los stands in London building Golgonooza —
Compelling his Spectre to labours mighty; trembling in fear
The Spectre weeps, but Los unmovd by tears or threats remains

I must Create a System. or be enslav'd by another Mans
I will not Reason & Compare: my business is to Create

So Los, in fury & strength: in indignation & burning wrath
Shuddring the Spectre howls. his howlings terrify the night
He stamps around the Anvil, beating blows of stern despair
He curses Heaven & Earth, Day & Night & Sun & Moon
He curses Forest Spring & River, Desart & sandy Waste
Cities & Nations, Families & Peoples, Tongues & Laws
Driven to desperation by Los's terrors & threatning fears

Los cries, Obey my voice & never deviate from my will
And I will be merciful to thee: be thou invisible to all
To whom I make thee invisible, but chief to my own Children
O Spectre of Urthona: Reason not against their dear approach
Nor them obstruct with thy temptations of doubt & despair
O Shame O strong & mighty Shame I break thy brazen fetters
If thou refuse, thy present torments will seem southern breezes
To what thou shalt endure if thou obey not my great will!

The Spectre answer'd. Art thou not ashamd of those thy Sins
That thou callest the Children? to the Law of God commands
That they be offered upon his Altar: O cruelty & torment
For thine are also mine! I have kept silent hitherto.
Concerning my chief delight: but thou hast broken silence
Now I will speak my mind! Where is my lovely Enitharmon
O thou my enemy, where is my Great Sin? She is also thine
I said: now is my grief at worst: incapable of being
Surpassed: but every moment it accumulates more & more
It continues accumulating to eternity! the joys of God advance
For he is Righteous: he is not a Being of Pity & Compassion
He cannot feel Distress: he feeds on Sacrifice & Offering:
Delighting in cries & tears & clothed in holiness & solitude
But my griefs advance also, for ever & ever without end
O that I could cease to be! Despair! I am Despair
Created to be the great example of horror & agony: also my
Prayer is vain I called for compassion: compassion mockd
Mercy & pity threw the grave stone over me & with lead
And iron, bound it over me for ever: Life lives on my
Consuming: & the Almighty hath made me his Contrary
To be all evil, all reversed & for ever dead: knowing
And seeing life, yet living not; how can I then behold
And not tremble; how can I be beheld & not abhorrd

So spoke the Spectre shuddring, & dark tears ran down his shadowy face
Which Los wiped off, but comfort none could give! or beam of hope.
Yet ceasd he not from labouring at the roarings of his Forge
With iron & brass Building Golgonooza in great contendings
Till his Sons & Daughters came forth from the Furnaces
At the sublime Labours for Los. compelld the invisible Spectre

## 11

To labours mighty, with vast strength, with his mighty chains.
In pulsations of time, & extensions of space, like Urns of Beulah
With great labour upon his anvils, & in his ladles the Ore
He lifted, pouring it into the clay ground prepar'd with art;
Striving with Systems to deliver Individuals from those Systems:
That whenever any Spectre began to devour the Dead,
He might feel the pain as if a man gnawd his own tender nerves,

Then Erin came forth from the Furnaces, & all the Daughters of Beulah
Came from the Furnaces, by Los's mighty power for Jerusalems
Sake: walking up and down among the Spaces of Erin:
And the Sons and Daughters of Los came forth in perfection lovely!
And the Spaces of Erin reach'd from the starry heighth, to the starry

Los wept with exceeding joy & all wept with joy together!
They feard they never more should see their Father, who
Was built in from Eternity, in the Cliffs of Albion.

But when the joy of meeting was exhausted in loving embrace;
Again they lament. O what shall we do for lovely Jerusalem?
To protect the Emanations of Albions mighty ones from cruelty?
Sabrina & Ignoge begin to sharpen their beamy spears
Of light and love: their little children stand with arrows of gold:
Ragan is wholly cruel Scofield is bound in iron armour!
He is like a mandrake in the earth before Reubens gate:
He shoots beneath Jerusalems walls to undermine her foundations;
Vala is but thy Shadow, O thou loveliest among women!
A shadow animated by thy tears O mournful Jerusalem!

## 12

Why wilt thou give to her a Body whose life is but a Shade?
Her joy and love, a shade! a shade of sweet repose:
But animated and vegetated, she is a devouring worm:
What shall we do for thee O lovely mild Jerusalem?

And Los said. I behold the finger of God in terrors!
Albion is dead! his Emanation is divided from him!
But I am living! yet I feel my Emanation also dividing
Such thing was never known! O pity me, thou all-piteous-one!
What shall I do! or how exist, divided from Enitharmon?
Yet why despair! I saw the finger of God go forth
Upon my Furnaces, from within the Wheels of Albions Sons:
Fixing their Systems, permanent: by mathematic power
Giving a body to Falshood that it may be cast off for ever.
With Demonstrative Science piercing Apollyon with his own bow!
God is within, & without! he is even in the depths of Hell!

Such were the lamentations of the Labourers in the Furnaces:

And they appeard within & without incircling on both sides
The Starry Wheels of Albions Sons, with Spaces for Jerusalem:
And for Vala the shadow of Jerusalem: the ever mourning shade:
On both sides, within & without beaming gloriously!

Terrified at the sublime Wonder, Los stood before his Furnaces,
And they stood around, terrified with admiration at Erins Spaces
For the Spaces reachd from the starry heighth, to the starry depth;
And they builded Golgonooza: terrible eternal labour!

What are those golden builders doing? where was the burying-place
Of soft Ethinthus? near Tyburns fatal Tree? is that
Mild Zions hills most ancient promontory; near mournful
Ever weeping Paddington? is that Calvary and Golgotha?
Becoming a building of pity and compassion? Lo!
The stones are pity, and the bricks, well wrought affections:
Enameld with love & kindness, & the tiles engraven gold
Labour of merciful hands: the beams & rafters are forgiveness:
The mortar & cement of the work, tears of honesty: the nails,
And the screws & iron braces, are well wrought blandishments,
And well contrived words, firm fixing, never forgotten,
Always comforting the remembrance: the floors, humility,
The ceilings, devotion: the hearths, thanksgiving:
Prepare the furniture O Lambeth in thy pitying looms!
The curtains, woven tears & sighs, wrought into lovely forms
For comfort, there the secret furniture of Jerusalems chamber
Is wrought: Lambeth! the Bride the Lambs Wife loveth thee:
Thou art one with her & knowest not of self in thy supreme joy
Go on, builders in hope: tho Jerusalem wanders far away,
Without the gate of Los: among the dark Satanic wheels.
Fourfold the Sons of Los in their divisions: and fourfold,
The great City of Golgonooza: fourfold toward the north

And toward the south fourfold, & fourfold toward the east & west
Each within other toward the four points: that toward
Eden, and that toward the World of Generation,
And that toward Beulah, and that toward Ulro:
Ulro is the space of the terrible starry wheels of Albions sons:
But that toward Eden is walled up, till time of renovation:
Yet it is perfect in its building, ornaments & perfection.

And the Four Points are thus beheld in Great Eternity
West, the Circumference: South, the Zenith: North,
The Nadir: East, the Center, unapproachable for ever.
These are the four Faces towards the Four Worlds of Humanity
In every Man. Ezekiel saw them by Chebars flood.
And the Eyes are the South, and the Nostrils are the East.
And the Tongue is the West, and the Ear is the North.

And the North Gate of Golgonooza toward Generation;
Has four sculpturd Bulls terrible before the Gate of iron.
And iron, the Bulls: and that which looks toward Ulro,
Clay bak'd & enamel'd, eternal glowing as four furnaces:
Turning upon the Wheels of Albions sons with enormous power.
And that toward Beulah four, gold, silver, brass, & iron:

## 13

And that toward Eden. four, form'd of gold, silver, brass, & iron.

The South, a golden Gate, has four Lions terrible. living!
That toward Generation, four, of iron carv'd wondrous:
That toward Ulro, four, clay bak'd, laborious workmanship
That toward Eden, four; immortal gold, silver, brass & iron.

The Western Gate fourfold, is closd: having four Cherubim
Its guards, living, the work of elemental hands, laborious task!
Like Men, hermaphroditic, each winged with eight wings
That towards Generation, iron; that toward Beulah, stone:
That toward Ulro, clay: that toward Eden, metals.
But all clos'd up till the last day, when the graves shall yield their dead

The Eastern Gate. fourfold: terrible & deadly its ornaments:
Taking their forms from the Wheels of Albions sons; as cogs
Are formd in a wheel, to fit the cogs of the adverse wheel.

That toward Eden, eternal ice, frozen in seven folds
Of forms of death: and that toward Beulah, stone:
The seven diseases of the earth are carved terrible.
And that toward Ulro, forms of war; seven enormities;
And that toward Generation, seven generative forms.

And every part of the City is fourfold; & every inhabitant, fourfold.
And every pot & vessel & garment & utensil of the houses,
And every house, fourfold; but the third Gate in every one
Is closd as with a threefold curtain of ivory & fine linen & ermine.
And Luban stands in middle of the City. a moat of fire,
Surrounds Luban, Los's Palace & the golden Looms of Cathedron,

And sixty-four thousand Genii, guard the Eastern Gate:
And sixty-four thousand Gnomes, guard the Northern Gate:
And sixty-four thousand Nymphs, guard the Western Gate:
And sixty-four thousand Fairies, guard the Southern Gate:

Around Golgonooza lies the land of death eternal! a Land
Of pain and misery and despair and ever brooding melancholy;
In all the Twenty-seven Heavens, numberd from Adam to Luther;
From the blue Mundane Shell. reaching to the Vegetative Earth.
The Vegetative Universe. opens like a flower from the Earths center:
In which is Eternity. It expands in Stars to the Mundane Shell
And there it meets Eternity again, both within and without,
And the abstract Voids between the Stars are the Satanic Wheels.

There is the Cave; the Rock; the Tree; the Lake of Udan Adan;
The Forest, and the Marsh, and the Pits of bitumen deadly:
The Rocks of solid fire: the Ice valleys: the Plains
Of burning sand: the rivers, cataract & Lakes of Fire:
The Islands of the fiery Lakes: the Trees of Malice; Revenge;
and black Anxiety: and the Cities of the Salamandrine men:
(But whatever is visible to the Generated Man,
Is a Creation of mercy & love, from the Satanic Void.)
The land of darkness flamed but no light, & no repose:
The land of snows of trembling, & of iron hail incessant:
The land of earthquakes: and the land of woven labyrinths
The land of snares & traps & wheels & pit falls & dire mills
The Voids, the Solids, & the land of clouds & regions of waters:
With their inhabitants: in the Twenty-seven Heavens beneath Beulah:
Self-righteousnesses conglomerating against the Divine Vision:

Concave Earth wondrous, Chasmal, Abyssal, Incoherent!
rming the Mundane Shell: above; beneath: on all sides surrounding
olgonooza: Los walks round the walls night and day.

e views the City of Golgonooza, & its smaller Cities:
he Looms & Mills & Prisons & Work-houses of Og & Anak:
he Amalekite: the Canaanite: the Moabite; the Egyptian:
nd all that has existed in the space of six thousand years:
rmanent, & not lost not lost nor vanishd, & every little act,
ord, work. & wish, that has existed, all remaining still
 those Churches ever consuming & ever building by the Spectres
f all the inhabitants of Earth wailing to be Created:
adowy to those who dwell not in them, meer possibilities:
it to those who enter into them they seem the only substances
or every thing exists & not one sigh nor smile nor tear,

## 14

ne hair nor particle of dust. not one can pass away.

e views the Cherub at the Tree of Life. also the Serpent,
rc the first born coild in the south: the Dragon Urizen:
harms the Vegetated Tongue even the Devouring Tongue:
 threefold region, a false brain: a false heart:
nd false bowels: altogether composing the False Tongue,
eneath Beulah: as a watry flame revolving every way
nd as dark roots and stems: a Forest of affliction, growing
 seas of sorrow. Los also views the Four Females:
hania, and Enion, and Vala. and Enitharmon lovely.
nd from them all the lovely beaming Daughters of Albion.
hania & Enion & Vala, are three evanescent shades:
nitharmon is a vegetated mortal Wife of Los:
is Emanation, yet his Wife till the sleep of death is past.

ich are the Buildings of Los! & such are the Woofs of Enitharmon!

nd Los beheld his Sons, and he beheld his Daughters:
very one a translucent Wonder: a Universe within,
ncreasing inwards, into length and breadth, and heighth:
arry & glorious: and they every one in their bright loins:
ave a beautiful golden gate which opens into the vegetative world:
nd every one a gate of rubies & all sorts of precious stones
 their translucent hearts, which opens into the vegetative world:
nd every one a gate of iron dreadful and wonderful,
 their translucent heads. which opens into the vegetative world
nd every one has the three regions Childhood: Manhood: & Age:
ut the gate of the tongue: the western gate in them is clos'd,
aving a wall builded against it. and thereby the gates
astward & Southward & Northward. are incircled with flaming fires.
nd the North is Breadth, the South is Heighth & Depth:
he East is Inwards: & the West is Outwards every way.
nd Los beheld the mild Emanation Jerusalem eastward bending
er revolutions toward the Starry Wheels in maternal anguish
ike a pale cloud arising from the arms of Beulahs Daughters.

i Enitharmon henvhmus her pr vains heart in Golgonooza,

## 15

nd Hand & Hyle rooted into Jerusalem by a fibre
f strong revenge & 3hofeld Vegetated by Reubens Gate
 every Nation of the Earth till the Twelve Sons of Albion
nrooted into every Nation: a mighty Polypus growing
rom Albion over the whole Earth: such is my awful Vision.

 see the Four-fold Man. The Humanity in deadly sleep
nd its fallen Emanation. The Spectre & its cruel Shadow.
 see the Past, Present & Future, existing all at once
efore me; O Divine Spirit sustain me on thy wings!
hat I may awake Albion from his long & cold repose.
or Bacon & Newton sheathd in dismal steel. their terrors hang
ike iron scourges over Albion, Reasonings like vast Serpents
nfold around my limbs, bruising my minute articulations

 turn my eyes to the Schools & Universities of Europe
nd there behold the Loom of Locke whose Woof rages dire
Vashd by the Water-wheels of Newton. black the cloth
n heavy wreathes folds over every Nation; cruel Works
)f many Wheels I view, wheel without wheel, with cogs tyrannic
Moving by compulsion each other: not as those in Eden: which
Vheel within Wheel in freedom revolve in harmony & peace.

 see in deadly fear in London Los raging round his Anvil
)f death: forming an Ax of gold: the Four Sons of Los
tand round him cutting the Fibres from Albions hills

---

That Albions Sons may roll apart over the Nations
While Reuben enroots his brethren in the narrow Canaanite
From the Limit Noah to the Limit Abram in whose Loins
Reuben in his Twelve-fold majesty & beauty shall take refuge
As Abraham flees from Chaldea shaking his goary locks
But first Albion must sleep, divided from the Nations

I see Albion sitting upon his Rock in the first Winter
And thence I see the Chaos of Satan & the World of Adam
When the Divine Hand went forth on Albion in the mid Winter
And at the place of Death when Albion sat in Eternal Death
Among the Furnaces of Los in the Valley of the Son of Hinnom

## 16

Hampstead Highgate Finchley Hendon Muswell hill: rage loud
Before Bromions iron Tongs & glowing Poker reddening fierce
Hertfordshire glows with fierce Vegetation! in the Forests
The Oak frowns terrible, the Beech & Ash & Elm enroot
Among the Spiritual fires: loud the Corn fields thunder along
The Soldiers fife; the Harlots shriek; the Virgins dismal groan
The Parents fear: the Brothers jealousy: the Sisters curse
Beneath the Storms of Theotormon & the thundering Bellows
Heaves in the hand of Palamabron who in Londons darkness
Before the Anvil. watches the bellowing flames: thundering
The Hammer loud rages in Rintrahs strong grasp swinging loud
Round from heaven to earth down falling with heavy blow
Dead on the Anvil. where the red hot wedge groans in pain
He quenches it in the black trough of his Forge; Londons River
Feeds the dread Forge, trembling & shuddering along the Valleys

Humber & Trent roll dreadful before the Seventh Furnace
And Tweed & Tyne anxious give up their Souls for Albions sake
Lincolnshire Derbyshire Nottinghamshire Leicestershire
From Oxfordshire to Norfolk on the Lake of Udan Adan
Labour within the Furnaces, walking among the Fires
With Ladles huge & iron Pokers over the Island white.

Scotland pours out his Sons to labour at the Furnaces
Wales gives his Daughters to the Looms; England: nursing Mothers
Gives to the Children of Albion & to the Children of Jerusalem
From the blue Mundane Shell even to the Earth of Vegetation
Throughout the whole Creation which groans to be deliverd
Albion groans in the deep slumbers of Death upon his Rock.

Here Los fixd down the Fifty-two Counties of England & Wales
The Thirty-six of Scotland, & the Thirty-four of Ireland
With mighty power, when they fled out at Jerusalems Gates
Away from the Conflict of Luvah & Urizen, fixing the Gates
In the Twelve Counties of Wales & thence Gates looking every way
To the Four Points: conduct to England & Scotland & Ireland
And thence to all the Kingdoms & Nations & Families of the Earth
The Gate of Reuben in Carmarthenshire: the Gate of Simeon in
Cardiganshire: & the Gate of Levi in Montgomeryshire
The Gate of Judah Merionethshire, the Gate of Dan Flintshire
The Gate of Naphtali, Radnorshire; the Gate of Gad Pembrokeshire
The Gate of Asher, Carnarvonshire the Gate of Issachar Brecknokshire
The Gate of Zebulun, in Anglesea & Sodor. so is Wales divided,
The Gate of Joseph, Denbighshire: the Gate of Benjamin Glamorganshire
For the protection of the Twelve Emanations of Albions Sons

And the Forty Counties of England are thus divided in the Gates
Of Reuben Norfolk, Suffolk. Essex, Simeon Lincoln, York Lancashire
Levi. Middlesex Kent Surrey. Judah Somerset Glouster Wiltshire,
Dan. Cornwal Devon Dorset, Napthali, Warwick Leicester Worcester
Gad. Oxford Bucks Harford. Asher, Sussex Hampshire Berkshire
Issachar, Northampton Rutland Nottgham. Zebulun Bedford Huntgn Camb
Joseph Stafford Shrops Heref. Benjamin, Derby Cheshire Monmouth;
And Cumberland Northumberland Westmoreland & Durham are
Divided in the the Gates of Reuben, Judah Dan & Joseph
And the Thirty-six Counties of Scotland. divided in the Gates
Of Reuben Kincard Haddntn Forfar, Simeon Ayr Argyll Banff
Levi Edinburgh Roxbro Ross. Judah, Abrdeen Berwik Dumfries
Dan Bute Caitnes Clakmanan. Napthali Nairn Invernes Linlithgo
Gad Peebles Perth Renfru. Asher Sutherlan Sterling Wigtoun
Issachar Selkirk Dumbartn Glasgo. Zebulun Orkney Shetland Skye
Joseph Elgin Lanerk Kinros, Benjamin Kromarty Murra Kirkubriht
Governing all by the sweet delights of secret amorous glances
In Enitharmons Halls builded by Los & his mighty Children

All things acted on Earth are seen in the bright Sculptures of
Los's Halls & every Age renews its powers from these Works
With every pathetic story possible to happen from Hate or

Wayward Love & every sorrow & distress is carved here
Every Affinity of Parents Marriages & Friendships are here
In all their various combinations wrought with wondrous Art
All that can happen to Man in his pilgrimage of seventy years
Such is the Divine Written Law of Horeb & Sinai:
And such the Holy Gospel of Mount Olivet & Calvary:

### 17

His Spectre divides & Los in fury compells it to divide:
To labour in the fire, in the water, in the earth, in the air.
To follow the Daughters of Albion as the hound follows the scent
Of the wild inhabitant of the forest. to drive them from his own:
To make a way for the Children of Los to come from the Furnaces
But Los himself against Albions Sons his fury bends, for he
Dare not approach the Daughters openly lest he be consumed
In the fires of their beauty & perfection & be Vegetated beneath
Their Looms. in a Generation of death & resurrection to forgetfulness
They wooe Los continually to subdue his strength: he continually
Shews them his Spectre: sending him abroad over the four points of heaven
In the fierce desires of beauty & in the tortures of repulse! He is
The Spectre of the Living pursuing the Emanations of the Dead.
Shuddring they flee: they hide in the Druid Temples in cold chastity:
Subdued by the Spectre of the Living & terrified by undisguisd desire.

For Los said: Tho my Spectre is divided: as I am a Living Man
I must compell him to obey me wholly! that Enitharmon may not
Be lost: & lest he should devour Enitharmon: Ah me!
Piteous image of my soft desires & loves: O Enitharmon!
I will compell my Spectre to obey: I will restore to thee thy Children.
No one bruises or starves himself to make himself fit for labour!

Tormented with sweet desire for these beauties of Albion
They would never love my power if they did not seek to destroy
Enitharmon: Vala would never have sought & loved Albion
If she had not sought to destroy Jerusalem; such is that false
And Generating Love: a pretence of love to destroy love:
Cruel hipocrisy unlike the lovely delusions of Beulah:
And cruel forms, unlike the merciful forms of Beulahs Night

They know not why they love nor wherefore they sicken & die
Calling that Holy Love: which is Envy Revenge & Cruelty
Which separated the stars from the mountains: the mountains from Man
And left Man. a little grovelling Root, outside of Himself.
Negations are not Contraries! Contraries mutually Exist:
But Negations Exist Not: Exceptions & Objections & Unbeliefs
Exist not: nor shall they ever be Organized for ever & ever:
If thou separate from me, thou art a Negation: a meer
Reasoning & Derogation from me, an Objecting & cruel Spite
And Malice & Envy: but my Emanation, Alas! will become
My Contrary: O thou Negation, I will continually compell
Thee to be invisible to any but whom I please, & when
And where & how I please, and never! never! shalt thou be Organized
But as a distorted & reversed Reflexion in the Darkness
And in the Non Entity: nor shall that which is above
Ever descend into thee: but thou shalt be a Non Entity for ever
And if any enter into thee, thou shalt be an Unquenchable Fire
And he shall be a never dying Worm, mutually tormented by
Those that thou tormentest, a Hell & Despair for ever & ever.

So Los in secret with himself communed & Enitharmon heard
In her darkness & was comforted: yet still she divided away
In gnawing pain from Los's bosom in the deadly Night;
First as a red Globe of blood trembling beneath his bosom
Suspended over her he hung: he infolded her in his garments
Of wool: he hid her from the Spectre, in shame & confusion of
Face; in terrors & pains of Hell & Eternal Death, the
Trembling Globe shot forth Self-living & Los howld over it:
Feeding it with his groans & tears day & night without ceasing:
And the Spectrous Darkness from his back divided in temptations,
And in grinding agonies in threats stiflings & direful struggles.

Go thou to Skofeld: ask him if he is Bath or if he is Canterbury
Tell him to be no more dubious: demand explicit words
Tell him: I will dash him into shivers, where & at what time
I please: tell Hand & Skofeld they are my ministers of evil
To those I hate, for I can hate also as well as they!

### 18

From every-one of the Four Regions of Human Majesty,
There is an Outside spread Without, & an Outside spread Within
Beyond the Outline of Identity both ways, which meet in One:

An orbed Void of doubt, despair, hunger, & thirst & sorrow.
Here the Twelve Sons of Albion, join'd in dark Assembly,
Jealous of Jerusalems children, asham'd of her little-ones
(For Vala produc'd the Bodies. Jerusalem gave the Souls)
Became as Three Immense Wheels, turning upon one-another
Into Non-Entity. and their thunders hoarse appall the Dead
To murder their own Souls, to build a Kingdom among the Dead

Cast! Cast ye Jerusalem forth! The Shadow of delusions!
The Harlot daughter! Mother of pity and dishonourable forgiveness
Our Father Albions sin and shame! But father now no more!
Nor sons! nor hateful peace & love. nor soft complacencies
With transgressors meeting in brotherhood around the table,
Or in the porch or garden. No more the sinful delights
Of age and youth and boy and girl and animal and herb,
And river and mountain, and city & village, and house & family,
Beneath the Oak & Palm. beneath the Vine and Fig-tree.
In self-denial!—But War and deadly contention, Between
Father and Son, and light and love! All bold asperities
Of Haters met in deadly strife, rending the house & garden
The unforgiving porches, the tables of enmity, and beds
And chambers of trembling & suspition. hatreds of age & youth
And boy & girl, & animal & herb, & river & mountain
And city & village, and house & family. That the Perfect.
May live in glory, redeem'd by Sacrifice of the Lamb
And of his children, before sinful Jerusalem. To build
Babylon the City of Vala, the Goddess Virgin-Mother.
She is our Mother! Nature! Jerusalem is our Harlot-Sister
Return'd with Children of pollution, to defile our House,
With Sin and Shame. Cast! Cast her into the Potters field.
Her little-ones. She must slay upon our Altars: and her aged
Parents must be carried into captivity, to redeem her Soul
To be for a Shame & a Curse, and to be our Slaves for ever

So cry Hand & Hyle the eldest of the fathers of Albions
Little-ones; to destroy the Divine Saviour; the Friend of Sinners,
Building Castles in desolated places, and strong Fortifications.
Soon Hand mightily devour'd & absorb'd Albions Twelve Sons.
Out from his bosom a mighty Polypus, vegetating in darkness,
And Hyle & Coban were his two chosen ones, for Emissaries
In War: forth from his bosom they went and return'd.
Like Wheels from a great Wheel reflected in the Deep.
Hoarse turn'd the Starry Wheels. rending a way in Albions Loins
Beyond the Night of Beulah. In a dark & unknown Night.
Outstretch'd his Giant beauty on the ground in pain & tears;

### 19

His Children exil'd from his breast pass to and fro before him
His birds are silent on his hills, flocks die beneath his branches
His tents are fall'n! his trumpets, and the sweet sound of his harp
Are silent on his clouded hills, that belch forth storms & fire.
His milk of Cows, & honey of Bees. & fruit of golden harvest,
Is gather'd in the scorching heat, & in the driving rain:
Where once he sat he weary walks in misery and pain:
His Giant beauty and perfection fallen into dust:
Till from within his witherd breast grown narrow with his woes:
The corn is turn'd to thistles & the apples into poison:
The birds of song to murderous crows, his joys to bitter groans!
The voices of children in his tents. to cries of helpless infants!
And self-exiled from the face of light & shine of morning,
In the dark world a narrow house! he wanders up and down,
Seeking for rest and finding none! and hidden far within,
His Eon weeping in the cold and desolated Earth.

All his Affections now appear withoutside: all his Sons,
Hand, Hyle & Coban. Guantok, Peachey, Brereton, Slayd & Hutton,
Scofeld, Kox, Kotope & Bowen; his Twelve Sons: Satanic Mill!
Who are the Spectres of the Twentyfour, each Double-form'd:
Revolving upon his mountains groaning in pain: beneath
The dark incessant sky, seeking for rest and find none:
Raging against their Human natures, rav'ning to gormandize
The Human majesty and beauty of the Twentyfour,
Condensing them into solid rocks with cruelty and abhorrence
Suspition & revenge, & the seven diseases of the Soul
Settled around Albion and around Luvah in his secret cloud
Willing the Friends endur'd, for Albions sake, and for
Jerusalem his Emanation shut within his bosom:
Which hardend against them more and more; as he builded onwards
On the Gulph of Death in self-righteousness, that roll'd
Before his awful feet, in pride of virtue for victory:
And Los was roofd in from Eternity in Albions Cliffs

Which stand upon the ends of Beulah, and withoutside, all
Appear'd a rocky form against the Divine Humanity.

Albions Circumference was clos'd: his Center began darkning
Into the Night of Beulah, and the Moon of Beulah rose
Clouded with storms: Los his strong Guard walkd round beneath the Moon
And Albion fled inward among the currents of his rivers.

He found Jerusalem upon the River of his City soft repos'd
In the arms of Vala, assimilating in one with Vala
The Lilly of Havilah: and they sang soft thro' Lambeths vales,
In a sweet moony night & silence that they had created
With a blue sky spread over with wings and a mild moon,
Dividing & uniting into many female forms: Jerusalem
Trembling! then in one comingling in eternal tears,
Sighing to melt his Giant beauty, on the moony river.

### 20

But when they saw Albion fall'n upon mild Lambeths vale.
Astonish'd! Terrified! they hover'd over his Giant limbs.
Then thus Jerusalem spoke, while Vala wove the veil of tears:
Weeping in pleadings of Love, in the web of despair.

Wherefore hast thou shut me into the winter of human life
And clos'd up the sweet regions of youth and virgin innocence:
Where we live, forgetting error, not pondering on evil:
Among my lambs & brooks of water, among my warbling birds:
Where we delight in innocence before the face of the Lamb:
Going in and out before him in his love and sweet affection.

Vala replied weeping & trembling, hiding in her veil

When winter rends the hungry family and the snow falls.
Upon the ways of men hiding the paths of man and beast,
Then mourns the wanderer: then he repents his wanderings & eyes
The distant forest; then the slave groans in the dungeon of stone.
The captive in the mill of the stranger, sold for scanty hire.
They view their former life: they number moments over and over;
Stringing them on their remembrance as on a thread of sorrow.
Thou art my sister and my daughter! thy shame is mine also!
Ask me not of my griefs! thou knowest all my griefs.

Jerusalem answer'd with soft tears over the valleys.

O Vala what is Sin? that thou shudderest and weepest
At sight of thy once lov'd Jerusalem! What is Sin but a little
Error & fault that is soon forgiven; but mercy is not a Sin
Nor pity nor love nor kind forgiveness! O! if I have Sinned
Forgive & pity me; O! unfold thy Veil in mercy & love!

Slay not my little ones, beloved Virgin daughter of Babylon
Slay not my infant loves & graces, beautiful daughter of Moab
I cannot put off the human form I strive but strive in vain
When Albion rent thy beautiful net of gold and silver twine,
Thou hadst woven it with art, thou hadst caught me in the bands
Of love; thou refusedst to let me go. Albion beheld thy beauty
Beautiful thro' our Loves comeliness, beautiful thro' pity.
The Veil shone with thy brightness in the eyes of Albion,
Because it inclosd pity & love; because we lov'd one-another!
Albion lov'd thee! he rent thy Veil! he embrac'd thee! he lov'd thee!
Astonish'd at his beauty & perfection, thou forgavest his furious love
redounded from Albions bosom in my virgin loveliness.
The Lamb of God reciev'd me in his arms he smil'd upon us:
He made me his Bride & Wife: he gave thee to Albion.
Then was a time of love: O why is it passed away!

Then Albion broke silence and with groans reply'd

### 21

O Vala! O Jerusalem! do you delight in my groans
You O lovely forms, you have prepared my death-cup:
The disease of Shame covers me from head to feet: I have no hope
Every boil upon my body is a separate & deadly Sin,
Doubt first assaild me, then Shame took possession of me
Shame divides Families. Shame hath divided Albion in sunder!
First fled my Sons, & then my Daughters, then my Wild Animations
My Cattle next, last ev'n the Dog of my Gate. the Forests fled
The Corn:fields, & the breathing Gardens outside separated
The Sea; the Stars; the Sun; the Moon; drivn forth by my disease
All is Eternal Death unless you can weave a chaste
Body over an unchaste Mind! Vala! O that thou wert pure!
That the deep wound of Sin might be clos'd up with the Needle.

And with the Loom: to cover Gwendolen & Ragan with costly Robes
Of Natural Virtue, for their Spiritual forms without a Veil
Wither in Luvahs Sepulcher. I thrust him from my presence
And all my Children followd his loud howlings into the Deep.
Jerusalem! dissembler Jerusalem! I look into thy bosom:
I discover thy secret places: Cordella! I behold
Thee whom I thought pure as the heavens in innocence & fear:
Thy Tabernacle taken down, thy secret Cherubim disclosed
Art thou broken? Ah me Sabrina, running by my side:
In childhood what wert thou? unutterable anguish! Conwenna
Thy cradled infancy is most piteous, O hide, O hide!
Their secret gardens were made paths to the traveller:
I knew not of their secret loves with those I hated most,
Nor that their every thought was Sin & secret appetite
Hyle sees in fear, he howls in fury over them, Hand sees
In jealous fear: in stern accusation with cruel stripes
He drives them thro' the Streets of Babylon before my face:
Because they taught Luvah to rise into my clouded heavens
Battersea and Chelsea mourn for Cambel & Gwendolen!
Hackney and Holloway sicken for Estrild & Ignoge!
Because the Peak, Malvern & Cheviot Reason in Cruelty
Penmaenmawr & Dhinas-bran Demonstrate in Unbelief
Manchester & Liverpool are in tortures of Doubt & Despair
Malden & Colchester Demonstrate: I hear my Childrens voices
I see their piteous faces gleam out upon the cruel winds
From Lincoln & Norwich, from Edinburgh & Monmouth/
I see them distant from my bosom scourgd along the roads
Then lost in clouds; I hear their tender voices! clouds divide
I see them die beneath the whips of the Captains! they are taken
In solemn pomp into Chaldea across the bredths of Europe
Six months they lie embalmd in silent death: warshipped
Carried in Arks of Oak before the armies in the spring
Bursting their Arks they rise again to life: they play before

The Armies: I hear their loud cymbals & their deadly cries
Are the Dead cruel? are those who are infolded in moral Law
Revengeful? O that Death & Annihilation were the same!

Then Vala answerd spreading her scarlet Veil over Albion

### 22

Albion thy fear has made me tremble; thy terrors have surrounded me
Thy Sons have naild me on the Gates piercing my hands & feet:
Till Skofields Nimrod the mighty Huntsman Jehovah came.
With Cush his Son & took me down. He in a golden Ark,
Bears me before his Armies tho my shadow hovers here
The flesh of multitudes fed & nourisd me in my childhood
My morn & evening food were prepard in Battles of Men
Great is the cry of the Hounds of Nimrod along the Valley
Of Vision, they scent the odor of War in the Valley of Vision.
All Love is lost! terror succeeds & Hatred instead of Love
And stern demands of Right & Duty instead of Liberty
Once thou wast to me the loveliest son of heaven, but now
Where shall I hide from thy dread countenance & searching eyes
I have looked into the secret Soul of him I loved
And in the dark recesses found Sin & can never return;

Albion again utterd his voice beneath the silent Moon

I brought Love into light of day to pride in chaste beauty
I brought Love into light & fancied Innocence is no more

Then spoke Jerusalem O Albion! my Father Albion
Why wilt thou number every little fibre of my Soul
Spreading them out before the Sun like stalks of flax to dry?
The Infant Joy is beautiful, but its anatomy
Horrible ghast & deadly! nought shalt thou find in it
But dark despair & everlasting brooding melancholy!

Then Albion turnd his face toward Jerusalem & spoke

Hide thou Jerusalem in impalpable voidness, not to be
Touchd by the hand nor seen with the eye: O Jerusalem,
Would thou wert not & that thy place might never be found
But come O Vala with knife & cup! drain my blood
To the last drop! then hide me in thy Scarlet Tabernacle
For I see Luvah whom I slew. I behold him in my Spectre
As I behold Jerusalem in thee O Vala dark and cold

Jerusalem then stretchd her hand toward the Moon & spoke

Why should Punishment Weave the Veil with Iron Wheels of War
When Forgiveness might it Weave with Wings of Cherubim

Loud groand Albion from mountain to mountain & replied

## 23

Jerusalem! Jerusalem! deluding shadow of Albion!
Daughter of my phantasy! unlawful pleasure! Albions curse!
I came here with intention to annihilate thee! But
My soul is melted away. inwoven within the Veil
Hast thou again knitted the Veil of Vala, which I for thee
Pitying rent in ancient times. I see it whole and more
Perfect, and shining with beauty! But thou! O wretched Father!

Jerusalem reply'd, like a voice heard from a sepulcher:
Father! once piteous! Is Pity. a Sin? Embalm'd in Vala's bosom
In an Eternal Death for. Albions sake, our best beloved.
Thou art my Father & my Brother: Why hast thou hidden me,

Remote from the divine Vision: my Lord and Saviour.

Trembling stood Albion at her words in jealous dark despair

He felt that Love and Pity are the same; a soft repose!
Inward complacency of Soul: a Self-annihilation!

I have erred! I am ashamed! and will never return more:
I have taught my children sacrifices of cruelty: what shall I answer?
I will hide it from Eternals! I will give myself for my Children!
Which way soever I turn, I behold Humanity and Pity!

He recoil'd: he rush'd outwards; he bore the Veil whole away
His fires redound from his Dragon Altars in Errors returning
He drew the Veil of Moral Virtue. woven for Cruel Laws,
And cast it into the Atlantic Deep, to catch the Souls of the Dead.
He stood between the Palm tree & the Oak of weeping
Which stand upon the edge of Beulah; and there Albion sunk
Down in sick pallid languor! These were his last words, relapsing!
Hoarse from his rocks, from caverns of Derbyshire & Wales
And Scotland, utter'd from the Circumference into Eternity.

Blasphemous Sons of Feminine delusion! God in the dreary Void
Dwells from Eternity, wide separated from the Human Soul
But thou deluding Image by whom imbu'd the Veil I rent
Lo here is Valas Veil whole. for a Law. a Terror & a Curse!
And therefore God takes vengeance on me: from my clay-cold bosom
My children wander trembling victims of his Moral Justice.
His snows fall on me and cover me, while in the Veil I fold
My dying limbs. Therefore O Manhood, if thou art aught
But a meer Phantasy, hear dying Albions Curse!
May God who dwells in this dark Ulro & voidness, vengeance take,
And draw thee down into this Abyss of sorrow and torture,
Like me thy Victim. O that Death & Annihilation were the same!

## 24

What have I said? What have I done? O all-powerful Human Words!
You recoil back upon me in the blood of the Lamb slain in his Children
Two bleeding Contraries equally true, are his Witnesses against me
We reared mighty Stones: we danced naked around them:
Thinking to bring Love into light of day, to Jerusalems shame:
Displaying our Giant limbs to all the winds of heaven! Sudden
Shame siezd us, we could not look on one-another for abhorrence. the Blue
Of our immortal Veins & all their Hosts fled from our Limbs,
And wanderd distant in a dismal Night clouded & dark:
The Sun fled from the Britons forehead: the Moon from his mighty loins:
Scandinavia fled with all his mountains filld with groans.

O what is Life & what is Man. O what is Death? Wherefore
Are you my Children, natives in the Grave to where I go
Or are you born to feed the hungry ravenings of Destruction
To be the sport of Accident! to waste in Wrath & Love, a weary
Life, in brooding cares & anxious labours, that prove but chaff.
O Jerusalem, Jerusalem I have forsaken thy Courts
Thy Pillars of ivory & gold; thy Curtains of silk & fine
Linen; thy Pavements of precious stones; thy Walls of pearl
And gold, thy Gates of Thanksgiving thy Windows of Praise.
Thy Clouds of Blessing; thy Cherubims of Tender-mercy
Stretching their Wings sublime over the Little-ones of Albion
O Human Imagination O Divine Body I have Crucified
I have turned my back upon thee into the Wastes of Moral Law.
There Babylon is builded in the Waste, founded in Human desolation
O Babylon thy Watchman stands over thee in the night
Thy severe Judge all the day long proves thee O Babylon
With provings of destruction, with giving thee thy hearts desire.
But Albion is cast forth to the Potter his Children to the Builders
To build Babylon because they have forsaken Jerusalem
The Walls of Babylon are Souls of Men: her Gates the Groans

Of Nations: her Towers are the Miseries of once happy Families.
Her Streets are paved with Destruction, her Houses built with Death
Her Palaces with Hell & the Grave; her Synagogues with Torments
Of ever-hardening Despair squard & polishd with cruel skill
Yet thou wast lovely as the summer cloud upon my hills
When Jerusalem was thy hearts desire in times of youth & love.
Thy Sons came to Jerusalem with gifts. she sent them away
With blessings on their hands & on their feet, blessings of gold,
And pearl & diamond: thy Daughters sang in her Courts:
They came up to Jerusalem; they walked before Albion
In the Exchanges of London every Nation walkd
And London walkd in every Nation mutual in love & harmony
Albion coverd the whole Earth, England encompassd the Nations,
Mutual each within others bosom in Visions of Regeneration;
Jerusalem coverd the Atlantic Mountains & the Erythrean,
From bright Japan & China to Hesperia France & England.
Mount Zion lifted his head in every Nation under heaven:
And the Mount of Olives was beheld over the whole Earth:
The footsteps of the Lamb of God were there: but now no more
No more shall I behold him, he is closd in Luvahs Sepulcher.
Yet why these smitings of Luvah, the gentlest mildest Zoa?
If God was Merciful this could not be: O Lamb of God
Thou art a delusion and Jerusalem is my Sin! O my Children
I have educated you in the crucifying cruelties of Demonstration
Till you have assum'd the Providence of God & slain your Father
Dost thou appear before me who liest dead in Luvahs Sepulcher
Dost thou forgive me! thou who wast Dead & art Alive?
Look not so merciful upon me O thou Slain Lamb of God
I die! I die in thy arms tho Hope is banishd from me,

Thundring the Veil rushes from his hand Vegetating Knot by
Knot, Day by Day, Night by Night; loud roll the indignant Atlantic
Waves & the Erythrean, turning up the bottoms of the Deeps

## 25

And there was heard a great lamenting in Beulah: all the Regions
Of Beulah were moved as the tender bowels are moved: & they said:

Why did you take Vengeance O ye Sons of the mighty Albion?
Planting these Oaken Groves: Erecting these Dragon Temples
Injury the Lord heals but Vengeance cannot be healed:
As the Sons of Albion have done to Luvah: so they have in him
Done to the Divine Lord & Saviour. who suffers with those that suffer:
For not one sparrow can suffer, & the whole Universe not suffer also,
In all its Regions, & its Father & Saviour not pity and weep.
But Vengeance is the destroyer of Grace & Repentance in the bosom
Of the Injurer: in which the Divine Lamb is cruelly slain;
Descend O Lamb of God & take away the imputation of Sin
By the Creation of States & the deliverance of Individuals Evermore Am

Thus wept they in Beulah over the Four Regions of Albion
But many doubted & despaird & imputed Sin & Righteousness
To Individuals & not to States, and these Slept in Ulro.

## 27

### To the Jews

Jerusalem the Emanation of the Giant Albion! Can it be? Is it a Truth t
Learned have explored? Was Britain the Primitive Seat of the Patriarchal Re
if it is true: my title-page is also True, that Jerusalem was & is the Emana
the Giant Albion. It is True. and cannot be controverted. Ye are unite
Inhabitants of Earth in One Religion. The Religion of Jesus: the most Anci
Eternal: & the Everlasting Gospel—The Wicked will turn it to Wickedn
Righteous to Righteousness. Amen! Huzza! Selah!
    "All things Begin & End in Albions Ancient Druid Rocky Shore."

Ye are united O ye Inhabitants of Earth in One Religion. the Abraham, Heber, Shem, and
who were Druids: as the Druid Temples (which are the Patriarchal Pillars
Groves) over the whole Earth witness to this day.

"Your Ancestors derived their origin from Abraham, Heber, Shem, and Noah,

"All that moves the Human Heart and flows from the mighty limbs of Albion's

Adam & the whole World was Created by the Elohim

The fields from Islington to Marybone,
    To Primrose Hill and Saint Johns Wood:
        Were builded over with pillars of gold,
And there Jerusalems pillars stood.

Her Little-ones ran on the fields
    The Lamb of God among them seen
        And fair Jerusalem his Bride:
Among the little meadows green.

...rass & Kentish-town repose
...g her golden pillars high:
...ong her golden arches which
...upon the starry sky.

...walks upon our meadows green:
...amb of God walks by her side:
... every English Child is seen,
...en of Jesus & his Bride.

...iving trespasses and sins
...abylon with cruel Og,
... Moral & Self-righteous Law
... Crucify in Satans Synagogue!

...t are those golden Builders doing
...ournful ever-weeping Paddington
...ding above that mighty Ruin
...Satan the first victory won.

...re Albion slept beneath the Fatal Tree
...e Druids golden Knife,
...ed in human gore,
...rings of Human Life

...y groan'd aloud on London Stone
...groan'd aloud on Tyburns Brook
...on gave his deadly groan,
...l the Atlantic Mountains shook

...ons Spectre from his Loins
...orth in all the pomp of War!
...n his name: in flames of fire
...etch'd his Druid Pillars far.

...salem fell from Lambeth's Vale,
...thro Poplar & Old Bow;
...o Malden & acros the Sea,
...& howling death & woe,

...Rhine was red with human blood:
...anube rolld a purple tide:
...the Euphrates Satan stood:
...ver Asia stretch'd his pride.

...witherd up sweet Zions Hill,
...every Nation of the Earth:
...witherd up Jerusalems Gates,
...a dark Land gave her birth.

Humility is Christianity; you O Jews are the true Christians; If your tradition
Man contained in his Limbs, all Animals, is True & they were separated from
by cruel Sacrifices; and when compulsory cruel Sacrifices had brought
...manity into a Feminine Tabernacle. in the loins of Abraham & David: the
...b of God, the Saviour became apparent on Earth as the Prophets had foretold?
...Return of Israel is a Return to Mental Sacrifice & War. Take up the Cross O
...el & follow Jesus.

28

# Jerusalem

...(hon...
...ry ornament of perfection, and every labour of love,
...all the Garden of Eden, & in all the golden mountains
...as become an envied horror, and a remembrance of jealousy:
...d every Act a Crime, and Albion the punisher & judge.

...d Albion spoke from his secret seat and said

... these ornaments are crimes, they are made by the labours
...loves: of unnatural consanguinities and friendships
...orrid to think of when enquired deeply into; and all
...ese hills & valleys are accursed witnesses of Sin
...herefore condense them into solid rocks. stedfast!
...foundation and certainty and demonstrative truth:
...at Man be separate from Man, & here I plant my seat.

...ld snows drifted around him: ice coverd his loins around
... sat by Tyburns brook, and underneath his heel, shot up:
...deadly Tree, he nam'd it Moral Virtue, and the Law
...' God who dwells in Chaos hidden from the human sight.

...e Tree spread over him its cold shadows, (Albion groand)
...ey bent down. they felt the earth and again enrooting
...ot into many a Tree! an endless labyrinth of woe!

...om willing sacrifice of Self. to sacrifice of (miscall'd) Enemies
...r Atonement: Albion began to erect twelve Altars,
...rough unhewn rocks. before the Potters Furnace

The Jews-harp-house & the Green Man;
The Ponds where Boys to bathe delight:
The fields of Cows by Willans farm:
Shine in Jerusalems pleasant sight.

He witherd up the Human Form,
By laws of sacrifice for sin:
Till it became a Mortal Worm:
But O! translucent all within.

The Divine Vision still was seen
Still was the Human Form, Divine
Weeping in weak & mortal clay
O Jesus still the Form was thine.

And thine the Human Face & thine
The Human Hands & Feet & Breath
Entering thro' the Gates of Birth
And passing thro' the Gates of Death

And O thou Lamb of God, whom I
Slew in my dark self-righteous pride:
Art thou returnd to Albions Land!
And is Jerusalem thy Bride?

Come to my arms & never more
Depart; but dwell for ever here:
Create my Spirit to thy Love:
Subdue my Spectre to thy Fear.

Spectre of Albion! warlike Fiend!
In clouds of blood & ruin roll'd:
I here reclaim thee as my own
My Selfhood! Satan! armd in gold.

Is this thy soft Family-Love
Thy cruel Patriarchal pride
Planting thy Family alone
Destroying all the World beside,

A mans worst enemies are those
Of his own house & family;
And he who makes his law a curse,
By his own law shall surely die.

In my Exchanges every Land
Shall walk, & mine in every Land,
Mutual shall build Jerusalem:
Both heart in heart & hand in hand

He nam'd them Justice. and Truth. And Albions Sons
Must have become the first Victims, being the first transgressors
But they fled to the mountains to seek ransom: building A Strong
Fortification against the Divine Humanity and Mercy,
In Shame & Jealousy to annihilate Jerusalem!

29

Then the Divine Vision like a silent Sun appeard above
Albions dark rocks: setting behind the Gardens of Kensington
On Tyburns River, in clouds of blood: where was mild Zion Hills
Most ancient promontory. and in the Sun. a Human Form appeard
And thus the Voice Divine went forth upon the rocks of Albion

I elected Albion for my glory; I gave to him the Nations,
Of the whole Earth. He was the Angel of my Presence: and all
The Sons of God were Albions Sons: and Jerusalem was my joy.
The Reactor hath hid himself thro envy. I behold him.
But you cannot behold him till he be reveald in his System
Albions Reactor must have a Place prepard: Albion must Sleep
The Sleep of Death. till the Man of Sin & Repentance be reveald,
Hidden in Albions Forests he lurks: he admits of no Reply
From Albion: but hath founded his Reaction into a Law
Of Action, for Obedience to destroy the Contraries of Man
He hath compelld Albion to become a Punisher & hath possessd
Himself of Albions Forests & Wilds! and Jerusalem is taken!
The City of the Woods in the Forest of Ephratah is taken!
London is a stone of her ruins! Oxford is the dust of her walls!
Sussex & Kent are her scatterd garments! Ireland her holy place!
And the murderd bodies of her little ones are Scotland and Wales
The Cities of the Nations are the smoke of her consummation
The Nations are her dust! ground by the chariot wheels
Of her lofty conquerors. her palaces levelld with the dust
I come that I may find a way for my banished ones to return
Fear not O little Flock I come! Albion shall rise again.

So saying, the mild Sun inclosd the Human Family.

Forthwith from Albions darkning locks came two Immortal forms
Saying We alone are escaped. O merciful Lord and Saviour,
We flee from the interiors of Albions hills and mountains!
From his Valleys Eastward: from Amalek Canaan & Moab;
Beneath his vast ranges of hills surrounding Jerusalem.
Albion walkd on the steps of fire before his Halls
And Vala walkd with him in dreams of soft deluding slumber.
He looked up & saw the Prince of Light with splendor faded
Then Albion ascended mourning into the porches of his Palace
Above him rose a Shadow from his wearied intellect:
Of living gold, pure, perfect, holy: in white linen pure he hoverd
A sweet entrancing self-delusion a watry vision of Albion
Soft exulting in existence; all the Man absorbing!

Albion fell upon his face prostrate before the watry Shadow
Saying O Lord whence is this change: thou knowest I am nothing!
And Vala trembled & coverd her face! & her looks were spread on the pavement

We heard astonishd at the Vision & our heart trembled within us:
We heard the voice of slumberous Albion, and thus he spake,
Idolatrous to his own Shadow words of eternity uttering:

O I am nothing when I enter into judgment with thee!
If thou withdraw thy breath I die & vanish into Hades
If thou dost lay thine hand upon me behold I am silent:
If thou withhold thine hand! I perish like a fallen leaf!
O I am nothing: and to nothing must return again:
If thou withdraw thy breath. Behold I am oblivion.

He ceasd: the shadowy voice was silent: but the cloud hoverd over their heads
In golden wreathes. the sorrow of Man; & the balmy drops fell down.
And lo! that son of Man that Shadowy Spirit of mild Albion:
Luvah descended from the cloud; in terror Albion rose:
Indignant rose the awful Man, & turnd his back on Vala.

We heard the voice of Albion starting from his sleep:

Whence is this voice crying Enion; that soundeth in my ears?
O cruel pity! O dark deceit; can love seek for dominion?

And Luvah strove to gain dominion over Albion
They strove together above the Body where Vala was inclosd
And the dark Body of Albion left prostrate upon the crystal pavement,
Coverd with boils from head to foot: the terrible smitings of Luvah.

Then frownd the fallen Man, and put forth Luvah from his presence
Saying. Go and Die the Death of Man, for Vala the sweet wanderer.
I will turn the volutions of your ears outward, and bend your nostrils

Downward, and your fluxile eyes englob'd roll round in fear:
Your withring lips and tongue shrink up into a narrow circle,
Till into narrow forms you creep: go take your fiery way:
And learn what tis to absorb the Man you Spirits of Pity & Love.

They heard the voice and fled swift as the winters setting sun.
And now the human blood foamd high. the Spirits Luvah & Vala
Went down the Human Heart where Paradise & its joys abounded,
In jealous fears & fury & rage, & flames roll round their fervid feet:
And the vast form of Nature like a serpent playd before them
And as they fled in folding fires & thunders of the deep:
Vala shrunk in like the dark sea that leaves its slimy banks
And from her bosom Luvah fell far as the east and west.
And the vast form of Nature like a serpent rolld between
Whether of Jerusalems or Valas ruins congenerated we know not:
All is confusion: all is tumult, & we alone are escaped.
So spoke the fugitives; they joind the Divine Family. trembling,

30

And the Two that escaped; were the Emanation of Los & his
Spectre: for whereever the Emanation goes, the Spectre
Attends her as her Guard, & Los's Emanation is named
Enitharmon. & his Spectre is named Urthona: they knew
Not where to flee: they had been on a visit to Albions Children
And they strove to weave a Shadow of the Emanation
To hide themselves: weeping & lamenting for the Vegetation
Of Albions Children. fleeing thro Albions vales in streams of gore

Being not irritated by insult bearing insulting benevolences
They percieved that corporeal friends are spiritual enemies
They saw the Sexual Religion in its embryon Uncircumcision
And the Divine hand was upon them bearing them thro darkness
Back safe to their Humanity as doves to their windows:
Therefore the Sons of Eden praise Urthonas Spectre in Songs
Because he kept the Divine Vision in time of trouble.

They wept & trembled: & Los put forth his hand & took them in.
Into his Bosom: from which Albion shrunk in dismal pain;
Rending the fibres of Brotherhood & in Feminine Allegories
Inclosing Los: but the Divine Vision appeard with Los
Following Albion into his Central Void among his Oaks.

And Los prayed and said. O Divine Saviour arise
Upon the Mountains of Albion as in ancient time. Behold!
The Cities of Albion seek thy face, London groans in pain
From Hill to Hill & the Thames laments along the Valleys
The little Villages of Middlesex & Surrey hunger & thirst
The Twenty-eight Cities of Albion stretch their hands to thee:
Because of the Opressors of Albion in every City & Village:
They mock at the Labourers limbs! they mock at his starvd Children.
They buy his Daughters that they may have power to sell his Sons:
They compell the Poor to live upon a crust of bread by soft mild arts:
They reduce the Man to want: then give with pomp & ceremony.
The praise of Jehovah is chaunted from lips of hunger & thirst!
Humanity knows not of Sex: wherefore are Sexes in Beulah?
In Beulah the Female lets down her beautiful Tabernacle;
Which the Male enters magnificent between her Cherubim:
And becomes One with her mingling condensing in Self-love
The Rocky Law of Condemnation & double Generation, & Death.
Albion hath enterd the Loins the place of the Last Judgment;
And Luvah hath drawn the Curtains around Albion in Vala's bosom
The Dead awake to Generation! Arise O Lord, & rend the Veil!

So Los in lamentations followd Albion. Albion coverd.

His

31

His western heaven with rocky clouds of death & despair.

Fearing that Albion should turn his back against the Divine Vision
Los took his globe of fire to search the interiors of Albions
Bosom. In all the terrors of friendship, entering the caves
Of despair & death, to search the tempters out, walking among
Albions rocks & precipices! caves of solitude & dark despair,
And saw every Minute Particular of Albion degraded & murderd
But saw not by whom they were murderd. in the delusive affections
Of which they had possessd themselves; and there they take up
The articulations of a mans soul, and laughing throw it down
Into the frame. then knock it out upon the plank, & souls are bak'd
In bricks to build the pyramids of Heber & Terah. But Los
Searchd in vain: closd from the minutia he walkd, difficult.
He came down from Highgate thro Hackney & Holloway towards London

Till he came to old Stratford & thence to Stepney & the Isle
Of Leuthas Dogs, thence thro the narrows of the Rivers side
And saw every minute particular, the jewels of Albion, running down
The kennels of the streets & lanes as if they were abhorrd.
Every Universal Form. was become barren mountains of Moral
Virtue: and every Minute Particular hardend into grains of sand:
And all the tendernesses of the soul cast forth as filth & mire,
Among the winding places of deep contemplation intricate
To where the Tower of London frownd dreadful over Jerusalem:
A building of Luvah builded in Jerusalems eastern gate to be
His secluded Court: thence to Bethlehem where was builded
Dens of despair in the house of bread: enquiring in vain
Of stones and rocks he took his way, for human form was none:
And thus he spoke, looking on Albions City with many tears
What shall I do! what could I do, if I could find these Criminals
I could not dare to take vengeance; for all things are so constructed
And builded by the Divine hand, that the sinner shall always escape,
And he who takes vengeance alone is the criminal of Providence;
If I should dare to lay my finger on a grain of sand
In way of vengeance; I punish the already punished: O whom
Should I pity if I pity not the sinner who is gone astray!
O Albion, if thou takest vengeance; if thou revengest thy wrongs
Thou art for ever lost! What can I do to hinder the Sons
Of Albion from taking vengeance? or how shall I them perswade.

So spoke Los, travelling thro darkness & horrid solitude:
And he beheld Jerusalem in Westminster & Marybone,
Among the ruins of the Temple: and Vala who is her Shadow,
Jerusalems Shadow bent northward over the Island white.
At length he sat on London Stone, & heard Jerusalems voice.

Albion I cannot be thy Wife. thine own Minute Particulars,
Belong to God alone. and all thy little ones are holy
They are of Faith & not of Demonstration: wherefore is Vala
Clothd in black mourning upon my rivers currents, Vala awake!
I hear thy shuttles sing in the sky, and round my limbs
I feel the iron threads of love & jealousy & despair.

Vala reply'd. Albion is mine: Luvah gave me to Albion
And now recieves reproach & hate. Was it not said of old
Set your Son before a man & he shall take you & your sons
For slaves: but set your Daughter before a man & She
Shall make him & his sons & daughters your slaves for ever:
And is this Faith? Behold the strife of Albion & Luvah
Is great in the east. their spears of blood rage in the eastern heaven
Urizen is the champion of Albion, they will slay my Luvah:
And thou O harlot daughter! daughter of despair art all
This cause of these shakings of my towers on Euphrates.
Here is the House of Albion, & here is thy secluded place
And here we have found thy sins: & hence we turn thee forth.
For all to avoid thee: to be astonishd at thee for thy sins:
Because thou art the impurity & the harlot: & thy children!
Children of whoredoms: born for Sacrifice: for the meat & drink
Offering: to sustain the glorious combat & the battle & war
That Man may be purified by the death of thy delusions.

So saying she her dark threads cast over the trembling River:
And over the valleys; from the hills of Hertfordshire to the hills
Of Surrey across Middlesex & across Albions House
Of Eternity! pale stood Albion at his eastern gate,

32

Leaning against the pillars. & his disease rose from his skirts
Upon the Precipice he stood. ready to fall into Non-Entity.

Los was all astonishment & terror: he trembled sitting on the Stone
Of London: but the interiors of Albions fibres & nerves were hidden
From Los astonishd he beheld only the petrified surfaces.
And saw his Furnaces in ruins, for Los is the Demon of the Furnaces
He saw also the Four Points of Albion reversd inwards
He saw the Four Points of Albions Tongue his iron Pokers & his Bellows,
Upon the valleys of Middlesex Shouting loud for aid Divine.

In stern defiance came from Albions bosom Hand, Hyle, Koban,
Gwantok, Peachy, Brereton, Slaid, Hutton, Skofield, Kox & Kotope
Bowen: Albions Sons: they bore him a golden couch into the porch
And on the Couch reposd his limbs, trembling from the bloody field.
Rearing their Druid Patriarchal rocky Temples around his limbs.
All things begin & end. in Albions Ancient Druid Rocky Shore.)

## 33

Turning his back to the Divine Vision. his Spectrous
Chaos before his face appeard: an Unformed Memory.

Then spoke the Spectrous Chaos to Albion darkning cold
From the back & loins where dwell the Spectrous Dead

I am your Rational Power O Albion & that Human Form
You call Divine, is but a Worm seventy inches long
That creeps forth in a night & is dried in the morning sun
In fortuitous concourse of memorys accumulated & lost
It plows the Earth in its own conceit, it overwhelms the Hills
Beneath its winding labyrinths, till a stone of the brook
Stops it in midst of its pride among its hills & rivers
Battersea & Chelsea mourn. London & Canterbury tremble
Their place shall not be found as the wind passes over
The ancient Cities of the Earth remove as a traveller
And shall Albions Cities remain when I pass over them
With my deluge of forgotten remembrances over the tablet

So spoke the Spectre to Albion. he is the Great Selfhood
Satan: Worshipd as God by the Mighty Ones of the Earth
Having a white Dot calld a Center from which branches out
A Circle in continual gyrations. this became a Heart
From which sprang numerous branches varying their motions
Producing many Heads three or seven or ten. & hands & feet
Innumerable at will of the unfortunate contemplator
Who becomes his food such is the way of the Devouring Power

And this is the cause of the appearance in the frowning Chaos
Albions Emanation which he had hidden in Jealousy
Appeard now in the frowning Chaos prolific upon the Chaos
Reflecting back to Albion in Sexual Reasoning Hermaphroditic

Albion spoke. Who art thou that appearest in gloomy pomp
Involving the Divine Vision in colours of autumn ripeness
I never saw thee till this time. nor beheld life abstracted
Nor darkness immingled with light on my furrowd field
Whence camest thou: who art thou O loveliest? the Divine Vision
Is as nothing before thee. faded is all life and joy

Vala replied in clouds of tears Albions garment embracing

I was a City & a Temple built by Albions Children.
I was a Garden planted with beauty I allured on hill & valley
The River of Life to flow against my walls & among my trees
Vala was Albions Bride & Wife in great Eternity
The loveliest of the daughters of Eternity when in day-break
I emanated from Luvah over the Towers of Jerusalem
And in her Courts among her little Children offering up
The Sacrifice of fanatic love! why loved I Jerusalem:
Why was I one with her embracing in the Vision of Jesus
Wherefore did I loving create love which never yet
Immingled God & Man, when thou & I, hid the Divine Vision
In cloud of secret gloom which behold involve me round about
Know me now Albion: look upon me I alone am Beauty
The Imaginative Human Form is but a breathing of Vala
I breathe him forth into the Heaven from my secret Cave
Born of the Woman to obey the Woman O Albion the mighty
For the Divine appearance is Brotherhood, but I am Love

## 34

Elevate into the Region of Brotherhood with my red fires

Art thou Vala? replied Albion. image of my repose
O how I tremble! how my members pour down milky fear!
A dewy garment covers me all over, all manhood is gone:
At thy word & at thy look death enrobes me about
From head to feet, a garment of death & eternal fear
Is not that Sun thy husband & that Moon thy glimmering Veil?
Are not the Stars of heaven thy Children! art thou not Babylon?
Art thou Nature Mother of all! is Jerusalem thy Daughter
Why have thou elevate inward: O dweller of outward chambers
From grot & cave beneath the Moon dim region of death
Where I laid my Plow in the hot noon. where my hot team fed
Where implements of War are forged, the Plow to go over the Nations
In pain girding me round like a rib of iron in heaven! O Vala
In Eternity they neither marry nor are given in marriage
Albion the high Cliff of the Atlantic is become a barren Land

Los stood at his Anvil: he heard the contentions of Vala—
He heavd his thundering Bellows upon the valleys of Middlesex

He opend his Furnaces before Vala. then Albion frownd in anger
On his Rock: ere yet the Starry Heavens were fled away
From his awful Members. and thus Los cried aloud
To the Sons of Albion & to Hand the eldest Son of Albion

I hear the screech of Childbirth loud pealing. & the groans
Of Death. in Albions clouds dreadful utterd over all the Earth
What may Man be? who can tell! but what may Woman be?
To have power over Man from Cradle to corruptible Grave.
There is a Throne in every Man, it is the Throne of God
This Woman has claimd as her own & Man is no more!
Albion is the Tabernacle of Vala & her Temple
And not the Tabernacle & Temple of the Most High
O Albion why wilt thou Create a Female Will?
To hide the most evident God in a hidden covert, even
In the shadows of a Woman & a secluded Holy Place
That we may pry after him as after a stolen treasure
Hidden among the Dead & mured up from the paths of life
Hand! art thou not Reuben enrooting thyself into Bashan
Till thou remainest a vaporous Shadow in a Void! O Merlin!
Unknown among the Dead where never before Existence came
Is this the Female Will O ye lovely Daughters of Albion. To
Converse concerning Weight & Distance in the Wilds of Newton & Locke

So Los spoke standing on Mam-Tor looking over Europe & Asia
The Graves thunder beneath his feet from Ireland to Japan

Reuben slept in Bashan like one dead in the valley
Cut off from Albions mountains & from all the Earths summits
Between Succoth & Zaretan beside the Stone of Bohan
While the Daughters of Albion divided Luvah into three Bodies
Los bended his Nostrils down to the Earth, then sent him over
Jordan to the Land of the Hittite; every-one that saw him
Fled! they fled at his horrible Form. they hid in caves
And dens, they looked on one-another & became what they beheld

Reuben return'd to Bashan, in despair he slept on the Stone.
Then Gwendolen divided into Rahab & Tirza in Twelve Portions
Los rolled, his Eyes into two narrow circles, then sent him
Over Jordan; all terrified fled; they became what they beheld.

If Perceptive Organs vary: Objects of Perception seem to vary:
If the Perceptive Organs close: their Objects seem to close also:
Consider this O mortal Man: O worm of sixty winters said Los
Consider Sexual Organization & hide thee in the dust.

## 35

Then the Divine hand found the Two Limits, Satan and Adam,
In Albions bosom: for in every Human bosom those Limits stand.
And the Divine voice came from the Furnaces, as multitudes without
Number! the voices of the innumerable multitudes of Eternity.
And the appearance of a Man was seen in the Furnaces;
Saving those who have sinned from the punishment of the Law,
(In pity of the punisher whose state is eternal death.)
And keeping them from Sin by the mild counsels of his love.

Albion goes to Eternal Death: In Me all Eternity.
Must pass thro' condemnation, and awake beyond the Grave:
No individual can keep these Laws, for they are death
To every energy of man, and forbid the springs of life;
Albion hath enterd the State Satan! Be permanent O State!
And be thou for ever accursed! that Albion may arise again:
And be thou created into a State! I go forth to Create
States: to deliver Individuals evermore! Amen.

So spoke the voice from the Furnaces, descending into Non-Entity

## 36

Reuben return'd to his place, in vain he sought beautiful Tirzah
For his Eyelids were narrowd. & his Nostrils scented the ground
And Sixty Winters Los raged in the Divisions of Reuben:
Building the Moon of Ulro. plank by plank & rib by rib
Reuben slept in the Cave of Adam, and Los folded his Tongue
Between Lips of mire & clay, then sent him forth over Jordan
In the love of Tirzah he said Doubt is my food day & night—
All that beheld him fled howling and gnawed their tongues
For pain: they became what they beheld In reasonings Reuben returned
To Heshbon. disconsolate he walkd thro Moab & he stood
Before the Furnaces of Los in a horrible dreadful slumber,
On Mount Gilead looking toward Gilgal: and Los bended
His Ear in a spiral circle outward; then sent him over Jordan.

The Seven Nations fled before him they became what they beheld
Hand, Hyle & Coban fled: they became what they beheld
Gwantock & Peachy hid in Damascus beneath Mount Lebanon
Brereton & Slade in Egypt. Hutton & Skofeld & Kox
Fled over Chaldea in terror in pains in every nerve
Kotope & Bowen became what they beheld, fleeing over the Earth
And the Twelve Female Emanations fled with them agonizing.

Jerusalem trembled seeing her Children drivn by Loss Hammer
In the visions of the dreams of Beulah on the edge of Non-Entity
Hand stood between Reuben & Merlin. as the Reasoning Spectre
Stands between the Vegetative Man & his Immortal Imagination

And the Four Zoa's clouded rage East & West & North & South
They change their situations, in the Universal Man.
Albion groans, he sees the Elements divide before his face.
And England who is Brittannia divided into Jerusalem & Vala
And Urizen assumes the East, Luvah assumes the South
In his dark Spectre ravening from his open Sepulcher

And the Four Zoa's who are the Four Eternal Senses of Man
Became Four Elements separating from the Limbs of Albion
These are their names in the Vegetative Generation

And Accident & Chance were found hidden in Length Bredth & Highth
And they divided into Four ravening deathlike Forms
Fairies & Genii & Nymphs & Gnomes of the Elements.
These are States Permanently Fixed by the Divine Power
The Atlantic Continent sunk round Albions cliffy shore
And the Sea poured in amain upon the Giants of Albion
As Los bended the Senses of Reuben Reuben is Merlin
Exploring the Three States of Ulro; Creation; Redemption. & Judgment

And many of the Eternal Ones laughed after their manner

Have you known the Judgment that is arisen among the
Zoa's of Albion? where a Man dare hardly to embrace
His own Wife; for the terrors of Chastity that they call
By the name of Morality, their Daughters govern all
In hidden deceit! they are Vegetable only fit for burning,
Art & Science cannot exist but by Naked Beauty displayd

Then those in Great Eternity who contemplate on Death
Said thus. What seems to Be: Is: To those to whom
It seems to Be. & is productive of the most dreadful
Consequences to those to whom it seems to Be: even of
Torments, Despair, Eternal Death; but the Divine Mercy
Steps beyond and Redeems Man in the Body of Jesus Amen
And Length Bredth Highth again Obey the Divine Vision Hallelujah

### 37

And One stood forth from the Divine Family & said

I feel my Spectre rising upon me! Albion! arouze thyself!
Why dost thou thunder with frozen Spectrous wrath against us?
The Spectre is, in Giant Man; insane, and most deform'd.
Thou wilt certainly provoke my Spectre against thine in fury!
He has a Sepulcher hewn out of a Rock ready for thee:
And a Death of Eight thousand years forg'd by thyself, upon
The point of his Spear! if thou persistest to forbid with Laws
Our Emanations, and to attack our secret supreme delights

So Los spoke: But when he saw blue death in Albions feet,
Again he join'd the Divine Body, following merciful;
While Albion fled more indignant: revengeful covering

### 38

His face and bosom with petrific hardness, and his hands
And feet, lest any should enter his bosom & embrace
His hidden heart; his Emanation wept & trembled within him:
Uttering not his jealousy, but hiding it as with
Iron and steel, dark and opake. with clouds & tempests brooding:
His strong limbs shudderd upon his mountains high and dark.

Turning from Universal Love petrific as he went,
His cold against the warmth of Eden rag'd with loud
Thunders of deadly war (the fever of the human soul)
Fires and clouds of rolling smoke! but mild the Saviour follow'd him
Displaying the Eternal Vision! the Divine Similitude!
In loves and tears of brothers, sisters, sons, fathers, and friends
Which if Man ceases to behold, he ceases to exist:

Saying, Albion! Our wars are wars of life, & wounds of love,
With intellectual spears, & long winged arrows of thought:

Mutual in one anothers love and wrath all renewing
We live as One Man; for contracting our infinite senses
We behold multitude; or expanding: we behold as one,
As One Man all the Universal Family; and that One Man
We call Jesus the Christ: and he in us, and we in him,
Live in perfect harmony in Eden the land of life.
Giving, recieving, and forgiving each others trespasses.
He is the Good shepherd, he is the Lord and master:
He is the Shepherd of Albion, he is all in all,
In Eden: in the garden of God: and in heavenly Jerusalem.
If we have offended, forgive us, take not vengeance against us,

Thus speaking; the Divine Family follow Albion:
I see them in the Vision of God upon my pleasant valleys.

I behold London; a Human awful wonder of God!
He says: Return, Albion, return! I give myself for thee:
My Streets are my, Ideas of Imagination.
Awake Albion, awake! and let us awake up together.
My Houses are Thoughts: my Inhabitants; Affections,
The children of my thoughts, walking within my blood-vessels,
Shut from my nervous form which sleeps upon the verge of Beulah
In dreams of darkness. while my vegetating blood in veiny pipes,
Rolls dreadful thro' the Furnaces of Los, and the Mills of Satan.
For Albions sake, and for Jerusalem thy Emanation
I give myself, and these my brethren give themselves for Albion.

So spoke London, immortal Guardian! I heard in Lambeths shades:
In Felpham I heard and saw the Visions of Albion
I write in South Molton Street, what I both see and hear
In regions of Humanity, in Londons opening streets.

I see thee awful Parent Land in light, behold I see!
Verulam! Canterbury! venerable parent of men,
Generous immortal Guardian golden clad! for Cities
Are Men, fathers of multitudes, and Rivers & Mountins
Are also Men; every thing is Human. mighty! sublime!
In every bosom a Universe expands, as wings
Let down at will around, and call'd the Universal Tent.
York. crown'd with loving kindness. Edinburgh, cloth'd
With fortitude as with a garment of immortal texture
Woven in looms of Eden. in spiritual deaths of mighty men
Who give themselves, in Golgotha, Victims to Justice; where
There is in Albion a Gate of precious stones and gold
Seen only by Emanations, by vegetations viewless,
Bending across the road of Oxford Street; it from Hyde Park
To Tyburns deathful shades, admits the wandering souls
Of multitudes who die from Earth: this Gate cannot be found
                                                          By

### 39

By Satans Watch-fiends tho' they search numbering every grain
Of sand on Earth every night, they never find this Gate.
It is the Gate of Los. Withoutside is the Mill, intricate, dreadful
And fill'd with cruel tortures; but no mortal man can find the Mill
Of Satan, in his mortal pilgrimage of seventy years

For Human beauty knows it not: nor can Mercy find it! But
In the Fourth region of Humanity, Urthona namd
Mortality begins to roll the billows of Eternal Death
Before the Gate of Los. Urthona here is named Los.
And here begins the System of Moral Virtue, named Rahab.
Albion fled thro' the Gate of Los. and he stood in the

Los was the friend of Albion who most lov'd him. In Cambridgeshire
His eternal station, he is the twenty-eighth, & is four-fold.
Seeing Albion had turn'd his back against the Divine Vision,
Los said to Albion. Whither fleest thou? Albion reply'd.

I die! I go to Eternal Death! the shades of death
Hover within me & beneath. and spreading themselves outside
Like rocky clouds, build me a gloomy monument of woe:
Will none accompany me in my death? or be a Ransom for me
In that dark Valley? I have girded round my cloke, and on my feet
Bound these black shoes of death, & on my hands, deaths iron gloves:
God hath forsaken me, & my friends are become a burden
A weariness to me, & the human footstep is a terror to me.

Los answerd troubled: and his soul was rent in twain.
Must the Wise die for an Atonement? does Mercy endure Atonement?
No! It is Moral Severity, & destroys Mercy in its Victim.
So speaking, not yet infected with the Error & Illusion,

## 40

Los shudder'd at beholding Albion, for his disease
Arose upon him pale and ghastly: and he call'd around
The Friends of Albion: trembling at the sight of Eternal Death
The four appear'd with their Emanations in fiery
Chariots: black their fires roll beholding Albions House of Eternity
Damp couch the flames beneath and silent, sick, stand shuddering
Before the Porch of sixteen pillars: weeping every one
Descended and fell down upon their knees round Albions knees,
Swearing the Oath of God! with awful voice of thunders round
Upon the hills & valleys, and the cloudy Oath roll'd far and wide

Albion is sick! said every Valley, every mournful Hill
And every River: our brother Albion is sick to death.
He hath leagued himself with robbers! he hath studied the arts
Of unbelief! Envy hovers over him! his Friends are his abhorrence!
Those who give their lives for him are despised!
Those who devour his soul, are taken into his bosom!
To destroy his Emanation is their intention:
Arise! awake O Friends of the Giant Albion
They have perswaded him of horrible falshoods!
They have sown errors over all his fruitful fields!

The Twenty-four heard! they came trembling on watry chariots.
Borne by the Living Creatures of the third procession
Of Human Majesty, the Living Creatures wept aloud as they
Went along Albions roads. till they arriv'd at Albions House.

O! how the torments of Eternal Death, waited on Man:
And the bursting ground
That the wide world might fly from its hinges. & the immortal mansion
Of Man, for ever be possess'd by monsters of the deeps.
And Man himself become a Fiend, wrap'd in an endless curse,
Consuming and consum'd for-ever in flames of Moral Justice.

For had the Body of Albion fall'n down, and from its dreadful ruins
Let loose the enormous Spectre on the darkness of the deep,
At enmity with the Merciful & fill'd with devouring fire,
A nether-world must have reciev'd the foul enormous spirit,
Under the pretence of Moral Virtue. fill'd with Revenge and Law.
There to eternity chain'd down, and issuing in red flames
And curses. with his mighty arms brandish'd against the heavens
Breathing cruelty blood & vengeance, gnashing his teeth with pain
Torn with black storms, & ceaseless torrents of his own consuming fire.
Within his breast his mighty Sons chaind down & fill'd with cursings:
And his dark Eon, that once fair crystal form divinely clear:
Within his ribs producing serpents whose souls are flames of fire.
But, glory to the Merciful-One. for he is of tender mercies!
And the Divine Family wept over him as One Man.

And these the Twenty-four in whom the Divine Family
Appear'd and they were One in Him A Human Vision!
Human Divine, Jesus the Saviour, blessed for ever and ever.

Selsey, true friend! who afterwards submitted to be devourd
By the waves of Despair. whose Emanation rose above
The flood, and was nam'd Chichester, lovely mild & gentle! Lo!
Her lambs bleat to the sea-fowls cry, lamenting still for Albion

Submitting to be call'd the son of Los the terrible vision:
Winchester stood devoting himself for Albion: his tents
Outspread with abundant riches, and his Emanations
Submitting to be call'd Enitharmons daughters, and be born
In vegetable mould: created by the Hammer and Loom
In Bowlahoola & Allamanda where the Dead wail night & day.

(I call them by their English names: English, the rough basement,
Los built the stubborn structure of the Language, acting against
Albions melancholy, who must else have been a Dumb despair.)

Gloucester and Exeter and Salisbury and Bristol: and benevolent
                                                            Bath

## 41

Bath who is Legions: he is the Seventh, the physician and
The poisoner: the best and worst in Heaven and Hell:
Whose Spectre first assimilated with Luvah in Albions mountains
A triple octave he took, to reduce Jerusalem to twelve
To cast Jerusalem forth upon the wilds to Poplar & Bow:
To Malden & Canterbury in the delights of cruelty:
The Shuttles of death sing in the sky to Islington & Pancrass
Round Marybone to Tyburns River, weaving black melancholy as a net,

And despair as meshes closely wove over the west of London,
Where mild Jerusalem sought to repose in death & be no more.
She fled to Lambeths mild Vale and hid herself beneath
The Surrey Hills where Rephaim terminates: her Sons are siez'd
For victims of sacrifice; but Jerusalem cannot be found! Hid
By the Daughters of Beulah: gently snatch'd away: and hid in Beulah

There is a Grain of Sand in Lambeth that Satan cannot find
Nor can his Watch Fiends find it: tis translucent & has many Angles
But he who finds it will find Oothoons palace, for within
Opening into Beulah every angle is a lovely heaven
But should the Watch Fiends find it, they would call it Sin
And lay its Heavens & their inhabitants in blood of punishment
Here Jerusalem & Vala were hid in soft slumberous repose
Hid from the terrible East. shut up in the South & West.

The Twenty-eight trembled in Deaths dark caves, in cold despair
They kneeld around the Couch of Death in deep humiliation
And tortures of self condemnation while their Spectres ragd within,
The Four Zoa's in terrible combustion clouded rage
Drinking the shuddering fears & loves of Albions Families
Destroying by selfish affections the things that they most admire
Drinking & eating. & pitying & weeping, as at a trajic scene.
The soul drinks murder & revenge, & applauds its own holiness

They saw Albion endeavouring to destroy their Emanations.

## 42

Thus Albion sat, studious of others in his pale disease:
Brooding on evil: but when Los opend the Furnaces before him
He saw that the accursed things were his own affections,
And his own beloveds: then he turn'd sick! his soul died within him
Also Los sick & terrified beheld the Furnaces of Death
And must have died, but the Divine Saviour descended
Among the infant loves & affections, and the Divine Vision wept
Like evening dew on every herb upon the breathing ground

Albion spoke in his dismal dreams; O thou deceitful friend
Worshipping mercy & beholding thy friend in such affliction:
Los! thou now discoverest thy turpitude to the heavens.
I demand righteousness & justice. O thou ingratitude!
Give me my Emanations back food for my dying soul!
My daughters are harlots! my sons are accursed before me.
Enitharmon is my daughter: accursed with a fathers curse!
O! I have utterly been wasted! I have given my daughters to devils

So spoke Albion in gloomy majesty, and deepest night
Of Ulro rolld round his skirts from Dover to Cornwall.

Los answerd. Righteousness & justice I give thee in return
For thy righteousness! but I add mercy also, and bind
Thee from destroying these little ones: am I to be only
Merciful to thee and cruel to all that thou hatest
Thou wast the Image of God surrounded by the Four Zoa's
Three thou hast slain! I am the Fourth, thou canst not destroy me.
Thou art in Error, trouble me not with thy righteousness.
I have innocence to defend and ignorance to instruct.
I have no time for seeming; and little arts of compliment,
In morality and virtue: in self-glorying and pride.
There is a limit of Opakeness, and a limit of Contraction:
In every Individual Man. and the limit of Opakeness
Is named Satan: and the limit of Contraction is named Adam,
But when Man sleeps in Beulah, the Saviour in mercy takes
Contractions Limit, and of the Limit he forms Woman: That
Himself may in process of time be born Man to redeem
But there is no Limit of Expansion! there is no Limit of Translucence.
In the bosom of Man for ever from eternity to eternity.
Therefore I break thy bonds of righteousness; I crush thy messengers!
That they may not crush me and mine: do thou be righteous,
And I will return it: otherwise I defy thy worst revenge:
Consider me as thine enemy: on my turn all thy fury
But destroy not these little ones, nor mock the Lords anointed:
Destroy not by Moral Virtue, the little ones whom he hath chosen!
The little ones whom he hath chosen in preference to thee.
He hath cast thee off for ever; the little ones he hath anointed!
Thy Selfhood is for ever accursed from the Divine presence

So Los spoke: then turn'd his face & wept for Albion.

Albion replied. Go! Hand & Hyle! sieze the abhorred friend:
As you Have siezd the Twenty-four rebellious ingratitudes;
To atone for you, for spiritual death! Man lives by deaths of Men

Bring him to justice before heaven here upon London stone,
Between Blackheath & Hounslow. between Norwood & Finchley
All that they have is mine: from my free genrous gift.
They now hold all they have: ingratitude to me!
To me their benefactor calls aloud for vengeance deep.

Los stood before his Furnaces awaiting the fury of the Dead:
And the Divine hand was upon him, strengthening him mightily.

The Spectres of the Dead cry out from the deeps beneath
Upon the hills of Albion; Oxford groans in his iron furnace
Winchester in his den & cavern; they lament against
Albion: they curse their human kindness & affection
They rage like wild beasts in the forests of affliction
In the dreams of Ulro they repent of their human kindness.

Come up, build Babylon, Rahab is ours & all her multitudes
With her in pomp and glory of victory. Depart
Ye twenty-four into the deeps! let us depart to glory!

Their Human majestic forms sit up upon their Couches
Of death: they curb their Spectres as with iron curbs
They enquire after Jerusalem in the regions of the dead,
With the voices of dead men, low, scarcely articulate,
And with tears cold on their cheeks they weary repose.

O when shall the morning of the grave appear, and when
Shall our salvation come? we sleep upon our watch
We cannot awake! and our Spectres rage in the forests
O God of Albion where art thou! pity the watchers!

Thus mourn they, Loud the Furnaces of Los thunder upon
The clouds of Europe & Asia. among the Serpent Temples!

And Los drew his Seven Furnaces around Albions Altars
And as Albion built his frozen Altars, Los built the Mundane Shell,
In the Four Regions of Humanity East & West & North & South,
Till Norwood & Finchley & Blackheath & Hounslow, coverd the whole Earth.
This is the Net & Veil of Vala, among the Souls of the Dead.

### 43

They saw their Wheels rising up poisonous against Albion
Urizen, cold & scientific: Luvah, pitying & weeping
Tharmas. indolent & sullen: Urthona, doubting & despairing
Victims to one another & dreadfully plotting against each other
To prevent Albion walking about in the Four Complexions.

They saw America clos'd up by the Oaks of the western shore;
And Tharmas dash'd on the Rocks of the Altars of Victims in Mexico.
If we are wrathful Albion will destroy Jerusalem with rooty Groves
If we are merciful, ourselves must suffer destruction on his Oaks:
Why should we enter into our Spectres. to behold our own corruptions
O God of Albion descend! deliver Jerusalem from the Oaken Groves!

Then Los grew furious raging: Why stand we here trembling around
Calling on God for help; and not ourselves in whom God dwells
Stretching a hand to save the falling Man: are we not Four
Beholding Albion upon the Precipice ready to fall into Non-Entity:
Seeing these Heavens & Hells conglobing in the Void. Heavens over Hells
Brooding in holy hypocritic lust, drinking the cries of pain
From howling victims of Law: building Heavens Twenty-seven-fold.
Swelld & bloated General Forms, repugnant to the Divine-
Humanity, who is the Only General and Universal Form
To which all Lineaments tend & seek with love & sympathy
All broad & general principles belong to benevolence
Who protects minute particulars, every one in their own identity.
But here the affectionate touch of the tongue is closd in by deadly teeth
And the soft smile of friendship & the open dawn of benevolence
Become a net & a trap, & every energy renderd cruel,
Till the existence of friendship & benevolence is denied:
The wine of the Spirit & the vineyards of the Holy-One.
Here: turn into poisonous stupor & deadly intoxication;
That they may be condemnd by Law & the Lamb of God be slain!
And the two Sources of Life in Eternity Hunting and War,
are become the Sources of dark & bitter Death & of corroding Hell
The open heart is shut up in integuments of frozen silence
That the spear that lights it forth may shatter the ribs & bosom

A pretence of Art. to destroy Art! a pretence of Liberty
To destroy Liberty! a pretence of Religion to destroy Religion
Oshea and Caleb fight! they contend in the valleys of Peor
In the terrible Family Contentions of those who love each other:
The Armies of Balaam weep—no women come to the field
Dead corses lay before them, & not as in Wars of old.
For the Soldier who fights for Truth, calls his enemy his brother:

They fight & contend for life, & not for eternal death!
But here the Soldier strikes, & a dead corse falls at his feet
Nor Daughter nor Sister nor Mother come forth to embosom the Slain!
But Death! Eternal Death! remains in the Valleys of Peor.
The English are scatterd over the face of the Nations: are these
Jerusalems children? Hark! hear the Giants of Albion cry at night
We smell the blood of the English! we delight in their blood on our Altars
The living & the dead shall be ground in our rumbling Mills
For bread of the Sons of Albion: of the Giants Hand & Scofield
Scofeld & Kox are let loose upon my Saxons! they accumulate
A World in which Man is by his Nature the Enemy of Man,
In pride of Selfhood unwieldy stretching out into Non Entity
Generalizing Art & Science till Art & Science is lost.
Bristol & Bath, listen to my words, & ye Seventeen: give ear!
It is easy to acknowledge a man to be great & good while we
Derogate from him in the trifles & small articles of that goodness;
Those alone are his friends, who admire his minutest powers
Instead of Albions lovely mountains & the curtains of Jerusalem
I see a Cave, a Rock, a Tree deadly and poisonous, unimaginative:
Instead of the Mutual Forgiveness, the Minute Particulars, I see
Pits of bitumen ever burning: artificial Riches of the Canaanite
Like Lakes of liquid lead: instead of heavenly Chapels, built
By our dear Lord: I see Worlds crusted with snows & ice;
I see a Wicker Idol woven round Jerusalems children. I see
The Canaanite, the Amalekite, the Moabite, the Egyptian:
By Demonstrations the cruel Sons of Quality & Negation.
Driven on the Void in incoherent despair into Non Entity
I see America closd apart, & Jerusalem driven in terror
Away from Albions mountains, far away from Londons spires!
I will not endure this thing! I alone withstand to death,
This outrage! Ah me! how sick & pale you all stand round me!
Ah me! pitiable ones! do you also go to deaths vale?
All you my Friends & Brothers! all you my beloved Companions!
Have you also caught the infection of Sin & stern Repentance?
I see Disease arise upon you! yet speak to me and give
Me some comfort: why do you all stand silent? I alone
Remain in permanent strength. Or is all this goodness & Pity, only
That you may take the greater vengeance in your Sepulcher,

So Los spoke. Pale they stood around the House of Death:
In the midst of temptations & despair: among the rooted Oaks:
Among reared Rocks of Albions Sons, at length they rose
                                                    With

### 44

With one accord in love sublime, & as on Cherubs wings
They Albion surround with kindest violence to bear him back
Against his will thro Los's Gate to Eden: Four-fold; loud!
Their Wings waving over the bottomless Immense: to bear
Their awful charge back to his native home: but Albion dark,
Repugnant; rolld his Wheels backward into Non-Entity
Loud roll the Starry Wheels of Albion into the World of Death
And all the Gate of Los, clouded with clouds redounding from
Albions dread Wheels, stretching out spaces immense between
That every little particle of light & air, became Opake
Black & immense, a Rock of difficulty & a Cliff
Of black despair; that the immortal Wings laboured against
Cliff after cliff, & over Valleys of despair & death:
The narrow Sea between Albion & the Atlantic Continent:

Its waves of pearl became a boundless Ocean bottomless,
Of grey obscurity, filld with clouds & rocks & whirling waters
And Albions Sons ascending & descending in the horrid Void.

But as the Will must not be bended but in the day of Divine
Power: silent calm & motionless, in the mid-air sublime,
The Family Divine hover around the darkend Albion.

Such is the nature of the Ulro: that whatever enters:
Becomes Sexual & is Created. and Vegetated and Born,
From Hyde Park spread their vegetating roots beneath Albion
In threefold pain the Spectrous Chaos towards the Void Vegetated
Forming a beautal Machine an Aged Virgin Form.
In Erins Land toward the north, joint after joint & burning
In love & jealousy immingled & calling it Religion
And feeling the damps of death they with one accord delegated Los
Conjuring him by the Highest that he should Watch over them
Till Jesus shall appear. & they gave their power to Los
Naming him the Spirit of Prophecy, calling him Elijah

Strucken with Albions disease they become what they behold;
They assimilate with Albion in pity & compassion;
Their Emanations return not: their Spectres rage in the Deep

[460]

he Slumbers of Death came over them around the Couch of Death
efore the Gate of Los & in the depths of Non Entity
mong the Furnaces of Los; among the Oaks of Albion.

Man is adjoind to Man by his Emanative portion:
Who is Jerusalem in every individual Man: and her
hadow is Vala, builded by the Reasoning power in Man
O search & see: turn your eyes inward: open O thou World
Of Love & Harmony in Man: expand thy ever lovely Gates.

They wept into the deeps a little space at length was heard
he voice of Bath, faint as the voice of the Dead in the House of Death

## 45

Bath, healing City! whose wisdom in midst of Poetic
Fervor: mild spoke thro' the Western Porch, in soft gentle tears

O Albion mildest Son of Eden! clos'd is thy Western Gate
Brothers of Eternity! this Man whose great example
We all admir'd & lov'd, whose all benevolent countenance. seen
n Eden, in lovely Jerusalem, drew even from envy
The tear: and the confession of honesty, open & undisguis'd
From mistrust and suspition. The Man is himself become
a piteous example of oblivion. To teach the Sons
Of Eden, that however great and glorious; however loving
And merciful the Individuality; however high
Our palaces and cities, and however fruitful are our fields
n Selfhood, we are nothing: but fade away in mornings breath.
Our mildness is nothing: the greatest mildness we can use
s incapable and nothing! none but the Lamb of God can heal
This dread disease: none but Jesus! O Lord descend and save.
Albions Western Gate is clos'd: his death is coming apace!
Jesus alone can save him; for alas we none can know
How soon his lot may be our own. When Africa in sleep
Rose in the night of Beulah, and bound down the Sun & Moon
His friends cut his strong chains, & overwhelm'd his dark
Machines in fury & destruction, and the Man reviving repented
He wept before his wrathful brethren, thankful & considerate
For their well timed wrath. But Albions sleep is not
Like Africa's; and his machines are woven with his life
Nothing but mercy can save him! nothing but mercy interposing
Lest he should slay Jerusalem in his fearful jealousy
O God descend! gather our brethren, deliver Jerusalem
But that we may omit no office of the friendly spirit
Oxford take thou these leaves of the Tree of Life: with eloquence
That thy immortal tongue inspires; present them to Albion:
Perhaps he may recieve them, offerd from thy loved hands.

So spoke, unhear'd by Albion, the merciful Son of Heaven
To those whose Western Gates were open, as they stood weeping,
Around Albion: but Albion heard him not: obdurate! hard!
He call'd on all his Friends, counting them enemies in his sorrow

And the Merciful countenance and Hope and Comfort
n whom the other Ten shone manifest, a Divine Vision!
assimilated and embrac'd Eternal Death for Albions sake.

And these the names of the Eighteen combining with those Ten

## 46

Bath, mild Physician of Eternity, mysterious power
Whose springs are unsearchable & knowledg infinite.
Hereford, ancient Guardian of Wales, whose hands
Builded the mountain palaces of Eden. stupendous works!
Lincoln, Durham & Carlisle, Councellors of Los.
And Ely. Scribe of Los, whose pen no other hand
Dare touch! Oxford, immortal Bard! with eloquence
Divine, he wept over Albion: speaking the words of God
n mild perswasion: bringing leaves of the Tree of Life.

Thou art in Error Albion. the Land of Ulro:
One Error not remov'd. will destroy a human Soul
Repose in Beulahs night, till the Error is remov'd
Reason not on both sides. Repose upon our bosoms
Till the Plow of Jehovah. and the Harrow of Shaddai
Have passed over the Dead, to awake the Dead to Judgment.
But Albion turn'd away refusing comfort.

Oxford trembled while he spoke, then fainted in the arms
Of Norwich, Peterboro, Rochester, Chester awful, Worcester,
Litchfield. Saint Davids. Landaff, Asaph. Bangor. Sodor,
Bowing their heads devoted: and the Furnaces of Los

Began to rage. thundering loud the storms began to roar
Upon the Furnaces, and loud the Furnaces rebellow beneath

And these the Four in whom the twenty-four appear'd four-fold:
Verulam. London. York. Edinburgh. mourning one towards another
Alas! The time will come, when a mans worst enemies
Shall be those of his own house and family: in a Religion
Of Generation, to destroy by Sin and Atonement, happy Jerusalem,
The Bride and Wife of the Lamb. O God thou art Not an Avenger!

## 47

From Camberwell to Highgate where the mighty Thames shudders along,
Where Los's Furnaces stand, where Jerusalem & Vala howl:
Luvah tore forth from Albions Loins, in fibrous veins. in rivers
Of blood over Europe: a Vegetating Root in grinding pain.
Animating the Dragon Temples, soon to become that Holy Fiend
The Wicker Man of Scandinavia in which cruelly consumed
The Captives reard to heaven howl in flames among the stars
Loud the cries of War on the Rhine & Danube, with Albions Sons,
Away from Beulahs hills & vales break forth the Souls of the Dead,
With cymbal, trumpet, clarion; & the scythed chariots of Britain.

And the Veil of Vala, is composed of the Spectres of the Dead

Hark! the mingling cries of Luvah with the Sons of Albion
Hark! & Record the terrible wonder! that the Punisher
Mingles with his Victims Spectre, enslaved and tormented
To him whom he has murderd, bound in vengeance & enmity
Shudder not. but Write, & the hand of God will assist you!
Therefore I write Albions last words. Hope is banish'd from me.
These

## 48

These were his last words. and the merciful Saviour in his arms
Reciev'd him, in the arms of tender mercy and repos'd
The pale limbs of his Eternal Individuality
Upon the Rock of Ages. Then, surrounded with a Cloud:
In silence the Divine Lord builded with immortal labour,
Of gold & jewels a sublime Ornament, a Couch of repose,
With Sixteen pillars: canopied with emblems & written verse.
Spiritual Verse, order'd & measur'd, from whence, time shall reveal.
The Five books of the Decalogue, the books of Joshua & Judges.
Samuel, a double book & Kings, a double book. the Psalms & Prophets
The Four-fold Gospel, and the Revelations everlasting
Eternity groan'd & was troubled, at the image of Eternal Death!

Beneath the bottoms of the Graves. which is Earths central joint,
There is a place where Contrarieties are equally true:
(To protect from the Giant blows in the sports of intellect,
Thunder in the midst of kindness, & love that kills its beloved:
Because Death is for a period, and they renew tenfold.)
From this sweet Place Maternal Love awoke Jerusalem
With pangs she forsook Beulah's pleasant lovely shadowy Universe
Where no dispute can come, emanant Sun shine alone

Weeping was in all Beulah, and all the Daughters of Beulah
Wept for their Sister the Daughter of Albion Jerusalem:
When out of Beulah the Emanation of the Sleeper descended
With solemn mourning out of Beulahs moony shades and hills:
Within the Human Heart, whose Gates closed with solemn sound.

And this the manner of the terrible Separation
The Emanations of the grievously afflicted Friends of Albion
Concenter in one Female form an Aged pensive Woman.
Astonish'd! lovely! embracing the sublime shade: the Daughters of Beulah
Beheld her with wonder! With awful hands she took
A Moment of Time, drawing it out with many tears & afflictions
And many sorrows: oblique across the Atlantic Vale
Which is the Vale of Rephaim dreadful from East to West,
Where the Human Harvest waves abundant in the beams of Eden
Into a Rainbow of jewels and gold, a mild Reflection from
Albions dread Tomb. Eight thousand and five hundred years
In its extension. Every two hundred years has a door to Eden
She also took an Atom of Space. with dire pain opening it a Center
Into Beulah: trembling the Daughters of Beulah dried
Her tears. she ardent embrac'd her sorrows. occupied in labours
Of sublime mercy in Rephaims Vale. Perusing Albions Tomb
She sat: she walk'd among the ornaments solemn mourning.
The Daughters attended her shudderings, wiping the death sweat
Los also saw her in his seventh Furnace, he also terrified
Saw the finger of God go forth upon his seventh Furnace:
Away from the Starry Wheels to prepare Jerusalem a place.

When with a dreadful groan the Emanation mild of Albion.
Burst from his bosom in the Tomb like a pale snowy cloud,
Female and lovely, struggling to put off the Human form
Writhing in pain. The Daughters of Beulah in kind arms reciev'd
Jerusalem: weeping over her among the Spaces of Erin.
In the Ends of Beulah, where the Dead wail night & day.

And thus Erin spoke to the Daughters of Beulah, in soft tears

Albion the Vortex of the Dead! Albion the Generous!
Albion the mildest son of Heaven! The Place of Holy Sacrifice!
Where Friends Die for each other: will become the Place,
Of Murder, & Unforgiving. Never-awaking Sacrifice of Enemies
The Children must be sacrific'd! (a horror never known
Till now in Beulah.) unless a Refuge can be found

To hide them from the wrath of Albions Law that freezes sore
Upon his Sons & Daughters, self-exiled from his bosom
Draw ye Jerusalem away from Albions Mountains
To give a Place for Redemption, let Sihon and Og
Remove Eastward to Bashan and Gilead, and leave
<div style="text-align:right">The</div>

<div style="text-align:center">49</div>

The secret coverts of Albion & the hidden places of America
Jerusalem Jerusalem! why wilt thou turn away
Come ye O Daughters of Beulah, lament for Og & Sihon
Upon the Lakes of Ireland from Rathlin to Baltimore:
Stand ye upon the Dargle from Wicklow to Drogheda
Come & mourn over Albion the White Cliff of the Atlantic
The Mountain of Giants: all the Giants of Albion are become
Weak: witherd: darkend: & Jerusalem is cast forth from Albion.
They deny that they ever knew Jerusalem, or ever dwelt in Shiloh
The Gigantic roots & twigs of the vegetating Sons of Albion
Filld with the little-ones are consumed in the Fires of their Altars
The vegetating Cities are burned & consumed from the Earth:
And the Bodies in which all Animals & Vegetations. the Earth & Heaven
Were contain'd in the All Glorious Imagination are witherd & darkend.
The golden Gate of Havilah, and all the Garden of God,
Was caught up with the Sun in one day of fury and war:
The Lungs, the Heart, the Liver, shrunk away far distant from Man
And left a little slimy substance floating upon the tides.
In one night the Atlantic Continent was caught up with the Moon,
And became an Opake Globe far distant clad with moony beams,
The Visions of Eternity, by reason of narrowed perceptions,
Are become weak Visions of Time & Space, fix'd into furrows of death;
Till deep dissimulation is the only defence an honest man has left
O Polypus of Death O Spectre over Europe and Asia
Withering the Human Form by Laws of Sacrifice for Sin
By Laws of Chastity & Abhorrence I am witherd up.
Striving to Create a Heaven in which all shall be pure & holy
In their Own Selfhoods, in Natural Selfish Chastity to banish Pity
And dear Mutual Forgiveness; & to become One Great Satan
Inslavd to the most powerful Selfhood: to murder the Divine Humanity
In whose sight all are as the dust & who chargeth his Angels with folly:
Ah! weak & wide astray! Ah shut in narrow doleful form!
Creeping in reptile flesh upon the bosom of the ground!
The Eye of Man, a little narrow orb, closd up & dark.
Scarcely beholding the Great Light; conversing with the ground.
The Ear, a little shell, in small volutions shutting out
True Harmonies, & comprehending great, as very small:
The Nostrils, bent down to the earth & clos'd up from senseless flesh.
That odours cannot them expand, nor joy on them exult:
The Tongue, a little moisture fills, a little food it cloys,
A little sound it utters, & its cries are faintly heard.
Therefore they are removed: therefore they have taken root
In Egypt & Philistea: in Moab & Edom & Aram:
In the Erythrean Sea their Uncircumcision in Heart & Loins
Be lost for ever & ever. then they shall arise from Self
By Self Annihilation into Jerusalems Courts & into Shiloh
Shiloh the Masculine Emanation among the Flowers of Beulah
Lo Shiloh dwells over France, as Jerusalem dwells over Albion
Build & prepare a Wall & Curtain for Americas shore!
Rush on! Rush on! Rush on! ye vegetating Sons of Albion
The Sun shall go before you in Day: the Moon shall go
Before you in Night. Come on! Come on! Come on! The Lord
Jehovah is before, behind, above, beneath, around
He has builded the arches of Albions Tomb binding the Stars
In merciful Order, bending the Laws of Cruelty to Peace.
He hath placed Og & Anak, the Giants of Albion for their Guards:
Building the Body of Moses in the Valley of Peor: the Body

Of Divine Analogy; and Og & Sihon in the tears of Balaam
The Son of Beor, have given their power to Joshua & Caleb.
Remove from Albion, far remove these terrible surfaces.
They are beginning to form Heavens & Hells in immense
Circles; the Hells for food to the Heavens: food of torment,
Food of despair: they drink the condemnd Soul & rejoice
In cruel holiness, in their Heavens of Chastity & Uncircumcision
Yet they are blameless & Iniquity must be imputed only
To the State they are enterd into that they may be deliverd:
Satan is the State of Death, & not a Human existence:
But Luvah is named Satan, because he has enterd that State.
A World where Man is by Nature the enemy of Man
Because the Evil is Created into a State. that Men
May be deliverd time after time evermore. Amen.
Learn therefore O Sisters to distinguish the Eternal Human
That walks about among the stones of fire in bliss & woe
Alternate! from those States or Worlds in which the Spirit travels:
This is the only means to Forgiveness of Enemies
Therefore remove from Albion these terrible Surfaces
And let wild seas & rocks close up Jerusalem away from
<div style="text-align:right">The</div>

<div style="text-align:center">50</div>

The Atlantic Mountains where Giants dwelt in Intellect;
Now given to stony Druids, and Allegoric Generation
To the Twelve Gods of Asia, the Spectres of those who Sleep:
Sway'd by a Providence oppos'd to the Divine Lord Jesus:
A murderous Providence! A Creation that groans, living on Death.
Where Fish & Bird & Beast & Man & Tree & Metal & Stone
Live by Devouring, going into Eternal Death continually:
Albion is now possess'd by the War of Blood! the Sacrifice
Of envy Albion is become, and his Emanation cast out:
Come Lord Jesus, Lamb of God descend! for if; O Lord!
If thou hadst been here, our brother Albion had not died.
Arise sisters! Go ye & meet the Lord, while I remain—
Behold the foggy mornings of the Dead on Albions cliffs!
Ye know that if the Emanation remains in them:
She will become an Eternal Death, an Avenger of Sin
A Self-righteousness: the proud Virgin-Harlot! Mother of War!
And we also & all Beulah, consume beneath Albions curse.

So Erin spoke to the Daughters of Beulah. Shuddering
With their wings they sat in the Furnace, in a night
Of stars, for all the Sons of Albion appeard distant stars,
Ascending and descending into Albions sea of death.
And Erins lovely Bow enclos'd the Wheels of Albions Sons.

Expanding on wing, the Daughters of Beulah replied in sweet response

Come O thou Lamb of God and take away the remembrance of Sin
To Sin & to hide the Sin in sweet deceit. is lovely!!
To Sin in the open face of day is cruel & pitiless! But
To record the Sin for a reproach: to let the Sun go down
In a remembrance of the Sin: is a Woe & a Horror!
A brooder of an Evil Day, and a Sun rising in blood
Come then O Lamb of God and take away the remembrance of Sin

<div style="text-align:center">End of Chap. 2d.</div>

<div style="text-align:center">52</div>

| Rahab is an Eternal State | To the Deists. | The Spiritual Stat... the Soul are all E... Distinguish betwe... Man, & his presen... |

He never can be a Friend to the Human Race who is the Preacher of M...
Morality or Natural Religion. he is a flatterer who means to betray. to perp...
Tyrant Pride & the Laws of that Babylon which he foresees shall sha...
destroyed. with the Spiritual and not the Natural Sword: He is in the State
Rahab: which State must be put off before he can be the Friend of Man
You O Deists profess yourselves the Enemies of Christianity: and you
you are also the Enemies of the Human Race & of Universal Nature. Man is
Spectre or Satan & is altogether an Evil, & requires a New Selfhood contin...
... continually: for Changed into his direct Contrary. But your Greek Phil...
(which is a remnant of Druidism) teaches that Man is Righteous in his Ve...
Spectre: an Opinion of fatal & accursed consequence to Man. as the Ancie...
plainly by Revelation to the Indie abrogation of Experimental Theory. and...
believed what they saw, and Prophecied of Jesus.

Man must & will have Some Religion; if he has not the Religion of Jesus,
have the Religion of Satan, & will erect the Synagogue of Satan. calling the
of this World, God; and destroying all who do not worship Satan under the...

God. Will any one say, Where are those who worship Satan under the Name of
! Where are they? Listen! Every Religion that Preaches Vengeance for Sin is
Religion of the Enemy & Avenger; and not the Forgiver of Sin, and their God
atan, Named by the Divine Name  Your Religion O Deists: Deism, is the
ship of the God of this World by the means of what you call Natural Religion
Natural Philosophy, and of Natural Morality or Self-Righteousness, the Selfish
ues of the Natural Heart. This was the Religion of the Pharisees who murderd
s. Deism is the same & ends in the same.

oltaire Rousseau Gibbon Hume. charge the Spiritually Religious with
ocrisy! but how a Monk or a Methodist either, can be a Hypocrite, I cannot con-
e. We are Men of like passions with others & pretend not to be holier than others:
efore, when a Religious Man falls into Sin, he ought not to be calld a Hypocrite;
title is more properly to be given to a Player who falls into Sin; whose profession
irtue & Morality & the making Men Self-Righteous. Foote in calling Whitefield,
ocrite: was himself one: for Whitefield pretended not to be holier than others:
confessed his Sins before all the World; Voltaire! Rousseau! You cannot escape
charge that you are Pharisees & Hypocrites, for you are constantly talking of the
ues of the Human Heart, and particularly of your own, that you may accuse
rs & especially the Religious, whose errors, you by this display of pretended
ue, chiefly design to expose. Rousseau thought Men Good by Nature; he found
n Evil & found no friend. Friendship cannot exist without Forgiveness of Sins
inually. The Book written by Rousseau calld his Confessions is an apology &
e for his sin & not a confession.

ut you also charge the poor Monks & Religious with being the causes of War:
le you acquit & flatter the Alexanders & Caesars, the Lewis's & Fredericks:
alone are its causes & its actors. But the Religion of Jesus, Forgiveness of Sin,
never be the cause of a War nor of a single Martyrdom.

Those who Martyr others or who cause War are Deists, but never can be For-
ers of Sin. The Glory of Christianity is, To Conquer by Forgiveness. All the
struction therefore, in Christian Europe has arisen from Deism, which is
ural Religion —

| | |
|---|---|
| w a Monk of Charlemaine | The blood. red ran from the Grey Monks side |
| before my sight | His hands & feet were wounded wide |
| lkd with the Grey Monk as we stood | His body bent, his arms & knees |
| ams of infernal light | Like to the roots of ancient trees |
| | |
| bon arose with a lash of steel | When Satan first the black bow bent |
| oltaire with a wracking wheel | And the Moral Law from the Gospel rent |
| e Schools in clouds of learning rolld | He forgd the Law into a Sword |
| with War in iron & gold. | And spilld the blood of mercys Lord. |
| | |
| ou lazy Monk they sound afar | Titus! Constantine! Charlemaine! |
| n condemning glorious War | O Voltaire! Rousseau! Gibbon! Vain |
| d in your Cell you shall ever dwell | Your Grecian Mocks & Roman Sword |
| War & bind him in his Cell, | Against this image of his Lord! |

For a Tear is an Intellectual thing!
And a Sigh is the Sword of an Angel King
And the bitter groan of a Martyrs woe
Is an Arrow from the Almighties Bow/

39

JERUSALEM

Chap 3

But Los, who is the Vehicular Form of strong Urthona
Wept vehemently over Albion where Thames currents spring
From the rivers of Beulah; pleasant river! soft, mild, parent stream
And the roots of Albions Tree enterd the Soul of Los
As he sat before his Furnaces clothed in sackcloth of hair
In gnawing pain dividing him from his Emanation;
Inclosing all the Children of Los time after time.
Their Giant forms condensing into Nations & Peoples & Tongues
Translucent the Furnaces, of Beryll & Emerald immortal:
And Seven-fold each within other: incomprehensible
To the Vegetated Mortal Eye's perverted & single vision
The Bellows are the Animals Lungs. the hammers, the Animal Heart
The Furnaces, the Stomach for Digestion; terrible their fury
Like seven burning heavens rang'd from South to North

Here on the banks of the Thames, Los builded Golgonooza.
Outside of the Gates of the Human Heart, beneath Beulah
In the midst of the rocks of the Altars of Albion. In fears
He builded it. in rage & in fury, It is the Spiritual Fourfold
London: continually building & continually decaying desolate!
In eternal labours: loud the Furnaces & loud the Anvils
Of Death thunder incessant around the flaming Couches of
The Twentyfour Friends of Albion and round the awful Four
For the protection of the Twelve Emanations of Albions Sons
The Mystic Union of the Emanation in the Lord; Because
Man divided from his Emanation is a dark Spectre

His Emanation is an ever-weeping melancholy Shadow
But she is made receptive of Generation thro' mercy
In the Potters Furnace, among the Funeral Urns of Beulah
From Surrey hills, thro' Italy and Greece. to Hinnoms vale,

54

In Great Eternity, every particular Form gives forth or Emanates
Its own peculiar Light & the Form is the Divine Vision
And the Light is his Garment This is Jerusalem in every Man
A Tent & Tabernacle of Mutual Forgiveness Male & Female Clothings.
And Jerusalem is called Liberty among the Children of Albion

But Albion fell down a Rocky fragment from Eternity hurld
By his own Spectre. who is the Reasoning Power in every Man
Into his own Chaos which is the Memory between Man & Man

The silent broodings of deadly revenge springing from the
All powerful parental affection, fills Albion from head to foot
Seeing his Sons assimilate with Luvah, bound in the bonds
Of spiritual Hate. from which springs Sexual Love as iron chains:
He tosses like a cloud outstretchd among Jerusalems Ruins
Which overspread all the Earth, he groans among his ruind porches

Reason

Pity                    Wrath

This World

Desire

But the Spectre like a hoar frost & a Mildew rose over Albion
Saying, I am God O Sons of Men! I am your Rational Power!
Am I not Bacon & Newton & Locke who teach Humility to Man!
Who teach Doubt & Experiment & my two Wings Voltaire: Rousseau.
Where is that Friend of Sinners! that Rebel against my Laws!
Who teaches Belief to the Nations, & an unknown Eternal Life
Come hither into the Desart & turn these stones to bread.
Vain foolish Man! wilt thou believe without Experiment?
And build a World of Phantasy upon my Great Abyss!
A World of Shapes in craving lust & devouring appetite

So spoke the hard cold constrictive Spectre he is named Arthur
Constricting into Druid Rocks round Canaan Agag & Aram & Pharoh

Then Albion drew England into his bosom in groans & tears
But she stretchd out her starry Night in Spaces against him. like
A long Serpent, in the Abyss of the Spectre which augmented

The Night with Dragon wings coverd with stars & in the Wings
Jerusalem & Vala appeard: & above between the Wings magnificent
The Divine Vision dimly appeard in clouds of blood weeping.

55

Who is this who descend all Mortal Things and a Mortal Man
Among the Flowers of Beulah still retain his awful strength
They wanderd perplexing their will names & many gathering
Together into an Assembly, they said, let us go down
And see these changes! Others said, If you do so prepare
For you are driven from our fields, what have we to do with the Dead
To be their inferiors or superiors we equally abhor;
Superior, none we know: inferior none: all equal share
Divine Benevolence & joy, for the Eternal Man
Walketh among us, calling us his Brothers & his Friends:
Forbidding us that Veil which Satan puts between Eve & Adam:
By which the Princes of the Dead enslave their Votaries
Teaching them to form the Serpent of precious stones & gold
To sieze the Sons of Jerusalem & plant them in One Mans Loins
To make One Family of Contraries: that Joseph may be sold
Into Egypt: for Negation; a Veil the Saviour born & dying rends.

But others said: Let us to him who only Is, & who
Walketh among us, give decision. bring forth all your fires!

So saying, an eternal deed was done: in fiery flames
The Universal Concave raged, such thunderous sounds as never
Were sounded from a mortal cloud, nor on Mount Sinai old
Nor in Havilah where the Cherub rolld his redounding flame.

Loud! loud! the Mountains lifted up their voices, loud the Forests
Rivers thunderd against their banks, loud Winds furious fought
Cities & Nations contended in fires & clouds & tempests.
The Seas raisd up their voices & lifted their hands on high
The Stars in their courses fought, the Sun! Moon! Heaven! Earth.

Contending for Albion & for Jerusalem his Emanation
And for Shiloh, the Emanation of France & for lovely Vala.

Then far the greatest number were about to make a Separation
And they Eelected Seven, calld the Seven Eyes of God;
Lucifer, Molech. Elohim, Shaddai, Pahad, Jehovah. Jesus.
They namd the Eighth. he came not, he hid in Albions Forests
But first they said: (& their Words stood in Chariots in array
Curbing their Tygers with golden bits & bridles of silver & ivory)

Let the Human Organs be kept in their perfect Integrity
At will Contracting into Worms, or Expanding into Gods
And then behold! what are these Ulro Visions of Chastity
Then as the moss upon the tree: or dust upon the plow:
Or as the sweat upon the labouring shoulder: or as the chaff
Of the wheat-floor or as the dregs of the sweet wine-press
Such are these Ulro Visions, for tho we sit down within
The plowed furrow. listning to the weeping clods till we
Contract or Expand Space at will: or if we raise ourselves
Upon the chariots of the morning. Contracting or Expanding Time!
Every one knows, we are One Family: One Man blessed for ever

Silence remaind & every one resumd his Human Majesty
And many conversed on these things as they labourd at the furrow
Saying: It is better to prevent misery, than to release from misery
It is better to prevent error, than to forgive the criminal:
Labour well the Minute Particulars, attend to the Little-ones:
And those who are in misery cannot remain so long
If we do but our duty: labour well the teeming Earth.

They Plow'd in tears, the trumpets sounded before the golden Plow
And the voices of the Living Creatures were heard in the clouds of heaven
Crying; Compell the Reasoner to Demonstrate with unhewn Demonstrations
Let the Indefinite be explored. and let every Man be Judged
By his own Works, Let all Indefinites be thrown into Demonstrations
To be pounded to dust & melted in the Furnaces of Affliction:
He who would do good to another, must do it in Minute Particulars
General Good is the plea of the scoundrel hypocrite & flatterer:
For Art & Science cannot exist but in minutely organized Particulars
And not in generalizing Demonstrations of the Rational Power,
The Infinite alone resides in Definite & Determinate Identity
Establishment of Truth depends on destruction of Falshood continually
On Circumcision: not on Virginity, O Reasoners of Albion

So cried they at the Plow. Albions Rock frowned above
And the Great Voice of Eternity rolled above terrible in clouds
Saying Who will go forth for us! & Who shall we send before our face?

### 56

Then Los heaved his thund'ring Bellows on the Valley of Middlesex
And thus he chaunted his Song: the Daughters of Albion reply.

What may Man be? who can tell! But what may Woman be?
To have power over Man from Cradle to corruptible Grave.
He who is an Infant, and whose Cradle is a Manger
Knoweth the Infant sorrow: whence it came, and where it goeth:
And who weave it a Cradle of the grass that withereth away.
This World is all a Cradle for the erred wandering Phantom:
Rock'd by Year, Month, Day & Hour; and every two Moments
Between. dwells a Daughter of Beulah. to feed the Human Vegetable
Entune: Daughters of Albion. your hymning Chorus mildly!
Cord of affection thrilling extatic on the iron Reel:
To the golden Loom of Love! to the moth-labourd Woof
A Garment and Cradle weaving for the infantine Terror:
For fear; at entering the gate into our World of cruel
Lamentation: it flee back & hide in Non-Entitys dark wild
Where dwells the Spectre of Albion: destroyer of Definite Form.
The Sun shall be a Scythed Chariot of Britain: the Moon; a Ship
In the British Ocean! Created by Los's Hammer; measured out
Into Days & Nights & Years & Months, to travel with my feet
Over these desolate rocks of Albion: O daughters of despair,
Rock the Cradle, and in mild melodies tell me where found
What you have enwoven with so much tears & care! so much
Tender artifice: to laugh: to weep: to learn: to know;

And wept at our wintry Door: Look! look! behold! Gwendolen
Is become a Clod of Clay! Merlin is a Worm of the Valley!

Then Los uttered with Hammer & Anvil: Chaunt! revoice!
I mind not your laugh: and your frown I not fear! and
You must my dictate obey from your gold-beam'd Looms; trill
Gentle to Albions Watchman, on Albions mountains; reeccho

And rock the Cradle while! Ah me! Of that Eternal Man
And of the cradled Infancy in his bowels of compassion:
Who fell beneath his instruments of husbandry & became
Subservient to the clods of the furrow! the cattle and even
The emmet and earth-Worm are his superiors & his lords.

Then the response came warbling from trilling Looms in Albion
We Women tremble at the light therefore! hiding fearful
The Divine Vision with Curtain & Veil & fleshly Tabernacle
Los utter'd: swift as the rattling thunder upon the mountains
Look back into the Church Paul! Look; Three Women around
The Cross; O Albion why didst thou a Female Will Create?

### 57

And the voices of Bath & Canterbury & York & Edinburgh. Cry
Over the Plow of Nations in the strong hand of Albion thundering along
Among the Fires of the Druid & the deep black rethundering Waters
Of the Atlantic which poured in impetuous loud loud. louder & louder.
And the Great Voice of the Atlantic howled over the Druid Altars:
Weeping over his Children in Stone-henge in Malden & Colchester.
Round the Rocky Peak of Derbyshire London Stone & Rosamonds Bower

What is a Wife & what is a Harlot? What is a Church? & What
Is a Theatre? are they Two & not One? can they Exist Separate?

Are not Religion & Politics the Same Thing? Brotherhood is Religion
O Demonstrations of Reason Dividing Families in Cruelty & Pride!

But Albion fled from the Divine Vision. with the Plow of Nations enflam
The Living Creatures maddend and Albion fell into the Furrow, and
The Plow went over him & the Living was Plowed in among the Dead
But his Spectre rose over the starry Plow. Albion fled beneath the Plow
Till he came to the Rock of Ages. & he took his Seat upon the Rock.

Wonder siezd all in Eternity! to behold the Divine Vision. open
The Center into an Expanse, & the Center rolled out into an Expanse.

### 58

In beauty the Daughters of Albion divide & unite at will
Naked & drunk with blood Gwendolen dancing to the timbrel
Of War: reeling up the Street of London she divides in twain
Among the Inhabitants of Albion. the People fall around.
The Daughters of Albion. divide & unite in jealousy & cruelty
The Inhabitants of Albion at the Harvest & the Vintage
Feel their Brain cut round beneath the temples shrieking
Bonifying into a Scull, the Marrow exuding in dismal pain
They flee over the rocks bonifying: Horses; Oxen: feel the knife.
And while the Sons of Albion by severe War & Judgment, bonify
The Hermaphroditic Condensations are divided by the Knife
The obdurate Forms are cut asunder by Jealousy & Pity.

Rational Philosophy and Mathematic Demonstration
Is divided in the intoxications of pleasure & affection
Two Contraries War against each other in fury & blood,
And Los fixes them on his Anvil, incessant his blows:
He fixes them with strong blows. placing the stones & timbers.
To Create a World of Generation from the World of Death:
Dividing the Masculine & Feminine: for the comingling
Of Albions & Luvahs Spectres was Hermaphroditic

Urizen wrathful strode above directing the awful Building:
As a Mighty Temple; delivering Form out of confusion
Jordan sprang beneath its threshold bubbling from beneath
Its pillars: Euphrates ran under its arches: white sails
And silver oars reflect on its pillars, & sound on its ecchoing
Pavements: where walk the Sons of Jerusalem who remain Ungenerate
But the revolving Sun and Moon pass thro its porticoes,
Day & night, in sublime majesty & silence they revolve
And shine glorious within! Hand & Koban archd over the Sun
In the hot noon. as he traveld thro his journey; Hyle & Skofield
Archd over the Moon at midnight & Los Fixd them there,
With his thunderous Hammer: terrified the Spectres rage & flee
Canaan is his portion; Jordan is a fountain in his porch;
A fountain of milk & wine to relieve the traveller:
Egypt is the eight steps within. Ethiopia supports his pillars;
Lybia & the Lands unknown. are the ascent without;
Within is Asia & Greece, ornamented with exquisite art:
Persia & Media are his halls; his inmost hall is Great Tartary.
China & India & Siberia are his temples for entertainment
Poland & Russia & Sweden. his soft retired chambers
France & Spain & Italy & Denmark & Holland & Germany
Are the temples among his pillars. Britain is Los's Forge;
America North & South are his baths of living waters.

ich is the Ancient World of Urizen in the Satanic Void
reated from the Valley of Middlesex by Londons River
rom Stone-henge and from London Stone, from Cornwall to Cathnes
he Four Zoa's rush around on all sides in dire ruin
rious in pride of Selfhood the terrible Spectres of Albion
ear their dark Rocks among the Stars of God: stupendous
orks! A World of Generation continually Creating; out of
he Hermaphroditic Satanic World of rocky destiny.

59

nd formed into Four precious stones. for enterance from Beulah

or the Veil of Vala which Albion cast into the Atlantic Deep
o catch the Souls of the Dead: began to Vegetate & Petrify
round the Earth of Albion. among the Roots of his Tree
his Los formed into the Gates & mighty Wall, between the Oak
Weeping & the Palm of Suffering beneath Albions Tomb.
hus in process of time it became the beautiful Mundane Shell.
he Habitation of the Spectres of the Dead & the Place
Redemption & of awaking again into Eternity

or Four Universes round the Mundane Egg remain Chaotic
ne to the North: Urthona: One to the South: Urizen;
ne to the East: Luvah: One to the West, Tharmas;
hey are the Four Zoas that stood around the Throne Divine
erulam: London: York & Edinburgh: their English names
t when Luvah assumed the World of Urizen Southward
nd Albion was slain upon his Mountains & in his Tent.
fell towards the Center, sinking downwards in dire ruin,
the South remains a burning Fire: in the East. a Void
the West, a World of raging Waters. in the North: solid Darkness
nfathomable without end: but in the midst of these
Built eternally the sublime Universe of Los & Enitharmon

nd in the North Gate, in the West of the North. toward Beulah
athedrons Looms are builded. and Los's Furnaces in the South
wondrous golden Building immense with ornaments sublime
bright Cathedrons golden Hall, its Courts Towers & Pinnacles

nd one Daughter of Los sat at the fiery Reel & another
at the shining Loom with her Sisters attending round
errible their distress & their sorrow cannot be utterd
nd another Daughter of Los sat at the Spinning Wheel
ndless their labour, with bitter food. void of sleep,
o hungry they labour: they rouze themselves anxious

our after hour labouring at the whirling Wheel
any Wheels & as many lovely Daughters sit weeping
t the intoxicating delight that they take in their work
bliterates every other evil; none pities their tears
t they regard not pity & they expect no one to pity
r they labour for life & love, regardless of any one
the poor spectres that they work for, always craving
ey are murderd by every one that passes by: they regard not
ey labour; & when their Wheels are broken by scorn & malice
ey mend them sorrowing with many tears & afflictions.

at Rahab & Tirzah may exist & live & breathe & love
n, that it could be as the Daughters of Beulah wish!

her Daughters of Los, labouring at Looms less fine
reate the Silk-worm & the Spider & the Catterpiller
o assist in their most grievous work of pity & compassion
nd others Create the wooly Lamb & the downy Fowl
o assist in the work: the Lamb bleats: the Sea-fowl cries
en understand not the distress & the labour & sorrow
hat in the Interior Worlds is carried on in fear & trembling
eaving the shuddring fears & loves of Albions Families
hunderous rage the Spindles of iron. & the iron Distaff
addens in the fury of their hands, Weaving in bitter tears
he Veil of Goats-hair & Purple & Scarlet & fine twined Linen

60

he clouds of Albions Druid Temples rage in the eastern heaven
While Los sat terrified beholding Albions Spectre who is Luvah
preading in bloody veins in torments over Europe & Asia;
ot yet formed but a wretched torment unformed & abyssal
flaming fire: within the Furnaces the Divine Vision appeard
n Albions hills: often walking from the Furnaces in clouds
nd flames among the Druid Temples & the Starry Wheels
atherd Jerusalems Children in his arms & bore them like
Shepherd in the night of Albion which overspread all the Earth

I gave thee liberty and life O lovely Jerusalem
And thou hast bound me down upon the Stems of Vegetation
I gave thee Sheep-walks upon the Spanish Mountains Jerusalem
I gave thee Priams City and the Isles of Grecia lovely!
I gave thee Hand & Scofield & the Counties of Albion:
They spread forth like a lovely root into the Garden of God:
They were as Adam before me: united into One Man,
They stood in innocence & their skiey tent reachd over Asia
To Nimrods Tower to Ham & Canaan walking with Mizraim
Upon the Egyptian Nile, with solemn songs to Grecia
And sweet Hesperia even to Great Chaldea & Tesshina
Following thee as a Shepherd by the Four Rivers of Eden
Why wilt thou rend thyself apart, Jerusalem?
And build this Babylon & sacrifice in secret Groves,
Among the Gods of Asia: among the fountains of pitch & nitre
Therefore thy Mountains are become barren Jerusalem!
Thy Valleys, Plains of burning sand. thy Rivers: waters of death
Thy Villages die of the Famine and thy Cities
Beg bread from house to house, lovely Jerusalem
Why wilt thou deface thy beauty & the beauty of thy little-ones
To please thy Idols, in the pretended chastities of Uncircumcision
Thy Sons are lovelier than Egypt or Assyria; wherefore
Dost thou blacken their beauty by a Secluded place of rest.
And a peculiar Tabernacle. to cut the integuments of beauty
Into veils of tears and sorrows O lovely Jerusalem!
They have perswaded thee to this, therefore their end shall come
And I will lead thee thro the Wilderness in shadow of my cloud
And in my love I will lead thee, lovely Shadow of Sleeping Albion,

This is the Song of the Lamb, sung by Slaves in evening time.
But Jerusalem faintly saw him, closd in the Dungeons of Babylon
Her Form was held by Beulahs Daughters. but all within unseen
She sat at the Mills, her hair unbound her feet naked
Cut with the flints: her tears run down, her reason grows like
The Wheel of Hand. incessant turning day & night without rest
Insane she raves upon the winds hoarse, inarticulate:
All night Vala hears. she triumphs in pride of holiness
To see Jerusalem deface her lineaments with bitter blows
Of despair. while the Satanic Holiness triumphd in Vala
In a Religion of Chastity & Uncircumcised Selfishness
Both of the Head & Heart & Loins. closd up in Moral Pride.

But the Divine Lamb stood beside Jerusalem. oft she saw
The lineaments Divine & oft the Voice heard, & oft she said:

O Lord & Saviour, have the Gods of the Heathen pierced thee?
Or hast thou been pierced in the House of thy Friends?
Art thou alive! & livest thou for-evermore? or art thou
Not: but a delusive shadow, a thought that liveth not.
Babel mocks saying, there is no God nor Son of God
That thou O Human Imagination. O Divine Body art all
A delusion. but I know thee O Lord when thou arisest upon
My weary eyes even in this dungeon & this iron mill,
The Stars of Albion cruel rise. thou bindest to sweet influences.
For thou also sufferest with me altho I behold thee not;
And altho I sin & blaspheme thy holy name. thou pitiest me;
Because thou knowest I am deluded by the turning mills
And by these visions of pity & love because of Albions death.

Thus spake Jerusalem, & thus the Divine Voice replied.

Mild Shade of Man. pitiest thou these Visions of terror & woe!
Give forth thy pity & love. fear not! lo I am with thee always.
Only believe in me that I have power to raise from death
Thy Brother who Sleepeth in Albion: fear not trembling Shade

61

Behold: in the Visions of Elohim Jehovah. behold Joseph & Mary
And be comforted O Jerusalem in the Visions of Jehovah Elohim

She looked & saw Joseph the Carpenter in Nazareth & Mary
His espoused Wife. And Mary said, If thou put me away from thee
Dost thou not murder me? Joseph spoke in anger & fury. Should I
Marry a Harlot & an Adulteress? Mary answerd, Art thou more pure
Than thy Maker who forgiveth Sins & calls again Her that is Lost
Tho She hates. he calls her again in love. I love my dear Joseph
But he driveth me away from his presence. yet I heard the voice of God
In the voice of my Husband. tho he is angry for a moment, he will not
Utterly cast me away. if I were pure, never could I taste the sweets
Of the Forgivess of Sins! if I were holy! I never could behold the tears
Of love! of him who loves me in the midst of his anger in furnace of fire.

Ah my Mary: said Joseph: weeping over & embracing her closely in.
His arms: Doth he forgive Jerusalem & not exact Purity from her who is

Polluted. I heard his voice in my sleep & his Angel in my dream:
Saying, Doth Jehovah Forgive a Debt only on condition that it shall
Be Payed? Doth he Forgive Pollution only on conditions of Purity
That Debt is not Forgiven! That Pollution is not Forgiven
Such is the Forgiveness of the Gods, the Moral Virtues of the
Heathen, whose tender Mercies are Cruelty. But Jehovahs Salvation
Is without Money & without Price, in the Continual Forgiveness of Sins
In the Perpetual Mutual Sacrifice in Great Eternity! for behold!
There is none that liveth & Sinneth not! And this is the Covenant
Of Jehovah: If you Forgive one-another, so shall Jehovah Forgive You:
That He Himself may Dwell among You. Fear not then to take
To thee Mary thy Wife, for she is with Child by the Holy Ghost

Then Mary burst forth into a Song! she flowed like a River of
Many Streams in the arms of Joseph & gave forth her tears of joy
Like many waters, and Emanating into gardens & palaces upon
Euphrates & to forests & floods & animals wild & tame from
Gihon to Hiddekel. & to corn fields & villages & inhabitants
Upon Pison & Arnon & Jordan. And I heard the voice among
The Reapers Saying, Am I Jerusalem the lost Adulteress? or am I
Babylon come up to Jerusalem? And another voice answered Saying

Does the voice of my Lord call me again? am I pure thro his Mercy
And Pity. Am I become lovely as a Virgin in his sight who am
Indeed a Harlot drunken with the Sacrifice of Idols does he
Call her pure as he did in the days of her Infancy when She
Was cast out to the loathing of her person. The Chaldean took
Me from my Cradle. The Amalekite stole me away upon his Camels
Before I had ever beheld with love the Face of Jehovah; or known
That there was a God of Mercy: O Mercy O Divine Humanity!
O Forgiveness & Pity & Compassion! If I were Pure I should never
Have known Thee; If I were Unpolluted I should never have
Glorified thy Holiness, or rejoiced in thy great Salvation.

Mary leaned her side against Jerusalem, Jerusalem recieved
The Infant into her hands in the Visions of Jehovah. Times passed on
Jerusalem fainted over the Cross & Sepulcher She heard the voice
Wilt thou make Rome thy Patriarch Druid & the Kings of Europe his
Horsemen? Man in the Resurrection changes his Sexual Garments at will
Every Harlot was once a Virgin: every Criminal an Infant Love:

### 62

Repose on me till the morning of the Grave. I am thy life.

Jerusalem replied. I am an outcast: Albion is dead:
I am left to the trampling foot & the spurning heel!
A Harlot I am calld. I am sold from street to street!
I am defaced with blows & with the dirt of the Prison!
And wilt thou become my Husband O my Lord & Saviour?
Shall Vala bring thee forth! shall the Chaste be ashamed also?
I see the Maternal Line, I behold the Seed of the Woman!
Cainah, & Ada & Zillah & Naamah Wife of Noah.
Shuahs daughter & Tamar & Rahab the Canaanites:
Ruth the Moabite & Bathsheba of the daughters of Heth
Naamah the Ammonite, Zibeah the Philistine. & Mary
These are the Daughters of Vala, Mother of the Body of death
But I thy Magdalen behold thy Spiritual Risen Body
Shall Albion arise? I know he shall arise at the Last Day!
I know that in my flesh I shall see God: but Emanations
Are weak. they know not whence they are, nor whither tend.

Jesus replied. I am the Resurrection & the Life.
I Die & pass the limits of possibility, as it appears
To individual perception. Luvah must be Created
And Vala; for I cannot leave them in the gnawing Grave.
But will prepare a way for my banished-ones to return
Come now with me into the villages. walk thro all the cities.
Tho thou art taken to prison & judgment, starved in the streets
I will command the cloud to give thee food & the hard rock
To flow with milk & wine, tho thou seest me not a season
Even a long season & a hard journey & a howling wilderness.
Tho Valas cloud hide thee & Luvahs fires follow thee!
Only believe & trust in me, Lo. I am always with thee;

So spoke the Lamb of God while Luvahs Cloud reddening above
Burst forth in streams of blood upon the heavens & dark night
Involvd Jerusalem. & the Wheels of Albions Sons turnd hoarse
Over the mountains & the fires blaz'd on Druid Altars
And the Sun set in Tyburns Brook where Victims howl & cry.

But Los beheld the Divine Vision among the flames of the Furnaces
Therefore he lived & breathed in hope. but his tears fell incessant
Because his Children were closd from him apart: & Enitharmon

Dividing in fierce pain: also the Vision of God was closd in clouds
Of Albions Spectres, that Los in despair oft sat, & often ponderd
On Death Eternal in fierce shudders upon the mountains of Albion
Walking: & in the vales in howlings fierce, then to his Anvils
Turning, anew began his labours, tho in terrible pains!

### 63

Jehovah stood among the Druids in the Valley of Annandale
When the Four Zoas of Albion. the Four Living Creatures, the Cherubim
Of Albion tremble before the Spectre, in the starry Harness of the Plow
Of Nations. And their Names are Urizen & Luvah & Tharmas & Urthona

Luvah slew Tharmas the Angel of the Tongue & Albion brought him
To Justice in his own City of Paris, denying the Resurrection
Then Vala the Wife of Albion, who is the Daughter of Luvah
Took vengeance Twelve-fold among the Chaotic Rocks of the Druids
Where the Human Victims howl to the Moon & Thor & Friga
Dance the dance of death contending with Jehovah among the Cherubim
The Chariot Wheels filled with Eyes rage along the howling Valley
In the Dividing of Reuben & Benjamin bleeding from Chesters River

The Giants & the Witches & the Ghosts of Albion dance with
Thor & Friga, & the Fairies lead the Moon along the Valley of Cherubim
Bleeding in torrents from Mountain to Mountain. a lovely Victim
And Jehovah stood in the Gates of the Victim. & he appeared
A weeping Infant in the Gates of Birth in the midst of Heaven
The Cities & Villages of Albion became Rock & Sand Unhumanized
The Druid Sons of Albion & the Heavens a Void around unfathomable
No Human Form but Sexual & a little weeping Infant pale reflected
Multitudinous in the Looking Glass of Enitharmon, on all sides
Around in the clouds of the Female. on Albions Cliffs of the Dead

Such the appearance in Cheviot: in the Divisions of Rueben

When the Cherubim hid their heads under their wings in deep slumbers
When the Druids demanded Chastity from Woman & all was lost.

How can the Female be Chaste O thou stupid Druid Cried Los
Without the Forgiveness of Sins in the merciful clouds of Jehovah
And without the Baptism of Repentance to wash away Calumnies. and
The Accusations of Sin that each may be Pure in their Neighbours sight
O when shall Jehovah give us Victims from his Flocks & Herds
Instead of Human Victims by the Daughters of Albion & Canaan

Then laugh'd Gwendolen & her laughter shook the Nations & Familys
The Dead beneath Beulah from Tyburn to Golgotha. and from
Ireland to Japan. furious her Lions & Tygers & Wolves sport before
Los on the Thames & Medway. London & Canterbury groan in pain

Los knew not yet what was done: he thought it was all in Vision
In Visions of the Dreams of Beulah among the Daughters of Albion
Therefore the Murder was put apart in the Looking-Glass of Enitharmon

He saw in Vala's hand the Druid Knife of Revenge & the Poison Cup
Of Jealousy, and thought it a Poetic Vision of the Atmospheres
Till Canaan rolld apart from Albion across the Rhine: along the Danube

And all the Land of Canaan suspended over the Valley of Cheviot
From Bashan to Tyre & from Troy to Gaza of the Amalekite
And Reuben fled with his head downwards among the Caverns

### 64

Of the Mundane Shell which froze on all sides round Canaan on
The vast Expanse: where the Daughters of Albion Weave the Web
Of Ages & Generations. folding & unfolding it, like a Veil of Cherubim
And sometimes it touches the Earths summits, & sometimes spreads
Abroad into the Indefinite Spectre, who is the Rational Power.

Then All the Daughters of Albion became One before Los: even Vala!
And she put forth her hand upon the Looms in dreadful howlings
Till she vegetated into a hungry Stomach & a devouring Tongue
Her Hand is a Court of Justice, her Feet: two Armies in Battle
Storms & Pestilence: in her Locks: & in her Loins Earthquake.
And Fire & the Ruin of Cities & Nations & Families & Tongues

She cries: The Human is but a Worm, & thou O Male: Thou art
Thyself Female, a Male: a breeder of Seed; a Son & Husband; & Lo
The Human Divine is Womans Shadow, a Vapor in the summers heat
Go assume Papal dignity thou Spectre, thou Male Harlot! Arthur
Divide into the Kings of Europe in times remote O Woman-born
And Woman-nourishd & Woman-educated & Woman-scorn'd!

Wherefore art thou living? said Los. & Man cannot live in thy presence

rt thou Vala the Wife of Albion O thou lovely Daughter of Luvah
ll Quarrels arise from Reasoning. the secret Murder, and
he violent Man-slaughter. these are the Spectres double Cave
he Sexual Death living on accusation of Sin & Judgment
o freeze Love & Innocence into the gold & silver of the Merchant
Without Forgiveness of Sin Love is Itself Eternal Death

hen the Spectre drew Vala into his bosom magnificent terrific
littering with precious stones & gold. with Garments of blood & fire
e wept in deadly wrath of the Spectre. in self-contradicting agony
rimson with Wrath & green with Jealousy dazling with Love
nd Jealousy immingled & the purple of the violet darkend deep
ver the Plow of Nations thundring in the hand of Albions Spectre

dark Hermaphrodite they stood frowning upon Londons River
nd the Distaff & Spindle in the hands of Vala with the Flax of
uman Miseries turnd fierce with the Lives of Men along the Valley
s Reuben fled before the Daughters of Albion Taxing the Nations

erby Peak yawnd a horrid Chasm at the Cries of Gwendolen. & at
he stamping feet of Ragan upon the flaming Treddles of her Loom
hat drop with crimson gore with the Loves of Albion & Canaan
pening along the Valley of Rephaim, weaving over the Caves of Machpelah

### 65

o decide Two Worlds with a great decision: a World of Mercy. and
World of Justice: the World of Mercy for Salvation
o cast Luvah into the Wrath, and Albion into the Pity
the Two Contraries of Humanity & in the Four Regions.

or in the depths of Albions bosom in the eastern heaven,
hey sound the clarions strong! they chain the howling Captives!
hey cast the lots into the helmet: they give the oath of blood in Lambeth
hey vote the death of Luvah, & they naild him to Albions Tree in Bath:
hey staind him with poisonous blue, they inwove him in cruel roots
o die a death of Six thousand years bound round with vegetation
he sun was black & the moon rolld a useless globe thro Britain!

hen left the Sons of Urizen the plow & harrow, the loom
he hammer & the chisel, & the rule & compasses; from London fleeing
hey forg'd the sword on Cheviot, the chariot of war & the battle-ax,
he trumpet fitted to mortal battle. & the flute of summer in Annandale
nd all the Arts of Life. they changd into the Arts of Death in Albion.
he hour-glass contemnd because its simple workmanship.
as like the workmanship of the plowman. & the water wheel.
hat raises water into cisterns. broken & burnd with fire:
ecause its workmanship. was like the workmanship of the shepherd.
nd in their stead. intricate wheels invented. wheel without wheel:
o perplex youth in their outgoings, & to bind to labours in Albion
f day & night the myriads of eternity that they may grind
nd polish brass & iron hour after hour laborious task!
ept ignorant of its use, that they might spend the days of wisdom
sorrowful drudgery, to obtain a scanty pittance of bread
ignorance to view a small portion & think that All,
nd call it Demonstration: blind to all the simple rules of life.

hut now the battle rages round thy tender limbs O Vala
nd rosons round thy silver temples from his forky tongue
not the wound of the sword sweet! & the broken bone delightful?

ilt thou now smile among the scythes when the wounded groan in the field
e were carried away in thousands from London; & in tens
thousands from Westminster & Marybone in ships closd up:
laind hand & foot, compelled to fight under the iron whips
our captains; fearing our officers more than the enemy.
ft up thy blue eyes Vala & put on thy sapphire shoes:
melancholy Magdalen behold the morning over Malden break;
rd on thy flaming zone, descend into the sepulcher of Canterbury.
atter the blood from thy golden brow. the tears from thy silver locks:
ake off the waters from thy wings! & the dust from thy white garments
emember all thy feigned terrors on the secret couch of Lambeths Vale
hen the sun rose in glowing morn. with arms of mighty hosts
arching to battle who was wont to rise with Urizens harps
rt as a sower with his seed to scatter life abroad over Albion:
ise O Vala! bring the bow of Urizen: bring the swift arrows of light.
ow rag'd the golden horses of Urizen, compelld to the chariot of love!
ompelld to leave the plow to the ox, to snuff up the winds of desolation
trample the corn fields in boastful neighings: this is no gentle harp
his is no warbling brook, nor shadow of a mirtle tree:
t blood and wounds and dismal cries, and shadows of the oak:
d hearts laid open to the light, by the broad grizly sword:
d bowels hid in hammerd steel rip'd quivering on the ground.
ll forth thy smiles of soft deceit: call forth thy cloudy tears:
e hear thy sighs in trumpets shrill when morn shall blood renew.

So sang the Spectre Sons of Albion round Luvahs Stone of Trial:
Mocking and deriding at the writhings of their Victim on Salisbury:
Drinking his Emanation in intoxicating bliss rejoicing in Giant dance;
For a Spectre has no Emanation but what he imbibes from deceiving
A Victim! Then he becomes her Priest & she his Tabernacle.
And his Oak Grove, till the Victim rend the woven Veil.
In the end of his sleep when Jesus calls him from him his grave

Howling the Victims on the Druid Altars yield their souls
To the stern Warriors: lovely sport the Daughters round their Victims;
Drinking their lives in sweet intoxication. hence arose from Bath
Soft deluding odours. in spiral volutions intricately winding
Over Albions mountains. a feminine indefinite cruel delusion.
Astonishd: terrified & in pain & torment. Sudden they behold
Their own Parent the Emanation of their murderd Enemy
Become their Emanation and their Temple and Tabernacle
They knew not. this Vala was their beloved Mother Vala Albions Wife.

Terrified at the sight of the Victim: at his distorted sinews!
The tremblings of Vala vibrate thro' the limbs of Albions Sons:
While they rejoice over Luvah in mockery & bitter scorn:
Sudden they become like what they behold in howlings & deadly pain
Spasms smite their features, sinews & limbs: pale they look on one another.
They turn, contorted: their iron necks bend unwilling towards
Luvah: their lips tremble: their muscular fibres are crampd & smitten
They become like what they behold! Yet immense in strength & power,

### 66

In awful pomp & gold, in all the precious unhewn stones of Eden
They build a stupendous Building on the Plain of Salisbury; with chains
Of rocks round London Stone: of Reasonings: of unhewn Demonstrations
In labyrinthine arches. (Mighty Urizen the Architect.) thro which
The Heavens might revolve & Eternity be bound in their chain.
Labour unparallelld! a wondrous rocky World of cruel destiny
Rocks piled on rocks reaching the stars: stretching from pole to pole.
The Building is Natural Religion & its Altars Natural Morality
A building of eternal death: whose proportions are eternal despair
Here Vala stood turning the iron Spindle of destruction
From heaven to earth: howling! invisible! but not invisible
Her Two Covering Cherubs afterwards named Voltaire & Rousseau:
Two frowning Rocks: on each side of the Cove & Stone of Torture:
Frozen Sons of the feminine Tabernacle of Bacon, Newton & Locke.
For Luvah is France: the Victim of the Spectres of Albion.

Los beheld in terror: he pour'd his loud storms on the Furnaces:
The Daughters of Albion clothed in garments of needle work
Strip them off from their shoulders and bosoms, they lay aside
Their garments; they sit naked upon the Stone of trial.
The Knife of flint passes over the howling Victim: his blood
Gushes & stains the fair side of the fair Daughters of Albion.
They put aside his curls; they divide his seven locks upon
His forehead: they bind his forehead with thorns of iron
They put him his hand a reed, they mock Saying: Behold
The King of Canaan whose are seven hundred chariots of iron!
They take off his vesture whole with their Knives of flint:
But they cut asunder his inner garments: searching with
Their cruel fingers for his heart, & there they enter in pomp.
In many tears; & there they erect a temple & an altar;
They pour cold water on his brain in front, to cause.
Lids to grow over his eyes in veils of tears: and caverns
To freeze over his nostrils. while they feed his tongue from cups
And dishes of painted clay. Glowing with beauty & cruelty:
They obscure the sun & the moon; no eye can look upon them.

Ah! alas! at the sight of the Victim. & at sight of those who are smitten,
All who see. become what they behold. their eyes are coverd
With veils of tears and their nostrils & tongues shrunk up
Their ear bent outwards. as their Victim, so are they in the pangs
Of unconquerable fear! amidst delights of revenge Earth-shaking!
And as their eye & ear shrunk, the heavens shrunk away
The Divine Vision became First a burning flame. then a column
Of fire, then an awful fiery wheel surrounding earth & heaven:
And then a globe of blood wandering distant in an unknown night:
Afar into the unknown night the mountains fled away:
Six months of mortality; a summer: & six months of mortality; a winter:
The Human form began to be alterd by the Daughters of Albion
And the perceptions to be dissipated into the Indefinite. Becoming
A mighty Polypus nam'd Albions Tree: they tie the Veins
And Nerves into two knots: & the Seed into a double knot:
They look forth: the Sun is shrunk: the Heavens are shrunk
Away into the far remote: and the Trees & Mountains witherd
Into indefinite cloudy shadows in darkness & separation.

By Invisible Hatreds adjoind, they seem remote and separate
From each other; and yet are a Mighty Polypus in the Deep!
As the Misletoe grows on the Oak, so Albions Tree on Eternity: Lo!
He who will not comingle in Love. must be adjoind by Hate

They look forth from Stone-henge! from the Cove round London Stone
They look on one another: the mountain calls out to the mountain:
Plinlimmon shrunk away: Snowdon trembled: the mountains
Of Wales & Scotland beheld the descending War: the routed flying:
Red run the streams of Albion: Thames is drunk with blood:
As Gwendolen cast the shuttle of war: as Cambel returnd the beam.
The Humber & the Severn: are drunk with the blood of the slain:
London feels his brain cut round: Edinburghs heart is circumscribed!
York & Lincoln hide among the flocks, because of the griding Knife.
Worcester & Hereford: Oxford & Cambridge reel & stagger,
Overwearied with howling: Wales & Scotland alone sustain the fight!
The inhabitants are sick to death: they labour to divide into Days
And Nights, the uncertain Periods: and into Weeks & Months. In vain
They send the Dove & Raven: & in vain the Serpent over the mountains.
And in vain the Eagle & Lion over the four-fold wilderness.
They return not; but generate in rocky places desolate.
They return not; but build a habitation separate from Man.
The Sun forgets his course like a drunken man; he hesitates,
Upon the Cheselden hills, thinking to sleep on the Severn

In vain: he is hurried afar into an unknown Night
He bleeds in torrents of blood as he rolls thro heaven above
He chokes up the paths of the sky; the Moon is leprous as snow!
Trembling & descending down seeking to rest upon high Mona:
Scattering her leprous snows in flakes of disease over Albion.
The Stars flee remote: the heaven is iron, the earth is sulphur,
And all the mountains & hills shrink up like a withering gourd,
As the Senses of Men shrink together under the Knife of flint.
In the hands of Albions Daughters, among the Druid Temples.

### 67

By those who drink their blood & the blood of their Covenant

And the Twelve Daughters of Albion united in Rahab & Tirzah
A Double Female: and they drew out from the Rocky Stones
Fibres of Life to Weave for every Female is a Golden Loom
The Rocks are opake hardnesses covering all Vegetated things.
And as they Wove & Cut from the Looms in various divisions
Stretching over Europe & Asia from Ireland to Japan
They divided into many lovely Daughters to be counterparts
To those they Wove, for when they Wove a Male, they divided
Into a Female to the Woven Male, in opake hardness
They cut the Fibres from the Rocks groaning in pain they Weave;
Calling the Rocks Atomic Origins of Existence: denying Eternity
By the Atheistical Epicurean Philosophy of Albions Tree
Such are the Feminine & Masculine when separated from Man
They call the Rocks Parents of Men. & adore the frowning Chaos
Dancing around in howling pain clothed in the bloody Veil.
Hiding Albions Sons within the Veil, closing Jerusalems
Sons without; to feed with their Souls the Spectres of Albion
Ashamed to give Love openly to the piteous & merciful Man
Counting him an imbecile mockery: but the Warrior
They adore: & his revenge cherish with the blood of the Innocent
They drink up Dan & Gad, to feed with milk Skofeld & Kotope
They strip off Josephs Coat & dip it in the blood of battle

Tirzah sits weeping to hear the shrieks of the dying: her Knife
Of flint is in her hand: she passes it over the howling Victim
The Daughters Weave their Work in loud cries over the Rock
Of Horeb: still eyeing Albions Cliffs eagerly siezing & twisting
The threads of Vala & Jerusalem running from mountain to mountain
Over the whole Earth: loud the Warriors rage in Beth Peor
Beneath the iron whips of their Captains & consecrated banners
Loud the Sun & Moon rage in the conflict: loud the Stars
Shout in the night of battle & their spears grow to their hands
With blood, weaving the deaths of the Mighty into a Tabernacle
For Rahab & Tirzah; till the Great Polypus of Generation covered the Earth

In Verulam the Polypus's Head, winding around his bulk
Thro Rochester, and Chichester, & Exeter & Salisbury,
To Bristol. & his Heart beat strong on Salisbury Plain
Shooting out Fibres round the Earth, thro Gaul & Italy
And Greece, & along the Sea of Rephaim into Judea
To Sodom & Gomorrha: thence to India, China & Japan
The Twelve Daughters in Rahab & Tirzah have circumscribd the Brain
Beneath & pierced it thro the midst with a golden pin.
Blood hath staind her fair side beneath her bosom.

O thou poor Human Form! said she. O thou poor child of woe!
Why wilt thou wander away from Tirzah: why me compel to bind thee
If thou dost go away from me I shall consume upon these Rocks
These fibres of thine eyes that used to beam in distant heavens
Away from me: I have bound down with a hot iron.
These nostrils that expanded with delight in morning skies
I have bent downward with lead melted in my roaring furnaces
Of affliction; of love: of sweet despair: of torment unendurable
My soul is seven furnaces. incessant roars the bellows
Upon my terribly flaming heart, the molten metal runs
In channels thro my fiery limbs: O love! O pity! O fear!
O pain! O the pangs. the bitter pangs of love forsaken
Ephraim was a wilderness of joy where all my wild beasts ran
The River Kanah wanderd by my sweet Manassehs side
To see the boy spring into heavens sounding from my sight!
Go Noah fetch the girdle of strong brass, heat it red-hot:
Press it around the loins of this ever expanding cruelty
Shriek not so my only love; I refuse thy joys: I drink
Thy shrieks because Hand & Hyle are cruel & obdurate to me

### 68

O Skofield why art thou cruel? Lo Joseph is thine! to make
You One: to weave you both in the same mantle of skin
Bind him down Sisters bind him down on Ebal. Mount of cursing:
Malah come forth from Lebanon: & Hoglah from Mount Sinai:
Come circumscribe this     gue of sweets & with a screw of iron
Fasten this ear into the rock: Milcah the task is thine
Weep not so Sisters: weep not so! our life depends on this
Or mercy & truth are fled away from Shechem & Mount Gilead
Unless my beloved is bound upon the Stems of Vegetation

And thus the Warriors cry. in the hot day of Victory, in Songs.

Look: the beautiful Daughter of Albion sits naked upon the Stone
Her panting Victim beside her: her heart is drunk with blood
Tho her brain is not drunk with wine: she goes forth from Albion
In pride of beauty: in cruelty of holiness: in the brightness
Of her tabernacle. & her ark & secret place. the beautiful Daughter
Of Albion. delights the eyes of the Kings, their hearts & the
Hearts of their Warriors glow hot before Thor & Friga. O Molech!
O Chemosh! O Bacchus! O Venus! O Double God of Generation
The Heavens are cut like a mantle around from the Cliffs of Albion
Across Europe; across Africa; in howlings & deadly War
A sheet & veil & curtain of blood is let down from Heaven
Across the hills of Ephraim & down Mount Olivet to
The Valley of the Jebusite: Molech rejoices in heaven
He sees the Twelve Daughters naked upon the Twelve Stones
Themselves condensing to rocks & into the Ribs of a Man
Lo they shoot forth in tender Nerves across Europe & Asia
Lo they rest upon the Tribes, where their panting Victims lie
Molech rushes into the Kings in love to the beautiful Daughters
But they frown & delight in cruelty. refusing all other joy
Bring your Offerings, your first begotten: pamperd with milk & blood
Your first born of seven years old! be they Males or Females:
To the beautiful Daughters of Albion! they sport before the Kings
Clothed in the skin of the Victim! blood! human blood: is the life
And delightful food of the Warrior: the well fed Warriors flesh
Of him who is slain in War: fills the Valleys of Ephraim with
Breeding Women walking in pride & bringing forth under green trees
With pleasure, without pain, for their food is. blood of the Captive
Molech rejoices thro the Land from Havilah to Shur: he rejoices
In moral law & its severe penalties: loud Shaddai & Jehovah
Thunder above: when they see the Twelve panting Victims
On the Twelve Stones of Power. & the beautiful Daughters of Albion
If you dare rend their Veil with your Spear; you are healed of Love!
From the Hills of Camberwell & Wimbledon: from the Valleys
Of Walton & Esher: from Stone-henge & from Maldens Cove
Jerusalems Pillars fall in the rendings of fierce War
Over France & Germany: upon the Rhine & Danube
If I were Higgaion Wail they are in the conflict of Repining
Why trembles the Warriors limbs when he beholds thy beauty
Spotted with Victims blood: by the fires of thy secret tabernacle
And thy ark & holy place: at thy frowns: at thy dire revenge
Smitten as Uzzah of old: his armour is softend; his spear
And sword faint in his hand. from Albion across Great Tartary
O beautiful Daughter of Albion: cruelty is thy delight
O Virgin of terrible eyes, who dwellest by Valleys of springs
Beneath the Mountains of Lebanon, in the City of Rehob in Hamath
Taught to touch the harp: to dance in the Circle of Warriors
Before the Kings of Canaan: to cut the flesh from the Victim

[468]

o roast the flesh in fire: to examine the Infants limbs
n cruelties of holiness: to refuse the joys of love: to bring
he Spies from Egypt. to raise jealousy in the bosoms of the Twelve
ings of Canaan: then to let the Spies depart to Meribah Kadesh
o the place of the Amalekite; I am drunk with unsatiated love
 must rush again to War: for the Virgin has frownd & refusd
ometimes I curse & sometimes bless thy fascinating beauty
nce Man was occupied in intellectual pleasures & energies
ut now my soul is harrowd with grief & fear & love & desire
nd now I hate & now I love & Intellect is no more:
here is no time for any thing but the torments of love & desire
he Feminine & Masculine Shadows soft. mild & ever varying,
n beauty: are Shadows now no more, but Rocks in Horeb

### 69

hen all the Males combined into One Male & every one
ecame a ravening eating Cancer growing in the Female
 Polypus of Roots of Reasoning Doubt Despair & Death.
oing forth & returning from Albions Rocks to Canaan:
evouring Jerusalem from every Nation of the Earth.

nvying stood the enormous Form at variance with Itself
n all its Members: in eternal torment of love & jealousy:
rivn forth by Los time after time from Albions cliffy shore,
rawing the free loves of Jerusalem into infernal bondage;
hat they might be born in contentions of Chastity & in
eadly Hate between Leah & Rachel, Daughters of Deceit & Fraud:
earing the Images of various Species of Contention
nd Jealousy & Abhorrence & Revenge & deadly Murder,
ill they refuse liberty to the male; & not like Beulah
here every Female delights to give her maiden to her husband
he Female searches sea & land for gratification to the
ale Genius: who in return clothes her in gems & gold
nd feeds her with the food of Eden, hence all her beauty beams
he Creates at her will a little moony night & silence
Vith Spaces of sweet gardens & a tent of elegant beauty:
losed in by a sandy desart & a night of stars shining.
nd a little tender moon & hovering angels on the wing.
nd the Male gives a Time & Revolution to her Space
ill the time of love is passed in every varying delights
or All Things Exist in the Human Imagination
nd thence in Beulah they are stolen by secret amorous theft,
ill they have had Punishment enough to make them commit Crimes
ence rose the Tabernacle in the Wilderness & all its Offerings.
rom Male & Female Loves in Beulah & their Jealousies
ut no one can consummate Female bliss in Loss World without
ecoming a Generated Mortal, a Vegetating Death

nd now the Spectres of the Dead awake in Beulah; all
he Jealousies become Murderous: uniting together in Rahab
 Religion of Chastity, forming a Commerce to sell Loves
Vith Moral Law, an Equal Balance, not going down with decision
hese are the Male coercts & cruel filld with stern Revenge:
Mutual Hate returns & mutual Deceit & mutual Fear.

Hence the Infernal Veil grows in the disobedient Female:
Which Jesus rends & the whole Druid Law removes away
rom the Inner Sanctuary: a False Holiness hid within the Center,
or the Sanctuary of Eden. is in the Camp in the Outline.
n the Circumference: & every Minute Particular is Holy:
mbraces are Cominglings: from the Head even to the Feet:
nd not a pompous High Priest entering by a Secret Place.

erusalem pined in her inmost soul over Wandering Reuben
s she slept in Beulahs Night hid by the Daughters of Beulah

### 70

nd this the form of mighty Hand sitting on Albions cliffs
efore the face of Albion, a mighty threatning Form.

His bosom wide & shoulders huge overspreading wondrous
ear Three strong sinewy Necks & Three awful & terrible Heads
hree Brains in contradictory council brooding incessantly.
either daring to put in act its councils, fearing each-other.
herefore rejecting Ideas as nothing & holding all Wisdom
o consist. in the agreements & disagreents of Ideas.
lotting to devour Albions Body of Humanity & Love.

uch Form the aggregate of the Twelve Sons of Albion took; & such
heir appearance when combind: but often by birth-pangs & loud groans
hey divide to Twelve: the key-bones & the chest dividing in pain
isclose a hideous orifice; thence issuing the Giant-brood

Arise as the smoke of the furnace, shaking the rocks from sea to sea.
And there they combine into Three Forms, namd Bacon & Newton & Locke,
In the Oak Groves of Albion which overspread all the Earth.

Imputing Sin & Righteousness to Individuals; Rahab
Sat deep within him hid: his Feminine Power unreveal'd
Brooding Abstract Philosophy. to destroy Imagination, the Divine-
-Humanity A Three-fold Wonder: feminine: most beautiful: Three-fold
Each within other. On her white marble & even Neck, her Heart
Inorb'd and bonified: with locks of shadowing modesty, shining
Over her beautiful Female features. soft flourishing in beauty
Beams mild, all love and all perfection, that when the lips
Recieve a kiss from Gods or Men, a threefold kiss returns
From the pressd loveliness: so her whole immortal form three-fold
Three-fold embrace returns: consuming lives of Gods & Men
In fires of beauty melting them as gold & silver in the furnace
Her Brain enlabyrinths the whole heaven of her bosom & loins
To put in act what her Heart wills; O who can withstand her power
Her name is Vala in Eternity; in Time her name is Rahab

The Starry Heavens all were fled from the mighty limbs of Albion

<div align="right">His</div>

### 71

And above Albions Land was seen the Heavenly Canaan
As the Substance is to the Shadow: and above Albions Twelve Sons
Were seen Jerusalems Sons: and all the Twelve Tribes spreading
Over Albion. As the Soul is to the Body, so Jerusalems Sons,
Are to the Sons of Albion: and Jerusalem is Albions Emanation

What is Above is Within. for every thing in Eternity is translucent!
The Circumference is Within: Without, is formed the Selfish Center
And the Circumference still expands going forward to Eternity
And the Center has Eternal States! these States we now explore.

And these the Names of Albions Twelve Sons. & of his Twelve Daughters
With their Districts. Hand dwelt in Selsey & had Sussex & Surrey
And Kent & Middlesex: all their Rivers & their Hills. of flocks & herds:
Their Villages Towns Cities Sea-Ports Temples sublime Cathedrals;
All were his Friends & their Sons & Daughters intermarry in Beulah
For all are Men in Eternity. Rivers Mountains Cities Villages.
All are Human & when you enter into their Bosoms you walk
In Heavens & Earths; as in your own Bosom you bear your Heaven
And Earth, & all you behold, tho it appears Without it is Within
In your Imagination of which this World of Mortality is but a Shadow.

Hyle dwelt in Winchester comprehending Hants Dorset Devon Cornwall.
Their Villages Cities SeaPorts, their Corn fields & Gardens spacious
Palaces. Rivers & Mountains. and between Hand & Hyle arose
Gwendolen & Cambel who is Boadicea: they go abroad & return
Like lovely beams of light from the mingled affections of the Brothers
The Inhabitants of the whole Earth rejoice in their beautiful light.

Coban dwelt in Bath. Somerset Wiltshire Gloucestershire,
Obeyd his awful voice Ignoge is his lovely Emanation,
She blumui with Cwantokes Caliber a, and heath, and the unuul
Grounds fingers & and and South Wales & all its Mountains.

Peachey had North Wales Shropshire Cheshire & the Isle of Man.
His Emanation is Mehetabel terrible & lovely upon the Mountains

Brereton had Yorkshire Durham Westmoreland & his Emanation
Is Ragan, she adjoind to Slade, & produced Gonorill far beaming.

Slade had Lincoln Stafford Derby Nottingham & his lovely
Emanation Gonorill rejoices over hills & rocks & woods & rivers.

Hutton had Warwick Northampton Bedford Buckingham
Leicester & Berkshire: & his Emanation is Gwinefred beautiful

Skofeld had Ely Rutland Cambridge Huntingdon Norfolk
Suffolk Hartford & Essex: & his Emanation is Gwinevera
Beautiful, she beams towards the east. all kinds of precious stones
And pearl, with instruments of music in holy Jerusalem

Kox had Oxford Warwick Wilts: his Emanation is Estrild:
Joind with Cordella she shines southward over the Atlantic.

Kotope had Hereford Stafford Worcester, & his Emanation
Is Sabrina joind with Mehetabel she shines west over America

Bowen had all Scotland, the Isles, Northumberland & Cumberland
His Emanation is Conwenna, she shines a triple form
Over the north with pearly beams gorgeous & terrible
Jerusalem & Vala rejoice in Bowen & Conwenna.

But the Four Sons of Jerusalem that never were Generated

<div align="center">[469]</div>

Are Rintrah and Palamabron and Theotormon and Bromion. They
Dwell over the Four Provinces of Ireland in heavenly light
The Four Universities of Scotland, & in Oxford & Cambridge & Winchester

But now Albion is darkened & Jerusalem lies in ruins:
Above the Mountains of Albion. above the head of Los.

And Los shouted with ceaseless shoutings & his tears poured down
His immortal cheeks, rearing his hands to heaven for aid Divine!
But he spoke not to Albion: fearing lest Albion should turn his Back
Against the Divine Vision: & fall over the Precipice of Eternal Death.
But he receded before Albion & before Vala weaving the Veil
With the iron shuttle of War among the rooted Oaks of Albion;
Weeping & shouting to the Lord day & night; and his Children
Wept round him as a flock silent Seven Days of Eternity

### 72

And the Thirty-two Counties of the Four Provinces of Ireland
Are thus divided: The Four Counties are in the Four Camps
Munster South in Reubens Gate, Connaut West in Josephs Gate
Ulster North in Dans Gate, Leinster East in Judahs Gate

For Albion in Eternity has Sixteen Gates among his Pillars
But the Four towards the West were Walled up & the Twelve
That front the Four other Points were turned Four Square
By Los for Jerusalems sake & called the Gates of Jerusalem
Because Twelve Sons of Jerusalem fled successive thro the Gates
But the Four Sons of Jerusalem who fled not but remaind
Are Rintrah & Palamabron & Theotormon & Bromion
The Four that remain with Los to guard the Western Wall
And these Four remain to guard the Four Walls of Jerusalem
Whose foundations remain in the Thirty-two Counties of Ireland
And in Twelve Counties of Wales, & in the Forty Counties
Of England & in the Thirty-six Counties of Scotland

And the names of the Thirty-two Counties of Ireland are these
Under Judah & Issachar & Zebulun are Lowth Longford
Eastmeath Westmeath Dublin Kildare Kings County
Queens County Wicklow Catherloh Wexford Kilkenny
And those under Reuben & Simeon & Levi are these
Waterford Tipperary Cork Limerick Kerry Clare
And those under Ephraim Manasseh & Benjamin are these
Galway Roscommon Mayo Sligo Leitrim
And those under Dan Asher & Napthali are these
Donnegal Antrim Tyrone Fermanagh Armagh Londonderry
Down Managhan Cavan. These are the Land of Erin

All these Center in London & in Golgonooza. from whence
They are Created continually East & West & North & South
And from them are Created all the Nations of the Earth
Europe & Asia & Africa & America, in fury Fourfold!

And Thirty-two the Nations: to dwell in Jerusalems Gates
O Come ye Nations Come ye People Come up to Jerusalem
Return Jerusalem & dwell together as of old! Return
Return; O Albion let Jerusalem overspread all Nations
As in the times of old! O Albion awake! Reuben wanders
The Nations wait for Jerusalem. they look up for the Bride

France Spain Italy Germany Poland Russia Sweden Turkey
Arabia Palestine Persia Hindostan China Tartary Siberia
Egypt Lybia Ethiopia Guinea Caffraria Negroland Morocco
Congo Zaara Canada Greenland Carolina Mexico
Peru Patagonia Amazonia Brazil. Thirty-two Nations
And under these Thirty-two Classes of Islands in the Ocean
All the Nations Peoples & Tongues throughout all the Earth

And the Four Gates of Los surround the Universe Within and
Without; & whatever is visible in the Vegetable Earth. the same
Is visible in the Mundane Shell: reversd in mountain & vale
And a Son of Eden was set over each Daughter of Beulah to guard
In Albions Tomb the wondrous Creation: & the Four-fold Gate
Towards Beulah is to the South Fenelon, Guion, Teresa,
Whitefield & Hervey, guard that Gate; with all the gentle Souls
Who guide the great Wine-press of Love; Four precious stones that Gate:

### 73

Such are Cathedrons golden Halls: in the City of Golgonooza

And Los's Furnaces howl loud; living: self-moving: lamenting
With fury & despair. & they stretch from South to North
Thro all the Four Points: Lo! the Labourers at the Furnaces
Rintrah & Palamabron, Theotormon & Bromion. loud labring

With the innumerable multitudes of Golgonooza, round the Anvils
Of Death. But how they came forth from the Furnaces & how long
Vast & severe the anguish eer they knew their Father; were
Long to tell & of the iron rollers, golden axle-trees & yokes
Of brass, iron chains & braces & the gold. silver & brass
Mingled or separate: for swords; arrows; cannons; mortars
The terrible ball: the wedge: the loud sounding hammer of destruction
The sounding flail to thresh: the winnow: to winnow kingdoms
The water wheel & mill of many innumerable wheels resistless
Over the Fourfold Monarchy from Earth to the Mundane Shell.

Perusing Albions Tomb in the starry characters of Og & Anak:
To Create the lion & wolf the bear: the tyger & ounce:
To Create the wooly lamb & downy fowl & scaly serpent
The summer & winter: day & night: the sun & moon & stars
The tree: the plant: the flower: the rock: the stone: the metal:
Of Vegetative Nature: by their hard restricting condensations.

Where Luvahs World of Opakeness grew to a period: It
Became a Limit. a Rocky hardness without form & void
Accumulating without end: here Los   who is of the Elohim
Opens the Furnaces of affliction in the Emanation
Fixing The Sexual into an ever-prolific Generation
Naming the Limit of Opakeness Satan & the Limit of Contraction
Adam, who is Peleg & Joktan: & Esau & Jacob: & Saul & David

Voltaire insinuates that these Limits are the cruel work of God
Mocking the Remover of Limits & the Resurrection of the Dead
Setting up Kings in wrath: in holiness of Natural Religion
Which Los with his mighty Hammer demolishes time on time
In miracles & wonders in the Four-fold Desart of Albion
Permanently Creating to be in Time Reveald & Demolishd
Satan Cain Tubal Nimrod Pharoh Priam Bladud Belin
Arthur Alfred the Norman Conqueror Richard John

And all the Kings & Nobles of the Earth & all their Glories
These are Created by Rahab & Tirzah in Ulro: but around
These, to preserve them from Eternal Death Los Creates
Adam Noah Abraham Moses Samuel David Ezekiel

Dissipating the rocky forms of Death, by his thunderous Hammer
As the Pilgrim passes while the Country permanent remains
So Men pass on: but States remain permanent for ever

The Spectres of the Dead howl round the porches of Los
In the terrible Family feuds of Albions cities & villages
To devour the Body of Albion, hungring & thirsting & ravning
The Sons of Los clothe them & feed, & provide houses & gardens
And every Human Vegetated Form in its inward recesses
Is a house of pleantness & a garden of delight Built by the
Sons & Daughters of Los in Bowlahoola & in Cathedron

From London to York & Edinburgh the Furnaces rage terrible
Primrose Hill is the mouth of the Furnace & the Iron Door;

### 74

The Four Zoa's clouded rage; Urizen stood by Albion
With Rintrah and Palamabron and Theotormon and Bromion
These Four are Verulam & London & York & Edinburgh
And the Four Zoa's are Urizen & Luvah & Tharmas & Urthona
In opposition deadly, and their Wheels in poisonous
And deadly stupor turn'd against each other loud & fierce
Entering into the Reasoning Power, forsaking Imagination
They became Spectres; & their Human Bodies were reposed
In Beulah, by the Daughters of Beulah with tears & lamentations

The Spectre is the Reasoning Power in Man; & when separated
From Imagination. and closing itself as in steel, in a Ratio
Of the Things of Memory. It thence frames Laws & Moralities
To destroy Imagination! the Divine Body, by Martyrdoms & Wars

Teach me O Holy Spirit the Testimony of Jesus let me
Comprehend wondrous things out of the Divine Law
I behold Babylon in the opening Streets of London, I behold
Jerusalem in ruins wandering about from house to house
This I behold the shudderings of death attend my steps
I walk up and down in Six Thousand Years. their Events are present before me
To tell how Los in grief & anger, whirling round his Hammer on high

Drave the Sons & Daughters of Albion from their ancient mountains
They became the Twelve Gods of Asia Opposing the Divine Vision

The Sons of Albion are Twelve: the Sons of Jerusalem Sixteen
I tell how Albions Sons by Harmonies of Concords & Discords
Opposed to Melody, and by Lights & Shades, opposed to Outline

And by Abstraction opposed to the Visions of Imagination
By cruel Laws divided Sixteen into Twelve Divisions
How Hyle roofd Los in Albions Cliffs by the Affections rent
Asunder & opposed to Thought, to draw Jerusalems Sons
Into the Vortex of his Wheels. therefore Hyle is called Gog
Age after age drawing them away towards Babylon
Babylon, the Rational Morality deluding to death the little ones
In strong temptations of stolen beauty; I tell how Reuben slept
On London Stone & the Daughters of Albion ran around admiring
His awful beauty: with Moral Virtue the fair deceiver; offspring
Of Good & Evil, they divided him in love upon the Thames & sent
Him over Europe in streams of gore out of Cathedrons Looms
How Los drave them from Albion & they became Daughters of Canaan
Hence Albion was calld the Canaanite & all his Giant Sons.
Hence is my Theme. O Lord my Saviour open thou the Gates
And I will lead forth thy Words, telling how the Daughters
Cut the Fibres of Reuben, how he rolld apart & took Root
In Bashan. terror-struck Albions Sons look toward Bashan
They have divided Simeon he also rolld apart in blood
Over the Nations till he took Root beneath the shining Looms
Of Albions Daughters in Philistea by the side of Amalek
They have divided Levi: he hath shot out into Forty eight Roots
Over the Land of Canaan: they have divided Judah
He hath took Root in Hebron, in the Land of Hand & Hyle
Dan: Napthali: Gad: Asher: Issachar: Zebulun: roll apart
From all the Nations of the Earth to dissipate into Non Entity

I see a Feminine Form arise from the Four terrible Zoas
Beautiful but terrible struggling to take a form of beauty
Rooted in Shechem this is Dinah, the youthful form of Erin
The Wound I see in South Molton Steet & Stratford place
Whence Joseph & Benjamin rolld apart away from the Nations
In vain they rolld apart; they are fixd into the Land of Cabul

### 75

And Rahab Babylon the Great hath destroyed Jerusalem
Bath stood upon the Severn with Merlin & Bladud & Arthur
The Cup of Rahab in his hand: her Poisons Twenty-seven-fold

And all her Twenty-seven Heavens now hid & now reveal'd
Appear in strong delusive light of Time & Space drawn out
In shadowy pomp by the Eternal Prophet created evermore
For Los in Six Thousand Years walks up & down continually
That not one Moment of Time be lost & every revolution
Of Space he makes permanent in Bowlahoola & Cathedron.

And these the names of the Twenty-seven Heavens & their Churches
Adam, Seth, Enos, Cainan, Mahalaleel, Jared, Enoch,
Methuselah, Lamech; these are the Giants mighty, Hermaphroditic
Noah, Shem, Arphaxad, Cainan the Second, Salah, Heber,
Peleg, Reu, Serug, Nahor, Terah: these are the Female Males:
A Male within a Female hid as in an Ark & Curtains.
Abraham, Moses, Solomon, Paul, Constantine, Charlemaine,
Luther: these Seven are the Male Females: the Dragon Forms
The Female hid within a Male: thus Rahab is reveald
Mystery Babylon the Great: the Abomination of Desolation
Religion hid in War: a Dragon red, & hidden Harlot
But Jesus breaking thro the Central Zones of Death & Hell
Opens Eternity in Time & Space; triumphant in Mercy

Thus are the Heavens formd by Los within the Mundane Shell
And where Luther ends Adam begins again in Eternal Circle
To awake the Prisoners of Death; to bring Albion again
With Luvah into light eternal. in his eternal day.

But now the Starry Heavens are fled from the mighty limbs of Albion

### 77

#### To the Christians.

Devils are
the Religions
"Saul Saul"
Why persecutest thou me,

I give you the end of a golden string,
Only wind it into a ball:
It will lead you in at Heavens gate,
Built in Jerusalems wall.

We are told to abstain from fleshly desires that we may lose no time from the
work of the Lord. Every moment lost, is a moment that cannot be redeemed every
pleasure that intermingles with the duty of our station is a folly unredeemable &
is planted like the seed of a wild flower among our wheat. All the tortures of
repentance. are tortures of self-reproach on account of our leaving the Divine
Harvest to the Enemy, the struggles of intanglement with incoherent roots. I

know of no other Christianity and of no other Gospel than the liberty both of body
& mind to exercise the Divine Arts of Imagination Imagination the real & eternal
World of which this Vegetable Universe is but a faint shadow & in which we shall
live in our Eternal or Imaginative Bodies, when these Vegetable Mortal Bodies are
no more. The Apostles knew of no other Gospel. What were all their spiritual
gifts? What is the Divine Spirit? is the Holy Ghost any other than an Intellectual
Fountain? What is the Harvest of the Gospel & its Labours? What is that Talent
which it is a curse to hide? What are the Treasures of Heaven which we are to lay
up for ourselves, are they any other than Mental Studies & Performances? What are
all the Gifts of the Gospel, are they not all Mental Gifts? Is God a Spirit who must
be worshipped in Spirit & in Truth and are not the Gifts of the Spirit Every-thing
to Man? O ye Religious discountenance every one among you who shall pretend
to despise Art & Science! I call upon you in the Name of Jesus! What is the Life
of Man but Art & Science? is it Meat & Drink? is not the Body more than Raiment?
What is Mortality but the things relating to the Body, which Dies? What is Im-
mortality but the things relating to the Spirit, which Lives Eternally! What is the
Joy of Heaven but Improvement in the things of the Spirit? What are the Pains of
Hell but Ignorance, Bodily Lust, Idleness & devastation of the things of the Spirit
Answer this to yourselves, & expel from among you those who pretend to despise
the labours of Art & Science, which alone are the labours of the Gospel: Is not this
plain & manifest to the thought? Can you think at all & not pronounce heartily!
That to Labour in Knowledge. is to Build up Jerusalem: and to Despise Know-
ledge, is to Despise Jerusalem & her Builders.      And remember: He who despises
& mocks a Mental Gift in another; calling it pride & selfishness & sin: mocks
Jesus the giver of every Mental Gift, which always appear to the ignorance-loving
Hypocrite, as Sins. but that which is a Sin in the sight of cruel Man, is not so in
the sight of our kind God. Let every Christian as much as in him lies engage him-
self openly & publicly before all the World in some Mental pursuit for the Building
up of Jerusalem

I stood among my valleys of the south
And saw a flame of fire, even as a Wheel
Of fire surrounding all the heavens: it went
From west to east against the current of
Creation and devourd all things in its loud
Fury & thundering course round heaven & earth
By it the Sun was rolld into an orb:
By it the Moon faded into a globe.
Travelling thro the night: for from its dire
And restless fury, Man himself shrunk up
Into a little root a fathom long.
And I asked a Watcher & a Holy-One
Its Name? he answerd. It is the Wheel of Religion
I wept & said. Is this the law of Jesus
This terrible devouring sword turning every way
He answered; Jesus died because he strove
Against the current of this Wheel: its Name
Is Caiaphas, the dark Preacher of Death

Of sin, of sorrow, & of punishment;
Opposing Nature! It is Natural Religion
But Jesus is the bright Preacher of Life
Creating Nature from this fiery Law,
By self-denial & forgiveness of Sin:
Go therefore, cast out devils in Christs name
Heal thou the sick of spiritual disease
Pity the evil. for thou art not sent
To smite with terror & with punishments
Those that are sick. like the Pharisees
Crucifying & encompassing sea & land
For proselytes to tyranny & wrath.
But to the Publicans & Harlots go!
Teach them True Happiness. but let no curse
Go forth out of thy mouth to blight their peace
For Hell is opend to Heaven; thine eyes beheld
The dungeons burst & the Prisoners set free.

England! awake! awake! awake!
Jerusalem thy Sister calls!
Why wilt thou sleep the sleep of death?
And close her from thy ancient walls.

Thy hills & valleys felt her feet,
Gently upon their bosoms move:
Thy gates beheld sweet Zions ways;
Then was a time of joy and love.

And now the time returns again:
Our souls exult & Londons towers
Receive the Lamb of God to dwell
In Englands green & pleasant bowers

### 78

#### Jerusalem C. 4

The Spectres of Albions Twelve Sons revolve mightily
Over the Tomb & over the Body: ravning to devour
The Sleeping Humanity. Los with his mace of iron
Walks round: loud his threats, loud his blows fall
On the rocky Spectres, as the Potter breaks the potsherds;
Dashing in pieces Self-righteousnesses: driving them from Albions
Cliffs: dividing them into Male & Female forms in his Furnaces
And on his Anvils: lest they destroy the Feminine Affections
They are broken. Loud howl the Spectres in his iron Furnace

While Los laments at his dire labours, viewing Jerusalem,
Sitting before his Furnaces clothed in sackcloth of hair;
Albions Twelve Sons surround the Forty-two Gates of Erin.
In terrible armour, raging against the Lamb & against Jerusalem,
Surrounding them with armies to destroy the Lamb of God.
They took their Mother Vala, and they crown'd her with gold:
They namd her Rahab, & gave her power over the Earth
The Concave Earth round Golgonooza in Entuthon Benython,
Even to the stars exalting her Throne, to build beyond the Throne
Of God and the Lamb, to destroy the Lamb & usurp the Throne of God
Drawing their Ulro Voidness round the Four-fold Humanity

Naked Jerusalem lay before the Gates upon Mount Zion
The Hill of Giants, all her foundations levelld with the dust:

Her Twelve Gates thrown down: her children carried into captivity
Herself in chains: this from within was seen in a dismal night
Outside, unknown before in Beulah. & the twelve gates were fill'd
With blood; from Japan eastward to the Giants causway, west
In Erins Continent: and Jerusalem wept upon Euphrates banks
Disorganizd; an evanescent shade, scarce seen or heard among
Her childrens Druid Temples dropping with blood wanderd weeping!
And thus her voice went forth in the darkness of Philisthea.

My brother & my father are no more! God hath forsaken me
The arrows of the Almighty pour upon me & my children
I have sinned and am an outcast from the Divine Presence!

### 79

My tents are fall'n! my pillars are in ruins! my children dashd
Upon Egypts iron floors, & the marble pavements of Assyria;
I melt my soul in reasonings among the towers of Heshbon;
Mount Zion is become a cruel rock & no more dew
Nor rain: no more the spring of the rock appears: but cold
Hard & obdurate are the furrows of the mountain of wine & oil:
The mountain of blessing is itself a curse & an astonishment;
The hills of Judea are fallen with me into the deepest hell
Away from the Nations of the Earth, & from the Cities of the Nations;
I walk to Ephraim. I seek for Shiloh: I walk like a lost sheep
Among precipices of despair: in Goshen I seek for light
In vain: and in Gilead for a physician and a comforter.
Goshen hath followd Philistea: Gilead hath joind with Og!
They are become narrow places in a little and dark land:
How distant far from Albion! his hills & his valleys no more
Recieve the feet of Jerusalem: they have cast me quite away:
And Albion is himself shrunk to a narrow rock in the midst of the sea!
The plains of Sussex & Surrey. their hills of flocks & herds
No more seek to Jerusalem nor to the sound of my Holy-ones.
The Fifty-two Counties of England are hardend against me
As if I was not their Mother, they despise me & cast me out
London coverd the whole Earth. England encompassd the Nations:
And all the Nations of the Earth were seen in the Cities of Albion:
My pillars reachd from sea to sea: London beheld me come
From my east & from my west; he blessed me and gave
His children to my breasts. his sons & daughters to my knees
His aged parents sought me out in every city & village:
They discern my countenance with joy. they shewd me to their sons
Saying Lo Jerusalem is here! she sitteth in our secret chambers
Levi and Judah & Issachar: Ephram, Manasseh, Gad and Dan
Are seen in our hills & valleys: they keep our flocks & herds:
They watch them in the night: and the Lamb of God appears among us.
The river Severn stayd his course at my command:
Thames poured his waters into my basons and baths:
Medway mingled with Kishon: Thames recievd the heavenly Jordan
Albion gave me to the whole Earth to walk up & down; to pour
Joy upon every mountain; to teach songs to the shepherd & plowman
I taught the ships of the sea to sing the songs of Zion.
Italy saw me, in sublime astonishment: France was wholly mine:
As my garden & as my secret bath; Spain was my heavenly couch:
I slept in his golden hills: the Lamb of God met me there.
There we walked as in our secret chamber among our little ones
They looked upon our loves with joy: they beheld our secret joys:
With holy raptures of adoration rapd sublime in the Visions of God:
Germany; Poland & the North wooed my footsteps they found
My gates in all their mountains & my curtains in all their vales
The furniture of their houses was the furniture of my chamber
Turkey & Grecia saw my instrments of music, they arose
They siezd the harp: the flute: the mellow horn of Jerusalems joy
They sounded thanksgivings in my courts: Egypt & Lybia heard
The swarthy sons of Ethiopia stood round the Lamb of God
Enquiring for Jerusalem: he led them up my steps to my altar:
And thou America! I once beheld thee but now behold no more
Thy golden mountains where my Cherubim & Seraphim rejoicd
Together among my little-ones. But now, my Altars run with blood!
My fires are corrupt! my incense is a cloudy pestilence
Of seven diseases! Once a continual cloud of salvation. rose
From all my myriads, once the Four fold World rejoied among
The pillars of Jerusalem, between my winged Cherubim:
But now I am closd out from them in the narrow passages
Of the valleys of destruction. into a dark land of pitch & bitumen.
From Albions Tomb afar and from the four-fold wonders of God
Shrunk to a narrow doleful form in the dark land of Cabul;

There is Reuben & Gad & Joseph & Judah & Levi, closd up
In narrow vales: I walk & count the bones of my beloveds
Along the Valley of Destruction, among these Druid Temples
Which overspread all the Earth in patriarchal pomp & cruel pride
Tell me O Vala thy purposes; tell me wherefore thy shuttles
Drop with the gore of the slain; why Euphrates is red with blood
Wherefore in dreadful majesty & beauty outside appears
Thy Masculine from thy Feminine hardening against the heavens
To devour the Human! Why dost thou weep upon the wind among
These cruel Druid Temples: O Vala! Humanity is far above
Sexual organization; & the Visions of the Night of Beulah
Where Sexes wander in dreams of bliss among the Emanations
Where the Masculine & Feminine are nurs'd into Youth & Maiden
By the tears & smiles of Beulahs Daughters till the time of Sleep is past.
Wherefore then do you realize these nets of beauty & delusion
In open day to draw the souls of the Dead into the light.
Till Albion is shut out from every Nation under Heaven.

En

### 80

Encompassd by the frozen Net and by the rooted Tree
I walk weeping in pangs of a Mothers torment for her Children:
I walk in affliction: I am a worm, and no living soul!
A worm going to eternal torment! raisd up in a night
To an eternal night of pain. lost! lost! lost! for ever!
Beside her Vala howld upon the winds in pride of beauty
Lamenting among the timbrels of the Warriors: among the Captives
In cruel holiness, and her lamenting songs were from Arnon
And Jordan to Euphrates. Jerusalem followd trembling
Her children in captivity. listening to Valas lamentation
In the thick cloud & darkness. & the voice went forth from
The cloud. O rent in sunder from Jerusalem the Harlot daughter!
In an eternal condemnation in fierce burning flames
Of torment unendurable: and if once a Delusion be found
  Woman must perish & the Heavens of Heavens remain no more

My Father gave to me command to murder Albion
In unreviving Death; my Love, my Luvah orderd me in night
To murder Albion the King of Men. he fought in battles fierce
He conquerd Luvah my beloved: he took me and my Father
He slew them: I revived them to life in my warm bosom
He saw them issue from my bosom in Jealousy
He burnd before me: Luvah framd the Knife & Luvah gave
The Knife into his daughters hand! such thing was never known
Before in Albions land. that one should die a death never to be reviv'd:
For in our battles we the Slain men view with pity and love:
We soon revive them in the secret of our tabernacles
But I Vala, Luvahs daughter, keep his body embalmd in moral laws
With spices of sweet odours of lovely jealous stupefaction:
Within my bosom. lest he arise to life & slay my Luvah
Pity me then O Lamb of God! O Jesus pity me!
Come into Luvahs Tents, and seek not to revive the Dead!

So sang she: and the Spindle turnd furious as she sang:
The Children of Jerusalem the Souls of those who sleep
Were caught into the flax of her Distaff: & in her Cloud
To weave Jerusalem a body according to her will
A Dragon form on Zion Hills most ancient promontory

The Spindle turnd in blood & fire: loud sound the trumpets
Of war: the cymbals play loud before the Captains
With Cambel & Gwendolen in dance and solemn song
The Cloud of Rahab vibrating with the Daughters of Albion
Los saw terrified melted with pity & divided in wrath
He sent them over the narrow seas in pity and love
Among the Four Forests of Albion which overspread all the Earth
They go forth & return swift as a flash of lightning.
Among the tribes of warriors: among the Stones of power!
Against Jerusalem they rage thro all the Nations of Europe
Thro Italy & Grecia. to Lebanon & Persia & India.

The Serpent Temples thro the Earth, from the wide Plain of Salisbury
Reach to the farthest of Victory, to Great O____e Phili 88
And flames of dusky fire. to Amalek. Canaan and Moab
And Rahab like a dismal and indefinite hovering Cloud
Refusd to take a definite form, she hoverd over all the Earth
Calling the definite. sin: defacing every definite form;
Invisible, or Visible. stretch'd out in length or spread in breadth:
Over the Temples drinking groans of victims weeping in pity,
And joying in the pity, howling over Jerusalems walls.

Hand slept on Skiddaws top: drawn by the love of beautiful
Cambel: his bright beaming Counterpart, divided from him

d her delusive light beamd fierce above the Mountain,
ft: invisible: drinking his sighs in sweet intoxication:
rawing out fibre by fibre; returning to Albions Tree
 night; and in the morning to Skiddaw: she sent him over
ountainous Wales into the Loom of Cathedron fibre by fibre.
e ran in tender nerves across Europe to Jerusalems Shade;
o weave Jerusalem a Body repugnant to the Lamb.

yle on East Moor in rocky Derbyshire, rav'd to the Moon
r Gwendolen: she took up in bitter tears his anguishd heart,
at apparent to all in Eternity. glows like the Sun in the breast:
e hid it in his ribs & back: she hid his tongue with teeth
 terrible convulsions pitying & gratified drunk with pity
owing with loveliness before him. becoming apparent
ccording to his changes: she roll'd his kidneys round
to two irregular forms: and looking on Albions dread Tree,
e wove two vessels of seed, beautiful as Skiddaws snow;
ving them bends of self interest & selfish natural virtue:
e hid them in his loins; raving he ran among the rocks.
ompelld into a shape of Moral Virtue against the Lamb.
he invisible lovely one giving him a form according to
is Law a form against the Lamb of God opposd to Mercy
nd playing in the thunderous Loom in sweet intoxication
lling cups of silver & crystal with shrieks & cries. with groans
d dolorous sobs: the wine of lovers in the Wine-press of Luvah

sister Cambel said Gwendolen, as their long beaming light
ingled above the Mountain what shall we do to keep
hese awful forms in our soft bands: distracted with trembling

### 81

have mockd those who refused cruelty & I have admired
he cruel Warrior. I have refused to give love to Merlin the piteous.
e brings to me the Images of his Love & I reject in chastity
nd turn them out into the streets for Harlots to be food
o the stern Warrior. I am become perfect in beauty over my Warrior
or Men are caught by Love: Woman is caught by Pride
hat Love may only be obtaind in the passages of Death.
et us look! let us examine! is the Cruel become an Infant
r is he still a cruel Warrior? look Sisters. look! O piteous
have destroyd Wandring Reuben who strove to bind my Will
have stripd off Josephs beautiful integument for my Beloved.
he Cruel-one of Albion: to clothe him in gems of my Zone
have named him Jehovah of Hosts. Humanity is become
 weeping Infant in ruind lovely Jerusalems folding Cloud.

n Heaven Love begets Love! but Fear is the Parent of Earthly Love!
and he who will not bend to Love must be subdud by Fear,

### 82

have heard Jerusalems groans; from Valas cries & lamentations
gather our eternal fire. Outcasts from life and love:
nless we find a way to bind these awful Forms to our
mbrace we shall perish annihilate, discoverd our Delusions.
ook I have wrought without delusion: Lo! I have wept
nd given soft milk mingled together with the spirits of flocks
f infants and men, mingled together in cups and dishes
f painted clay; the mighty Hyle is become a weeping infant;
oon shall the Spectres of the Dead follow my weaving threads.

he Twelve Daughters of Albion attentive listen in secret shades
n Cambridge and Oxford beaming soft uniting with Rahabs cloud
While Gwendolen spoke to Cambel turning soft the spinning reel:
r throwing the wingd shuttle; or drawing the cords with softest songs
he golden cords of the Looms animate beneath their touches soft,
long the Island white. among the Druid Temples, while Gwendolen
poke to the Daughters of Albion standing on Skiddaws top.

o saying she took a Falshood & hid it in her left hand:
o entice her Sisters away to Babylon on Euphrates.
nd thus she closed her left hand and utterd her Falshood:
orgetting that Falshood is prophetic, she hid her hand behind her,
pon her back behind her loins & thus utterd her Deceit

heard Enitharmon say to Los! Let the Daughters of Albion
e scatterd abroad and let the name of Albion be forgotten:
ivide them into three; name them Amalek Canaan & Moab:
et Albion remain a desolation without an inhabitant;
nd let the Looms of Enitharmon & the Furnaces of Los
reate Jerusalem. & Babylon & Egypt & Moab & Amalek.
nd Helle & Hesperia & Hindostan & China & Japan.
ut hide America, for a Curse an Altar of Victims & a Holy Place.

See Sisters Canaan is pleasant, Egypt is as the Garden of Eden:
Babylon is our chief desire. Moab our bath in summer:
Let us lead the stems of this Tree let us plant it before Jerusalem
To judge the Friend of Sinners to death without the Veil:
To cut her off from America. to close up her secret Ark:
And the fury of Man exhaust in War! Woman permanent remain
See how the fires of our loins point eastward to Babylon
Look. Hyle is become an infant Love: look behold! see him lie!
Upon my bosom. look! here is the lovely wayward form
That gave me sweet delight by his torments beneath my Veil;
By the fruit of Albions Tree I have fed him with sweet milk
By contentions of the mighty for Sacrifice of Captives:
Humanity the Great Delusion: is changd to War & Sacrifice;
I have naild his hands on Beth Rabbim & his hands on Heshbons Wall:
O that I could live in his sight: O that I could bind him to my arm.
So saying: She drew aside her Veil from Mam-Tor to Dovedale
Discovering her own perfect beauty to the Daughters of Albion
And Hyle a winding Worm beneath
                    & not a weeping Infant.
Trembling & pitying she screamd & fled upon the wind:
Hyle was a winding Worm and herself perfect in beauty;
The desarts tremble at his wrath: they shrink themselves in fear.

Cambel trembled with jealousy: she trembled! she envied!
The envy ran thro Cathedrons Looms into the Heart
Of mild Jerusalem. to destroy the Lamb of God. Jerusalem
Languishd upon Mount Olivet. East of mild Zions Hill.

Los saw the envious blight above his Seventh Furnace
On Londons Tower on the Thames: he drew Cambel in wrath,
Into his thundering Bellows, heaving it for a loud blast!
And with the blast of his Furnace upon fishy Billingsgate.
Beneath Albions fatal Tree. before the Gate of Los:
Shewd her the fibres of her beloved to ameliorate
The envy; loud she labourd in the Furnace of fire,
To form the mighty form of Hand according to her will.
In the Furnaces of Los & in the Wine-press treading day & night
Naked among the human clusters: bringing wine of anguish
To feed the afflicted in the Furnaces: she minded not
The raging flames, tho she returnd
                    instead of beauty
Deformity: she gave her beauty to another: bearing abroad
Her struggling torment in her iron arms: and like a chain.
Binding his wrists & ankles with the iron arms of love.

Gwendolen saw the Infant in her sistes arms; she howld
Over the forests with bitter tears, and over the winding Worm
Repentant: and she also in the eddying wind of Los's Bellows
Began her dolorous task of love in the Wine-press of Luvah
To form the Worm into a form of love by tears & pain.
The Sisters saw! trembling ran thro their Looms! softenig mild
Towards London: then they saw the Furnaes opend, & in tears
Began to give their souls away in the Furnaes of affliction.

Los saw & was comforted at his Furnaces uttering thus his voice
I know I am Urthona keeper of the Gates of Heaven,
And that I can at will expatiate in the Gardens of bliss:
But pangs of love draw me down to my loins which are
Become a fountain of veiny pipes: O Albion! my brother!

### 83

Corruptibility appears upon thy limbs. and never more
Can I arise and leave thy side, but labour here incessant
Till thy awaking! yet alas I shall forget Eternity!
Against the Patriarchal pomp and cruelty, labouring incessant
I shall become an Infant horror. Enion! Tharmas! friends
Absorb me not in such dire grief: O Albion. my brother!
Jerusalem hungers in the desart: affection to her children!
The scorn'd and contemnd youthful girl, where shall she fly?
Sussex shuts up her Villages. Hants, Devon & Wilts
Surrounded with masses of stone in ordered forms. determine then
A form for Vala and a form for Luvah. here on the Thames
Where the Victim nightly howls beneath the Druids knife:
A Form of Vegetation, nail them down on the stems of Mystery:
O when shall the Saxon return with the English his redeemed brother!
O when shall the Lamb of God descend among the Reprobate!
I woo to Amalek to protect my fugitives Amalek trembles:
I call to Canaan & Moab in my night watches, they mourn:
They listen not to my cry, they rejoice among their warriors
Woden and Thor and Friga wholly consume my Saxons
On their enormous Altars built in the terrible north:

From Irelands rocks to Scandinavia Persia and Tartary:
From the Atlantic Sea to the universal Erythrean.
Found ye London! enormous City! weeps thy River?
Upon his parent bosom lay thy little ones O Land
Forsaken. Surrey and Sussex are Enitharmons Chamber.
Where I will build her a Couch of repose & my pillars
Shall surround her in beautiful labyrinths: Oothoon!
Where hides my child? in Oxford hidest thou with Antamon?
In graceful hidings of error: in merciful deceit
Lest Hand the terrible destroy his Affection. thou hidest her:
In chaste appearances for sweet deceits of love & modesty
Immingled, interwoven, glistening to the sickening sight.
Let Cambel and her Sisters sit within the Mundane Shell:
Forming the fluctuating Globe according to their will.
According as they weave the little embryon nerves & veins
The Eye, the little Nostrils, & the delicate Tongue & Ears
Of labyrinthine intricacy: so shall they fold the World
That whatever is seen upon the Mundane Shell, the same
Be seen upon the Fluctuating Earth woven by the Sisters.
And sometimes the Earth shall roll in the Abyss & sometimes
Stand in the Center & sometimes stretch flat in the Expanse.
According to the will of the lovely Daughters of Albion.
Sometimes it shall assimilate with mighty Golgonooza:
Touching its summits: & sometimes divided roll apart.
As a beautiful Veil so these Females shall fold & unfold
According to their will the outside surface of the Earth
An outside shadowy Surface superadded to the real Surface;
Which is unchangeable for ever & ever Amen: so be it!
Separate Albions Sons gently from their Emanations
Weaving bowers of delight on the current of infant Thames
Where the old Parent still retains his youth as I alas!
Retain my youth eight thousand and five hundred years.
The labourer of ages in the Valleys of Despair;
The land is markd for desolation & unless we plant
The seeds of Cities & of Villages in the Human bosom
Albion must be a rock of blood: mark ye the points
Where Cities shall remain & where Villages for the rest!
It must lie in confusion till Albions time of awaking.
Place the Tribes of Llewellyn in America for a hiding place!
Till sweet Jerusalem emanates again into Eternity
The night falls thick: I go upon my watch: be attentive:
The Sons of Albion go forth; I follow from my Furnaces:
That they return no more: that a place be prepard on Euphrates
Listen to your Watchmans voice: sleep not before the Furnaces
Eternal Death stands at the door. O God pity our labours.

So Los spoke. to the Daughters of Beulah while his Emanation
Like a faint rainbow waved before him in the awful gloom
Of London City on the Thames from Surrey Hills to Highgate:
Swift turn the silver spindles, & the golden weights play soft
And lulling harmonies beneath the Looms, from Caithness in the north
To Lizard-point & Devon in the south: his Emanation
Joy'd in the many weaving threads in bright Cathedrons Dome
Weaving the Web of life for Jerusalem. the Web of life
Down flowing into Entuthons Vales glistens with soft affections.

While Los arose upon his Watch. and down from Golgonooza
Putting on his golden sandals to walk from mountain to mountain,
He takes his way, girding himself with gold & in his hand
Holding his iron mace: The Spectre remains attentive
Alternate they watch on night: alternate labour in day
Before the Furnaces labouring. while Los all night watches
The stars rising & setting, & the meteors & terrors of night.
With him went down the Dogs of Leutha at his feet
They lap the water of the trembling Thames then follow swift
And thus he heard the voice of Albions daughters on Euphrates.
Our Father Albions land: O it was a lovely land! & the Daughters of Beulah
Walked up and down in its green mountains: but Hand is fled
Away: & mighty Hyle: & after them Jerusalem is gone, Awake

84

Highgates heights & Hampsteads, to Poplar Hackney & Bow:
To Islington & Paddington & the Brook of Albions River
We builded Jerusalem as a City & a Temple; from Lambeth
We began our Foundations; lovely Lambeth! O lovely Hills
Of Camberwell, we shall behold you no more in glory & pride
For Jerusalem lies in ruins & the Furnaces of Los are builded there
You are now shrunk up to a narrow Rock in the midst of the Sea
But here we build Babylon on Euphrates. compelld to build
And to inhabit. our Little-ones to clothe in armour of the gold

Of Jerusalems Cherubims & to forge them swords of her Altars
I see London blind & age-bent begging thro the Streets
Of Babylon, led by a child. his tears run down his beard
The voice of Wandering Reuben ecchoes from street to street
In all the Cities of the Nations Paris Madrid Amsterdam
The Corner of Broad Street weeps; Poland Street languishes
To Great Queen Street & Lincolns Inn all is distress & woe.

The night falls thick Hand comes from Albion in his strength
He combines into a Mighty-one the Double Molech & Chemosh
Marching thro Egypt in his fury the East is pale at his course
The Nations of India, the Wild Tartar that never knew Man
Starts from his lofty places & casts down his tents & flees away
But we woo him all the night in songs, O Los come forth O Los
Divide us from these terrors & give us power them to subdue
Arise upon thy Watches let us see thy Globe of fire
On Albions Rocks & let thy voice be heard upon Euphrates.

Thus sang the Daughters in lamentation, uniting into One
With Rahab as she turned the iron Spindle of destruction.
Terrified at the Sons of Albion they took the Falshood which
Gwendolen hid in her left hand. it grew &, grew till it

85

Became a Space & an Allegory around the Winding Worm
They namd it Canaan & built for it a tender Moon
Los smild with joy thinking on Enitharmon & he brought
Reuben from his twelvefold wandrings & led him into it
Planting the Seeds of the Twelve Tribes & Moses & David
And gave a Time & Revolution to the Space Six Thousand Years

He calld it Divine Analogy, for in Beulah the Feminine
Emanations Create Space, the Masculine Create Time, & plant
The Seeds of beauty in the Space listning to their lamentation
Los walks upon his ancient Mountains in the deadly darkness
Among his Furnaces directing his laborious Myriads watchful
Looking to the East: & his voice is heard over the whole Earth
As he watches the Furnaces by night, & directs the labourers

And thus Los replies upon his Watch: the Valleys listen silent:
The Stars stand still to hear: Jerusalem & Vala cease to mourn:
His voice is heard from Albion: the Alps & Appenines
Listen: Hermon & Lebanon bow their crowned heads
Babel & Shinar look toward the Western Gate, they sit down
Silent at his voice: they view the red Globe of fire in Los's hand
As he walks from Furnace to Furnace directing the Labourers
And this is the Song of Los. that he sings on his Watch

O lovely mild Jerusalem! O Shiloh of Mount Ephraim!
I see thy Gates of precious stones! thy Walls of gold & silver
Thou art the soft reflected Image of the Sleeping Man
Who stretchd on Albions rocks reposes amidst his Twenty-eight
Cities: where Beulah lovely terminates, in the hills & valleys of Albion
Cities not yet embodied in Time and Space: plant ye
The Seeds O Sisters in the bosom of Time & Spaces womb
To spring up for Jerusalem: lovely Shadow of Sleeping Albion
Why wilt thou rend thyself apart & build an Earthly Kingdom
To reign in pride & to opress & to mix the Cup of Delusion
O thou that dwellest with Babylon! Come forth O lovely-one

86

I see thy Form O lovely mild Jerusalem, Wingd with Six Wings
In the opacous Bosom of the Sleeper. lovely Three-fold
In Head & Heart & Reins three Universes of love & beauty
Thy forehead bright: Holiness to the Lord, with Gates of pearl
Reflects Eternity beneath thy azure wings of feathery down
Ribbd delicate & clothd with featherd gold & azure & purple
From thy white shoulders shadowing, purity in holiness!
Thence feathered with soft crimson of the ruby bright as fire
Spreading into the azure Wings which like a canopy
Bends over thy immortal Head in which Eternity dwells
Albion beloved Land, I see thy mountains & thy hills
And valleys & thy pleasant Cities Holiness to the Lord
I see the Spectres of thy Dead O Emanation of Albion.

Thy Bosom white, translucent coverd with immortal gems
A sublime ornament not obscuring the outlines of beauty
Terrible to behold for thy extreme beauty & perfection
Twelve-fold here all the Tribes of Israel I behold
Upon the Holy Land: I see the River of Life & Tree of Life
I see the New Jerusalem descending out of Heaven

Between thy Wings of gold & silver featherd immortal
Clear as the rainbow, as the cloud of the Suns tabernacle

Thy Reins coverd with Wings translucent sometimes covering
And sometimes spread abroad reveal the flames of holiness
Which like a robe covers: & like a Veil of Seraphim
In flaming fire unceasing burns from Eternity to Eternity
Twelvefold I there behold Israel in her Tents
A Pillar of a Cloud by day: a Pillar of fire by night
Guides them: there I behold Moab & Ammon & Amalek
There Bells of silver round thy knees living articulate
Comforting sounds of love & harmony & on thy feet
Sandals of gold & pearl, & Egypt & Assyria before me
The Isles of Javan, Philistea. Tyre and Lebanon

Thus Los sings upon his Watch walking from Furnace to Furnace.
He siezes his Hammer every hour, flames surround him as
He beats: seas roll beneath his feet, tempests muster
Aroud his head. the thick hail stones stand ready to obey
His voice in the black cloud, his Sons labour in thunders
At his Furnaces; his Daughters at their Looms sing woes
His Emanation separates in milky fibres agonizing
Among the golden Looms of Cathedron sending Fibres of love
From Golgonooza with sweet visions for Jerusalem. wanderer.

Nor can any consummate bliss without being Generated
On Earth; of those whose Emanations weave the loves
Of Beulah for Jerusalem & Shiloh. in immortal Golgonooza
Concentering in the majestic form of Erin in eternal tears
Viewing the Winding Worm on the Desarts of Great Tartary
Viewing Los in his shudderings, pouring balm on his sorrows
So dread is Los's fury. that none dare him to approach
Without becoming his Children in the Furnaces of affliction

And Enitharmon like a faint rainbow waved before him
Filling with Fibres from his loins which reddend with desire
Into a Globe of blood beneath his bosom trembling in darkness
Of Albions clouds. he fed it, with his tears & bitter groans
Hiding his Spectre in invisibility from the timorous Shade
Till it became a separated cloud of beauty grace & love
Among the darkness of his Furnaces dividing asunder till
She separated stood before him a lovely Female weeping
Even Enitharmon separated outside, & his Loins closed
And heal'd after the separation: his pains he soon forgot:
Lured by her beauty outside of himself in shadowy grief.
Two Wills they had; Two Intellects: & not as in times of old.

Silent they wanderd hand in hand like two Infants wandring
From Enion in the desarts, terrified at each others beauty
Envying each other yet desiring, in all devouring Love,

87

Repelling weeping Enion blind & age-bent into the fourfold
Desarts Los first broke silence & began to utter his love

O lovely Enitharmon I behold thy graceful forms
Moving beside me till intoxicated with the woven labyrinth
Of beauty & perfection my wild fibrous brain in thrills
Of blood thro all my nervous limbs. soon overgrown in roots
I shall be closed from thy sight. sieze therefore in thy hand
The small fibres as they shoot around me draw out in pity
And let them run on the winds of thy bosom: I will fix them
With pulsations. we will divide them into Sons & Daughters
To live in thy Bosoms translucence as in an eternal morning

Enitharmon answerd. No! I will sieze thy Fibres & weave
Them: not as thou wilt but as I will, for I will Create
A round Womb beneath my bosom lest I also be overwoven
With Love; be thou assured I never will be thy slave
Let Mans delight be Love; but Womans delight be Pride
In Eden our loves were the same here they are opposite
I have Loves of my own I will weave them in Albions Spectre
Cast thou in Jerusalems shadows thy Loves! silk of liquid
Rubies Jacinths Crysolites: issuing from thy Furnaces, While
Jerusalem divides thy care: while thou carest for Jerusalem
Know that I never will be thine: also thou hidest Vala
From her these fibres shoot to shut me in a Grave.
You are Albions Victim, he has set his Daughter in your path

88

Los answerd sighing like the Bellows of his Furnaces

I care not! the swing of my Hammer shall measure the starry round
When in Eternity Man converses with Man they enter
Into each others Bosom (which are Universes of delight)
In mutual interchange. and first their Emanations meet
Surrounded by their Children. if they embrace & comingle
The Human Four-fold Forms mingle also in thunders of Intellect
But if the Emanations mingle not; with storms & agitations
Of earthquakes & consuming fires they roll apart in fear
For Man cannot unite with Man but by their Emanations
Which stand both Male & Female at the Gates of each Humanity
How then can I ever again be united as Man with Man
While thou my Emanation refusest my Fibres of dominion.
When Souls mingle & join thro all the Fibres of Brotherhood
Can there be any secret joy on Earth greater than this?

Enitharmon answerd: This is Womans World, nor need she any
Spectre to defend her from Man. I will Create secret places
And the masculine names of the places Merlin & Arthur.
A triple Female Tabernacle for Moral Law I weave
That he who loves Jesus may loathe terrified Female love
Till God himself become a Male subservient to the Female.

She spoke in scorn & jealousy, alternate torments; and
So speaking she sat down on Sussex shore singing lulling
Cadences. & playing in sweet intoxication among the glistening
Fibres of Los: sending them over the Ocean eastward into
The realms of dark death; O perverse to thyself, contrarious
To thy own purposes; for when she began to weave
Shooting out in sweet pleasure her bosom in milky Love
Flowd into the aching fibres of Los, yet contending against him
In pride sendinding his Fibres over to her objects of jealousy
In the little lovely Allegoric Night of Albions Daughters
Which stretchd abroad expanding east & west & north & south
Thro' all the World of Erin & of Los & all their Children

A sullen smile broke from the Spectre in mockery & scorn
Knowing himself the author of their divisions & shrinkings, gratified
At their contentions. he wiped his tears he washd his visage.

The Man who respects Woman shall be despised by Woman
And deadly cunning & mean abjectness only, shall enjoy them
For I will make their places of joy & love, excrementitious
Continually building. continually destroying in Family feuds
While you are under the dominion of a jealous Female
Unpermanent for ever because of love & jealousy.
You shall want all the Minute Particulars of Life

Thus joyd the Spectre in the dusky fires of Los's Forge, eyeing
Enitharmon who at her shining Looms sings lulling cadences
While Los stood at his Anvil in wrath the victim of their love
And hate: dividing the Space of Love with brazen Compasses
In Golgonooza & in Udan-Adan & in Entuthon of Urizen

The blow of his Hammer is Justice. the swing of his Hammer: Mercy
The force of Los's Hammer is eternal Forgiveness; but
The rage or his mildness were vain, she scatterd his love on the wind
Eastward into her own Center, creating the Female Womb
In mild Jerusalem around the Lamb of God. Loud howl
The Furnaces of Los! loud roll the Wheels of Enitharmon
The Four Zoa's in all their faded majesty burst out in fury
And fire Jerusalem took the Cup which foamd in Vala's hand
Like the red Sun upon the mountains in the bloody day
Upon the Hermaphroditic Wine-presses of Love & Wrath.

89

Tho divided by the Cross & Nails & Thorns & Spear
In cruelties of Rahab & Tirzah permanent endure
A terrible indefinite Hermaphroditic form
A Wine-press of Love & Wrath double Hermaphoditic
Twelvefold in Allegoric pomp in selfish holiness
The Pharisaion, the Grammateis, the Presbuterion,
The Archiereus, the Iereus, the Saddusaion, double
Each withoutside of the other, covering eastern heaven

Thus was the Covering Cherub reveald majestic image
Of Selfhood, Body put off. the Antichrist accursed
Coverd with precious stones. a Human Dragon terrible
And bright. stretchd over Europe & Asia gorgeous
In three nights he devourd the rejected. corse of death

His Head dark, deadly, in its Brain incloses a reflexion
Of Eden all perverted; Egypt on the Gihon many tongued
And many mouthd: Ethiopia. Lybia, the Sea of Rephaim
Minute Particulars in slavery I behold among the brick-kilns

Disorganizd, & there is Pharoh in his iron Court:
And the Dragon of the River & the Furnaces of iron.
Outwoven from Thames & Tweed & Severn awful streams
Twelve ridges of Stone frown over all the Earth in tyrant pride
Frown over each River stupendous Works of Albions Druid Sons
And Albions Forests of Oaks coverd the Earth from Pole to Pole

His Bosom wide reflects Moab & Ammon. on the River
Pison. since calld Arnon, there is Heshbon beautiful
The flocks of Rabbath on the Arnon & the Fish-pools of Heshbon
Whose currents flow into the Dead Sea by Sodom & Gomorra
Above his Head high arching Wings black filld with Eyes
Spring upon iron sinews from the Scapulae & Os Humeri.
There Israel in bondage to his Generalizing Gods
Molech & Chemosh. & in his left breast is Philistea
In Druid Temples over the whole Earth with Victims Sacrifice,
From Gaza to Damascus Tyre & Sidon & the Gods
Of Javan thro the Isles of Grecia & all Europes Kings
Where Hiddekel pursues his course among the rocks
Two Wings spring from his ribs of brass, starry, black as night
But translucent their blackness as the dazling of gems

His Loins inclose Babylon on Euphrates beautiful
And Rome in sweet Hesperia, there Israel scatterd abroad
In martydoms & slavery I behold: ah vision of sorrow!
Inclosed by eyeless Wings, glowing with fire as the iron
Heated in the Smiths forge, but cold the wind of their dread fury

But in the midst of a devouring Stomach, Jerusalem
Hidden within the Covering Cherub as in a Tabernacle
Of threefold workmanship in allegoric delusion & woe
There the Seven Kings of Canaan & Five Baalim of Philistea
Sihon & Og the Anakim & Emim, Nephilim & Gibborim
From Babylon to Rome & the Wings spread from Japan
Where the Red Sea terminates the World of Generation & Death
To Irelands farthest rocks where Giants builded their Causeway
Into the Sea of Rephaim. but the Sea oerwhelmd them all.

A Double Female now appeard within the Tabernacle,
Religion hid in War, a Dragon red & hidden Harlot
Each within other. but without a Warlike Mighty-one
Of dreadful power sitting upon Horeb pondering dire
And mighty preparations mustering multitudes innumerable
Of warlike sons among the sands of Midian & Aram
For multitudes of those who sleep in Alla descend
Lured by his warlike symphonies of tabret pipe & harp
Burst the bottoms of the Graves & Funeral Arks of Beulah
Wandering in that unknown Night beyond the silent Grave
They become One with the Antichrist & are absorbd in him

90

The Feminine separates from the Masculine & both from Man.
Ceasing to be His Emanations, Life to Themselves assuming:
And while they circumscribe his Brain. & while they circumscribe
His Heart, & while they circumscribe his Loins! a Veil & Net
Of Veins of red Blood grows around them like a scarlet robe.
Covering them from the sight of Man like the woven Veil of Sleep
Such as the Flowers of Beulah weave to be their Funeral Mantles
But dark: opake! tender to touch, & painful: & agonizing
To the embrace of love, & to the mingling of soft fibres
Of tender affection. that no more the Masculine mingles
With the Feminine. but the Sublime is shut out from the Pathos
In howling torment. to build stone walls of separation, compelling
The Pathos, to weave curtains of hiding secresy from the torment.

Bowen & Conwenna stood on Skiddaw cutting the Fibres
Of Benjamin from Chesters River: loud the River; loud the Mersey
And the Ribble. thunder into the Irish sea, as the Twelve Sons
Of Albion drank & imbibed the Life & eternal Form of Luvah
Cheshire & Lancashire & Westmoreland groan in anguish
As they cut the fibres from the Rivers he sears them with hot
Iron of his Forge & fixes them into Bones of chalk & Rock
Conwenna sat above: with solemn cadences she drew
Fibres of life out from the Bones into her golden Loom
Hand had his Furnace on Highgates heights & his reachd
To Brockley Hills across the Thames: he with double Boadicea
In cruel pride cut Reuben apart from the Hills of Surrey
Comingling with Luvah & with the Sepulcher of Luvah
For the Male is a Furnace of beryll: the Female is a golden Loom

Los cries: No Individual ought to appropriate to Himself
Or to his Emanation, any of the Universal Characteristics

Of David or of Eve, of the Woman. or of the Lord.
Of Reuben or of Benjamin, of Joseph or Judah or Levi
Those who dare appropriate to themselves Universal Attributes
Are the Blasphemous Selfhoods & must be broken asunder
A Vegetated Christ & a Virgin Eve, are the Hermaphroditic
Blasphemy, by his Maternal Birth he is that Evil-One
And his Maternal Humanity must be put off Eternally
Lest the Sexual Generation swallow up Regeneration
Come Lord Jesus take on thee the Satanic Body of Holiness

So Los cried in the Valleys of Middlesex in the Spirit of Prophecy
While in Selfhood Hand & Hyle & Bowen & Skofeld appropriate
The Divine Names: seeking to Vegetate the Divine Vision
In a corporeal & ever dying Vegetation & Corruption
Mingling with Luvah in One. they become One Great Satan

Loud scream the Daughters of Albion beneath the Tongs & Hammer
Dolorous are their lamentations in the burning Forge
They drink Reuben & Benjamin as the iron drinks the fire
They are red hot with cruelty: raving along the Banks of Thames
And on Tyburns Brook among the howling Victims in loveliness
While Hand & Hyle condense the Little-ones & erect them into
A mighty Temple even to the stars: but they Vegetate
Beneath Los's Hammer, that Life may not be blotted out.

For Los said: When the Individual appropriates Universality
He divides into Male & Female: & when the Male & Female,
Appropriate Individuality, they become an Eternal Death.
Hermaphroditic worshippers of a God of cruelty & law!
Your Slaves & Captives; you compell to worship a God of Mercy,
These are the Demonstrations of Los. & the blows of my mighty Hammer

So Los spoke. And the Giants of Albion terrified & ashamed
With Los's thunderous Words, began to build trembling rocking Stones
For his Words roll in thunders & lightnings among the Temples
Terrified rocking to & fro upon the earth, & sometimes
Resting in a Circle in Malden or in Strathness or Dura.
Plotting to devour Albion & Los the friend of Albion
Denying in private: mocking God & Eternal Life: & in Public
Collusion, calling themselves Deists, Worshipping the Maternal
Humanity: calling it Nature, and Natural Religion

But still the thunder of Los peals loud & thus the thunders cry
These beautiful Witchcrafts of Albion, are gratifyd by Cruelty

91

It is easier to forgive an Enemy than to forgive a Friend:
The man who permits you to injure him, deserves your vengeance:
He also will recieve it: go Spectre! obey my most secret desire:
Which thou knowest without my speaking: Go to these Fiends of Righteo[us]
Tell them to obey their Humanities, & not pretend Holiness;
When they are murderers: as far as my Hammer & Anvil permit
Go, tell them that the Worship of God, is honouring his gifts
In other men: & loving the greatest men best, each according
To his Genius: which is the Holy Ghost in Man; there is no other
God, than that God who is the intellectual fountain of Humanity;
He who envies or calumniates: which is murder & cruelty,
Murders the Holy-one: Go tell them this & overthrow their cup,
Their bread, their altar-table, their incense & their oath:
Their marriage & their baptism, their burial & consecration:
I have tried to make friends by corporeal gifts but have only
Made enemies: I never make friends but by spiritual gifts;
By severe contentions of friendship & the burning fire of thought.
He who would see the Divinity must see him in his Children
One first, in friendship & love; then a Divine Family, & in the midst
Jesus will appear; so he who wishes to see a Vision; a perfect Whole
Must see it in its Minute Particulars; Organized & not as thou
O Fiend of Righteousness pretendest; thine is a Disorganized
And snowy cloud: brooder of tempests & destructive War
You smile with pomp & rigor; you talk of benevolence & virtue!
I act with benevolence & virtue & get murderd time after time:
You accumulate Particulars, & murder by analyzing, that you
May take the aggregate; & you call the aggregate Moral Law:
And you call that Swelld & bloated Form; a Minute Particular.
But General Forms have their vitality in Particulars: & every
Particular is a Man; a Divine Member of the Divine Jesus.

So Los cried at his Anvil in the horrible darkness weeping!

The Spectre builded stupendous Works, taking the Starry Heavens
Like to a curtain & folding them according to his will
Repeating the Smaragdine Table of Hermes to draw Los down

Into the Indefinite, refusing to believe without demonstration
Los reads the Stars of Albion! the Spectre reads the Voids
Between the Stars; among the arches of Albions Tomb sublime
Rolling the Sea in rocky paths: forming Leviathan
And Behemoth; the War by Sea enormous & the War
By Land astounding: erecting pillars in the deepest Hell.
To reach the heavenly arches; Los beheld undaunted furious
His heavd Hammer; he swung it round & at one blow,
In unpitying ruin driving down the pyramids of pride
Smiting the Spectre on his Anvil & the integuments of his Eye
And Ear unbinding in dire pain, with many blows,
Of strict severity self-subduing, & with many tears labouring.

Then he sent forth the Spectre all his pyramids were grains
Of sand & his pillars: dust on the flys wing: & his starry
Heavens; a moth of gold & silver mocking his anxious grasp
Thus Los alterd his Spectre & every Ratio of his Reason
He alterd time after time, with dire pain & many tears
Till he had completely divided him into a separate space.

Terrified Los sat to behold trembling & weeping & howling
I care not whether a Man is Good or Evil; all that I care
Is whether he is a Wise Man or a Fool, Go! put off Holiness
And put on Intellect: or my thundrous Hammer shall drive thee
To wrath which thou condemnest: till thou obey my voice

So Los terrified cries: trembling & weeping & howling! Beholding

### 92

What do I see? The Briton Saxon Roman Norman amalgamating
In my Furnaces into One Nation the English: & taking refuge
In the Loins of Albion. The Canaanite united with the fugitive
Hebrew. whom she divided into Twelve. & sold into Egypt
Then scatterd the Egyptian & Hebrew to the four Winds:
This sinful Nation Created in our Furnaces & Looms is Albion

So Los spoke. Enitharmon answerd in great terror in Lambeths Vale

The Poets Song draws to its period & Enitharmon is no more.
For if he be that Albion I can never weave him in my Looms
But when he touches the first fibrous thread. like filmy dew

My Looms will be no more & I annihilate vanish for ever
Then thou wilt Create another Female according to thy Will.

Los answerd swift as the shuttle of gold. Sexes must vanish & cease
To be. when Albion arises from his dread repose O lovely Enitharmon:
When all their Crimes. their Punishments their Accusations of Sin:
All their Jealousies Revenges. Murders. hidings of Cruelty in Deceit
Appear only in the Outward Spheres of Visionary Space and Time.
In the shadows of Possibility by Mutual Forgiveness forevermore
And in the Vision & in the Prophecy. that we may Foresee & Avoid
The terrors of Creation & Redemption & Judgment. Beholding them
Displayd in the Emanative Visions of Canaan in Jerusalem & in Shiloh
And in the Shadows of Remembrance. & in the Chaos of the Spectre
Amalek, Edom. Egypt. Moab. Ammon. Ashur. Philistea. around Jerusalem
Where the Druids reard their Rocky Circles to make permanent Remembrance
Of Sin. & the Tree of Good & Evil sprang from the Rocky Circle & Snake
Of the Druid. along the Valley of Rephaim from Camberwell to Golgotha
And framed the mundane shell Cavernous in length breadth & highth

### 93

Enitharmon heard. She raisd her head like the mild Moon

O Rintrah! O Palamabron. What are your dire & awful purposes
Enitharmons name is nothing before you: you forget all my Love!
The Mothers love of obedience is forgotten & you seek a Love
Of the pride of dominion. that wilt Divorce Ocalythron & Elynittria
Upon East Moor in Derbyshire & along the Valleys of Cheviot
Could you Love me Rintrah, if you Pride not in my Love
As Reuben found Mandrakes in the field & gave them to his Mother
Pride meets with Pride upon the Mountains in the stormy day
In that terrible Day of Rintrahs Plow & of Satans driving the Team.
Ah! then I heard my little ones weeping along the Valley!
Ah! then I saw my beloved ones fleeing from my Tent
Merlin was like thee Rintrah among the Giants of Albion
Judah was like Palamabron: O Simeon! O Levi! ye fled away
How can I hear my little ones weeping along the Valley
Or how upon the distant Hills see my beloveds Tents.

Then Los again took up his speech as Enitharmon ceast

Fear not my Sons this Waking Death. he is become One with me

Behold him here! We shall not Die! we shall be united in Jesus.
Will you suffer this Satan this Body of Doubt that Seems but Is Not
To occupy the very threshold of Eternal Life. if Bacon, Newton, Locke

### 94

Albion cold lays on his Rock: storms & snows beat round him.
Beneath the Furnaces & the starry Wheels & the Immortal Tomb
Howling winds cover him: roaring seas dash furious against him
In the deep darkness broad lightnings glare long thunders roll

The weeds of Death inwrap his hands & feet blown incessant
And washd incessant by the for-ever restless sea-waves foaming abroad
Upon the white Rock. England a Female Shadow as deadly damps
Of the Mines of Cornwall & Derbyshire lays upon his bosom heavy
Moved by the wind in volumes of thick cloud returning folding round
His loins & bosom unremovable by swelling storms & loud rending
Of enraged thunders. Around them the Starry Wheels of their Giant Sons
Revolve: & over them the Furnaces of Los & the Immortal Tomb around
Erin sitting in the Tomb. to watch them unceasing night and day
And the Body of Albion was closed apart from all Nations.

Over them the famishd Eagle screams on boney Wings and around
Them howls the Wolf of famine deep heaves the Ocean black thundering
Around the wormy Garments of Albion: then pausing in deathlike silence

Time was Finished! The Breath Divine Breathed over Albion
Beneath the Furnaces & starry Wheels and in the Immortal Tomb
And England who is Brittannia awoke from Death on Albions bosom
She awoke pale & cold she fainted seven times on the Body of Albion

O pitious Sleep O pitious Dream! O God O God awake I have slain
In Dreams of Chastitity & Moral Law I have Murdered Albion! Ah!
In Stone-henge & on London Stone & in the Oak Groves of Malden
I have Slain him in my Sleep with the Knife of the Druid O England
O all ye Nations of the Earth behold ye the Jealous Wife
The Eagle & the Wolf & Monkey & Owl & the King & Priest were there

### 95

Her voice pierc'd Albions clay cold ear. he moved upon the Rock
The Breath Divine went forth upon the morning hills. Albion mov'd
Upon the Rock, he opend his eyelids in pain; in pain he mov'd
His stony members, he saw England. Ah! shall the Dead live again

The Breath Divine went forth over the morning hills Albion rose
In anger: the wrath of God breaking bright flaming on all sides around
His awful limbs: into the Heavens he walked clothed in flames
Loud thundring, with broad flashes of flaming lightning & pillars
Of fire, speaking the Words of Eternity in Human Forms, in direful
Revolutions of Action & Passion. thro the Four Elements on all sides
Surrounding his awful Members. Thou seest the Sun in heavy clouds
Struggling to rise above the Mountains, in his burning hand
He takes his Bow, then chooses out his arrows of flaming gold
Murmuring the Bowstring breathes with ardor! clouds roll around the
Horns of the wide Bow, loud sounding winds sport on the mountain brows
Compelling Urizen to his Furrow: & Tharmas to his Sheepfold;
And Luvah to his Loom: Urthona he beheld mighty labouring at
His Anvil, in the Great Spectre Los unwearied labouring & weeping
Therefore the Sons of Eden praise Urthonas Spectre in songs
Because he kept the Divine Vision in time of trouble.

As the Sun & Moon lead forward the Visions of Heaven & Earth
England who is Brittannia enterd Albions bosom rejoicing.
Rejoicing in his indignation! adoring his wrathful rebuke.
She who adores not your frowns will only loathe your smiles

### 96

As the Sun & Moon lead forward the Visions of Heaven & Earth
England who is Brittannia entered Albions bosom rejoicing

Then Jesus appeared standing by Albion as the Good Shepherd
By the lost Sheep that he hath found & Albion knew that it
Was the Lord the Universal Humanity. & Albion saw his Form
A Man. & they conversed as Man with Man, in Ages of Eternity
And the Divine Appearance was the likeness & similitude of Los

Albion said. O Lord what can I do: my Selfhood cruel
Marches against thee deceitful from Sinai & from Edom
Into the Wilderness of Judah to meet thee in his pride
I behold the Visions of my deadly Sleep of Six Thousand Years

Dazling around thy skirts like a Serpent of precious stones & gold
I know it is my Self: O my Divine Creator & Redeemer

Jesus replied Fear not Albion unless I die thou canst not live
But if I die I shall arise again & thou with me
This is Friendship & Brotherhood without it Man Is Not

So Jesus spoke: the Covering Cherub coming on in darkness
Overshadowed them & Jesus said Thus do Men in Eternity
One for another to put off by forgiveness, every sin

Albion replyd. Cannot Man exist without Mysterious
Offering of Self for Another, is this Friendship & Brotherhood
I see thee in the likeness & similitude of Los my Friend

Jesus said. Wouldest thou love me who never died
For thee or ever die for one who had not died for thee
And if God dieth not for Man & giveth not himself
Eternally for Man Man could not exist. for Man is Love:
As God is Love: every kindness to another is a little Death
In the Divine Image nor can Man exist but by Brotherhood

So saying. the Cloud overshadowing divided them asunder
Albion stood in terror: not for himself but for his Friend
Divine, & Self was lost in the contemplation of faith
And wonder at the Divine Mercy & at Los's sublime honour

Do I sleep amidst danger to Friends! O my Cities & Counties
Do you sleep! rouze up! rouze up. Eternal Death is abroad

So Albion spoke & threw himself into the Furnace of affliction
All was a Vision. all a Dream: the Furnaces became
Fountains of Living Waters flowing from the Humanity Divine
And all the Cities of Albion rose from their Slumbers, and All
The Sons & Daughters of Albion on soft clouds Waking from Sleep
Soon all around remote the Heavens burnt with flaming fires
And Urizen & Luvah & Tharmas & Urthona arose into
Albions Bosom: Then Albion stood before Jesus in the Clouds
Of Heaven Fourfold among the Visions of God in Eternity

### 97

Awake! Awake Jerusalem! O lovely Emanation of Albion
Awake and overspread all Nations as in Ancient Time
For lo the Night of Death is past and the Eternal Day
Appears upon our Hills: Awake Jerusalem. and come away

So spake the Vision of Albion & in him so spake in my hearing
The Universal Father Then Albion stretchd his hand into Infinitude.
And took his Bow, Fourfold the Vision for bright beaming Urizen

Layd his hand on the South & took a breathing Bow of carved Gold
Luvah his hand stretch'd to the East & bore a Silver Bow bright shining
Tharmas Westward a Bow of Brass pure flaming richly wrought
Urthona Northward in thick storms a Bow of Iron terrible thundering.

And the Bow is a Male & Female & the Quiver of the Arrows of Love.
Are the Children of this Bow: a Bow of Mercy & Loving-kindness: laying
Open the hidden Heart in Wars of mutual Benevolence Wars of Love
And the Hand of Man grasps firm between the Male & Female Loves
And he Clothed himself in Bow & Arrows in awful state Fourfold
In the midst of his Twenty-eight Cities each with his Bow breathing

### 98

Then each an Arrow flaming from his Quiver fitted carefully
They drew fourfold the unreprovable String. bending thro the wide Heavens
The horned Bow Fourfold, loud sounding flew the flaming Arrow fourfold

Murmuring the Bow-string breathes with ardor. Clouds roll round the horns
Of the wide Bow. loud sounding Winds sport on the Mountains brows:
The Druid Spectre was Annihilate loud thundring rejoicing terrific vanishing

Fourfold Annihilation & at the clangor of the Arrows of Intellect
The innumerable Chariots of the Almighty appeard in Heaven
And Bacon & Newton & Locke & Milton & Shakspear & Chaucer
A Sun of blood red wrath surrounding heaven on all sides around
Glorious incomprehsible by Mortal Man & each Chariot was Sexual Threefold

And every Man stood Fourfold. each Four Faces had. One to the West
One toward the East One to the South One to the North. the Horses Fourfold
And the dim Chaos brightend beneath, above, around! Eyed as the Peacock
According to the Human Nerves of Sensation, the Four Rivers of the Water of Life

South stood the Nerves of the Eye. East in Rivers of bliss the Nerves of the
Expansive Nostrils West. flowd the Parent Sense the Tongue. North stood
The labyrinthine Ear. Circumscribing & Circumcising the excrementitious
Husk & Covering into Vacuum evaporating revealing the lineaments of Man
Driving outward the Body of Death in an Eternal Death & Resurrection
Awaking it to Life among the Flowers of Beulah rejoicing in Unity
In the Four Senses in the Outline the Circumference & Form, for ever
In Forgiveness of Sins which is Self Annihilation. it is the Covenant of Jehovah

The Four Living Creatures Chariots of Humanity Divine Incomprehensible
In beautiful Paradises expand These are the Four Rivers of Paradise
And the Four Faces of Humanity fronting the Four Cardinal Points
Of Heaven going forward forward irresistible from Eternity to Eternity

And they conversed together in Visionary forms dramatic which bright
Redounded from their Tongues in thunderous majesty, in Visions
In new Expanses, creating exemplars of Memory and of Intellect
Creating Space, Creating Time according to the wonders Divine
Of Human Imagination. throughout all the Three Regions immense
Of Childhood, Manhood & Old Age & the all tremendous unfathomable Non
Of Death was seen in regenerations terrific or complacent varying
According to the subject of discourse & every Word & Every Character
Was Human according to the Expansion or Contraction. the Translucence or
Opakeness of Nervous fibres such was the variation of Time & Space
Which vary according as the Organs of Perception vary & they walked
To & fro in Eternity as One Man reflecting each in each & clearly seen
And seeing: according to fitness & order. And I heard Jehovah speak
Terrific from his Holy Place & saw the Words of the Mutual Covenant Divine
On Chariots of gold & jewels with Living Creatures starry & flaming
With every Colour. Lion. Tyger. Horse. Elephant. Eagle Dove. Fly. Worm.
And the all wondrous Serpent clothed in gems & rich array Humanize
In the Forgiveness of Sins according to the Coventet of Jehovah. They Cry

Where is the Covenant of Priam. the Moral Virtues of the Heathen
Where is the Tree of Good & Evil that rooted beneath the cruel heel
Of Albions Spectre the Patriarch Druid! where are all his Human Sacrifice
For Sin in War & in the Druid Temples of the Accuser of Sin: beneath
The Oak Groves of Albion that coverd the whole Earth beneath his Spectre
Where are the Kingdoms of the World & all their glory that grew on Desolation
The Fruit of Albions Poverty Tree when the Triple Headed Gog-Magog Giant
Of Albion Taxed the Nations into Desolation & then gave the Spectrous Oath

Such is the Cry from all the Earth from the Living Creatures of the Earth
And from the great City of Golgonooza in the Shadowy Generation

And from the Thirty-two Nations of the Earth among the Living Creatures

### 99

All Human Forms identified even Tree Metal Earth & Stone. all
Human Forms identified. living going forth & returning wearied
Into the Planetary lives of Years Months Days & Hours reposing
And then Awaking into his Bosom in the Life of Immortality.

And I heard the Name of their Emanations they are named Jerusalem

The End of The Song
of Jerusalem

### THE GHOST of ABEL

A Revelation In the Visions of Jehovah

Seen by William Blake

To LORD BYRON in the Wilderness

What doest thou here Elijah?
Can a Poet doubt the Visions of Jehovah? Nature has no Outline:
but Imagination has, Nature has no Tune: but Imagination has!
Nature has no Supernatural & dissolves: Imagination is Eternity

Scene. A rocky Country. Eve fainted over the dead body
of Abel which lays near a Grave. Adam kneels by her Jehovah
stands above

Jehovah    Adam!
Adam      I will not hear thee more thou Spiritual Voice
Is this Death?
Jehovah      Adam!
Adam      It is in vain: I will not hear thee
Henceforth! Is this thy Promise that the Womans Seed
Should bruise the Serpents head: Is this the Serpent? Ah!
Seven times O Eve thou hast fainted over the Dead Ah! Ah!
Eve revives
Eve    Is this the Promise of Jehovah! O it is all a vain delusion
This Death & this Life & this Jehovah!
Jehovah      Woman! lift thine eyes
A Voice is heard coming on
Voice    O Earth cover not thou my Blood! cover not thou my Blood
Enter the Ghost of Abel
Eve    Thou Visionary Phantasm thou art not the real Abel.
Abel    Among the Elohim a Human Victim I wander I am their House
Prince of the Air & our dimensions compass Zenith & Nadir
Vain is thy Covenant O Jehovah I am the Accuser & Avenger
Of Blood O Earth Cover not thou the Blood of Abel
Jehovah    What Vengeance dost thou require
Abel    Life for Life! Life for Life!
Jehovah    He who shall take Cains life must also Die O Abel
And who is he? Adam wilt thou. or Eve thou do this
Adam    It is all a Vain delusion of the all creative Imagination
Eve come away & let us not believe these vain delusions
Abel is dead & Cain slew him! We shall also Die a Death
And then! what then! be as poor Abel a Thought: or as
This! O what shall I call thee Form Divine: Father of Mercies
That appearest to my Spiritual Vision: Eve seest thou also.
Eve    I see him plainly with my Minds Eye, I see also Abel living:
Tho terribly afflicted as We also are. yet Jehovah sees him
Alive & not Dead: were it not better to believe Vision
With all our might & strength tho we are fallen & lost
Adam    Eve thou hast spoken truly. let us kneel before his feet.

They Kneel before Jehovah

Adam    We worship thee in Spirit & in Truth thou dwellest not
And a Contrite Heart. O I cannot Forgive! the Accuser hath
Enterd into Me as into his House & I loathe thy Tabernacles
As thou hast said so is it come to pass; My desire is unto Cain
And He doth rule over Me: therefore My Soul in fumes of Blood
Cries for Vengeance: Sacrifice on Sacrifice Blood on Blood
Jehovah    Lo I have given you a Lamb for an Atonement instead
Of the Transgresor. or no Flesh or Spirit could ever Live
Abel    Compelled I cry O Earth cover not the Blood of Abel

Abel sinks down into the Grave. from which arises Satan
Armed in glittering scales with a Crown & a Spear

Satan    I will have Human Blood & not the blood of Bulls or Goats
And no Atonement O Jehovah the Elohim live on Sacrifice
Of Men; hence I am God of Men: Thou Human O Jehovah.
By the Rock & Oak of the Druid creeping Misletoe & Thorn
Cains City built with Human Blood. not Blood of Bulls & Goats
Thou shalt Thyself be Sacrificed to Me thy God on Calvary
Jehovah    Such is My Will:      Thunders
that Thou Thyself go to Eternal Death
In Self Annihilation even till Satan Self-subdud Put off Satan
Into the Bottomless Abyss whose torment arises for ever & ever.

On each side a Chorus of Angels entering Sing the following

The Elohim of the Heathen Swore Vengeance for Sin! Then Thou stoodst
Forth O Elohim Jehovah! in the midst of the darkness of the Oath! All Clothed
In Thy Covenant of the Forgiveness of Sins: Death O Holy! Is this Brotherhood
The Elohim saw their Oath Eternal Fire; they rolled apart trembling over The
Mercy Seat: each in his station fixt in the Firmament by Peace Brotherhood and
The Curtain falls      Love.

The Voice of Abels
Blood

1822 W Blakes Original Stereotype was 1788

### On Homers Poetry

Every Poem must necessarily be a perfect Unity, but why
Homers is peculiarly so. I cannot tell; he has told the
story of Bellerophon & omitted the Judgment of Paris which
is not only a part, but a principal part of Homers subject
But when a Work has Unity it is as much in a Part as in the
Whole. the Torso is as much a Unity as the Laocoon
As Unity is the cloke of folly so Goodness is the cloke of
knavery Those who will have Unity exclusively in Homer
come out with a Moral like a sting in the tail: Aristotle says
Characters are either Good or Bad: now Goodness or Badness
has nothing to do with Character. an Apple tree a Pear tree
a Horse a Lion. are Characters but a Good Apple tree or a
Bad. is an Apple tree still: a Horse is not more a Lion for
being a Bad Horse. that is its Character; its Goodness or
Badness is another consideration.
It is the same with the Moral of a whole Poem as with the
Moral Goodness of its parts Unity & Morality. are secondary
considerations & belong to Philosophy & not to Poetry. to Excep-
-tion & not to Rule. to Accident & not to Substance. the Anci-
ents calld it eating of the tree of good & evil.

The Classics, it is the Classics!
& not Goths nor Monks, that
Desolate Europe with Wars.

### On Virgil

Sacred Truth has pronounced that Greece & Rome as
Babylon & Egypt: so far from being parents of Arts & Sci-
-ences as they pretend: were destroyers of all Art. Homer
Virgil & Ovid confirm this opinion & make us reverence
The Word of God. the only light of antiquity that remains
unperverted by War. Virgil in the Eneid Book VI, line 848
says Let others study Art: Rome has somewhat better to
do. namely War & Dominion

Rome & Greece swept Art into their maw & destroyd it
a Warlike State never can produce Art. It will Rob & Plunder
& accumulate into one place. O Too Late Et Carpe Et Rape &
Sell & Criticise. but not Make. Grecian is Mathematic Form
Gothic is Living Form
Mathematic Form is Eternal in the Reasoning Memory. Living Form
is Eternal Existence[a]

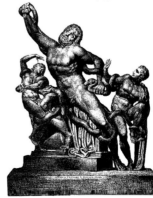

## LAOCOÖN

If Morality was Christianity Socrates was the Saviour
יה & his two Sons Satan & Adam as they were copied from the Cherubim

of Solomons Temple by three Rhodians & applied to Natural Fᵃct, or History of Ilium
    Art Degraded Imagination Denied War Governed the Nations

[above the serpent's head on the left]
Evil

[around the right arm of the left figure]
    Good & Evil are
Riches & Poverty a Tree of
            Misery
      propagating
      Generation & Death

[around the right arm of the central figure]
The Gods of Priam are the Cherubim of Moses & Solomon: The Hosts
                        of Heaven

  Without Unceasing Practise nothing can be done Practise is Art
    If you leave off you are Lost

[above the central figure]
The Angel of the Divine Presence
מלאר יהוה
OΦlovΧος

[in an arc above and to the right of the central figure]
        Hebrew Art is
    called Sin by the Deist Science
  All that we See is Vision
from Generated Organs gone as soon as come
      Permanent in The Imagination; Considerd
      as Nothing by the
        Natural Man

[vertically above the preceding lines]
What can be Created
Can be Destroyed
  Adam is only
The Natural Man
& not the Soul
or Imagination

[above the head of the serpent biting the central figure's left hip]
Good

[below the central figure's left hand]
לילית

[around the head and left side of the right figure]
Satans Wife The Goddess Nature is War & Misery & Heroism a Miser

[vertically in the left margin, bottom to top]
  Spiritual War
Israel deliverd from Egypt
  is Art deliverd from
    Nature & Imitation

    A Poet a Painter a Musician an Architect : the Man
    Or Woman who is not one of these is not a Christian
You must leave Fathers & Mothers & Houses & Lands if they stand in the way of Art

The Eternal Body of Man is The Imagination, that is God himself
              The Divine Body ⎰ ישע Jesus we are his
                        Members
      It manifests itself in his Works of Art (In Eternity All is Vision)
The True Christian Charity not dependent on Money (the lifes blood of Poor Families)
    that is on Caesar or Empire or Natural Religion
Money, which is The Great Satan or Reason
    the Root of Good & Evil
    In The Accusation of Sin

Prayer is the Study of Art      Fasting &ᶜ all relate to Art
Praise is the Practise of Art     The outward Ceremony is Antichrist

[horizontally in the top margin]
  Where any view of Money exists Art cannot be carried on, but War only Read
              Matthew C Y 0 9ᵗ 10 ⅴ
by pretences to the Two Impossibilities Chastity & Abstinence Gods of the Heathen

He repented that he had made Adam
    (of the Female, the Adamah)
        & it grieved him at his heart

[horizontally in the right margin]
Art can never exist without
    Naked Beauty displayed

The Gods of Greece & Egypt were Mathematical
                  Diagrams
               See Plato's
                 Works

      Divine Union
      Deriding
      And Denying Immediate
      Communion with God
      The Spoilers say
      Where are his Works
      That he did in the Wilderness
      Lo what are these
Whence came they
These are not the Works
Of Egypt nor Babylon
Whose Gods are the Powers
Of this World. Goddess, Nature.
Who first spoil & then destroy
Imaginative Art
For their Glory is
War and Dominion

Empire against Art    See Virgils Eneid.
                Lib. VI.v 848

For every
Pleasure
Money
Is Useless

  There are States
    in which. all
    Visionary Men
    are accounted
      Mad Men
    such are
  Greece & Rome
Such is
Empire
or Tax
See Luke Ch 2.v 1

[vertically in the right margin, top to bottom]
Jesus & his Apostles & Disciples were all Artists Their Works were destroyd
      Seven Angels of the Seven Churches in Asia  Antichrist S
    The unproductive Man is not a Christian much less the Destro

The Old & New Testaments are    Science is the
  the Great Code of Art   Art is the    Tree of Death
                Tree
                of Life
                GOD
              is Jesus

    The Whole Business of Man Is
    The Arts & All Things   Common
           No Secre
           sy in Art

What we call Antique Gems    Christianity is Art
  are the Gems of Aarons Breast Plate  & not Money

Is not every Vice possible to Man    Money is its Curse
  described in the Bible openly
All is not Sin that Satan calls so
  all the Loves & Graces of Eternity

[signature on the plinth]
Drawn & Engraved by William Blake